FORMULA ONLE THE ILLUSTRATED HISTORY

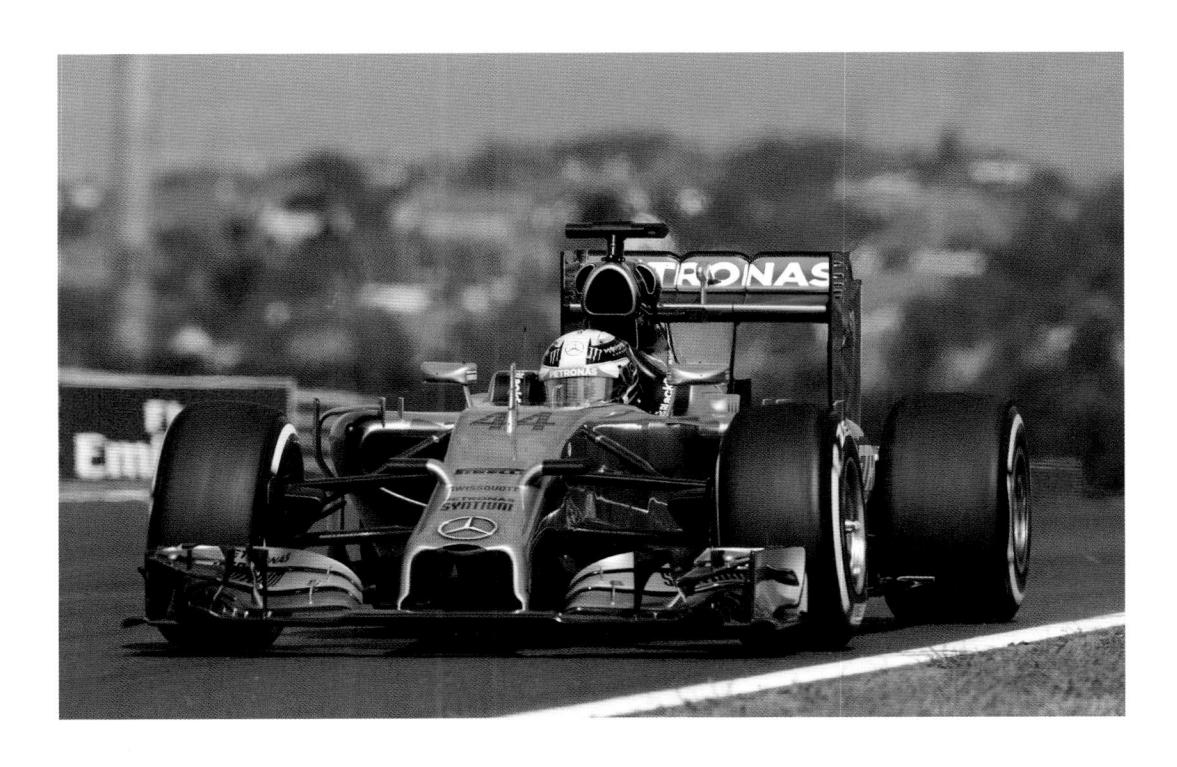

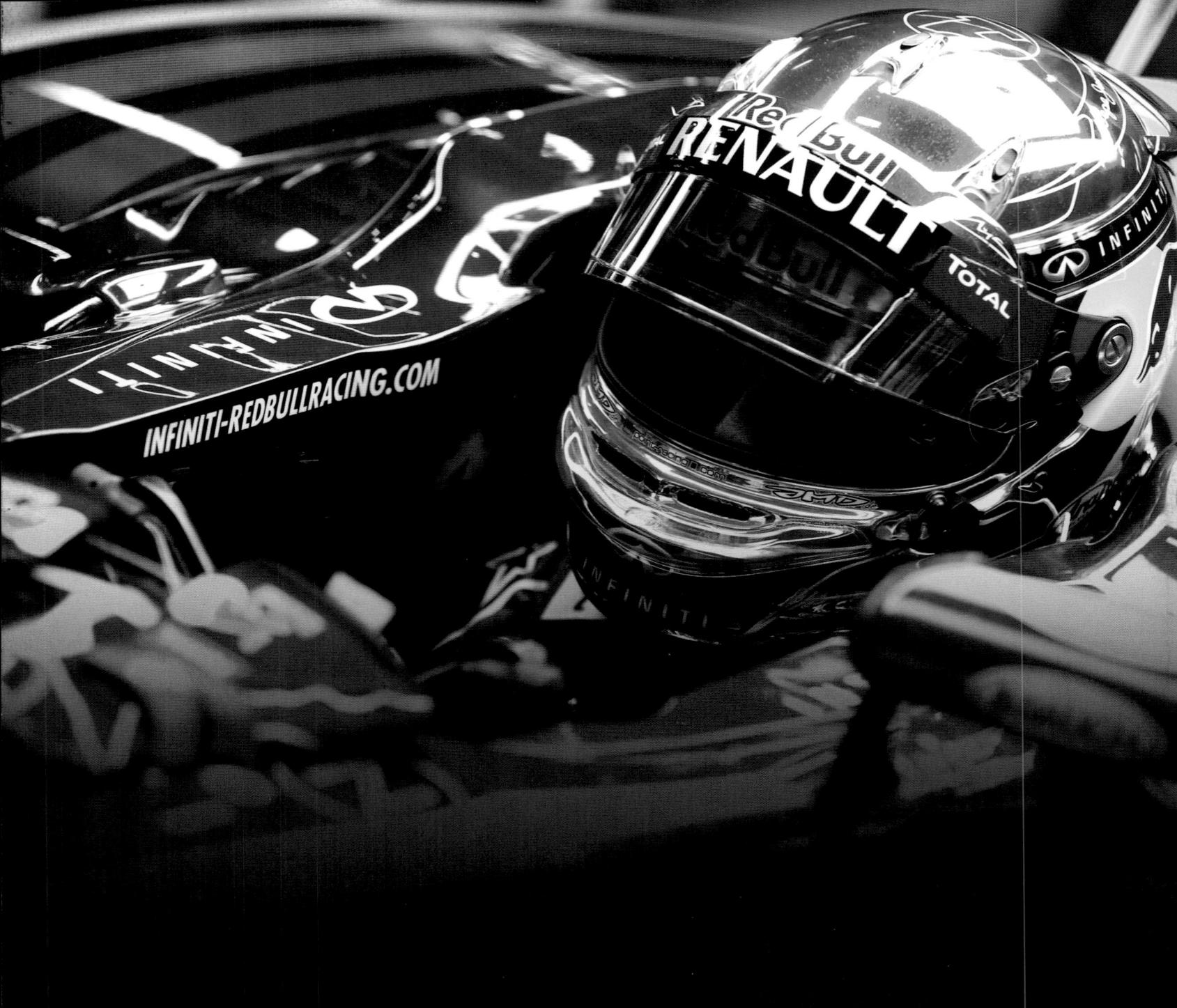

First published in 1999 (as 50 Years of the Formula One World Championship)

Second Edition 2005 (as 55 Years of the Formula One World Championship)

Third Edition 2009 (as 60 Years of the Formula One World Championship) This edition published in 2015 (as Formula One: The Illustrated History)

Copyright © Carlton Books Limited 1999, 2005, 2009, 2015

Carlton Books Limited 20 Mortimer Street London W1T 3JW

PREVIOUS PAGE LEWIS HAMILTON IN ACTION FOR MERCEDES IN 2014.

All rights reserved. No part of this publication may be reproduced, stored in a retrieval system, or transmitted in any form or by any means, electronic, mechanical, photocopying, recording or otherwise, without the prior permission of the copyright owner and the publishers.

A CIP catalogue record for this book is available from the British Library

ISBN: 978-1-78097-631-0

Editor: Martin Corteel Designer: Luke Griffin Picture research: Paul Langan Production: Janette Burgin

Printed in Dubai

ABOVE QUADRUPLE WORLD CHAMPION SEBASTIAN VETTEL IN HIS RED BULL RB10 IN 2014.

FORMULA COLL THE ILLUSTRATED HISTORY

Featuring **exclusive** contributions from:

TONY BROOKS, JOHN SURTEES, JACKIE STEWART, NIGEL MANSELL, DAVID COULTHARD, JARNO TRULLI & MARK WEBBER

BRUCE JONES

CONTENTS

11 INTRODUCTION

THE FIFTIES

includes an interview with TONY BROOKS

THE SIXTIES

includes an interview with JOHN SURTEES

108
THE SEVENTIES

includes an interview with JACKIE STEWART

156 THE EIGHTIES

includes an interview with NIGEL MANSELL

THE NINETIES

includes an interview with DAVID COULTHARD

258 THE NOUGHTIES

includes an interview with JARNO TRULLI

THE TEENS

includes an interview with MARK WEBBER

FORMULA ONE RECORDS

INTRODUCTION

Sixty-five years, more than half a century, is a long time by anyone's reckoning. Yet in few walks of life can anything have been transformed as comprehensively as Formula One during this period. There had been Grands Prix both before and after the Second World War, but the motor industry was ready for something more cohesive. Enter the Formula One World Championship in 1950, and motor sport has not looked back since.

Compare the machinery assembled on the grid for that first World Championship at Silverstone with the cars gracing the tracks as the second decade of the twenty-first century reaches its midway point and it's a case of crude and front-engined versus sleek, safe and rear-engined.

Everything bar the pure love of speed has changed, with the development and innovation continual and frequently coming in astonishing jumps as the great technical minds such as that of Lotus founder Colin Chapman came up with yet another way to make the most of the rules. The engines had been moved to sit behind the driver before the first decade was out, with aerodynamic wings hitting the tracks in the 1960s and slick tyres in the 1970s. Then came ground-effect, turbo engines and carbon fibre brakes. Driver aids such as anti-lock brakes, semi-automatic gearboxes and traction control followed, with developments of many of these trickling down to the cars that we would drive on the road.

Amazing as this progress has been, it raises the most often imponderable of all racing questions: how can you compare drivers from different eras? The simple answer is that you can't, although understanding the infinite variables helps when you compare the skills of Juan Manuel Fangio, Ayrton Senna and Michael Schumacher, despite the fact Fangio stopped racing before the 1950s were out, Senna didn't arrive in Formula One until 1984 and Schumacher hit the front 10 years later and was undeniably the man to beat until he retired at the end of 2006.

To help you understand Formula One's remarkable evolution, I looked to speed and brains in picking drivers from each of the seven decades to talk about their time in F1. Hopefully, the collected thoughts of Tony Brooks, John Surtees, Jackie Stewart, Nigel Mansell, David Coulthard, Jarno Trulli and Mark Webber will enlighten and entertain you as we celebrate Formula One's enduring appeal.

THE FIFTIES

TONY BROOKS

Honours: 2ND 1959, 3RD 1958

Grand Prix record: 38 STARTS, 6 WINS

Tony Brooks was possibly the most talented driver from Britain to race in the 1950s, yet, like his contemporary Stirling Moss he was never to become World Champion, retiring from Formula One with six Grand Prix wins to his name and yet without having brought his career to fruition. However, the fact that he survived it at all in an age when so many of his contemporaries died in action shows that he was an intelligent mastercraftsman.

Most people recall the race that made Tony's name, the non-championship Syracuse Grand Prix in Sicily in 1955. Even today mention of this race elicits a wry smile from Tony. "Yes, it launched my career, but it almost swamped it as people always want to talk about that before talking about anything else." Mind you, this isn't surprising as it was his first race in a Formula One car and he beat the works Maseratis on a circuit that he'd never seen until that weekend.

Tony recalls the race thus: "First I have to tell you how I came to be racing there. John Riseley-Pritchard and I had a successful test with Aston Martin in the winter of 1954 and were invited to join the works team for 1955. John's first drive was at Le Mans, the dreadful one in which 80 spectators were killed, and his family put pressure on him to stop. He had a Formula Two Connaught and he asked me to drive it. I wanted to try a single-seater, so I drove it in four national races and as a result of my performances in these I was invited to race Connaught's Formula One car at Syracuse. I shouldn't kid myself that I was first choice, as it was

after the end of the season and I'm sure they couldn't get anyone else to drive. Secondly, the Connaught was not very reliable and, thirdly, Syracuse was at the far end of Italy.

"I was more concerned with my upcoming dentistry exams than graduating to Formula One. Luckily, the car handled beautifully, and if it had had a good engine it would have been a regular World Championship challenger. As it was, this one had a 2.5-litre Alta which had been bored out from two litres and lost out as it had insufficient power and poor reliability. But it was a lot more powerful than the 1.5-litre Formula Two Connaught I'd raced.

"Worried about the car's reliability and wanting to be sure I started so that the team could claim start money, we limited my mileage in qualifying so that I was still learning the car and the track when I started the race from third on the grid. I went straight into the lead and broke clear, but I soon started thinking that Connaughts didn't often finish and backed off 500 revs to be sure. Luckily the engine had plenty of torque and I scored the first win for a British driver in a British car since 1924."

TONY BROOKS

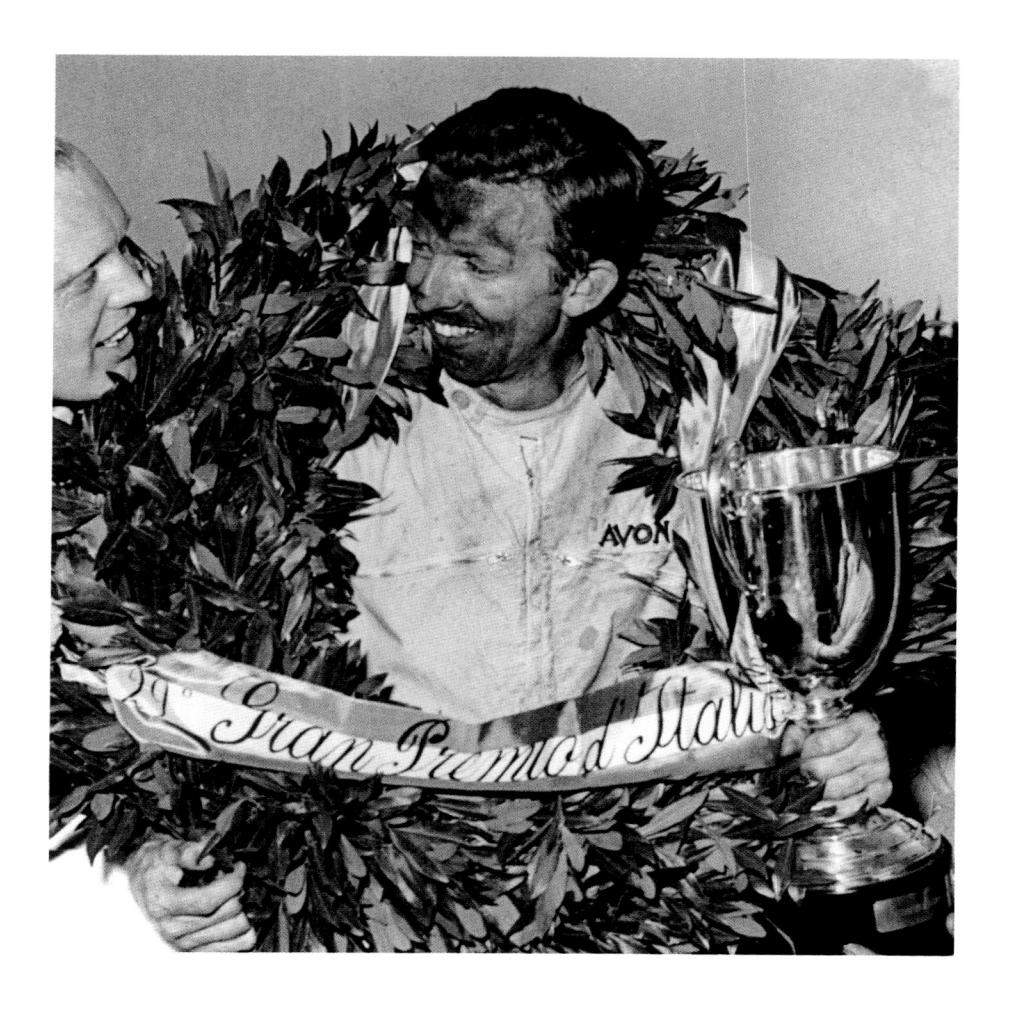

Not surprisingly, this led to offers and Tony joined Mike Hawthorn at BRM for 1956. But it didn't run smoothly. Although the car was fast with a fantastic power-to-weight ratio, inadequate brakes were the root of the BRM P25's problems, including in the Aintree 200 when fading brakes dropped Tony to second behind Moss's Maserati.

"All in all, 1956 was a disaster, and my first World Championship start was nearly my last. This was the British Grand Prix driving the lethal BRM. Mike turned his over at Goodwood and then I did the same at Silverstone, but at least I did the decent thing and set it on fire. My accelerator stuck at Abbey, this after it had broken earlier and I had lost several laps in the pits as it was lashed up. When I rejoined I knew that it was sticking, but I knew I could take Abbey flat. Trouble was, there was now more oil and rubber down and I needed a quick lift, but the throttle didn't respond and I ran onto the grass. With a decent car I could have run along the grass and eased back onto the track. With the BRM, if there was anything untoward you lost it. So I spun, hit the bank and was flipped out

onto the grass. It was stupid that I was out there trying to go as fast as that even though I was laps down, but I had only raced at Syracuse and wanted to prove that I could drive a Formula One car quickly. With more experience, I would have parked up, but it taught me a lesson, nearly a fatal one and I escaped with a broken jaw."

Tony had started 1957 by having his eyes opened by racing a Cooper in the International Trophy at Silverstone. "This was the defining moment of the 1950s for me, the event that made people take notice of the potential of rear-engined cars when I qualified on pole with a 2-litre engine ahead of the 2.5-litre opposition. It wasn't a World Championship entry, but it showed people that they had to put the weight where it should be, over the back wheels, which makes sense when you're trying to put the power down through these back wheels. Design never looked back after that. The cars were easier to drive, turned better, and being lighter stopped better, as well as being more aerodynamic. This performance proved that they were more than toys."

THE FIFTIES

Tony entered the World Championship with Vanwall and kicked off with second behind Fangio's Maserati at Monaco. But then came a second incident that shaped his thoughts on racing a defective car. This came at Le Mans when he was again racing for Aston Martin.

"I was taking over from Noel Cunnigham-Reid at 3AM with the car lying in second place but stuck in fourth gear. I thought I knew how to fix it and made the mistake of looking at the gear lever rather than the road ahead. When I looked up, I realised I had missed the braking point for Tertre Rouge. I ran wide, clipped a sandbank and flipped, landing upside down in the track. I was trapped and was left to wonder if it would be a simple run-over job or incineration. Umberto Maglioli was the first on the scene, knocking the car off me. I then leapt clear with burned legs. It was sheer stupidity and I should have waited until the Mulsanne Straight before trying to fix it. Hereafter, I made myself a promise never to drive flat-out in a mechanically flawed car. It never affected my attitude to risk, as shown by the fact I scored my six Grand Prix wins after this second mishap, but it modified it when all was not right with a car."

Back in the cockpit for the British Grand Prix at Aintree, Tony wasn't well enough to go the distance and so handed his car over to team leader Moss when his own car had blown its engine, and Moss drove on to give them a combined victory.

So, 1957 saw Tony join the ranks of Grand Prix winners, but latter-day fans often question the level of competition in the late 1950s, especially as the grids were rounded out with Formula Two cars. Tony has views on this: "Even today the races tend to be between three or four people. Certainly, the last third of the field was sometimes made up by Formula Two cars, but this didn't make it any less competitive, it merely provided mobile chicanes for the drivers at the front to steer around. They added to the show. One has to look at the time differential not from the front of the grid to the back, but from the front of the grid to the slowest 2.5-litre car."

There was another factor that has to be considered when trying to compare the merits of drivers across the decades. And this is reliability, something that was poor in the 1950s, requiring drivers to learn how to nurse their machinery to reach the finish.

"Reliability was poor, but it gave drivers a chance to show their skills. Niki Lauda said how easy drivers have it in the 1990s after he drove the McLaren two-seater and found everything was done for the driver in the cockpit. In the 1950s there was much more scope for a driver to demonstrate superiority, whereas it's now down to technology, with a few tenths difference between Michael Schumacher and the rest.

"My philosophy was that you should try to win at the lowest speed possible. It seemed obvious, but not everybody practiced this, to my advantage actually. If you drove a car to the limit all the time, taking it up to maximum revs, hauling the gear lever through, you were going to increase your chance of failure, because the standard of engineering was blacksmith-like compared to today's space-age standards. You had to watch the rev counter as there were no rev limiters. And it wasn't just changing down when you ran the risk of over-revving, as you could do so accelerating out of a corner if you were drifting and trying to watch where you were heading and the rev counter at the same time.

"We also had excess power. This was only around 280bhp, but

that was on narrow tyres that were extremely hard. So, if someone had slightly more power than you, you could still do something about it by making sure that you didn't spin your wheels out of a corner and thus would be as quick or quicker up the next straight. Today, with the amazing grip the cars have, you just bang your foot down and 20 extra horsepower will really show. The scope to compensate has long since gone. There was so much scope for a driver to show his skill in the 1950s. Not just in speed, but also in reliability. This point is not always recognised. I'm not going to name names, but there were some people who'd have won a lot more races if they'd had more empathy with the car."

The quality of circuits was something else that could separate the men from the boys, with trees and walls often lining the narrow tracks. They were bumpy, too. Tony continued: "The roughness of the surface was an additional challenge rather than a car breaker as the cars were generally massively-built and suspension failures were a rarity. It was transmissions that tended to go. If you were hammering a car out of a corner over bumps, it was rather like a speedboat on waves with its prop leaving the water, you could do a lot of damage through excess wheelspin then sudden grip.

"The races were longer, too, with distances of 500 kilometres before 1958 before they were shortened to 300 kilometres. To be honest, 500 kilometres was too long for the spectators and for some of the cars. Stamina was crucial, as even though distances were reduced, it took us longer to cover 300 kilometres than it does the same distance today.

"People often talk of how physical it must have been to drive these cars, but it's a myth that the steering was ultra-heavy. What was physically draining was the heat from the engine. It could affect your concentration. The brakes were heavy, though. As to the steering, racing at somewhere like Spa you would caress the steering wheel and the throttle as the car was balanced on a knife-edge with all four tyres sliding. You would alter the angle of the car by delicate inputs, not like today when it's a matter of brute force. I find all this 4-g business gruesome. What's that got to do with ordinary driving? Do we really want to know if we've got Mike Tyson-size neck muscles? If we want to find this out, let's have neck wrestling events... It's anathema to me, as driving should be poetry in motion. Take Spa, apart from La Source, every other corner was taken in a four-wheel drift. Today the whole finesse has gone. I think they're missing so much. But they seem to enjoy it and they get paid a fortune, so good luck to them. In terms of the sensual pleasure of driving I think they're missing out. But I must be careful as I haven't driven a contemporary Formula One car. In fact, I don't think I want to as it would have to be all or nothing for me."

Understandably, drivers in the 1990s have to spend a great deal of time in the gym getting fit enough to survive the g-forces they encounter in a race. Surely this is something that would have been alien to Tony?

"Well, I played a lot of squash and tennis and was always fit, keeping a sensible diet. But I never visited a gym. Stirling (Moss) was probably the first really professional driver. Behind the wheel I took it just as seriously as he did, but out of the car I wasn't tyring to be commercial, whereas Stirling was. Neither Stirling nor I drank, whereas Mike (Hawthorn) was the contrast..."

Safety is another factor that has changed out of all recognition. "There were on average three or four drivers killed each year in the

TONY BROOKS

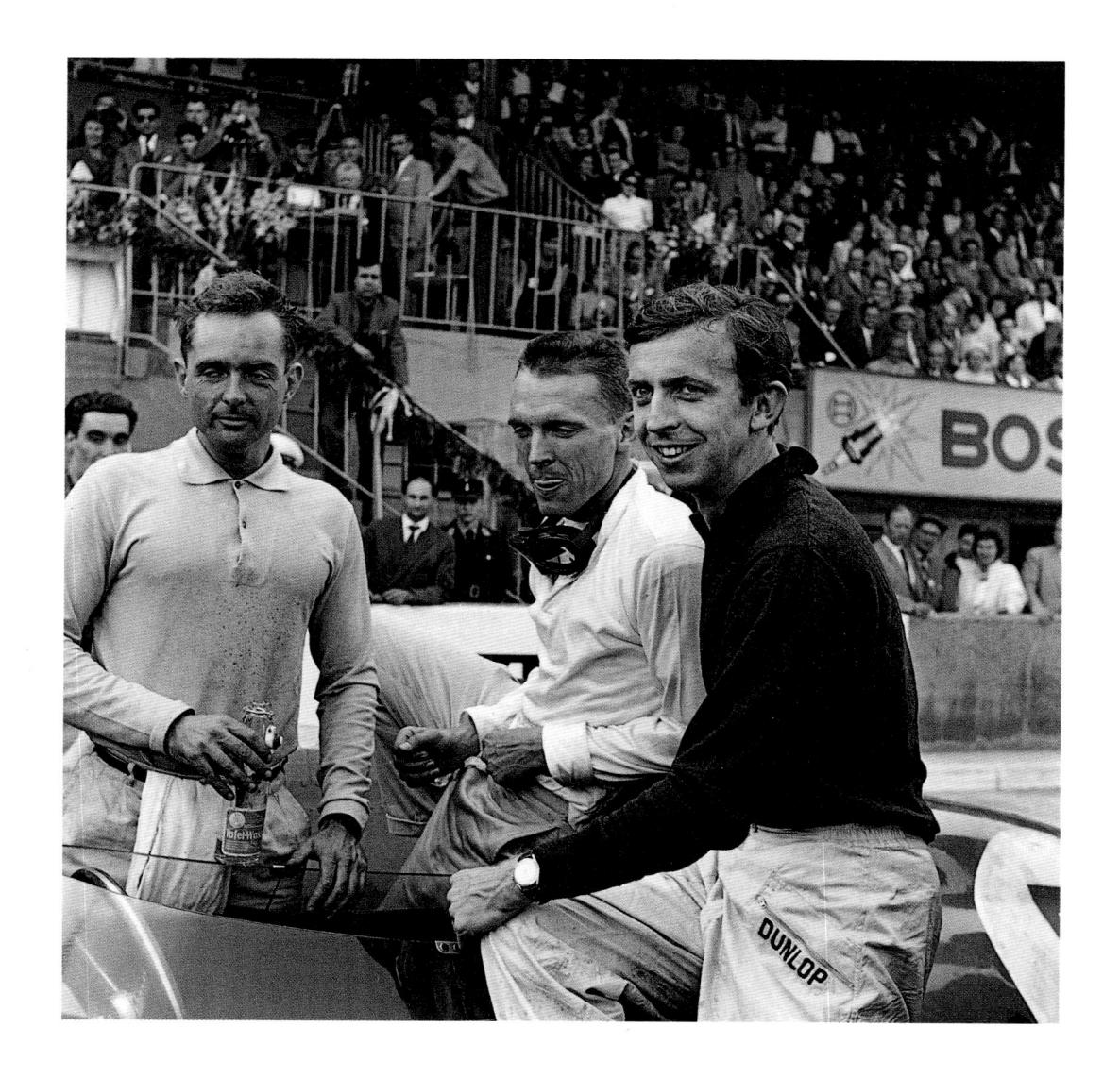

1950s. It's wonderful that it's so much safer now, but Formula One today is not the same. In my day it was Grand Prix motor racing, today it's Formula One, it's a totally different sport because we knew that one mistake could be our last. It's a different psychological challenge today as a driver knows that if he has a shunt, however big it is, the worst thing will be having to think of an excuse as to why it wasn't his fault while the computer will be producing a print-out that shows it jolly well was... After all, would mountaineering be the same if you had a safety net? Suddenly everyone would manage to climb the North Face of the Eiger without a mistake because of the different psychological approach. I'm not anti-Formula One, but it's show business now."

Staying with Vanwall for 1958, Tony was again number two to Moss but was able to win three times to Moss's four, while Hawthorn won just once and lifted the title for Ferrari.

It was all-change for 1959 and, with the withdrawal of Vanwall, Tony joined Ferrari. "This was my happiest year in racing, especially as I had the same car as everybody else, unlike at Vanwall where I was number two to Stirling and the whole team was run around him, which I accepted. But the fact is that he had the pick of the cars and engines, and I'm not even sure that I didn't sometimes start races in chassis that I hadn't driven in practice. Certainly, engines that I hadn't tried, as Stirling might say he didn't like his engine, try my car and like mine. In theory they were all the same, but in those days they weren't. Sensibly, team manager David Yorke would limit my practice laps, as if I went quicker than Stirling he would feel that he had to beat this time, putting race miles on the car.

"We had equal cars at Ferrari until it became evident which of us was most likely to become World Champion, then I became the number one. However, there was no difference in the cars, rather that if the situation arose that my team-mates would have to back me up. But that moment never came, unlike in 1958 when Phil Hill yielded two second places to Hawthorn.

"The atmosphere in the team was good, too, with our Anglo-American drivers. Phil Hill was a great guy as were Dan Gurney and Cliff Allison. Jean Behra was the odd man out as he couldn't speak English or Italian. Luckily, I could speak Italian, not that I got to use it much with Enzo Ferrari as I met him only twice as he never came to the races.

"I never encountered any political problems, but I'm not a political animal. Amazingly, in the 40 minutes it took to agree on my contract with the team, which also included a full sportscar programme, I managed to negotiate a bye for Le Mans as I had agreed to continue driving for Aston Martin there. That wouldn't happen now.

"Team manager (Romolo) Tavoni may have fallen out with Behra, but he never tried it with me. He recognised that I was always doing my best and that it was either going to be good enough or it wasn't. Although Phil lived in Modena and probably bore the brunt of any politics.

LEFT RIDING HIGH: BROOKS GUIDES HIS FERRARI AROUND THE BANKING AT AVUS IN 1959 EN ROUTE TO WINNING THE GERMAN GRAND PRIX. "Enzo was a dictator and very stubborn. Indeed, it took lengthy argument from Hawthorn and Peter Collins in 1958 to convince him to fit disc brakes. And it took a change of formula (to the 1.5-litre formula that came in for 1961) to follow the rear-engined route."

Having won the French and German Grands Prix, Tony went to the final round at Sebring with a shot at the title, having to win with fastest lap to lift the crown. "I should have been on the front row, but Harry Schell was credited with a time that no-one thought he'd done. Well, not legitimately, as the course was marked out with barrels, so he must have taken a shortcut. Trouble was, this put me on the second row with "Taffy" von Trips behind me and he hit me half way around the lap. This put me up the escape road and I had the tremendous dilemma as to whether I should have the car checked over or not, overturning the promise I had made myself after Le Mans in 1957. I came in and instantly threw away my hopes of the title. As it was, I rejoined and finished third, giving the title to Jack Brabham. But if I hadn't pitted for a check-over it could have been a case of third time unlucky... Enzo probably didn't see it that way, but I'd do the same again if faced with the same situation.

"I decided to rejoin Vanwall for 1960, as Tony Vandervell said he'd have a rear-engined car. With Ferrari sticking with a front-engined car this sounded good, especially as I was starting a garage business and wanted to spend more time in England and not having a sportscar programme would enable me to do this. But by doing this I realised that I was putting my post-racing career ahead of my racing career as logic dictated that Ferrari would provide the 1961 World Champion when the rules changed to 1.5-litre engines as they already had the best package around with their 'Sharknose' 156s already running away with all the Formula Two races."

Then the Vanwall deal folded... "I should have taken a sab-batical, but I was offered a drive in a Yeoman Credit Cooper and took it." And this was the start of the decline of Tony's career as it wasn't competitive. The following season with a BRM was little better although he did round it off with third place at the US Grand Prix and then retired from racing to concentrate on his family and his garage business.

Tony doesn't hesitate to rank his contemporaries: "Fangio then Moss, perhaps with Moss the better in sportscars. Behra was next ahead of Hawthorn and Collins, although both the latter had their off days. Of the drivers of today, Schumacher stands out, but the contribution of the driver is far less today so I can't see anything much to chose between the rest. Driving in the wet boosts the drivers' contribution as it gives drivers excess power and this is when Schumacher is even more dominant."

Ask Tony where he sees Formula One heading and this is what he reckons: "The future is dicey. Look at the dramas when Senna died in 1994. If a driver, drivers or, worse still, spectators were killed, one could visualise a terrible public reaction. The other risk is that Formula One is supported by tobacco money, but if it gained a bad image then sponsors wouldn't replace the tobacco sponsorship when it's no longer allowed. So, because of political pressures and the risk of accident, I think its future is not totally assured, even though Bernie Ecclestone has done a marvellous job in making it into show business for an audience of billions."

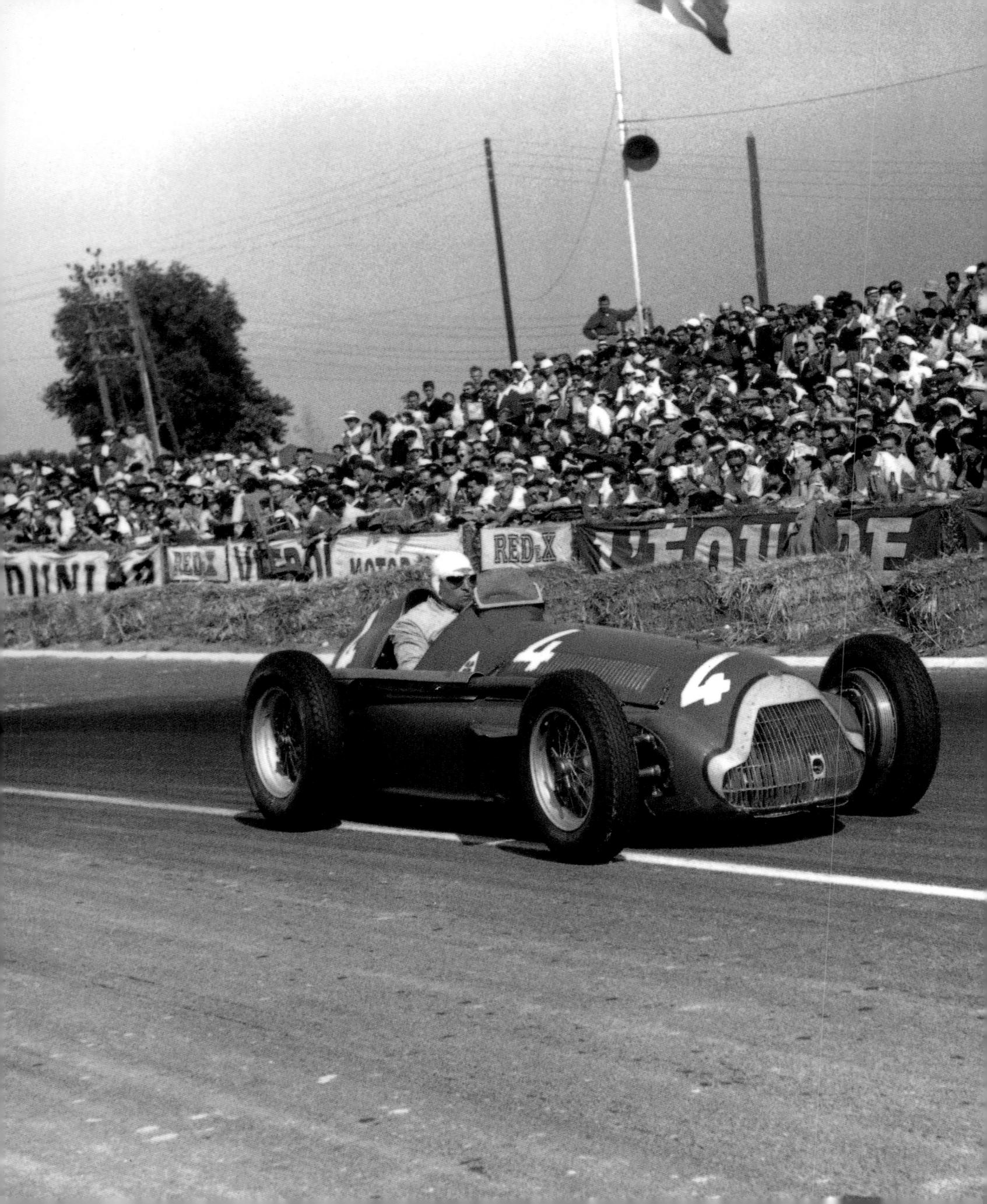

ALFA ROMEO ROSIER KURTIS KRAFT ACSARI DEIDT

FARINA THE FIRST

he Formula One World Championship was held for the first time in 1950, linking established Grands Prix from just six countries. Alfa Romeo and its drivers Farina, Fangio and Fagioli dominated, but Ferrari was waiting to pounce.

All was quiet in the years immediately after the Second World War, but it did not take long for motor racing to re-establish itself. By 1950, the governing body had decided that the time was right to bind the various Grands Prix together to launch a World Championship. There was plenty of pre-war racing equipment available, and no shortage of drivers who had raced in the 1930s. True, they had lost some of the best years of their careers during the hostilities but, despite the enforced break, they were still at the top of their game.

ALFA ROMEO TAKES CONTROL

This inaugural year was all about Alfa Romeo, with the great Italian marque's cars winning every race, with the exception of the stand-alone Indianapolis 500 that was included in the World Championship to give it some appeal to the American market but not entered by any of the regular Formula One teams.

Alfa Romeo's squad comprised the legendary "three Fs": Dr Giuseppe "Nino" Farina (then aged 44), Juan Manuel Fangio (a stripling at 38), and Luigi Fagioli (53). Equipped with an update of the pre-war Tipo 158, they steamrollered the opposition, chased by Ferrari.

Ferrari had suffered a disappointing run of results in 1949, and the team was absent from the first race, held at a rudimentary Silverstone on May 13 in the presence of the royal family. There were 21 cars in the field, many of which were a good 15 years old, and Farina had the honour of taking the first pole position. Fagioli led initially, but dropped to third place behind Farina and Fangio. When Fangio's engine failed, Fagioli took second place ahead of local star Reg Parnell, who drove Alfa Romeo's fourth works car.

A week later at Monaco, Farina's luck changed when he triggered a nine-car pile-up on the opening lap, which also took out Fagioli. Fangio was ahead of the carnage, and somehow survived when he came across the pile-up at speed on the next lap, going on to score a memorable win. Alberto Ascari rewarded Ferrari with second place, a lap down.

Farina and Fagioli finished first and second in the Swiss Grand Prix at the tricky Bremgarten road circuit, and once again Fangio suffered an engine failure –

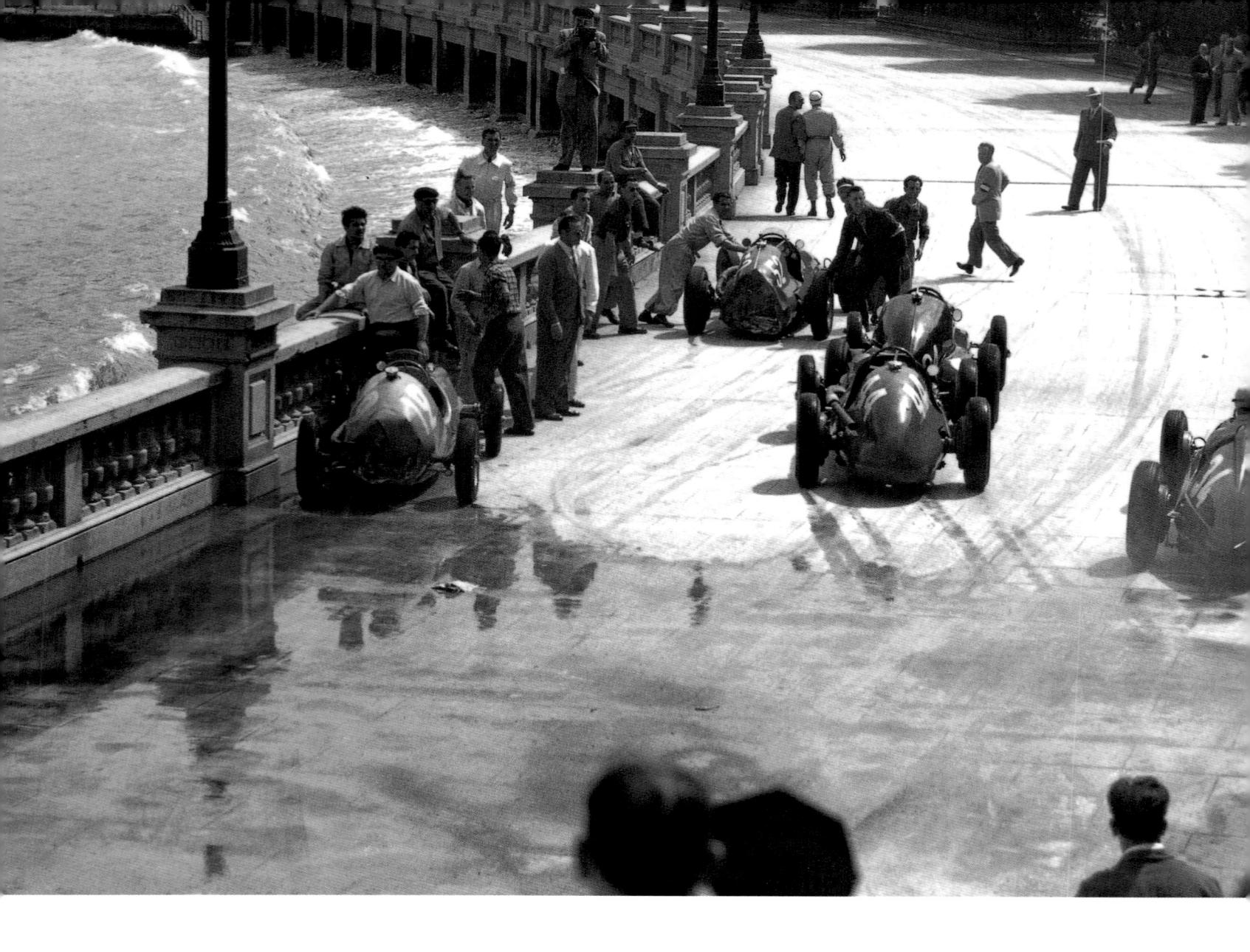

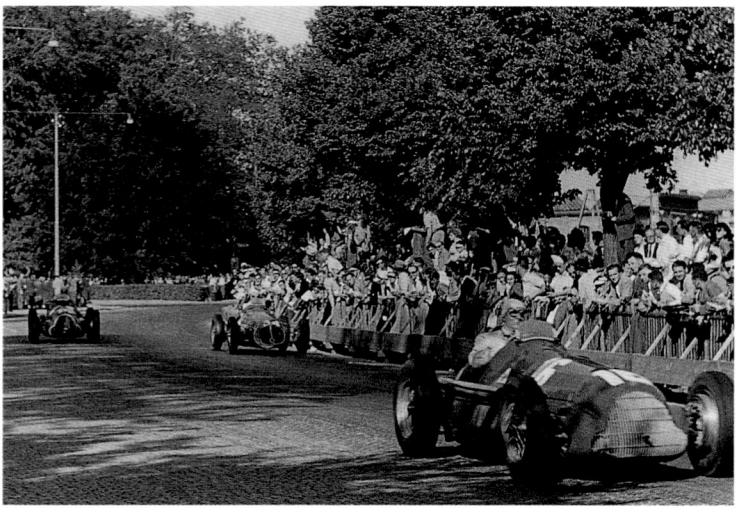

ABOVE A LUCKY AVOIDANCE: JUAN MANUEL FANGIO (34) TAKES A LOOK AT THE CARNAGE FROM THE OPENING LAP AT MONACO.

LEFT ON A SWISS ROLL: FARINA RACED TO VICTORY FOR ALFA ROMEO IN THE SWISS GRAND PRIX AT BREMGARTEN.

RIGHT FLYING AMATEUR: PETER WHITE-HEAD WAS A GENTLEMAN DRIVER, BUT HE WAS QUICK TOO. HERE HE TAKES HIS FERRARI ACROSS THE LINE IN THE ITALIAN GRAND PRIX.

as did all three works Ferraris. In the Belgian Grand Prix, held at the mighty Spa-Francorchamps circuit in the Ardennes hills, Fangio fought back with his second win of the year, this time ahead of Fagioli. Variety was provided by Raymond Sommer, who led in his Talbot before blowing up.

FARINA TAKES THE TITLE

The first championship, like so many to follow, came to a head in the final round at Monza. Fangio arrived at the race with

26 points as opposed to the 24 of the consistent Fagioli and the 22 of Farina. Fangio and Farina had the new and more powerful Alfa Romeo 159 model, but the title was settled when Fangio retired with a seized gearbox. Farina won the race, and with it the World Championship.

Ferrari had been working hard on a new unsupercharged engine during the season, which had been showing well in non-championship races, and Ascari was on the pace with the latest model in the Italian Grand Prix. When his car retired, he took over the machine of team-mate Dorino Serafini and finished second, ahead of Fagioli.

In addition to the establishment of the World Championship, the 1950 season was also notable for the introduction of much new racing machinery. However, the year's most talked-about car never appeared at a Grand Prix. The much-vaunted V16 BRM made an ignominious debut in the International Trophy at Silverstone in August, retiring on the startline with driveshaft failure.

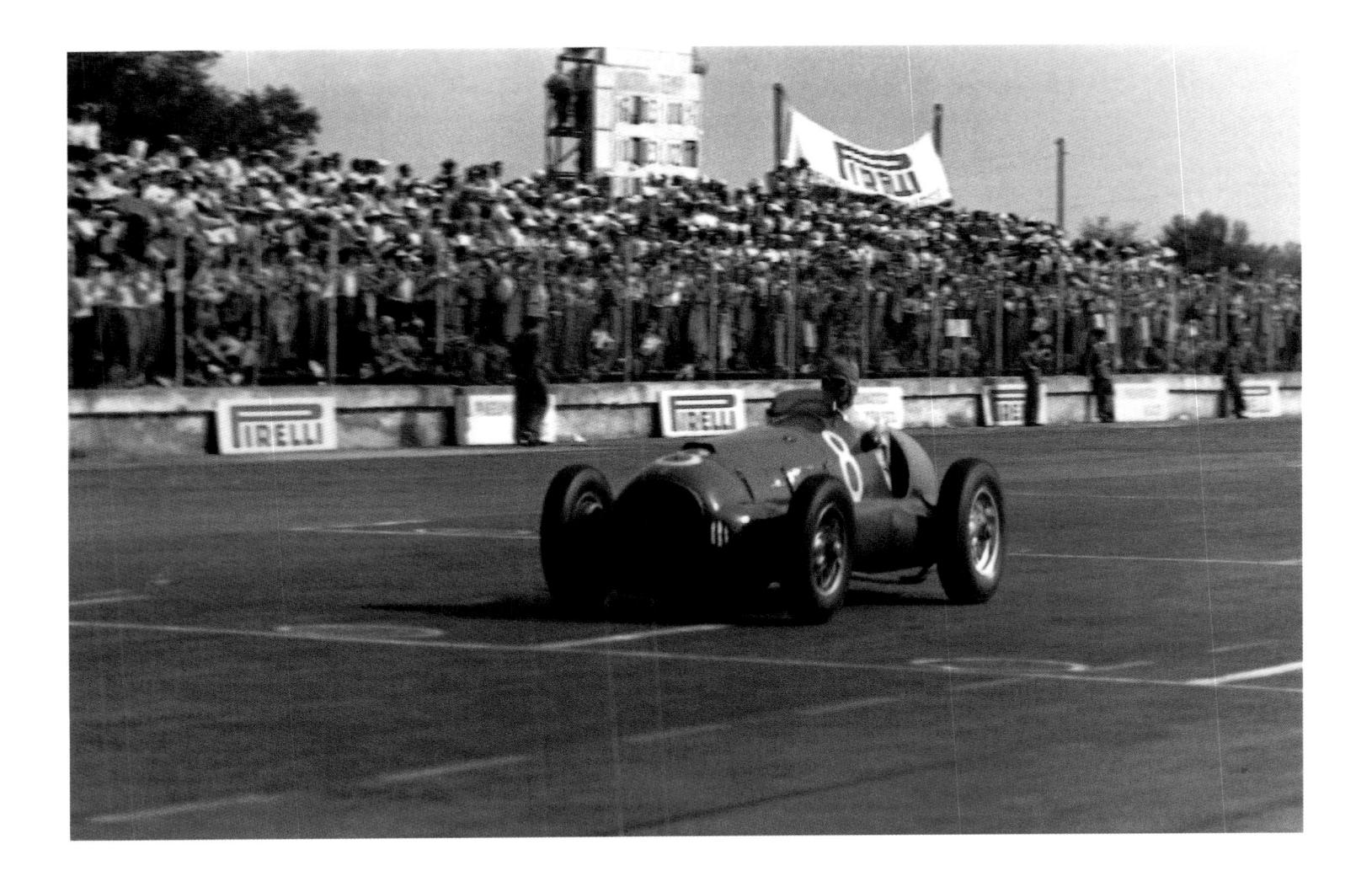

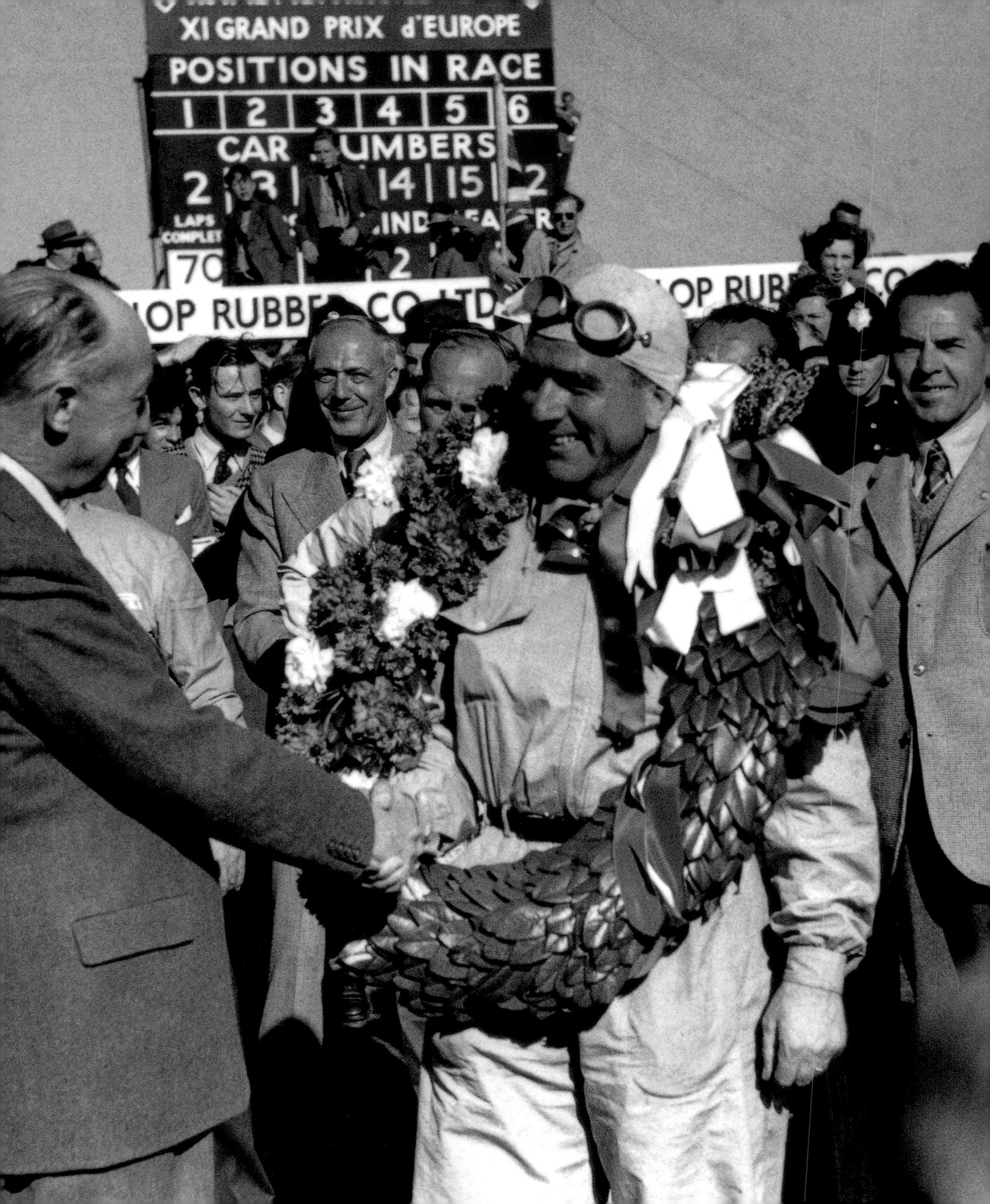

ARGENTINA'S ACE

Ifa Romeo continued to set the pace in 1951, but Ferrari came close to toppling the champions. Mechanical problems had robbed him the previous year, but now Juan Manuel Fangio was dominant and claimed his first world title.

For 1951, Alfa Romeo broke up the "three Fs" team, replacing Fagioli with 48-year-old Felice Bonetto. Jose Froilan Gonzalez, who had previously driven a Maserati, joined Ascari and Luigi Villoresi at Ferrari. The stocky young Argentinian, known as the "Pampas Bull", was to become a major force during the season.

The World Championship was expanded to a total of seven races, with Monaco dropped from the calendar and Grands Prix in Germany and Spain added. This time the championship began in Switzerland, and in soaking

conditions Fangio scored a fine win, almost a minute ahead of Piero Taruffi's Ferrari, with Farina a distant third. Meanwhile, a promising young Englishman made his debut in a British HWM, qualifying 14th and finishing eighth. His name was Stirling Moss.

The Indianapolis 500 was the next race, with Lee Wallard controlling proceedings. As in the year before, not one of the Formula One drivers took part. Indeed, ironically, they only started to do so as the race was dropped from the World Championship, a decade later.

FANGIO HITS TROUBLE

Farina and Fangio dominated the Belgian Grand Prix at Spa-Francorchamps, but when Fangio pitted, a rear wheel stuck and his race was ruined. Farina duly won from the Ferraris of Ascari and Villoresi, while a fired-up Fangio set the fastest lap in his recovery drive, but finished last.

Fagioli was back in an Alfa Romeo for the French Grand Prix at Reims and went on to score his first victory – but only after Fangio took over his car when his own mount had retired in a race of high attrition. Another shared car – the Ferrari of Gonzalez and Ascari – took second, ahead of Villoresi. After tyre troubles, Farina was a distant fifth.

FERRARI'S BREAKTHROUGH

A Ferrari win had seemed on the cards, and the first one finally came in the British Grand Prix at Silverstone, where Gonzalez put in a fine performance to take the lead from countryman Fangio when the Alfa Romeo driver pitted and stalled while trying to rejoin. The BRM made its first championship appearance,

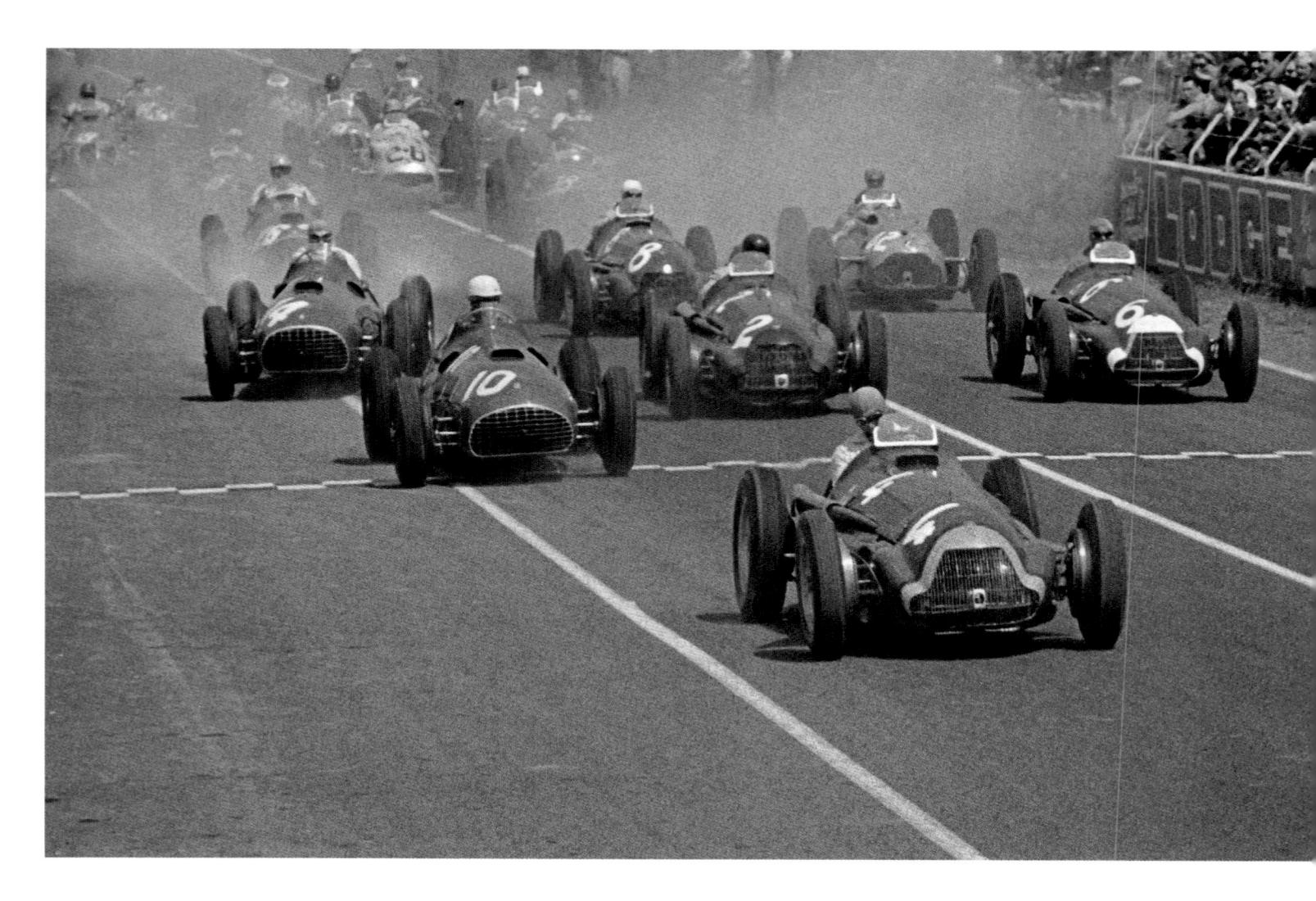

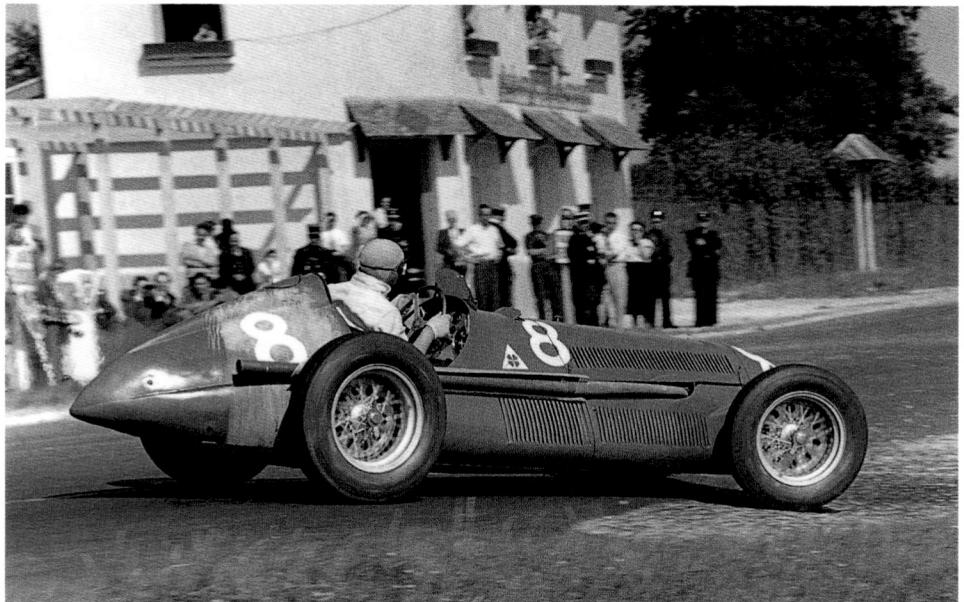

ABOVE AND THEY'RE OFF: FANGIO (4)
OUTDRAGS ASCARI'S FERRARI (12) AT
THE START OF THE FRENCH GRAND
PRIX.

LEFT HOLD ON A SECOND: THAT'S
FANGIO LATER IN THE SAME RACE AT
REIMS AND NOW HE'S IN ALFA ROMEO
NUMBER 6.

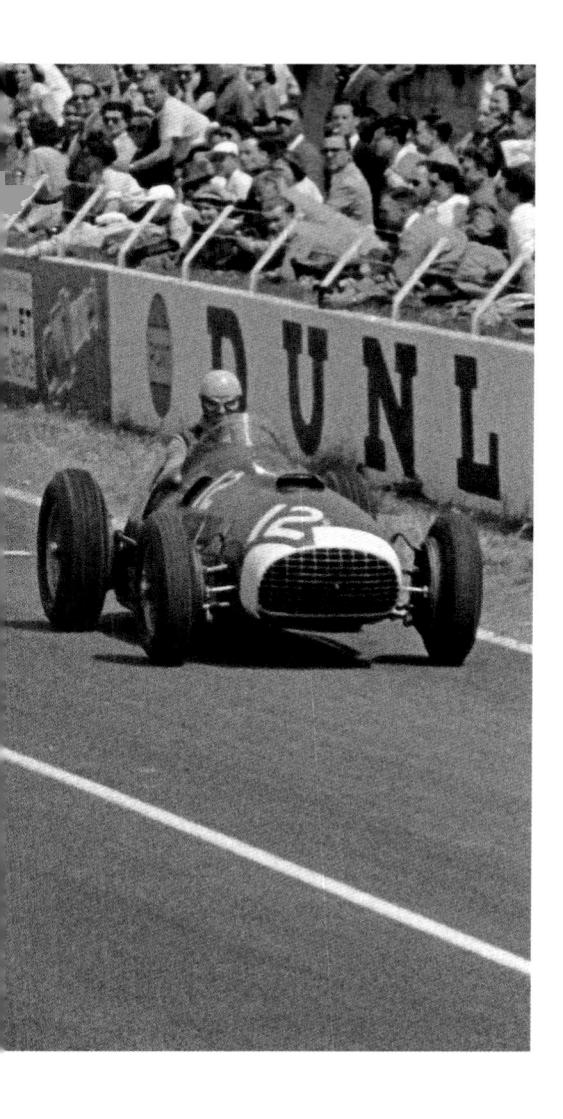

with Reg Parnell taking a promising fifth place and Peter Walker finishing seventh.

Ferrari was the dominant force in the German Grand Prix at the Nurburgring, the first championship race held on the long, tortuous circuit in the forests of the Eifel mountains. Ascari notched up his first win, despite a late stop for rear tyres. Fangio, who required an extra non-scheduled fuel stop, took second for Alfa Romeo. Third to sixth places were filled with Ferraris, while Farina retired with gearbox trouble.

The Italian Grand Prix was the penultimate round this year, and Ascari and Gonzalez celebrated a fine one-two result for Ferrari in front of the home crowd. Alfa Romeo had a much-modified car, the 159M, and Fangio was battling for the lead until a tyre failed. His storming recovery drive ended with engine failure. Farina retired early in the race, but took

over Bonetto's car and eventually earned third place.

The final race at Pedralbes in Spain proved to be Alfa Romeo's swansong. Despite his Monza retirement, Fangio led Ascari by 28 points to 25 going into the race, and a dominant win secured Juan Manuel's first crown. The Ferraris suffered tyre troubles, with Gonzalez and pole man Ascari taking second and fourth places, split by Farina's Alfa Romeo.

At the end of the year, Alfa Romeo withdrew from Grand Prix racing, unable to finance a new car to challenge Ferrari in 1952. Partly in response to Alfa Romeo's departure, the Fédération Internationale de l'Automobile announced that for 1952, the World Championship would run to less powerful Formula Two rules. It was hoped that this would encourage a wider variety of cars and avoid a Ferrari walkover.

RIGHT CHAMPIONSHIP CHALLENGER:
ALBERTO ASCARI (SECOND RIGHT)
DISPLAYS HIS OPTIMISM PRIOR TO THE
ITALIAN GRAND PRIX, A RACE HE
WENT ON TO WIN.

BELOW TRUE BRIT: REG PARNELL ON HIS
WAY TO A FOURTH PLACE FINISH IN
REIMS AT THE FRENCH GRAND PRIX.

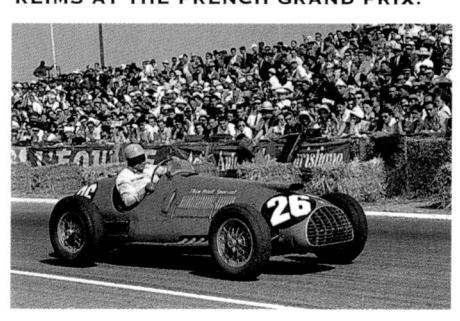

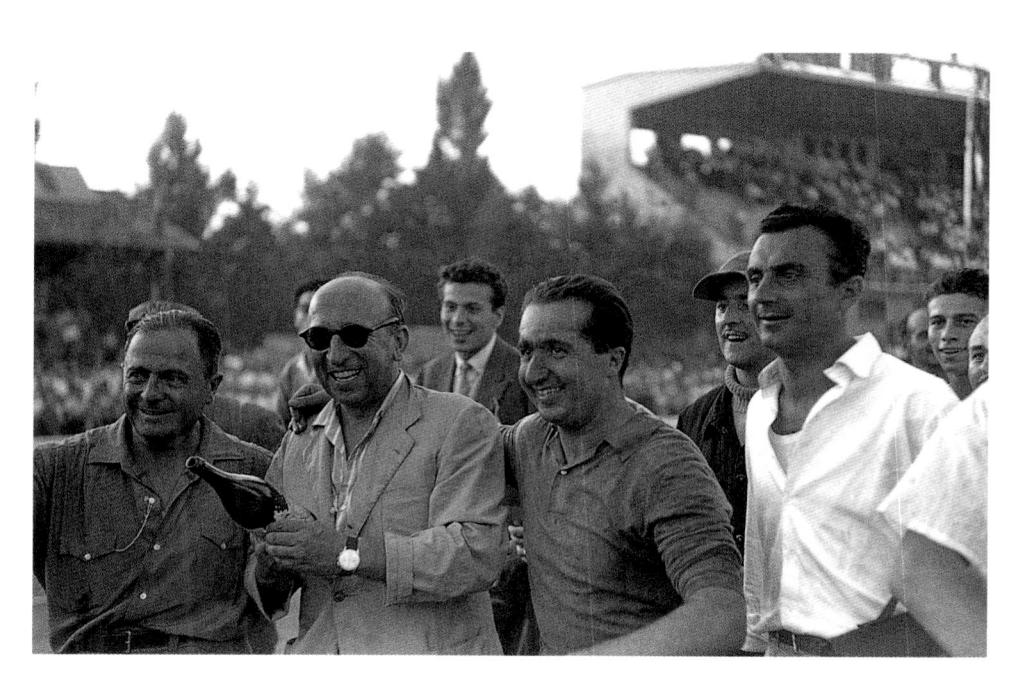

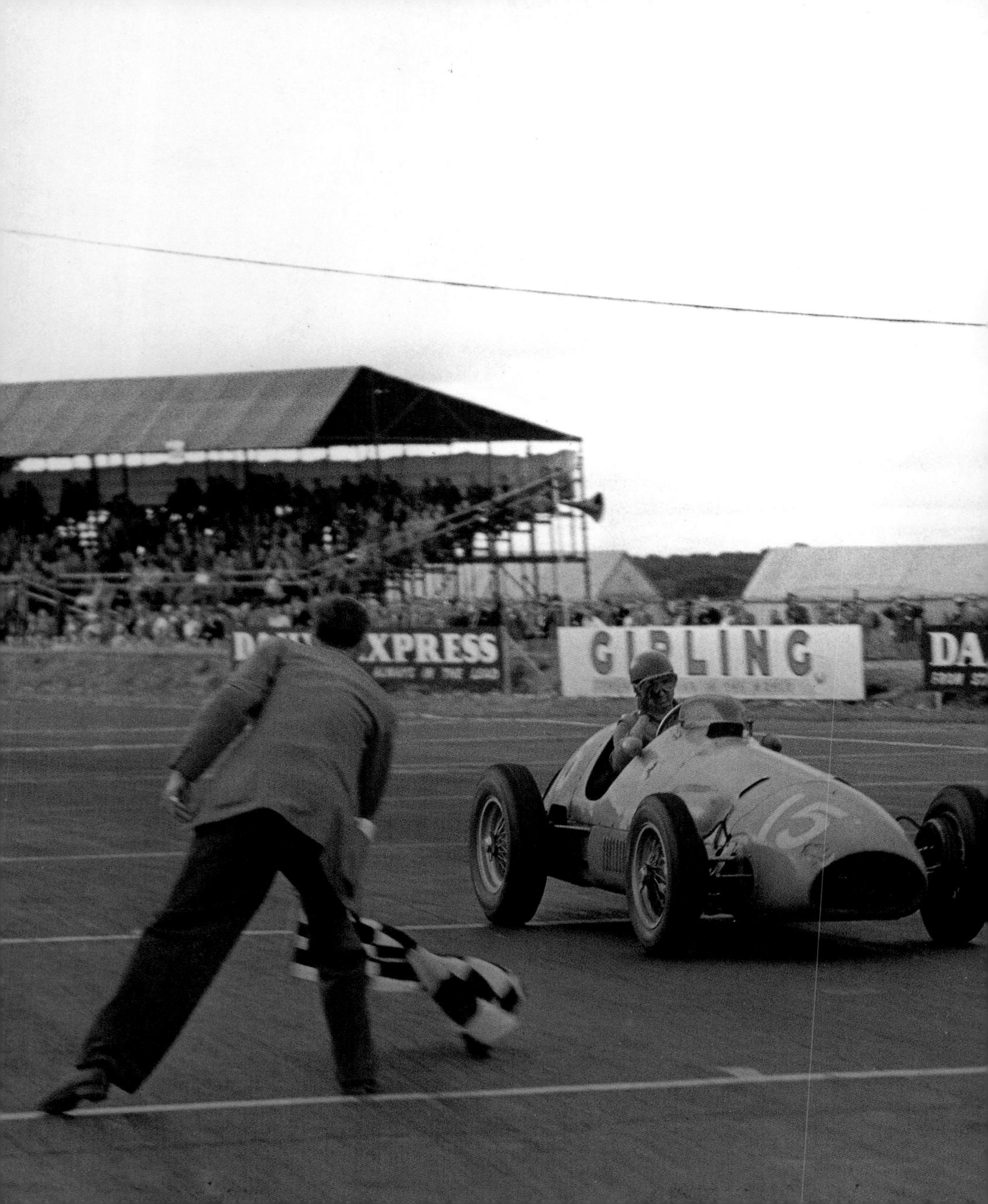

FERRARI'S FAMOUS FIRST

errari responded to the introduction of Formula Two rules changes by dominating. Alberto Ascari won every race he entered to become world champion, while an injured Juan Manuel Fangio could only watch from the sidelines.

Despite the change of regulations, Ferrari entered 1952 as the major force. The marque had already been highly successful in Formula Two, and had a first-class driver line-up. Ascari, Luigi Villoresi and Piero Taruffi were joined by Giuseppe Farina – now on the market after Alfa Romeo's withdrawal. The main opposition should have come from reigning champion Fangio, who had switched from Alfa Romeo to Maserati to drive the new A6GCM. However, the Argentinian was forced to miss the entire season after breaking his neck in a crash during a non-

championship race at Monza.

BURGEONING INTEREST

The rule change achieved its aim of attracting a variety of cars to take on the red machines. From France came the Gordinis of Jean Behra and Robert Manzon, while in Britain there was a host of projects underway, including the Cooper-Bristol, Connaught, HWM, Alta, Frazer Nash and ERA. The most successful of these would prove to be the Cooper-Bristol, an underpowered machine blessed with superb handling. Its brilliant young driver was a flamboyant Englishman by the name of Mike Hawthorn, who proved to be the find of the year.

The championship began with the Swiss Grand Prix, a race notable for the absence of Ascari, who was busy with Ferrari commitments at Indianapolis. Taruffi scored an easy win, well ahead of local Ferrari privateer Rudi Fischer. Encouragingly, the Gordini showed promise, with Behra racing to third place. That place had been held by Stirling Moss in the HWM, but his car was withdrawn after two of its sister entries suffered hub failures.

Ascari's trip to the Indianapolis 500 came to naught, as he could qualify his Ferrari only midgrid and was out of the race by one fifth distance. Troy Ruttman triumphed in a Kuzma. Ascari then scored his first win of the new Formula Two era in soaking conditions in the Belgian Grand Prix at Spa-Francorchamps, crossing the finish line almost a minute ahead of team-mate Farina. Manzon gave Gordini another third place, but all eyes were on

1952

BELOW RISING BRITISH
STAR: MIKE HAWTHORN
MADE A MAJOR IMPACT
BY FINISHING FOURTH
ON HIS DEBUT IN
BELGIUM.

BOTTOM TO THE FORE:
ASCARI LEADS TEAMMATE FARINA AT THE
DOWNHILL START AT
ROUEN.

RIGHT BIG MAN, BIG
RESULT: JOSE FROILAN
OVERFLOWS FROM HIS
MASERATI AS HE RACES
TO SECOND AT MONZA.

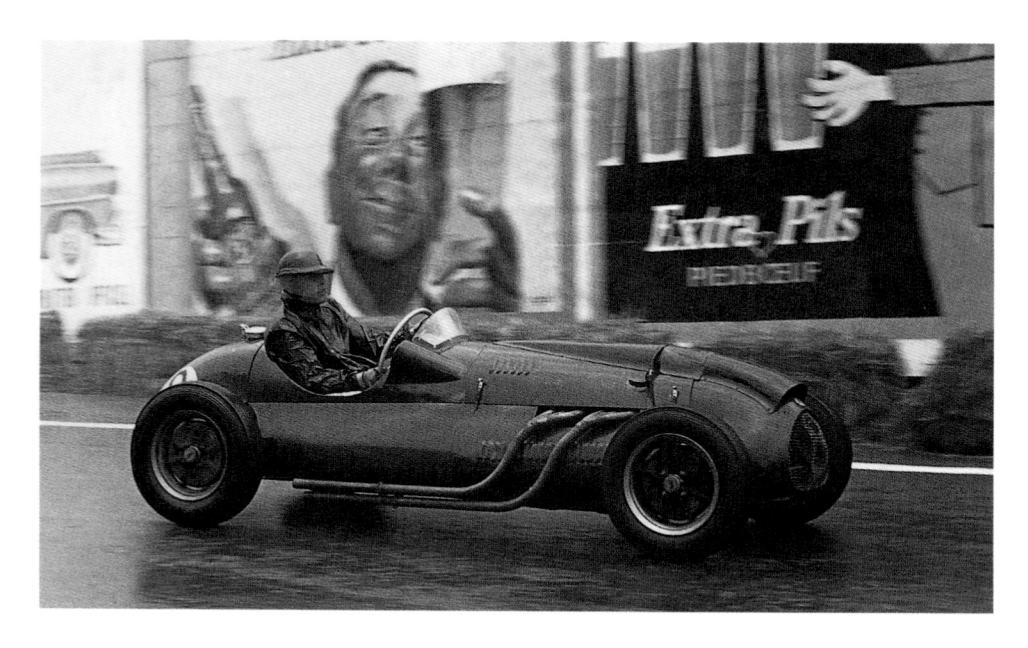

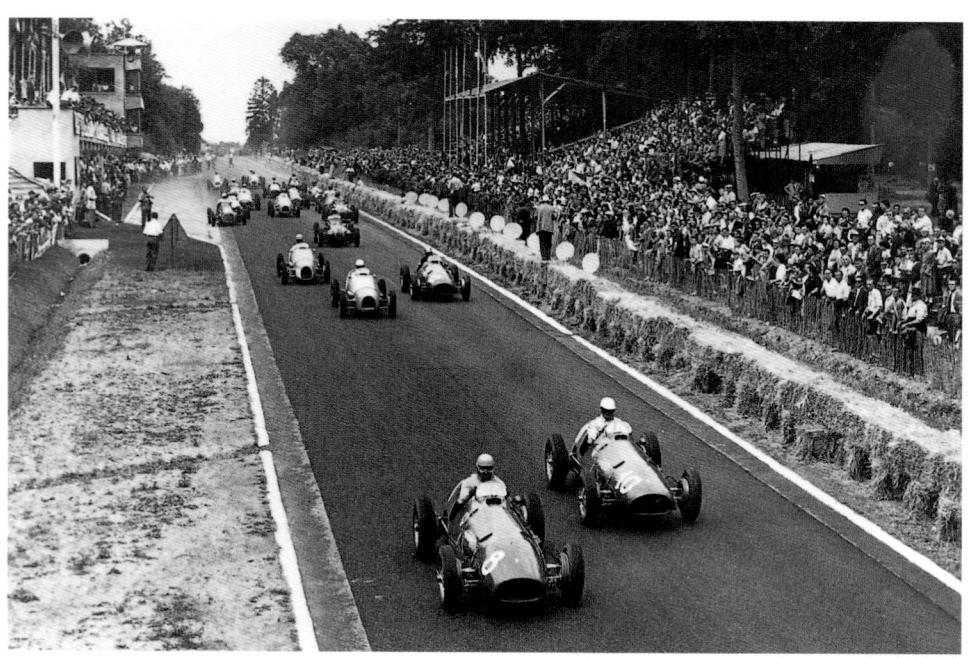

Hawthorn, making his championship debut. He ran third and, after a fuel leak delayed him, finished a fine fourth. It was the highest place to date for a British car, and the first sign of great things to come from John Cooper's small company.

Behra's Gordini surprisingly beat the Ferraris at Reims but, unfortunately for him, in this particular year it was a nonchampionship race.

FERRARI MAINTAINS ITS DOMINANCE

The French Grand Prix itself took place at Rouen a week later, and Ferrari's Ascari, Farina and Taruffi finished first, second and third, with Manzon fourth. Ascari and Taruffi were then first and second in the British Grand Prix, but Hawthorn was the darling of the home crowd, rising to the challenge and finishing third. Dennis Poore also impressed with his Connaught, leading Hawthorn until he had to make a long fuel stop, finally coming home fourth.

The German Grand Prix at the Nurburgring was a complete Ferrari whitewash, with Ascari heading Farina, Fischer and Taruffi. Ascari had to work hard for his win though, for a late pit stop for oil dropped him to second and forced

him to catch and re-pass Farina. The new Dutch Grand Prix among the sand dunes of the coastal resort of Zandvoort was next up, and saw Ascari leading Farina and Villoresi home, with Hawthorn again leading the challenge in a gallant fourth place finish with his Cooper-Bristol.

Ascari had already clinched the championship title before the season's final race, the Italian Grand Prix, but just for good measure he rattled off his sixth win from six starts, this time with a minute's advantage over Gonzalez and a further minute's advantage over Villoresi and Farina.

ADVANTAGE ASCARI

Iberto Ascari claimed his second world title in a row as Ferrari were again supreme in the second and final year of the Formula Two category. However, Juan Manuel Fangio struck back for Maserati, signalling the start of four years of domination by the maestro.

Fangio was back and fit at the start of 1953, and heading a Maserati outfit which looked as if it might upset the Ferrari bandwagon. Joining him in a strong Argentinian line-up were Jose Froilan Gonzalez and Onofre Marimon. Meanwhile, Mike Hawthorn's 1952 performances with the Cooper had not gone unnoticed, and he had earned a seat with Ferrari, alongside Ascari, Giuseppe Farina and Luigi Villoresi. With Hawthorn gone, Cooper lacked a driver of substance, and so Gordini provided the only

real opposition to the Italian cars.

A DARK DAY IN ARGENTINA

For the first time, the "World Championship" tag was justified by a race outside Europe that the regulars actually contested - unlike the anomaly of the Indianapolis 500 - with the series kicking off at Buenos Aires.

Unfortunately the race was marred by undisciplined spectators, and Farina was involved in a tragic incident when he hit a boy who crossed the track during the race. Nine people were killed in the mayhem that followed. It was the first fatality in a World Championship race, but sadly it would not be the last. Meanwhile, Ascari and Villoresi finished first and second for Ferrari ahead of debutant Marimon. Hawthorn had a steady race to fourth, while local hero Fangio ran second before retiring.

Over in the US, Bill Vukovich made amends for losing the 1952 Indianapolis 500 with nine laps to go by starting from pole in his Kurtis Kraft and winning this time around.

Maserati's new car arrived in time for the Dutch Grand Prix. It showed promise, but Ascari and Farina took the usual Ferrari one-two, with the best Maserati - shared by Felice Bonetto and Gonzalez - in third. Fangio broke a rear axle and scored nothing.

The Maseratis were the cars to beat in the Belgian Grand Prix, however, and Gonzalez and Fangio led the field until retiring. Inevitably, though, Ascari was there to pick up the pieces, scoring his ninth consecutive win.

A BRITISH FIRST

The French Grand Prix was back at

LEFT A WINNING START: ALBERTO
ASCARI ACKNOWLEDGES THE OVERFLOWING CROWD AS HE WINS THE
ARGENTINIAN GRAND PRIX.

BELOW LEFT QUIETER SURROUNDINGS:
ASCARI ENJOYS THE TWISTS OF
BREMGARTEN WHERE HE WRAPPED
UP THE CHAMPIONSHIP WITH A
ROUND STILL TO GO.

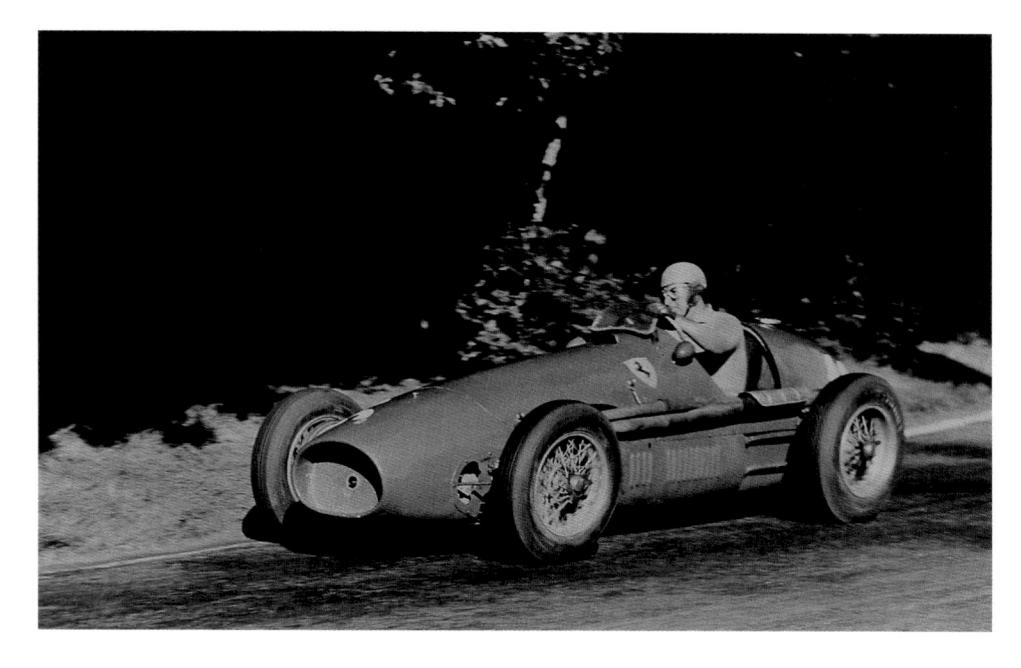

Reims, and it proved to be a classic encounter which saw Hawthorn truly come of age. After taking two fourth places and a sixth in the season's opening races, he emerged as a front-runner, getting the better of a sensational duel with Fangio to score his first win - the first for any British driver. Strangely, Hawthorn could not repeat his French form in the British Grand

Prix, where Ascari was utterly dominant. Fangio chased hard, and finished ahead of Farina, Gonzalez and Hawthorn.

Ascari was again the man to beat in the German Grand Prix, but he lost a front wheel early on. However, he made it back around the Nurburgring's lengthy lap to the pits, and later took over Villoresi's fourth-placed car. Farina maintained Ferrari's record though, winning ahead of Fangio and Hawthorn. In his new car, Ascari was closing in on the British driver when the engine blew.

The Ferrari driver clinched his second title at the penultimate race, the Swiss Grand Prix at Bremgarten, yet it was anything but easy. Fangio led Ascari until gearbox and engine troubles intervened,

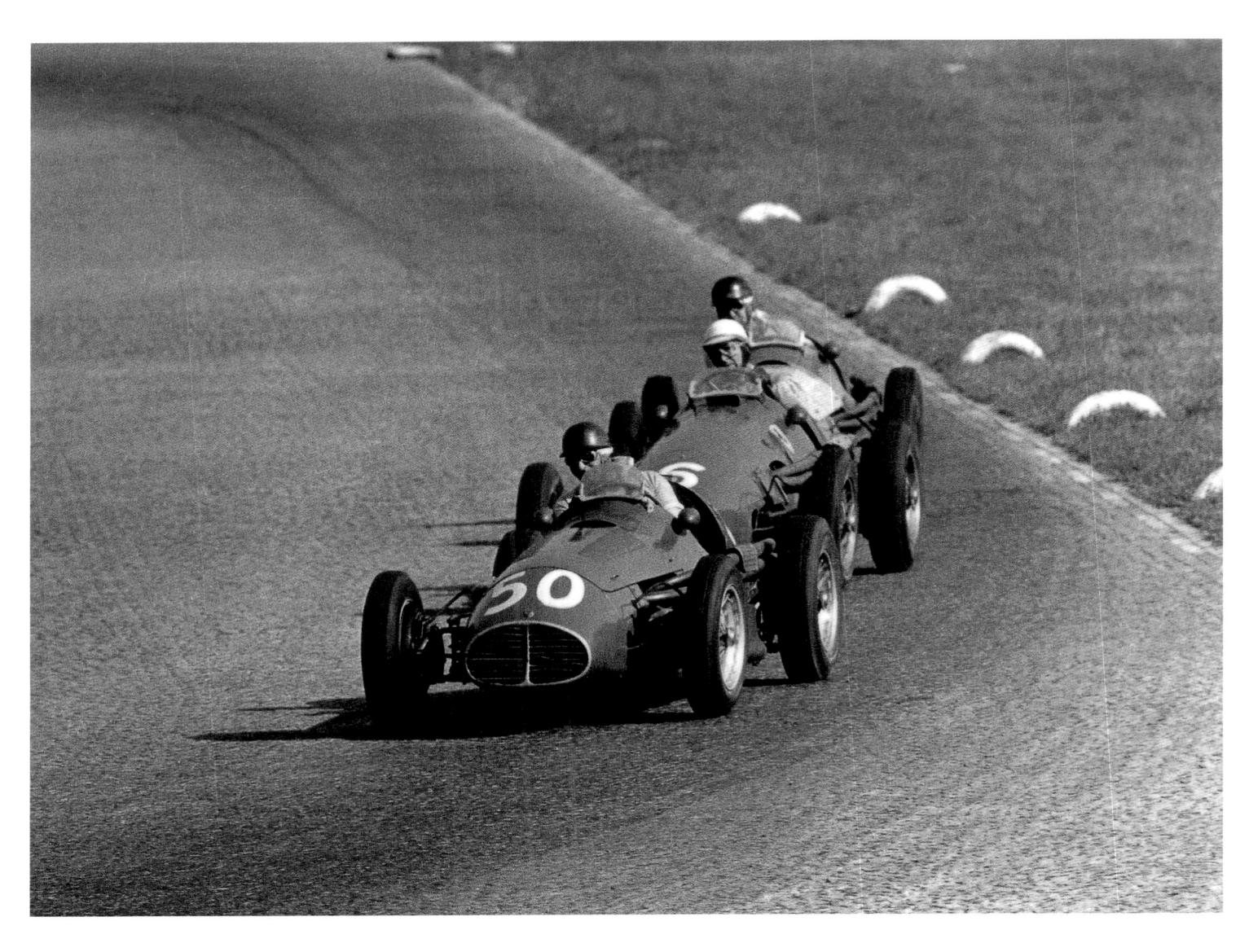

ABOVE HE'S BACK: JUAN MANUEL FANGIO RETURNED FROM INJURY AND HIT THE VICTORY TRAIL AT THE ITALIAN GRAND PRIX.

RIGHT THE SMILE SAYS IT ALL: JUAN MANUEL FANGIO SHOWS HIS PLEASURE AT HIS REFOUND FORM AT MONZA.

and then Ascari lost the lead with a plug change. He dropped to fourth, but worked his way back to the lead, heading home Farina and Hawthorn.

Maserati had threatened to win all year, and it eventually happened in the finale at Monza, albeit in bizarre circumstances. After a great slipstreaming battle Ascari looked set to win, but on the last

lap he spun and forced Farina wide. The lapped Marimon also got involved, and through the dust cloud emerged Fangio, to score his first win since 1951, crossing the line just ahead of Farina. And so Fangio moved above Farina to rank second overall, while fourth place was also enough to give Hawthorn fourth overall ahead of Villoresi.

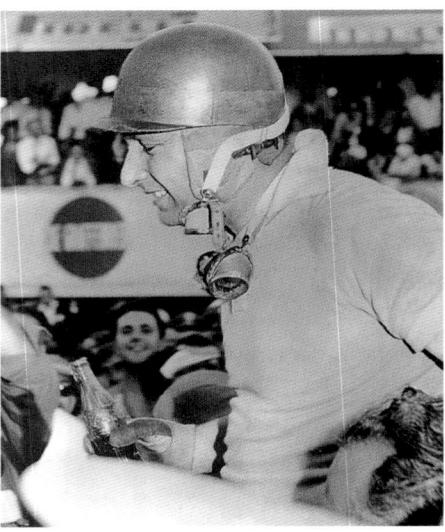

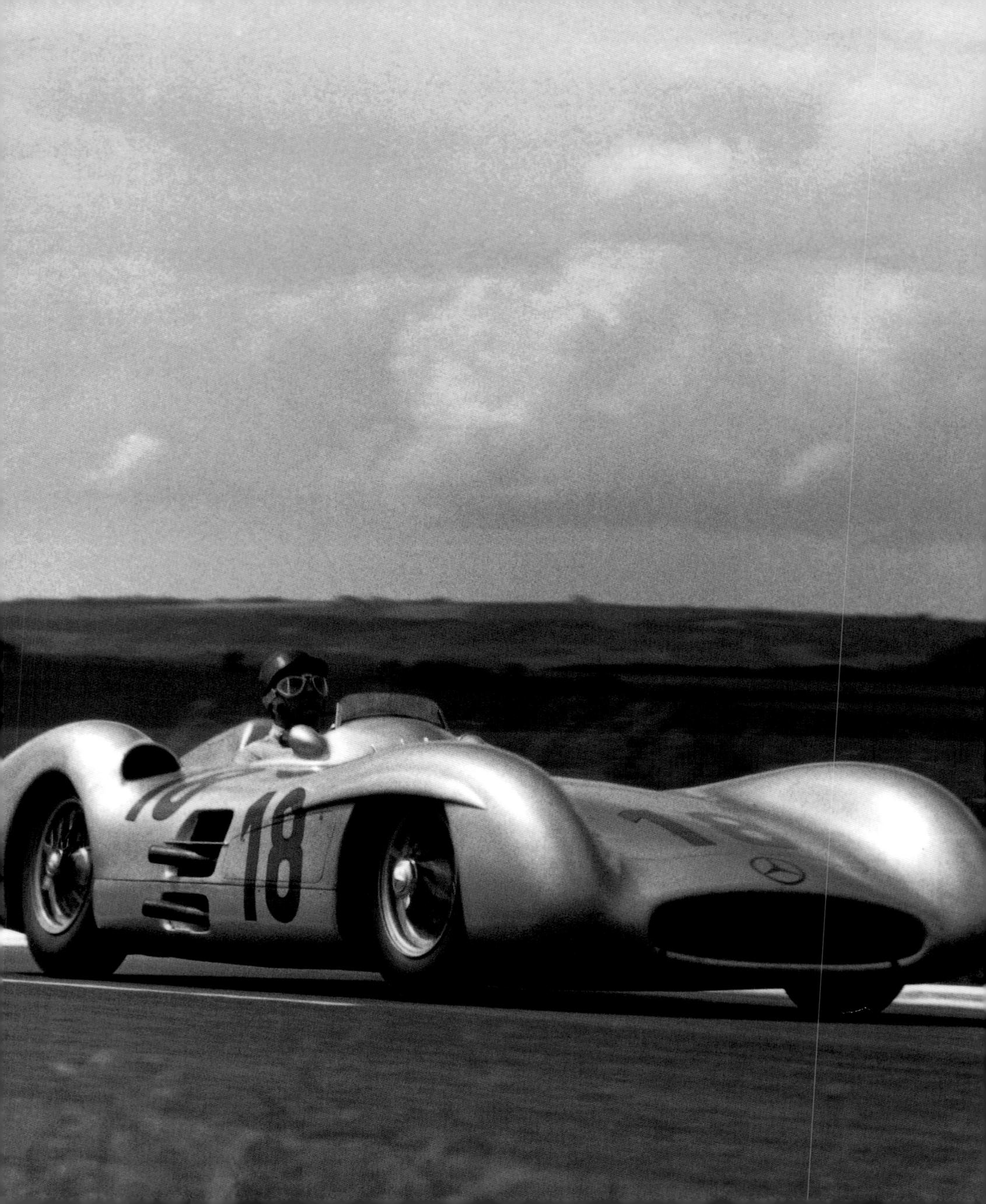

MERCEDES MOVES IN

ercedes-Benz finally returned to racing, and their "blank cheque" operation immediately set new standards that transformed Formula One. Juan Manuel Fangio and his wonderful W196 Silver Arrow were unstoppable. Meanwhile, Britain found a new star in Stirling Moss.

After two years of Formula Two it was all change for 1954, with the introduction of new 2.5-litre regulations. The big story was the decision by Mercedes-Benz to return to Grand Prix racing for the first time since the Second World War. The legendary Alfred Neubauer, who had masterminded their dominance in the 1930s, was still at the helm, and he snapped up Fangio to join Hans Herrmann and Karl Kling on his driving force. Mercedes' new W196 was a technical marvel, but was not ready until the

third race of the year. Also on the way was Lancia's new D50. The Italian marque hired Alberto Ascari and Luigi Villoresi to drive it, but it was ready even later than the Mercedes, not joining in until the final race. Thus, after two titles, Ascari effectively wasted the season.

Fangio was luckier, for he was allowed to start the year in the new Maserati, the 250F. An attractive and effective car, it proved to be one of the mainstays of Grand Prix racing over the next few seasons. Ferrari had lost Ascari and Villoresi, but Mike Hawthorn, Giuseppe Farina, Jose Froilan Gonzalez and Frenchman Maurice Trintignant were on hand to drive the latest model.

FANGIO'S WINNING START

Fangio's decision to start the year in a Maserati was a wise one, and he duly won the opening Grands Prix in Argentina and Belgium. The first race was a rain-hit affair with the track conditions changing several times. Dominant in the wet, Fangio won ahead of the Ferraris of Farina, Gonzalez and Trintignant. Farina led the early laps in Belgium, but when he hit trouble Fangio went by, and headed home Trintignant. Moss showed he would be a force to be reckoned with by taking third in another Maserati. Splitting these two races was the Indianapolis 500, with Bill Vukovich making it two wins on the trot

Mercedes finally appeared at Reims, with three of the magnificent W196s in streamlined, full-bodied form. The cars were perfectly suited to the fast track, and Fangio and Kling finished first and second, with Hermann retiring after setting fastest lap. However, Mercedes came

down to earth with a bang at Silverstone, as their streamlined bodies did not suit the airfield circuit. Fangio finished fourth, while Gonzalez scored his second British Grand Prix win, again in a Ferrari.

Tragedy struck at the Nurburgring when Marimon was killed in practice; he was the first driver to die at a World Championship event. Fellow Argentinians Fangio and Gonzalez were distraught but, to his credit, Fangio got on with the job and won the race, his Mercedes now using the new open-

wheel body. Fangio then led from start to finish in the Swiss Grand Prix. Moss pursued him until retiring, and then Gonzalez took up the challenge.

MOSS MAKES HIS MARK

The Italian Grand Prix established Moss as a star of the future. His performances had earned him a works Maserati seat, and he led until nine laps from the end when the car's oil tank split. He would eventually push the car over the line in 11th place, but he had made his mark. Meanwhile,

Fangio swept by to win in his streamlined Mercedes, ahead of Hawthorn.

The Lancia team was finally ready for the last race in Spain, and the radical car showed promise, for Ascari led for ten laps and set the fastest lap before retiring. However, it was to be Hawthorn's day, as the Englishman went on to score his second win, ahead of Maserati's young find, Luigi Musso. Mercedes had a bad day, and Fangio finished only in third place. However, his second title was already in the bag.

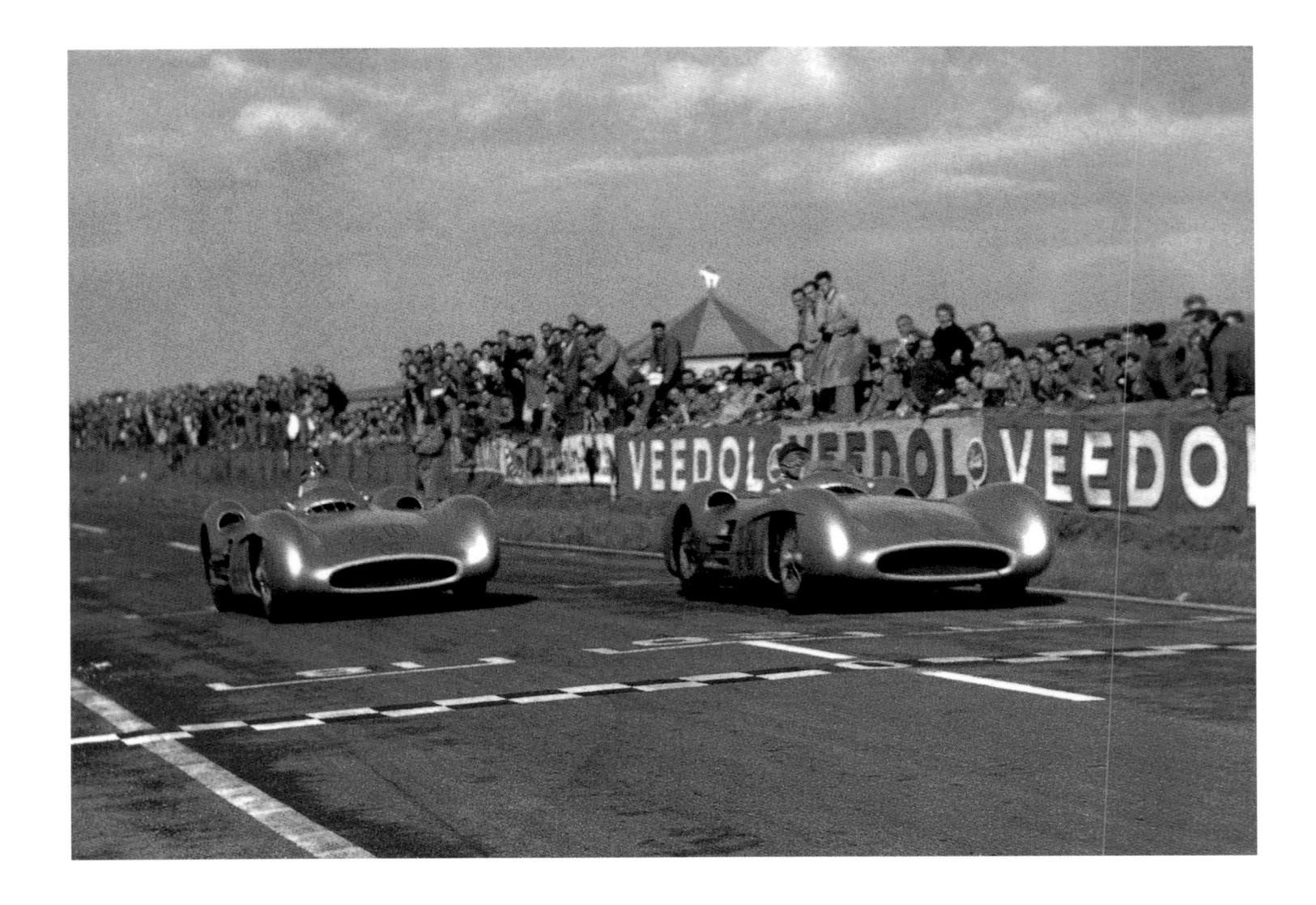

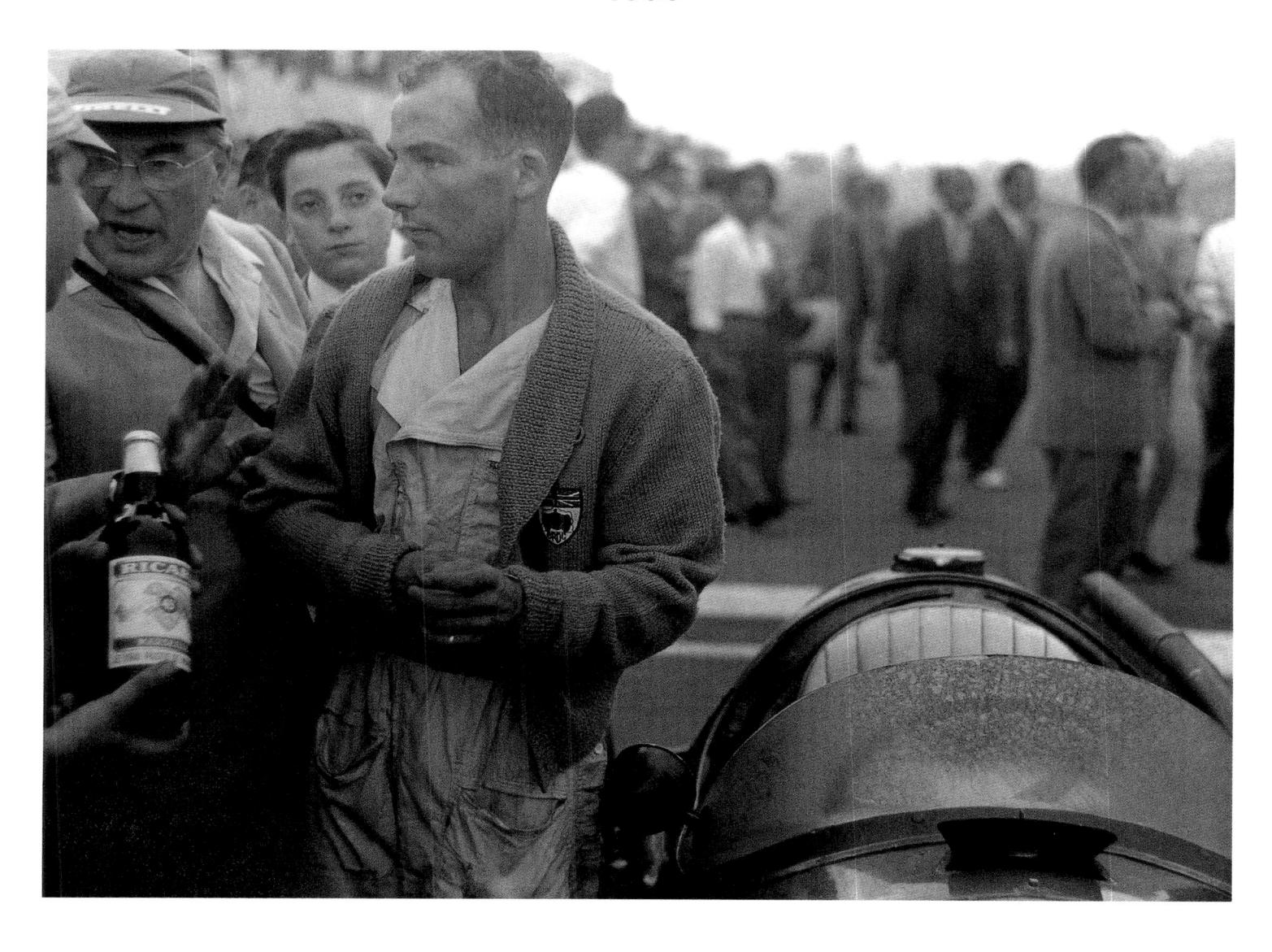

ABOVE DRINK THIS LAD: A YOUTHFUL STIRLING MOSS LOOKS BEMUSED AS HE'S OFFERED A PRE-RACE TIPPLE AT THE ITALIAN GRAND PRIX.

LEFT FORMATION FINISH: KARL KLING
SHADOWS MERCEDES TEAM-MATE FANGIO ACROSS THE LINE AT REIMS, THE
OPPOSITION WAS LEFT STUNNED.

RIGHT RUBBISH COLLECTOR: PAPER STUCK IN FRONT OF MIKE HAWTHORN'S RADIATOR DIDN'T STOP HIM FROM WINNING THE SPANISH GRAND PRIX.

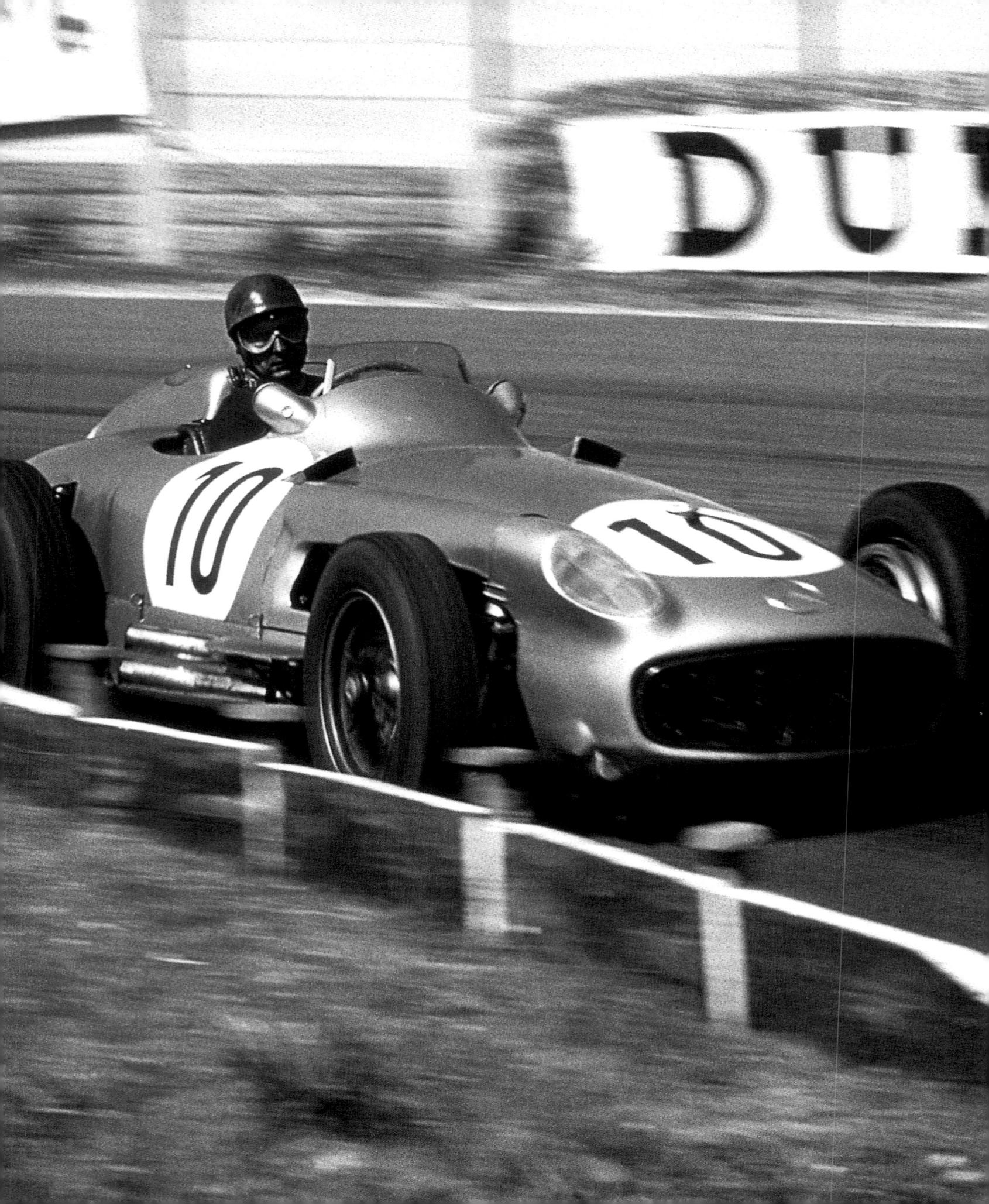

FANGIO'S HAT-TRICK

ercedes, Juan Manuel Fangio and Stirling Moss dominated the 1955 Formula One season, but the appalling tragedy at Le Mans – which cost over 80 lives – overshadowed everything, and caused Mercedes to announce its withdrawal from racing.

June 11, 1955, is the blackest day in motor racing history. More than 80 people were killed when Pierre Levegh's Mercedes crashed into the crowd during the Le Mans 24 Hours. Formula One stars Juan Manuel Fangio and Mike Hawthorn were both peripherally involved in the incident, which had major repercussions for the sport. As a knee-jerk reaction, the Grands Prix in France, Germany, Switzerland and Spain were cancelled, and motor racing never returned to Switzerland again.

MERCEDES MUSCLE

Mercedes went into the season with morale high. Team boss Alfred Neubauer had signed Stirling Moss to partner Fangio, and now had two top drivers in his Silver Arrows. Maserati signed up Jean Behra to replace Moss, while Hawthorn left Ferrari to drive for Vanwall, with family business pressures dictating that it was better if he was based closer to home.

The season opener in Argentina was run in sweltering conditions, and saw Fangio score a comfortable win. Indeed, he was one of only two drivers able to go the distance solo, and the three pursuing cars were each shared by three drivers apiece as the heat took its toll, with José Froilan Gonzalez, Giuseppe Farina and Maurice Trintignant all taking stints in the second-placed Ferrari.

Alberto Ascari hit the headlines in Monaco by flipping his car into the harbour. Fortunately, he escaped with minor injuries. At the time he was leading -Fangio and Moss had both retired their Mercedes - and this left the way open for Trintignant to become a popular and surprise winner ahead of Eugenio Castellotti's Lancia. Four days later, Ascari's luck ran out when he was killed in a bizarre accident at Monza, whilst he was testing a Ferrari sports car. Already struggling for finance, Lancia announced its withdrawal from the sport, regrettably before the D50 had been able to fulfil its promise.

The Indianapolis 500 remained as part of the championship, and continued to stand apart from the events for Formula One machinery. Bob Sweikert triumphed after Bill Vukovich crashed

LEFT SURPRISE WINNER: MAURICE TRINTIGNANT TAKES VICTORY AT MONACO FOR FERRARI IN AN UNUSUAL RACE.

FAR RIGHT MASTER AND PUPIL: FANGIO LEADS STIRLING MOSS AT AINTREE, BUT IT WAS THE BRITISH DRIVER WHO WON THE RACE.

BELOW CHAMPION'S LAST RACE:
ALBERTO ASCARI PRESSES ON
BEFORE FLIPPING INTO MONACO'S
HARBOUR. FOUR DAYS LATER HE
WAS KILLED WHEN TESTING.

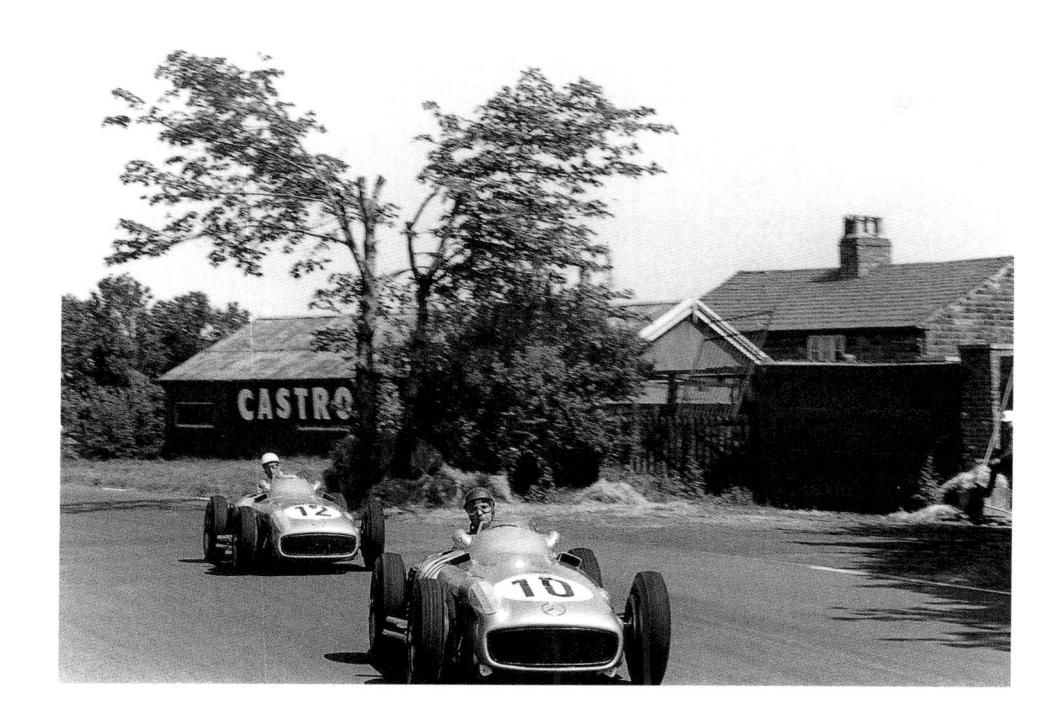

fatally when heading for his third consecutive win. Mercedes meanwhile bounced back at the Belgian Grand Prix at the tricky Spa-Francorchamps circuit, with Fangio and Moss finishing first and second at their ease. Castellotti was allowed a final fling in a Lancia – as a privateer – and ran third before retiring to leave the spot for Ferrari's Farina.

LIFE AFTER LE MANS

The following weekend came the Le Mans tragedy and, despite the outcry, the Grand Prix circus reconvened for the Dutch Grand Prix at Zandvoort just a week later. Fangio and Moss scored another Mercedes one-two finish at the seaside circuit, chased to the line by Luigi Musso's Maserati. By now Hawthorn had given up on the Vanwall project, and his return to Ferrari was rewarded with a creditable seventh place.

The British Grand Prix forsook Silverstone and moved to Aintree for the first time, racing on a circuit laid out around the outside of the course of the famous Grand National steeplechase. Mercedes scored a crushing one-two-three-four finish. This time Moss headed home Fangio, with Karl Kling and Piero Taruffi following on. It was Stirling's first win, but for years afterwards people wondered if Fangio had allowed him to take the glory at home.

A QUIET REVOLUTION

At the back of the grid that day in a little Cooper was a rookie called Jack Brabham. He failed to finish, but it was the start of an amazing partnership, one that was to change the very face of Formula One beyond all recognition.

With all the cancellations, only the Italian Grand Prix remained to be run, this time on Monza's banked circuit. After Moss retired, Fangio headed Taruffi in another one-two, with Castellotti third in a Ferrari. Fangio's third title was already secure, with Moss a distant second. But both men would be hit hard when Mercedes announced its withdrawal.

A significant result came in a nonchampionship race late in the season, when Tony Brooks took his Connaught to victory at Syracuse in Sicily. It was the first major victory for a British car in the World Championship era.

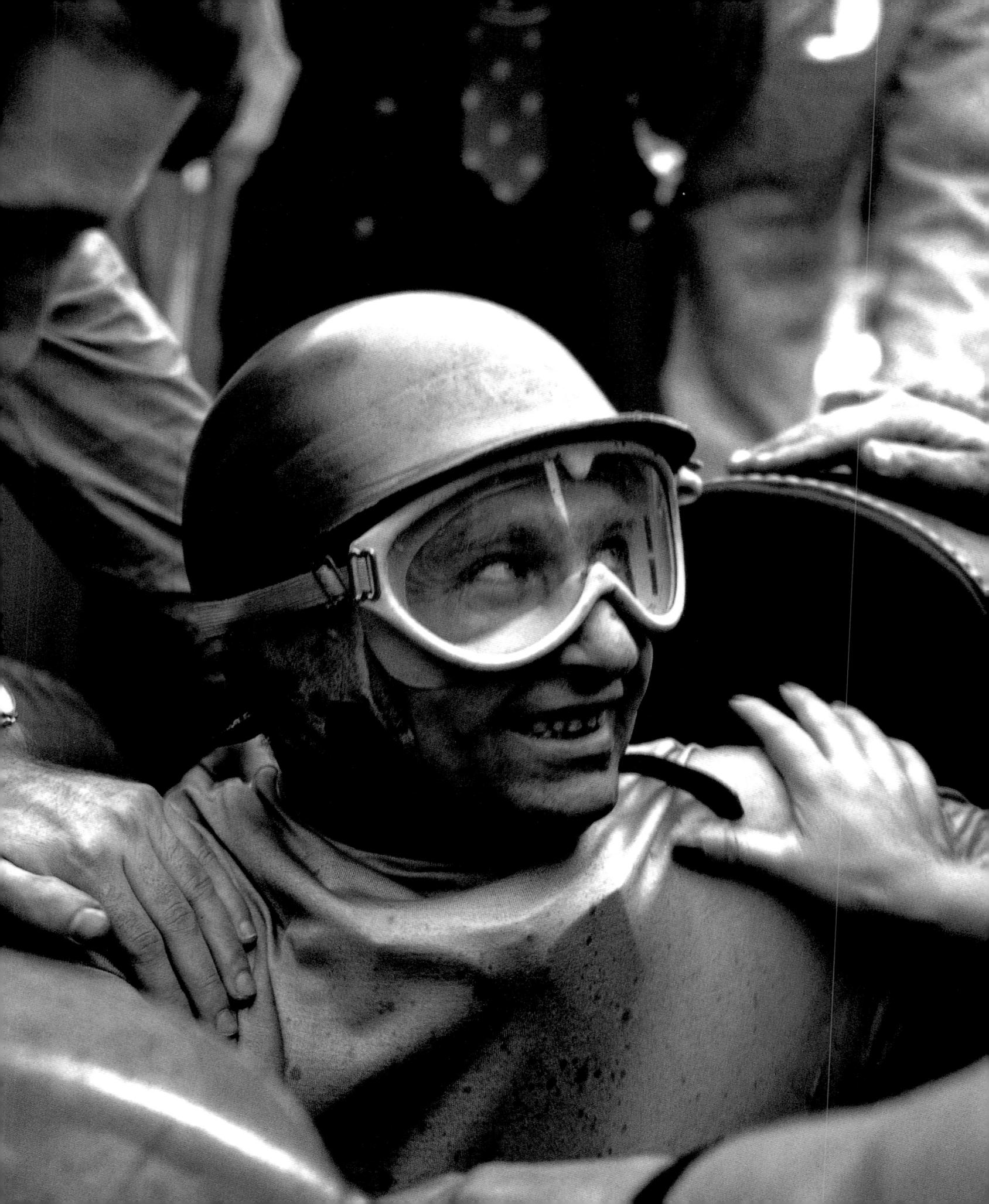

FANGIO FOR FERRARI

ollowing the withdrawal of Mercedes from all motor sport activities, Juan Manuel Fangio switched to Ferrari and landed his fourth World Championship crown. But the Argentinian needed some luck – and the incredible generosity of his sensational new team-mate, Peter Collins.

The two Mercedes stars of 1955 did not spend much time contemplating unemployment, as Fangio joined Ferrari, where another new face that season was talented British youngster Collins, along with Luigi Musso and Eugenio Castellotti. The promising Lancias had also found a new home at Ferrari. They had, in fact, been entered by the Scuderia at the Italian Grand Prix the previous year, but had not started owing to tyre troubles. Modified over the winter, they became Lancia Ferraris for 1956.

Meanwhile, Stirling Moss returned to Maserati to race the still competitive 250F alongside French ace Jean Behra. Prospects also looked good for the British teams as Mike Hawthorn and Tony Brooks joined BRM, while Vanwall had modified cars for Maurice Trintignant and Harry Schell, and Connaught hoped to build on its Syracuse success.

MASERATI HITS BACK

Fangio won the opening round in Argentina, but he did so only after taking over Musso's car when his own retired. The Maseratis struggled in the heat, although Behra took second place. Maserati then hit back at Monaco, where Moss scored a fine second Grand Prix victory. A seemingly very off-form Fangio damaged his own car and this time took over the sister machine of Collins, which

he guided to second place. Over in the US, pole-placed Pat Flaherty avoided a pile-up early in the race to win the Indianapolis 500 in a Watson. Again, no Formula One regulars took part.

Fangio and Moss both hit trouble in the Belgian Grand Prix, and Collins scored a famous victory in his Lancia Ferrari, becoming the third British race winner in as many seasons. Local star Paul Frère earned a fine second place, while Moss took over Cesare Perdisa's car and recovered to finish third. Collins scored his second win at Reims a month later, heading home Castellotti, Behra and Fangio, the champion, who was delayed by a pit stop. The surprise of the race was Harry Schell, who flew to fourth in the Vanwall after an early delay.

Collins went into the British Grand Prix leading the championship from the consistent Behra and Fangio. His thunder at Silverstone was stolen by Hawthorn and Brooks, who led the field on the return of BRM. Both hit trouble early on, though. Then Moss and Roy Salvadori ran at the front until retiring, which allowed a rather fortunate Fangio to take the honours. Collins took over Alfonso de Portago's Lancia Ferrari and finished as runner-up, ahead of Behra.

Fangio was then an easy winner at the Nurburgring, while Collins was out of luck. With his own car retiring with a fuel leak, he took over de Portago's machine, but crashed out of the race.

A FINAL SORT-OUT

For the first time in several seasons the title fight went down to the wire, at the Italian Grand Prix. Fangio was well placed on 30 points, but Collins and Behra were eight behind – they could only take the title by winning the race and setting fastest lap with Fangio failing to score. Schell again surprised everyone by running at the front in the Vanwall and, when he retired, Moss, Fangio and Collins were left to fight it out. Fangio's

hopes faded with steering trouble, but he was saved when Collins – who could still have won the title – stopped and handed his car over to him. It was a gesture, which Fangio would never forget. Despite a scare when he ran out of fuel, Moss just held on from the Collins/Fangio Lancia Ferrari. With BRM and Vanwall having already shown well during the year, it was Connaught's turn to earn some success. Ron Flockhart took advantage of a high attrition rate to come home third. Further British success seemed just around the corner.

LEFT THE TITLE DECIDER: FANGIO IS CHASED BY MOSS IN THE ITALIAN GRAND PRIX.

BELOW LEFT A TRUE GENTLEMAN: PETER
COLLINS SPURNED PERSONAL GLORY
TO HELP FERRARI TEAM-MATE FANGIO
TO HIS FOURTH TITLE.

RIGHT MOSS'S MONACO MAGIC: STIRLING MOSS LED EACH OF THE 100 LAPS TO WIN AT MONACO FOR MASERATI.

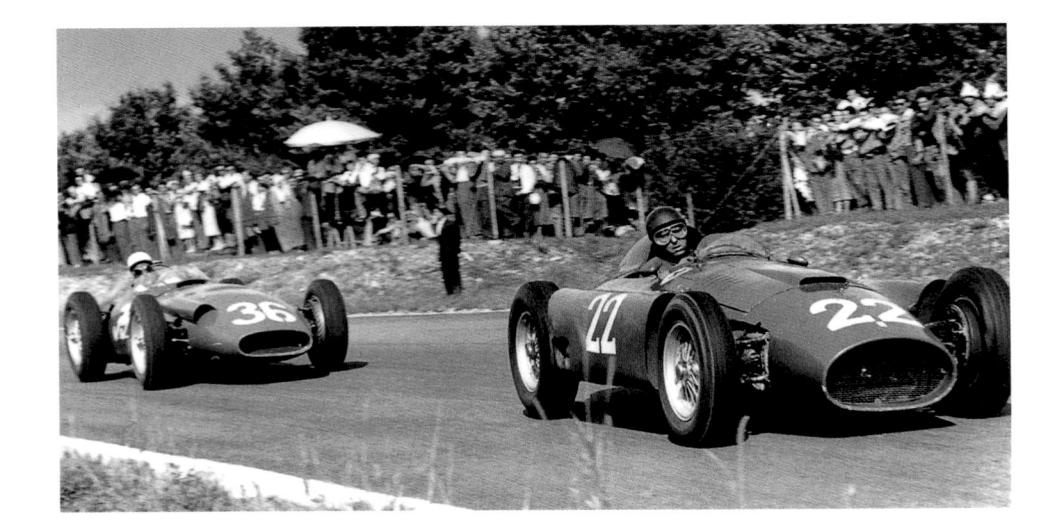

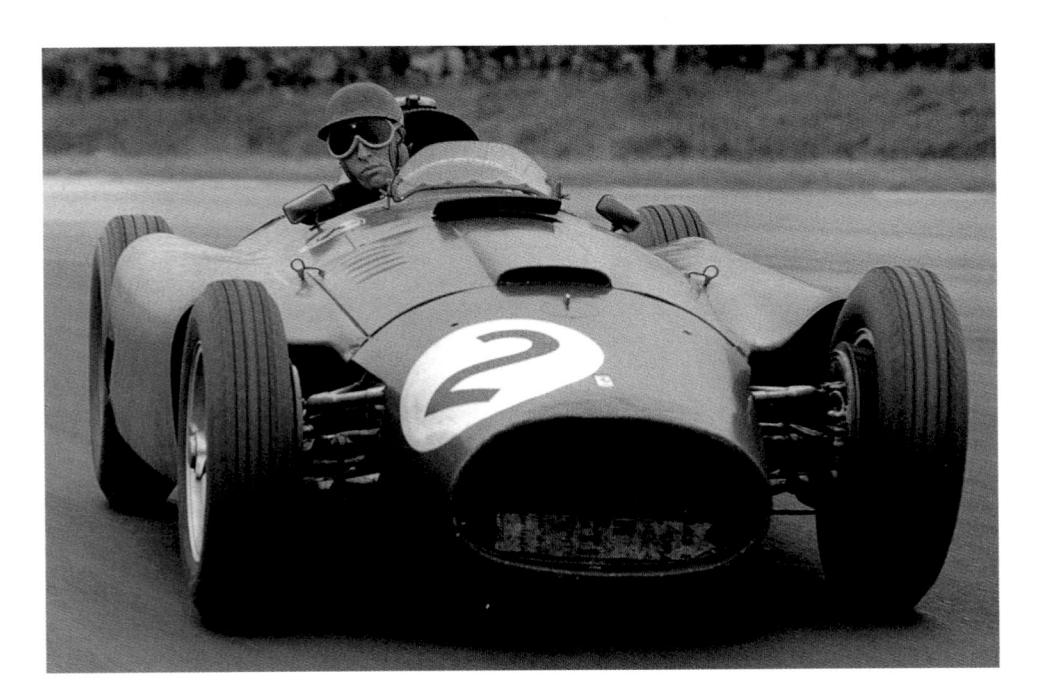

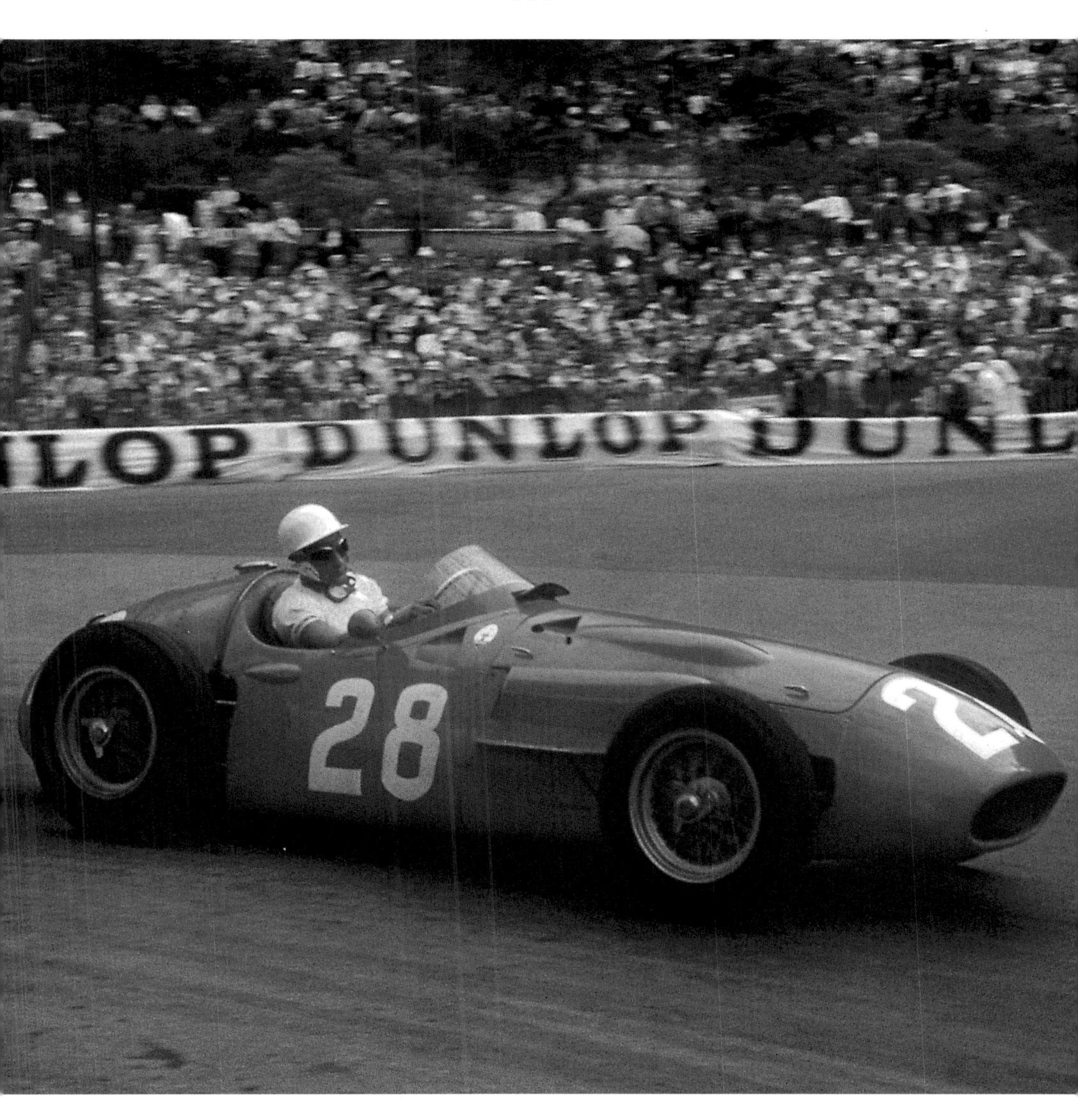

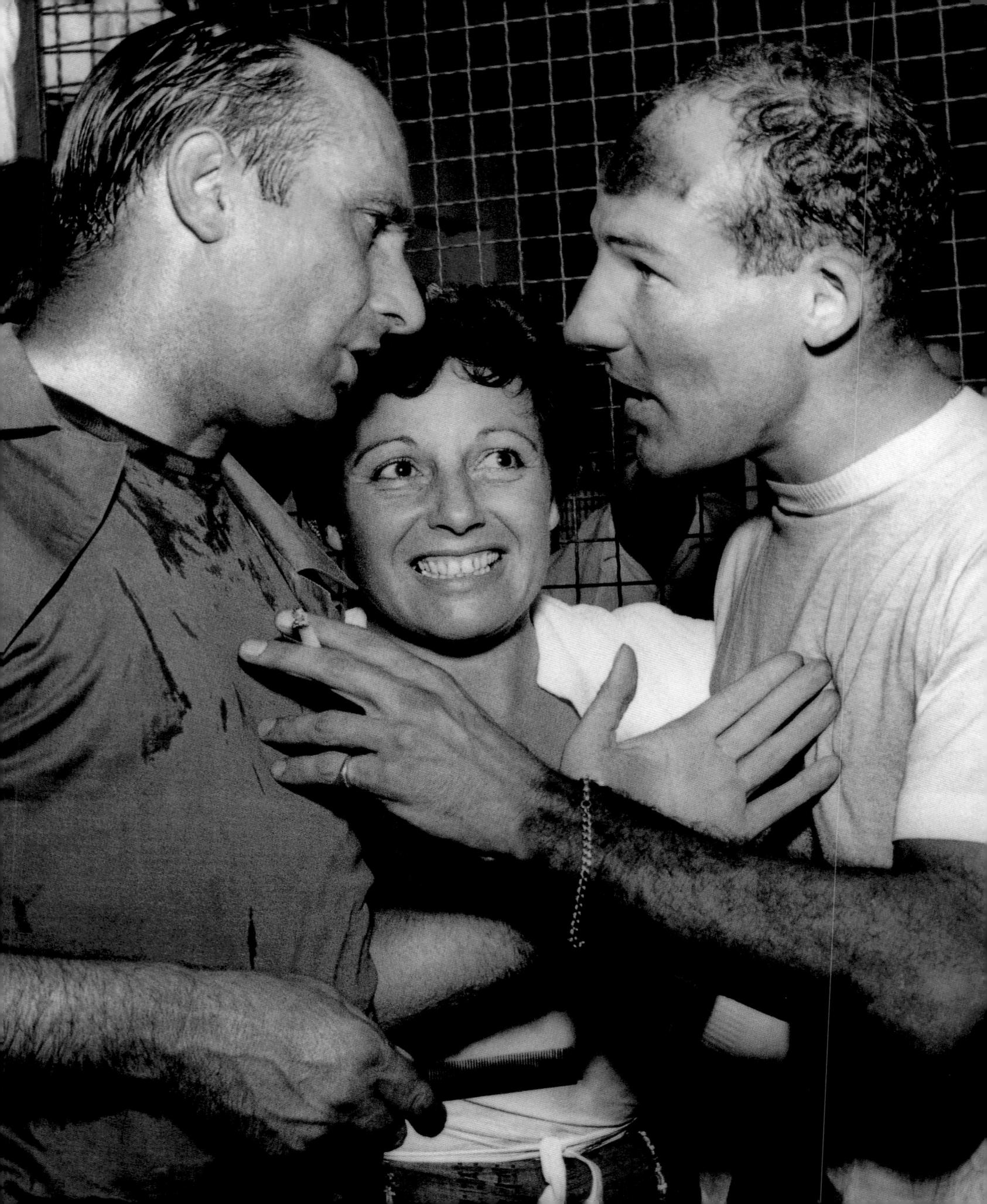

FANGIO'S FIFTH AND FINAL

uan Manuel Fangio acquired his fifth and last World Championship title, this time for Maserati, but Stirling Moss and Vanwall were the true stars of a year during which the all-British team won three times as Ferrari struggled to keep up.

There was plenty of activity during the winter, the most notable news being Fangio's switch from Ferrari to Maserati. It was quite a coup for Maserati to entice the reigning champion back to drive its latest 250F model, and it proved to be an extremely wise choice for the great Argentinian. Meanwhile Moss, always keen to drive British cars wherever possible, headed to Vanwall. Indeed, he had already won the previous year's International Trophy for Tony Vandervell's promising concern. Mike Hawthorn continued to hop back and forth across the

English Channel, rejoining Ferrari for a third spell after a bad time with BRM. He teamed up with his great buddy Peter Collins, plus Luigi Musso and Eugenio Castellotti.

Once again Fangio won his home race in Argentina, heading a Maserati one-two-three-four finish made up by Jean Behra, Carlos Menditeguy and Harry Schell as the Ferrari challenge fell apart. Vanwall did not enter the race, and Moss had trouble at the start in his borrowed Maserati, then set fastest lap as he recovered to seventh. After the Argentinian Grand Prix, the talented Castellotti lost his life in a testing crash at Modena, and he was replaced by Maurice Trintignant. Then the enigmatic Alfonso de Portago was killed in the Mille Miglia. It was a bleak period indeed for Enzo Ferrari.

There was a spectacular pile-up at the

start of the Monaco Grand Prix, which eliminated Moss, Collins and Hawthorn, letting Fangio score an easy win. Brooks took his Vanwall to second after extricating it from the mess. Star of the race was Jack Brabham, who got his underpowered Cooper up to third before the fuel pump failed, then pushed it home sixth. Sam Hanks finally came good to win the Indianapolis 500, a race he had been trying to win since 1940, and promptly retired.

BULLSEYE FOR BRITAIN

The French Grand Prix returned to Rouen, and Fangio stormed to victory ahead of Ferrari men Musso, Collins and Hawthorn. The next race was at Aintree, and it proved to be a memorable day for Britain. After Moss retired his leading Vanwall, he took over the sixth-placed car of team-mate Brooks. The opposition

BELOW LEFT BRITISH DOUBLE: TONY
BROOKS CONGRATULATES STIRLING
MOSS AFTER THEIR COMBINED WIN
IN THE BRITISH GRAND PRIX AT
AINTREE.

BELOW RIGHT GIVING CHASE: TONY
BROOKS'S VANWALL HEADS OUT OF
THE STATION HAIRPIN IN THE WAKE OF
FANGIO'S MASERATI.

BOTTOM EPIC VICTORY: JUAN MANUEL FANGIO STORMS AFTER THE FERRARIS TO WIN THE GERMAN GRAND PRIX AT THE NURBURGRING IN HIS MASERATI.

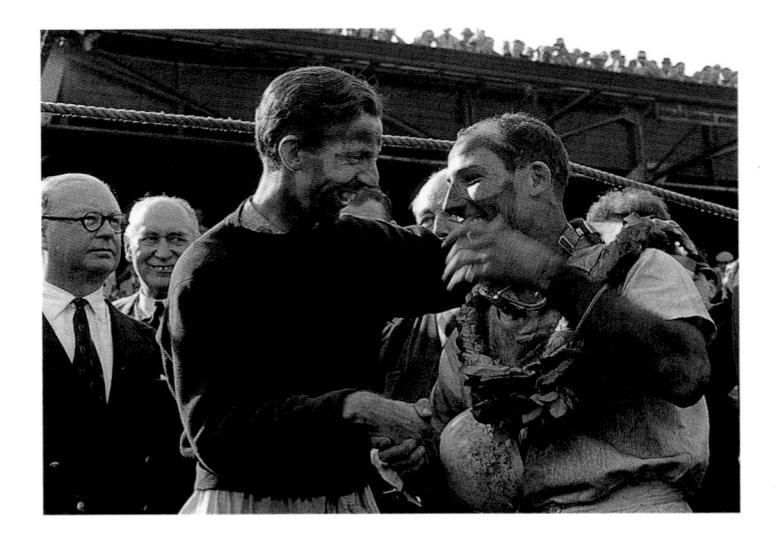

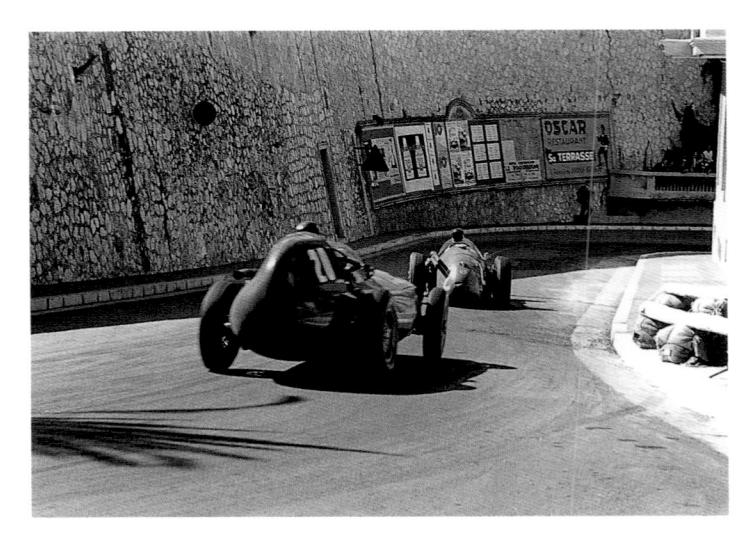

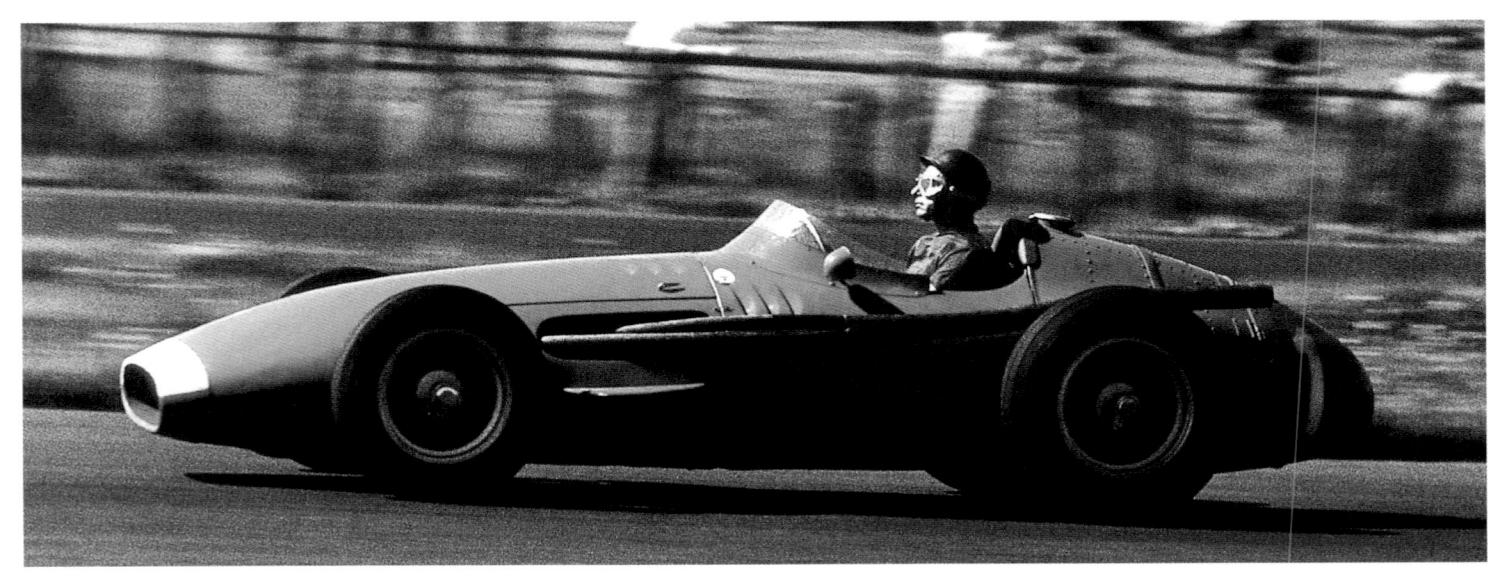

BELOW LONG WAY HOME: STIRLING MOSS
TRIUMPHED FOR VANWALL IN THE
ONE-OFF RACE ON THE ULTRA-LONG
PESCARA ROAD COURSE.

RIGHT MASSED RANKS: THE FIELD LINES UP FOR THE START OF THE ITALIAN GRAND PRIX AT MONZA.

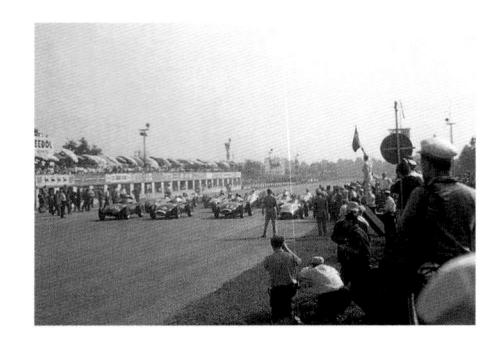

wilted, and when Behra blew his engine – and Hawthorn punctured on the debris – Moss swept home to a wonderful victory.

Vanwall was out of luck in the German Grand Prix, with both cars suffering suspension problems. But the race is remembered as one of the all-time classics, as Fangio came storming back to win after an over-long fuel stop, catching up with Collins and Hawthorn and then leaving them in his wake.

Because the Belgian and Dutch Grands Prix at Spa-Francorchamps and Zandvoort respectively had been cancelled, an extra Italian race was added to the series. This was the Pescara Grand Prix, held on a 16-mile circuit of public roads on Italy's Adriatic coast. Enzo Ferrari, supposedly opposed to Italian road circuits after the Mille Miglia disaster, did not enter Hawthorn and Collins, but loaned a "private" car to Musso. He was in front for the first couple of laps, before Moss took the lead and scored his second victory of the year. Fangio finished second, and sealed his fifth and final title.

MOSS FOR VANWALL

The Monza finale, no longer using the banking, saw a spectacular fight between Vanwall and Maserati. Moss headed Fangio home, with promising German Wolfgang von Trips upholding Ferrari honour in third. It was a lame season for the Prancing Horse, as Ferrari had not won a race all year, and clearly needed to resolve that situation in 1958. The job was made easier when Maserati withdrew its works team at the end of the season, citing a lack of funds.

BRITISH BREAKTHROUGH

ike Hawthorn pipped Stirling Moss to become the first British World Champion, but his success was overshadowed by the death of his team-mate and friend, Peter Collins. Hawthorn then elected to retire from racing, only to lose his life in a road accident before the start of the 1959 season.

The departure of the works Maserati team from Formula One was a major blow to the World Championship, although the cars survived in the hands of privateers. The marque's withdrawal coincided with the retirement of Juan Manuel Fangio. The five-time World Champion would run just a couple of 1958 Grands Prix before calling it a day.

Ferrari abandoned its old Lancia-based 801s, and had a new model, the 246 Dino, with Hawthorn, Collins and Luigi Musso the star drivers. Moss, Tony Brooks and Stuart Lewis-Evans stayed with Vanwall, while John Cooper mounted a serious effort with Jack Brabham and Roy Salvadori as drivers. Rob Walker entered a private Cooper-Climax for Maurice Trintignant, while Jean Behra and Harry Schell headed a revived BRM effort.

BRITISH GLORY

The season started off with a surprise at the Argentinian Grand Prix. Most of the British teams were absent, including Vanwall, so Moss was free to replace Trintignant in Rob Walker's little rearengined Cooper. He won the race with a canny display of tactical driving, although his tyres were all but worn out by the end. In the following Grand Prix, at Monaco, Trintignant was at the wheel of Rob Walker's car and, amazingly, he

scored his second success in the street race as, once again, the faster cars hit trouble, including Moss's Vanwall.

The British run of success continued in the Dutch Grand Prix at Zandvoort, where Vanwall swept the front row. Moss won the race, while the BRMs of Schell and Behra finished second and third after the other Vanwalls had retired. Salvadori's Cooper came home fourth, and even the best Ferrari – that of fifth-placed Hawthorn – had a British driver.

Good fortune smiled on Jimmy Bryan as he avoided numerous accidents that marred the Indianapolis 500 to win America's biggest race. The Belgian Grand Prix was next and Brooks came good for Vanwall, giving the team its second win on the trot, followed home by Hawthorn and Lewis-Evans.

Ferrari had been without a win since

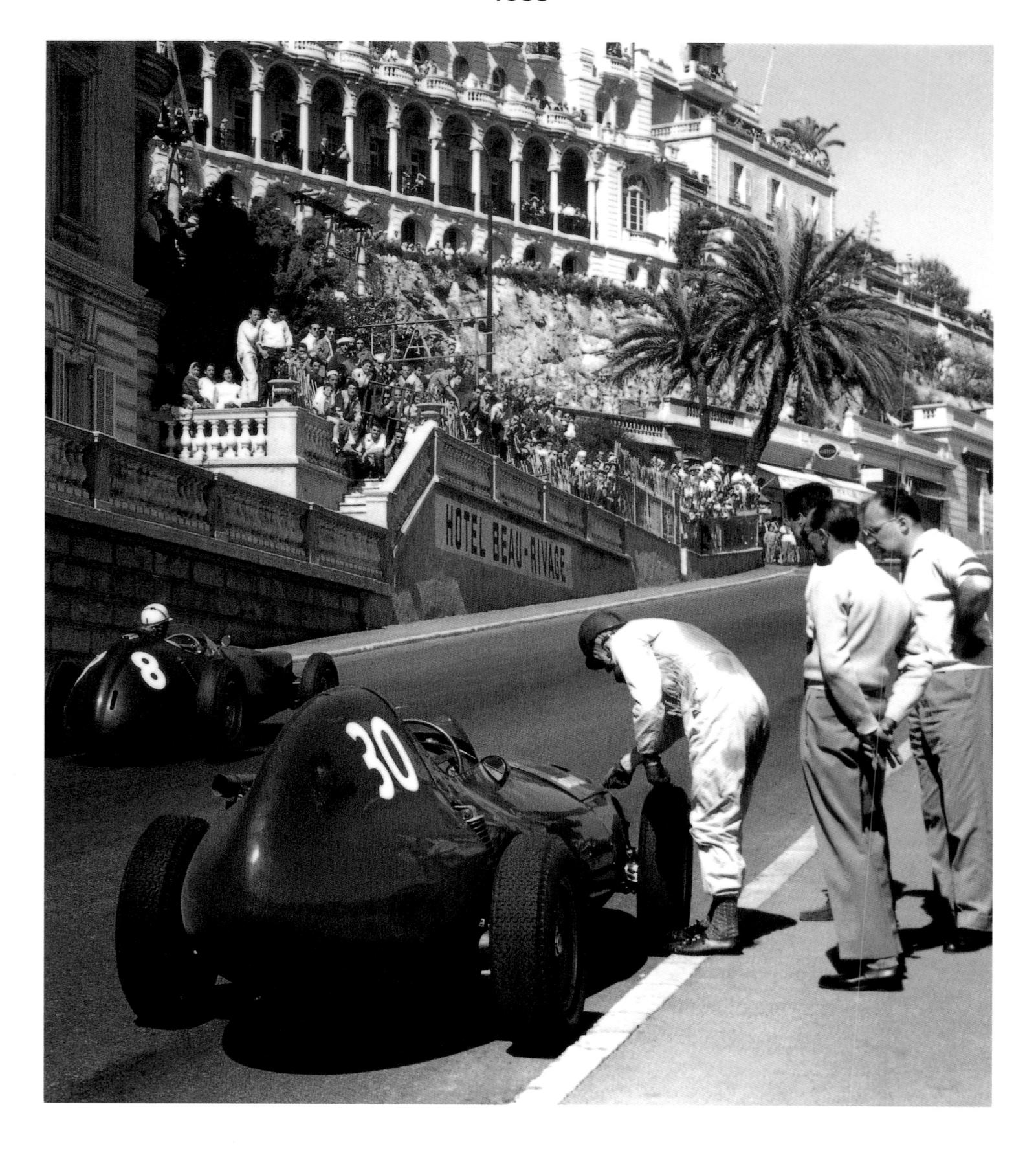

LEFT IT'S BROKEN MISTER: TONY BROOKS EXAMINES HIS
VANWALL AT MONACO AS SCHELL'S BRM MOTORS BY.

RIGHT FINAL ADVICE: STIRLING MOSS CHATS WITH THE VANWALL CREW BEFORE THE START OF THE MOROCCAN GRAND PRIX. HIS WIN WAS NOT ENOUGH.

BELOW LEFT THAT'S MORE LIKE IT: BROOKS HIT A WINNING VEIN WHEN HE LED THE WAY FOR VANWALL AT SPAFRANCORCHAMPS.

BELOW RIGHT CHAMPION'S DRIVE: SECOND PLACE AT CASABLANCA
IN HIS FERRARI WAS SUFFICIENT FOR MIKE HAWTHORN TO
BECOME BRITAIN'S FIRST WORLD CHAMPION.

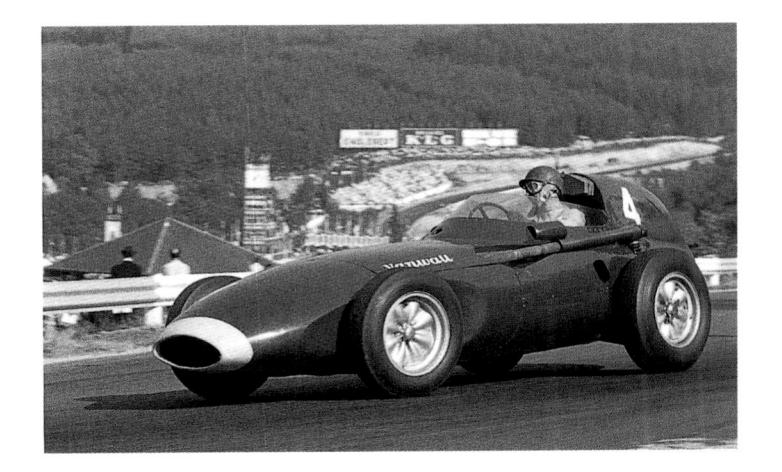

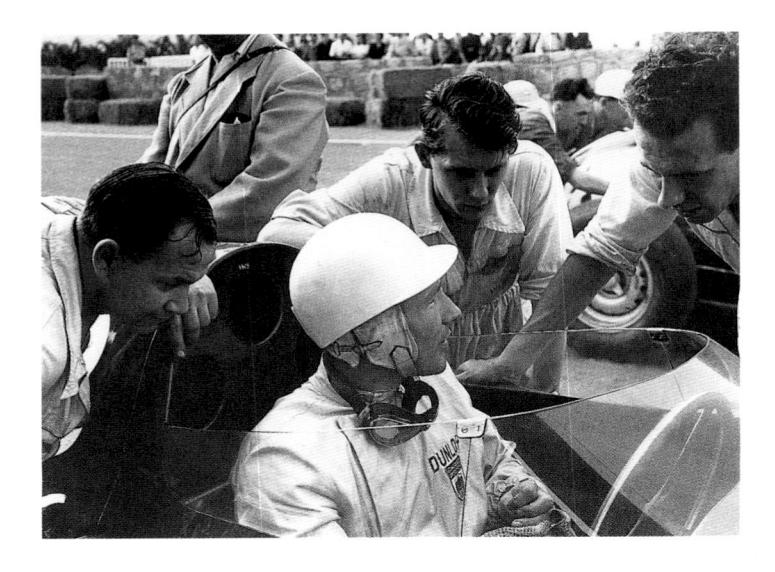

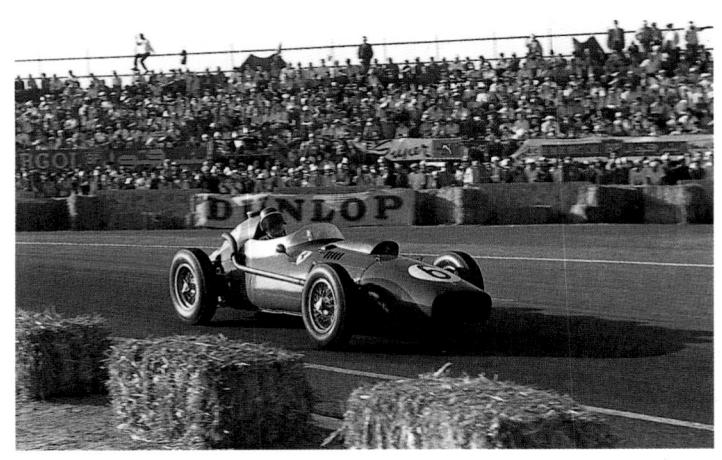

1956, but the waiting ended at Reims where Hawthorn scored what would be his only victory of the season. However, there was no celebrating as team-mate Musso, who had qualified second, was killed in the race. Fangio ducked out of the World Championship, after finishing fourth in his last race.

FERRARI IN THE GROOVE

At the British Grand Prix, back at Silverstone, it was the turn of Collins to win for Ferrari, with Hawthorn taking second. But a fortnight later tragedy struck again when Collins lost his life in the German Grand Prix. Brooks went on to score a hollow victory a long way clear of the Coopers of Salvadori and Trintignant. Moss had retired while leading at the Nurburgring, and he gained some revenge at the first ever Portuguese Grand Prix at Oporto, winning from pole position with Hawthorn second.

A GRAND FINALE

The title battle went to the final round – the Moroccan Grand Prix on the outskirts of Casablanca. In one of the closest points battles ever, Moss led all the way and set fastest lap. However, with Brooks blowing up, Hawthorn eased into second place, which was all he required to take the crown. It was a terrible day for both Vanwall and Stirling, made worse when Lewis-Evans crashed and later succumbed to his injuries. The only consolation for Vanwall was the inaugural constructors' title.

After quitting the sport while at his peak, Mike Hawthorn was ironically killed in a tragic road accident in January of 1959. He was just 29 years old.

BRABHAM MOVES UP

when Jack Brabham took his Cooper-Climax to the 1959 championship. It was the first title for a rear-engined car, marking a triumph of handling over old-fashioned power. The revolution started here.

The big news of the winter was the surprise withdrawal of the Vanwall team, just as it had reached full competitiveness. However, Cooper, BRM and Lotus upheld British honour. After the previous year's tragedies there were big changes at Ferrari as Tony Brooks joined from Vanwall and Jean Behra moved across from BRM, while Phil Hill – an occasional Ferrari driver in 1958 – went full time. Stirling Moss kept his options open, and appeared in both Rob Walker's Cooper-Climax and a BRM, in the colours of the British Racing Partnership.

SUCCESS FOR COOPER-CLIMAX

In previous years, Climax had given away a few cubic centimetres of engine capacity, but the company's latest engine was a full 2.5-litre unit. Although still a little down on power compared with its rivals, the Cooper chassis' handling proved vastly superior to even up the balance of overall performance.

With the Argentinian Grand Prix cancelled, the World Championship opened at Monaco. Behra's Ferrari led until retiring, and then Moss's nimble Cooper expired, leaving Brabham to score his first win in the works Cooper ahead of Tony Brooks's Ferrari. Meanwhile, the Indianapolis 500 enjoyed one of its most competitive runnings ever, as Rodger Ward fought with Jim Rathmann, Johnny Thomson and Pat Flaherty before winning.

BRM WINS AT LAST

The Dutch Grand Prix saw a major surprise as Jo Bonnier notched up BRM's first victory – nine years after the marque took its first, stumbling steps. The bearded Swede had to work hard to hold off the Coopers, and was helped when Moss retired.

Ferrari fought back with a fine win for Brooks at Reims, team-mate Phil Hill following him home. Moss was in the BRP BRM on this occasion, and was battling for second when he went off the road. Three marques had won the first three races, but Cooper was back in the frame at the British Grand Prix as Brabham scored his second win, ahead of Moss's BRM which crossed the line just ahead of young Kiwi Bruce McLaren in the second works Cooper. Ferrari did not turn up at Aintree, blaming Italian industrial action.

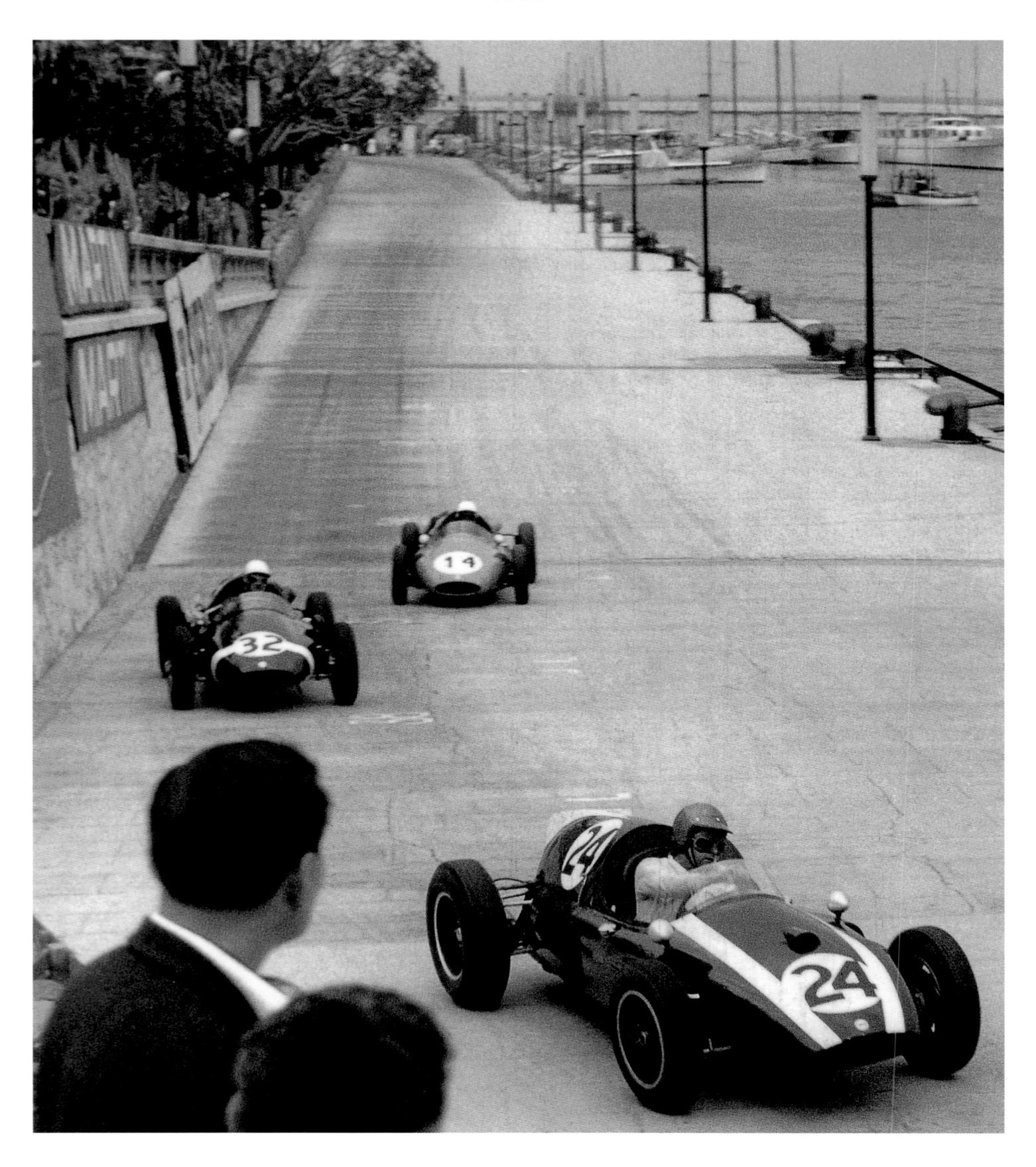

For the first and only time the German Grand Prix was held on the daunting, banked Avus circuit in Berlin and, uniquely, the result was an aggregate of two 30-lap heats. Missing Aintree had obviously done Ferrari some good, for Brooks dominated the event. But, as at Reims the year before, Ferrari's celebration was muted by tragedy. Veteran Behra, who had been a mainstay of the championship since its inception, died after a crash in the sports car support race, just one race after quitting the team to race his own Porsche.

BRABHAM CLOSES IN

Moss had to wait until the Portuguese Grand Prix to pick up his first win of the year in Rob Walker's Cooper. Brabham crashed out, but still led the championship as the circus moved to the penultimate race at Monza. Moss won again, ahead of Hill, while third place for Brabham kept his title challenge alive.

It was then a full three months before the final race, the first ever US Grand Prix, and the only one to be held on the Sebring airfield track in Florida – home of the famous 12 hours sports car race. Moss could still lift the crown and, after taking pole position, he was leading comfortably when his gearbox failed. Brabham ran out of fuel and had to push his car home in fourth place, but the title was his come what may. A surprise win went to his team-mate McLaren, who, at 22 became the youngest Grand Prix winner – a record which still stands. Trintignant was second in another Cooper, ahead of Brooks, with Cooper thus taking the second constructor's cup.

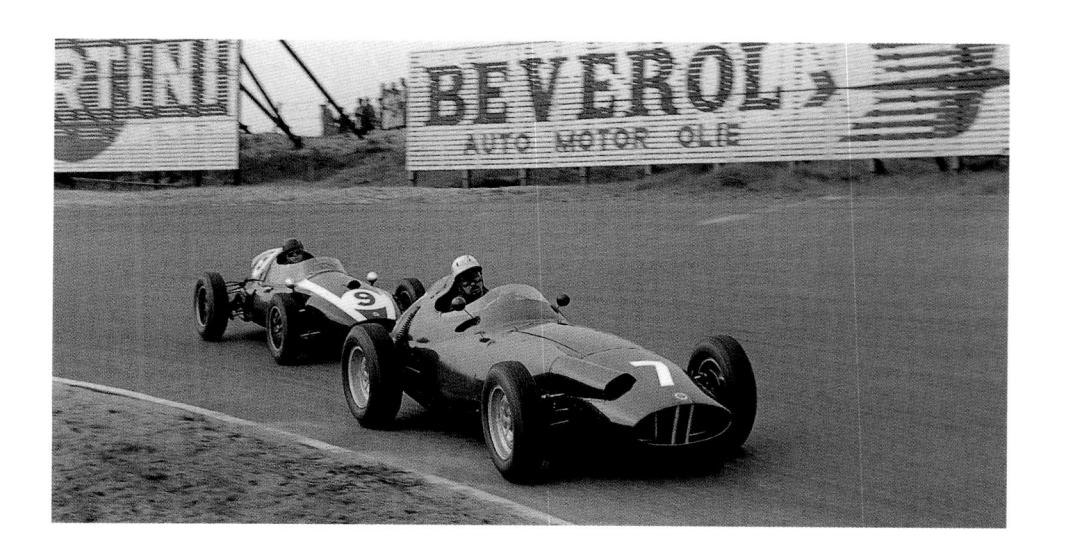

LEFT COOPERS IN CONTROL: JACK
BRABHAM LEADS THE WAY AT MONACO
WITH MAURICE TRINTIGNANT (32)
HEADING FOR THIRD IN ROB WALKER'S
COOPER.

ABOVE RIGHT BRM WINS AT LAST: JO
BONNIER HOLDS OFF MASTEN
GREGORY'S COOPER EN ROUTE TO
WINNING AT ZANDVOORT.

RIGHT THE PRICE OF GLORY: JACK BRABHAM IS EXHAUSTED AFTER PUSHING HIS COOPER HOME AT SEBRING.

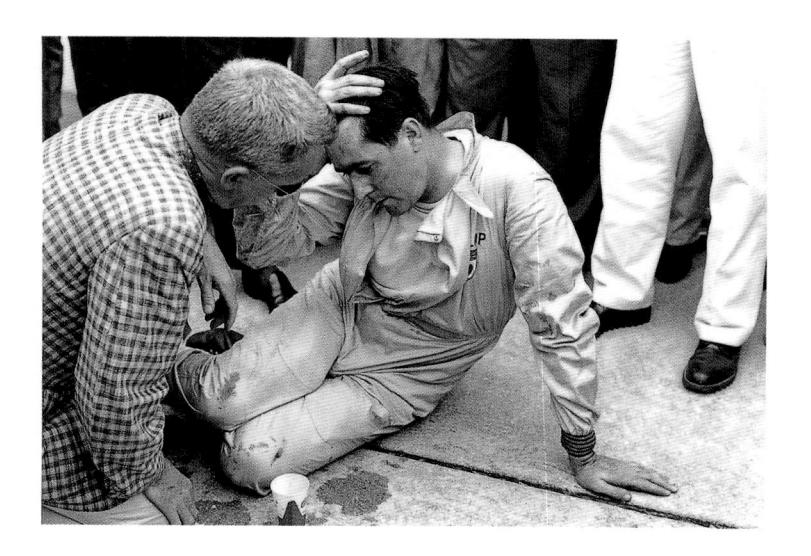

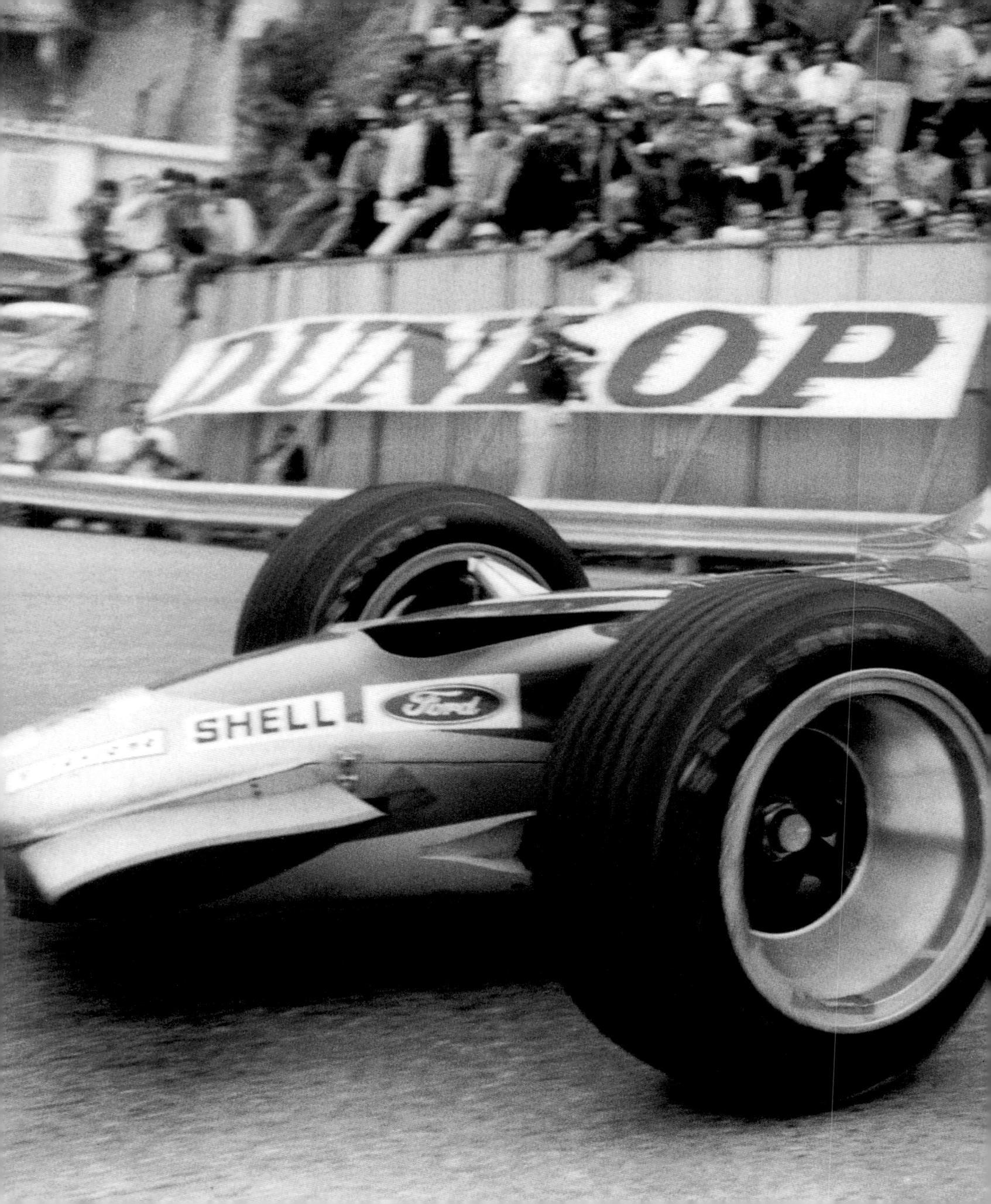

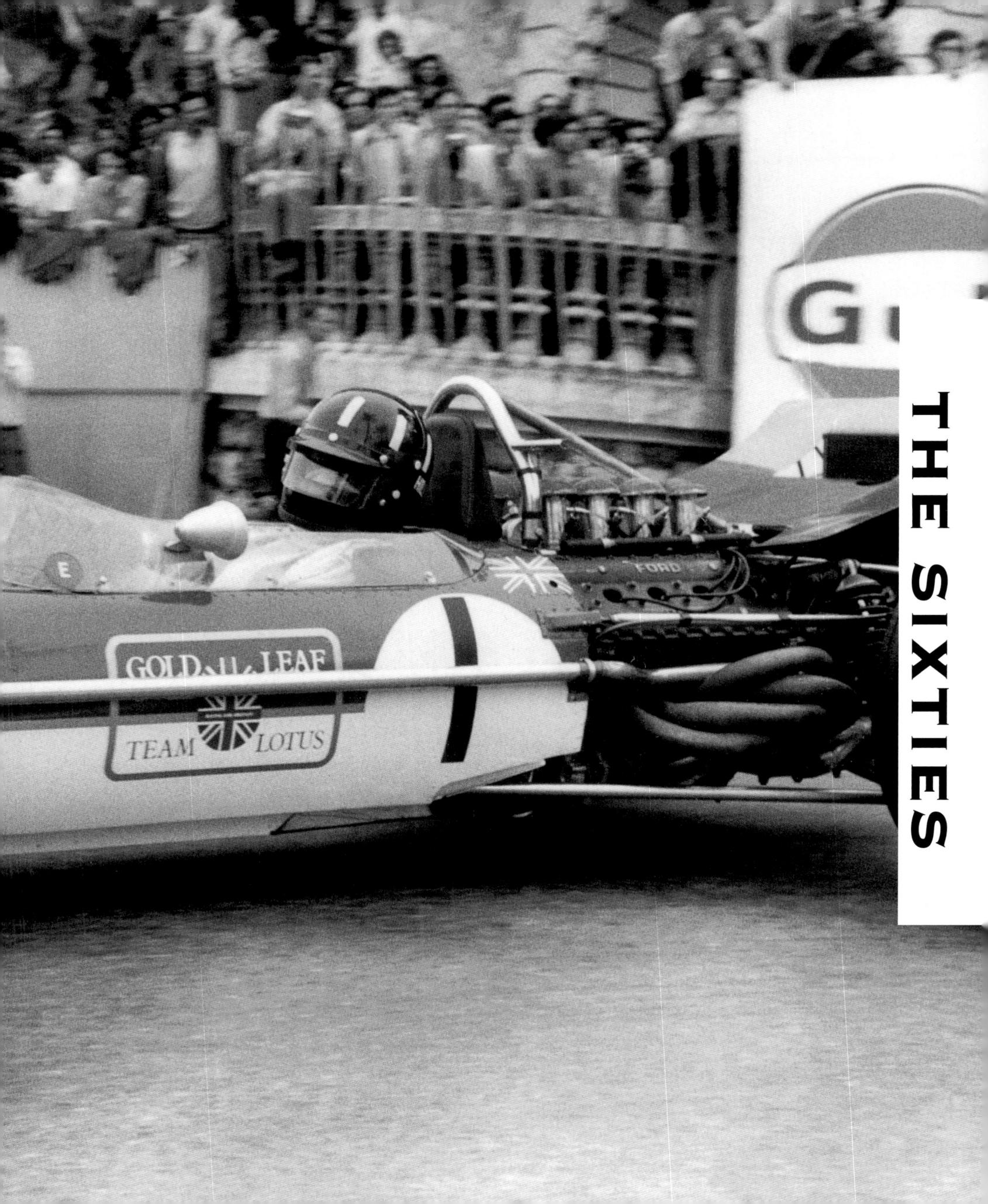

THE SIXTIES

JOHN SURTEES

Honours: World Champion 1964

Grand Prix record: 111 starts, 6 wins

Asking a motorcycle racer what he thinks of Formula One will elicit an interesting response, particularly if that racer is a seven-time World Motorcycle Champion. However, though John Surtees fits that bill, he is also the obvious person to talk about Formula One in the 1960s as he turned from two-wheeled competition to four and became World Champion in 1964, a unique feat, before going on to form his own racing team.

"I look upon the 1960s in a number of ways," says John. "It was a time of total mismanagement by the governing body as the movement from the 2.5-litre formula to a 1.5-litre formula and then to a 3-litre formula was ludicrous. Secondly, it was the decade of the two Cs: the Climax and the Cosworth, as they governed everything."

Armed with his successes with MV Agusta, John looked at cars in 1960 after some promising tests in 1959 and it went from there: "Apart from watching practice at Monza," John explains, "I'd never seen a car race before I sat in a Formula Junior at Goodwood for my first race. Indeed, the only four-wheeled experience I had before that was driving around Goodwood in first an Aston Martin DBR1 sportscar then in one of the three recently retired Vanwall Formula One cars and a couple of laps in the Aston Martin Formula One car.

"I was a part-timer in 1960, as I was still involved in my motorcycle career and came on the World Championship scene after only three drives – one in Ken Tyrrell's Formula Junior Cooper in which I came second behind Jimmy Clark's works Lotus at Goodwood, another at Oulton Park in my own Formula Two Cooper when I was second this time behind Innes Ireland's works Lotus and then a third in which I set a lap record at Aintree – as Colin Chapman asked me to join Lotus after a test at Silverstone. So I drove in the International Trophy at Silverstone when an oil leak forced me out. Then I went to Monaco for my World Championship debut. This was a totally new experience as I'd never ridden at Monaco, and one major difference when adapting to cars was getting organised to take slow corners. Sadly, we were plagued by gearbox problems.

"The British Grand Prix at Silverstone was next and I came second. Then came the Portuguese Grand Prix at Oporto where I started on pole, set fastest lap and led until I made a mistake passing Stirling Moss when I got my wheels caught in the tramlines. He'd just come from the pits and I suppose I was a bit wound-up as certain people – but not Stirling – were less than happy that I'd joined the four-wheeled scene. I rounded out the year with the

JOHN SURTEES

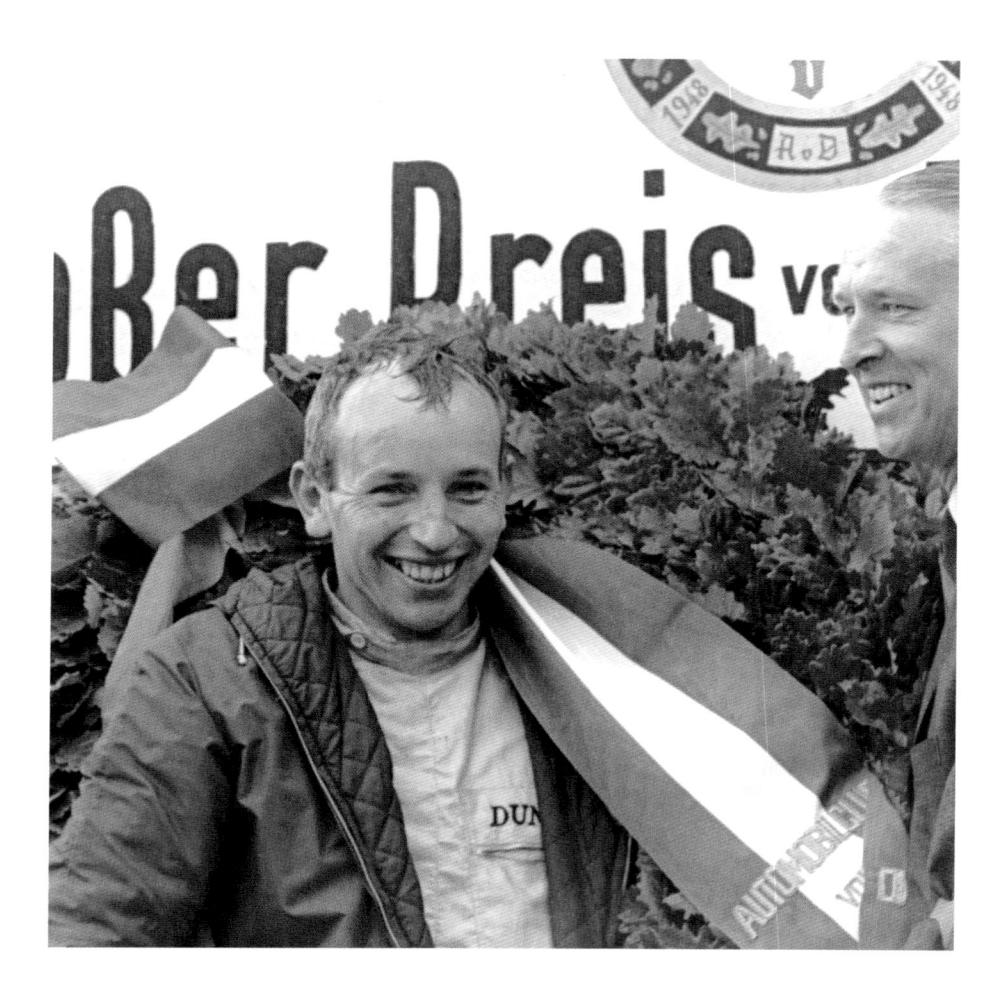

American Grand Prix when after a bad start I tried too hard to get back to the front, spun and took out my team-mate Jimmy Clark.

"Chapman could see that I didn't have much experience, but the fact that the first time I sat in a car I was able to go as quickly as anyone had been in that car was good enough for him. And that's why he asked me to be his team leader for 1961. When he asked me who I wanted as my team-mate, I said Jimmy. Colin said that this was fine as he'd fixed for Innes (Ireland) to drive a UDT Laystall Lotus. Innes then ranted at me down the 'phone, so we went to see Colin to sort it out, there was a big row and I walked away from Lotus, which wasn't the best thing to do with no top-level drives available. And so I joined Cooper instead.

"It's strange when I look back, for in that Lotus 18 I was probably sitting in the most competitive car of my career. The reliability wasn't good, but that aside there was no reason that I couldn't have won three of the four Grands Prix I contested."

This was a time of rapid change in Formula One, and nowhere were the changes greater than in the hotbed of the

British teams: "The constructors had modernised Dr Porsche's concepts from the days of his Auto Union racers and hadn't gone along with the standard concept of what a racing car should be. So, what John Cooper had started with Jack Brabham, who provided a nice balance and was very feet on the ground, was followed by the more gifted Chapman.

"The arrival of the Climax engine signalled a new way of thinking. It was engineered so that it had a similar power output to its rivals, but so that it had very useable power which allowed drivers to adjust the car's handling. And this is what set the scene for the 1960s.

"Because of indecision about what format Formula One would adopt in 1961, people weren't prepared for the 1.5-litre formula. You had the Climax still, but they weren't getting a lot of development into them as Climax was working on its V8, while Ferrari had a lot of experience with its V6 and made a 1.5-litre version of it that worked well. The Ferrari chassis wouldn't have been as effective as the Lotus or the Cooper, but when you have

THE SIXTIES

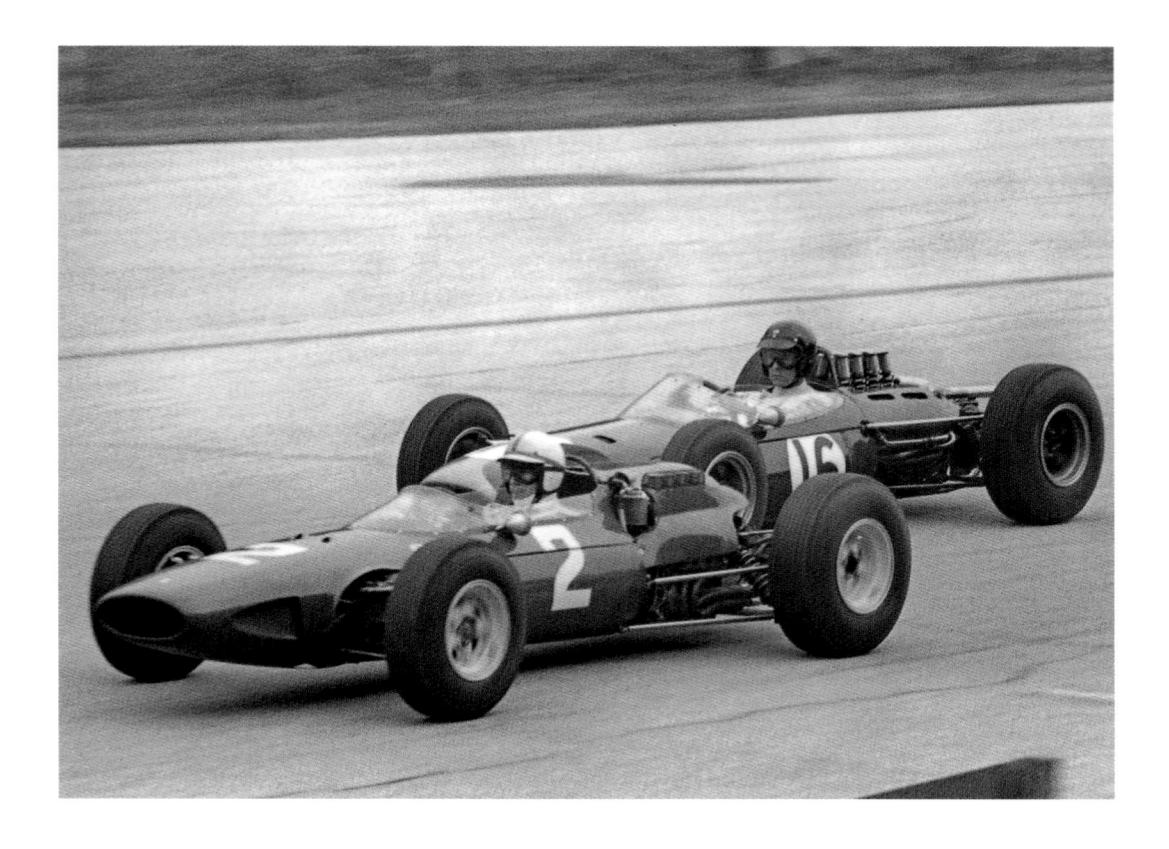

a 1.5-litre formula it doesn't give drivers the same amount of opportunity to grab back time." John's best result in 1961 was a pair of fifths in his Yeoman Credit Cooper. For 1962, John insisted on joining a works outfit and thus raced a works Lola under the Bowmaker Racing banner, twice coming second. He also won national races and several in the Tasman series.

"When I went to Ferrari in 1963," John continues, "that was largely due to an engine factor as we'd had the Lola in its first year and had been extremely unfortunate not to win at least one Grand Prix as it broke a few times. Then it was announced that Climax would concentrate on Lotus and Cooper in 1963. Drivers at BRM didn't like the idea of me going there, so I joined Ferrari.

"I had been asked to go to Ferrari in 1961, and had talked to Enzo Ferrari and Carlo Chiti, but felt I wasn't ready for them as they were riding high and overestimating what they could do. They asked again at the end of 1962, when they were down, and from what I'd seen in bike racing I thought this was the best time to join an Italian outfit.

"When I arrived at Ferrari, it was virtually a new team as Chiti and many of the team had left for ATS. Luckily Franco Rocchi had stayed as project engineer, while Mauro Forghieri joined as a coordinator. We found bits and pieces of the 1962 car and tested

these with bits we reckoned we needed then took it from there. Michael May was brought in to work on the V6's direct injection to up its power, with the promise that a V8 and a V12 would follow.

"We had a new team manager, Eugenio Dragoni, a maverick who was a link man to Mr Ferrari and, as it subsequently turned out, also to Fiat. We had a 'cat and mouse' game from the very beginning, meaning you had to watch over your shoulder.

"The car was very driveable in a Cooper sort of way rather than in a Lotus sort of way as it could be driven hard and was forgiving, but there were continuous troubles with changing characteristics of the engine, because the fuel injection was too sensitive. To go along and meter it for a whole speed range was very difficult and changing ambient temperatures would affect the way it ran. We agreed that I should see Bosch about their fuel injection. This coincided with the non-championship race at Solitude, just down the road from their base. It should have been our first win of the year, as it was fantastic in the wet, but it dried and Jimmy Clark pipped me. However, I could use the throttle more and be sure it would respond. So we were in good spirits for the next race at the Nurburgring. And we had the edge all meeting, enabling me to be the hare to Jimmy for a change." This was John's first win for Ferrari and boosted his standing within a team that was becoming

increasingly important to him.

"When I joined Ferrari, I got on well with the Old Man and so thought that it would be my life," John explains. "But to have done justice to myself I should have behaved as Jackie Stewart did and made sure that I only put my seat in the best possible car. However, that would have meant going back to Chapman and saying that when I turned him down over Innes that I was wrong. Secondly, I enjoyed being part of a team like Ferrari and hauling it back to success. And I liked the environment and the people.

"The V8 came and it was a political thing which I questioned, as all of Ferrari's working had been with 12-cylinder engines. I wanted to know if Ferrari was going to make up enough ground to make a V8 as good as a Climax. But the deal with Fiat was beckoning and the V8 was something like a commercial project that was partly sponsored by Fiat. And again it had direct injection and was a little heavy. The car handled well, but it wasn't as efficient as the Lotus. You were able to push on, but we were lacking that vital mid-range power, an area that British engine builders seemed to concentrate on. On occasions when the atmospheric conditions were right, we were on par with the Climaxes, but it wasn't consistent." However, John won the German and Italian Grands Prix and this was enough to edge out Clark and Graham Hill in a last-round battle for the world title in Mexico.

Staying on for 1965, John was not impressed that Ferrari started off with the V8. This is why: "The only time I felt we could dominate was in the Italian Grand Prix at Monza when Rocchi had come up with a revised cylinder-head for the Flat-12 and it really sung. But I lost the clutch at the start... Unfortunately, I wasn't to drive it again as I had an accident in a CanAm race at Mosport Park. This was a great shame, as I was really looking forward to going to the American and Mexican Grands Prix on an equal footing." John's injuries were life-threatening and he didn't return to driving until 1966.

"I used to return to England to liaise with manufacturers like Lucas and Girling, and I asked Enzo if he minded if I got involved with the Lola CanAm project as I was worried that we were losing out to the gathering momentum of what was happening in England where all the manufacturers were building on each other which is why the industry is so strong here today. The Old Man said that I could try, but with one of our Ferraris rather than with Lola. So I took one of our old sportscars, stripped it, went to the States and did a few CanAm races. I then told him that the engine was too small and the car too heavy. So it was agreed that I would be allowed to stay in communication with other manufacturers. It was very positive, but it was partly the beginning of the end.

"Without going into details as to why I left, part of the reason that Dragoni had been trying to boot me out was that I had upset Forghieri by contradicting him about what worked on the car and what didn't. Secondly, although he wasn't involved in the race programme, I crossed swords with Mike Parkes. As he wanted to get into Formula One and he made a ready ally for Dragoni.

"When I was convalescing, I went out at Modena with what would have been my car for the Tasman series if I hadn't injured myself. This was a Formula One chassis to which we fitted a 2.4-litre V6. I was winched in and it flew. Then came the big day, the new 3-litre Formula One, new for 1966. Everyone said we'd shine,

but our original project engine hadn't been proceeded with and Ferrari had produced a short-stroke version of the sportscar engine which weighed 100lb too much and produced 280bhp rather than 320. I went out and found it 2.5 seconds slower per lap than with the 2.4-litre V6. The engine probably had the same power as Jack Brabham's Repco which was fitted in a car that was 100lb lighter...

"Anyhow, I said that I'd race the 2.4-litre Formula One car, not the 3-litre V12. But they asked me to try the 3-litre in the non-championship race at Syracuse. So I did so and luckily it was a bit wet. I pushed like hell and only just managed to beat (Lorenzo) Bandini who had the 2.4. They asked me to try the 3-litre again in the International Trophy at Silverstone, which I did. And I was passed as though I was standing still by Brabham and by Jackie Stewart's 2.3-litre BRM. Monaco was the year's first World Championship race and I told them that I wanted to race the more agile 2.4-litre car. Furthermore, I told them our V12 wouldn't last and that we were marginal on the gearbox. However, Dragoni said that Ferrari sold 12-cylinder road cars, so I would race the 3-litre V12. I duly led the race until, guess what, the gearbox packed up. I wasn't happy, especially as Lorenzo got to drive the 2.4 and pressed Stewart for victory..

"At Spa, I still had to use the 3-litre, but Rocchi modified the cylinder head to boost power and it made such a difference that I got pole. Then it poured as we came down the hill towards Burnenville. I drove off line there to avoid trouble and the next lap saw that there had been mayhem. I went on to win after a dice with Jochen Rindt's Cooper. The mechanics were delighted of course, but there was not a word of congratulation from Dragoni. People forget, too, that this had been a difficult time for me, coming back from my CanAm shunt.

"However, it all came to a head at Le Mans. We were facing a threat from Ford and the plan was for me to go off like a hare and have the Fords give chase, hoping they would break. However, as I got ready, Dragoni told me that Ludovico Scarfiotti would start the race as his uncle, Fiat boss Gianni Agnelli, was there to watch. Ludovico was going to be a second and a half off my pace and this would blow our plan, so I was furious and told them to forget it and quit.

"So there I was leading the championship with no car to drive. I then finished the season in a Cooper-Maserati. And, if I hadn't had a gear strip at the Nurburgring when I finished second, or the bag tank hadn't popped at Monza, or I hadn't been hit by Peter Arundell at Watkins Glen, then it was quite possible that I could have stolen the title.

"Dragoni finally brought out the proper 3-litre engine – the one we were supposed to have at the start – in time for the Italian Grand Prix, and it flew. But it was a one-off success.

"I rounded out the year with a win in Mexico, but it was here that I discovered that Maserati were doubtful about continuing, even though they eventually did. Shell then asked if I would go back to Ferrari, for 1967, but this wasn't on. I had a slim chance of racing a Lola powered by a BMW V8. Then Mr Nakamura of Honda said that Honda would only stay in racing if I joined them and helped them run the team. I'd seen what Honda had done with its 1.5-litre Formula One engine and in motorcycle racing, so

I decided to give it a chance.

"However, all normal reckoning of what teams were doing that year was affected by the arrival of the Ford Cosworth DFV. This had an even bigger impact than the Climax, as the Climax was more widely available. The Cosworth on the other hand, started only with Lotus."

The first Honda John drove was overweight, but a lighter carbuilt in association with Lola made its debut in the Italian Grand Prix and John won first time out...

"Sadly, the best years of my racing potential were lost in this period. But I find it a lot easier to live with today as I'm sure that if the programme as it was laid down had proceeded, you would have seen Honda challenging for the title in 1969. You only need to need to look at the overweight 1968 car to see that if the continuous development programme had happened – a lightweight 12-cylinder coupled with a lighter chassis – then it would have been a winner. However, Mr Honda's politics took it over and the impractical air-cooled V8 RA302 was made instead." A disaster, this led to Honda quitting at the end of the year.

"I had no intention of forming my own team, but three things caused it and it all came at the wrong time. Firstly, I had the experience of joining BRM in 1969 at a period when it would have been best forgotten. Secondly, I agreed to get involved in a ridiculous CanAm project with Jim Hall. Thirdly, I agreed to find a project for actor James Garner who wanted to steal a march on Steve McQueen and become a team owner. Between the dreadful political scene at BRM and the situation with Hall's car it nearly brought me to the point of a mental breakdown.

"While I was in America, I'd been approached to find a car for Garner, and I found that Len Terry had a car that he'd designed. So I'd virtually put the deal together, but it didn't exactly work when we tested it and then it broke. Secondly, Garner quit. We were thus faced with sinking our losses, but I decided we'd sort it and after a major rehash it became the Surtees TS5 which ended up winning a number of Formula 5000 races in David Hobbs's hands. We decided to make a few more to amatise costs, so I sent Hobbs over to the US to try and drum up custom. And we sold all the cars we could make after he finished second in the British and American championships. But when I went down with pneumonia at the time of the US Grand Prix I decided that enough was enough and that I would make my own Formula One car. And this, the TS7, ran in 1970.

"The only reason teams like mine could come into existence was because of Cosworth. Look at the top teams today, almost all are there because of Cosworth. It was a wonderful product for people to be able to build cars around and to be able to compete with the world's best. Only Renault have come close to making this sort of impact since."

Despite winning the non-championship Gold Cup in 1970 and 1971, John's driving career came to a close in 1972, with John rounding out his career with wins in the Formula Two races at Fuji and Imola in a year when fellow fomrer motorcycle racer Mike Hailwood guided Surtees to the European Formula Two crown. The team continued in Formula One until the end of 1978, albeit without conspicuous success.

When asked to pick the great drivers from the 1960s, John

offers these views: "Comparing drivers of any age is never easy as you had different characters in different equipment. But there were the constants. You could be sure that Jimmy Clark would be quick. He wasn't the world's most aggressive driver, the most forceful or necessarily the fastest. But he was able to come together with the right machine and particularly with Chapman to form a formidable combination. Jimmy was fully appreciative that if you pushed a Lotus too hard it would fail, so he got into the groove as he was able to understand how to get the most out of them.

"However, you mustn't overlook that when I came into Formula One that the most competitive driver was Stirling Moss. He wasn't necessarily the fastest around, either. But there was one thing about Stirling that even if he'd had a pitstop and was out of the reckoning, he'd have a go.

"Jack Brabham would also always have a go, too. He was sometimes travelling more sideways than forwards, but it was partly due to the fact that he was in Coopers. Dan Gurney was another who was quick.

"Then there was Graham Hill, who I always looked on as steady, able to put it all together and relate to his machine well. He wasn't as aggressive as the others, or as fast, but he was someone who could produce. In many ways, there's an awful lot between Graham and Damon that's similar.

"There are always drivers and racers at any time and Jimmy was a driver. He was just on the edge of being a racer, but not consistently. Jack and Dan were racers. Then, later on, you had people like Rindt who were drivers but became racers. Stewart was a very competent driver who came together with Ken Tyrrell and they made a formidable set-up with Cosworth. I always looked on him as a percentage driver who at times surpassed himself, such as when he won at the Nurburgring in the wet in 1968.

"I have a lot of respect for Chris Amon, but he was too easily affected by what happened around him. While I had a lot of time for Lorenzo Bandini who was quicker than people appreciated and I think Ferrari was wrong to put him in the position of having so much responsibility.

"It's crazy to compare people across the ages, but I loved to watch Ayrton Senna. At Donington on that wet day in 1993, I wasn't only interested in watching his progress but also in listening to how he used the throttle. Michael Schumacher's drive at Spa in 1998 was also wonderful. They are real people at work, treading on that narrow line between keeping it on the road and not. It was a pleasure, too, to watch the progress of Mika Hakkinen when he came of age in 1998.

"Formula One today is wonderful. Think of the amount of money put into those cars and what it has achieved in performance with safety. A purist might say that it would be nice to get rid of all the driver aids, but you can't stand still: Formula One must be the pinnacle. Sure, other forms of racing can be controlled to keep costs in check, but Formula One must always be coming up with innovations."

RIGHT: SURTEES RACES HIS BOWMAKER LOLA DOWNHILL INTO ROUEN'S NOUVEAU MONDE HAIRPIN IN THE 1962 FRENCH GRAND PRIX.

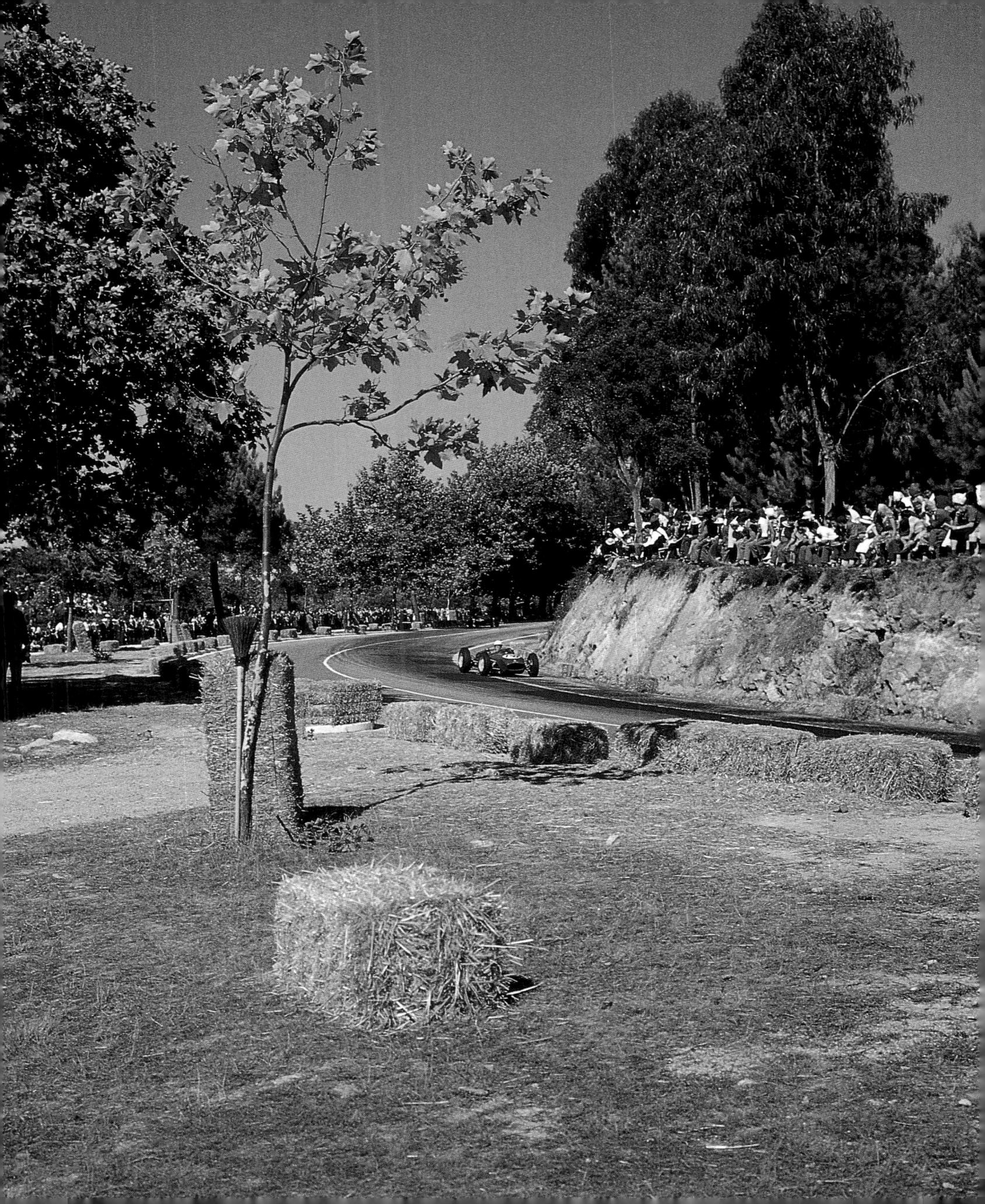

BRABHAM RESISTS MOSS

ack Brabham claimed his second consecutive World Championship for Cooper, with Lotus emerging as a major force. Yet, but for a mid-season accident putting him out for several races, Stirling Moss might have won that elusive title.

By 1960 the rear-engined machines were dominant. For one last year, though, Ferrari stuck with its front-engined D246 and won the Italian Grand Prix – but only because the British teams boycotted the event. Colin Chapman's Lotus team had been in Grand Prix racing for two years with very little success, but all that was to change with the new Lotus 18, its first rear-engined model.

BRM also had a new rear-engined car, which had debuted at Monza the previous year. Jo Bonnier stayed on, joined by Graham Hill from Lotus and American Dan Gurney from Ferrari. A further American,

Phil Hill and Wolfgang von Trips remained with Ferrari, while Brabham and Bruce McLaren maintained their successful partnership at Cooper.

McLaren won the Argentinian Grand Prix and Cliff Allison did well to get his Ferrari home second. Bonnier and Moss (still in Rob Walker's old Cooper) had both led before retiring. Allison was then injured in practice at Monaco, breaking his arm when he was flung from his Ferrari and thus ending his season. Meanwhile, Moss got his hands on the new Lotus, and won in fine style in the rain ahead of McLaren and Phil Hill. Once again, Bonnier's BRM led before retiring, while a notable newcomer was multiple motorcycle world champion John Surtees in a works Lotus.

Rodger Ward and Jim Rathmann did battle again in the Indianapolis 500, this time with Rathmann coming out on top after the latter's tyres went off with three laps to go.

Brabham had failed to score in either of the first two Grands Prix, but he bounced back by winning the Dutch Grand Prix. Innes Ireland guided his Lotus to second ahead of Graham Hill. And for the second race in a row Chapman gave a first chance to a future world champion. At Monaco it had been Surtees and in Holland it was a young Scot called Jim Clark who was battling for fourth when the gearbox broke.

DISASTER IN BELGIUM

The Belgian Grand Prix was one of the blackest weekends in the history of the World Championship. During practice Moss crashed heavily, breaking his legs. Then two young Britons, Chris Bristow and Alan Stacey, were killed in separate accidents during the race. Brabham and

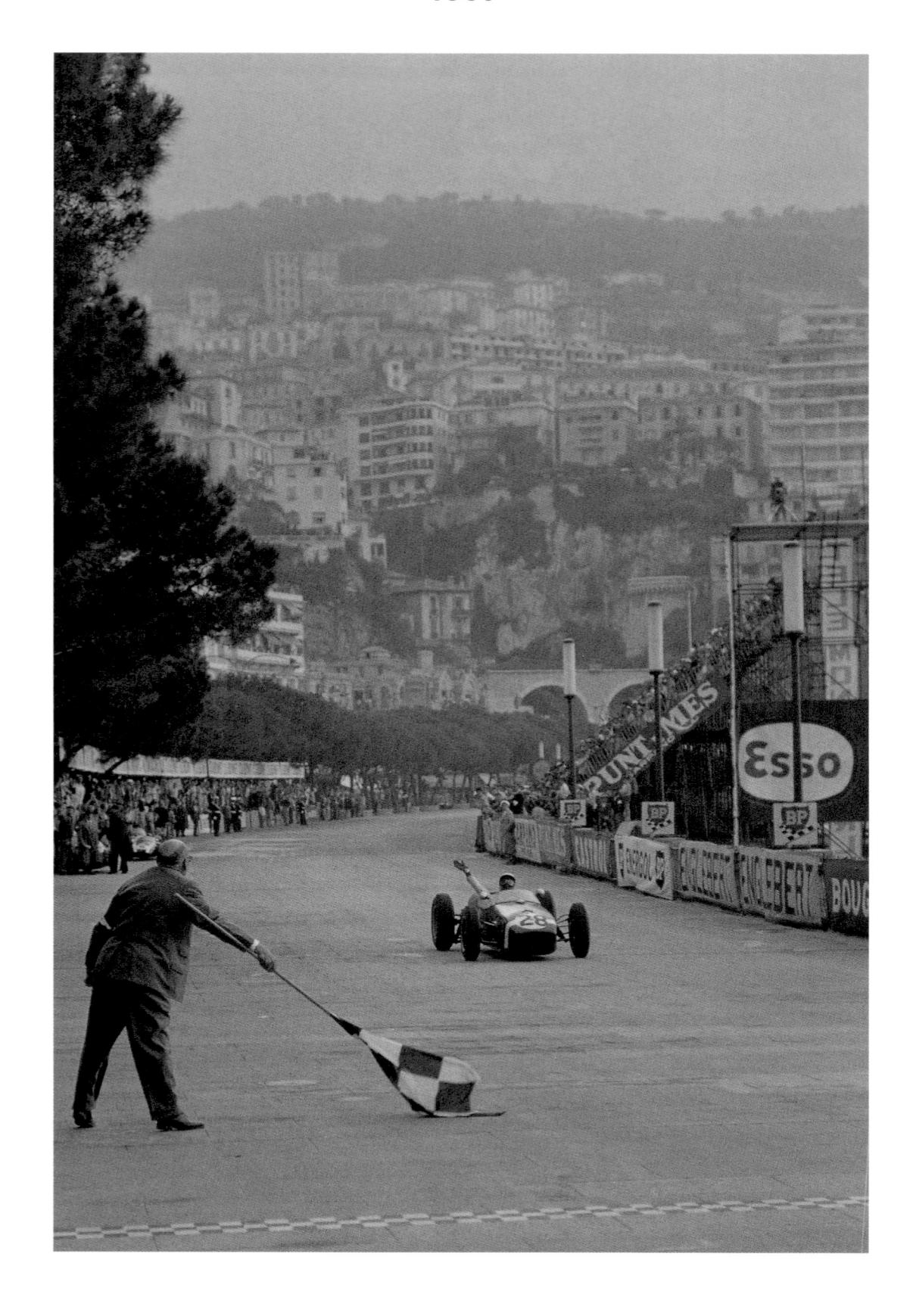

McLaren went on to score a one-two for Cooper, but only after Hill's BRM blew up when second.

At Reims Brabham took a third consecutive win, and on this fast track the front-engined Ferraris of Phil Hill and von Trips gave him a hard time until they broke. Graham Hill was then the star at the British Grand Prix at Silverstone. He stalled on the line, and drove superbly through to the lead before spinning off. Thus Brabham was able to come through

to score his fourth straight win, followed by the impressive Surtees and Ireland.

BRABHAM'S SECOND TITLE

Brabham scored a fifth win in Portugal, and with it clinched the title with two Grands Prix to run. After missing two races while his legs healed, Moss was back, and ran second before he had problems.

The Italian Grand Prix was a disappointment. The race was on Monza's banked track, and the British teams boy-

cotted it on safety grounds. Bound by blood ties, Ferrari turned up in force, and Phil Hill scored a hollow victory.

The US Grand Prix moved from Sebring to Riverside in California for the one and only time, and Moss won there to nip past Ireland to be third overall, with the race marking the demise of the 2.5-litre formula which had seen the transition from domination by Mercedes to the success of the British rear-engined machines.

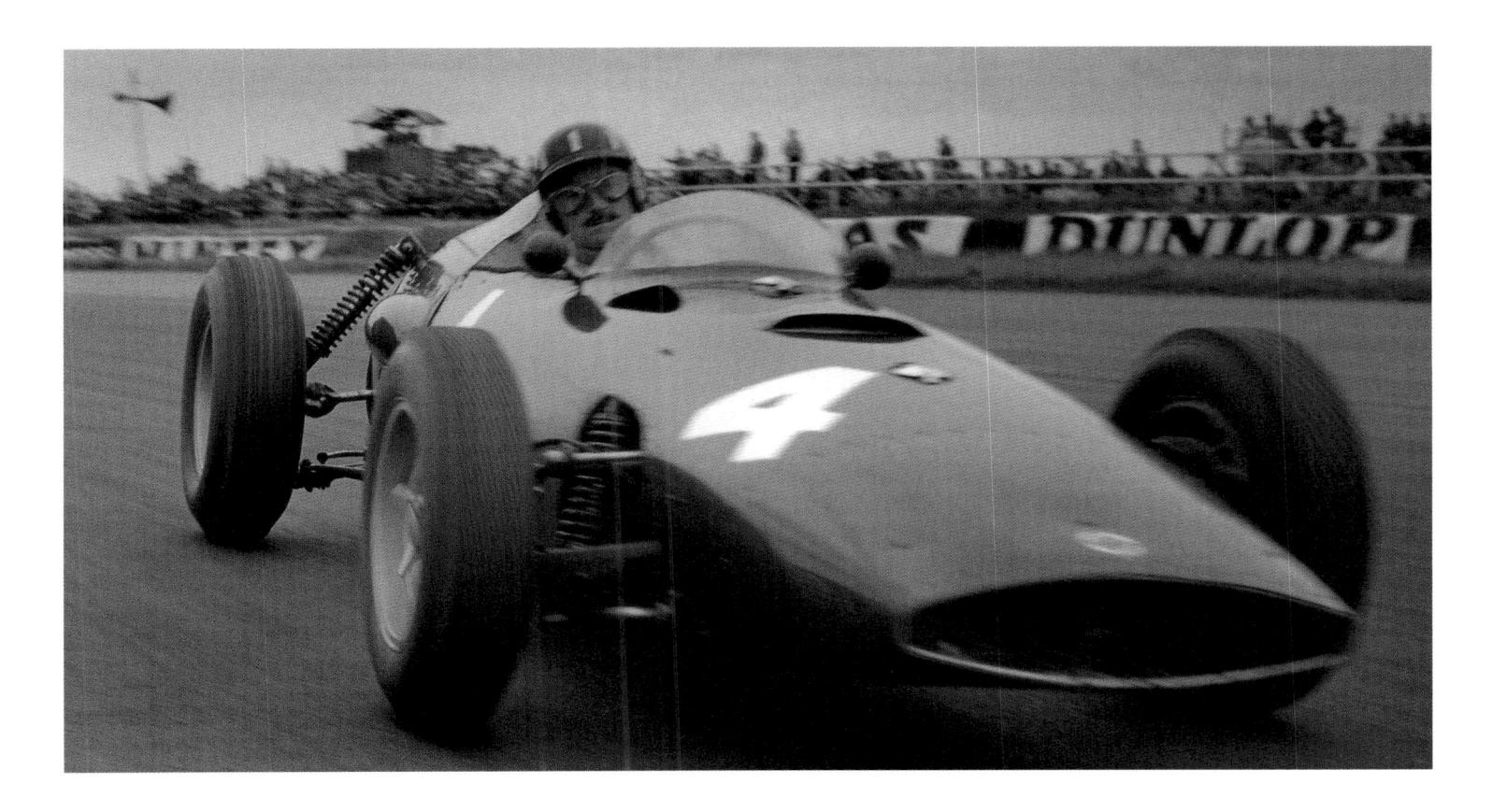

ABOVE BRM'S STAR: GRAHAM HILL STARRED AT THE
BRITISH GRAND PRIX BUT CAME AWAY WITH NOTHING.

LEFT A FIRST FOR LOTUS: STIRLING MOSS SCORES
LOTUS'S FIRST WIN IN ROB WALKER'S CAR IN MONACO.

RIGHT MAIDEN POLE: SURTEES (RIGHT) SITS ON POLE
FOR THE FIRST TIME, WITH GURNEY AND BRABHAM
ALONGSIDE IN OPORTO.

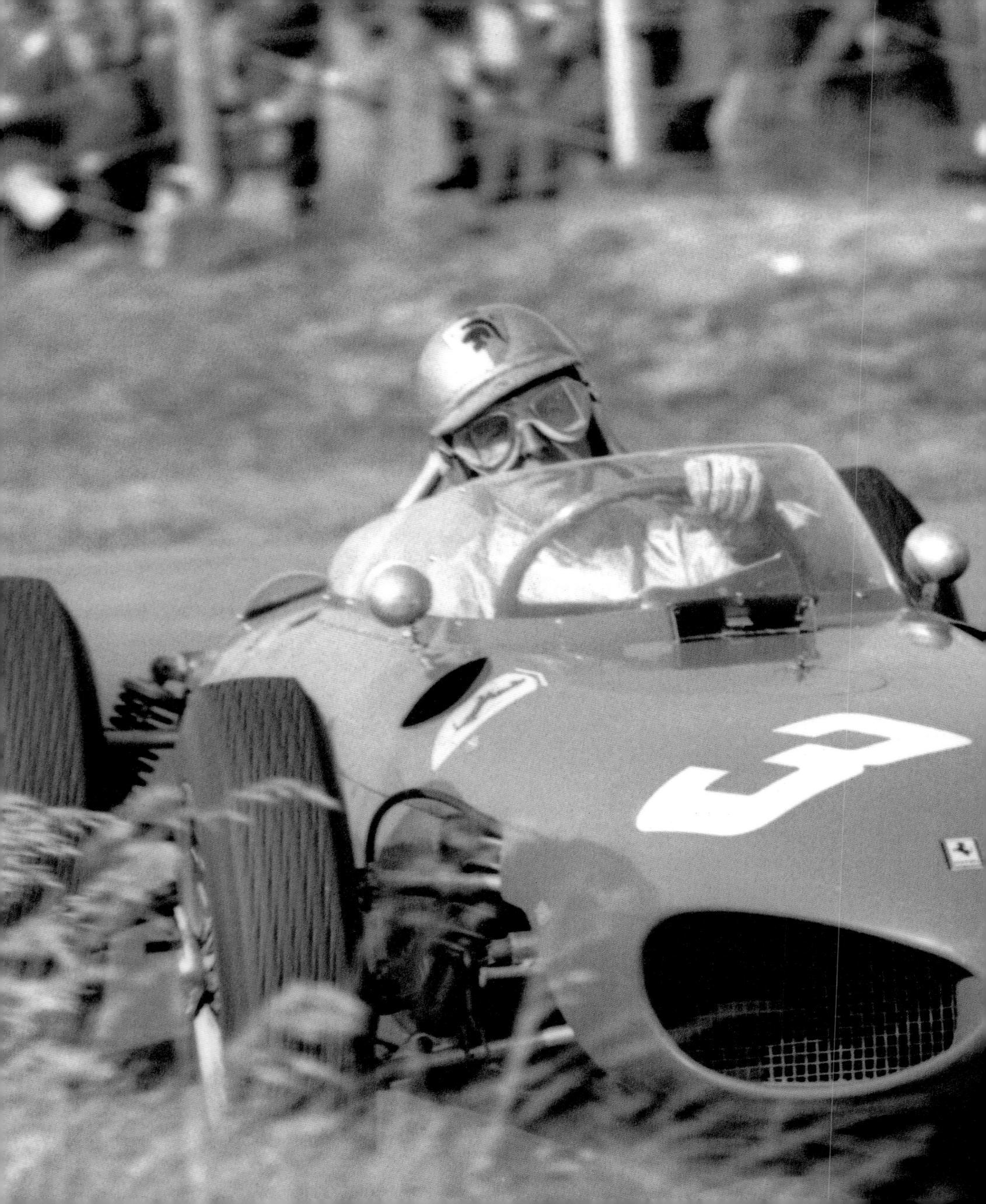

FERRARI'S BITTERSWEET YEAR

errari was better prepared than anybody else for the new formula, and dominated the season. Phil Hill took the title, but in the most tragic of circumstances after his teammate Wolfgang von Trips lost his life at Monza.

It was all change for 1961 with the introduction of a 1.5-litre formula. The British manufacturers had been slow to respond, but not so Ferrari. Effectively sacrificing the previous season, the Italian team had developed a rear-engined car, dubbed the "sharknose" – and a new V6 engine. Climax and BRM lagged behind, so much so that the only engine available for the British teams was the four-year-old 1475cc Climax Formula Two unit.

PORSCHE JOINS IN

While von Trips, Phil Hill and fellow

American Richie Ginther were in the lucky position of driving the works Ferraris, welcome variety was provided by the arrival of Porsche. Already successful in Formula Two, the German marque signed Dan Gurney and Jo Bonnier from BRM. Lotus had an excellent new chassis, the 21, and the promising Jim Clark and Innes Ireland to drive it. BRM and Cooper used developments of their old cars, with Graham Hill and Tony Brooks leading the BRM attack, while once again Jack Brabham and Bruce McLaren teamed up at Cooper.

More than ever before, the still-uncrowned Stirling Moss had underdog status. Lotus refused to allow Rob Walker to buy a new Lotus 21, and he had to make do with the old 18 model. And yet in the season-opening Monaco Grand Prix Moss turned in one of the drives of

his career to brilliantly beat the Ferraris of Ginther and Hill.

Ferrari took its revenge at the Dutch Grand Prix when von Trips scored his first win, with Hill right on his heels in second. The result was reversed in the Belgian Grand Prix, where Ferrari filled the first four places and Hill took his first win against a representative field, following that boycotted Monza race in 1960. Von Trips was followed across the finish line by Ginther and local driver Olivier Gendebien.

The French Grand Prix at Reims was a sensational race. Hill, Ginther and von Trips retired, and Giancarlo Baghetti – making his first start in a privately-entered Ferrari – pipped Gurney's Porsche to the chequered flag. Baghetti remains the only driver to have won on his Grand Prix debut.

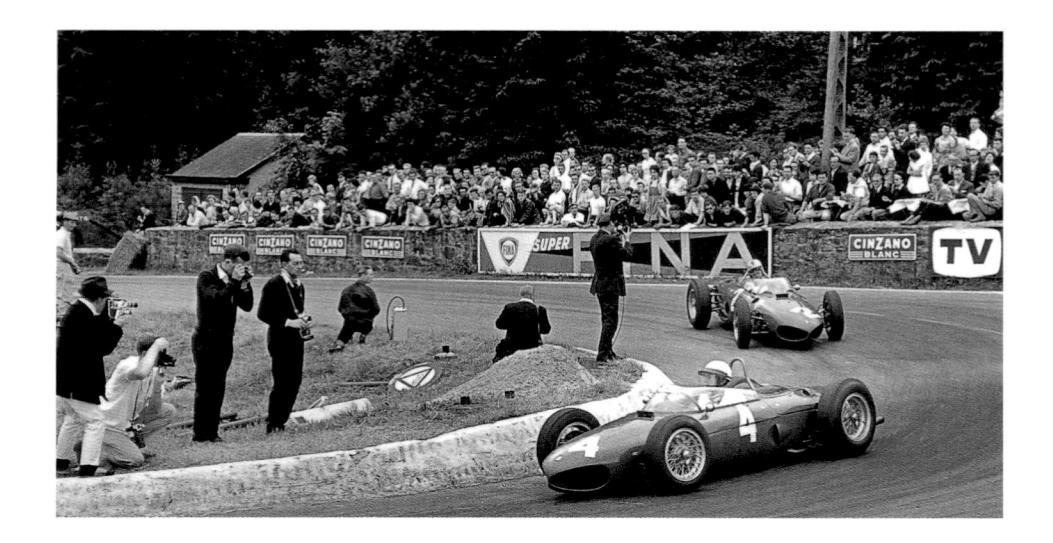

LEFT FERRARI TO THE FORE: PHIL HILL HEADS VON TRIPS IN A THRILLING, CONSTANTLY-CHANGING BATTLE FOR THE LEAD OF THE BELGIAN GRAND PRIX.

BELOW LEFT FIRST-TIME WINNER:

BAGHETTI RESISTS THE PORSCHES OF

BONNIER AND GURNEY TO WIN ON HIS

GRAND PRIX DEBUT AT REIMS.

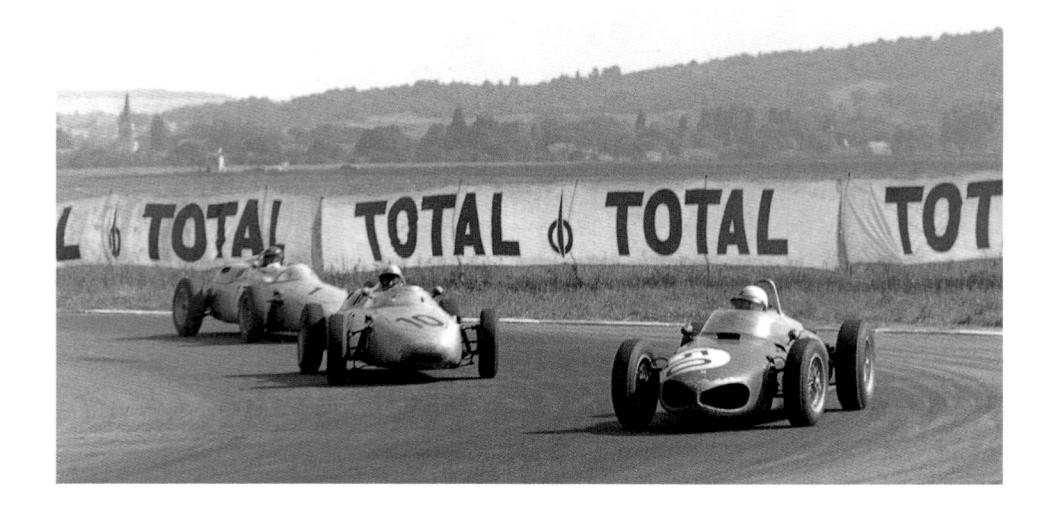

RIGHT CLASSIC POSE: STIRLING MOSS
WEARS A MASK OF CONCENTRATION
AS HE GUIDES HIS ROB WALKER LOTUS
TO VICTORY IN GERMANY.

It was back to normal at the British Grand Prix as von Trips, Hill and Ginther finished first, second and third in the rain at Aintree. Moss had tried to mix it with the Italian cars before his brakes failed, but then struck back at the Nurburgring. As at Monaco, he overcame his Lotus-Climax's power deficiency to beat Ferrari, heading home Hill and von Trips. The race was doubly good for Climax as its new V8 engine was finally ready and Jack Brabham had qualified on the outside of the front row but retired early on.

A FATAL VISIT TO MONZA

Nobody objected to the banked corners at Monza this time. Ironically the Italian Grand Prix, which should have seen the title fight between von Trips and Hill turned to tragedy as Clark and von Trips tangled at the end of the first lap, and the German was killed, along with 12 spectators. Almost unnoticed by stunned onlookers, Phil Hill won the race, and with it the title.

The US Grand Prix moved to a third new venue in as many years in the form

of Watkins Glen in upstate New York. With Ferrari not entering in the wake of Monza, Moss and Brabham battled for the lead. When they both retired from the race, Ireland came through to score his one and only win, and the first for the works Lotus team. Gurney was second for the second race in succession, ahead of the BRM of Tony Brooks who announced his retirement, after a distinguished career which was often overshadowed by the heroic exploits of Moss and Hawthorn.

A DIFFERENT HILL

errari's star faded in the most dramatic fashion, as BRM and Lotus battled it out for the World Championship and Graham Hill beat Jim Clark to claim his first world title at the beginning of another golden era for the British teams.

The biggest story of the 1962 season occurred, however, in a non-champion-ship race at Goodwood on Easter Monday. Stirling Moss suffered multiple injuries when he crashed his Lotus head-on into an earth bank. Despite having been at the top of the sport for a decade, Moss had never landed the ultimate prize. And, although he was nursed back to health, after he tried a car again he decided to quit as he'd lost that vital edge.

In addition to this, reigning champions Ferrari self-destructed over the winter, as some of the top staff walked out. However, the Italian team carried on with virtually unchanged cars and drivers Phil Hill and Giancarlo Baghetti. While promising new boys, Mexican Ricardo Rodriguez and Italian Lorenzo Bandini were also in the squad.

NEW BRM HORSES

BRM had a powerful new V8 engine for the 1962 season, and Graham Hill was joined by Richie Ginther, who had left Ferrari. Meanwhile, the Climax V8 looked good and was the choice of many top teams. Two-time World Champion Jack Brabham quit Cooper to design his own car – although he would start the year with a Lotus – so Bruce McLaren became Cooper's team leader.

Lotus had another new car, the 25, which featured a revolutionary monocoque chassis. Clark and Trevor Taylor were the works drivers. An interesting

newcomer was the Lola, entered by the Bowmaker team for John Surtees and Roy Salvadori, while Porsche had a new flat-eight engine for Dan Gurney and Jo Bonnier.

Unusually, the season opened with the Dutch Grand Prix in May, with Graham Hill scoring his first win, which was also the first for BRM since Bonnier's victory at the same track three years earlier. Taylor finished an encouraging second in only his second Grand Prix, ahead of Phil Hill. Then McLaren won at Monaco, chased home by Phil Hill in what was to prove the Ferrari driver's best race of the year.

The Belgian Grand Prix marked Clark's first win, the Lotus driver coming home ahead of Graham and Phil Hill.

Thus three marques had won the first three races, and it became four when

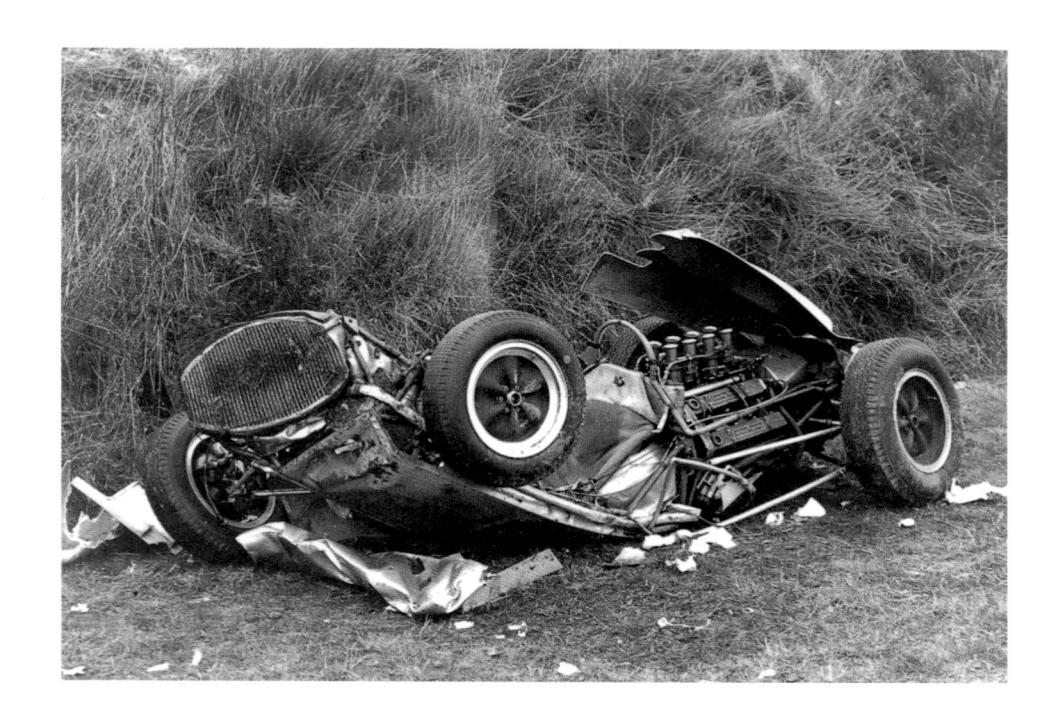

LEFT THE END OF A CAREER: STIRLING MOSS'S WRECKED LOTUS LIES TRACK-SIDE AFTER HE'D CRASHED OUT OF THE NON-CHAMPIONSHIP RACE AT GOODWOOD.

BELOW EMERGENCY ASSISTANCE: AN UNCONSCIOUS MOSS IS TENDED TO WHILE STILL IN HIS CAR AFTER HIS BONE-BREAKING CRASH AT GOODWOOD.

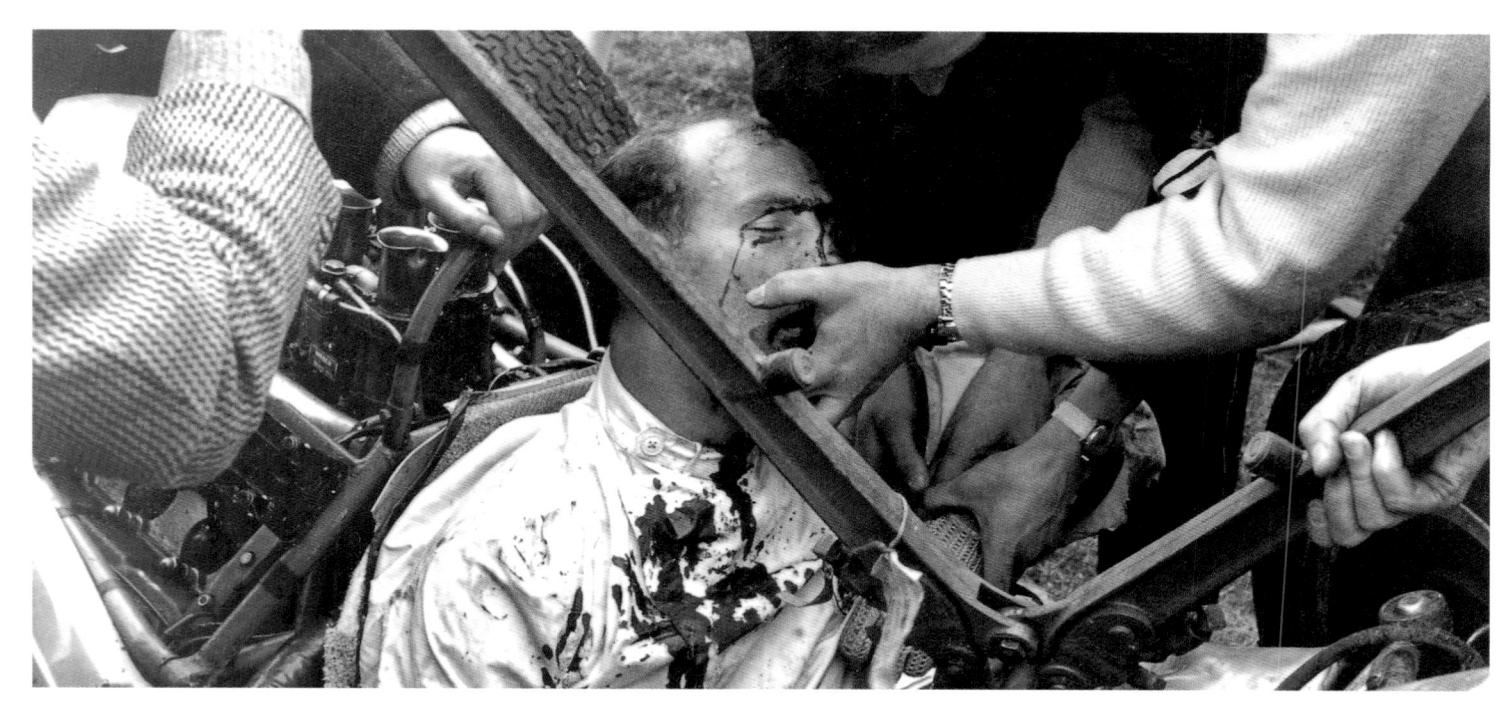

Gurney gave Porsche its maiden victory at Rouen – but only after three leaders, Clark, Surtees and Graham Hill, had all retired.

Clark then became the first repeat winner, dominating the British Grand Prix at Aintree ahead of Surtees and McLaren. Surtees continued his good form at the Nurburgring, finishing in second place behind Graham Hill's BRM, and just ahead of Gurney's Porsche.

The Italian Grand Prix was the turning

point in the title battle, for Graham Hill and Ginther gave BRM a one-two after a thrilling race, and Clark failed to finish. Clark then fought back in the US Grand Prix at Watkins Glen, heading Graham Hill home.

For the first time the finale was held at East London in South Africa, on December 29. Clark took pole position, and was leading the race until his engine failed. And through came Graham Hill to win and lift the championship crown. It

was to be BRM's only success. McLaren finished second, and took third behind Clark in the points after a consistent season as Cooper's top man.

It had been a poor year for Ferrari, and the team did not even enter the two final races. To make matters worse, upand-coming star driver Rodriguez, who had finished fourth in Belgium, was killed in practice for the non-championship Mexican Grand Prix. He was just 20 years of age.

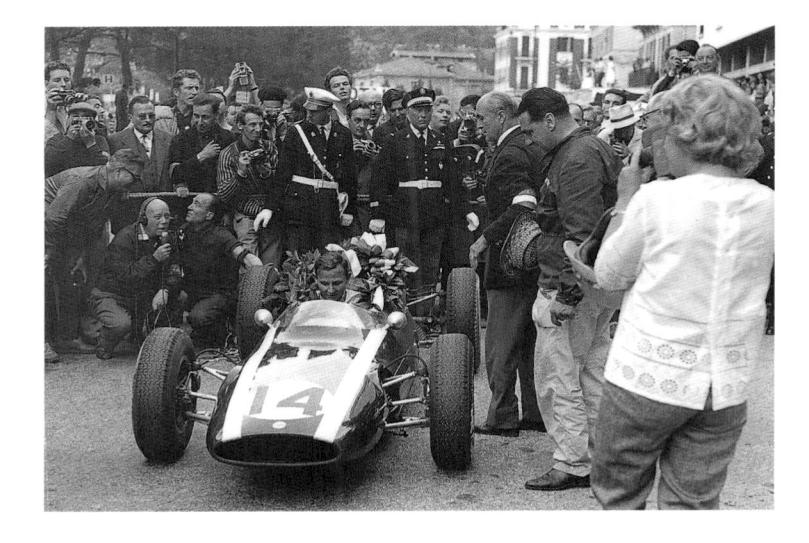

LEFT KIWI POWER: BRUCE McLAREN ON HIS WAY TO VICTORY IN MONACO.

BELOW A PORSCHE WINNER: DAN
GURNEY RACED TO THE FRONT AT
ROUEN AND GAVE PORSCHE ITS
MAIDEN FORMULA ONE WIN.

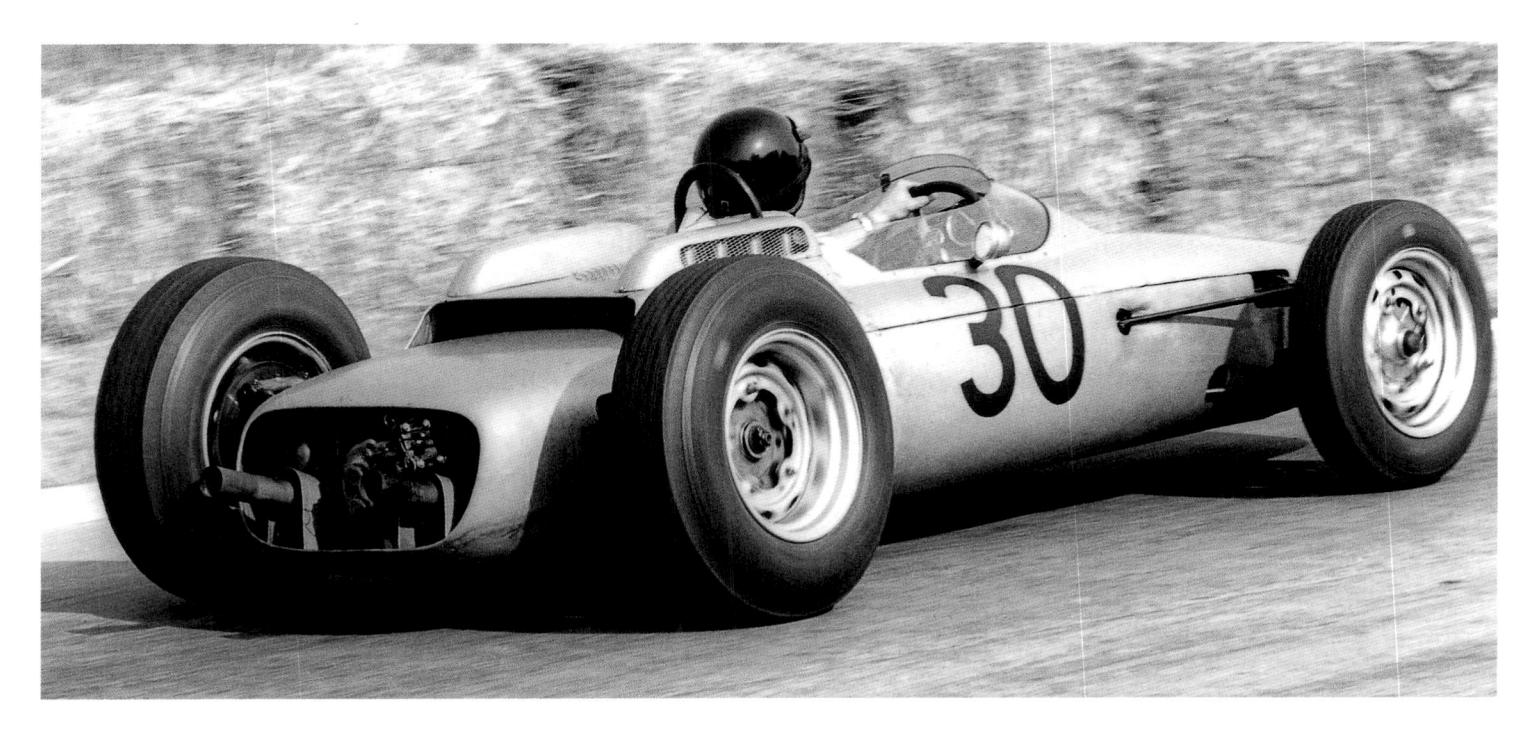

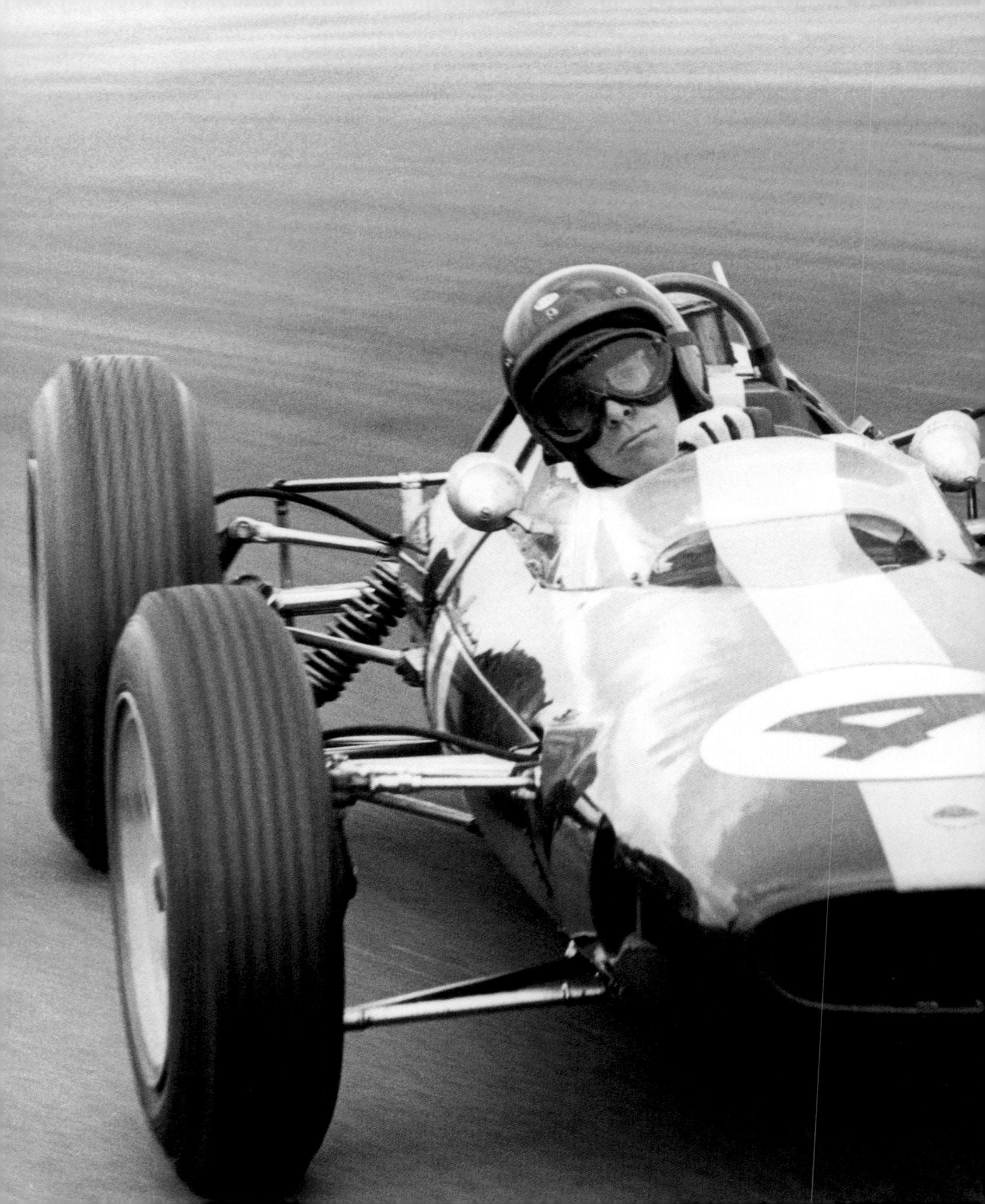

CLARK COOPER HILL LOTUS MCLAREN PORSCHE MAGGS

THE MAGIFICENT SEVEN

his World Championship proved to be a memorable one for Jim Clark and Lotus, for the uncannily talented Scot won seven races in all. It was simply the most devastating display of craftmanship by a single driver since Alberto Ascari's runaway success 11 years previously.

Absent from the tracks in the 1963 World Championship was the Porsche team, which had withdrawn to concentrate on sports car racing. The German marque would not return to Formula One for more than 20 years before coming back as an engine supplier. The Lotus, BRM and Cooper line-ups were unchanged but, as usual, the off-season had been busy. Having lost his Porsche ride, Dan Gurney teamed up with Jack Brabham to drive the double champion's own cars.

The promising Bowmaker/Lola team

withdrew from Formula One, but the cars were not lost to the championship as they were bought by Reg Parnell for the extremely talented young New Zealander Chris Amon.

With Bowmaker out, John Surtees moved to Ferrari, where he joined Belgian Willy Mairesse who had shown flashes of promise in the past. The Ferrari management breakaway of the previous year had spawned a new team, ATS, and a pair of works Ferrari drivers, Phil Hill and Giancarlo Baghetti, both jumped ship. They would come to regret their decision as they failed to score a point between them.

CLARK FALLS AT THE FIRST

Clark led the opener at Monaco, but he retired when his gearbox broke. It was to be his only retirement in an exceptionally reliable year for Lotus. With Clark out,

Graham Hill and Richie Ginther scored a one-two for BRM. And this was to be the first of five successes in the principality for Graham.

Clark's luck changed in the Belgian Grand Prix, and he took a memorable win in the rain, ahead of Bruce McLaren and Gurney, the latter scoring the Brabham team's first top three finish.

It was the same story in the Dutch Grand Prix, where Clark led all the way to win from Gurney and Surtees, and at Reims, where even a misfire could not stop him from winning the French Grand Prix. Clark scored his fourth win in a row at Silverstone, while Surtees took second place after Graham Hill ran out of fuel on the last lap. Another motorcycle star trying four wheels was Mike Hailwood, who finished eighth.

Surtees had threatened to win for a couple of years, and he finally came good

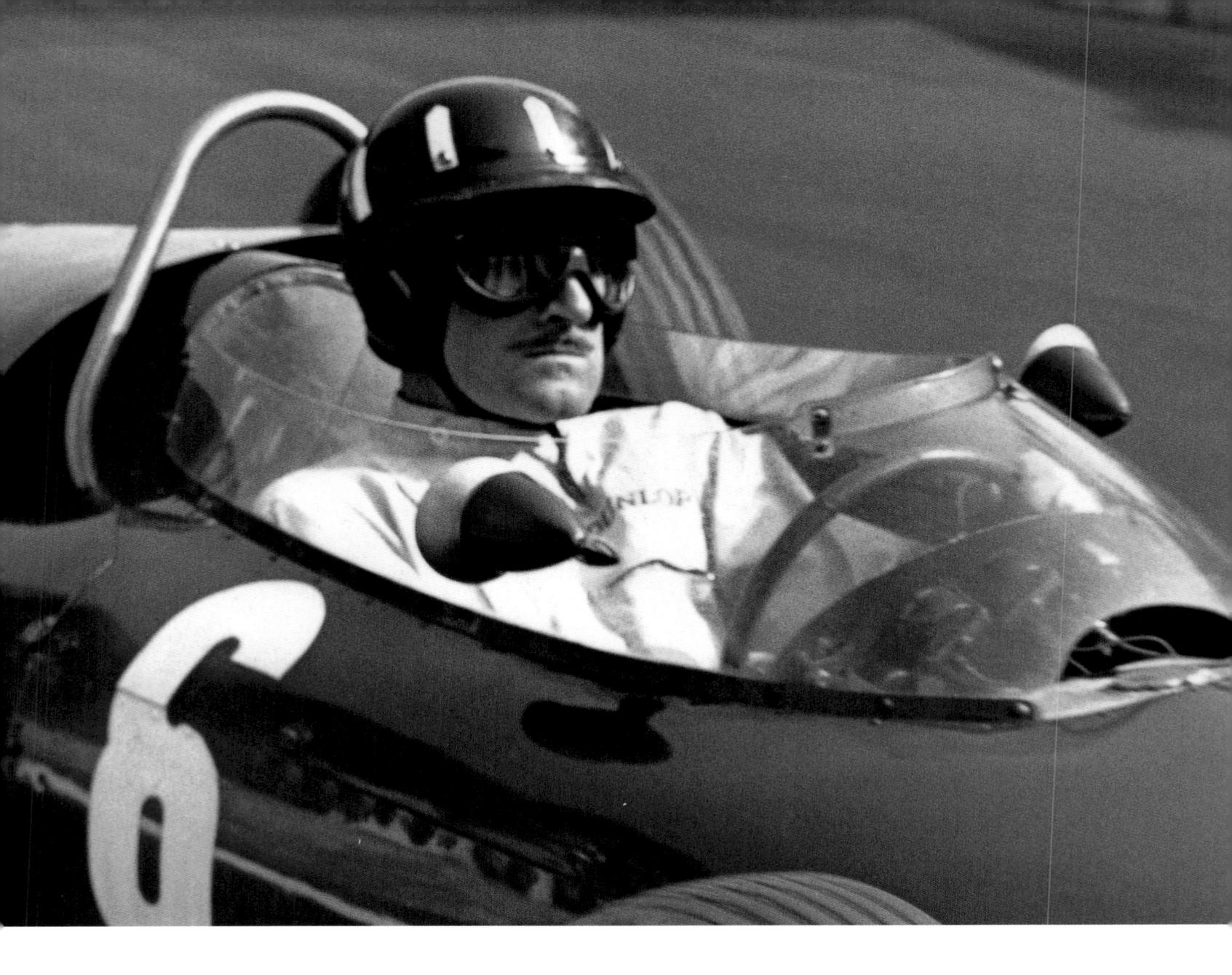

ABOVE A STUDY OF CONCENTRATION: GRAHAM HILL FOCUSES ON THE TRACK AHEAD WHILE HEADING FOR THE FIRST OF HIS FIVE WINS AT MONACO.

at the Nurburgring, scoring Ferrari's first success since the 1961 Italian Grand Prix. Clark took second, ahead of BRM's Ginther.

Ferrari had a new chassis ready for the Italian Grand Prix, one which owed a lot to Lotus thinking and was designed to accept the forthcoming 1964 spec V8 engine. Surtees duly battled with Clark for the lead until the overworked V6 gave up. Clark headed home Ginther and McLaren, and clinched the championship – even though there were still three races to run.

HILL'S MIXED FORTUNES

Graham Hill had suffered from unreliability and sheer bad luck all year, but struck back as he headed Ginther and Clark home in the US Grand Prix. By this time BRM had reverted to using its 1962 model. Clark was stymied by a flat battery, had to start from the back and did

well to finish a lapped third.

The Mexican Grand Prix was part of the championship for the first time, and Clark scored his sixth win of the year. He then added a record seventh victory in South Africa in December to cap an amazing season. Brabham finished second in Mexico and then team-mate Gurney repeated the feat in South Africa, showing that "Black Jack" had got his sums right and would be a force to reckon with.

RIGHT AND THEY'RE OFF: JIM CLARK
BLASTS AWAY FROM POLE AT REIMS,
CHASED BY GRAHAM HILL (2) AND DAN
GURNEY (8).

BOTTOM TWO-WHEELED CONVERT:

JOHN SURTEES RACES HIS FERRARI

TO SECOND AT SILVERSTONE. HE

WAS TO WIN AT THE NURBURGRING.

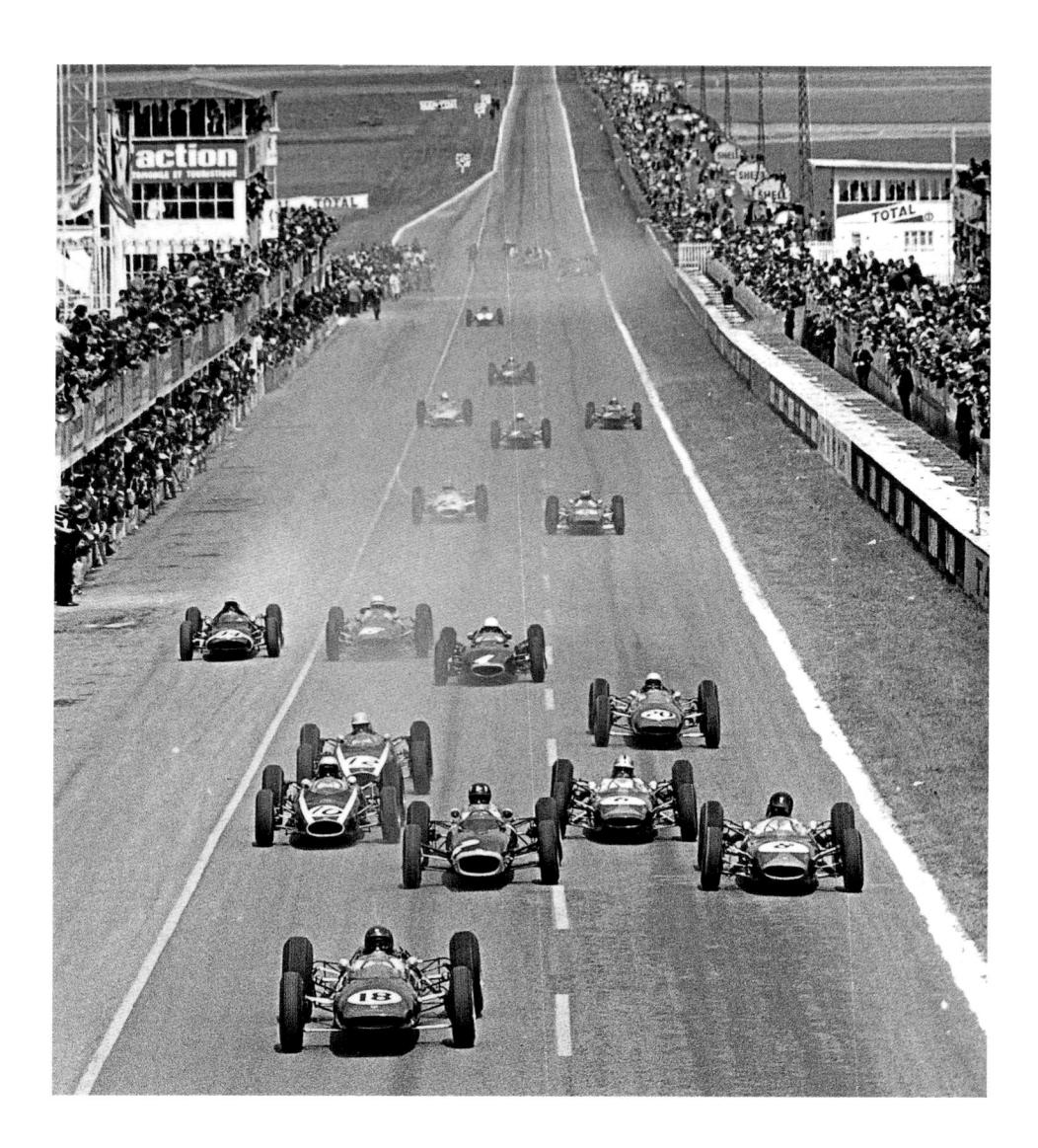

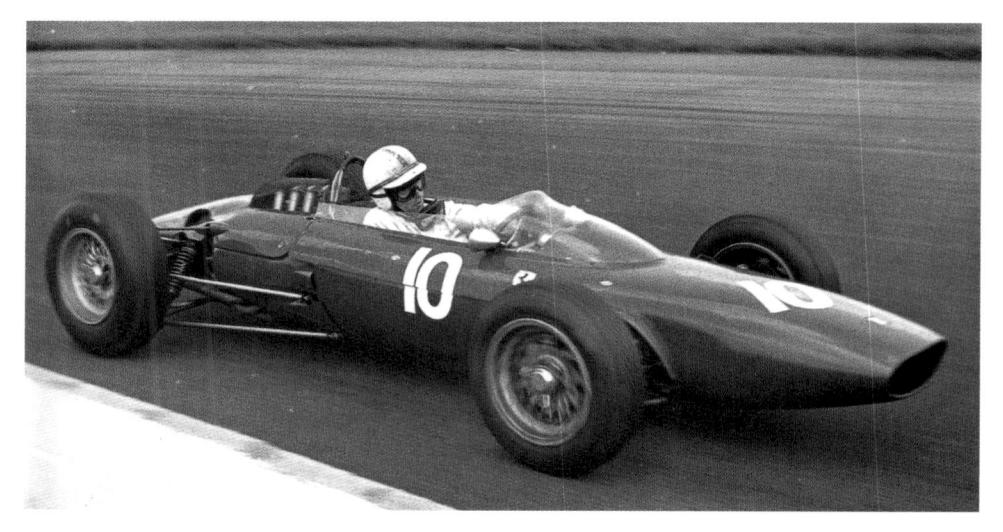

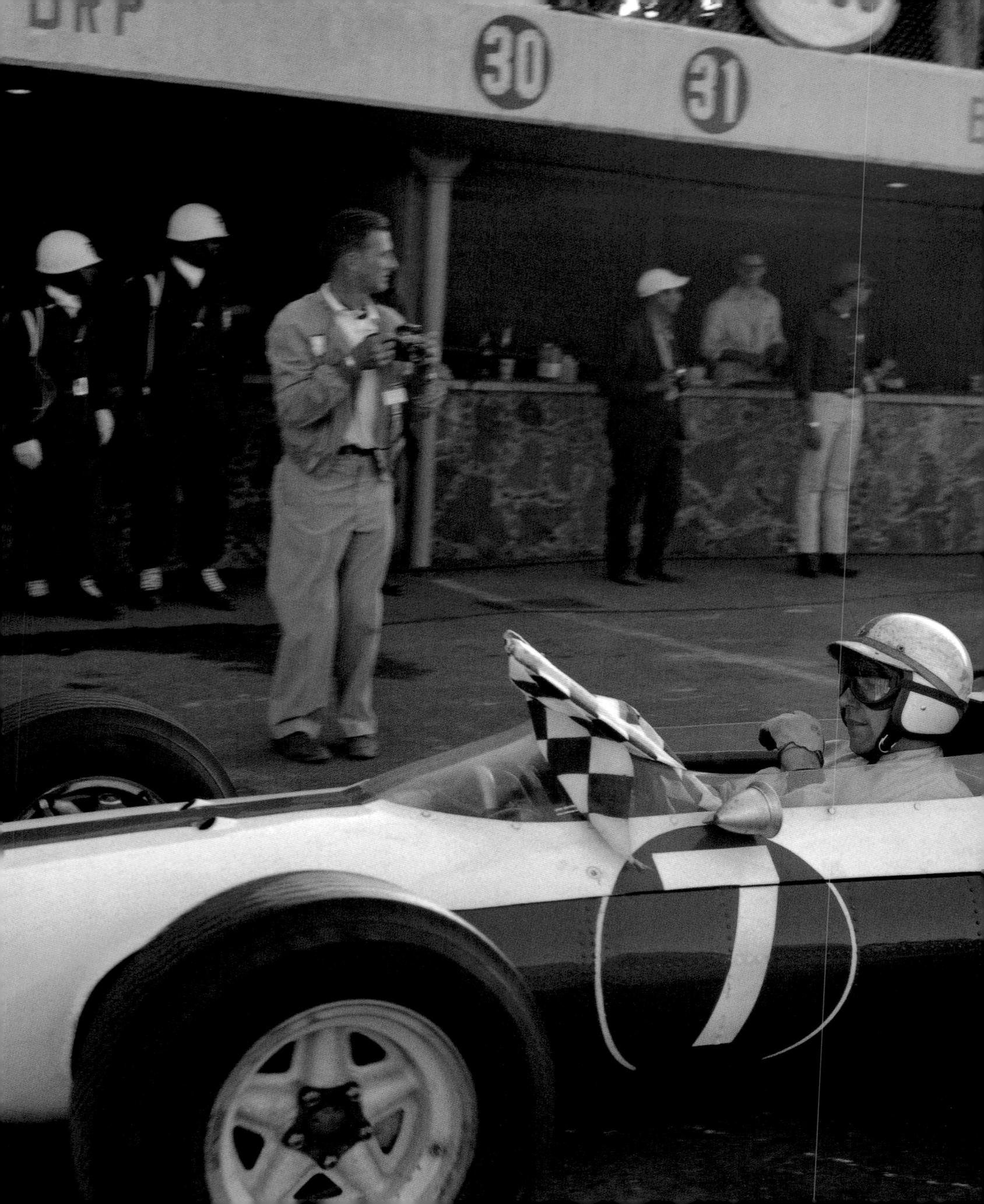

THE HISTORY MAN

ohn Surtees made racing history when he became the first man to win a World Championship on both two wheels and four. In a thrilling finale, the motorcycle racing great in his Ferrari just outscored Graham Hill and Jim Clark.

Ferrari hopes looked to be on the up for 1964 as its new V8 engine was mated to the team's 156 chassis which had shown promise in the previous year's Italian Grand Prix. Surtees stayed on to lead the team alongside the highly-rated Lorenzo Bandini. Lotus produced an updated car for Clark, the 33. Peter Arundell was the team's new number two. Hill and Richie Ginther stayed on at BRM, and had a revised car, while Cooper tried desperately to keep up with the new monocoque technology, updating a Formula Three chassis.

HIGHS AND LOWS FOR CLARK

Clark started on a high by leading at Monaco, but he had to pit when his rear roll-bar broke. And so Hill and Ginther scored another one-two result for BRM and a late engine failure for Clark handed third place to team-mate Arundell. Clark made amends with a demonstration run to victory in the Dutch Grand Prix, while Surtees gave notice of Ferrari's championship intentions with second place, ahead of the newcomer Arundell.

The Brabham team did not fare well in the early races, but Dan Gurney led comfortably in the Belgian Grand Prix until running out of fuel with two laps to go. In a farcical turn of events, Graham Hill took the lead and suffered fuel pump failure, then Bruce McLaren also ran out of gas. This allowed a surprised Clark – who had made an early stop – to take vic-

tory. At least McLaren was able to secure the points for second, coasting across the finish line.

Gurney made amends in the French Grand Prix at Rouen by scoring a fine first victory for the Brabham team. Graham Hill pipped Brabham himself for third, while once again Clark led the early stages before his engine failed.

For the first time the British Grand Prix moved to Brands Hatch, and Clark kept up his tradition of winning at home. Hill was second and Surtees was happy to finish third after two consecutive retirements. Surtees then began his surge towards the title by winning ahead of Hill and Bandini at the Nurburgring.

SURTEES'S LATE CHARGE

The first Austrian Grand Prix was held at the Zeltweg airfield circuit, and took a

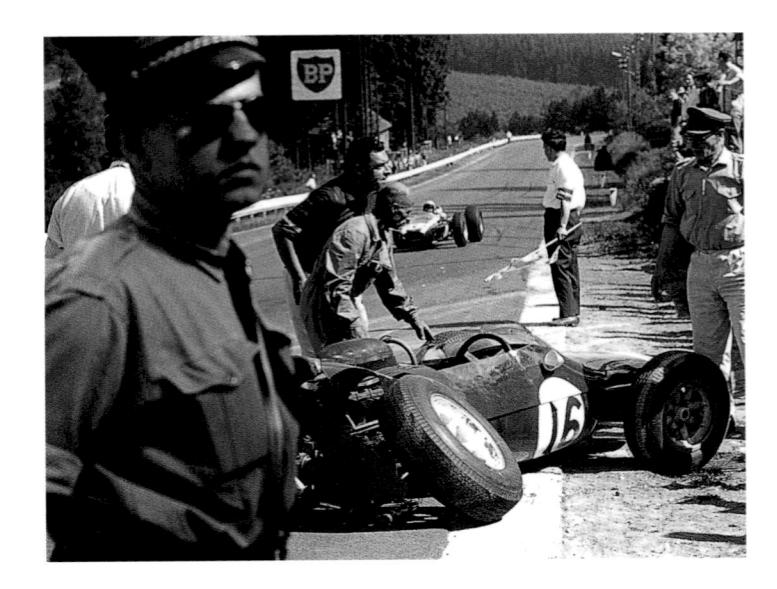

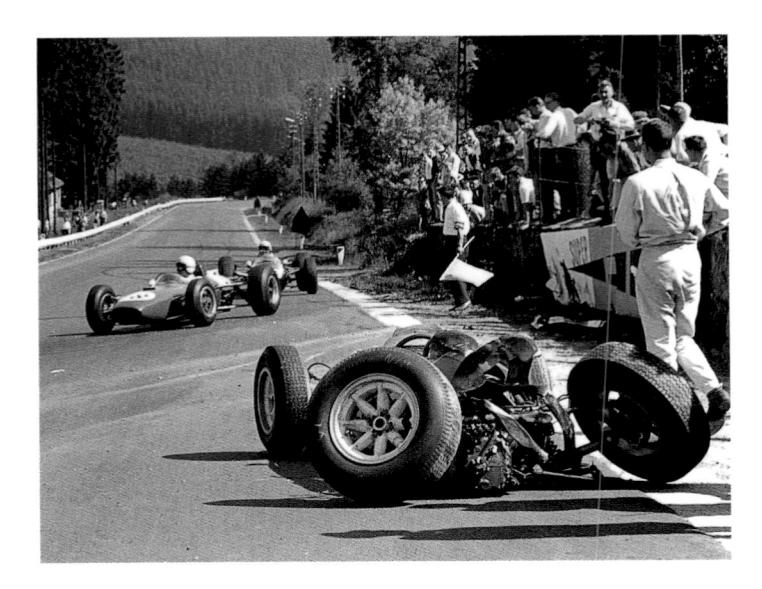

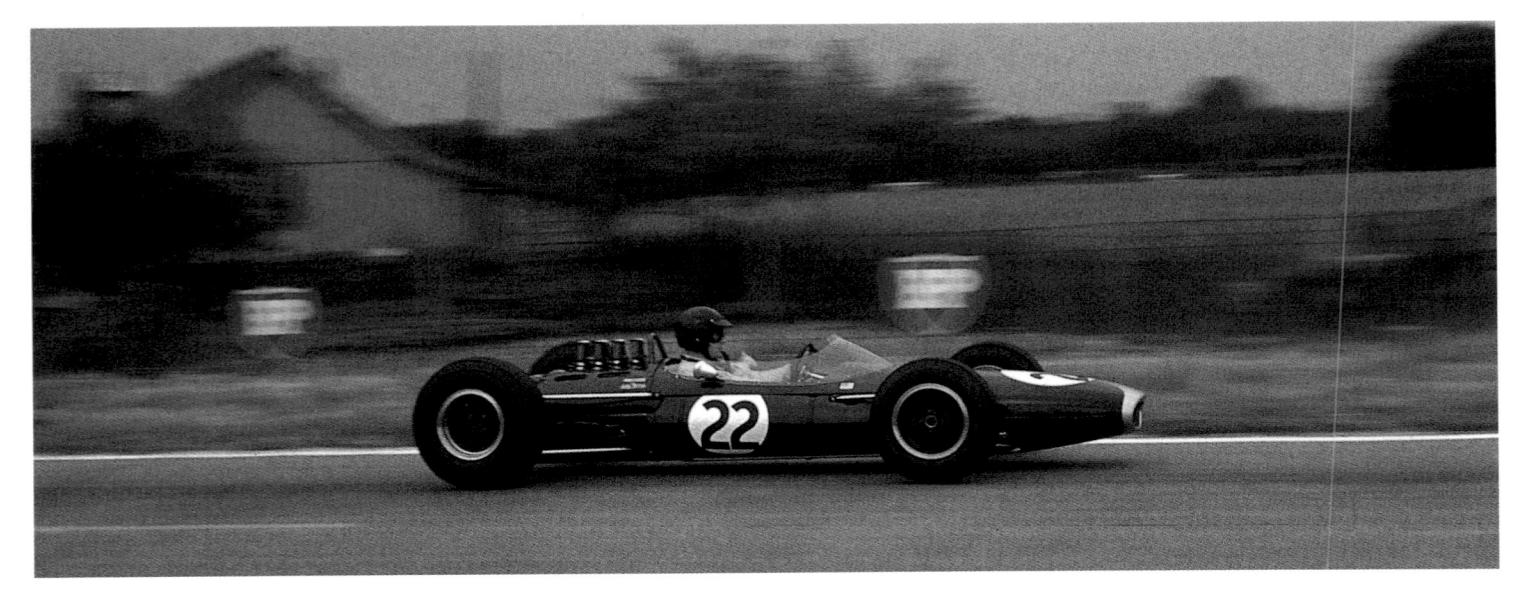

ABOVE QUICK AS A FLASH: DAN GURNEY RACES TO THE FIRST VICTORY BY A BRABHAM IN THE FRENCH GRAND PRIX AT ROUEN.

high toll on machinery. Hill, Surtees, Clark, McLaren and Gurney were among the retirements, leaving Bandini to score his first Grand Prix win, ahead of Ginther. Showing how the top runners were cleared out, third place went to privateer Bob Anderson and he was three laps down. Local hero Jochen Rindt made a quiet debut in his home race in a Rob Walker Racing Brabham-BRM.

Ferrari's run of success continued in

the Italian Grand Prix at Monza, where Surtees scored his second win of the year. It was a typically exciting slip-streamer and, after Clark and Gurney fell out, McLaren and Bandini completed the top three. Hill broke his clutch on the line in Italy, but kept his title challenge afloat by winning the US Grand Prix after Clark suffered engine problems. Surtees was second, ahead of an impressive Jo Siffert in one of Rob Walker's Brabhams.

Three drivers went to the finale in Mexico City with a crack at the title. Hill led on 39 points, Surtees had 34 and outsider Clark 30. Hill was soon out of contention for points, and Clark looked set for the title. But with just two laps to go, he struck engine trouble yet again. Surtees had worked his way up, and was waved into second place behind Gurney by team-mate Bandini. And it was enough to take the title from Hill.

PREVIOUS PAGE TOP LEFT AND RIGHT:

END OF THE GAME: JO BONNIER'S BRABHAM LIES TRACKSIDE AFTER HIS CRASH IN PRACTICE. HE WAS NOT IN A GOOD ENOUGH STATE TO START THE RACE.

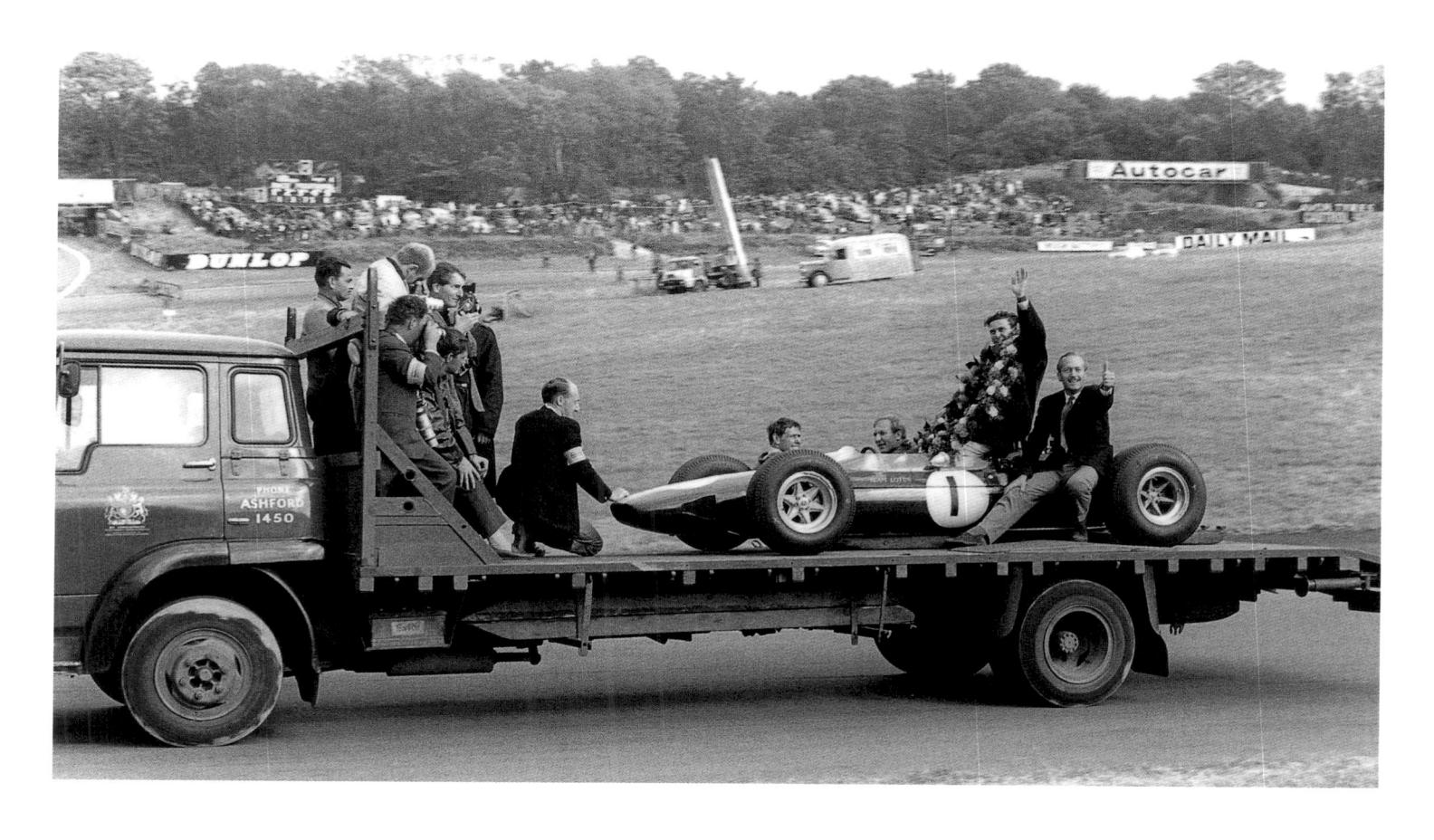

ABOVE VICTORY PARADE: JIM CLARK, HIS LOTUS 25 AND LOTUS BOSS COLIN CHAPMAN HITCH A RIDE FOR A LAP OF HONOUR AT BRANDS HATCH.

RIGHT THE ONE AND ONLY: LORENZO
BANDINI WON FOR FERRARI AT
ZELTWEG, BUT NEVER AGAIN BEFORE
HIS DEATH AT MONACO IN 1967.

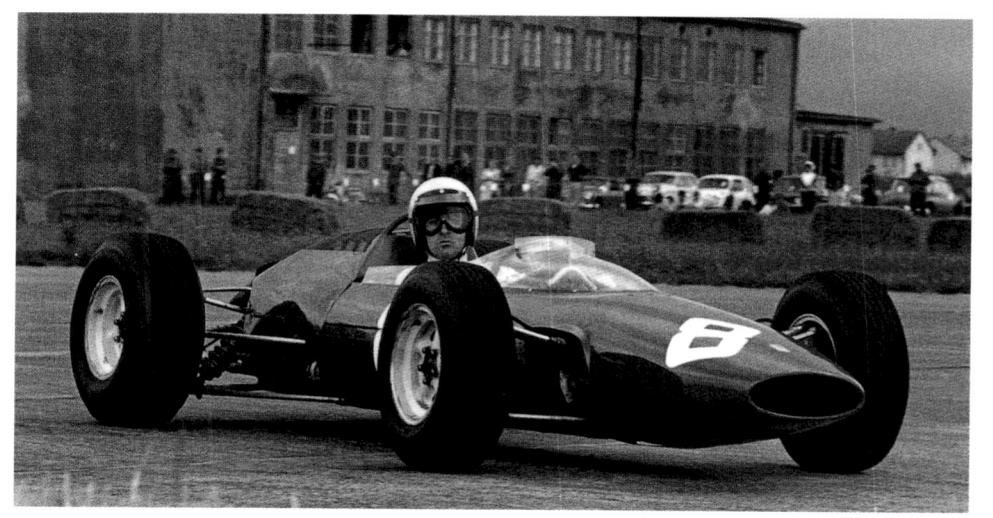

DUNLOP

HONDA BANDINI

A PERFECT SCORE

fter four straight retirements had robbed him of the world title in 1964, Jim Clark bounced back for Lotus to win the 1965 World Championship - and also the Indianapolis 500 for good measure. Once again a change of engine regulations at the end of the year was the signal of the passing of an era.

The British teams struck back against Ferrari in 1965, with Lotus and Brabham using a new and more powerful 32-valve version of the Climax V8. With Arundell still recuperating from a massive crash in 1964, Clark was joined at Lotus by another new team-mate in the form of Mike Spence, who had driven for the team in the previous year's Italian Grand Prix. Jack Brabham and Dan Gurney were joined in the Brabham line-up by a newcomer from New Zealand called Denny

Hulme, while Rob Walker entered a brace of Brabhams for Jo Bonnier and Jo Siffert.

Ferrari continued with reigning champion John Surtees and Lorenzo Bandini, and there was new competition, too, from Honda, who launched a full effort with Richie Ginther and the little-known Ronnie Bucknum. Ginther's departure from BRM left a seat open alongside Graham Hill, and it was very ably filled by a promising young Scot who had not even driven in a Grand Prix; his name was Jackie Stewart. Talented Austrian Jochen Rindt joined Bruce McLaren at Cooper.

The South African Grand Prix became the first race of the season rather than the last, and Clark, still using the older Climax engine, scored a runaway win. Surtees continued his championship form with second, ahead of Hill. Debutant Stewart finished sixth.

LOTUS AT INDIANAPOLIS

MCLAREN

GINTHER

Lotus was missing from the second race. at Monaco, as the team was competing instead at Indianapolis, where Clark notched up an historic first win for a rear-engined car. In his absence Hill scored a wonderful victory in the street classic, recovering from an early incident to overtake both Surtees and Bandini. Clark came back with a win in a typically wet Belgian Grand Prix at Spa-Francorchamps, ahead of Stewart and McLaren, while Ginther picked up a point in the fast-improving Honda. Clark and Stewart then repeated their double act in the French Grand Prix, held this year on the mountainous Clermont-Ferrand track wih Surtees a very distant third.

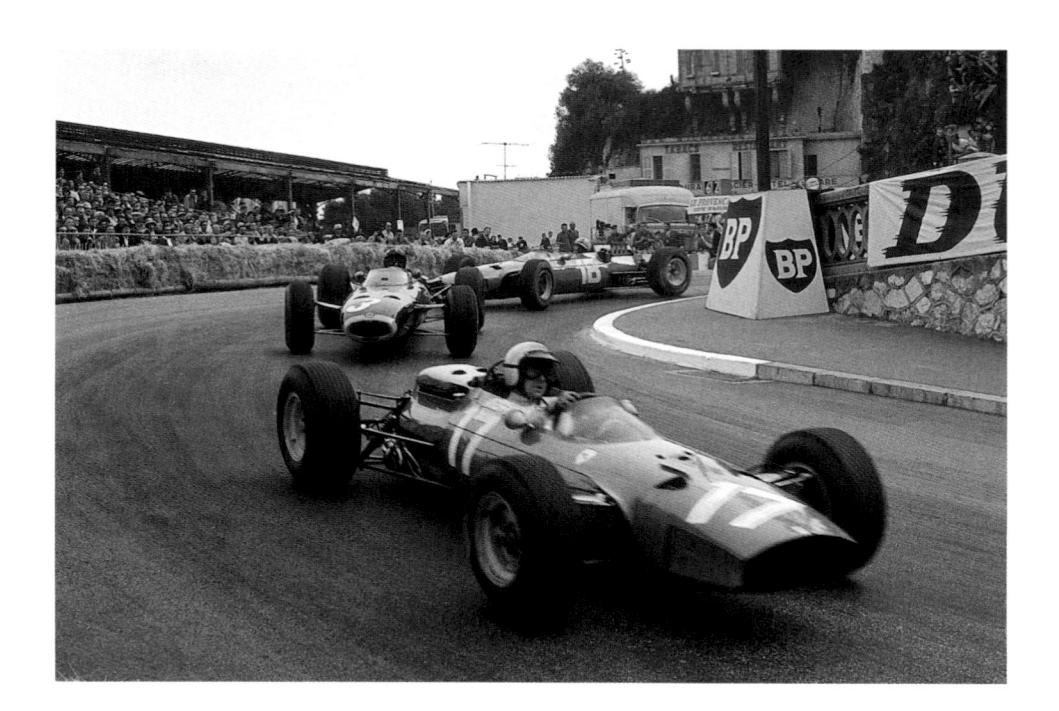

LEFT POWER PLAY: LORENZO BANDINI
KEEPS HIS FERRARI AHEAD OF
GRAHAM HILL'S BRM, BUT IT WAS
THE ENGLISHMAN WHO TRIUMPHED
AT MONACO.

BELOW LEFT POETRY IN MOTION: JIM CLARK POWERS THROUGH THE PUDDLES ON HIS WAY TO ANOTHER WIN AT THE BELGIAN GRAND PRIX.

RIGHT POETRY IN MOTION PART TWO: DAN GURNEY FOLLOWS THE BRM PAIRING OF JACKIE STEWART AND GRAHAM HILL AT MONZA.

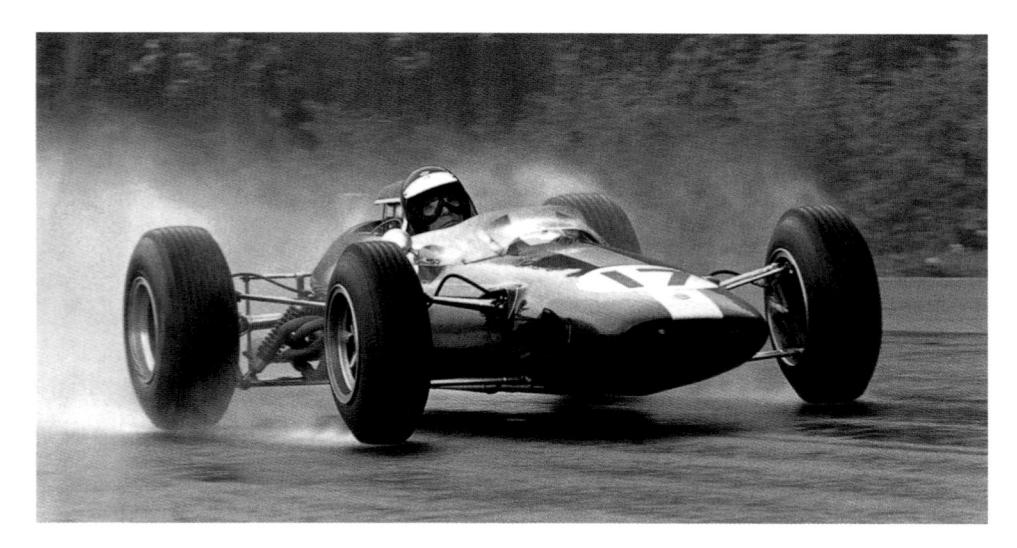

Clark won the British Grand Prix at Silverstone for the fourth consecutive time, this time by a short head from Hill with Surtees third again. Clark then continued his winning ways in the Dutch Grand Prix at Zandvoort, and for the third time countryman Stewart followed him home around the circuit amid the dunes. The big surprise at Zandvoort, however, was the performance of Ginther, who led for two laps in the Honda before sliding back to finish in an eventual sixth place.

CLARK TRIUMPHANT

At the Nurburgring Clark scored his sixth win of the year and his first on the daunting German track. With only six scores counting, he had reached maximum points, and the championship was his. He was then in the lead pack at the Italian Grand Prix at Monza and, after he retired with fuel pump trouble, Stewart scored a marvellous maiden win, fractionally ahead of Hill and Gurney. However, with the title sewn up, Clark's luck seemed to

desert him. He retired with engine problems from the US Grand Prix at Watkins Glen, and Hill scored BRM's third win of the year ahead of the Brabhams of Gurney and Brabham.

The season had a twist in the tail, however, as in Mexico City Ginther gave Honda (and tyre maker Goodyear) a first win, leading from start to finish to pip Gurney. It was to remain the Californian's only win. The race also marked the end of the 1.5-litre formula after four diverting years.

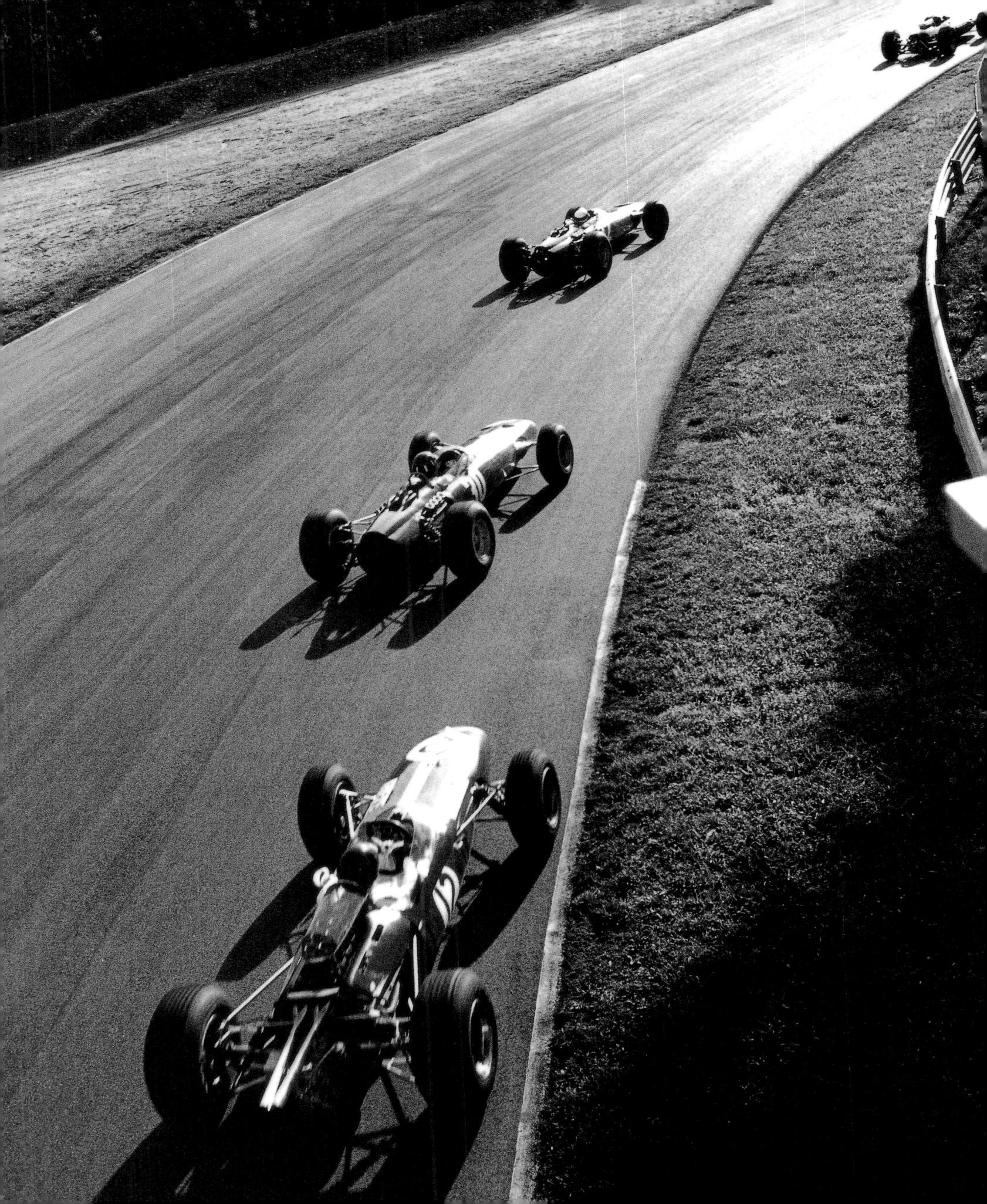

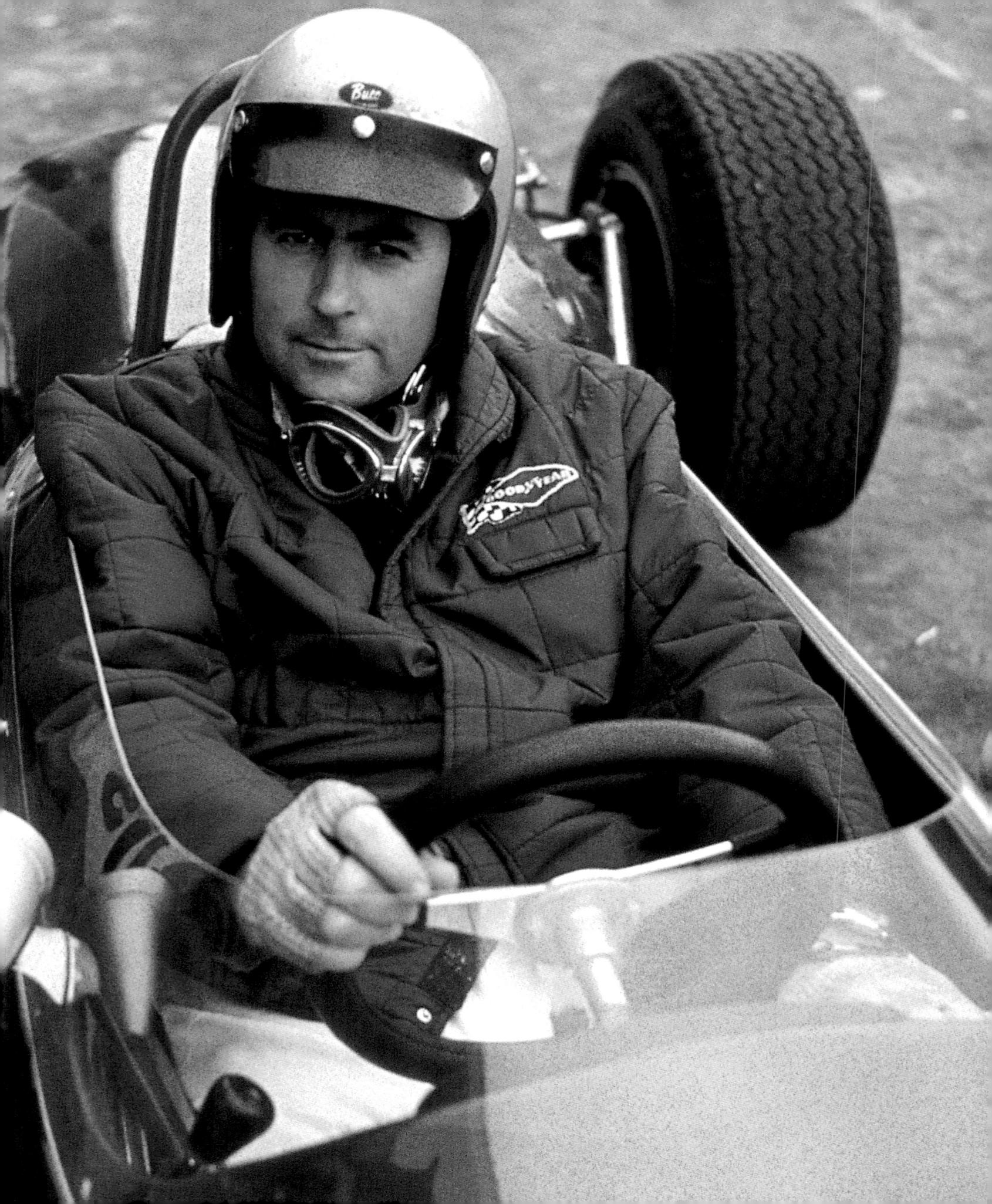

JACK IS BACK...

t was all change in 1966 as the 3-litre formula was introduced and there was a race to get new engines ready in time. Jack Brabham was better prepared than most and he earned a deserved third championship title, this time driving his own car powered by the hybrid Repco engine.

Teams and engine builders were furiously busy through the winter as they prepared for the new formula. There was no pukka new engine from Climax, so existing customers had to find their own solutions.

The man who did the best job was undoubtedly Brabham. He announced that he was using a new V8 from the Australian Repco company. The engine was not the most powerful around, but it was reliable, light and compact, and mated well with an updated version of

Brabham's existing chassis. Jack had not won a race himself since 1960, and the package was to give his career a new lease of life. With Dan Gurney moving on, Denny Hulme became his number two.

Cooper opted for a more far exotic solution, mating a Maserati V12 to a new chassis. Richie Ginther and Jochen Rindt were the works drivers, and Rob Walker bought one for Jo Siffert.

Former Cooper driver Bruce McLaren followed Brabham's example and set up his own team, initially using a Ford engine sourced from Indy Car racing. Another driver to copy the Brabham example was Gurney, whose All-American Racers concern built the neat Eagle.

It was no surprise to see Ferrari follow the V12 route, and the Scuderia

produced a promising new car for John Surtees. Lorenzo Bandini stayed on as his team-mate. Both BRM and Lotus were forced to use uprated 2-litre versions of their V8 and Climax engines. BRM had an unusual H16 under development, but this complicated engine did not race until late in the year. That said, it started very well at Monaco where less powerful cars proved a match for the new more powerful machinery. Clark took pole for Lotus, but he had an unlucky race, while fellow Scot Jackie Stewart won for BRM after Surtees had led with the new Ferrari.

SLIDING OFF AT SPA

There was chaos in the Belgian Grand Prix when eight cars retired on the wet first lap, among them Stewart, who had the worst crash of his Formula One career. He was made to ponder driver

LEFT FLYING SCOT:

JACKIE STEWART

RACES TO VICTORY

FOR BRM IN THE

FIRST RACE OF

THE SEASON AT

MONACO.

LEFT SURE-FOOTED:
JOHN SURTEES
KEPT CONTROL IN
THE WET AT SPAFRANCORCHAMPS
TO WIN FOR
FERRARI.

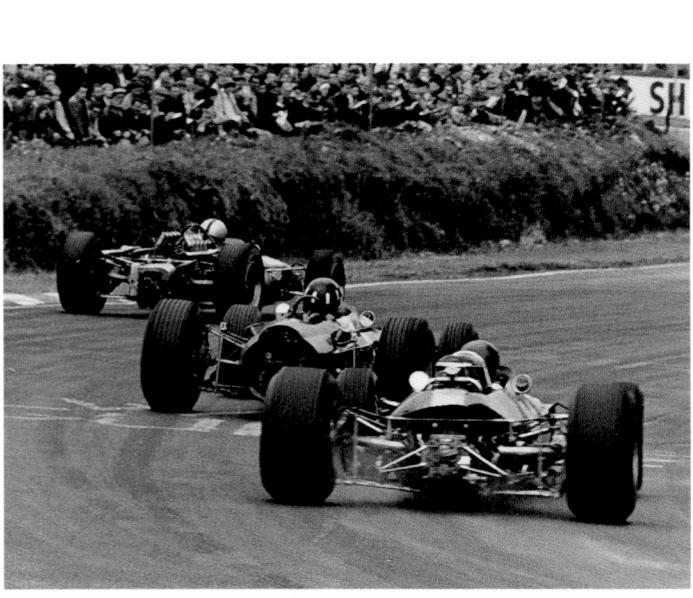

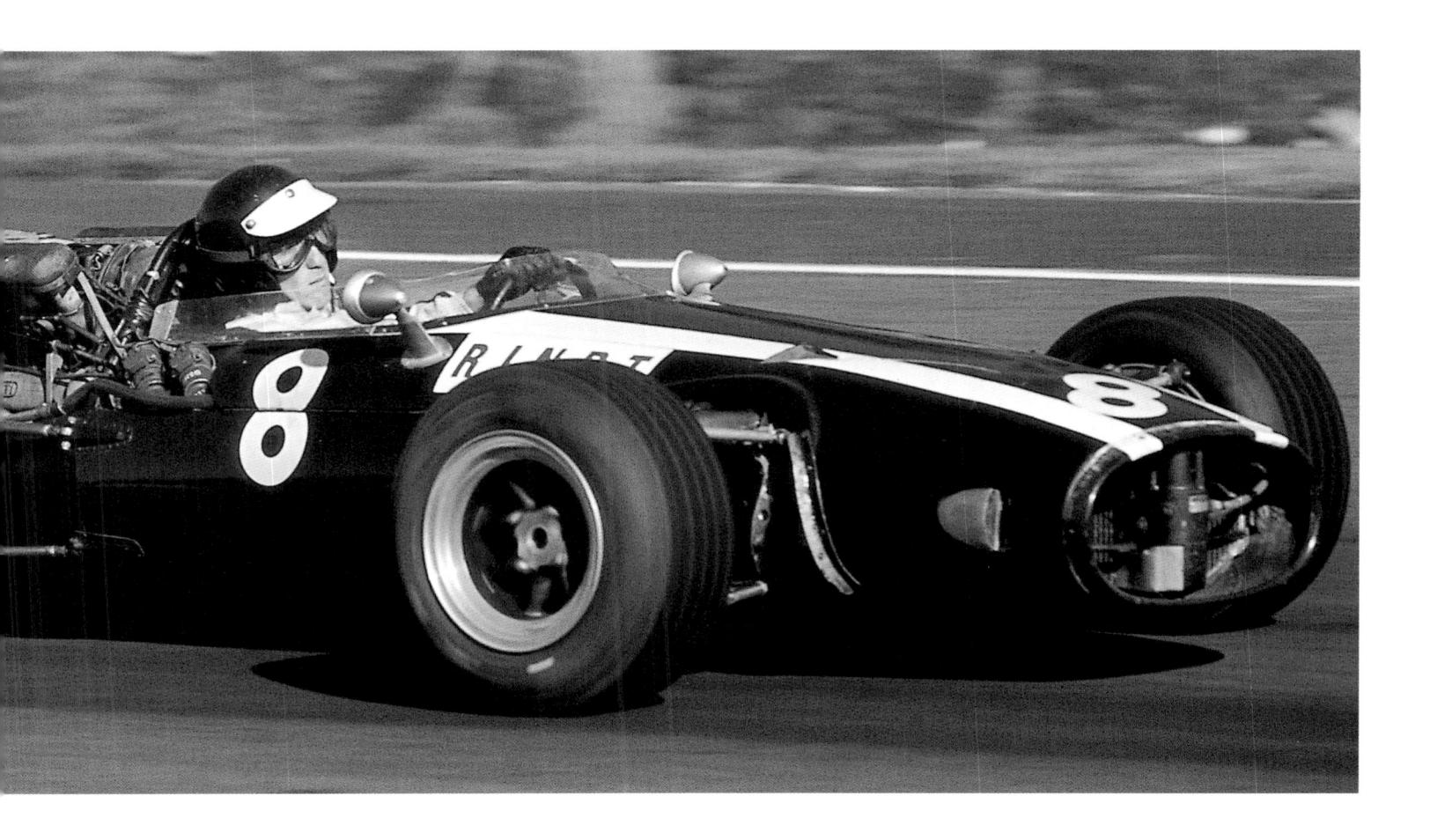

ABOVE AUSTRIAN CHARGER: JOCHEN RINDT PRESSES ON TO FINISH SECOND AT WATKINS GLEN IN HIS COOPER-MASERATI.

safety when trapped inverted in his car soaked in petrol. Surtees stayed on the island that day to win after overcoming a challenge from Rindt's Cooper-Maserati. But a few weeks later John fell out with the Italian team and left to join Cooper.

BRABHAM STARTS WINNING

The new Brabham-Repco came good in the French Grand Prix at Reims, Jack winning after Bandini had retired. Mike Parkes finished a promising second for Ferrari. Brabham won again in the British Grand Prix at Brands Hatch, with team-mate Hulme coming home second. Brabham then picked up a third win in a row at Zandvoort. And his winning streak continued in the German Grand Prix at the Nurburgring, where he held off the Coopers of Surtees and Rindt. His luck ran out at Monza, however, and he retired. But so too did nearly all the top runners, leaving the way clear for Ferrari newcomer Ludovico Scarfiotti to win.

Despite retiring in the Italian Grand Prix, Brabham had enough of a points advantage over his closest rivals to clinch his third title.

Clearly not backing off, Brabham was on pole for the US Grand Prix at Watkins Glen, but retired and Clark won. Cooper-Maseratis finished in second, third and fourth places in the hands of Rindt, Surtees and Siffert, and their good form continued in the championship finale in Mexico, which was won by Surtees.

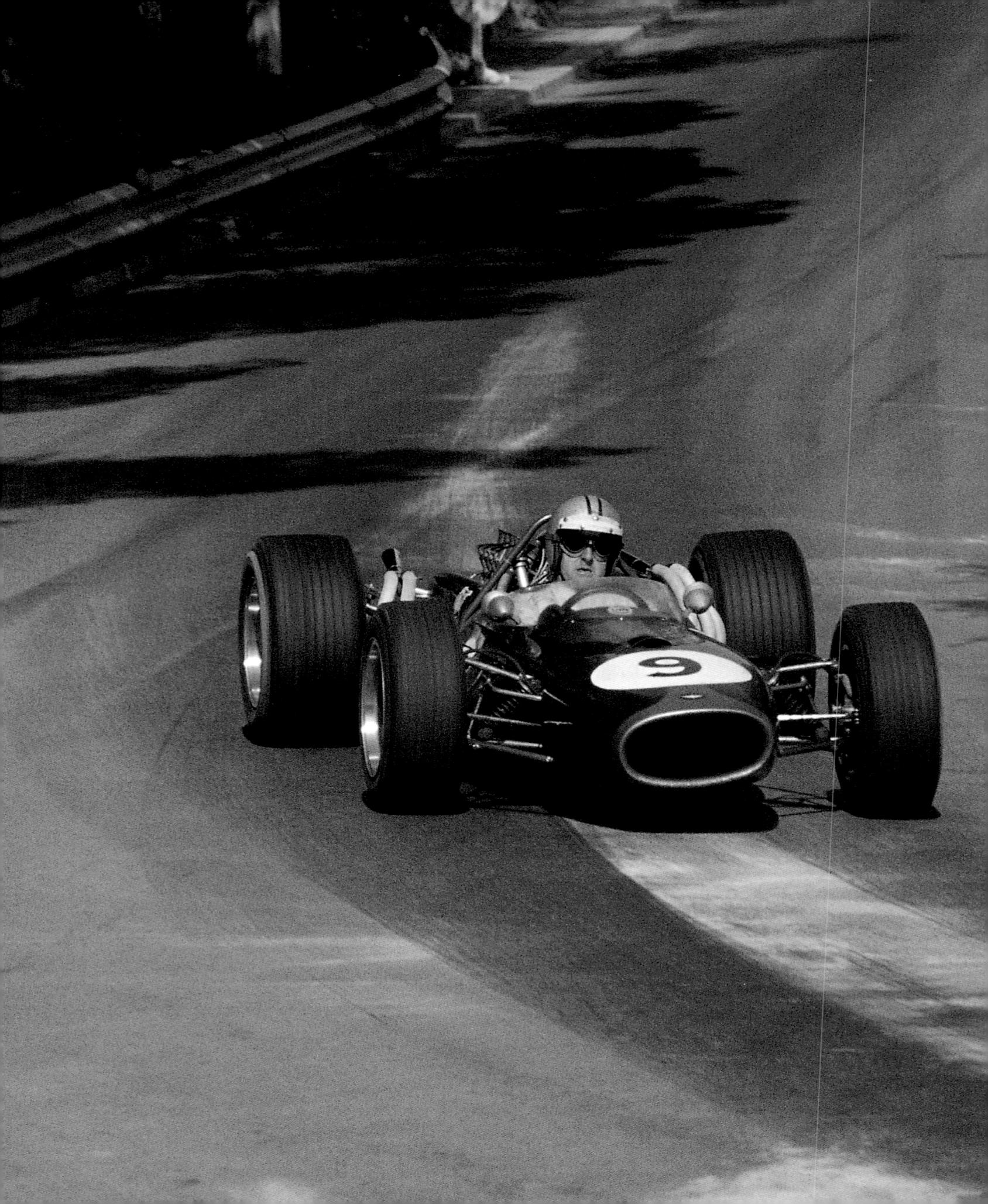

HULME: THE KIWI KING

rabham and Repco scored a second win through the efforts of Denny Hulme, but the story of the year was the arrival of the new Cosworth DFV engine. Packaged with the Lotus 49, it marked the beginning of an era.

Lotus had struggled through 1966, but in the March of that year Colin Chapman had persuaded Ford to invest in a new engine, to be built by Cosworth. The British firm duly embarked on an allnew V8 design for 1967, the Double Four Valve (DFV), which would initially be for the exclusive use of Lotus. Chapman drew a simple but effective car, the 49, to exploit it. And he further strengthened his package by bringing Graham Hill back to join Jim Clark.

That elevated Jackie Stewart to be team leader at BRM, where he was joined

by Mike Spence. Chris Amon teamed up with Lorenzo Bandini at Ferrari, while former Ferrari star John Surtees was signed to lead Honda's effort and Pedro Rodriguez joined Jochen Rindt at Cooper.

The season opened at the new Kyalami track in South Africa, and the race nearly saw a sensational win for privateer John Love in an old Cooper-Climax. Indeed, with the top names struggling, only a late stop for fuel dropped him to second, behind Rodriguez's Cooper.

DISASTER AT MONACO

Formula One had been through a safe – or lucky – couple of seasons, but Ferrari ace Bandini was to lose his life at Monaco. He crashed out of the lead and his car caught fire, burning him fatally. Hulme won for Brabham, ahead of Hill and Amon.

The eagerly awaited debut of the Ford Cosworth DFV and the Lotus 49 came at the Dutch Grand Prix. And it was an historic day, for Clark took victory ahead of Brabham and Hulme after poleman Hill's engine failed.

Hill also retired next time out, in the Belgian Grand Prix, then leader Clark had to pit for a plug change and Gurney took the often unreliable Eagle-Weslake to a memorable first and only win.

For one time only the French Grand Prix was staged at the Bugatti circuit at Le Mans, a shorter version of the track used for the 24-hour sports car race. The Lotuses were again quick, but both broke their transmissions, making it obvious that their reliability was a weak point. That left Brabham and Hulme to finish first and second ahead of Stewart.

However, Lotus fortunes looked up

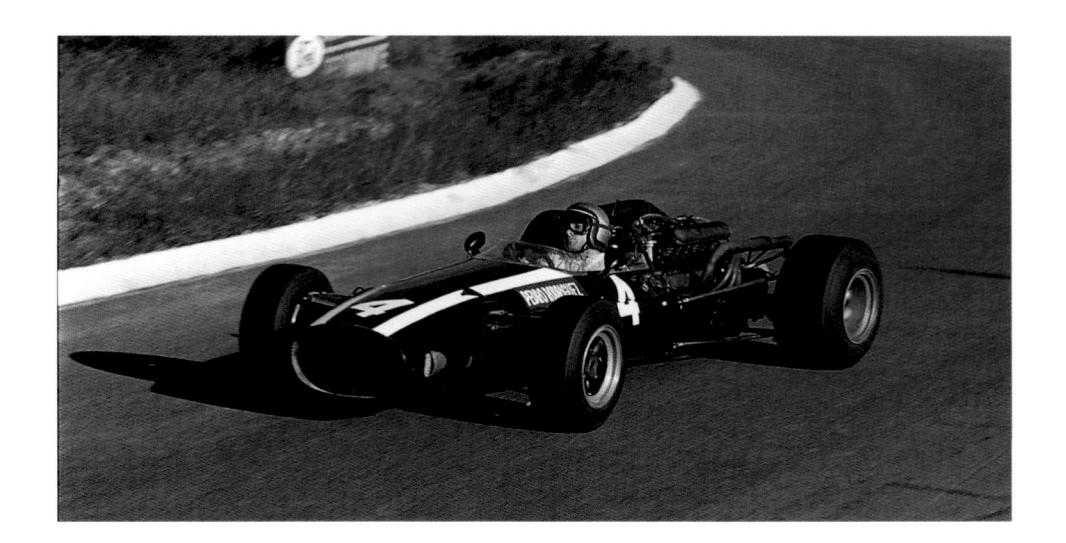

LEFT COOPER'S DAY: PEDRO ROGRIGUEZ LED HOME PRIVATEER JOHN LOVE FOR A COOPER ONE-TWO IN SOUTH AFRICA.

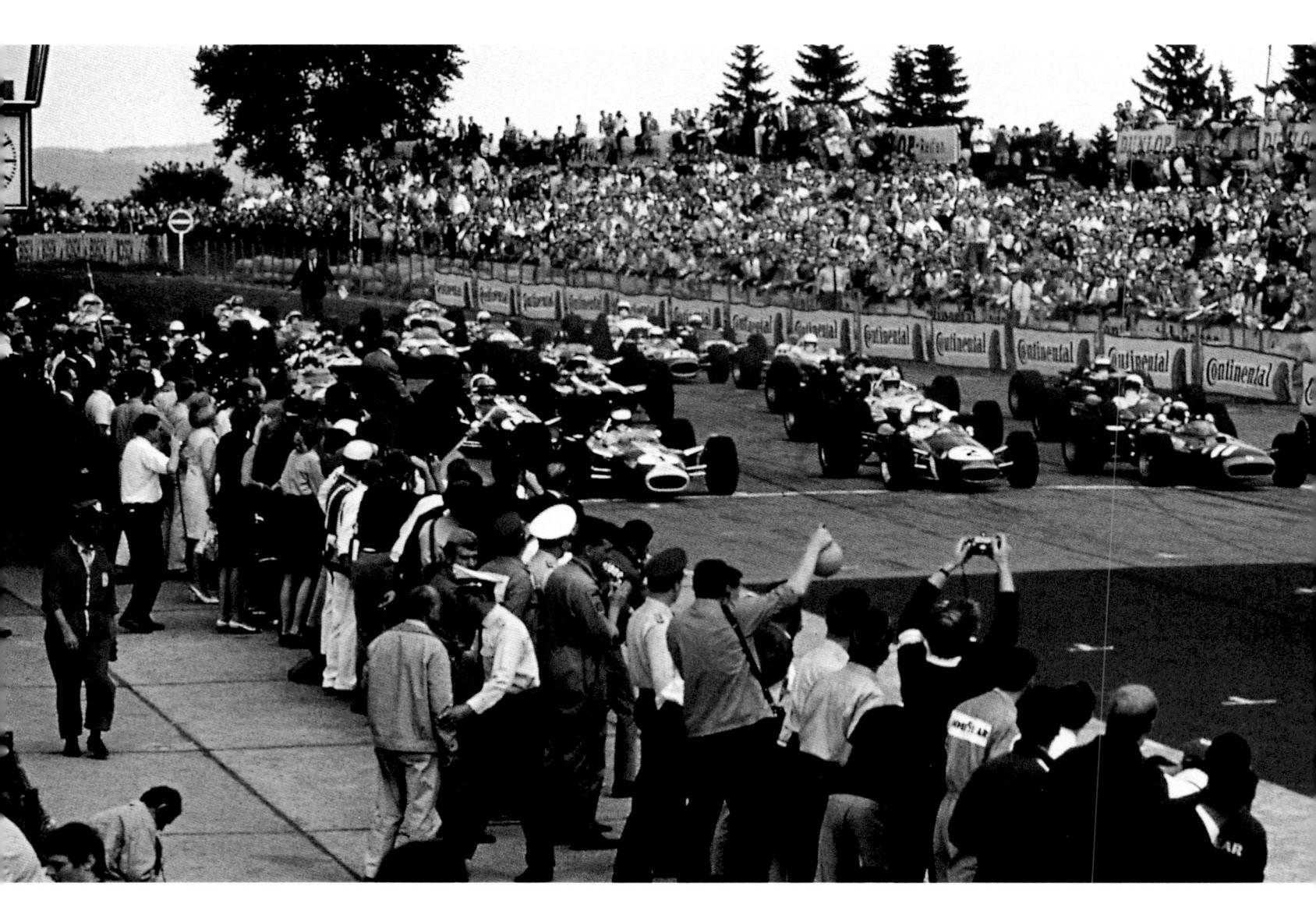

Silverstone, where Clark won the British Grand Prix for the fifth time in six years. Hill led much of the race, but had suspension problems before his engine blew. Hulme and Amon finished second and third.

Lotus gremlins struck again in the German Grand Prix, as Clark and Hill were sidelined by suspension failures. Gurney looked set to win, but when his Weslake blew Hulme and Brabham scored their second one-two.

For the first time the circus moved to the scenic Mosport Park track in Canada. Ignition problems put Clark out and Brabham and Hulme were there to take another one-two, with Hill finishing fourth behind Gurney.

AN ITALIAN SURPRISE

Clark was the hero in the Italian Grand Prix, coming back from problems early on to lead until he started to run out of fuel on the final lap. In a typically exciting finish, Surtees pipped Brabham to give Honda its first win of the 3-litre age, with Clark spluttering home third. Luck swung to Lotus once again in the US Grand Prix at Watkins Glen, where Clark and Hill managed a one-two finish.

However, Hulme had been a steady performer all year, and he just pipped his boss to the title in the season's final race in Mexico when Clark won from Brabham, but third was enough to keep Hulme ahead.

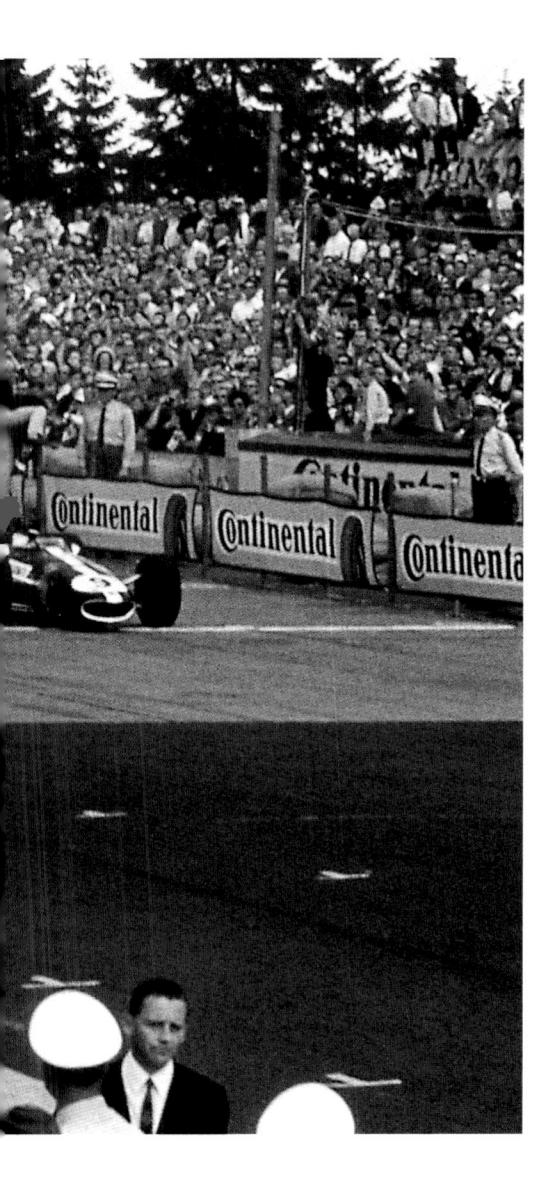

LEFT READY FOR THE OFF: THE FRONT OF JIM CLARK (3), DENNY HULME, JACKIE STEWART AND DAN GURNEY AWAIT THE START AT THE NURBURGRING.

BELOW JUMPING JACK FLASH: JIM CLARK ACKNOWLEDGES HIS VICTORY AT WATKINS GLEN AND THE FLAG-WAVER'S ACROBATICS.

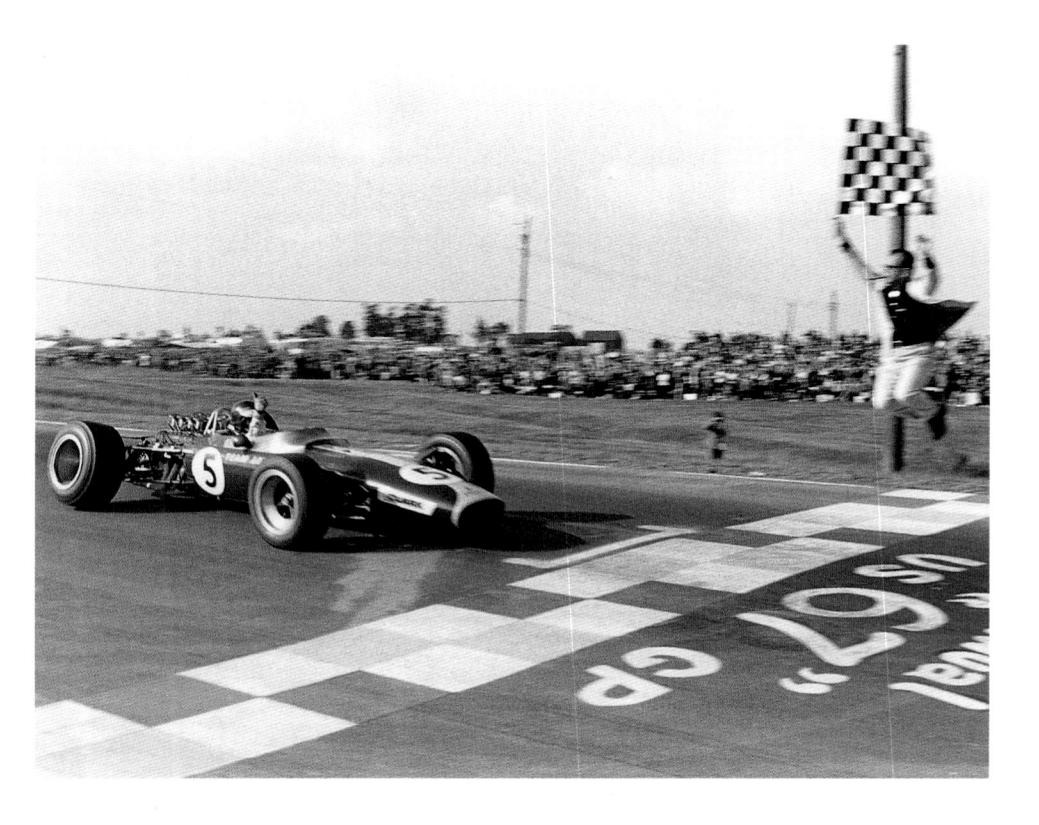

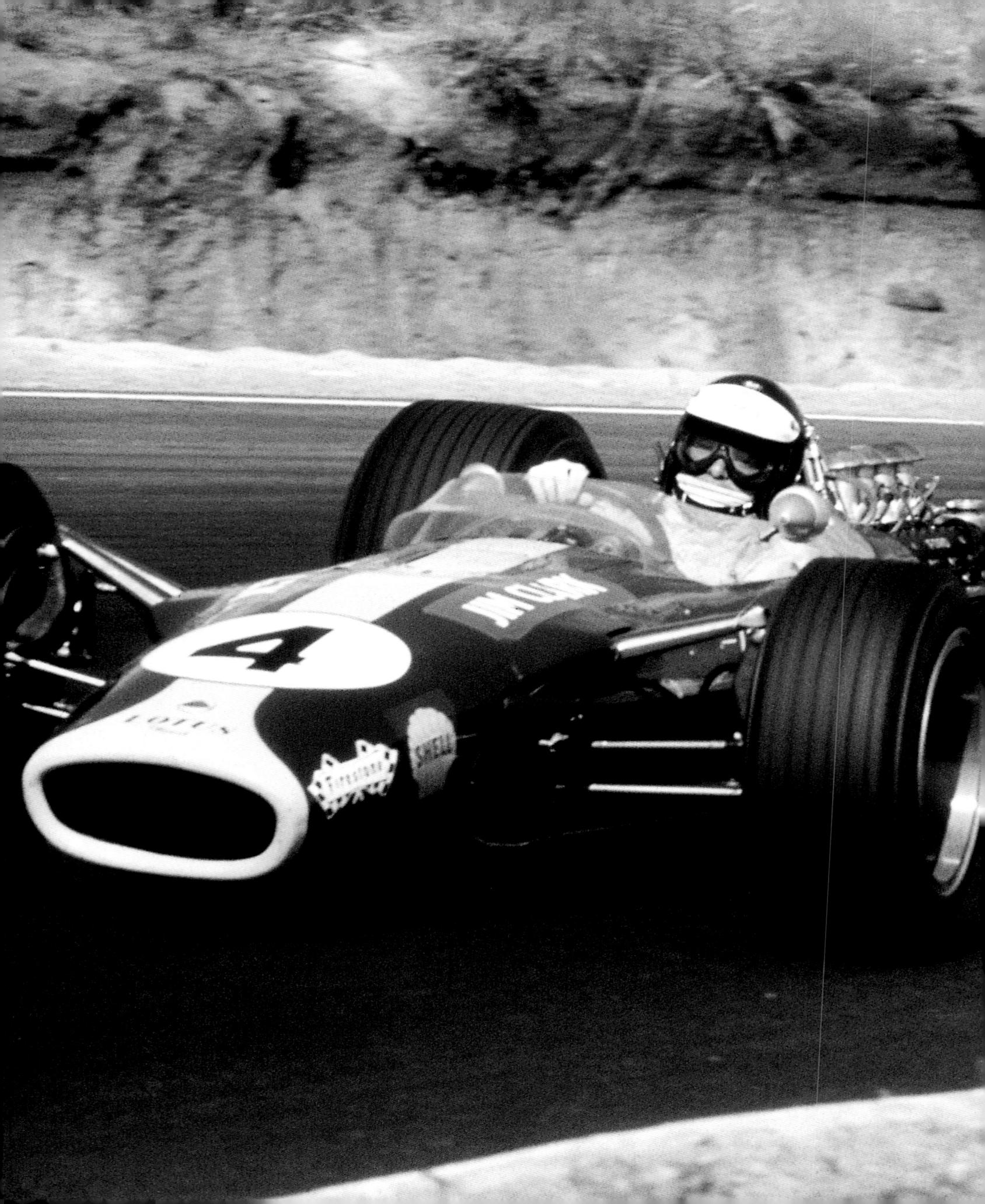

A YEAR OF CHANGE

ponsorship and wings arrived on the Formula One scene, but the new developments were overshadowed by the death of Jim Clark. In the sad aftermath, Graham Hill bravely won his second title for the grieving Lotus team.

Several things happened in 1968 which were to have long-term effects on Formula One, but nothing shook the racing world as much as Jim Clark's death in a Formula Two race at Hockenheim. This tragedy withstanding, the season was most notable for the introduction of overt commercial sponsorship. The previously green and yellow Lotuses were now red, white and gold, thanks to backing from Gold Leaf cigarettes. National colours were to become a thing of the past and British Racing Green Formula One cars confined to the history books.

FORD DFVS FOR ALL

Early in the year Lotus, Brabham and Ferrari began to experiment with downforce-enhancing wings, which soon became standard equipment, often in remarkably spindly form. Added to this, Formula One was further transformed as Ford's DFV was made available to all, and for the next 15 years it would be both an affordable and competitive choice for anyone who wanted it, opening the doors for a host of new teams to have a crack at the World Championship.

Other big news was the arrival of Ken Tyrrell to run Matra-Fords. He scooped up Jackie Stewart as his driver, and the partnership would blossom over the next six years. Meanwhile Matra's own team, with Henri Pescarolo and Jean-Pierre Beltoise, became a serious force. Belgian hotshot Jacky Ickx joined Chris Amon at

Ferrari, while Denny Hulme moved to join Bruce McLaren. Clark and Hill continued to lead the Lotus challenge, with Jo Siffert in a private Rob Walker car.

HILL REVIVES MORALE

A sign of what might have been came at the South African Grand Prix, when Clark dominated ahead of team-mate Hill. By the next race, at the new Jarama track in Spain, Clark was dead, with Jackie Oliver his replacement, and Hill revived Lotus morale with his first win with the 49, ahead of Hulme's McLaren. Hill then won again at Monaco, where Richard Attwood finished a fine second in a BRM.

McLaren gave his marque its first victory in the Belgian Grand Prix after Stewart ran out of fuel. It was also the first win for a DFV in something other than a Lotus. The next such win was not

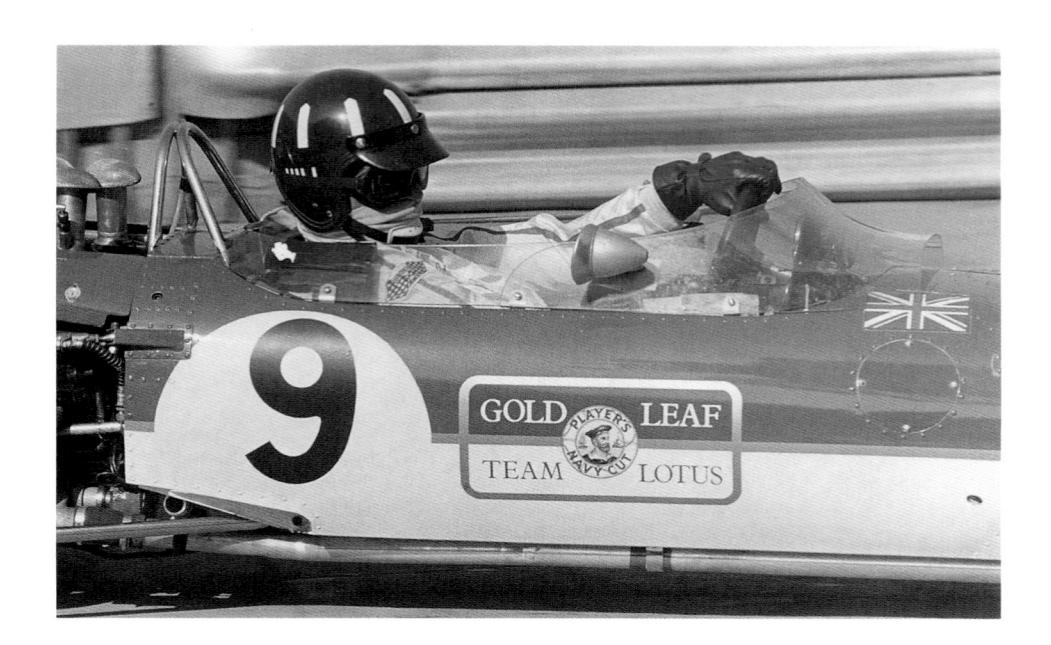

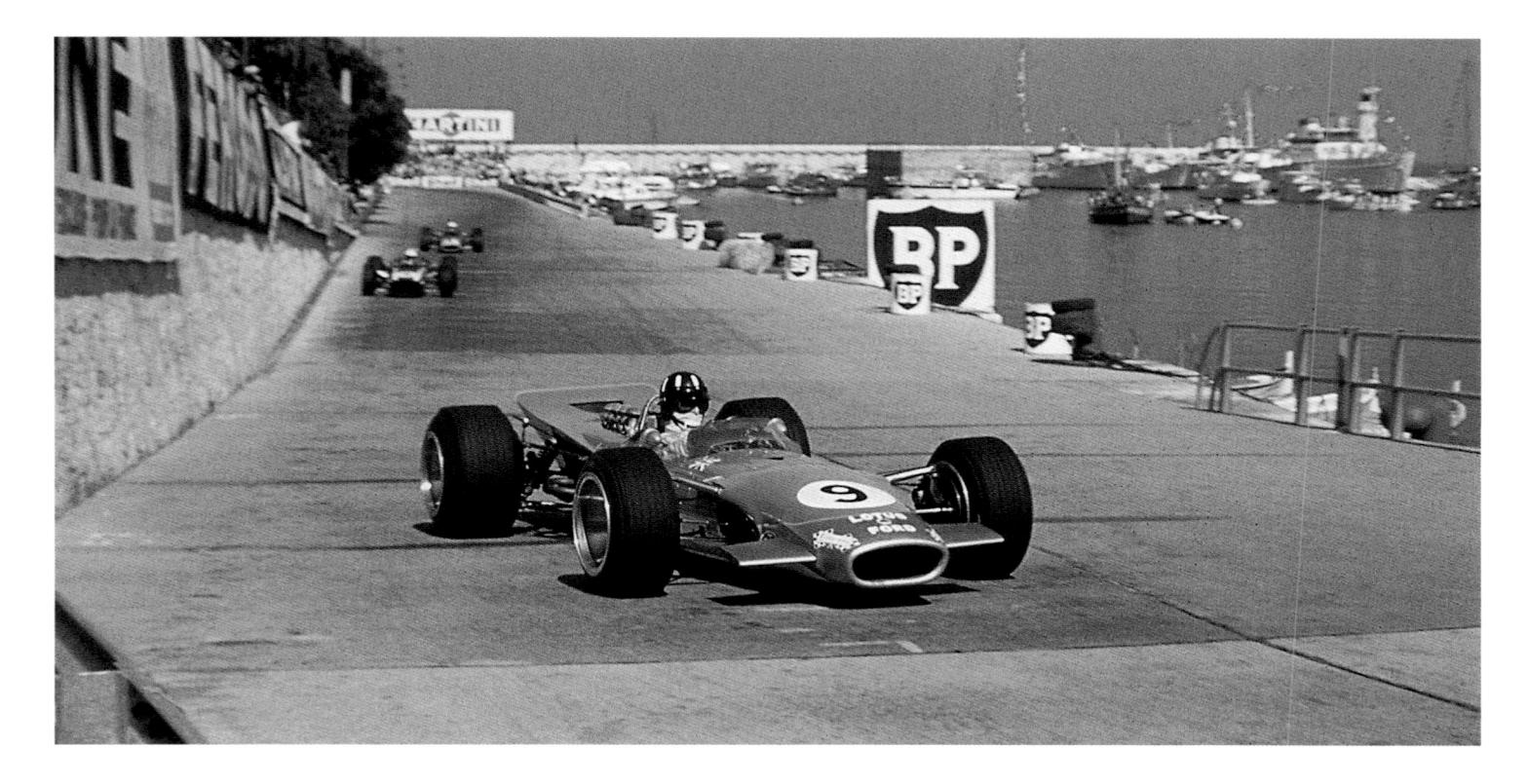

TOP LEFT NEW COLOURS: GRAHAM HILL SHOWS OFF THE REVOLUTIONARY GOLD LEAF LIVERY OF HIS LOTUS. TOP RIGHT FIRST-TIME WINNER: JACKY ICKX TAKES THE SPOILS OF VICTORY AFTER TRIUMPHING IN THE FRENCH GRAND PRIX.

ABOVE THE KING OF MONACO: GRAHAM HILL RACES CLEAR IN HIS LOTUS EN ROUTE TO HIS FOURTH VICTORY IN THE PRINCIPALITY.

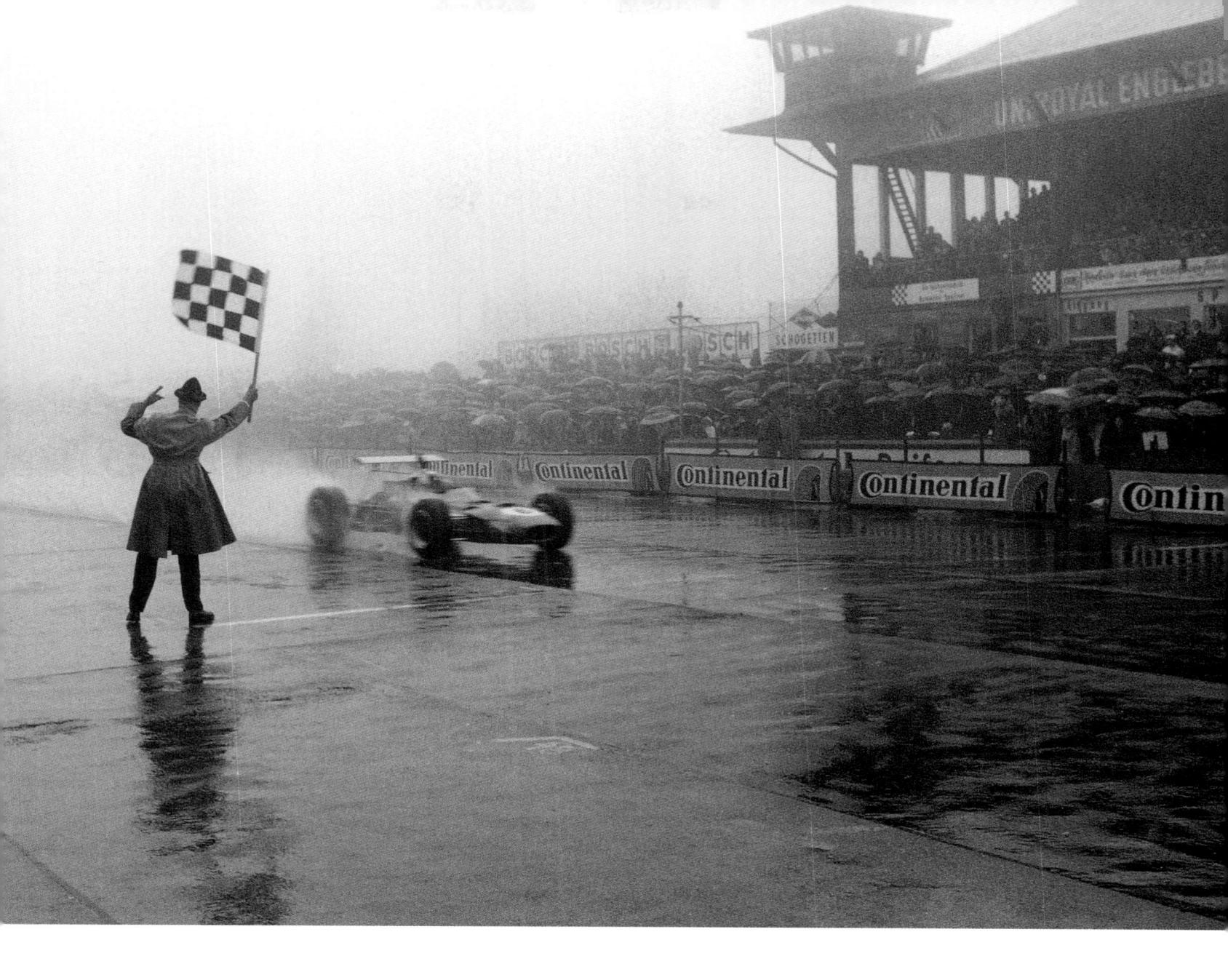

ABOVE A MASTERFUL DRIVE: JACKIE STEWART'S MATRA SPLASHES ACROSS THE LINE AFTER AN ASTONISHING DRIVE TO VICTORY AT THE NURBURGRING.

long in coming, for Stewart guided Tyrrell's Matra-Ford to victory next time out at Zandvoort. There was yet another different winner at Rouen, where young lckx gave Ferrari its only win of the year in pouring rain. Surtees was second for Honda, but his veteran team-mate Jo Schlesser was killed.

At Brands Hatch the popular Siffert gave Walker his first win in seven years with Rob Walker's Lotus, heading home the Ferraris of Amon and Ickx after early leaders Hill and Oliver both retired.

The German Grand Prix saw one of the greatest drives of all time, Stewart winning with a virtuoso performance in atrocious conditions.

Hulme then showed that his 1967 crown was deserved by winning the next two events at Monza and the Mont Tremblant circuit in Canada. Then newcomer Mario Andretti earned a sensational pole for Lotus at the US Grand Prix, but Stewart took his third win of the year.

Rounding out the season in Mexico City, Stewart and Hill battled for the lead until Stewart fell back with handling problems, leaving Hill to score his third win of the year which was enough to give him his second title.

If the losses of Clark and Schlesser were not enough, BRM's Mike Spence was killed in a Lotus during practice at Indianapolis, and former Italian Grand Prix winner Ludovico Scarfiotti died in a hillclimb.

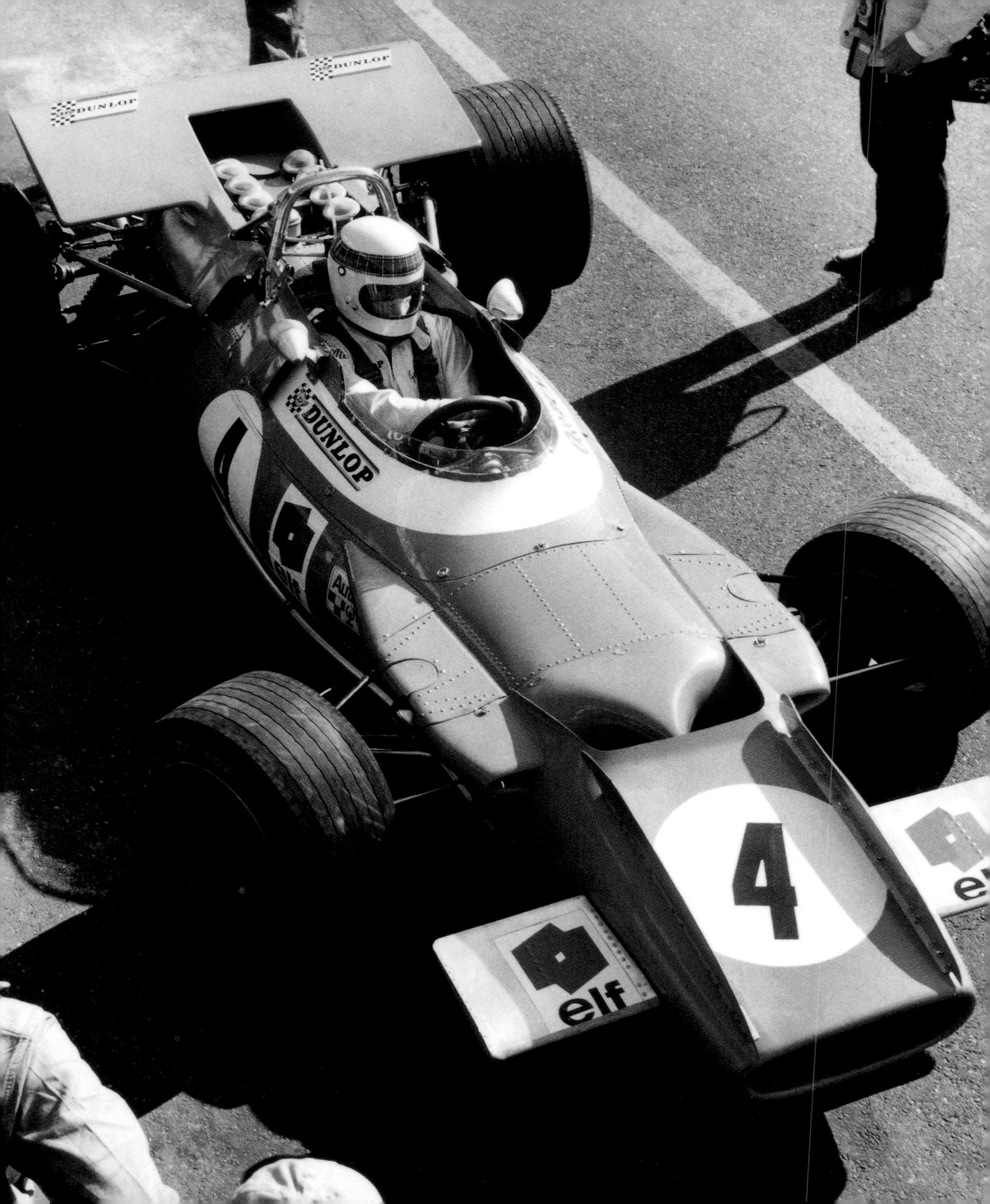

CONSISTENCY PAYS

ackie Stewart marched forward to take the world title with Ken Tyrrell's Matra-Ford in a season in which virtually no one else who could offer a consistent challenge. And it clearly established Stewart as the man to beat in Formula One.

Stewart had come close to the title the previous year, when he had been in with a shout until beaten by Graham Hill in the final round, but in 1969 everything went his way. With Matra withdrawing its own team, all efforts were concentrated on Tyrrell's Ford-powered outfit. Stewart and team-mate Johnny Servoz-Gavin – who had impressed in 1968 – were joined by Jean-Pierre Beltoise.

Jochen Rindt took up a golden opportunity and joined Hill at Lotus, while Jacky Ickx left Ferrari to replace the Austrian at Brabham, a team that had finally given up on Repco and joined the DFV bandwagon. John Surtees was available because Honda had withdrawn from Formula One at the end of 1968 as the DFV supremacy had taken its toll, and he joined ex-Lotus driver Jackie Oliver at BRM. Also gone from the scene were Eagle-Weslake and Cooper-Maserati.

The big development of the year, though, was four-wheel drive. Matra, McLaren and Lotus all tried it, but it was a white elephant and none of the cars really worked and were thus put to one side.

A DREAM START

Stewart started the season in fine form, dominating the South African Grand Prix at Kyalami. American ace Mario Andretti, who would have occasional drives in a third works Lotus, gave him a hard time early on in the race but retired and Hill

claimed second with Hulme third.

Stewart won again at Montjuich Park circuit in Barcelona, but this time he was helped by retirements ahead as Amon's Ferrari broke when leading, while Lotus had a bad break. First Hill and then Rindt had huge crashes after their wings failed, the latter being hospitalised.

The still-injured Rindt would have to miss the next race, at Monaco, where the FIA announced an immediate ban on the high-mounted aerofoils which had proliferated. They soon crept back in, but in a new and less outrageous form, attached to the bodywork. Stewart and Amon both led but retired, allowing Hill to score a historic fifth Monaco win. While Piers Courage finished in second place in a Brabham entered by Frank Williams, giving the British team owner his first significant result.

STEWART ON SONG

The Belgian Grand Prix was cancelled, and Rindt was fit enough to return at Zandvoort. He took pole and led until retiring, so Stewart scored another win, this time ahead of Siffert. Stewart's fourth victory came at Clermont-Ferrand in France, where team-mate Beltoise did a good job to finish second by a nose from lckx.

Stewart won once more at Silverstone, where he battled hard with Rindt until the

Austrian had to pit with a loose wing. Ickx had a good run to second with the Brabham, and two weeks later he went one better at the Nurburgring, where he gave the team its first win since 1967.

TITLE CLINCHER

The Scot clinched the title with a sixth win in an epic, slipstreaming battle in the Italian Grand Prix at Monza, where he headed home Rindt, Beltoise and

McLaren. But, after such a run of success, Stewart failed to win any of the last three races. Ickx triumphed in Canada, Rindt scored his first success at Watkins Glen and Hulme provided more variety with a win for McLaren in Mexico. Missing from the Mexican race, though, was Graham Hill, who had broken his legs in a massive accident at Watkins Glen. He was fit for the following season, but would never again win a Grand Prix.

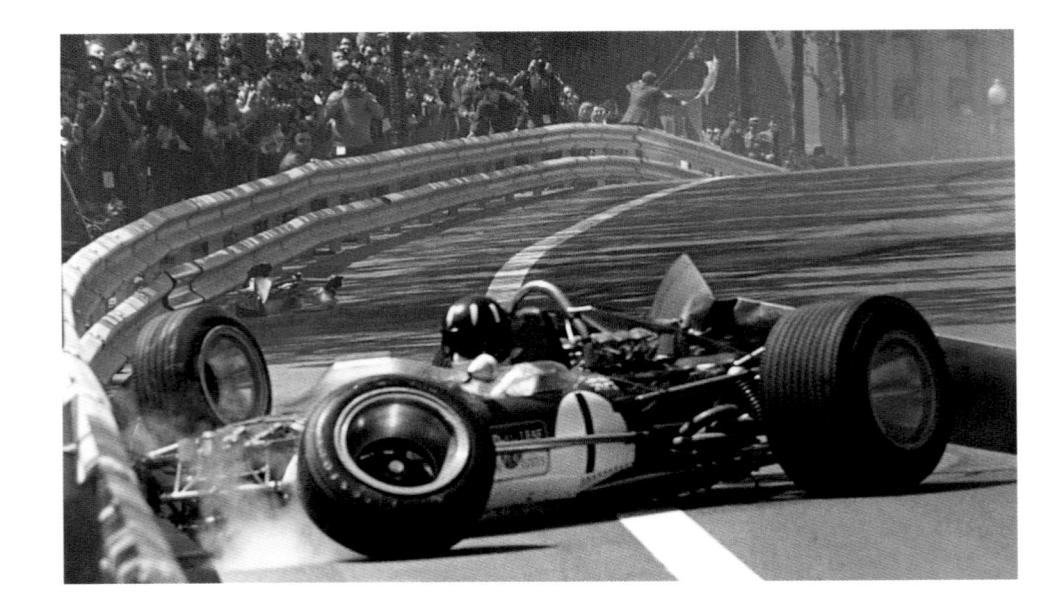

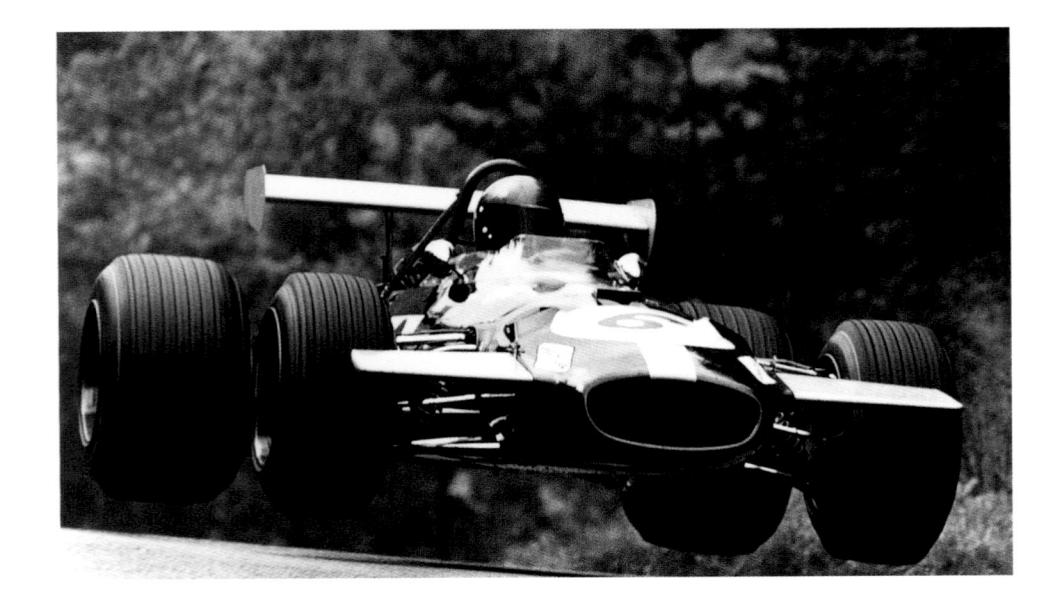

ABOVE LEFT WING FAILURE: GRAHAM HILL DISCOVERS IN SPAIN WHAT HAPPENS WHEN A WING COLLAPSES AND DOWNFORCE IS REMOVED.

LEFT JUMPING JACKY: JACKY ICKX
GETS AIRBORNE IN HIS BRABHAM ON
HIS WAY TO VICTORY IN THE GERMAN
GRAND PRIX.

OPPOSITE TAKING IT EASY: JOCHEN RINDT
AND JACKIE STEWART LISTEN ON AS
EX-FORMULA ONE DRIVER INNES
IRELAND CHATS TO THEM IN MEXICO.

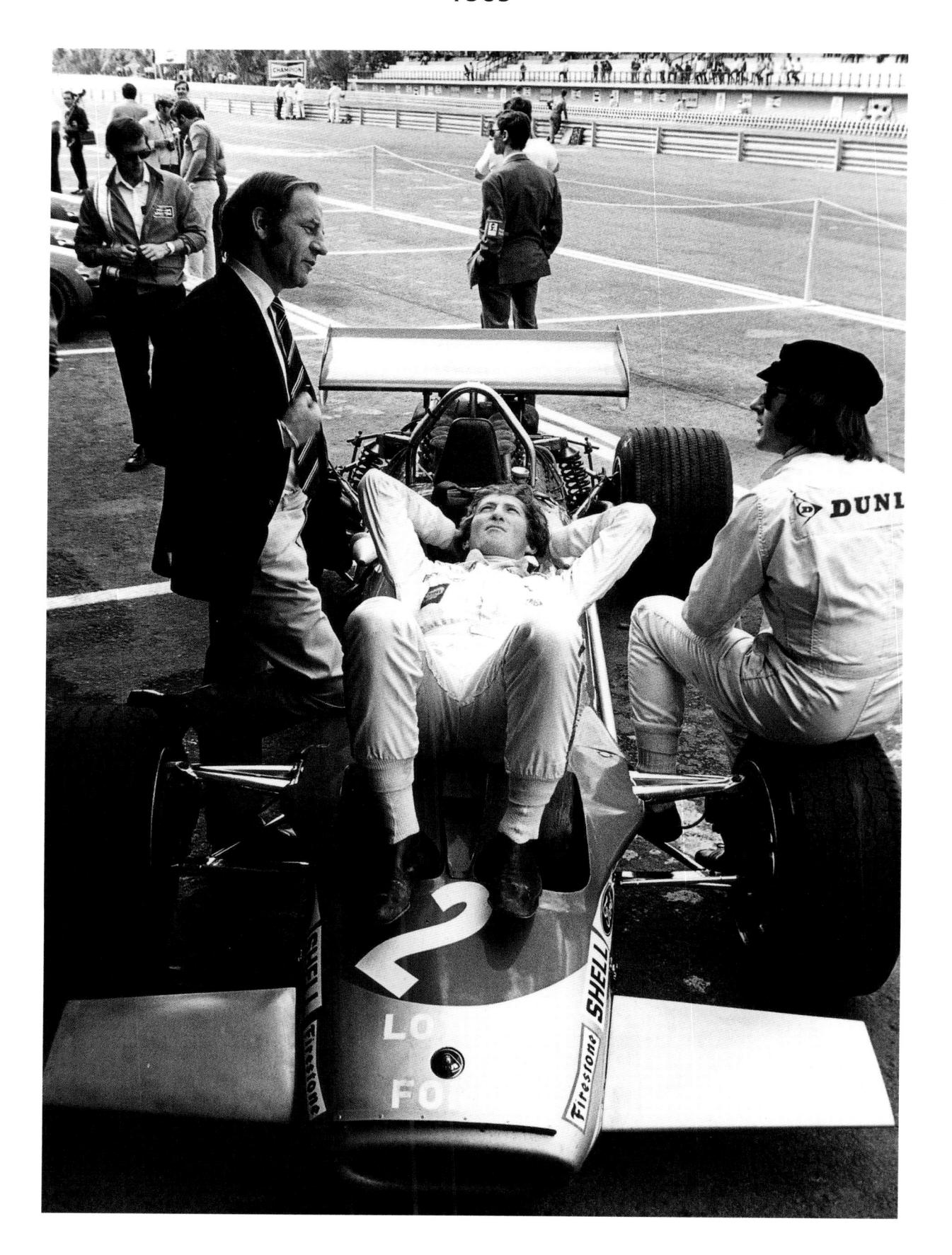

SEVENTIES

Niki Lauda

lariboro .

O CHAMPION DIE

THE SEVENTIES

JACKIE STEWART

Honours: World Champion 1969, 1971, 1973

Grand Prix record: 99 starts. 27 wins

Although Jackie Stewart is talking us through the 1970s, as World Champion twice in that decade – in 1971 and 1973 – his World Championship debut came back at the start of the 1965 season. But there is no-one alive with a greater understanding of the myriad factors that influence Formula One, which is fortunate now that he runs his own team.

"I remember going to a drive-in cinema with Jochen Rindt on the night before my first Grand Prix, the South African in 1965," recalls the tidy Scot. "We were in East London, it was New Year's Eve and it was too noisy in our hotel because of all the partying, so we had to get out. We were probably the only two men together in the drive-in... Of the race itself, I finished sixth in my BRM, but it wasn't a very good performance and I ran out of fuel.

"Considering the level of competition then, I thought of the established drivers as gods. Don't forget, I had come straight from Formula Three and hadn't raced a single-seater until just nine months before my Formula One debut. So, I wasn't surprised about the strength of the competition, but I was surprised that I was able to qualify in the top half of the grid.

"The parity of the equipment was very close and it became closer still as my career progressed from the 1960s to the 1970s. The Lotus-Climax was the combination to have in 1965. Ferrari was a contender, as it always is. BRM was obviously a leading team in 1965 and Cooper was still a contender as it still had

Climax engines. These were all factory teams, the big players.

"From 1968 on, the parity was fantastic as the Ford Cosworth DFV engine became available to all. Don't forget that a brand new DFV cost just £7500. And by 1969 just about everybody had them. Amazingly, they offered great equality as I don't think there was ever more than 10bhp difference between any of them. On top of this, the chassis weren't that different either as there weren't any real aerodynamics until 1969 after some small-scale wings appeared either side of the nose in 1968. So we knew that the cars were pretty much equal. It was up to the driver to find the time."

This considered, how was there so much overtaking then? "Well, with parity of power and with the cars having very little grip, people made mistakes and lost time. Also, there was plenty of drafting as there weren't chicanes every three seconds."

Known as a campaigner for safety in Formula One following an accident at Spa-Francorchamps in the 1966 Belgian GP, when he was left dangling upside down, soaked in petrol and waiting for an explosion, Jackie offers a surprising point-of-view about

JACKIE STEWART

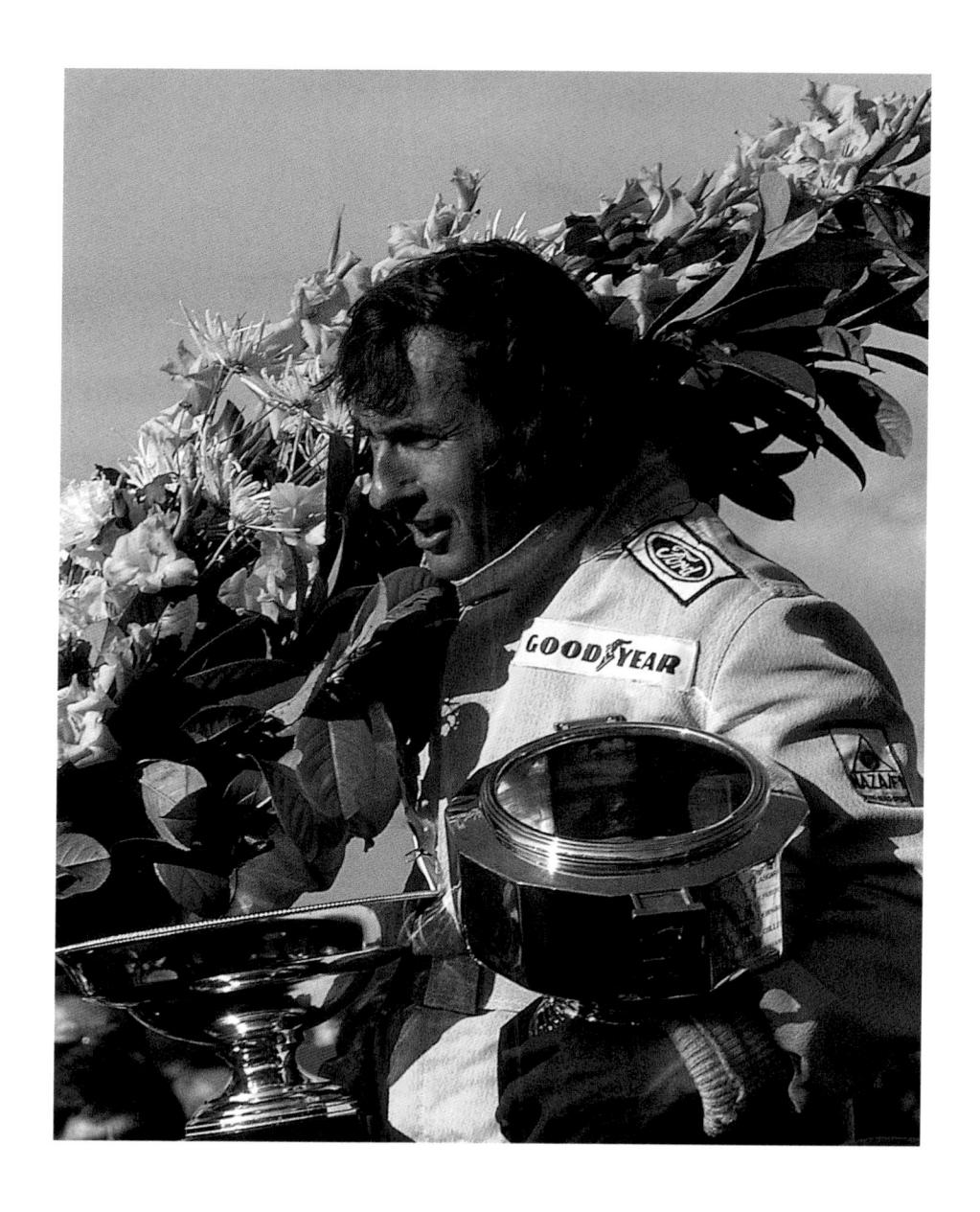

THE SEVENTIES

dicing wheel-to-wheel with his contemporaries on circuits that fall a long way short of today's safety standards.

"You knew who to dice with," Jackie explains. "You were 100% safe with Jim Clark, Jochen Rindt, Francois Cevert, Chris Amon, Dan Gurney, Graham Hill and Denny Hulme. Neither Jack Brabham nor John Surtees were as easy to pass, but that's not a criticism as it was their business. As to safety, this didn't affect my psyche at all. You have to understand that it was no good looking over your shoulder and saying that it wasn't safe then, as this was the best that we had. It was changing radically, as when I started we wore open-faced helmets with handkerchiefs covering our mouths below our goggles; we had no seatbelts; we wore overalls with no thermal underwear that were about as useful as a pair of pyjamas.

"I went to Indianapolis in 1965 and saw that the drivers wore seatbelts, which I thought made a good deal of sense and immediately had them fitted to my BRM. My contemporaries still wanted to be thrown clear of the car, but I was concerned that the cars were now such a tight fit that you'd get thrown halfway out and mash your legs. And that's what happened to Graham Hill in the 1969 US Grand Prix at Watkins Glen when he had pitted and rejoined without his belts done up, with his knees being bent the wrong way as he half came out of his car. Jochen Rindt didn't like wearing the thigh straps and he might not have died at Monza in 1970 if he had been wearing them."

So, although the quest for safety wasn't perhaps as all-encompassing to Jackie as observers would have you believe, his calculated approach to the sport soon saw him winning at the highest level, with the first of his 27 wins coming at Monza before his debut season was out after a magnificent scrap with Graham Hill's sister BRM. Third overall in 1965, his next two seasons with BRM weren't as successful, with race finishes a rarity with the BRM H16 in 1967, but then he moved back under the wing of mentor Ken Tyrrell who ran him in a Matra in 1968, ending up runner-up to champion Graham Hill after missing two races having broken a wrist in a Formula Two race. But it all came together in 1969 when Jackie won five of the first six Grands Prix and cruised to his first world title.

When it became clear that Tyrrell would be obliged to fit a Matra engine in place of a Cosworth for 1970, he bade farewell to Matra and struck out with his own team, starting the season with a March chassis. However, before the season was out, the first Tyrrell chassis had hit the grids. Although only equal fifth overall that year, Jackie and Ken struck back and steamrollered the 1971 title. Runner-up to Lotus's Emerson Fittipaldi in 1972, Jackie rounded off his career with another five wins and his third world title in 1973, although his retirement from the sport was brought forward by a race when the team withdrew from the season-closing US Grand Prix as a mark of respect for Jackie's number two Cevert who died in qualifying.

So, Jackie had a lengthy but extremely successful World Championship career, emerging not only intact but with three world titles and a clear understanding about who and what were good. "It's very hard to pick one moment as a highlight of my career, but I suppose that winning the Italian Grand Prix at Monza in 1969 to clinch my first world title was special. I won my

second title parked on the grass by the side of the track at the Osterreichring in 1971 after losing a wheel. And my third and last world title was won by finishing fourth at Monza.

"Equally, when I raced at Monaco in 1973 I knew that it was going to be my last race there, so winning that one was special to me. As was winning the German Grand Prix at the Nurburgring in 1968. But that was more a case of just wanting to get the race over with as the weather conditions were so diabolical.

"There were several defining moments in the 1970s for me. One was the realisation in 1973 that I no longer wanted to be a driver. I was too busy and the aggravation of all my extra business was burning me out. I also saw that unless I retired at a certain time that I might just be tempted to go on and 'Play It Again Sam' like everybody else seemed to be doing and ending up unsuccessful after a career that had diminished. I didn't want that. I wanted a life after driving a car and, at 34, thought that I had a five-year life as Jackie Stewart, three-time World Champion. Luckily, I was heavily used for promotional activities by Ford, Goodyear, Elf and others, sponsors from my racing days. And I also did a lot of commentary work with ABC TV which I enjoyed. And I couldn't have had a better tutor than Jim McKay who ran 'Wide World of Sports', the best sports show of its time. So, the 1970s were a good time for me and my life was expanding when it could have been contracting.

"When you consider the technology, the 1970s were no different to any other decade in that the acceleration of technology was just that little bit faster than before, as it always is in each succeeding decade. Suddenly you had aerodynamics playing a big role. And with aerodynamics you are creating ground effects. Colin Chapman of Lotus could well be put down as the greatest designer in the history of motor racing as he created more radical changes than anyone else. John Cooper created the rear-engined car, but Chapman was the ultimate rear-engined initiator, whether it was the Lotus 18, the early Lotus Indycars that showed the American roadsters the way, the 25 which was the first monocoque car, or the later ground effects cars. I'm sure that Jim Hall tried aerodynamics to a greater degree, but Chapman started the real ground effects and then Patrick Head and Gordon Murray became his disciples at Williams and Brabham respectively."

Acknowledging that the cars had progressed enormously with the introduction of ground effects in 1978, what did Jackie think when he tested one? "It was like being glued to the road. What was going on beneath the car was much more important than what was happening where I was sitting above it.

"The next most important thing was composite carbon brakes which were introduced in the late 1980s. They were amazing. And then came electronics, such as electronic gear shifting, fly-by-wire, telemetry and so on.

RIGHT FOLLOWING THE LINE: STEWART GUIDES HIS TYRRELL 003 TO VICTORY IN THE 1972 FRENCH GRAND PRIX AT CLERMONT-FERRAND.

GOODYEAR

elf

elf

THE SEVENTIES

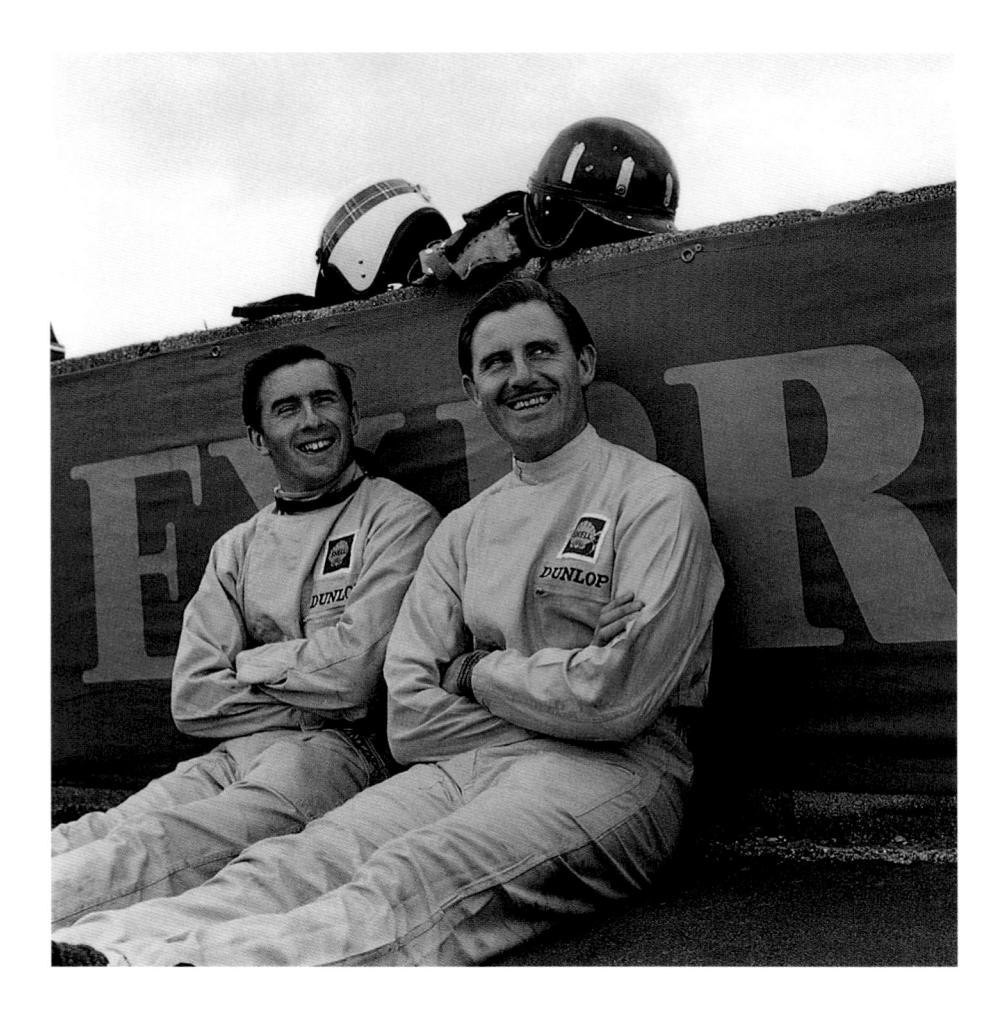

"The last time I drove a Formula One car was when I drove the Stewart SF-1 at Silverstone in 1997. I found it just the same to drive as cars had been in my day. Mind you I drove it to low limits as I wasn't prepared to go into Copse flat and left-foot brake. I was always competitive when I drove cars five or even 10 years after I'd retired, but then I drove a Williams with composite brakes at Paul Ricard in the late 1980s and although I was very close to the then Grand Prix drivers' times, I wouldn't go through Signes at the end of the back straight flat in top as I was older and wiser I suppose.

Certainly, the paddles have helped the gearshift, and that's a major issue as there are no missed gearchanges as this used to be one of the major ways of going past somebody. Nobody did a race in the 1970s without missing a gearchange."

"Looking at the teams, I've always viewed Ferrari as excitingly vulnerable. It's always been such an important name, ever since the early 1950s with Ascari and Villoresi, then later with Fangio in the late 1950s. Ferrari were always seen to be a serious player, as they are in 1999. And yet for 20 years they haven't won a World

JACKIE STEWART

Championship. Even when they ran Niki Lauda in the mid-1970s, they weren't dominant as James Hunt won the title in 1976. Yes, you could say that James won because Niki had his accident at the Nurburgring and pulled out of the final race in Japan, but Ferrari hadn't dominated. So, how is it that Ferrari have never actually dominated Formula One? They're simply excitingly unpredictable, then as now. Ferrari has an enormous budget and it's been a consistent threat, yet it has found ways of failing. It's even been beaten by teams who were makeshift at the start of their careers.

"I would say that my key rivals in Formula One were Jim Clark, Dan Gurney, Jochen Rindt, John Surtees, Jack Brabham, Denny Hulme, Francois Cevert and Chris Amon. Graham Hill sometimes drove some unconventional lines through corners, but this wasn't in an attempt to block you, it was just that this was the way that he did it.

"Compare the mental attitude of drivers in the 1960s and 1970s compared to that of those today, and I don't consider there to be any difference. Then as now, some grew horns, as people do in all sorts of contact sports. Driver input versus mechanical input has changed little, too, while the driver as an animal has stayed very similar. Take Jacques Villeneuve for example. He would have corresponded to a Tazio Nuvolari, while Lauda was much more like a latter-day Rudolf Caracciola. However, I don't think driver input has changed much since the 1970s. Michael Schumacher is very demanding, like Ayrton Senna was very demanding, as was Prost, Lauda, myself, Clark and Fangio. The natural leaders are not soft individuals with regards to his list of requirements to do the job.

"If you look back to Fangio, he was a cold and calculating man who knew that he had to have the best car to win and just went where he thought he wanted to go. He was ruthless and there was no emotional commitment to the teams that he drove for, either to Enzo Ferrari or to the Maserati brothers, or even to Mercedes-Benz. Actually, he stayed with Mercedes-Benz in later life even though he finished his career at Maserati as he saw the benefit to his long-term future to be allied to a multi-national corporation. If you think nowadays that somebody is totally commercial as he has Willi Weber or Mark McCormack behind him, just take a look at Fangio who is my idol to this day. He was well ahead of them in terms of professionalism and single-mindedness. He demanded in order to perform his art. Suddenly, Schumacher is starting to look slightly soft in suggesting that he will see his days through with Ferrari. Fangio wouldn't have done that."

So, was Jackie a latter-day Fangio when he left BRM at the end of 1967 and followed the guidance of Tyrrell to Matra in order to get a DFV behind his shoulders for 1968? And was he too taking professionalism and focused direction a stage further when he moved into the 1970s not only sponsored by Ford, Goodyear and Elf, but also working for them and forging long-term relationships that would see him through to the end of the millenium?

LEFT: NEAT AND TIDY: STEWART AND HIS BRM TEAM-MATE GRAHAM HILL WERE TOGETHER IN BOTH 1965 AND 1966. Certainly, he was seen as being the most professional driver of his time, both in and out of the cockpit. But, as he explains, it wasn't all a question of money.

"I did a lot of things as it gave me an extra edge, something I felt I needed at the time as I didn't feel that I was better than the other drivers. So, out of the cockpit, I tried to endear myself to designers, engineers, mechanics, gearbox people tyre people and so on. I felt that if was going to be a professional racing driver, then I would have to deliver. And if I delivered better than anyone else, then I'd be more valuable than anyone else and would thus have a better chance of driving for a better team and thus earning more money.

Money wasn't actually the driving issue, though: this just came through success, but had I not done that and laid those foundations by doing things like taking bus tours around Monte Carlo or doing breakfasts, lunches and dinners every day of a Grand Prix weekend, then I wouldn't be here now running my own Formula One team. In fact, it helped extend my life as a three-time Formula One World Champion well beyond where I thought it would stretch to."

Stewart Grand Prix has been on the World Championship grid for three seasons with, fittingly, Ford support and engines.

"I wouldn't have dreamed in 1973 when I retired that I'd have started a team. I might have done something with Ken (Tyrrell), but I'd never have entertained the thought of doing it on my own. However, I own a team because of creating Paul Stewart Racing when my son Paul went racing. I built it up because of him and it became obvious to me that it was economically sound to run two cars rather than one. Then I considered what Paul would do the following year and that's why we launched the 'Staircase of Talent', running three teams for six drivers in three different formulae - Formula Opel, Formula Three and Formula 3000. It was a very professional little operation which was no different to Jackie Stewart the racing driver. Here I was seeing my son participating and working with me. And that was nice, as blood is thicker than water and it's great working with Paul. Also, I thought it would give him something beyond driving. Then it seemed obvious that we should move on up after we'd clinched five Formula Opel titles in a row and six British Formula Three titles in seven years. We looked at the International Touring Car Championship and at Indycar racing, but as our eventual goal was going to be Formula One it seemed sensible to go straight there. But I'd never have done it if I hadn't had Paul as a son."

So, looking at Formula One today both as a former World Champion and as a team owner, what does Jackie think of it?

"Formula One today is incredibly complex and very expensive, but not to the detriment of the sport. Actually, it's been a plus and in a way it has been a plus as it has brought the sport to a level of perceived quality, whether it's hospitality, whether it's presentation, it's become unique. A Grand Prix paddock is now a very impressive arena. It doesn't matter who you are or what your interest, when you go into the paddock you can't fail to be impressed by the quality of the technology, the transporters, the tractor units, the motorhomes, the garages and the Paddock Club. And the new Sepang circuit in Malaysia is going to take the whole matter to an even higher level."

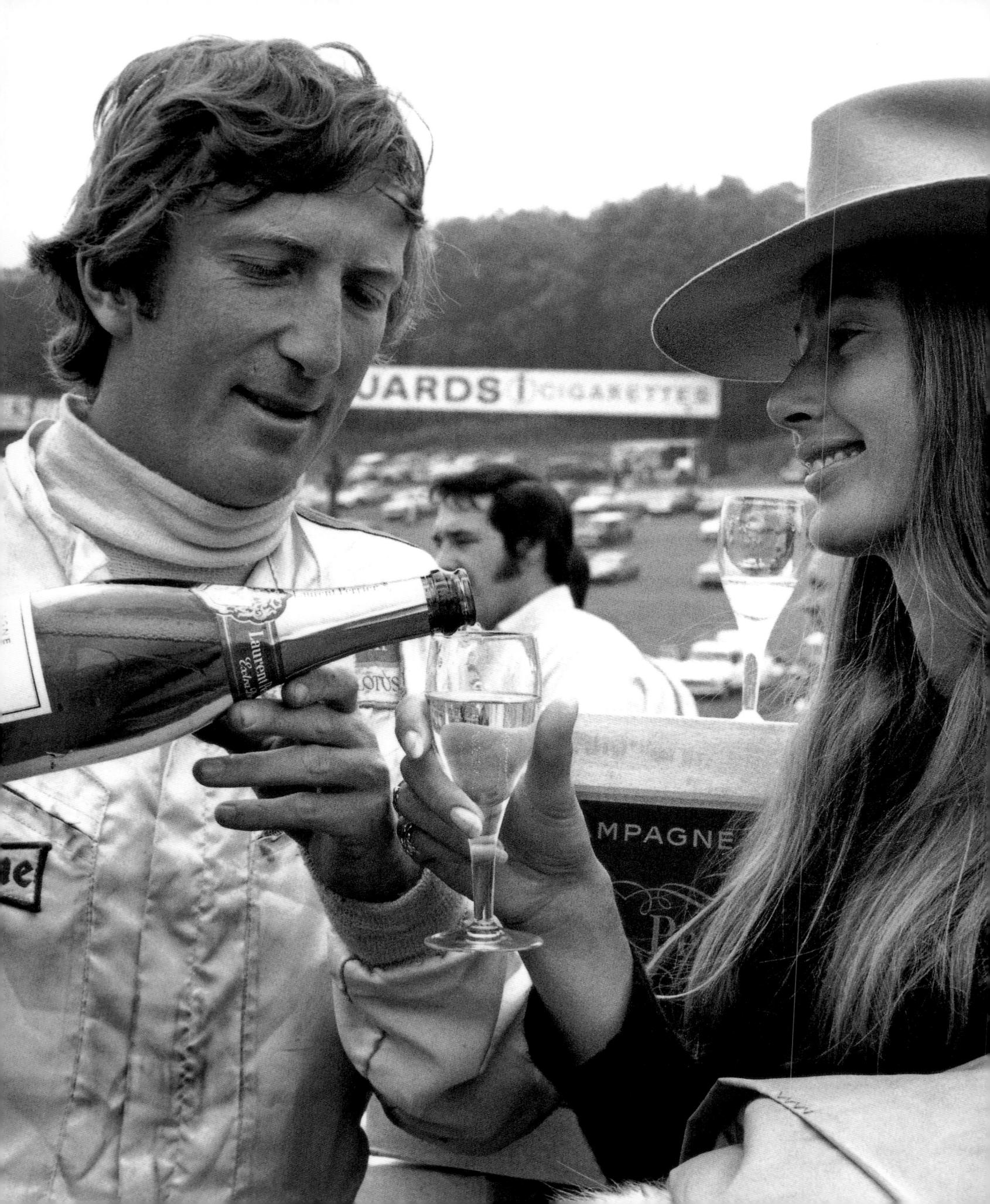

A TRAGIC YEAR

ochen Rindt was leading the World Championship for Lotus when he lost his life at Monza, but no one overhauled his score and the popular Austrian became the sport's first posthumous champion. In a dark year, Bruce McLaren and Piers Courage were also killed.

The big story of the winter was the arrival of March Engineering. Seemingly out of nowhere, the British company appeared at the first race with no fewer than five DFV-powered cars. March scored a coup by getting Ken Tyrrell to run a pair of its chassis after Matra decided to come back with its own team and V12-powered cars. Added to Tyrrell's two for Jackie Stewart and Johnny Servoz-Gavin, the works March team had strong drivers in Chris Amon and Jo Siffert, with Mario Andretti turning out for them occa-

sionally. Ferrari looked well placed with the all-new 312B, and Jacky lckx returned to drive it. BRM attracted backing from Yardley, and produced the much-improved P153.

Jack Brabham had not won since the 1967 Canadian Grand Prix, but he started the year with a fine win in South Africa with his new BT33. Stewart led before dropping to third place behind Hulme's McLaren.

MARCH TAKES GOLD

Stewart gave March a win in the marque's second ever race, the Spanish Grand Prix at Jarama. He was hounded by the rejuvenated Brabham, until Jack's engine broke. Brabham was to the fore at Monaco too, holding off Rindt in a fine battle for the lead. But the Australian slid off at the last corner,

allowing Rindt past to win. Tragedy struck before the next race in Belgium, though, when Bruce McLaren was killed while testing one of his CanAm cars at Goodwood and so the sport lost a great driver who had been a mainstay of Formula One since 1959.

BRM had not won since Monaco in 1966, but Rodriguez gave the team a sensational victory in the Belgian Grand Prix after holding off Amon's March. The delayed appearance of Chapman's slick new Lotus 72 came at the Dutch Grand Prix, and it scored a debut win in the hands of Rindt. Alas, Piers Courage perished when his De Tomaso crashed and caught fire.

Another new face was dashing young Frenchman François Cevert, who joined Tyrrell when Servoz-Gavin abruptly quit the sport. Rindt and the 72 won at

Clermont-Ferrand, and then again at Brands Hatch after Brabham ran out of fuel, while leading rookie Emerson Fittipaldi drove a works Lotus 49C to eighth place on his debut.

lckx was having a bad season, with just four points on the board. But he fought back with second place in the German Grand Prix, held for the first time at Hockenheim, while Rindt took his fifth win. lckx gave Ferrari a much-needed victory in the Austrian Grand Prix, heading

home new team-mate Clay Regazzoni.

RINDT DIES AT MONZA

Tragedy struck again in practice for the Italian Grand Prix at Monza when Rindt crashed fatally after a mechanical failure; he was just 28 years old. The race went ahead without Lotus, and Regazzoni scored a fine win on only his fifth start. Rindt had led the title race comfortably prior to Monza, and the only man who could usurp him was Ickx. He led

Regazzoni in a Ferrari one-two in Canada, finished fourth in Watkins Glen and then won in Mexico. But it was not enough, although even he really did not want to win the title by default.

The Canadian Grand Prix marked the first appearance of another new marque for Ken Tyrrell had built his own car to replace the March. It showed promise in Stewart's hands and qualified on pole, but would have to wait until 1971 for its first success.

ABOVE PEDRO RODRIGUEZ PUT BRM
BACK INTO THE WINNER'S CIRCLE
FOR THE FIRST TIME SINCE 1966 BY
WINNING IN BELGIUM.

LEFT PAGE A MONZA SLIPSTREAMER:
OLIVER LEADS REGAZZONI, STEWART,
ICKX ET AL IN A WONDERFUL LEADSWAPPING RACE.

LEFT: ON THE WINNING TRAIL: JACKY
ICKX HEADS FOR VICTORY IN THE
CANADIAN GRAND PRIX, HIS SECOND
WIN OF THE YEAR.

STEWART'S SECOND

ackie Stewart earned his second world title with a dominant performance for Tyrrell. But once again, the year was tinged with sadness as racing recorded the deaths of two of the fastest and most popular stars on the circuits.

If the Formula One grids appeared to be missing one of their staple ingredients, they were, for Jack Brabham was no longer racing, having retired at the end of the previous year after 126 starts and three world titles in a Formula One career that began way back in 1955. However, he settled into life as a full-time team owner, and Graham Hill was signed up to drive.

The works March team had had a poor first season in 1970, and the star drivers left, with Jo Siffert joining Porsche sports car colleague Pedro Rodriguez at BRM,

while Chris Amon went to the promising Matra-Simca outfit. The third STP March driver, Mario Andretti, joined Jacky Ickx and Clay Regazzoni as Ferrari's third driver. Sadly, early in the year the Italian team lost Ignazio Giunti in a sports car crash in Argentina. To replace them, March signed up Ronnie Peterson who had done a solid job in a privately-entered March in 1970 and soon emerged as a leading contender.

FERRARI STRIKES FIRST

Ferrari drew first blood in the South African Grand Prix when Andretti scored his maiden triumph, although Denny Hulme had looked set to win for McLaren until his right rear wheel came loose with four laps to go and he limped home sixth. Jackie Stewart finished second and followed it up with wins in the Spanish and Monaco Grands Prix, with Peterson scor-

ing a fine second place in the latter.

Stewart struggled at a wet Zandvoort, finishing a disappointing 11th in the Dutch Grand Prix while lckx won for Ferrari.

The French Grand Prix moved to the modern Paul Ricard facility in the south of France, where Stewart and team-mate Francois Cevert scored a fine one-two. Not long afterwards, BRM star Rodriguez, who had finished second in Holland, was killed in a minor sports car race at the Norisring.

Stewart won again at Silverstone, followed home by Peterson, and then at the Nurburgring he and Cevert picked up their second one-two result. This was a repeat of the Scot's 1969 form. BRM bounced back in fine style with a sensational win for Siffert in Austria and an even more spectacular one for Peter Gethin at Monza, where he won by just 0.01s, the closest margin ever. In Austria few noticed the

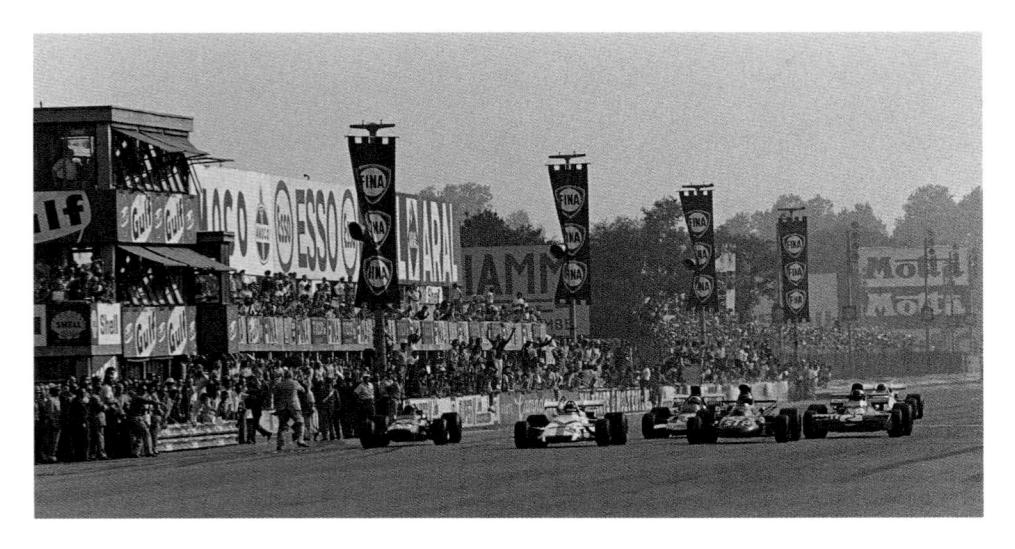

LEFT AMERICAN ABROAD: MARIO
ANDRETTI RACED TO VICTORY IN
THE SEASON'S OPENING GRAND PRIX
IN SOUTH AFRICA IN THE THIRD
FERRARI.

BOTTOM LEFT THE ULTIMATE FINISH: PETER GETHIN (18) PUSHES HIS BRM'S NOSE FORWARD TO PIP PETERSON (25), CEVERT (2), HAILWOOD (9) AND GANLEY (AT REAR).

RIGHT ALL SMILES: FRANCOIS CEVERT
BEAMS WITH DELIGHT AFTER SCORING
HIS MAIDEN WIN IN THE US GRAND
PRIX.

low-key debut of Niki Lauda in a rented March, while at Monza Amon looked set to score his first win in his Matra-Simca after years of being thwarted – until he accidentally ripped off his visor in the closing laps and dropped to sixth.

STEWART WRAPS IT UP

Stewart's engine had broken in the Italian Grand Prix, but he bounced back with a win in Canada, with Peterson again coming second. In the finale at Watkins Glen it was the turn of Cevert to score his maiden win, after Stewart slipped to fifth place with tyre troubles. The title was

long since in his pocket, though.

Peterson was adjudged the big find of the year, however, finishing second in the championship thanks to his consistent results. Cevert, another brilliant youngster, finished third overall.

Lotus had a disappointing year, the marque failing to win a race for the first time since 1960. A lot of effort was wasted with an Indy-derived gas turbine car, which never lived up to expectations. In October tragedy struck again and Siffert was killed when his BRM crashed and caught fire in a non-championship race at Brands Hatch. It was a sad end to the season.

FORMULA 1 FOR THE WORLD CHAMPIONSHIP OF DRIVERS AND A GUARANTEED PURSE OF OVER \$250,000

FORMULA I FUR TANTEED PURSE OF UNION

GLEN 3

GOODFYEAR

THE GLER

John Player Special

B

TEXASO

"EMMO" TAKES OVER

otus returned once again to the top of the podium and its rising star, Emerson Fittipaldi, who had shown much promise the previous year, became the youngest champion as there was no-one else able to offer a season-long challenge.

Lotus went into the 1972 World Championship armed with an updated version of the rather appropriately named Lotus 72 chassis, plus a dramatic new colour scheme. Gold Leaf's red, white and gold colours had been replaced by the black and gold hues of John Player Special and over the next few years the cigarette brand would become completely synonymous with the team, with its car soon becoming known car, which would soon be known as a JPS. Other team sponsors had been in the news as well, as Yardley left BRM to join a revitalized

McLaren effort, in which Hulme was partnered by Peter Revson, the latter returning to Formula One some eight years after a shaky debut in the mid-1960s.

Meanwhile, BRM found major backing from Marlboro and, in what proved to be an over-ambitious plan, ran up to five cars per race. There were some changes at Brabham, too, as the team was bought by businessman Bernie Ecclestone. Graham Hill was joined in the team's lineup by Argentina's Carlos Reutemann, the first talent to emerge from that country since the 1950s.

REUTEMANN IMPRESSES

Newcomer Reutemann stunned the field when he took pole for his debut at Buenos Aires, but it was back to normal in the race when he had to pit for tyres and Tyrrell's Jackie Stewart won

from McLaren's Denny Hulme. The Kiwi went one better in South Africa, giving McLaren its first win since the 1969 Mexican Grand Prix.

Fittipaldi then gave JPS its first win in the non-championship Race of Champions at Brands Hatch, and then dominated the Spanish Grand Prix at Jarama. The Monaco Grand Prix brought a total surprise when, in wet conditions, Frenchman Jean-Pierre Beltoise drove a fine race for BRM. It was to be the marque's last ever win.

Fittipaldi won at the new and boring Nivelles track in Belgium, and Stewart triumphed in the French Grand Prix at Clermont-Ferrand after Chris Amon again lost a race in the late stages – this time with his Matra-Simca suffering a puncture. Jacky lckx's Ferrari led the British Grand Prix at Brands Hatch until the

ABOVE MOTORBIKE ACES: MIKE HAILWOOD RACED TO SECOND PLACE IN THE ITALIAN GRAND PRIX IN A CAR ENTERED BY FELLOW MOTORCYCLE CHAMPION JOHN SURTEES.

BELOW FLYING KIWI: DENNY HULME LEADS FITTIPALDI IN THE EARLY LAPS AT KYALAMI.

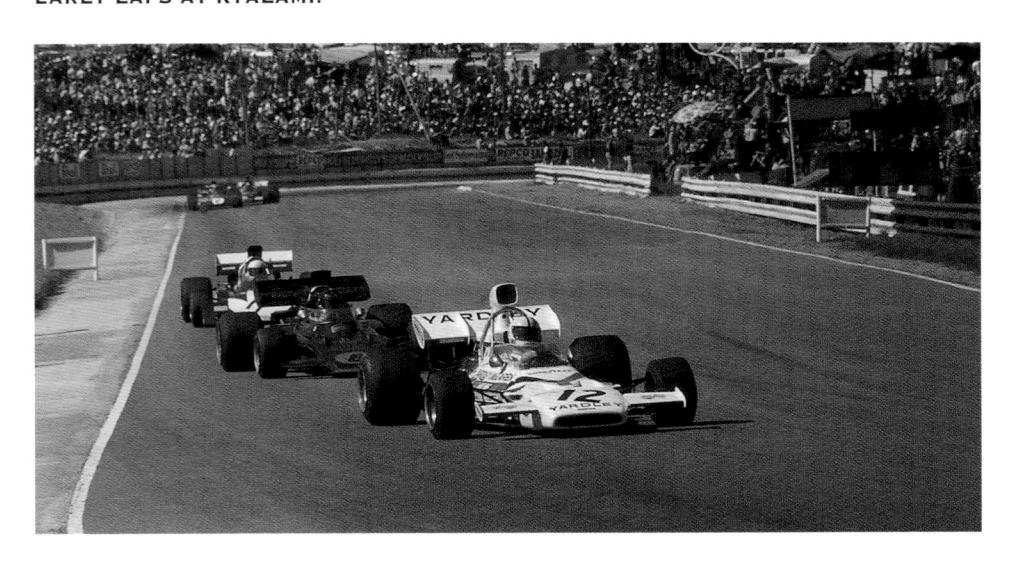

Belgian was stricken with an oil leak, allowing Fittipaldi to win. Ickx fought back with victory in the German Grand Prix at the Nurburgring, ahead of teammate Clay Regazzoni. Fittipaldi won the next race in Austria and then triumphed again in the Italian Grand Prix at Monza to clinch the title with two races still to run. Emerson also rewrote the record book by becoming the youngest ever champion, at the age of 25 years, eight months and twenty-nine days.

MIXED FORTUNES FOR STEWART

Stewart had not had much luck through the season, but a new car that was introduced in the Austrian Grand Prix improved his form. And he finished the season with wins in the Canadian and US Grands Prix, heading home McLaren's Revson and Hulme in the first race and Cevert and Hulme in the latter. It was enough for Jackie to make a late run to second place in the championship, ahead of Hulme. The previous year's runner-

up, Ronnie Peterson, had a poor season. March's new car failed and a slightly more successful replacement was hastily built. However, Peterson had impressed the right people: for 1973 he earned himself a Lotus ride, alongside champion Fittipaldi.

But there was sad news for Ronnie's country as well. In June veteran Jo Bonnier was killed when his Lola crashed at Le Mans. He raced from 1957 to 1971, but never matched the form which had given him BRM's first win in 1959.

BELOW EMERSON FITTIPALDI: ROARING TOWARDS WORLD CHAMPIONSHIP SUCCESS.

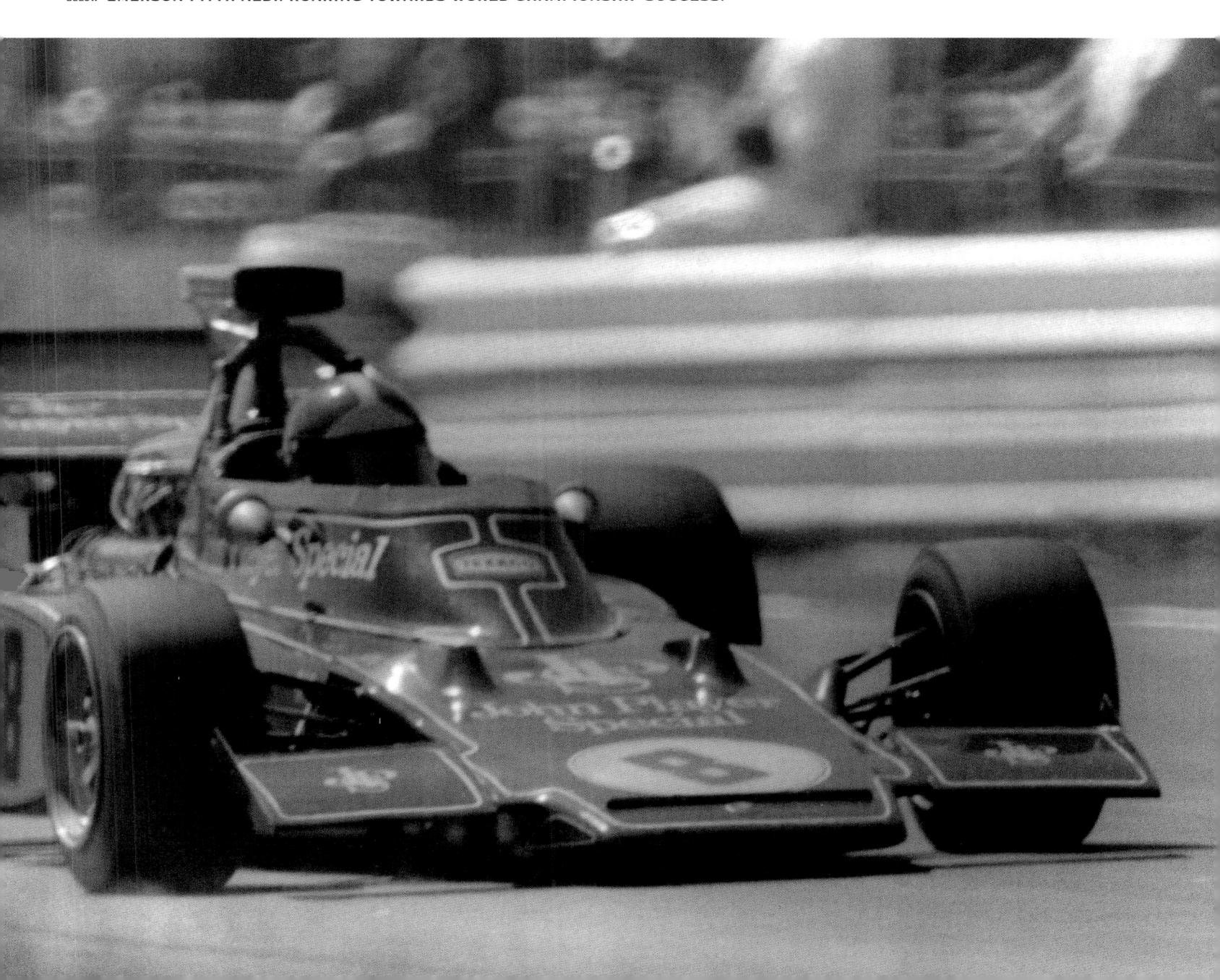

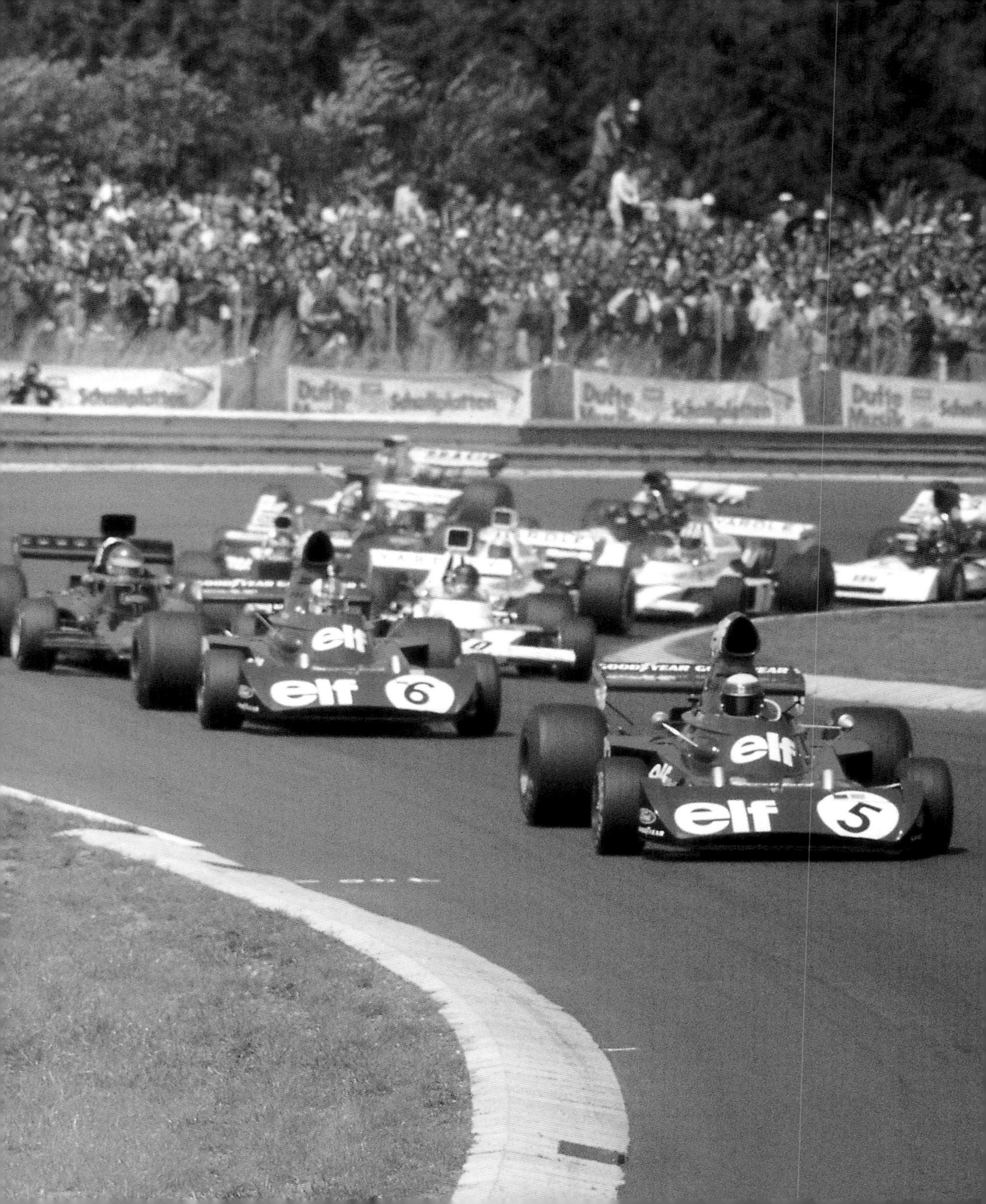

STEWART STRIKES BACK

ackie Stewart landed his third Formula One title after a seasonlong battle with Lotus and decided to quit while he was at the top. Once again the season was blighted, though, with the deaths of François Cevert and newcomer Roger Williamson.

Lotus boss Colin Chapman's fortunes looked good as in Emerson Fittipaldi and Ronnie Peterson the team had two top drivers. However, some people remembered the previous time the team tried to run two top drivers, Jochen Rindt and Graham Hill in 1969, and it didn't yield the desired championship.

Stewart and his Tyrrell team-mate Cevert had developed into a fine partnership in 1972, and Denny Hulme and Peter Revson looked good at McLaren. Jacky lckx was joined at Ferrari by Arturo Merzario, who had run a few races in 1972,

while Clay Regazzoni left to join Marlboro BRM. An intriguing new marque was the American-financed Shadow, whose sinister black cars were handled by Jackie Oliver and George Follmer, an American veteran with no Formula One experience. Meanwhile, Hill quit Brabham to set up his own team, Embassy Racing.

FITTIPALDI'S DOUBLE THROW

Fittipaldi had a dream start, winning in both Argentina and his native Brazil. The first win was by no means easy, since Regazzoni and Cevert both led the race before having problems. Then McLaren introduced the sleek and modern-looking M23 in the South African Grand Prix, which would ultimately have a lifetime of six seasons. Hulme put it on pole, but fell to fifth as Stewart bounced back from a heavy crash in practice to score a fine

win. Mike Hailwood became a hero in the race as he rescued an unconscious Regazzoni from his burning car after a massed accident on the third lap.

Fittipaldi scored a third win in Spain, and then Stewart added a second to his tally in Belgium, where the track broke up and many cars skated off. Jackie won again in Monaco, to make it three each, in a race that saw the debut of British driver James Hunt in a March run by flamboyant aristocrat Lord Hesketh.

For the first time Sweden hosted a race at Anderstorp and, although local hero Peterson was on pole, Hulme gave the M23 its first victory. Ronnie gained his revenge in France, finally scoring his first win after suffering appalling luck in the early races. It did not help him much at Silverstone, where the race was stopped after a multi-car pile-up was triggered by

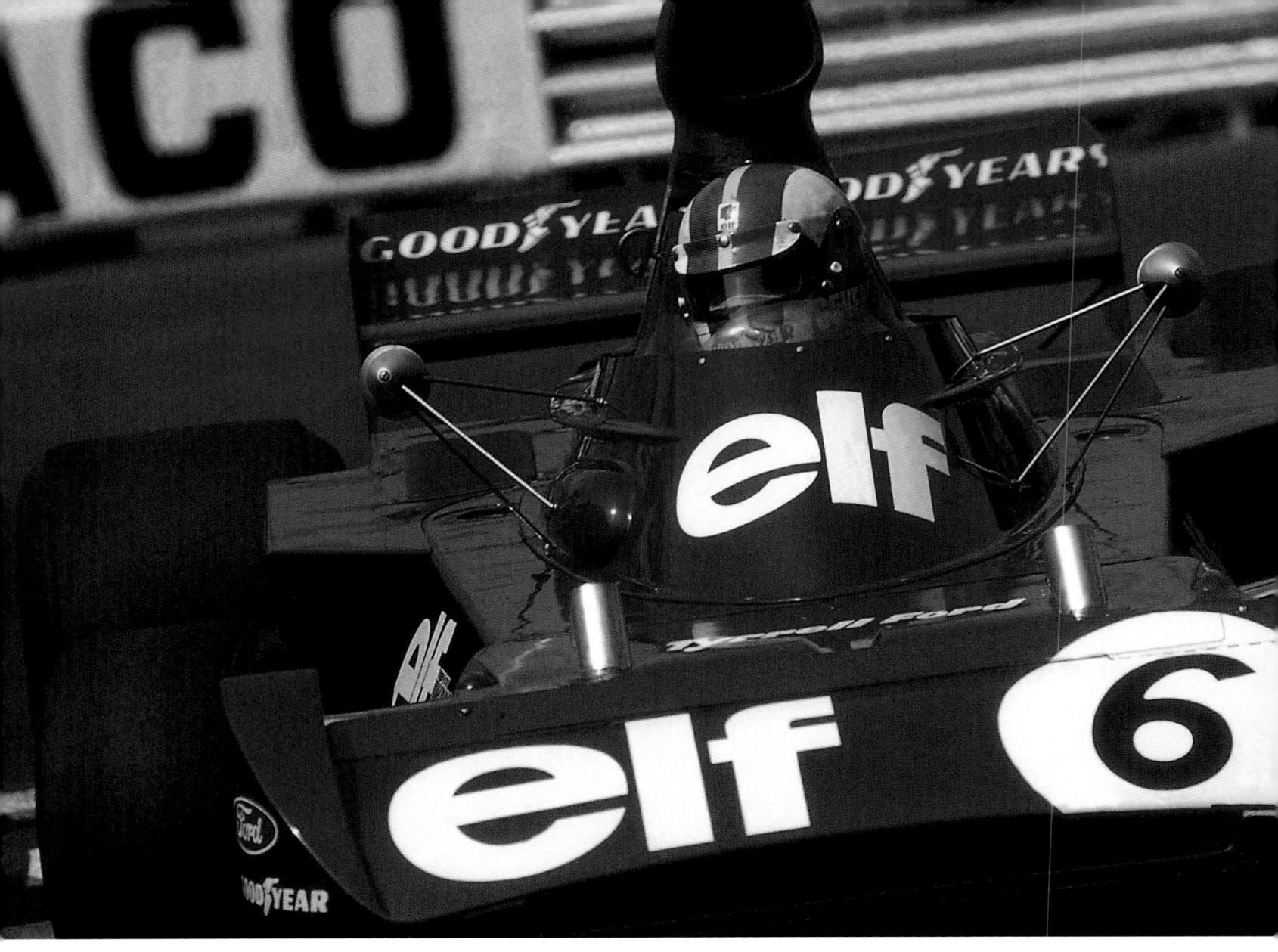

ABOVE LOST TALENT: FRANÇOIS CEVERT FINISHED SECOND ALMOST EVERYWHERE, THEN WAS KILLED AT WATKINS GLEN.

McLaren's third driver Jody Scheckter at the end of the first lap. Revson won the restarted race after Stewart spun out, with Peterson second home.

DUTCH DISASTER

Tragedy returned to the scene at Zandvoort, when Roger Williamson – in only his second race – was killed in a fiery crash. Stewart and Cevert scored a onetwo, a feat they repeated in Germany.

In Austria, Peterson waved Fittipaldi through, but won anyway when Emerson retired. Then at Monza Peterson and Fittipaldi finished one-two, but the title went to Stewart who, after an early stop, charged through the field from 20th to an amazing fourth place.

Revson won the rain-hit Canadian race, which saw the first use of a pace car in Formula One, but there was general confusion as the pace car had come out

ahead of Howden Ganley's Iso Williams which certainly wasn't in the lead.

The circus then moved to Watkins Glen for the US Grand Prix at which Stewart planned to have his 100th and last Grand Prix. But Cevert was killed in practice and Tyrrell withdrew. It was a bitter end to a fantastic farewell season for Stewart. In the race, Peterson picked up a fourth win, but he was pushed hard by the fast-improving Hunt.

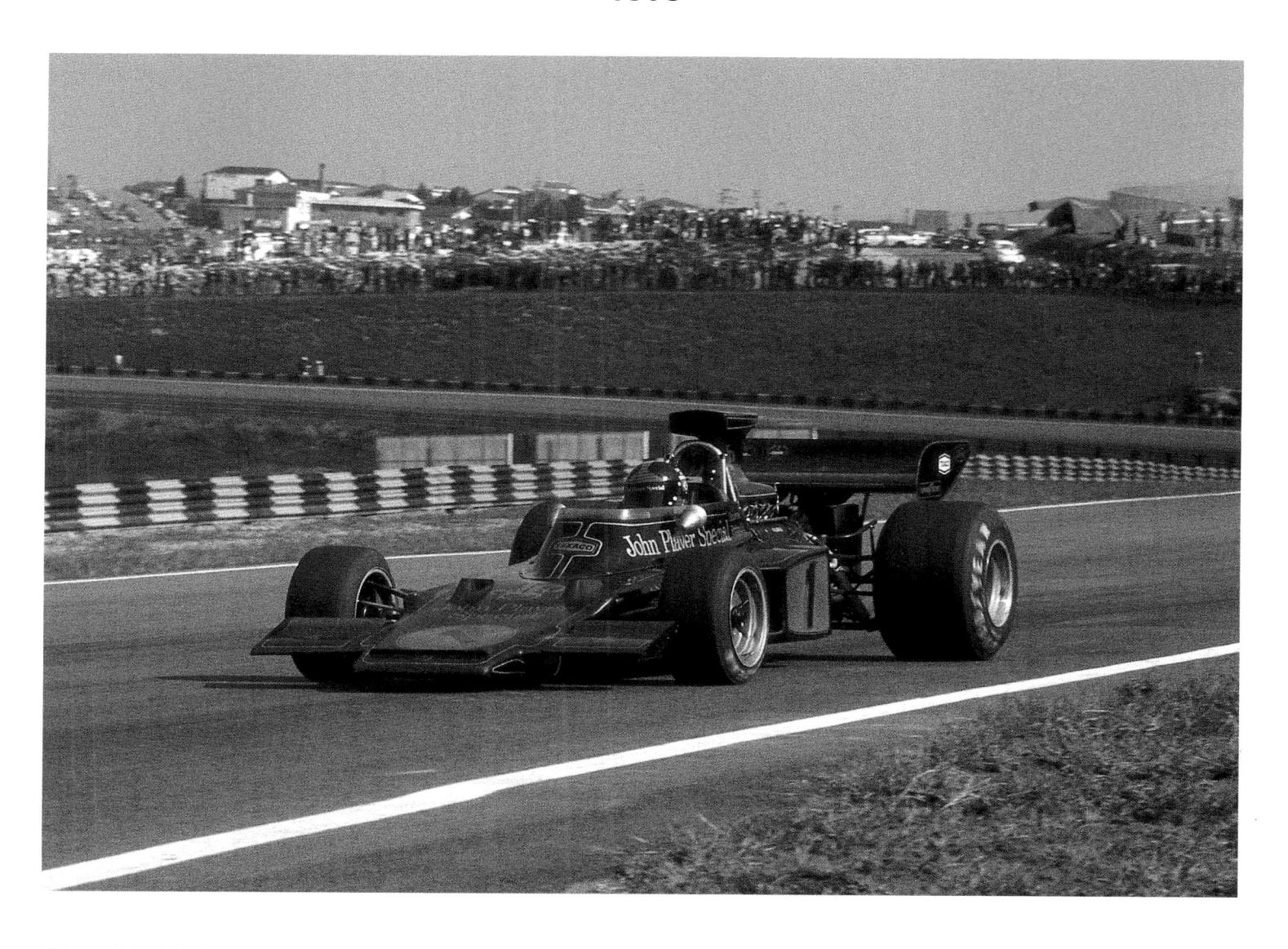

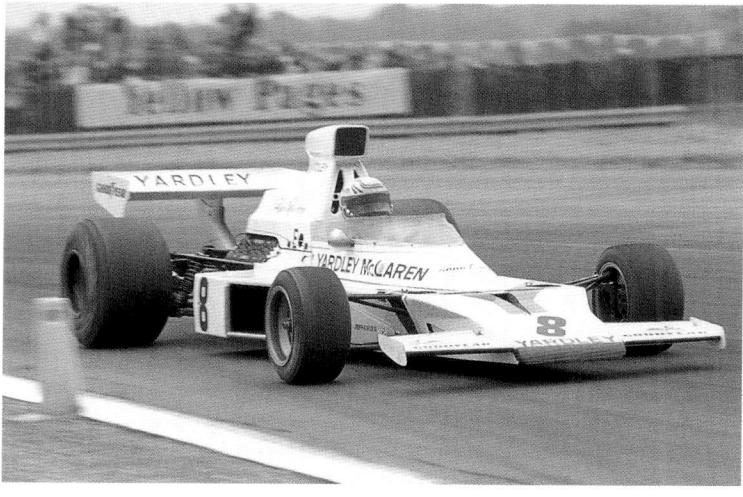

ABOVE FLYING START: FITTIPALDI
STARTED HIS TITLE DEFENCE BY
WINNING IN ARGENTINA AND ON
HOME GROUND IN BRAZIL (ABOVE).

LEFT AMERICAN ACE: PETER REVSON WON THE BRITISH GRAND PRIX.

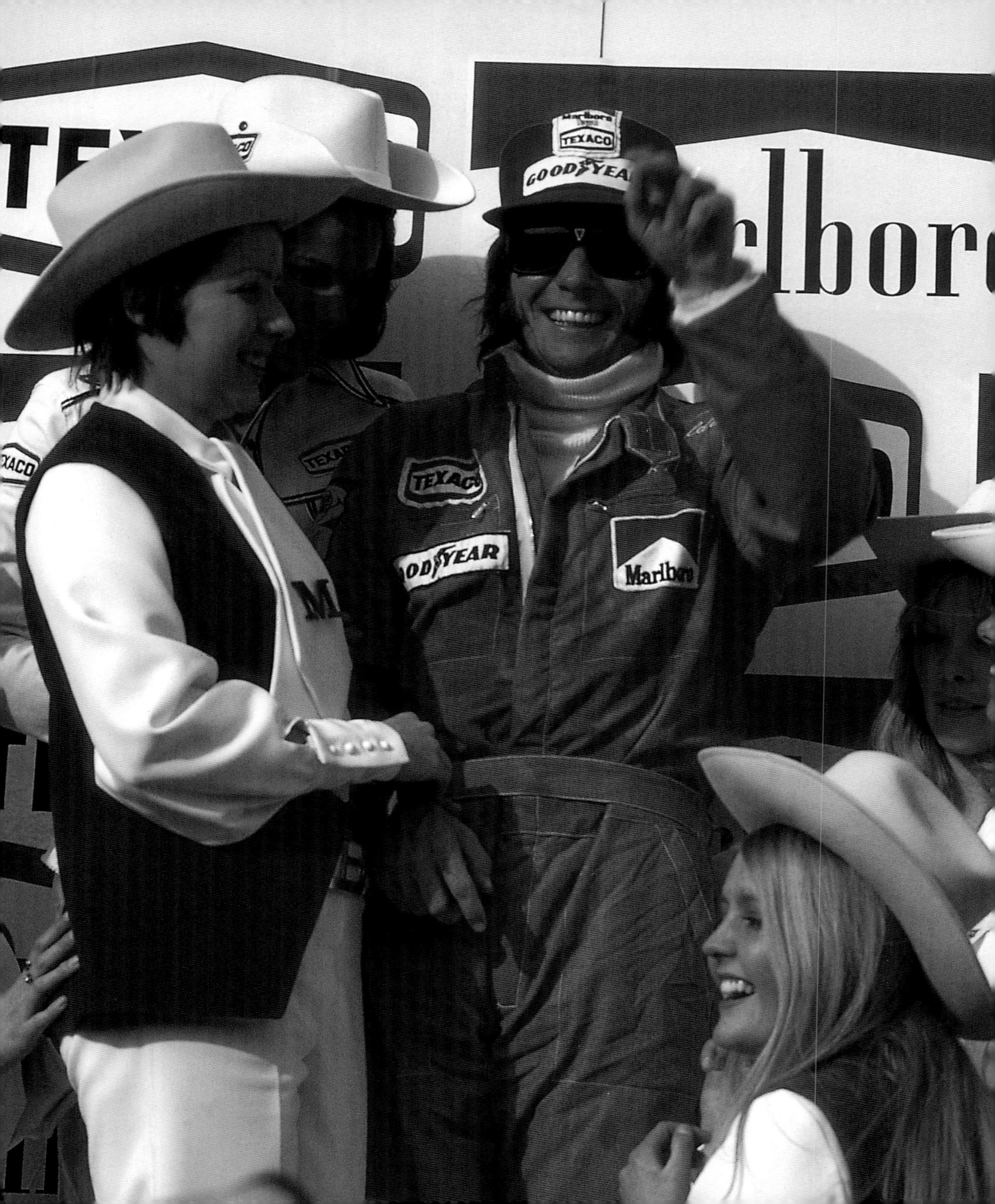

"EMMO" AT THE LAST

he 1974 season saw one of the closest Formula One World Championships in years, and in a highly dramatic finale Emerson Fittipaldi landed his second world title – and the first for the McLaren marque.

The winter of 1973–74 had been one of the busiest in memory, and the major news was that Fittipaldi had quit Lotus to join McLaren, along with substantial new backing from Texaco and Marlboro. Denny Hulme stayed on as his team-mate, while a third car – this in Yardley colours – was entered for Mike Hailwood.

Jacky lckx left Ferrari to join Ronnie Peterson at Lotus, filling the seat left vacant by Fittipaldi, while Ken Tyrrell found himself needing two new drivers. He hired South African hot-shot Jody Scheckter from McLaren and French newcomer Patrick Depailler. Peter Revson also left McLaren, joining French youngster Jean-Pierre Jarier at Shadow.

Graham Hill's team swapped from Shadow to Lola chassis, while Hesketh built its own car for James Hunt. BRM had new French sponsors in Motul, and Jean-Pierre Beltoise led a squad of three French drivers. Chris Amon's career took another dive when he tried to run his own team with his own car.

ALL CHANGE AT FERRARI

Perhaps the biggest shake-up was at Ferrari, though, where personnel changed and a totally new car was produced. Clay Regazzoni rejoined the Italian team after a year at BRM, and brought with him Niki Lauda who had shown some promise but was not particularly highly thought of. All that was to change once the races got underway.

From the start, the revised Ferrari line-up was competitive. Hulme won the first race in Argentina, but Regazzoni qualified on the front row and Lauda took second in the race. However, the real hero was Carlos Reutemann, who led in the neat new Brabham BT44.

Peterson and Fittipaldi duelled for the lead in the Brazilian Grand Prix until the Swede punctured, leaving Fittipaldi to score McLaren's second win. Reutemann led that race too, and finally came good by winning the South African Grand Prix at Kyalami – Brabham's first success for precisely four years. Sadly, in pre-race testing Revson was killed when he crashed his Shadow, the talented American having emerged as a frontrunner the previous season.

At the Spanish Grand Prix at Jarama, Ferrari's promise produced dividends

when Lauda won. Peterson led briefly in the wet in Chapman's new 76, but the car was generally uncompetitive and Lotus soon switched back to the faithful 72. Fittipaldi scored a second win in the Belgian Grand Prix at Nivelles, and then Peterson triumphed at Monaco. Two weeks later, Tyrrell new boys Scheckter and Depailler scored a one-two in Sweden; it was that sort of season, with no one taking a clear lead.

Lauda and Regazzoni finished behind Peterson in the French Grand Prix at the new Dijon-Prenois track, and then Scheckter took his second win at Brands Hatch. Lauda led until puncturing near the end, and his exit from the pitlane was controversially blocked by hangerson and an official car; he was eventually

awarded fifth place.

In the German Grand Prix at the Nurburgring, Lauda threw it away on the opening lap, leaving Regazzoni to save face for Ferrari. Reutemann won at the Osterreichring, and then Peterson was on top at Monza when the Ferraris failed. Still no one emerged as a likely World Champion.

FITTIPALDI GETS SERIOUS

Fittipaldi staked his claim in the penultimate race at Mosport Park, winning the Canadian Grand Prix ahead of Regazzoni. Amazingly, they went into the final race on equal points, while Scheckter was also in with a shout. In the end a fourth place at Watkins Glen was enough for Fittipaldi to take the honours, with nei-

ther of his rivals scoring. McLaren also beat Ferrari to the constructors' title. Unfortunately the race was marred by the death of Austrian rookie Helmuth Koinigg, who crashed his works Surtees early on.

The North American events saw the debut of two intriguing new marques from the USA, which had long been without representation in Formula One. Both Penske and Parnelli had ambitious plans to compete in Europe and, in Mark Donohue and Mario Andretti, each had a driver who could do the job.

The end of the year marked the retirement of Hulme, just a year after Stewart departed the scene, leaving Hill and Fittipaldi as the only World Champions still competing.

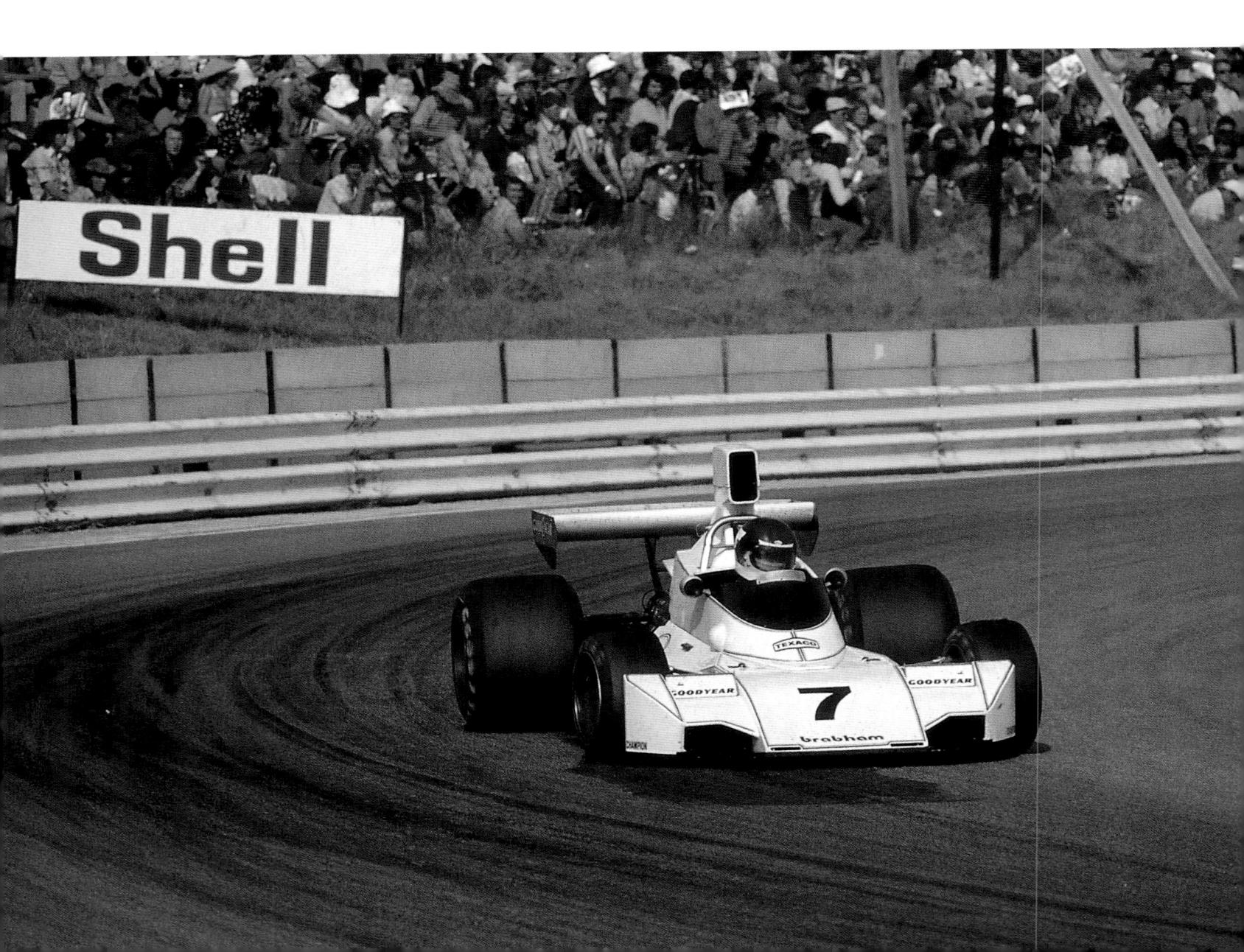

1974

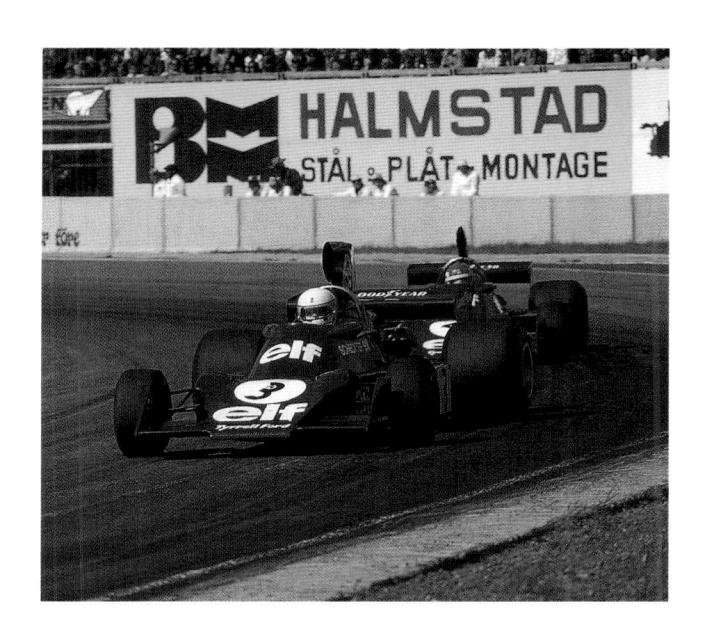

LEFT TYRRELL TWINS: SCHECKTER
HEADS DEPAILLER TO A ONE-TWO IN
SWEDEN.

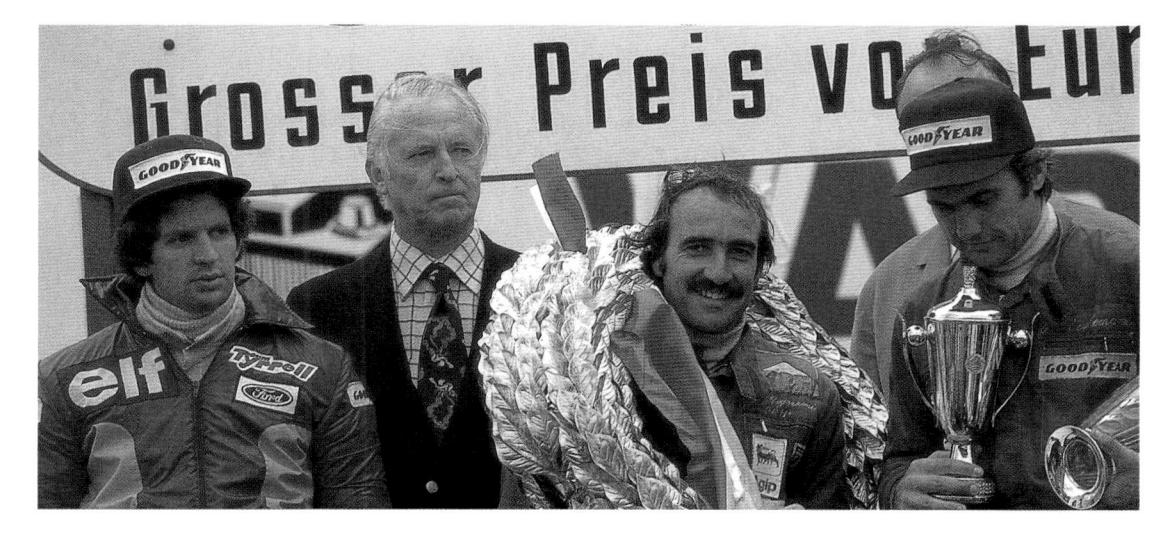

ABOVE THREE DRIVERS, ONE SMILE: CLAY REGAZZONI IS THE HAPPY ONE AFTER BEATING SCHECKTER (LEFT) AND PETERSON AT THE NURBURGRING.

LEFT MAKING BRABHAM SMILE: CARLOS REUTEMANN SCORED HIS MAIDEN WIN AT KYALAMI AND BRABHAM'S FIRST SUCCESS FOR FOUR YEARS.

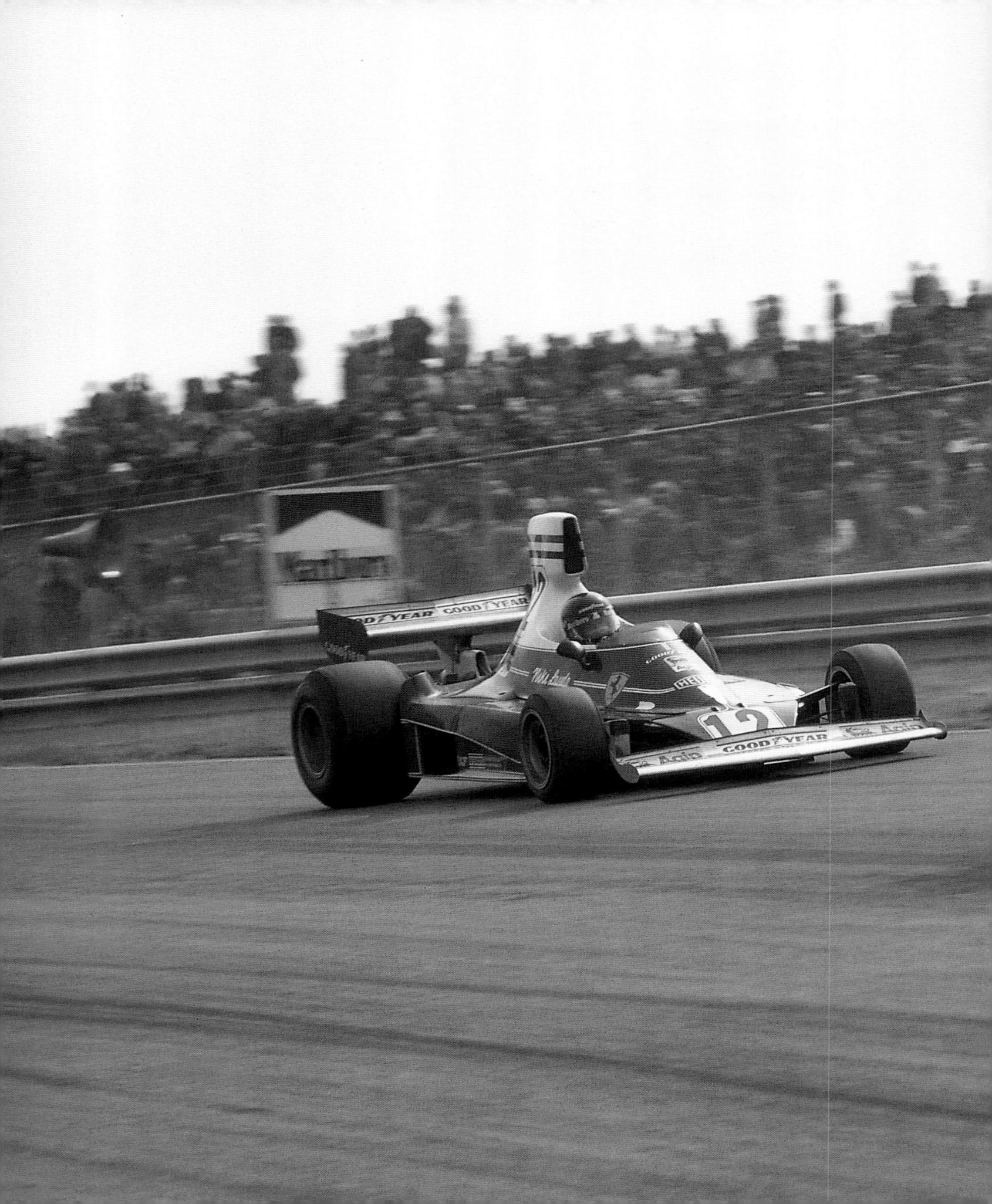

LAUDA SHADOW FITTIPALDI FERRARI PACE MCLAREN

A FRESH FACE

iki Lauda dominated the 1975 World Championship. Amazing to record, it was Ferrari's first title since John Surtees had taken the world crown 11 years earlier. Sadly, Graham Hill's death in a plane crash brought the year to a tragic close.

The close-season saw few changes apart from McLaren streamlining its operation to just one two-car team for Emerson Fittipaldi and Jochen Mass, while Graham Hill's Embassy Racing team switced from Lola chassis to its own Hill chassis. Then, following the first two races, Hill announced his retirement after a then record breaking 176 starts.

Jean-Pierre Jarier stunned everyone by giving Shadow its first pole position in the Argentinian Grand Prix, but then non-started when the transmission broke on the warm-up lap, leaving Fittipaldi to win for McLaren ahead of James Hunt's Hesketh after the Englishman surrendered the lead by sliding wide when under pressure.

Jean-Pierre Jarier was again on pole in Brazil, and duly led for 28 laps before retiring when his fuel metering unit failed. And this left Brabham's Carlos Pace to score a popular first win in his home race ahead of local hero Fittipaldi. Pace and Brabham team-mate Carlos Reutemann then shared the front row in South Africa, but Jody Scheckter came through to score a home win for Tyrrell.

DISASTER AT MONTJUICH

The Ferraris were the pacesetters at the Spanish Grand Prix, with Niki Lauda and Clay Regazzoni on the front row. But the event was beset by a dispute over safety standards at Barcelona's Montjuich Park.

Eventually a boycott was avoided, but the race turned to chaos. Half the field crashed in the first half of the race, including the Ferraris. And this left Rolf Stommelen leading, but his rear wing broke and his Hill vaulted over the barriers to kill several onlookers. The race was stopped with Mass leading, and half points were awarded.

In a wet race at Monaco, Lauda and the Ferrari 312T came good, winning from Fittipaldi. Lauda followed that with wins at Zolder and Anderstorp, then the Dutch Grand Prix at Zandvoort brought a first win for Hunt and Hesketh. Neither were taken seriously when they started in 1973, but James had developed into a top-rank driver, and in Holland beat Lauda in a dramatic wet/dry fight. The result was reversed in France when Lauda won at Paul Ricard.

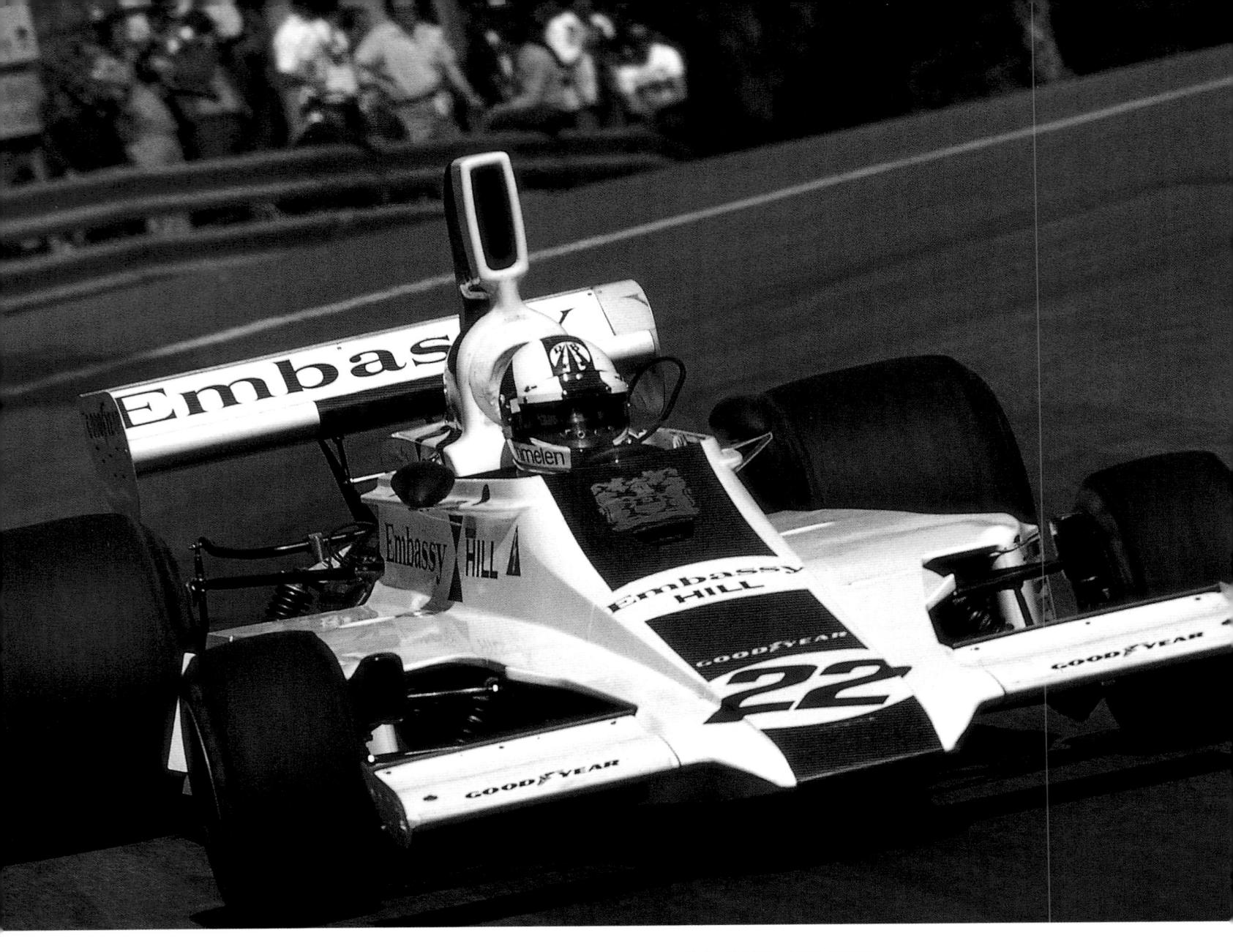

ABOVE SURPRISE LEADER: ROLF STOMMELN WAS IN CHARGE IN THE SPANISH GRAND PRIX, UNTIL...

SLIP SLIDING IN THE RAIN

The rain returned at Silverstone, causing 15 cars to crash out. Shadow's Tom Pryce stunned everyone with pole and he, Pace, Regazzoni, Jarier and Hunt all took turns in the lead. When a sudden rash of crashes finally forced a red flag, Fittipaldi was ahead. Surprisingly, it was to be his last ever Formula One win.

In Germany, Reutemann survived as most of the front runners had punctures, and then in Austria rain and confusion

struck once more. The popular Vittorio Brambilla was ahead when the race was curtailed to give the works March team its first win – and the first for any March since the 1970 season. Tragically, however, American driver Mark Donohue crashed his Penske-entered March in the warm-up and subsequently succumbed to head injuries.

Lauda had been quietly racking up the points, and clinched his first title with third place at Monza, as team-mate Regazzoni won. Just the US Grand Prix remained, and Lauda added yet another win. Lotus had its worst season to date, Peterson and lckx wasting their time with the ancient 72.

November brought a further tragedy which shocked the racing world. On the way back from a test session at Paul Ricard, Hill crashed his light plane. The double world champion, his protege Tony Brise and several team members were killed.

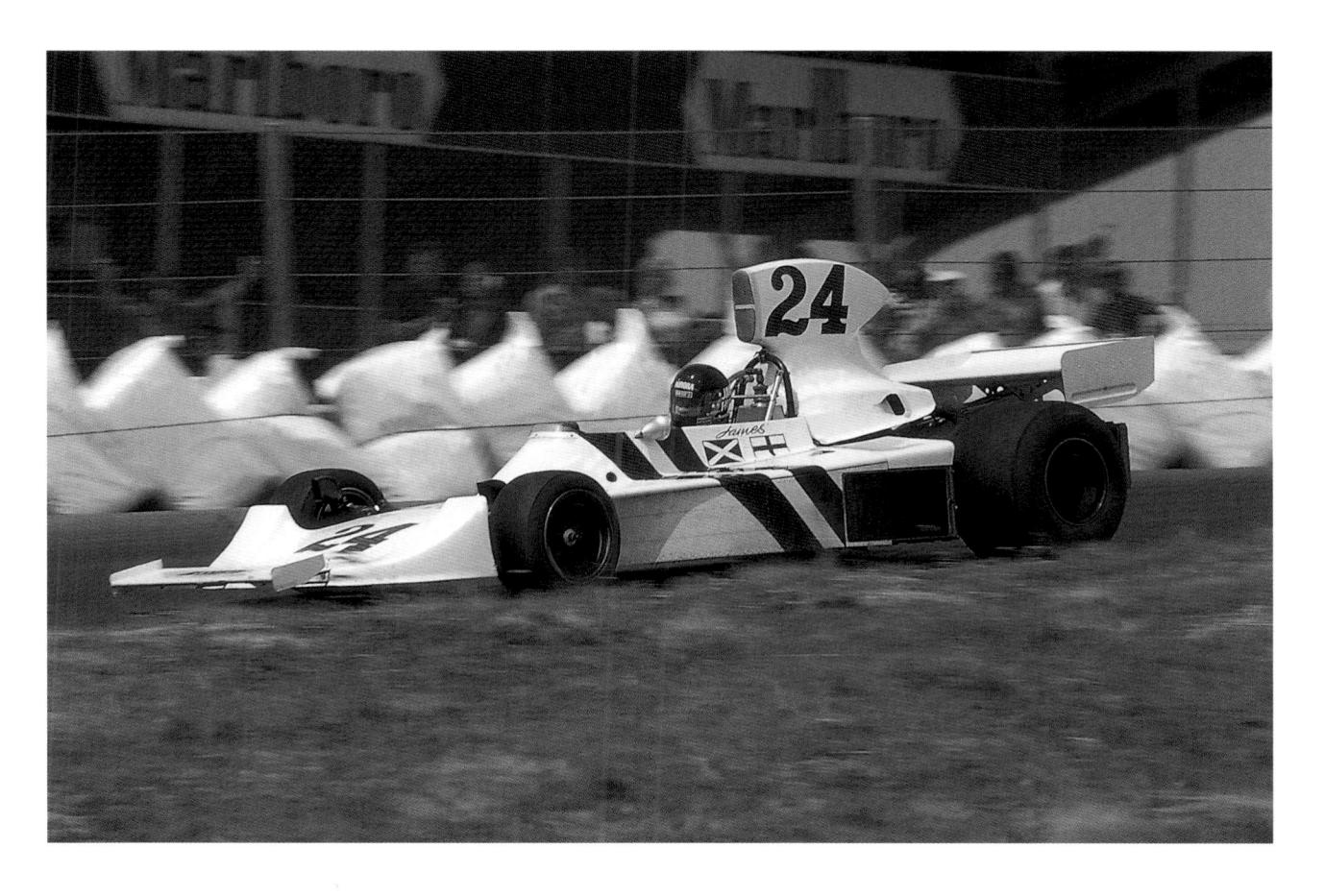

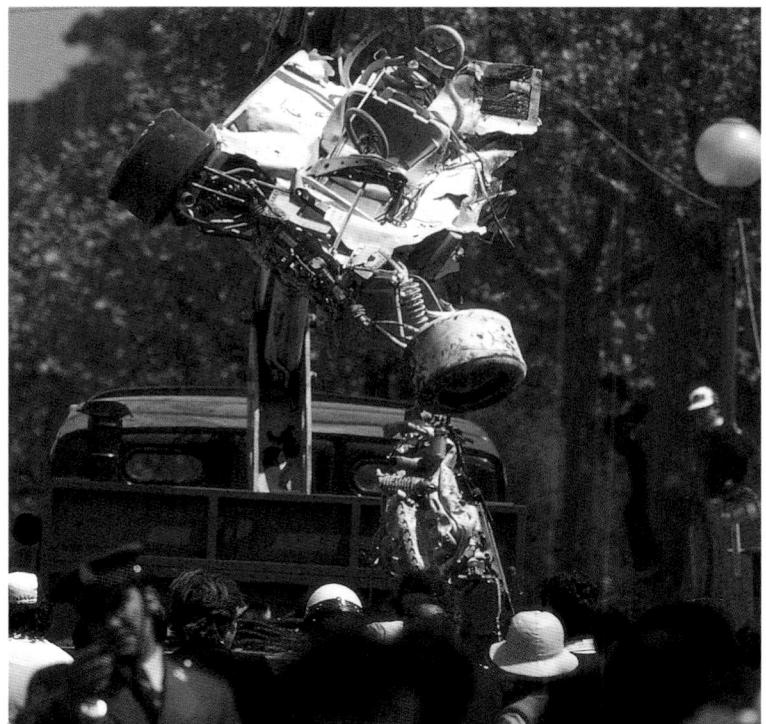

ABOVE BRITISH BREAKTHROUGH:

JAMES HUNT GUIDES THE PATRIOTICALLY LIVERIED HESKETH TO ITS ONE
AND ONLY WIN IN HOLLAND.

LEFT DISASTER: THE WRECK OF
STOMMELN'S HILL IS WINCHED BACK
OVER THE BARRIERS IN BARCELONA'S
MONTJUICH PARK.

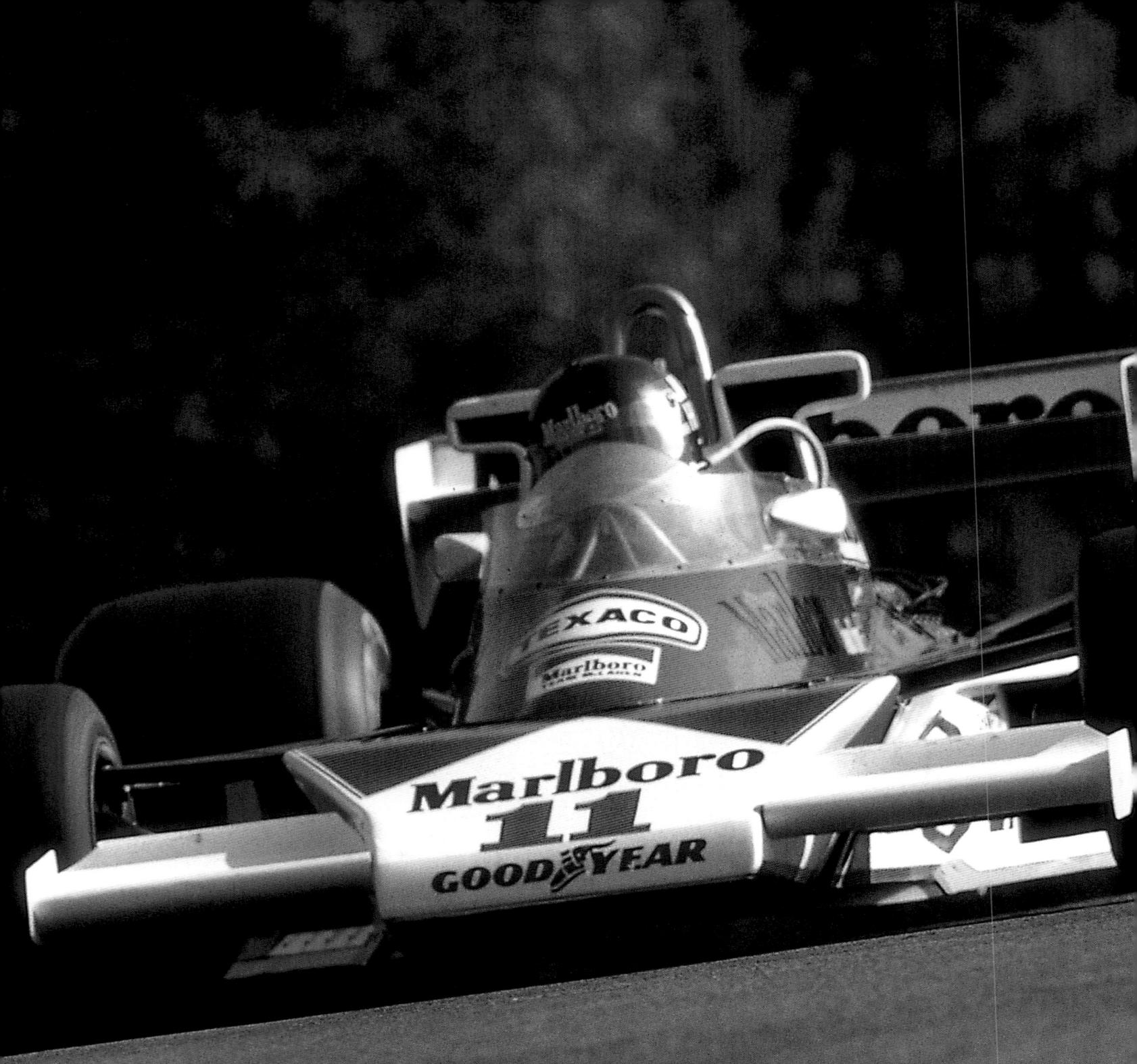

RAGAZZONI MCLAREN DEPAILLER PARNELLI & LOTUS

RIGHT TO THE END

his season will go down as one of the most dramatic in the long history of Formula One. Reigning champion Niki Lauda survived a terrible accident in Germany and was quickly back in harness, but James Hunt pipped him to the title by a point in the Japanese finale.

As in 1974, Emerson Fittipaldi was at the centre of the news over the close-season for, after two years, he decided to quit McLaren and join his brother Wilson's team, Copersucar. McLaren was left stranded without a number one driver, but the timing was perfect for Lord Hesketh had decided to pull the plug on his very competitive team, and Hunt was unemployed. Understandably, it did not take long for him to join McLaren. Ferrari, Shadow, Brabham and Tyrrell continued as before, but there were a couple of nov-

elties on the car front.

Brabham secured Alfa Romeo engines, while Tyrrell stunned everyone by announcing a six-wheeled car, the P34, with four small wheels at the front and two large ones at the rear. There was confusion at Lotus as Chapman had designed a new car, the 77, but Jacky. Ickx left for the Wolf-Williams team and Ronnie Peterson was joined at the first race by Mario Andretti, a Lotus driver back in 1968–69. Neither was certain to stay, though, and matters were not helped when they collided in the first race in Brazil.

Once again Shadow's Jean-Pierre Jarier shone in Interlagos, while Hunt repaid McLaren's faith with pole. But Lauda started, as he had finished the previous season, with a win. Hunt was on pole for the South African Grand Prix,

but again Lauda won, while Peterson had quit Lotus to rejoin March. An exciting addition to the calendar came next, this being a street race at Long Beach in California, dubbed the US Grand Prix West. And Ferrari's Clay Regazzoni led the whole way.

HOME TO EUROPE

The European season began at Jarama, and all the cars looked different since new rules banned their tall airboxes, with the race also seeing the debut of Tyrrell's six-wheeler. Hunt beat Lauda, but was disqualified when his car was found to be fractionally too wide. Lauda won in Belgium and Monaco, and at neither race did Hunt score. Sweden saw a fabulous one-two for the six-wheelers, Scheckter heading home Depailler. Hunt's luck turned at the French Grand Prix at Paul

Ricard when the Ferraris broke and he won easily. The same week he was reinstated as Spanish winner, but at the British Grand Prix at Brands Hatch fortune did not favour him. Lauda and Regazzoni collided at the first corner, Hunt became involved and the race was stopped. He won the restart in brilliant style, but was disqualified because he had not been running at the time of the red flag, giving Lauda another win.

LAUDA'S LUCKY ESCAPE

Disaster struck in the German Grand Prix when Lauda crashed heavily and was badly burned. Hunt won the race, but the world waited for news on Lauda. Somehow he pulled through and began a remarkable recovery. Unbelievably, Lauda was back in Monza, where Peterson won for March and Niki finished fourth. Hunt scored nothing, but struck back with wins at Mosport Park and

Watkins Glen. That put him to within three points of Lauda as the circus moved to Fuji for the first Japanese Grand Prix. The weather was atrocious, and Lauda immediately pulled out as he considered the conditions too dangerous for racing safely. In a thrilling chase, Hunt came storming back from a tyre stop to take the third place he required for the crown as Andretti made Lotus smile again in winning by a full lap.

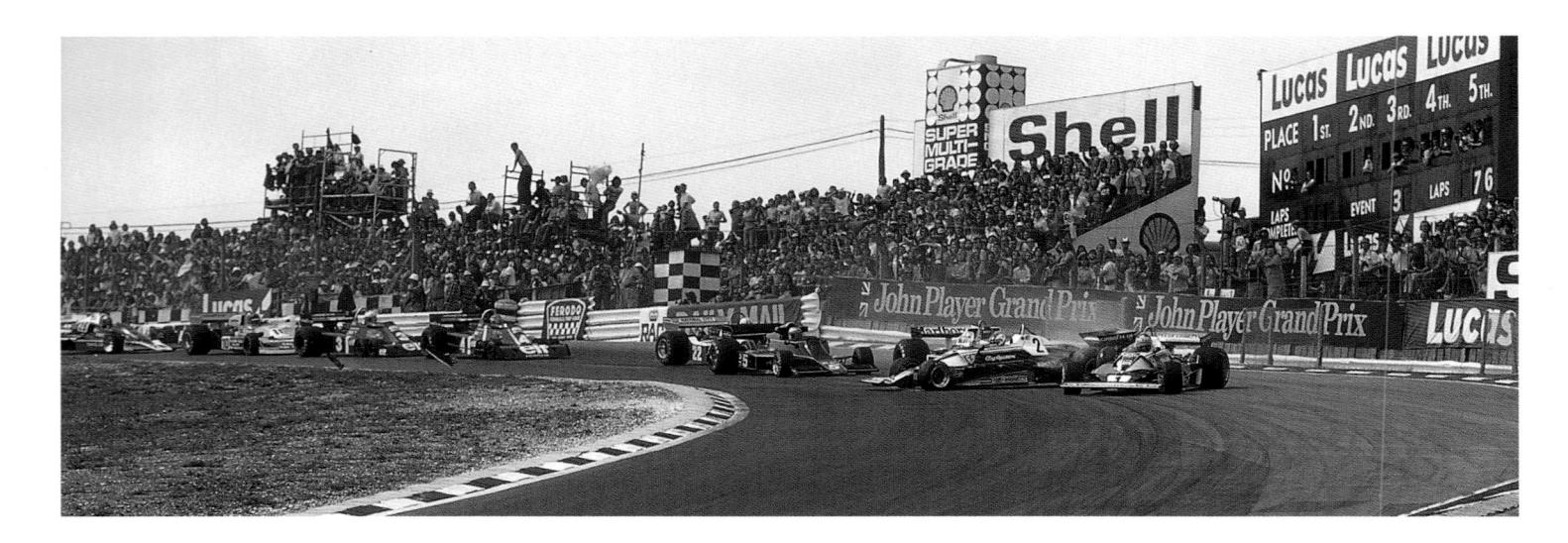

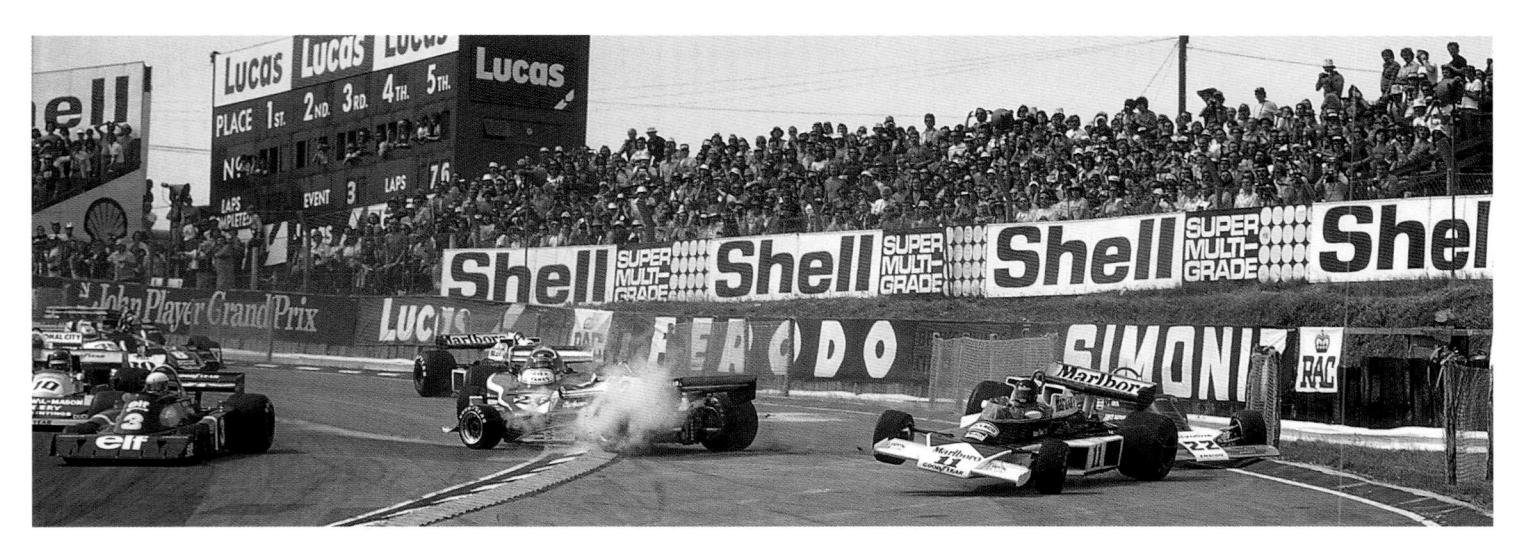

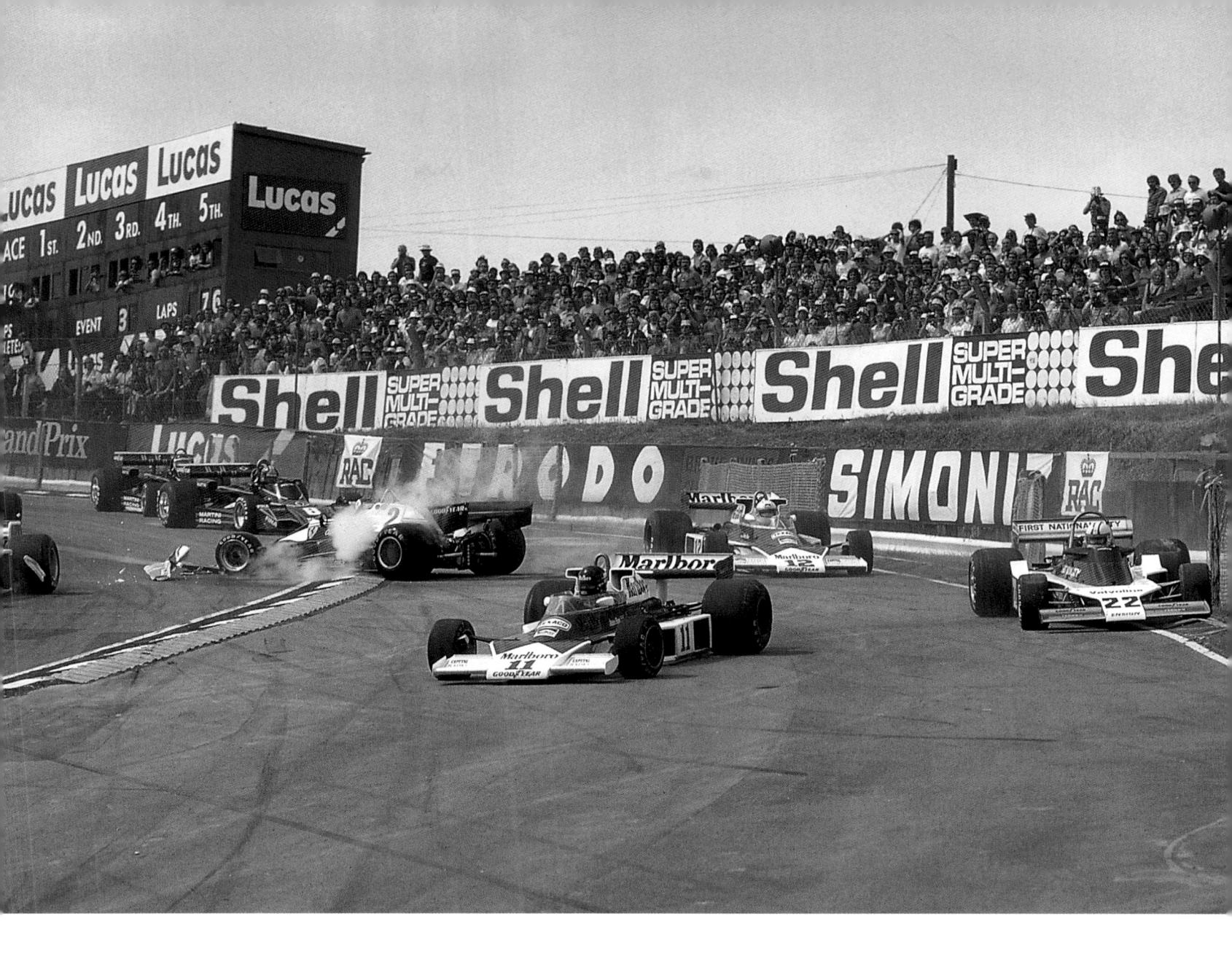

TOP LEFT START OF THE END: FERRARI TEAM-MATES REGAZZONI AND LAUDA (1) CLASH AT PADDOCK HILL BEND...

BOTTOM LEFT ... AND ALL HELL LETS LOOSE:
HUNT IS FLIPPED OFF THE GROUND AS
SCHECKTER (3) DUCKS INSIDE...

ABOVE ... THE DUST SETTLES: HUNT LANDS AGAIN AS AMON AND MASS CREEP BY REGAZZONI'S FERRARI

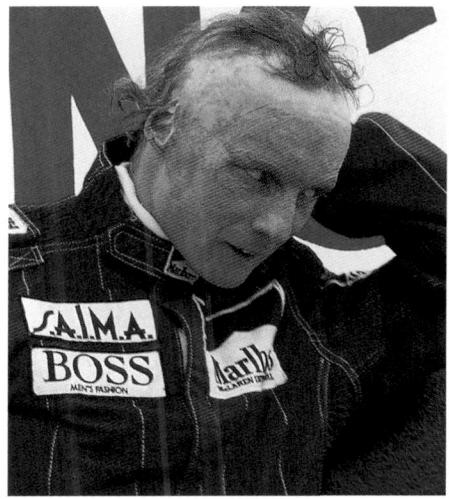

LEFT NIKI LAUDA SHOWED HUGE BRAVERY IN COMING BACK SO SOON AFTER BEING BURNT.

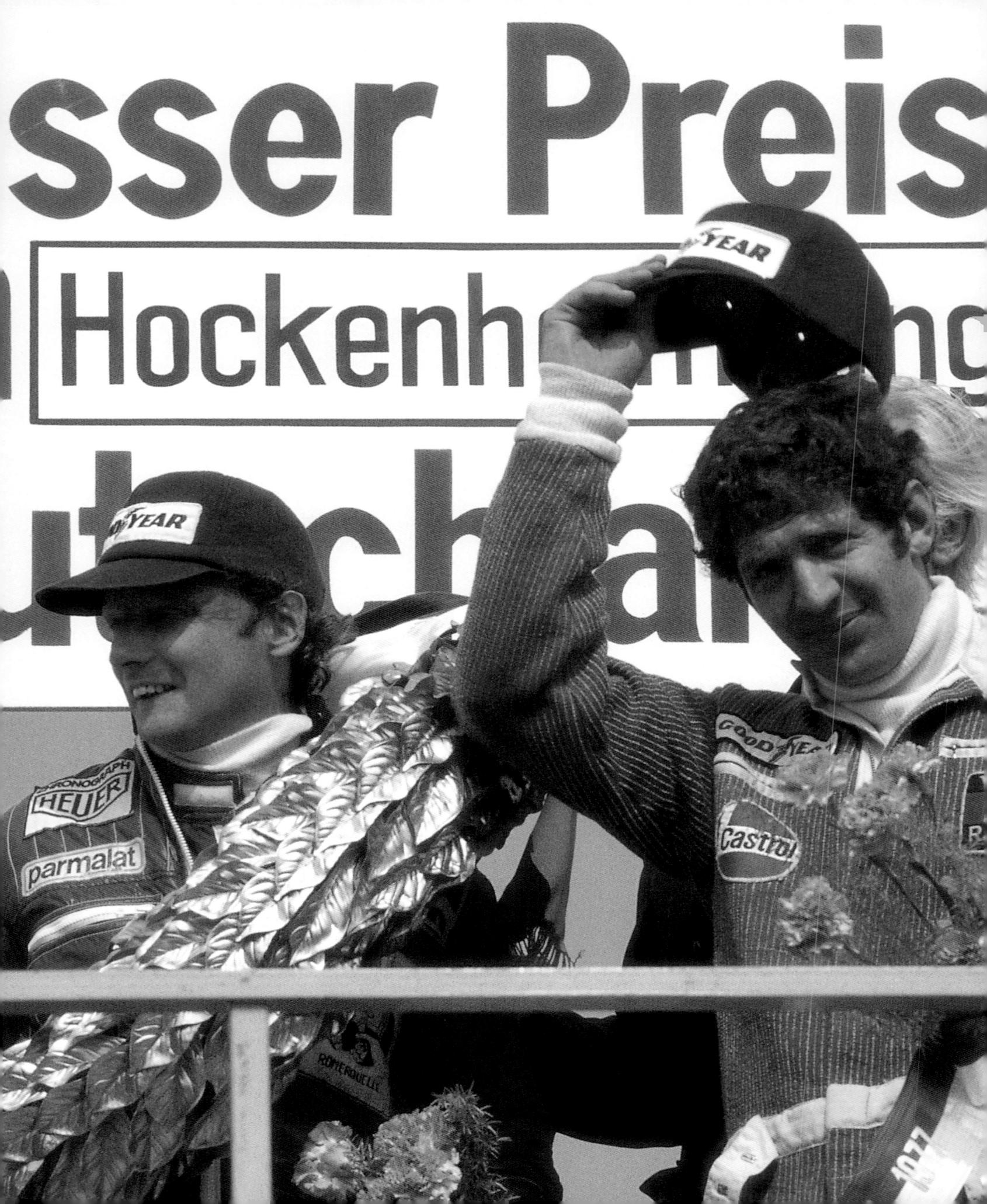
HUNT FERRARI REUTEMANN SHADOW ANDRETTI LIGIER

LIKE A PHOENIX...

iki Lauda was most not the fastest driver, but he was consistent and his Ferrari proved to be extremely reliable. He succeeded in beating off strong challenges from Andretti, Hunt and Scheckter to win his second world title.

After three years with Tyrrell, Jody Scheckter quit the team to join an intriguing new team, Walter Wolf Racing, a team financed by Canadian oil millionaire Walter Wolf who had backed Williams in 1976. James Hunt and Jochen Mass stayed at McLaren to drive the new M26, the replacement for the ageing M23 and, even before the end of the 1976 season, Carlos Reutemann had left Brabham to join Ferrari, taking over from Clay Regazzoni. In addition, Ronnie Peterson replaced Scheckter at Tyrrell, and John Watson left the defunct Penske

team to replace Carlos Reutemann at Brabham.

INTRODUCING "GROUND-EFFECTS"

Lotus boss Colin Chapman had pulled off another surprise, providing Mario Andretti and new team-mate Gunnar Nilsson with the stunning 78, the first "ground-effects" car. The car had prominent sidepods with sliding skirts which produced masses of downforce.

The latest Brabham-Alfa proved quick, with Watson leading the Argentinian Grand Prix until it broke. Team-mate Carlos Pace and Hunt also led, but victory went to Scheckter and the new Wolf. Ferrari's Reutemann won in Brazil, and then at Kyalami Lauda scored his first success since his accident in the 1976 German Grand Prix. Sadly, the race was marred by the death of Tom Pryce who hit

a marshal who ran across the track just over a blind brow. Formula One's grief was magnified when Pace lost his life in a plane crash before the next race.

Scheckter led most of the way at Long Beach but, when he suffered a puncture, Andretti gave the Lotus 78 its first win. He quickly added a second win in the Spanish Grand Prix, this time ahead of Reutemann.

Scheckter took his second win of the season in Monaco, which marked the 100th win for Ford's Cosworth DFV. In the Belgian Grand Prix at Zolder there was a typically confusing wet race and it resulted in victory for Nilsson. Hunt had had no luck in his title defence, but he beat Watson in a splendid duel at Silverstone in a race that marked the debut of the first turbocharged engine to race in Formula One, with Jean-Pierre Jabouille at the wheel of Renault's RS01.

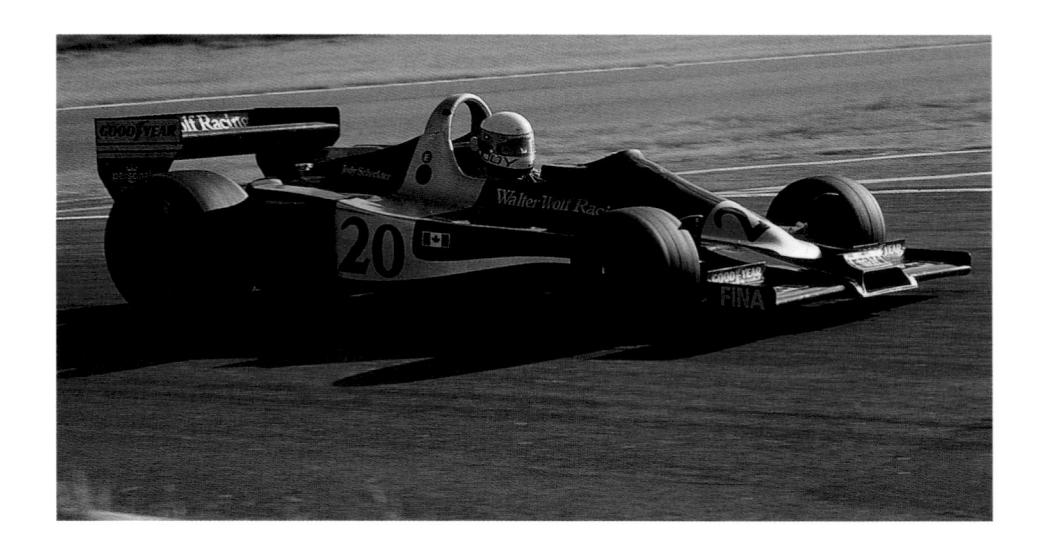

LEFT WOLF ON THE PROWL: JODY SCHECKTER WON FIRST TIME OUT ON THE WOLF TEAM'S DEBUT IN ARGENTINA.

BELOW V FOR VICTORY: SCHECKTER
CELEBRATES AFTER THAT MAIDEN WIN
IN BUENOS AIRES.

RIGHT CASTING NO SHADOW: ALAN
JONES'S MAIDEN WIN IN AUSTRIA
WAS ALSO THE FIRST FOR THE
ARROWS TEAM.

LAUDA MAKES IT TWO

Lauda scored Goodyear's 100th win in Hockenheim, and once again the Austrian Grand Prix produced an unusual result, Alan Jones giving Shadow its first win in another damp encounter.

The summer was notable for a spate of DFV failures, with Andretti having four in a row, while Hunt and Scheckter also suffered. Meanwhile, Lauda racked up points, scoring another win at Zandvoort.

Andretti's car held together to win in Monza. Then at a wet Watkins Glen Hunt won after Pace's Brabham replacement Hans-Joachim Stuck crashed from the lead, but Lauda's fourth place clinched the title. And, with that, he left Ferrari.

There were still two races left. Scheckter won in Canada, after Mass tipped team-mate Hunt off. But Hunt ended on a high note with a win in Japan. Tragically, the race was marred by the

deaths of two spectators after Ferrari new boy Gilles Villeneuve tangled with Peterson and flipped over the barrier.

Fittipaldi had another bad season with his own car, although he occasionally broke into the top six, while Peterson and Patrick Depailler struggled with the latest six-wheeler before Tyrrell ditched the concept. In contrast, Regazzoni did great things with the little Ensign team, picking up a few points along the way.

lsi

oline

SWISS CIGARD

GOODFTEAR

LOTUS CONTROLS ALL

ario Andretti won the World Championship title after a brilliant run with Chapman's outstanding Lotus 79. But it was a year of mixed feelings, as teammate Ronnie Peterson died from injuries received in the Italian Grand Prix.

Nobody seemed to cotton on to the secrets of the Lotus 78, and rivals were in for a shock when Colin Chapman introduced its successor, the beautiful 79. Chapman had a new second driver, too, with Peterson back at Lotus for the first time since the start of 1976. Meanwhile, the outgoing Gunnar Nilsson joined Arrows, a team formed by a breakaway group from Shadow. Sadly, hit by cancer, he was unable to start the season, and was replaced by former Shadow driver Riccardo Patrese. Fellow former Shadow driver Alan Jones also linked up

with what was effectively a new team: Williams, as Frank Williams and partner Patrick Head produced their first car after fielding a March in 1977.

Didier Pironi joined Patrick Depailler in the four-wheeled Tyrrell 008, while Patrick Tambay replaced Jochen Mass at McLaren. Gilles Villeneuve landed a full-time seat at Ferrari, alongside Carlos Reutemann. The 312T3 proved to be a superb machine, and Ferrari switched to Michelin which had been introduced to Formula One by Renault in the hope of finding a performance advantage over their Goodyear-shod rivals.

LOTUS STARTS WINNING

Starting with the old 78, Andretti won in Argentina, with Lauda coming second just ahead of Depailler and Hunt. Then Reutemann won the Brazilian Grand Prix

for Ferrari, and Emerson Fittipaldi came good with second place in the 'family car'. The South African Grand Prix was a classic as Patrese led for Arrows, and the race culminated in a fabulous duel between Peterson and Depailler, the Swede just edging the Frenchman. Villeneuve starred at Long Beach, leading until he hit backmarker Regazzoni and allowed Reutemann to score.

Seemingly forever the bridesmaid after finishing second eight times, Depailler finally earned his first win by beating Lauda in the Monaco Grand Prix. Andretti debuted the Lotus 79 in the Belgian Grand Prix, and gave notice of his intentions by disappearing into the distance, with Peterson finishing second in the 78. They scored another one-two in the Spanish Grand Prix when Peterson had his first run in the 79.

By now the other teams were reacting to Lotus's lead. Scheckter had a proper ground-effects Wolf, and Brabham responded with the amazing 'fan car'. Lauda dominated in its only race at Anderstorp before it was pushed into a garage and never raced again as team owner Bernie Ecclestone respected calls that it was outside the spirit of the regulations and thus enjoyed an unfair performance advantage. Andretti and Peterson scored a one-two in France. At Brands Hatch they both retired, and Reutemann dived past Lauda to take his third win of the year.

TRAGEDY AT MONZA

Rain struck in Austria, and Peterson drove brilliantly to win the red-flagged race after Andretti crashed on the first lap. At Monza, only Peterson could now beat Andretti to the title, but he was happy to obey orders and support team leader Andretti's title bid. He had to take the start in the old 78, and became entangled in a massive pile-up. After a long delay the race was restarted. Andretti won from Villeneuve, but both were penalized for jumped starts, allowing Lauda to take the honours. Peterson died in hospital the following morning from complications to his injured legs it was a death which stunned the racing world.

Jean-Pierre Jarier replaced Peterson, and was the star of the last two races, although he and Andretti retired in both the US East and Canadian Grands Prix. Reutemann held off the improving Jones in Watkins Glen, while Villeneuve scored a popular win on a new track in Montreal.

There was more sadness when Nilsson succumbed to cancer 12 days after the Canadian Grand Prix. He was just 29 years old.

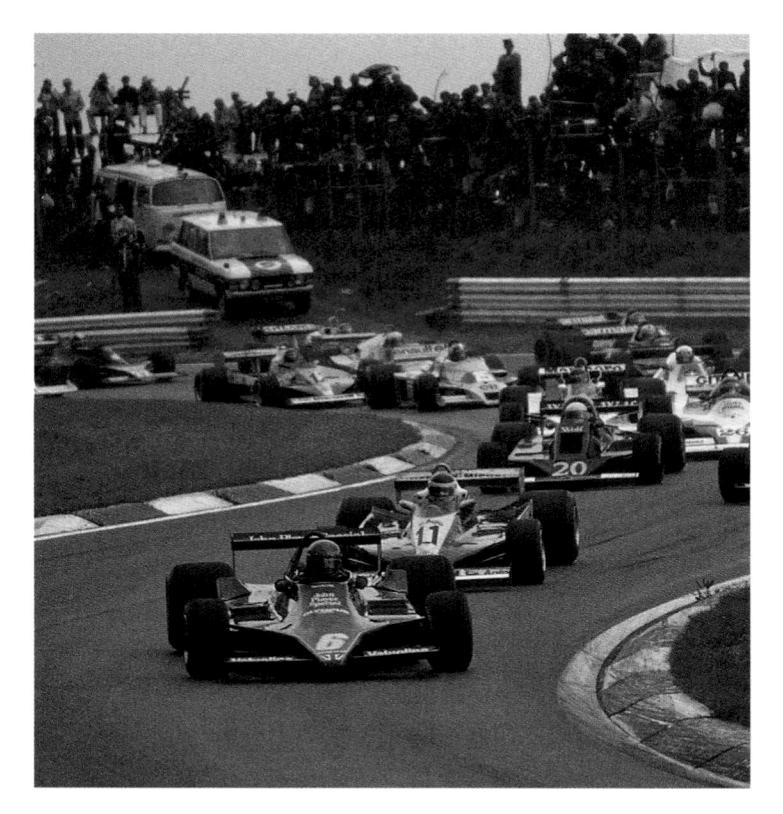

TOP FAN POWER: LAUDA PEDALS HIS BRABHAM "FAN CAR" AFTER ANDRET-TI'S LOTUS EN ROUTE TO VICTORY IN SWEDEN

ABOVE HIS FINAL WIN: PETERSON RACES
TO VICTORY IN AUSTRIA AHEAD OF
REUTEMANN AND THE PACK.

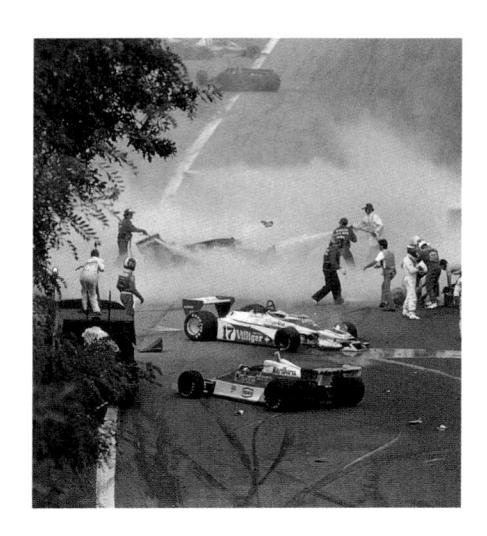

LEFT THE AFTERMATH: A MASSIVE PILE-UP AT MONZA INVOLVED HALF THE FIELD.

BELOW MEDICAL EMERGENCY: PETERSON IS TENDED TO AFTER BEING EXTRICATED FROM HIS LOTUS (6). NO-ONE THOUGHT IT WOULD BE FATAL.

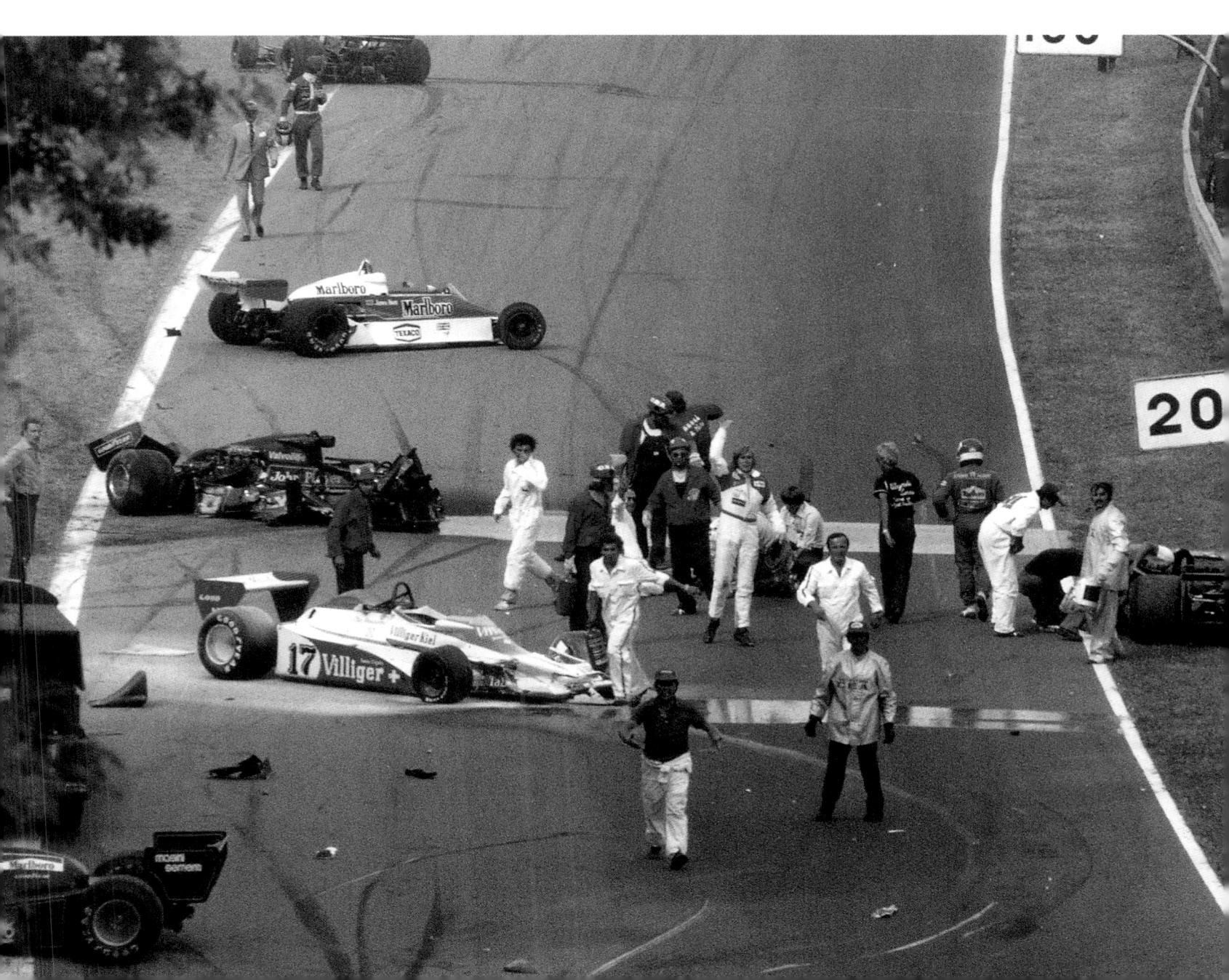

LOTUS LAFFITE FERRARI REGAZZONI RENAULT ARNOUX

FORZA FERRARI

round-effect cars took over the Formula One scene in 1979, although some of these worked better than others. In a very competitive season the reliability of the Ferraris put them in control and helped Jody Scheckter to scoop the title.

Things looked good at Lotus as Carlos Reutemann joined Mario Andretti, Martini replaced John Player Special as the team's title sponsor and team owner Colin Chapman still had the inside line on new technology. Or did he? The wingless Lotus 80 was supposed to be a leap forward, but it didn't work.

By way of contrast, Williams was spot-on with its FW07. It was not ready at the start of the season, though, so Alan Jones and new team-mate Clay Regazzoni started out in the FW06. Ferrari was also late introducing the

312T4, and while the Ferrari 312T4 didn't prove to be as a good a ground-effect car as its rivals, it was powerful and reliable and thus masked some of its shortcomings to the benefit of Scheckter who arrived from Wolf to join Gilles Villeneuve.

Meanwhile, after 18 months in the background, Renault expanded to a second entry for René Arnoux alongside Jean-Pierre Jabouille and built the very effective RS10.

LIGIER SPRINGS A SURPRISE

There was a major surprise when the little-fancied Ligier team started with a bang, and Jacques Laffite won the Argentinian and Brazilian Grands Prix with team-mate Patrick Depailler second in the latter. The new Ferrari arrived at Kyalami, and Villeneuve and Scheckter

finished first and second. Significantly, Jabouille's Renault took its first pole, but retired from the race. Villeneuve and Scheckter repeated the result at Long Beach, where they were chased by Jones. Ligier bounced back in Spain, sweeping the front row before Depailler led throughout. Lotus had a rare good day, with Reutemann and Andretti taking second and third.

The Belgian Grand Prix marked the debut of the Patrick Head-designed Williams FW07, and the goalposts suddenly moved, for Jones led easily until retiring, leaving victory to a grateful Scheckter who won again in Monaco, chased home by Regazzoni's FW07. After retiring in this race, James Hunt decided that he had had enough, leaving the Wolf team to sign fiery Finn Keke Rosberg to replace him, as he quit the sport.

RENAULT COMES GOOD

Renault's dreams came true when Jabouille gave the team its first win, fittingly in the French Grand Prix at Dijon-Prenois. And, in a thrilling finale, Villeneuve just edged Arnoux out of second after the pair banged wheels all the way around the last lap. Then luck went the way of Williams as Regazzoni gave the team a fabulous first victory at Silverstone, which was followed by wins for Jones at Hockenheim, the Osterreichring and Zandvoort. In Holland Villeneuve dragged his three-wheeled wreckage back to the pits after he had blown a tyre while leading, but the damage was too severe for him to rejoin.

Scheckter kept collecting points, though, and by winning at Monza he had amassed enough to claim the title with two races to go. Villeneuve, under orders, followed dutifully in his wheel tracks.

By Montreal, Brabham had abandoned the awful BT48 and replaced it with the neat DFV-powered BT49. It did not interest Lauda, though, and he announced that he was quitting. The race saw a fine battle between Jones and Villeneuve, which went the way of the Williams driver as he took his fourth win of the year. The pair fought again at a wet Watkins Glen finale, but Jones lost a wheel after a pit stop, and the gutsy little Canadian won thanks to another display of Ferrari reliability.

LEFT A FALSE DAWN: THE LIGIER PAIR
OF LAFITTE AND DEPAILLER CONTROL
THE ARGENTINIAN GRAND PRIX.

TIME IN

MULTelf Joh

rton Senna

An

THE EIGHTIES

THE EIGHTIES

NIGEL MANSELL

Honours: World Champion 1992

Grand Prix record: 187 STARTS, 31 WINS

No driver sums up the story of Formula One in the 1980s better than Nigel Mansell. For here was a man who experienced it all, from the highest high to the lowest low and, in doing so, brought Formula One a new following, especially in Britain.

"I was in Formula One for 15 years and in that time saw an incredible amount of change," explains Nigel. "If the 1990s is to be remembered, it will be for improvements in safety. The 1980s, though, will be remembered for massive changes in aerodynamics and transmission. Well, changes in every aspect really. Formula One took a major jump forward in the 1980s."

Nigel started in a small way with Lotus in 1980 after a promising but interrupted passage through the junior formulae, but came on strong and once with Williams hit a winning trail that seemed destined to make him Britain's first World Champion since James Hunt in 1976. Somehow, this didn't happen in the 1980s, with Nigel taking until 1992 to land his crown, but the experience he gained along the way offers an excellent insight.

"I'm very privileged that my career in Formula One spanned a spell that started with just over 400bhp and rose as high as 1400bhp in the turbo era," Nigel enthuses. "I also went from full ground effects to non-ground effects to flat bottoms, and from wide tyres to narrow tyres, so I sampled an enormous spread

of changes. And you must remember that ground effects were banned as drivers were blacking-out in fast corners. The drivers were going, otherwise, to have to start to wear g-force suits.

"My first Grand Prix – the Austrian in 1980 – is one that I'll never forget, because it was one of sheer excitement. Indeed, it was one of accomplishment, as with 10 minutes to go in qualifying I still hadn't qualified the third Lotus. Then to qualify with just one lap to go and only two or three minutes left was something very special as it could have gone each way. The race itself is one that left me with first and second degree burns on my legs and buttocks as I had been sitting in a bath of fuel all race until my engine expired. Afterwards, I remember being in hospital in Birmingham having my burns deroofed, so it was eventful.

"The competition was intense then and the learning curve a very steep one as almost all the cars on the grid had the same engine and we all had the same tyres, making it a more level playing field than it is now. Certainly, the car designs were different, but there was greater parity then. However, like now, it was

THE EIGHTIES

far better then to be a team's number one driver than the number two, and that was better than being the team's number three... However, like now, it came down to budgets."

Thanks to Lotus supremo Colin Chapman, Nigel not only raced in two more Grands Prix that year but signed up for a full campaign in 1981, his selection based on Nigel's talent alone as he had no budget to offer. Not a penny...

"When I look back at what I thought when I was trying to break into Formula One, it's amazing," Nigel muses. "I have no idea where I got the strength and direction, but I never thought that I wouldn't get in as others had money and I didn't. I simply thought that I couldn't compete on the money front and so I would have to get in through talent, dedication or sheer skill. I never thought I was in competition with them, as I pigeon-holed them in a different category. I had nothing on offer but just raw talent and that's why I got on so well with Colin Chapman."

So, his years of struggle were rewarded: "I think that in the 1970s it was far more difficult to rise to the top in motor racing than it is today. It was far more competitive as there was far less money around for racing. Sure, it was relatively less expensive, but there is more money around now because of a greater awareness of racing in Britain now since James Hunt, myself and Damon Hill became World Champion. Also, there are a lot more opportunities to make a career in racing, with so many other branches of the sport in which they can earn a living, such as Indycars and sportscars.

"You can always say that people today don't have to make the sacrifices we did, but I look at the positive side and the best have still got hunger. It doesn't matter what background they come from. Specialist writers talk of some drivers having natural talent and others not having it. But you have to have talent full stop to drive a Formula One car. Yes, people can say drivers have flair or are racers. I certainly was a racer and so was Ayrton (Senna), while others, including World Champions, were drivers rather than racers. But it sorts itself out at the pinnacle whether a driver has had an easy route to Formula One or not. The people who haven't got the dedication, haven't made the sacrifices and aren't prepared to put it on the line aren't going to achieve a lot."

On the podium at Zolder with third place at the fourth race of 1981, Nigel ended the season 14th overall, a feat he repeated the following year, both times classified behind team-mate Elio de Angelis. In 1983 Nigel pulled ahead of the Italian. But by then, Nigel had lost his mentor when Chapman died at the end of 1982. It was a loss that hit Nigel hard.

"I think of Colin every day," Nigel reminisces. "He did so much more for me than giving me my break in Formula One. He treated me as a son, taught me things as a father, consoled us when we had downs and helped us progress as human beings. For instance, the first year I drove for Lotus I couldn't afford for (my wife) Rosanne to give up work. When Colin found out how much we were struggling, he doubled my salary overnight then. It wasn't much, but it was enough to let Rosanne give up her job and come to the races. It was such a rewarding relationship that I reckon I would have won another couple of World Championships if Colin was still alive today, and I would have probably won my first World Championship a lot sooner."

However, world titles were still some way off as Nigel had yet

to score his first win. It looked on the cards at Monaco in 1984, but he skidded into the barriers in the wet when leading. Then a move to Williams in 1985 came good with two wins, with his breakthrough coming at Brands Hatch.

"My first win didn't change me, but it was simply such a relief," says Nigel. "It was so rewarding to drive for Frank (Williams) and Patrick (Head), and especially with Keke (Rosberg) as a former World Champion. He was the best team-mate I ever had. He was very honest."

And then the wins started flowing. Indeed, Nigel went into the 1986 finale at Adelaide with five wins under his belt and a sixpoint lead over McLaren's Alain Prost, with his own team-mate Nelson Piquet a further point behind. But then it all went wrong and he crashed out of the lead with a 180mph blow-out.

"The blow-out was not a favourite moment. I had a healthy advantage with 18 laps to go when it happened. With Nelson having hit tyre trouble, I asked to pit. But they told me to stay out and it blew..."

Six wins followed in 1987, but Nigel ended up second again, this time behind Piquet. Still, that was good next to what happened in 1988: "The 1988 season was a letdown as we lost an engine deal with Honda at the last minute when they went to McLaren and this left us with Judd engines. I finished only twice, but at least both times I finished I finished second."

And so it was time to change team, with Nigel moving on to Ferrari for 1989: "It was a sheer delight to drive for Ferrari," says Nigel, eyes bright at the memory. "Yes, there were a lot of politics, but I still have a great relationship with the team and a lot of respect for them. I would have been very disappointed if I'd never been able to drive for Ferrari. I have the accolade of winning my first race for them, a feat only one other driver achieved (Giancarlo Baghetti) and this means a lot to me as they have had some very special drivers drive for them. I hope that the team will land the success in 1999 they have been striving for for 20 years now. I certainly think things are much better at Ferrari than they were when I raced for them. Italians are very emotional people and in the past a lot of emotional decisions were taken that might have been for individuals but for the competitiveness of the team wasn't the correct thing to do. There's a better balance now."

After two years there, Nigel returned to Williams and ended up runner-up for the third time, this time finishing second behind McLaren's Senna. But then it all came good in 1992 and he raced away to win the first five races and then added four more before the season was out, wrapping up the title in Hungary with five races still to run. Yet, for all that, he was not kept on for 1993...

"The way I left Williams at the end of 1992 was a major disappointment," Nigel relates, "as everybody seemed to tell different people different things. I was sad that I wasn't offered a chance to defend my title, as they asked me to halve my salary. There was also pressure from Renault for Williams to run a French driver, thus Prost. This opened the door for my move

RIGHT PIPPED AT THE POST: AYRTON SENNA HOLDS OFF
MANSELL'S WILLIAMS TO WIN THE 1986 SPANISH GRAND PRIX
AT JEREZ BY JUST 0.014 SECONDS.

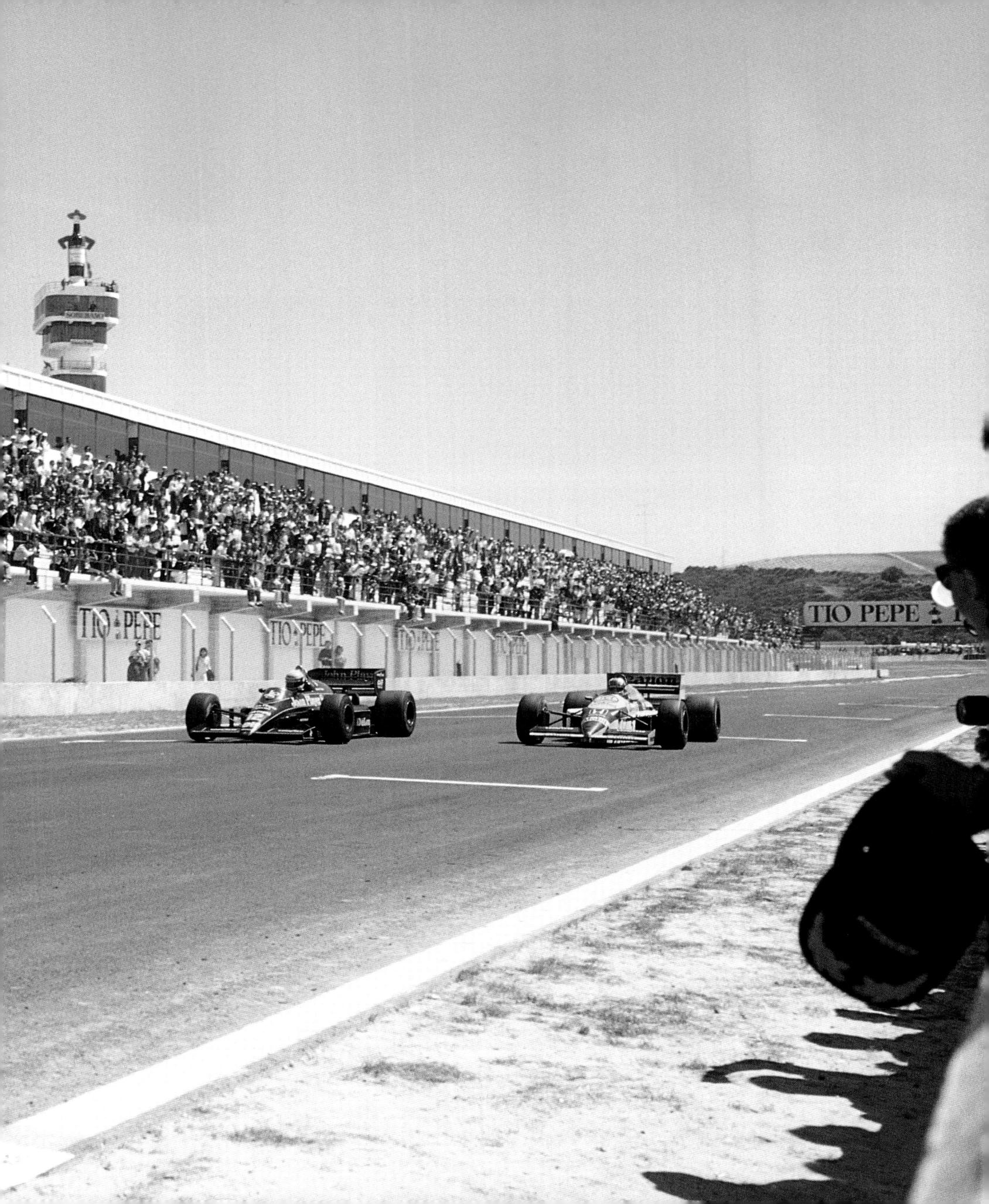

THE EIGHTIES

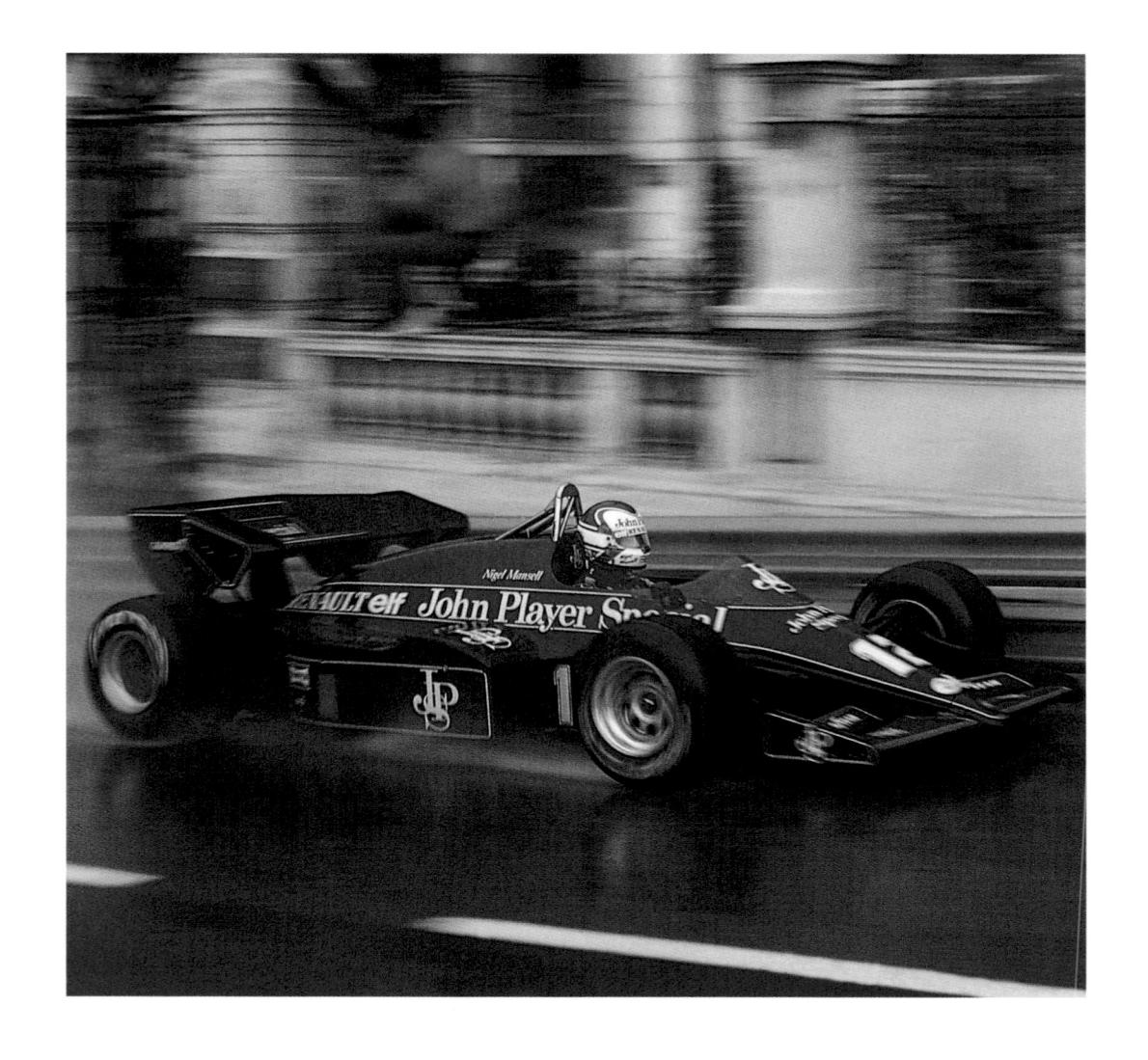

NIGEL MANSELL

to Indycar racing, but I would have loved to stay on in Formula One."

However, the day he claimed the crown at the Hungaroring was a memorable one: "It was probably the greatest moment of my career. Ayrton put his arm around me on the podium and said some very special words to me. Having done the apprenticeship and been the bridesmaid three times, it was a wonderful moment. As was winning the Indycar title in 1993."

So, Nigel's Formula One career was over and he was to spend the next two years Stateside. Yet, before 1994 was over, he was back on the grid for a Grand Prix with Williams: "It was fantastic to come back to Formula One, especially when I got on the front row at my return in the French Grand Prix and then won in Australia. I then had a contract with Williams for 1995, but that never happened."

Then, after a pair of unhappy outings in a McLaren in 1995, that was that. Since then Nigel has ventured out only in a handful of touring car races for Ford. But he still has strong views on the state of the sport today.

This is what he thinks of driver safety: "The year I came into Formula One, drivers sat with their feet within four inches of the front of the car and the front wheels were by our knees. So safety was nothing like it is today. We didn't consider it safe then and look back and say how it was so much safer then than it had been 10 years earlier as we were still losing drivers every year. Drivers in 1999 don't appreciate how the governing body and designers have helped pioneer racing to the standard it has.

"I feel, though, that there was an over-reaction after that terrible San Marino Grand Prix in 1994 when Ayrton Senna and Roland Ratzenberger were killed, as motor racing is dangerous but the changes made after this spoiled several circuits. All the fast and challenging corners were drastically changed and this made it easier for not such skilled drivers to be able to stay with the more talented ones.

"The skills used today are also a little different now, as in the early 1980s you couldn't bounce over the kerbs without risking damaging your car's suspension. Now it seems you can bounce off anything. I'll never forget one Grand Prix in 1994 when a driver who had just come into Formula One said at the drivers' briefing that a particular corner was too dangerous as it was approached at 120mph and that the barrier was within 30 metres of the corner. I thought 'wow', recalling the Ostkurve at Hockenheim and the Boschkurve at the Osterreichring that we used to approach at 200mph and the barriers there were more like five metres away. I'm all for safety, but I'm not all for making it so easy that if a driver makes a mistake that he doesn't hurt himself. Because part of having a really fast corner is the challenging and the calculating, and making sure that you don't make a mistake. When I raced at Indianapolis, you would be doing almost 250mph down the straight into Turn 1 knowing there was no bail-out if you got it wrong. That gets your attention...

"As great as it is, Formula One needs to have a few more fast

LEFT: CRUISING FOR A BRUISING: MANSELL LEADS AT MONACO IN 1984, SET FOR HIS FIRST WIN, BUT IT WAS NOT TO BE HIS DAY.

corners leading out onto straights so that there will be a lot more slipstreaming that will enable more overtaking to take place."

However, Nigel didn't come through his career unscathed: "Before I reached Formula One I'd broken my back, broken my neck and my toes. I'd carried broken bones in my left foot for 15 years. The accident I had in qualifying at Suzuka in 1987 crushed two vertebra and put 67g up my spine. Then, at the end of 1991, I crashed in the deluge at Adelaide and rebroke my left foot. There wasn't enough time to have this operated on over the winter, so I went through the training programme with special shoes with a Kevlar insole that took the pressure off the two outside toes and put it onto the other three. I then raced all season with Kevlar inserts. The only disappointing thing is that you carry a lot of scars, but I was accused of acting. Maybe I should have been more open with people, but I wasn't and as soon as I won the title I went to hospital and had the operation. If I wore shoes in 1992, like at a function, I would suffer internal bleeding, but I didn't want to reveal my weakness."

This reveals Nigel's oft-troubled relationship with the press: "I've no problem with being judged, as what you see is what you get. But there's an element in the press I don't approve of. There was certainly greater fairness from the press in the past and I found a major difference when I went to the USA, as they have more heroes and celebrities. Some journalists make a prediction, then you disprove it and that's when the problem starts if they can't accept that they were wrong. Some, however, have been man enough to admit that they were wrong to doubt me and that's alright."

Looking back at his contemporaries, though, Nigel is able to praise the best of them: "My greatest rivals were the people who were doing all the winning at the time, with Niki Lauda, Alain Prost, Keke Rosberg, Nelson Piquet and Ayrton Senna coming to the fore. Later on, Michael Schumacher too. It was wonderful to have raced against such a depth of talent. It was an unparalleled time in Formula One with so much competitiveness."

What of Formula One today? "Looking at the role of the driver in 1999, I have reservations about the change to automatic gearboxes, as this reduces the drivers' input. When we had manual gearboxes the driver had a lot of input, as if you changed down at the wrong time you could blow the engine. Also, if you missed just one shift you could lose a race. The synchronising of heeland-toeing and the changing down – a big part of driving a racing car with thousands of shifts per race – as well as nursing your machinery has been taken away now that computers do it all and won't let drivers select the wrong gear at the wrong revs. Technology is a fantastic thing, but I'd like to see drivers have more input. I used to make great standing starts, feel the clutch in. Now the computer more or less does it for you.

"That said, I must say that the Formula One package is fantastic at present. It's the pinnacle of motorsport and I love it. But I feel at times that with certain changes there's over-reaction. Perhaps it would be good if there could be someone to help and perhaps advise who knows something about the cars and tracks from the drivers' side. This would enable the people in power to maybe sometimes have a better balance and make Formula One an even better spectacle than it is already. Indeed, Formula One can be shipped anywhere in the world and be an unparalleled spectacle."

WILLIAMS ARNOUX ARROWS PATRESE LOTUS PIRONI

JUST WILLIAMS

lan Jones won the 1980 title after overcoming a strong challenge from Nelson Piquet. But, just as Colin Chapman failed to follow up on his 1978 success, so Enzo Ferrari's team lost its way in 1980. Scheckter and Villeneuve would struggle, with Jody's title defence consisting of a solitary fifth place.

In contrast, Williams maintained its momentum with the updated FW07B and Reutemann moved on from Lotus to join Jones. Ligier regained form with the JS11/15, and Pironi joined Laffite to be the find of the season.

Brabham fortunes picked up, and with Lauda and Alfa Romeo gone, Piquet assumed team leadership. Andretti stayed on at Lotus, with Elio de Angelis joining him, while Nigel Mansell was test driver. Renault continued with Jabouille

and Arnoux, while Alain Prost joined Watson at McLaren. Alfa Romeo entered cars for Bruno Giacomelli and Depailler, who was still recovering from his hang-gliding accident.

Jones kicked off by dominating the Argentinian Grand Prix in an old-spec FW07. Piquet was second, while Rosberg gave a hint of his potential with third.

Jabouille and Pironi shared the front row at Interlagos, but a heroic effort from Villeneuve earned third. After that it was an all-French battle and, when both Jabouille and Laffite had problems, Arnoux raced away to his first win.

Arnoux repeated his success in South Africa. Laffite and Pironi followed the Renault home. Long Beach saw the end of Clay Regazzoni's career, the Swiss having left Williams to rejoin Ensign. He crashed heavily, and was subsequently

confined to a wheelchair. Meanwhile, Piquet took pole and scored his first win, ahead of Patrese and Fittipaldi.

The FW07B made its bow at Zolder, and although it was quick, Jones and Reutemann were led home by Pironi, another first time winner. Pironi was on form again at Monaco, but after he hit the barrier Reutemann scored his first Williams win.

Politics and racing collided headon at Jarama as FOCA was in dispute with FISA. A confusing weekend ended with a "Formula DFV" race going ahead without Ferrari, Alfa and Renault. Laffite and Reutemann collided, Piquet's gearbox broke and Pironi lost a wheel – leaving Jones to win a race that was later declared non-championship.

At Paul Ricard, Jones delighted in beating Ligier and Renault on home

ground, Pironi and Laffite following him home. The Ligiers were superb at Brands Hatch, but they suffered wheel problems and Jones came through to win.

The Renaults were quick but fragile in Germany, and when leader Jones had a puncture Laffite took the victory. Sadly, in pre-race testing Depailler crashed fatally.

France took another win in Austria, Jabouille scoring his second success as he held off the determined Jones. Mansell was finally given his chance in a third Lotus, only to have to start the race

in a fuel-soaked race suit.

In Holland, Jones damaged a skirt and Piquet won ahead of Arnoux. The Italian GP moved to Imola, and Piquet won and took a one-point lead from Jones in the championship.

WILLIAMS'S FIRST TITLE

The situation was tense going to Montreal, and it blew up when Piquet and Jones triggered a huge pile-up. For the re-start, Piquet had to start in the spare, and his engine failed. Pironi led

throughout, but was penalized for a jumped start, so Jones took maximum points and the title. It was the first title for Williams. Jabouille broke his legs after a suspension breakage.

Jones went off at the first corner at Watkins Glen, then recovered to win from Reutemann and Pironi. Two big names drove their final races. Having failed to qualify in Canada, Scheckter finished 11th and last, while Fittipaldi broke his suspension, ending another disappointing season with his own team.

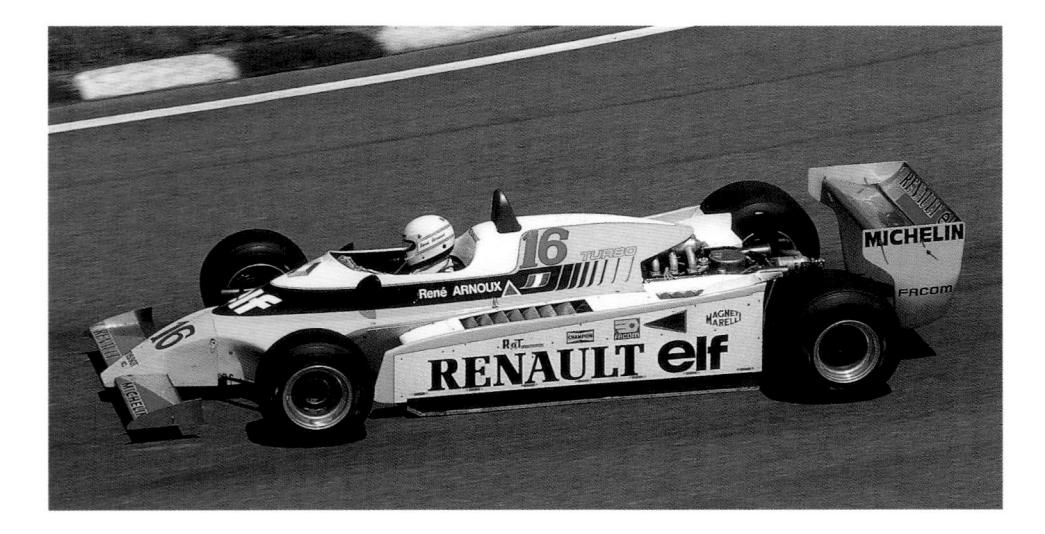

ABOVE FLYING START: RENE ARNOUX
WON TWO OF THE FIRST THREE
GRANDS PRIX FOR RENAULT BEFORE
HIS SEASON TAILED OFF.

RIGHT FLYING THE ENSIGN: CLAY REGAZZONI
CAME BACK FOR MORE WITH ENSIGN, BUT
CRASHED AND WAS CONFINED TO A
WHEELCHAIR AFTER A CRASH AT THE US
GRAND PRIX WEST.

PIQUET FOR BRAZIL

elson Piquet turned the tables on Alan Jones in 1981, winning his first World Championship title and the first for Brabham since Bernie Ecclestone took control. Unfortunately, off-track disputes dominated the headlines.

After the disaster of 1980, Ferrari switched to a new V6 turbo engine, becoming the first to follow Renault's pioneering route.

The other big news was Ron Dennis's takeover of McLaren, for whom John Barnard set to work on a revolutionary carbonfibre chassis, while Alain Prost left to replace Jean-Pierre Jabouille at Renault.

The season began at Long Beach and Riccardo Patrese took a surprise pole for Arrows, but victory went to champion Jones, ahead of Williams's Carlos Reutemann and Piquet. The Ferraris were quick but fragile. In Brazil the decision to ban sliding skirts turned to farce as Brabham had a perfected a hydro-pneumatic suspension system – the car was legal in the pits, but on the track it squatted and the skirts touched the ground. Piquet took pole, started the wet race on slicks and blew it. Reutemann controverisally led Jones home after reneging on a pre-race deal.

In Argentina Piquet made no mistake, winning easily, while unrated team-mate Hector Rebaque ran in second place until his car broke.

The European season started at Imola with the new San Marino Grand Prix – an excuse to have two races in Italy. Gilles Villeneuve and Didier Pironi both led the wet race early on, but Piquet came through to win from Patrese and Reutemann.

In the Belgian Grand Prix at Zolder, a mechanic from the Osella team died after being struck by a car in practice and an Arrows mechanic had his legs broken when hit attending Patrese's stalled car on the grid – just as the race started. Pironi led until his brakes went, Jones crashed out after earlier knocking Piquet off and victory went to Reutemann.

Nigel Mansell was in great form at Monaco for Lotus, qualifying third behind Piquet and Villeneuve. Piquet led, but Jones put him under pressure and he crashed. Then Jones suffered a fuel pick-up problem and Villeneuve sped by for a superb win in the unwieldy Ferrari. Amazingly, he repeated that success at Jarama. After Jones fell off, Villeneuve led home a train comprising Ligier's Jacques Laffite, McLaren's John Watson, Reutemann and Lotus's Elio de Angelis.

1981

RIGHT MCLAREN'S DAY: JOHN WATSON RACES TO VICTORY AT SILVERSTONE.

BELOW THE FIRST OF 51: ALAIN PROST FIRES THE BUBBLY AFTER SCORING HIS FIRST WIN, ON HOME GROUND IN DIJON-PRENOIS.

ABOVE DRIVING A WIDE CAR: VILLENEUVE HAD TO USE EVERY TRICK TO KEEP LAFFITE, WATSON AND REUTEMANN BEHIND HIM IN THE SPANISH GRAND PRIX.

The French Grand Prix at Dijon-Prenois was another odd race, for rain split it into two parts, and Prost scored his first win in the Renault ahead of Watson and Piquet.

WATSON TAKES GOLD

Watson's big day came at Silverstone. Prost and team-mate Rene Arnoux took turns leading, but when they failed Watson won. It was his first win since Austria in 1976.

Villeneuve, Prost and Arnoux all took turns to lead in Germany, but Piquet took a canny win, with Prost second. Then Austria brought a popular win for Laffite.

At Zandvoort Prost and Jones fought hard in the early stages, until Jones's tyres went off and Prost pulled away to win from Piquet, with Jones third. With Reutemann tangling with Laffite, Piquet took the title lead. Prost then led all the way at Monza, winning from Jones and Reutemann, the latter passing Piquet

when his engine blew on the last lap.

The Canadian Grand Prix was an exciting, wet event. Jones spun off while leading, Prost took over, then Laffite got to the front and held on to win. So they headed for the finale with Reutemann on 49, Piquet on 48, and Laffite on 43. The race was held in a car park in Las Vegas. Reutemann took pole, but faded away as Jones won with Piquet taking fifth and Laffite sixth, which gave Piquet the title by a point.

ONE WIN IS ENOUGH

he 1982 season proved to be one of the most turbulent – and tragic – in the history of Formula One. And Williams's Keke Rosberg became the first man since 1964 to secure the World Championship with just a single victory to his name.

Niki Lauda was back racing again after two years out of harness, joining John Watson at McLaren; Williams replaced Alan Jones with Keke Rosberg; and Brabham looked well set with Riccardo Patrese as Nelson Piquet's team-mate.

Piquet crashed in the opening race at Kyalami, and the Renaults dominated until Alain Prost had a puncture. But he charged back from eighth to win from Carlos Reutemann's Williams and Rene Arnoux's Renault. Piquet made amends by winning the Brazilian Grand Prix from

Rosberg and Prost, but the first two were then disqualified for being underweight. They had both had their water tanks for brake cooling topped up after the race, and this was adjudged an illegal way of bringing them back to the minimum weight.

Lauda won at Long Beach from Rosberg. The disqualifications of Piquet and Rosberg in Brazil led the FOCA teams to boycott the San Marino Grand Prix, and it was a half-hearted event with just 14 cars entering. Tyrrell, bound by Italian sponsors, broke ranks to join the manufacturer outfits. Ferrari's Didier Pironi and Gilles Villeneuve traded the lead in what many thought was a show for the fans. Pironi passed Villeneuve on the last lap to win, and since Villeneuve thought he had broken an agreement, a deadly feud began.

A BLACK DAY AT ZOLDER

The feud rumbled on to the Belgian Grand Prix at Zolder where, in final qualifying, desperate to outgun Pironi, Villeneuve hit the back of Jochen Mass's March and was launched into a roll and thrown from his car. The most entertaining driver of the era was killed. The race went ahead without Ferrari, and Watson won.

Monaco was unbelievably dramatic. Arnoux led until spinning, Prost took over until crashing heavily with three laps to go; Patrese then led, but spun, and Pironi and Alfa Romeo's Andrea de Cesaris went by. With one lap to go, Pironi stopped with electrical problems, de Cesaris ran out of fuel and Williams replacement Derek Daly retired after clouting the barrier. Patrese recovered to win a race that no-one seemed to want to win.

In Montreal, now named the Circuit Gilles Villeneuve. Pironi stalled on pole and was hit by newcomer Riccardo Paletti, who was killed. Piquet won the race, Patrese came in second. Then Ferrari finally had some good news, Pironi winning the Dutch Grand Prix in fine style ahead of Piquet and Rosberg.

Brands Hatch saw Lauda win but the star of the race was Derek Warwick, who

got the tank-like Toleman up to second before retiring. Pironi went to Hockenheim leading by nine points. But in wet practice struck the back of Prost's Renault in a career-ending accident that broke his legs. In the race, Patrick Tambay scored his first win in the second Ferrari, ahead of Arnoux and Rosberg.

In the Swiss Grand Prix, held at Dijon-Prenois in France, the Renaults led, but Rosberg came through to score his first win from Prost. After Arnoux won at Monza from Tambay, Watson then had to win the final race in the car park of Caesar's Palace at Las Vegas, to deprive Rosberg of the title. Arnoux and Prost both led, but a shock victory went to Tyrrell's Michele Alboreto. Watson was second, but it was not enough and fifth-placed Rosberg took the honours.

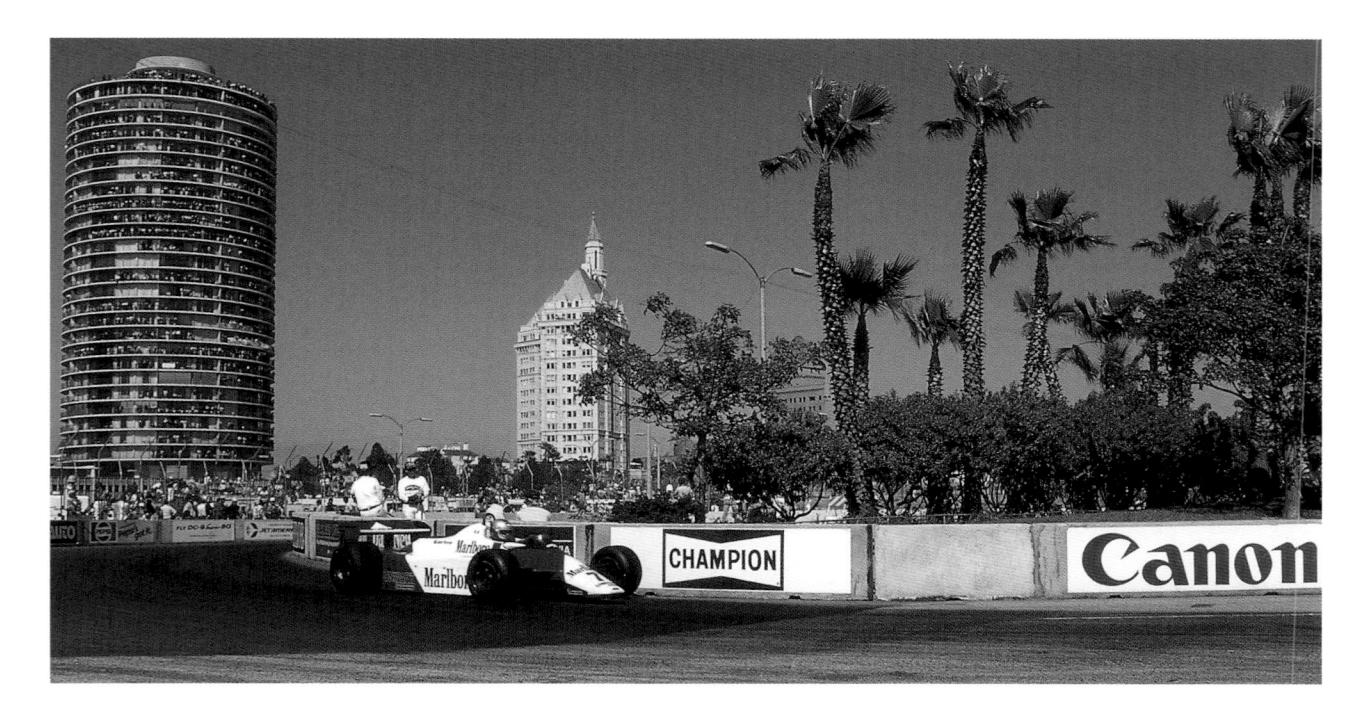

ABOVE COMEBACK KING: NIKI LAUDA
CAME BACK FROM RETIREMENT,
WINNING HERE AT LONG BEACH FOR
McLAREN.

RIGHT FALLING BACK: NELSON PIQUET HAD A DREADFUL TITLE DEFENCE WITH HIS BRABHAM-BMW.

Darmalal Parmalal Par

YEA

alvolip

Valvoline

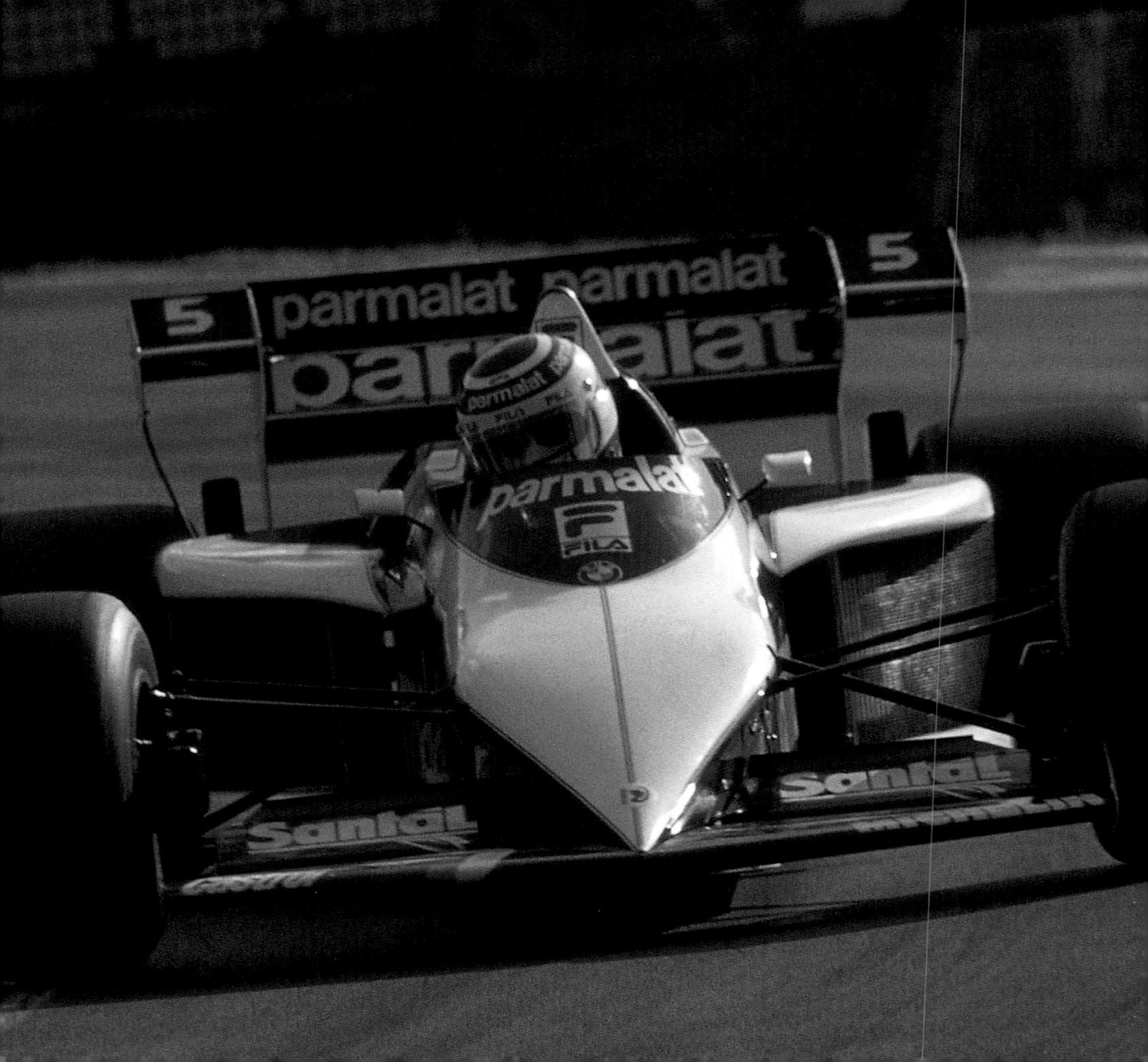

PIQUET DOES IT AGAIN

elson Piquet notched up his second world title as Alain Prost and Renault threw away their chances during what was a safe season that was also without strikes or technical squabbles.

New flat-bottom regulations cut downforce and got rid of the sidepods, while turbos (and pit stops) became essential. And Williams, for whom champion Keke Rosberg was joined by Jacques Laffite, wasn't ready and would have to spend another year with Ford Cosworth DFV power until its Honda-powered car was ready, with the Japanese manufacturer back after a 15-year break making a low-key start with the small Spirit team. McLaren, too, had to be patient. It had arranged for sponsor TAG to pay for Porsche's V6 and, until that was ready, Lauda and Watson were also stuck with

the DFV. Colin Chapman secured Renault engines for Lotus. Although he died suddenly, Lotus carried on: Elio de Angelis had the new car for race two, while Nigel Mansell used DFV power until mid-season.

PIQUET STARTS IN STYLE

Piquet won in impressive style in Rio, but Rosberg drew all the attention. He led, had a fire at his pit stop, recovered to second and was then excluded for a push start. McLaren's Niki Lauda and Laffite finished second and third.

Long Beach was a rare opportunity for the DFV cars to shine. John Watson and team-mate Lauda qualified 22nd and 23rd, but they got the race set-up right and came charging through to finish one-two, with Ferrari's Rene Arnoux third.

Unusually, the European season

kicked off at Paul Ricard and Renault continued its habit of winning at home, with Prost coming first.

Patrick Tambay scored an emotional win for Ferrari at Imola, well aware that a year earlier his friend Gilles Villeneuve had been robbed by Didier Pironi.

Rosberg qualified sixth behind the turbos at Monaco, but it rained and he chose to start on slicks. He was in the lead by the lap two and pulled away as the others pitted.

After a 13-year break, the Belgian Grand Prix returned to the Spa-Francorchamps circuit in rebuilt and shortened form. Alfa Romeo's Andrea de Cesaris took the lead, but retired with engine problems. Prost took over and held on to the flag.

Detroit saw Michele Alboreto score his second win for Tyrrell, taking the lead

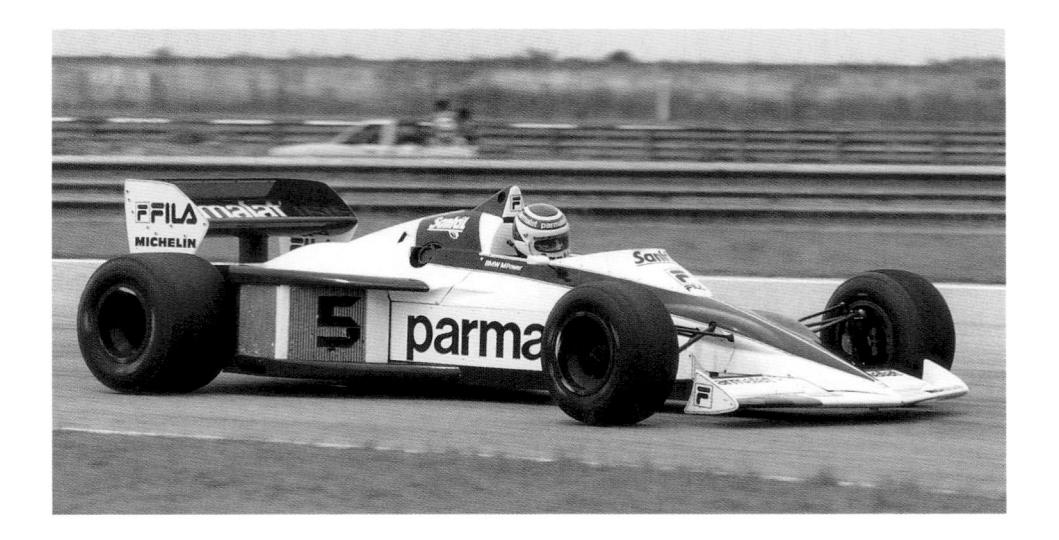

ABOVE SLEEK AND MEAN: THE GORDON MURRAY-DESIGNED BRABHAM BT52 WAS AN EFFECTIVE CHASSIS IN PIQUET'S HANDS.

RIGHT SURPRISE, SURPRISE: WATSON UNCORKS THE CHAMPAGNE IN LONG BEACH AFTER HE AND LAUDA CAME THROUGH FROM THE BACK.

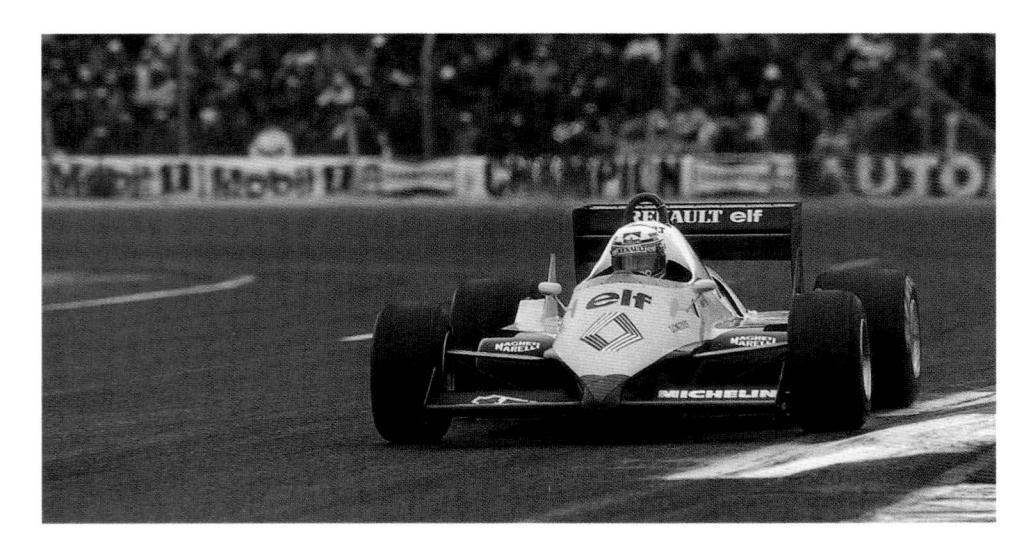

ABOVE RIGHT FERRARI'S FRIEND: TAMBAY
GAVE FERRARI AN EMOTIONAL WIN
AT IMOLA AND WAS PLACED FOURTH
OVERALL.

LEFT FALLEN AT THE LAST: PROST WON HERE IN FRANCE, BUT LOST THE TITLE AT THE LAST ROUND.

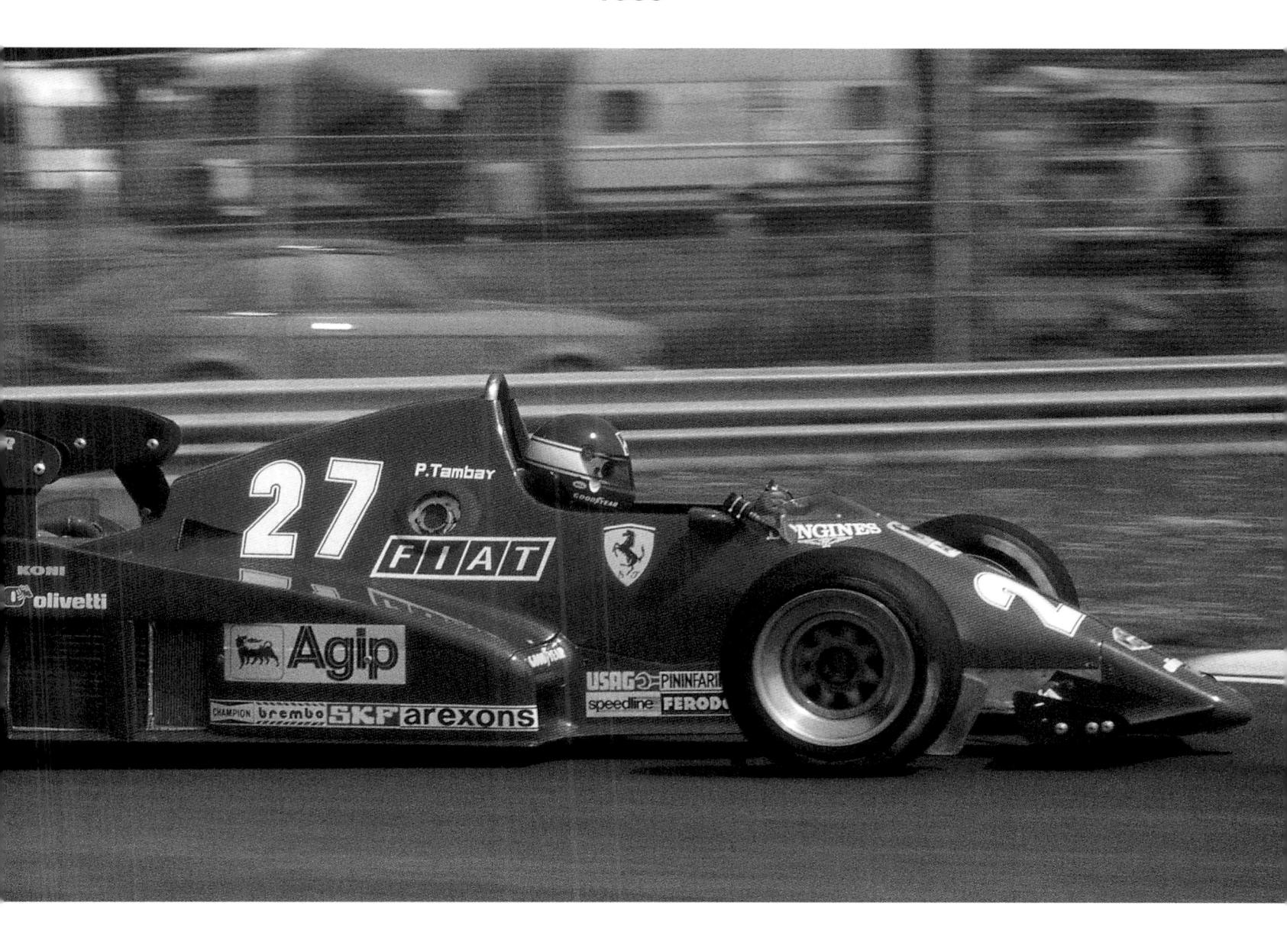

when Piquet pitted with a puncture. This was the 155th and last victory for the Ford Cosworth DFV. In Canada, Arnoux dominated for Ferrari, ahead of Renault's Eddie Cheever and Tambay.

The Ferraris led at Silverstone, but Prost pushed them as they used up their tyres. Piquet came through to take second, with Tambay third.

Arnoux won again at Hockenheim, although he defied team orders at the start when he was supposed to let

Tambay stay ahead. Tambay retired, while Piquet lost out with a major fire and de Cesaris took a lucky second place.

Prost had to work hard to win in Austria, passing Arnoux with six laps to go. Piquet kept his title hopes alive with third, and Prost's lead was now 14 points. He got it wrong in Holland, sliding into Piquet, putting them both out, leaving Arnoux to win from tenth.

Monza brought the worst possible result for Prost: retirement, while Piquet

won and Arnoux was second. Brands Hatch hosted the Grand Prix of Europe and Piquet won again, but Prost kept his hopes alive with second.

Just South Africa remained, and Piquet was quick in the first half, while Arnoux stopped early and Prost became stuck in a battle for third. But his turbo was failing and he retired. Piquet dropped to third, as Patrese won from de Cesaris, but ensured that he scored the vital points needed for the second title.

MICHELIN

Markey

RE

Marlbo

McLAREN MEN DOMINATE

iki Lauda displayed his judgement and guile when he beat his faster and younger McLaren team-mate Alain Prost to take the world title. This was to be the first of many great years for Ron Dennis's team.

Alain Prost stunned Formula One when he joined McLaren, after falling out with Renault. Indeed, it was all-change at Renault, with Patrick Tambay and Derek Warwick joining as Eddie Cheever found a new home at Alfa Romeo, where he was joined by Riccardo Patrese.

Ligier had sourced Renault engines and attracted Andrea de Cesaris. Arrows had a BMW deal, although Thierry Boutsen and Marc Surer, would start the year with Ford DFVs. Tyrrell was blessed with two great rookies in Stefan Bellof and Martin Brundle.

Ferrari's Michele Alboreto led in Brazil,

but spun off, letting Lauda and Warwick take turns in front, but Warwick's suspension broke and Prost came through to win, while Rosberg was second.

Piquet led at Kyalami until hitting turbo problems, and Lauda grabbed an easy win from Prost who'd started in the spare and stormed up from the back. Toleman's Ayrton Senna scored his first point.

Alboreto led all the way from pole at Zolder for his first win in a Ferrari, with Warwick second.

Prost led all the way at Imola, despite a spin. Lauda's engine blew and Piquet held second until a turbo failed, so Arnoux inherited the place. Tambay led for Renault at Dijon-Prenois, but had brake and clutch problems, letting Lauda by to win.

Monaco was wet, and Tambay and Warwick crashed at the first corner, while Prost led Nigel Mansell's Lotus. Then Mansell took the lead, only to crash. Prost regained the lead and was still in front of the fast-closing Senna and Bellof when the race was red-flagged.

Piquet was back on form in Montreal. The Brabham had a new oil cooler in the front, intended to help with weight distribution, but it burned his feet while leading from start to finish...

Detroit started with a shunt between Piquet, Prost and Mansell, for which Mansell got the blame. All three were back for the restart, and Piquet led throughout. Star of the race was Brundle, who climbed from 11th to second.

CRACKING IN THE HEAT

Next was Dallas. It was ragingly hot, the track broke up, many crashed and Formula One never returned. Rosberg dominated after passing Mansell who then hit gearbox trouble and collapsed while pushing his car to the line for sixth.

Sanity returned at Brands Hatch, although the race was stopped after Jonathan Palmer crashed his RAM. Prost led until his gearbox failed, leaving Lauda to win from Warwick and Senna.

Lotus's Elio de Angelis and Piquet retired while leading the German Grand Prix, leaving Prost to win from Lauda. Prost spun off in Austria when second, and Lauda won from Piquet and Alboreto.

Piquet led in Holland until he suffered an oil leak, so Prost and Lauda completed another demo.

LAUDA NICKS ONE

Prost's engine blew in Monza, and once Piquet did his usual trick of retiring while leading, Lauda cantered to victory from Alboreto.

By now Tyrrell had been banned for irregularities found in Detroit, losing their points. Many saw sinister undertones

in the way the sole "atmo" runner was thrown out.

For the first time Formula One went to the new Nürburgring for the European Grand Prix. Prost led all the way, while Alboreto and Piquet – both out of fuel at the finish – were second and third. Lauda was fourth after a spin.

Prost won the finale at Estoril, but Lauda did all he needed to do and came second to secure the title by the closest ever margin: half a point.

LEFT MAN FOR THE MOMENT: WHILE THE TRACK AND THE DRIVERS FLAKED IN DALLAS, ROSBERG RACED TO VICTORY FOR WILLIAMS.

ABOVE NOT LIKE THE ORIGINAL:
FORMULA ONE RETURNED TO THE
NURBURGRING, BUT THE NEW TRACK
WAS NOTHING LIKE THE OLD. PROST
WON.

CULES

UNIPART

HERCULES

PROST'S FIRST OF FOUR

lain Prost secured his first World Championship after a highly competitive year in the McLaren-TAG. Driver moves included Nigel Mansell joining Williams. Meanwhile, Ayrton Senna got out of a commitment to Toleman to join Lotus, alongside de Angelis. François Hesnault moved from Ligier to Brabham, so once again Piquet had a team-mate who was no threat. He also had the novelty of Pirelli rubber.

The McLaren, Ferrari and Renault line-ups went unchanged. Jacques Laffite returned to Ligier alongside de Cesaris. Tyrrell finally joined the turbo club, landing a Renault deal for Brundle and Bellof. However, they'd have to start with the DFV.

Several new teams appeared, with Pierluigi Martini handling the Minardi. From Germany came touring car specialist Zakspeed, while Indycar entrant Carl Haas had backing from Beatrice and enticed Alan Jones out of retirement to drive a Lola.

Alboreto put Ferrari on pole in Rio. Rosberg was alongside, and both led, but Prost won with Alboreto second. Senna stormed to his first win in the wet at Esttoril with Alboreto a minute behind in second and Tambay's Renault third.

Senna led at Imola until running out of fuel, then Johansson looked set to win, but he too ran dry. Prost won – only to be disqualified for being underweight and victory was awarded to de Angelis. Prost won in Monaco, with Alboreto second from de Angelis.

In Canada Lotus swept the front row. De Angelis led before Alboreto took over to win. Johansson made it a Ferrari onetwo, with Prost third.

COSWORTH SCORES FINAL POINTS

Senna was on pole in Detroit, but he was one of many to crash, along with Mansell and Prost. Rosberg gave Williams its first win of the year. Ferrari's Johansson and Alboreto filled the podium. History was made by the car in fourth; Bellof's Tyrrell gave the Cosworth its last top-six finish, 18 years after its debut.

Rosberg was on pole at Paul Ricard, but it was Brabham's day. Piquet won and gave Pirelli its first success since Monza 1957! Rosberg took second, ahead of Prost.

Senna led the British Grand Prix at Silverstone, until he ran out of fuel. Prost then won by a lap, from Alboreto, Laffite and Piquet. The new Nurburgring played host to the German Grand Prix for the first time. Teo Fabi took a surprise pole for Toleman. Ferrari's Alboreto and

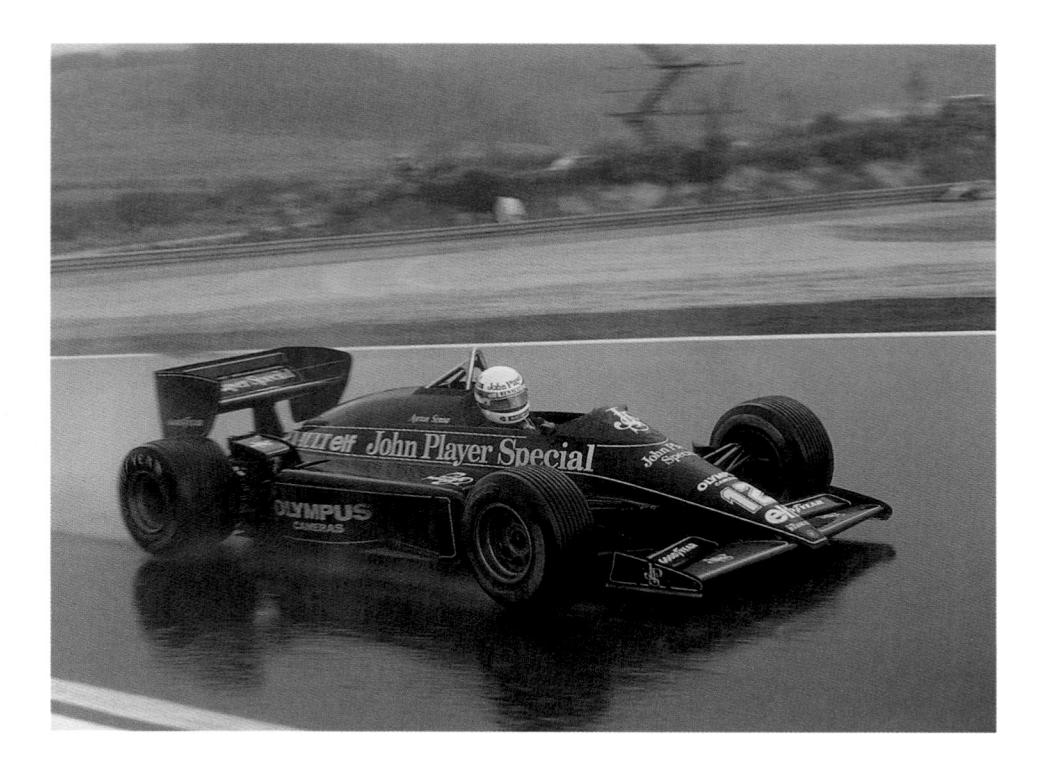

ABOVE KING OF THE DELUGE: SENNA
WAS IN A CLASS OF HIS OWN AT
ESTORIL, SCORING HIS FIRST WIN
FOR LOTUS.

RIGHT HOW NOT TO DO IT: PIQUET
AND PATRESE GET IT ALL WRONG AT
STE. DEVOTE. NEITHER CONTINUED.

Johansson tangled at the first corner, but Alboreto recovered to win with Alain Prost coming in second.

The Austrian Grand Prix was restarted after a first lap crash. Lauda led and, after he retired with turbo failure, Prost went on to win. Senna and Alboreto completed the top three.

Zandvoort hosted a Grand Prix for the last time. Piquet took pole, but Rosberg led, then Prost took control when Rosberg retired with a failed engine, but Lauda came through to score his first win of the season – and what turned out to be his last.

Senna took pole at Monza and Rosberg starred. But victory went to Prost, ahead of Piquet and Senna. Prost was on pole at Spa, but Senna won from Mansell. Prost took third, and put himself within reach of the title.

Brands Hatch hosted the European Grand Prix and Mansell won in front of his home crowd ahead of Senna and Rosberg. Meanwhile, fourth place clinched the title for a cautious Prost. Then Mansell took pole at Kyalami and led Rosberg home, with Prost third.

The season ended with a new race in Adelaide. Senna took pole, but Prost won the high-attrition event. Ligier ended on a high, with Laffite and Streiff second and third. Lauda retired from racing, but this time permanently. The Renault team quit too, after an awful season.

Although Formula One had enjoyed a relatively safe season, two drivers lost their lives in sportscars: Manfred Winkelhock died at Mosport, while Tyrrell's Bellof was killed at Spa.

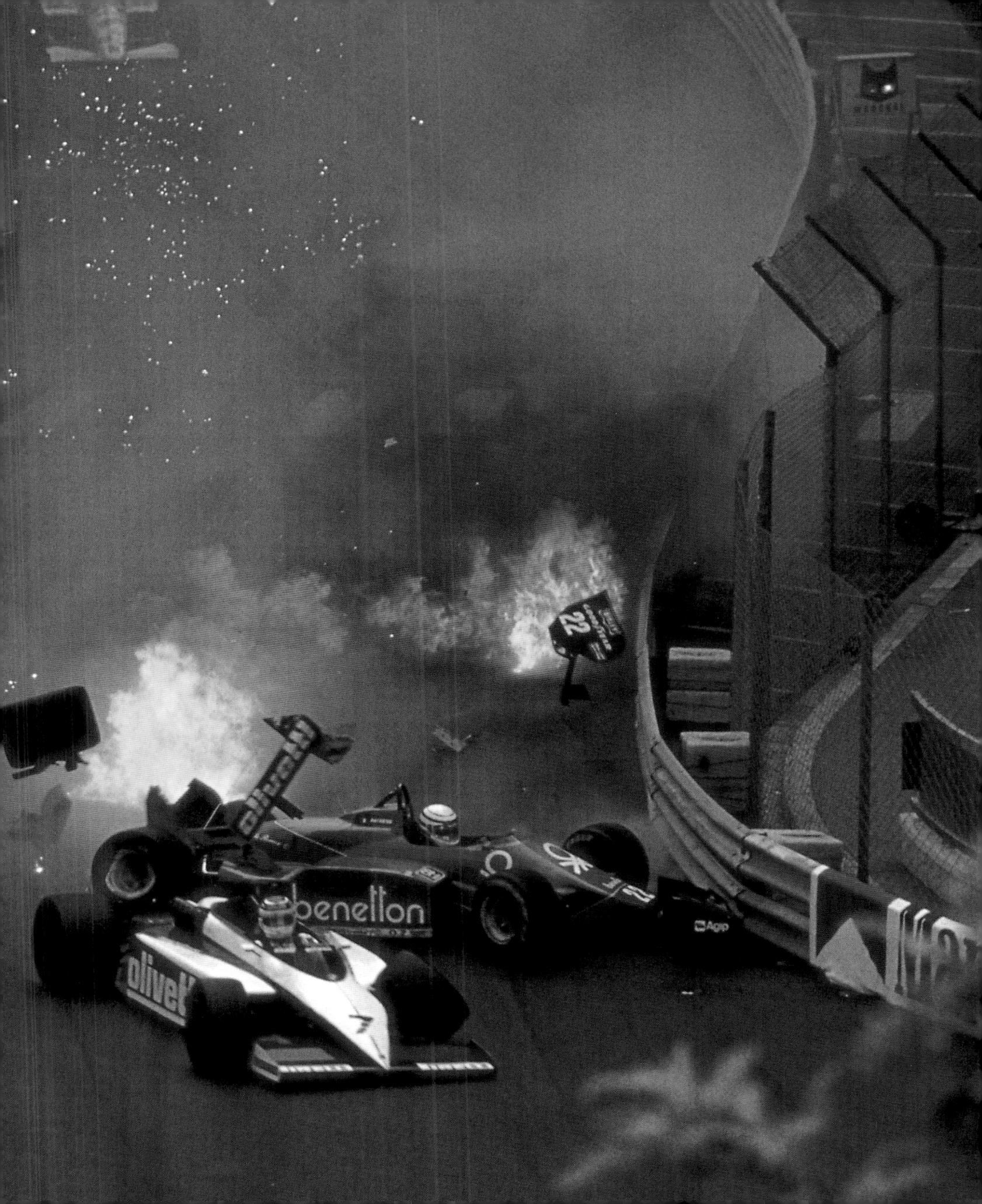

SENNA MCLAREN ROSBERG LIGIER JOHANNSON LOLA

OUT WITH A BANG

his championship saw one of the most dramatic conclusions ever. Williams team-mates Nigel Mansell and Nelson Piquet had fought hard all year for the championship lead, but in the final race Mansell blew a tyre, Piquet made a precautionary stop, and McLaren's Alain Prost sped through to the title.

Having lost Niki Lauda to retirement, McLaren replaced him with another former world champion: Keke Rosberg. The Finn was also replaced at Williams by a champion with Nelson Piquet moving across from Brabham. Lotus wanted to hire Derek Warwick, but Ayrton Senna did not want a top name alongside him, so they chose newcomer Johnny Dumfries. Meanwhile, Elio de Angelis left Lotus for Brabham. Over the winter Toleman turned into Benetton, and

Gerhard Berger joined Teo Fabi with BMW engines, perhaps the most powerful in the field.

Piquet won his home Grand Prix at Rio. Senna took pole, and he and Prost led before Piquet took over.

Spain had a Grand Prix again, this time at Jerez. And it produced a thrilling race, with Senna holding off Mansell by 0.014 second.

Senna was on pole at Imola, but a jammed wheel bearing forced him out, while Rosberg fell from second to fifth, his tank dry. Piquet and Rosberg led, but the reliable Prost was there to win from Piquet.

Prost broke Senna's string of poles at Monaco, and led Rosberg home after Senna led briefly, but fell to third.

Then tragedy struck when de Angelis was killed in testing at Paul Ricard.

Piquet took pole for the Belgian

Grand Prix, but Mansell came through to win from Senna and Johansson. In a black weekend in June, former Osella driver Jo Gartner was killed in the Le Mans 24 Hours, while Arrows star Marc Surer was badly injured in a rally.

Brabham was back to strength in Canada, Warwick returning from the Jaguar sports car team. But Mansell took pole and won from Prost.

Senna won from pole in Detroit, but both Ligiers took a turn in the lead, with Jacques Laffite finishing second.

Mansell won at Paul Ricard, ahead of Prost, Piquet and Rosberg. And nobody was going to stop him at Brands Hatch, although Piquet pipped him for pole. Mansell had a driveshaft break, but his day was saved by a red flag as Laffite hit a barrier and broke his legs. Mansell won the restart after a fierce tussle with Piquet.

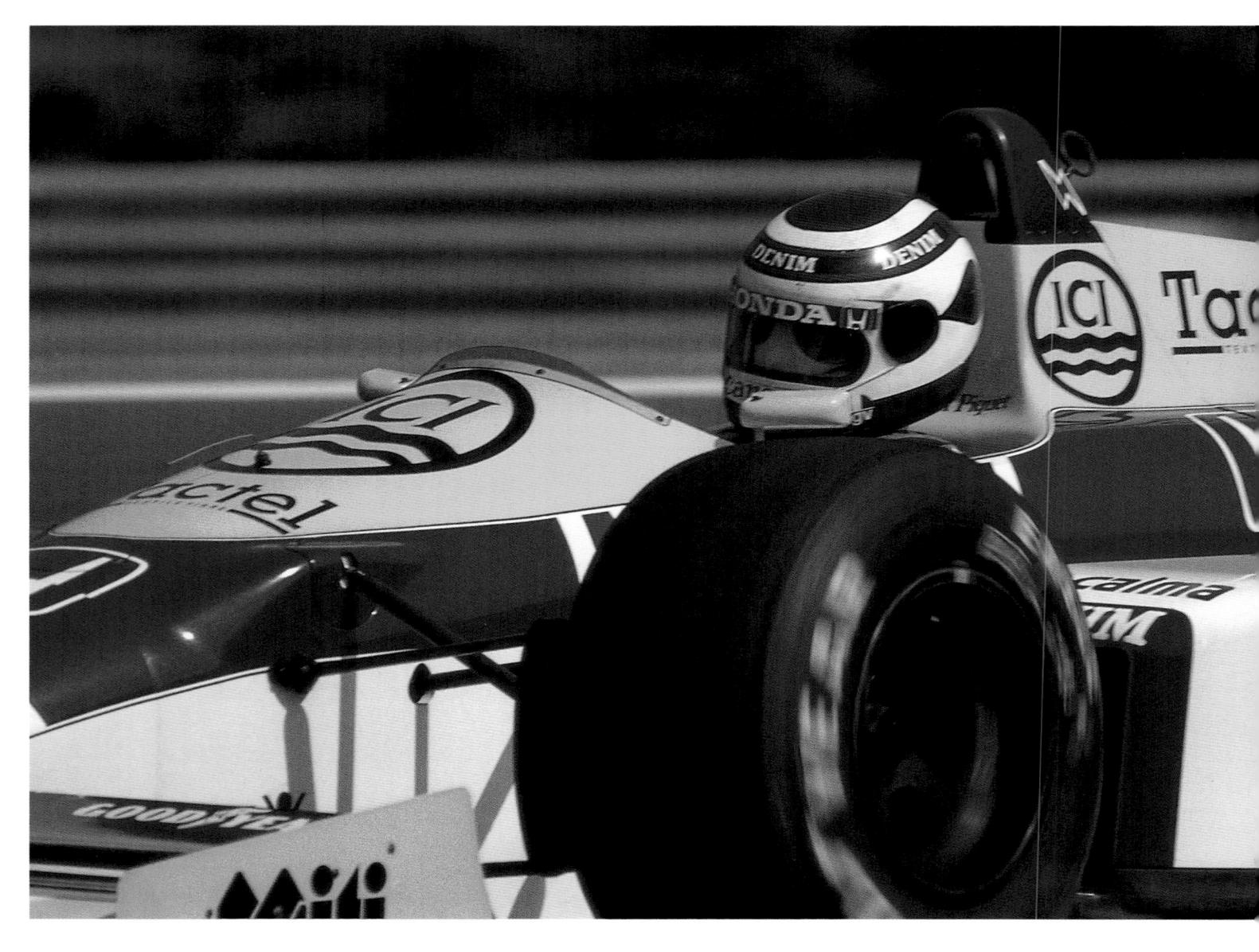

ABOVE NOT THIS TIME: NELSON PIQUET WON FOUR RACES FOR WILLIAMS, BUT IT WASN'T ENOUGH FOR HIS THIRD WORLD TITLE.

The German Grand Prix returned to Hockenheim. On this power track it was a surprise to see Rosberg and Prost on the front row, but the Finn led before Piquet took over and won to keep his title challenge alive.

LOOKING TO THE EAST

The twisty Hungaroring circuit made its debut, as Formula One made its first visit to the Eastern bloc and Piquet outran Senna to win.

BMW power ruled in Austria as Fabi and Berger filled the front row for Benetton. Berger led until his turbo blew, and in a race of high attrition it was inevitably Prost who kept it flowing to win from Ferrari's Michele Alboreto.

Fabi took pole at Monza with what was possibly the most powerful car ever seen in Formula One, but Piquet led Mansell to a Williams one-two. Senna was then on pole for the Portuguese Grand Prix, but Mansell led all the way to

win from Prost and Piquet.

The campaign's third new track was in fact an old one – but the circus had not visited Mexico City since 1970. Benetton came good and Berger scored his first win.

In a dramatic finale in Adelaide, Mansell was perfectly placed to take the title when a rear tyre blew. Williams made Piquet pit for a precautionary tyre change, and he fell to second behind Prost, with victory giving the little Frenchman his second title.

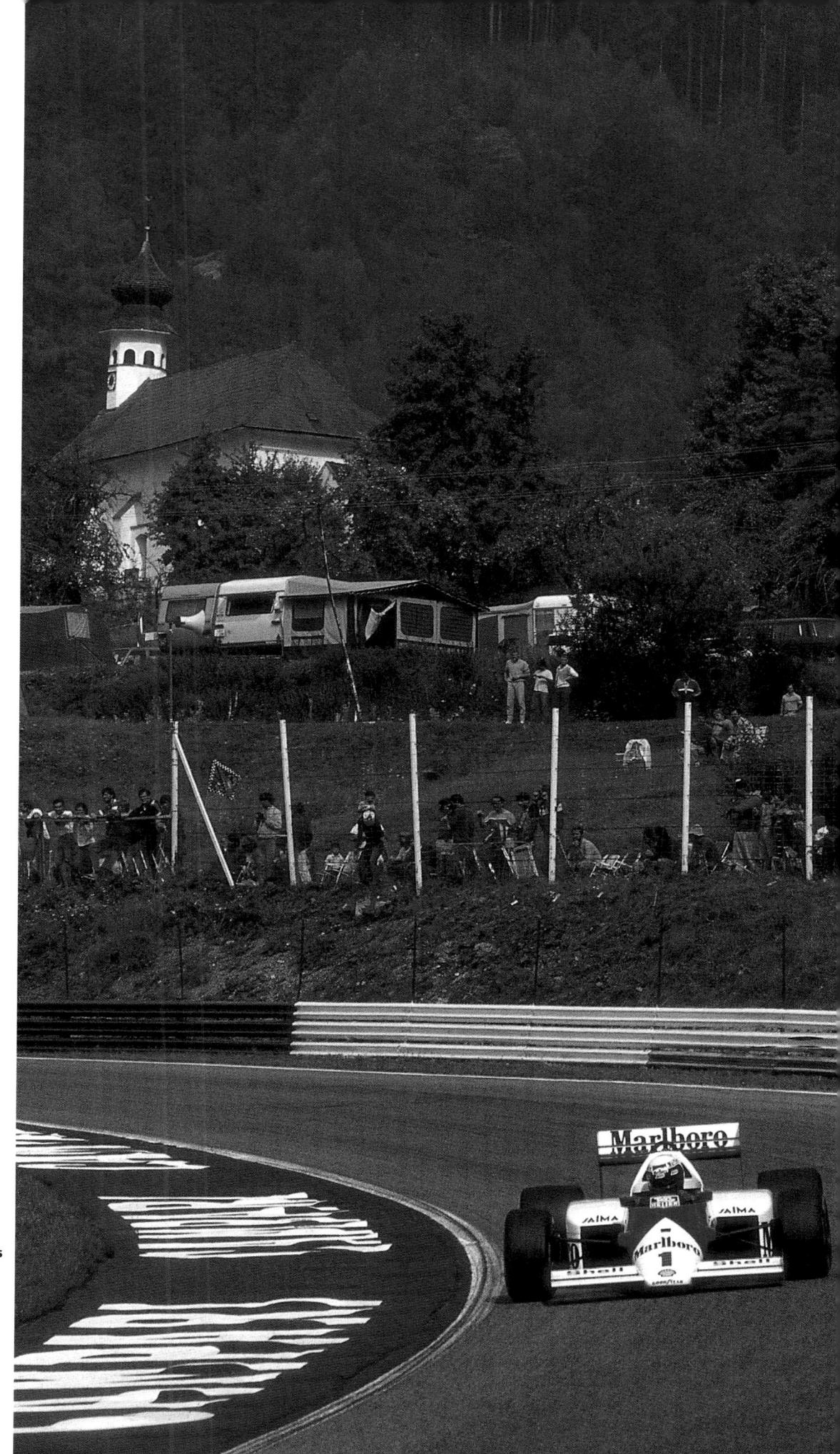

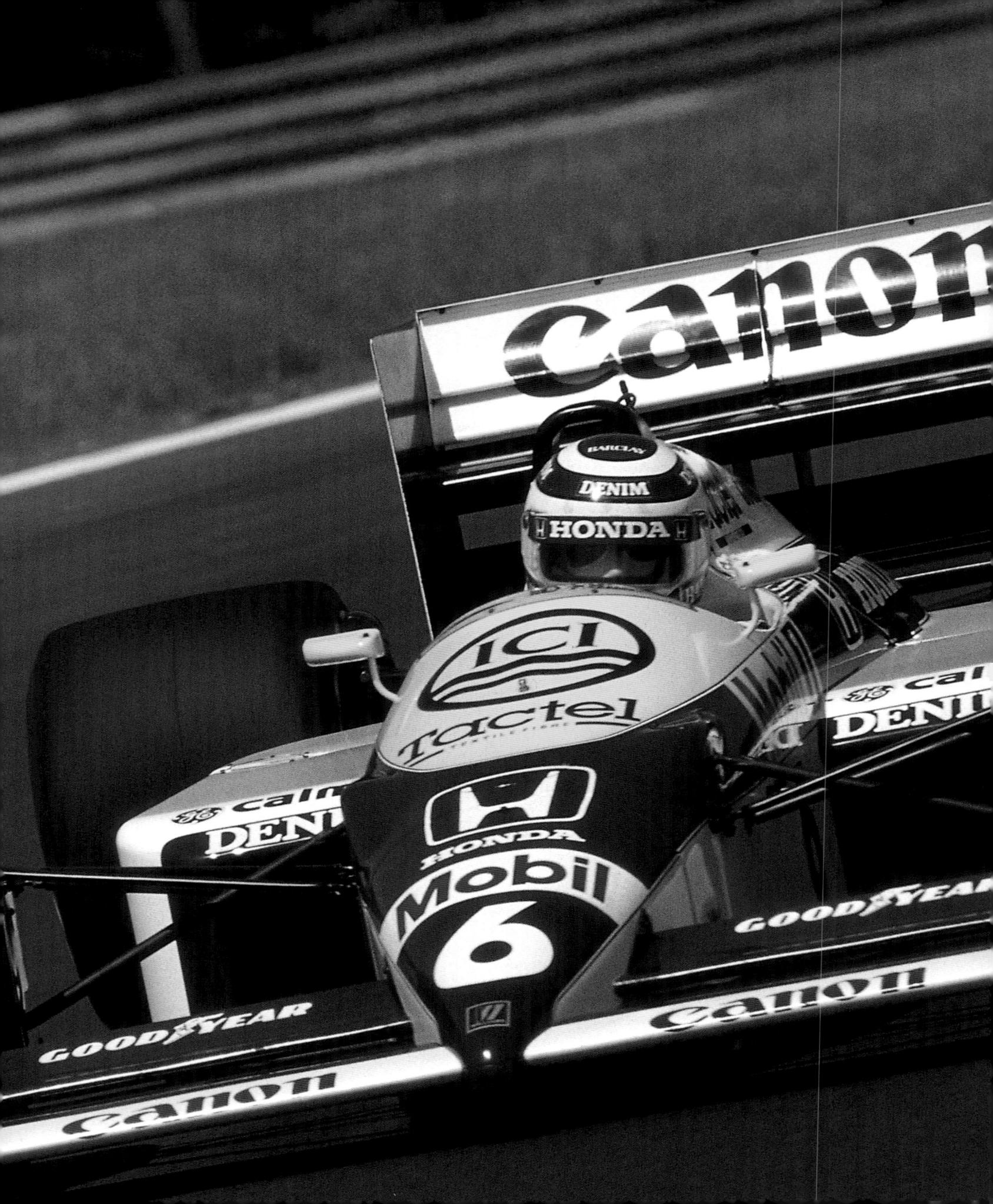

PIQUET MAKES IT THREE

illiams team-mates Nelson
Piquet and Nigel Mansell
fought for the title until an
accident sidelined Mansell
in Japan. And Piquet thus accepted the
laurels for the third time.

With the turbo era getting out of hand, a new formula was announced. From 1989, Formula One would revert to atmospheric engines, but at the larger 3.5-litre capacity. There would be two interim years, and to encourage teams to change, a separate classification was introduced, with "atmo" drivers battling for the Jim Clark Cup. Cosworth produced the DFZ, for which Tyrrell was the first major team to build cars. They hired Jonathan Palmer and Philippe Streiff, and would dominate. Their opponents were AGS and a new team from former Renault Sport boss Gerard Larrousse.

After a year as just an engine supplier Renault had withdrawn, and Lotus landed on its feet by attracting Honda, with Satoru Nakajima as part of the package. With Haas out, Ford teamed up with Benetton and Thierry Boutsen joined Teo Fabi there, as Gerhard Berger had moved to Ferrari, where he partnered Michele Alboreto as Stefan Johansson left Ferrari to join Alain Prost at McLaren.

Mansell and Piquet shared the front row in Rio and, although Piquet led early on, Prost won, with Piquet finishing second and Johansson third.

In Imola, Piquet crashed in practice and didn't start. Senna led, but Mansell powered past to win.

The Belgian Grand Prix was stopped after the Tyrrells crashed on lap two, then Prost won after Piquet retired, with Johansson clinching a McLaren one-two

and Andrea de Cesaris taking third place for Brabham.

Mansell led at Monaco until his turbo broke. Then Senna took over with Piquet second ahead of Alboreto and Berger. Mansell was hit by cramp in Detroit and Senna took over to win from Piquet and Prost. Things went Mansell's way at Paul Ricard, where he won from pole.

Despite losing ground after a late tyre stop at Silverstone, Mansell beat Piquet after a charge which culminated in a famous passing move into Stowe.

PIQUET COMES ON STRONG

Mansell was on pole in Germany, but his engine failed and Piquet won, while Johansson came second with a flat front tyre. Just seven cars finished as the turbos fell apart, with three DFZs in the top six.

RIGHT READY FOR ACTION: PROST DONS HIS HELMET, BUT IT WASN'T HIS BEST YEAR WITH McLAREN.

FAR RIGHT IN THE SHADE: SENNA WAS
THE MAIN THREAT TO THE WILLIAMS
DUO, BUT ENDED UP THIRD OVERALL
FOR LOTUS.

Mansell took pole in Hungary and failed to finish, as Piquet won ahead of Senna and Prost.

The circus visited the Osterreichring for the last time and the Austrian Grand Prix was stopped twice by pile-ups on the pit straight before Mansell won easily from Piquet.

Then at Monza Piquet won from Senna and Mansell. Berger took pole in the Portuguese Grand Prix then led most of the way but Prost won. Piquet took four vital points with third, while Mansell collected none. Mansell was back on the title trail after a win at Jerez, ahead of Prost, Johansson and Piquet. Then he won in Mexico, a race split in two by a huge accident from which Arrows' Derek Warwick emerged unscathed. Piquet was second ahead of Patrese.

For the first time since 1976 Japan had its own Grand Prix, this time at Suzuka. And all was resolved when Mansell hurt his back in practice, putting

himself out for the weekend. And neither did he go to Adelaide. Ironically, Piquet didn't score in either race. Instead, victory in both went to Berger. Senna and Johansson followed him home in Japan, and in Australia he led all the way to win from Senna. But the Brazilian's Lotus was disqualified for having illegal brakes, and it cost him second overall to Mansell. Alboreto took second from Boutsen. Just nine cars made the flag, with Jim Clark Cup winner Palmer fourth.

Senna

Shel

BOUTSEN McLAREN ALBORETO MARCH MANSELL MARCH

A McLAREN STEAMROLLER

lain Prost scored more points than McLaren team-mate Ayrton Senna, but the Brazilian claimed the title because they counted their best 11 results and, moreover, had eight wins to Prost's seven.

Their battle began in Brazil, and Prost won. Senna qualified on pole but had to start from the pits, driving the crowd wild as he rose to second. However, he was disqualified for using the spare car. Thus Ferrari's Gerhard Berger was second with Nelson Piquet third for Lotus. So, Senna had a point to prove at Imola, duly leading all the way from Prost.

Senna made a bolt for his apartment when he threw away the lead at Monaco. He was almost a minute up on Prost when his front left wheel grazed the barriers. It was several hours before he re-emerged, by which time Prost had

cruised to victory ahead of Berger and his Ferrari team-mate Michele Alboreto.

Prost beat Senna in Mexico with only Berger on the same lap. In Canada, Senna won from Prost and Boutsen. This trio finished in the same order in Detroit. In France, anxious that Senna was eroding his advantage, Prost won in unusually press-on style with Senna second, suffering from a gearbox problem.

It was wet when the circus moved to Silverstone. So difficult were the conditions that few will remember that Senna won. What people will recall is that Prost quit, saying it was dangerous. Senna was led away by Berger and Alboreto and took 14 laps to hit the front. Nigel Mansell grabbed second for Williams and Benetton's Alessandro Nannini was third, for his first visit to the podium.

Senna won in Germany, again in the

wet, with Prost second. Then Senna led in Hungary before hitting traffic on the main straight. Prost dived down the inside, but he was going too fast. Senna let him slide by, then retook the lead. Senna's fourth win on the trot came in Belgium, putting him into the championship lead. Prost was second, with Boutsen third.

FERRARI UPSETS McLAREN

The car to break McLaren's winning run was a Ferrari, the driver Berger. Amazingly, it was a Ferrari one-two, with Alboreto half a second behind. Better still, the race was in Italy... Prost retired when second, while Senna had a more dramatic departure. On the penultimate lap, he was leading but was struggling with his car's thirst for fuel. He was still five seconds ahead of Berger when he came across the

Williams replacement driver Jean-Louis Schlesser, driving in place of Mansell who had a viral infection. They met at the chicane, and they touched, sending Senna into retirement. The crowd went wild. Eddie Cheever and Derek Warwick were third and fourth for Arrows.

The Portuguese Grand Prix had to be restarted and Senna led the first lap and swerved at Prost when he pulled alongside. But Prost kept his foot in and took

the lead. Senna fell back and Ivan Capelli became Prost's challenger. Driving his March like never before, he was the star of the race, but settled for second, with Boutsen third.

Prost won again in Spain while and Senna was troubled by a computer that gave confusing fuel consumption readings and fell to fourth behind Mansell and Nannini.

Senna stalled on pole in Japan and

fell to 14th. Capelli had the temerity to lead briefly, but Prost regained control. Then Capelli's electrics failed. By this time Senna was up to second, with 31 laps to go. He passed Prost eight laps later, then motored for his eighth win and lift the title. Prost was second with Boutsen third.

Prost completed the year by winning in Australia from Senna and Piquet, bringing an end to the turbo era.

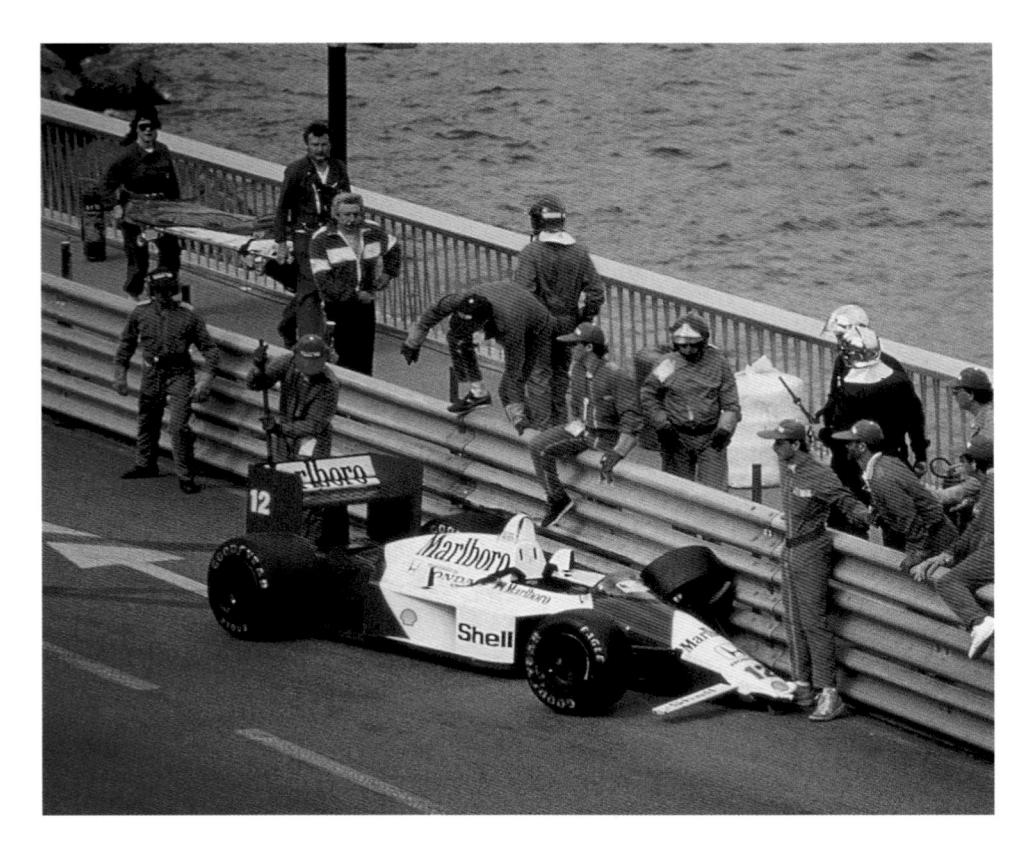

ABOVE HOW NOT TO DO IT: SENNA'S MCLAREN LIES ABANDONED AFTER
HE CRASHED OUT OF THE LEAD AT MONACO AND FLED THE SCENE.

RIGHT HOME WIN: BERGER BROKE THE McLAREN STRANGLEHOLD BY WINNING FOR FERRARI IN THE TEAM'S HOME RACE AT MONZA.

BELOW WATCH OUT: SENNA AND BOUTSEN SET ABOUT PROST ON THE PODIUM AT CANADA.

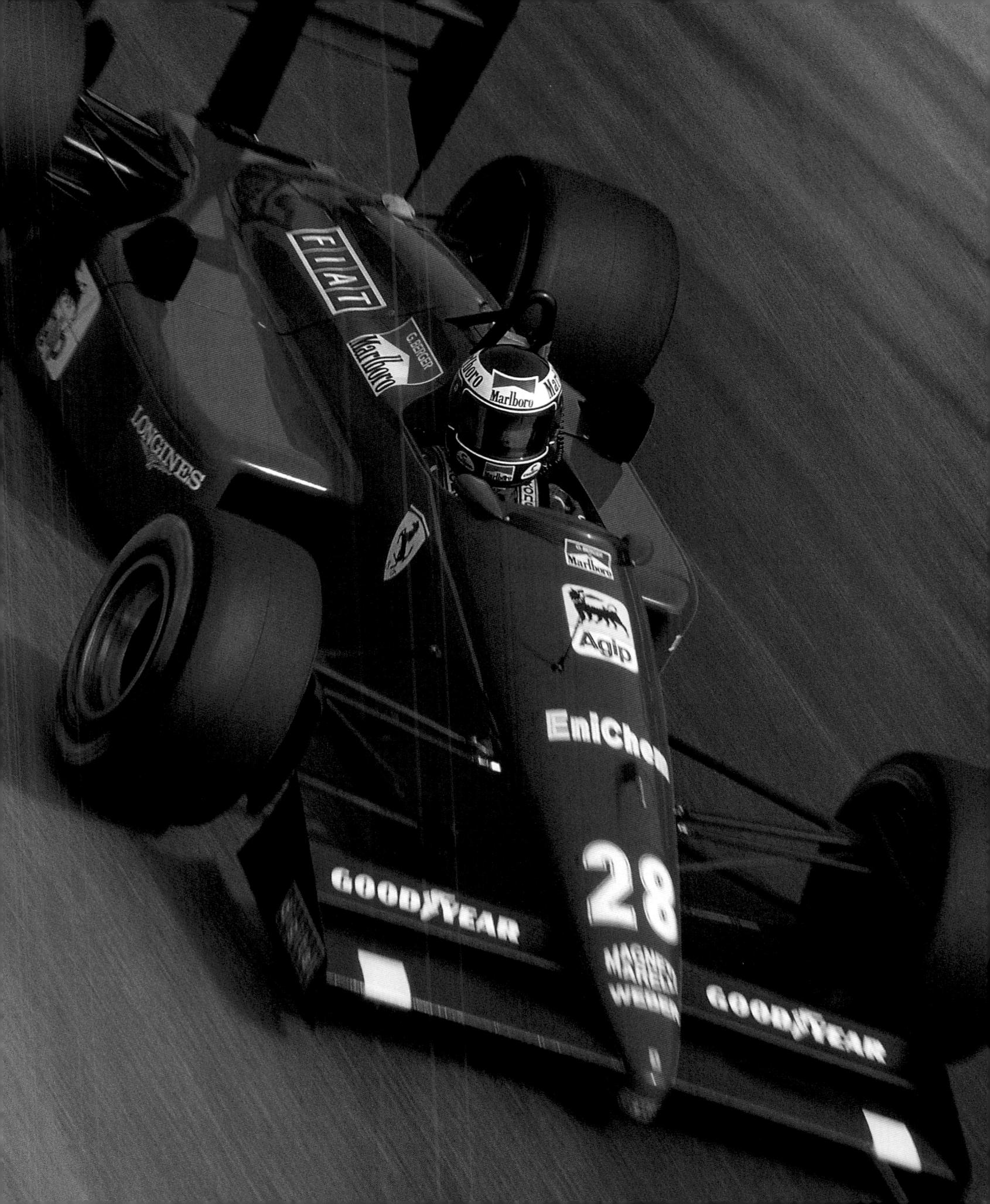

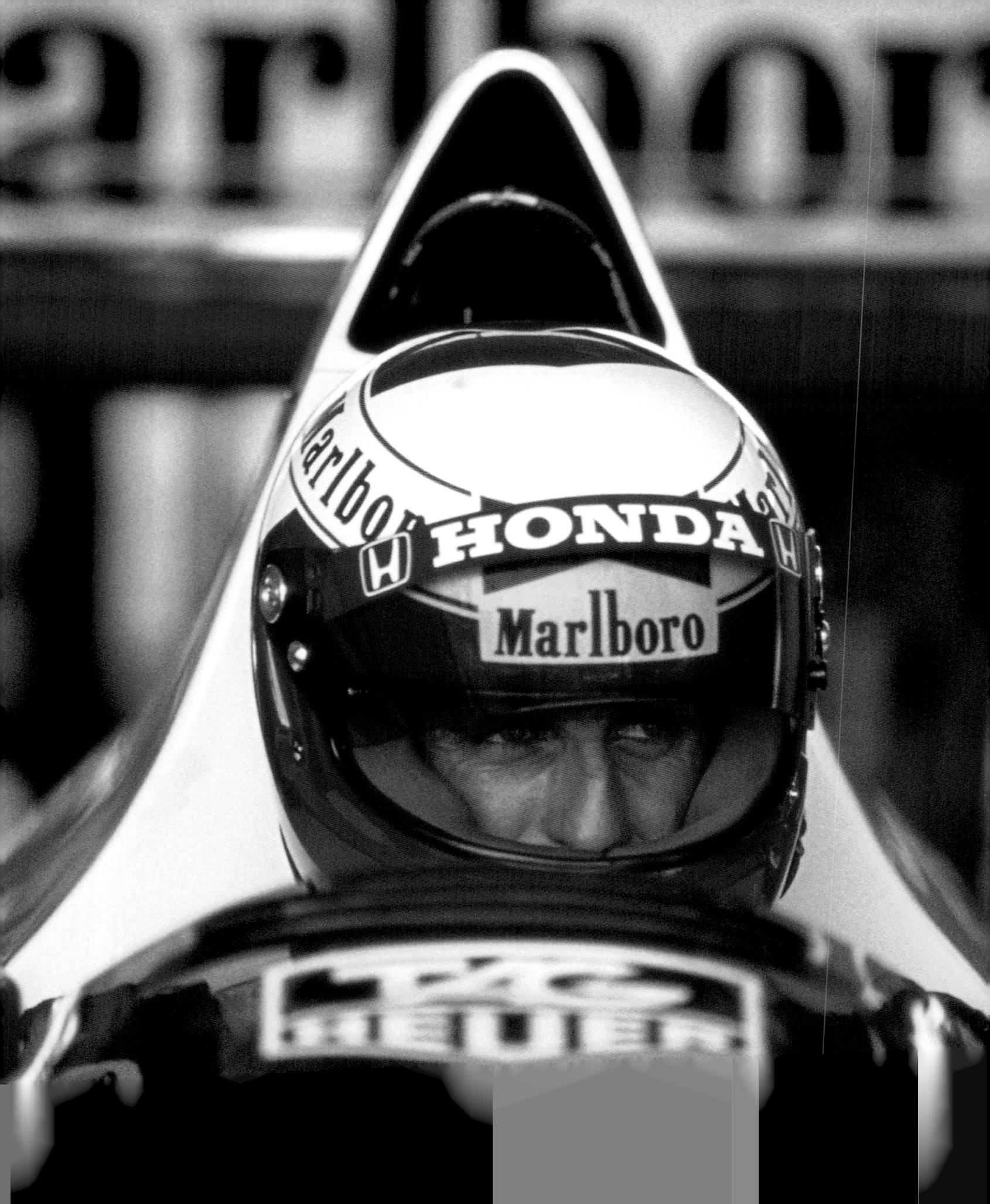

TON PROST BOUTSEN LOTUS NANNINI McLAREN TYRRELL

CLASH OF THE TITANS

he McLaren steamroller rolled on, this time with Alain Prost taking the title to join the ranks of three-time winners. The trouble was that he was no longer speaking to Ayrton Senna...

Senna claimed pole for the first race at Rio from Riccardo Patrese's Williams, but went off at the first corner with Gerhard Berger's Ferrari. Then Berger's teammate Nigel Mansell controlled the race as Prost struggled with a broken clutch. Sadly, AGS's Philippe Streiff broke his neck in testing and remains a paraplegic to this day.

Imola was next, and Senna made no mistake. He led away, but the race had to be stopped when Berger crashed, escaping with a broken rib and minor burns. Prost made the better getaway at the restart but Senna overturned a pre-race

deal and snatched the lead, then motored clear to win.

Senna led all the way to win from Prost in Monaco, while Brabham's Martin Brundle was denied third by an electrical problem, letting team-mate Stefano Modena claim the position. Berger was back in Mexico, but Senna led all the way while Prost chose the wrong tyres and struggled to fifth. Mansell's gearbox failed, letting Patrese and Tyrrell's Michele Alboreto come second and third.

Senna led the US Grand Prix on the streets of Phoenix, but his electrics failed, leaving Prost free to win from Patrese. McLaren domination was interrupted in Canada when Williams's Thierry Boutsen scored his first win after both McLarens retired, Senna losing the lead three laps from the end with engine failure. Patrese was second again.

PROST TAKES CONTROL

Prost led all the way at Paul Ricard as Senna retired on lap one. The first lap of the restart, that is, as Mauricio Gugelmin stopped the race by flipping his Leyton House. Mansell was second despite starting from the pits, while Patrese was third ahead of debutant Jean Alesi who replaced Alboreto at Tyrrell.

Senna spun out of the lead at Silverstone, letting Prost win with Mansell second, despite a puncture.

Senna led from Prost at Hockenheim, but had a slower pitstop and emerged in second. Three laps from home, Prost's gearbox started balking and Senna shot past. Mansell was third. However, Mansell tigered from 12th to win in Hungary, with Senna a distant second, Boutsen third and Prost fourth.

It was wet at Spa, and Senna led all

the way. Prost held off Mansell for second. Then Senna led at Monza until his engine blew, leaving Prost to win from Berger and Boutsen.

In Portugal, Berger won from Prost and Stefan Johansson's Onyx. Mansell overshot his pit, reversed and was black flagged. This he ignored and then Senna closed the door on him and both spun off. Mansell was fined \$50,000 and was given a one-race ban, so he

took no part in the Spanish Grand Prix. This left Senna to win with Berger second and Prost a cautious third.

Prost and Senna clashed at Suzuka to settle the World Championship, this time in Prost's favour. Their contact came with seven laps to go and saw Senna dive up the inside at the chicane. Prost refused to cede and they spun. Prost retired, but Senna was push-started to get

his car out of a dangerous position, pitted for a new nose and still was first home. But he was disqualified for external assistance, giving Benetton's Alessandro Nannini his first win. Patrese and Boutsen finished second and third.

Senna was well clear in Adelaide, but was unsighted in the wet and ploughed into Brundle's spray-hidden car, leaving Boutsen to win again.

Below WATCH OUT: MANSELL LOSES HIS REAR WING AS GUGELMIN FLIPS HIS LEYTON HOUSE AT PAUL RICARD'S FIRST CORNER.

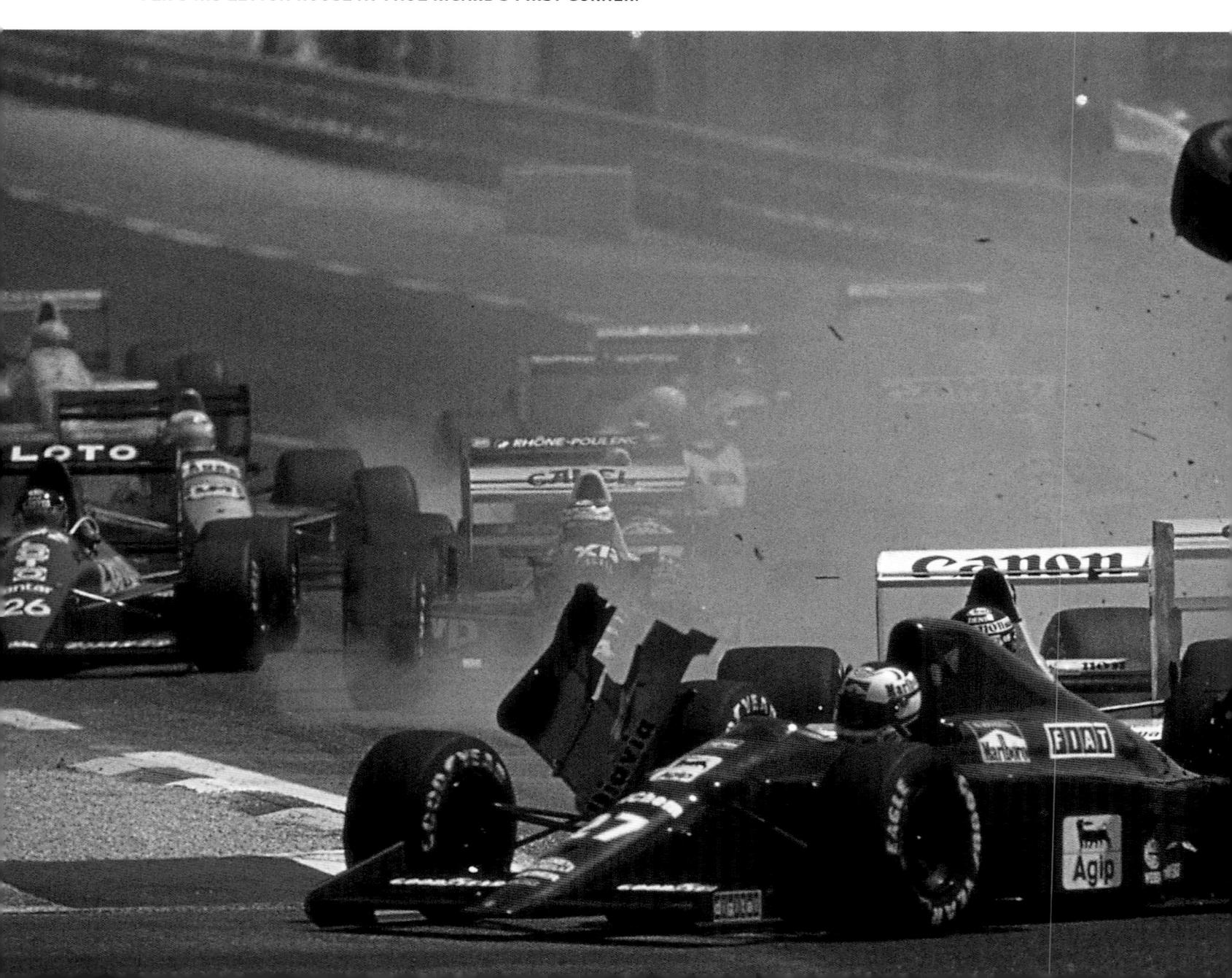

FAR LEFT INSTANT
IMPACT: MANSELL
WON FIRST TIME OUT
FOR FERRARI IN
BRAZIL.

LEFT STRING OF
SECONDS: PATRESE
WAS CONSISTENT FOR
WILLIAMS.

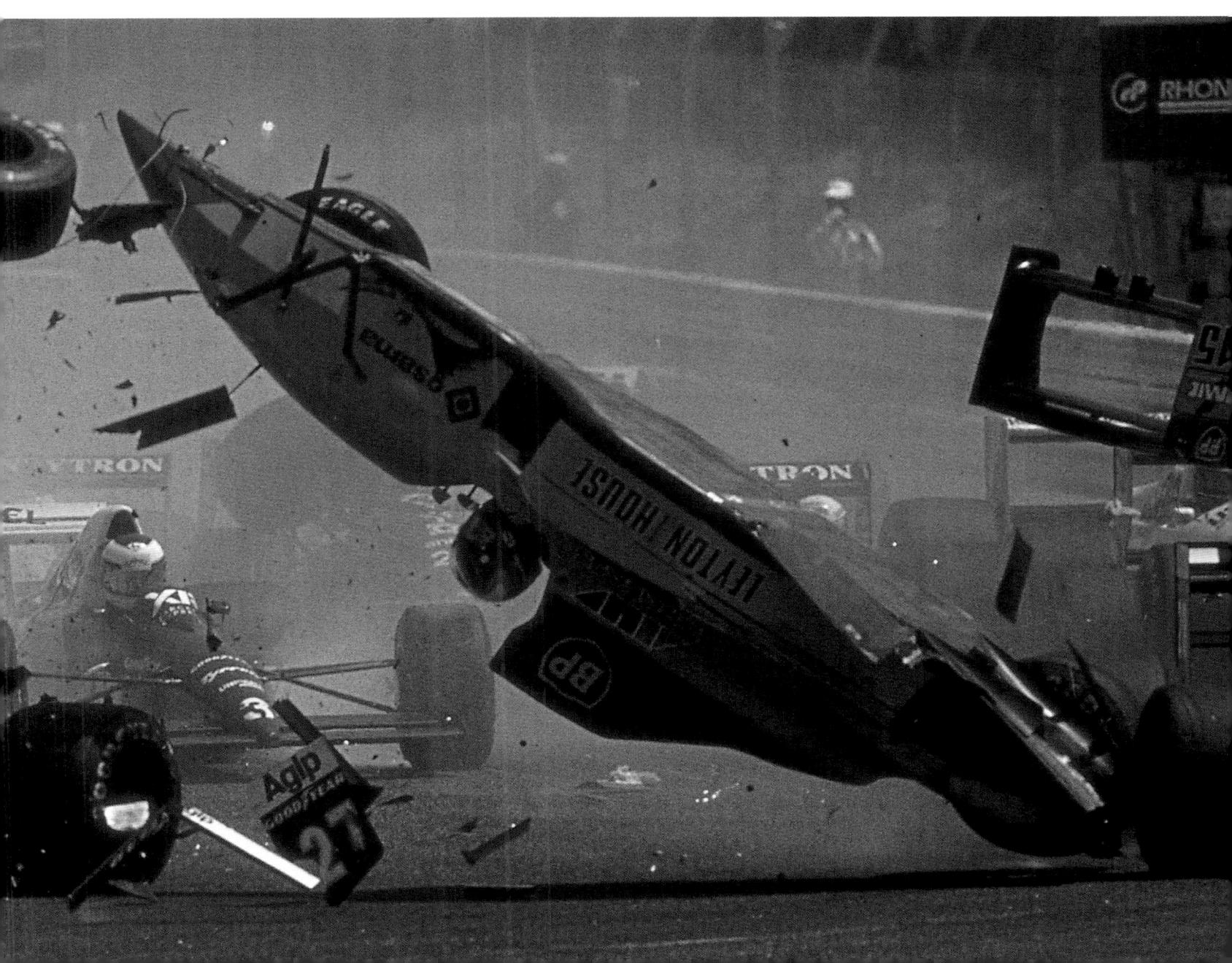

THE NINETIES

DAVID COULTHARD

Honours: 3RD 1995, 1997, 1998

Grand Prix record: 74 STARTS, 4 WINS

The prevalence of drivers in Formula One who began their competition days racing karts started to increase in the 1980s. And, by the 1990s, literally only Damon Hill and Eddie Irvine had not spent their early years aboard a kart. David Coulthard, on the other hand, was practically raised on one before rocketing through racing's junior ranks with spectacular ease. It was no surprise when he joined the ranks of Grand Prix winners.

However, David wasn't simply chosen to offer an overview of Formula One in the 1990s as he's a former kart racer, successful in cars and British, but also because he is one of the most erudite drivers of recent years and has also spent his career thus far driving for two of the sport's most successful teams: Williams and then McLaren, winning Grands Prix for both and placing third in the final standings in 1995, 1997 and 1998.

David came into Formula One as a direct result of one of its darkest weekends in recent memory, stepping up from the Williams test team to fill the seat left vacant after team leader Ayrton Senna was killed in the San Marino Grand Prix. After a one-race gap, David made his debut at the Spanish Grand Prix: "I remember being very relaxed before my first Grand Prix, completely pressure free as I knew everybody in the team. Mind you, I hadn't driven the car before, even though I was test driver, as it was early in the season and Senna and Damon Hill had done all the testing. Added to this, the teams boycotted Friday morning practice while they debated how the technical regulations

would be changed in the wake of Senna's accident, so the first time I drove the car properly was to go out for my 12 laps of qualifying that afternoon... I remember that as an interesting time. Nevertheless, I felt comfortable in the whole pressure situation of the weekend.

"It was an eye-opener, though, just how hard you have to drive in the race, as relative to other formulae it's a completely different pace and this is the only thing nowadays that's difficult for a Formula 3000 driver when they step up to Formula One. It's a sprint from start to pit stop and then again to the next pit stop or the finish. This is not to suggest that you don't drive hard in other formulae, it's just that Formula One is so much more physical. It's a whole new level of pressure and physical demand on the body. As the tyres change, you have to alter the way you drive. This makes it a different situation today in 1999 to when I started in Formula One in 1994 because slick tyres tended to have a good performance initially and then drop away progressively throughout the run. Today's grooved tyres can offer a lack of performance

DAVID COULTHARD

to start with until the grooves open up, picking up balance as they wear, rather like a Formula Ford tyre used to be. And this means that your lap time can thus be just as good at the end of your stint as at the beginning."

Ninth on the grid at that race at Barcelona's Catalunya circuit, David shot up to sixth before the first corner on the opening lap. So, David took to Formula One like a duck to water, but he had had the good fortune to break into Formula One with a team that had won the world title for the previous two seasons, a matter he readily acknowledges: "Looking at the state of competitivity in Formula One when I started and now, in 1999, and I don't think that it's changed much as there has always been a large difference

However, he wasn't to finish, as electrical problems delayed him and then led to his retirement. Meanwhile, team-mate Damon Hill passed Michael Schumacher's Benetton – which was stuck in fifth gear – to give Williams a much-needed boost after Senna's death.

from the front of the grid to the back. However, I think that this is different to the way that it was in the 1950s. You look at the 'good old days' that people talk about, 'when men were men' and there were those beautiful racing cars, but they had front-engined cars

DAVID COULTHARD

racing against rear-engined cars with an even bigger gap in lap times than we have in the 1990s."

Fortunate to have spent the mid and late 1990s with frontrunning teams, David also made the most of his opportunities, although kept in check by being number two at first to Hill at when we raced on slick tyres as I don't feel that secure in the car now. It's the way that Formula One has been driven, into using hard grooved tyres. And it would appear that we're being driven towards using a uni-tyre in the future, that is to say one that will be used in both dry and wet conditions. I certainly hope this

Williams and then seemingly to Mika Hakkinen at McLaren. However, for all the proximity to success, David is also aware of the proximity of danger: "Safety in Formula One was obviously a massive issue when I arrived after Senna's death," David explains. "But I think that in many cases there was too big a reaction, if there ever can be such a thing, in the way that some of the tracks were changed. Nonetheless, reducing speeds and improving run-offs does make it safer. It is safer, but it's always going to be dangerous as you're travelling at high speed with the potential to hit walls. Also the fact that the driver's head is still uncovered, which is something that I would like to see more protected, not just from a side-impact but also from a rolling impact as Alexander Wurz had in the 1998 Canadian Grand Prix. If he'd done that on top of a barrier, it could have been a very different story.

"The cars are actually more difficult to drive now. In fact, I'd say that I'm more aware of barriers and run-off than I ever was

LEFT WINNING TOOLS: THE 1998 McLAREN-MERCEDES MP4-13.

doesn't happen until I've finished with Formula One..."

Talking of changes to the regulations, David finds little difficulty in naming the principal technical development during the 1990s: "The greatest change in the cars during my time in Formula One has definitely been when the rules changed and the cars went from wide track to narrow track and from slicks onto grooved tyres. Aerodynamically, even though they've taken away wing size and cut floors, the designers have found ways not to create more downforce but to make the cars more efficient. And our lap times have improved. The brakes have remained very similar. However, they have taken away a lot of the gizmos so that you don't have automatic gear change now or anti-lock braking, and they've taken away the servo-assistance. It's a shame, as they were fun things to play with. It's back to a purer car if you like, but the relative performance of all the cars remains the same. It's probably just a little bit cheaper and so all the teams can afford the performance parts. However, the big teams will then argue that this restricition on technology means that they have to spend more on research and development in order to try and find new ways to get an advantage.

THE NINETIES

"If I have to pick a car that I enjoyed in my spell in Formula One for its level of technology and performance, and also in terms of being a pleasure to drive, it has to be the 1995 Williams FW17 that I drove to my first win. Despite the fact that we didn't win the championship that year, it was a great car relative to the opposition in every way, such as car performance, engine performance. Mind you, that was back in the days when you could still outdrag a Minardi on the straights... Nowadays, that's much more difficult with the narrower cars as you get less tow.

"Clearly, the 1998 McLaren MP4-13 was built to a different formula, offering a completely different driving sensation. So, this is why the 1995 Williams remains my favourite, although in terms of relative performance to the rest of the field, the combination of the MP4-13 chassis, the Mercedes and the Bridgestone tyres offered the greatest advantage."

When asked to consider his rivals, David is equally sure of his opinion: "Alain Prost was always my favourite driver. Take the fact that he was able to take a year off and then come back and win the World Championship in 1993. That was pretty impressive. You could say that he had the best car, but that's all part of the business: getting yourself into the best car.

"Senna was outstanding, but it was unusual to be part of a team that has suffered the loss of a driver. I had come across death before, in the year after I left Formula Three, when I was watching the Formula Three race at Thruxton in which Marcel Albers died right in front of me. Going to the funeral and everything surrounding it was a bit strange, but it gave me my first experience of this being a dangerous sport. Then, being involved with Williams after the loss of Senna was the second.

"Looking at my contemporaries, Michael Schumacher has had a pretty good record in Formula One... He's always been battling for the title, always been the thorn in the side of any current frontrunner, whether it be Damon Hill in his time, Jacques Villeneuve or Mika Hakkinen. I have had some incidents with Michael, but they're all sorted out now.

"Michael will be remembered for the particular image that he has, while Jacques Villeneuve will be remembered for his unusual character and style. And Mika Hakkinen will be remembered for the fact that he fought back from that life-threatening accident in Australia at the end of 1995 and yet fought back to become World Champion.

"Actually, there are also lots of characters around in Formula One. There's Damon, Eddie (Irvine), Johnny (Herbert) and others, all with their own personalities, some of whom will be remembered in the future and others who won't. I just hope that I'm one of the ones who gets remembered as that means that I will have won a few more races and the championship."

So, that was what David thought of his rivals. But what about the teams?

"Ferrari definitely has a mystique about it," says David. "It's known throughout the world, with McLaren the next best known, then Williams and the rest. Ferrari has a more glamorous and sexy image than McLaren, just because of the road cars. After all, even those who don't know about the racing side will know about Ferrari road cars. If they had to pick a fast car, they would probably pick Ferrari, and we'd probably all like to have a Ferrari parked in our garage. For those who are enthusiasts of the sport, then it's

the mystique of Enzo Ferrari with his dark glasses and the team's Maranello base and everything that is so attractive.

"When you're on the inside of the sport, though, the bubble gets burst as you know that it comes down to the individuals rather than the team's image. When considering whether I would like to drive for Ferrari, I don't treat them as a special case and would say that one has to consider each team individually and whether it would offer you the best opportunity that year for success. However, it would be unusual for me to imagine not driving for a British team, as I have every year since I started. I think largely that the British mechanics have the work ethic and that everything is the best available. Clearly, though, Ferrari is a well organised and well structured team now with all the 'foreign' influence in the key positions such as Jean Todt, Ross Brawn and Rory Byrne, and they are McLaren's main rivals right now. Maybe, too, they will be a team that I will drive for."

Talking of the 2000 World Championship and beyond, David is confident that Formula One will advance with continued strength and purpose into the third millennium: "I consider that Formula One will always be popular and that its popularity will continue to grow. After all, most people drive and love doing so. But I just thing that as long as it's perceived as the fastest form of car racing with the best technology and the best engineers supported by the level of investment that makes it stay at the forefront of automotive technology, then it will retain its appeal. If that's taken away by fitting silencers because of noise restrictions and narrow grooved tyres as that's what there used to be 'when men were men', then it will lose something. To me, the noise and the smell, and the aggressive look of the car is definitely part of the appeal of Formula One."

While the sport's powers-that-be continue to search, ineffectually it seems, for ways of improving the spectacle, David isn't so sure that they need to do anything artificial to ensure that Formula One contains more overtaking. He is confident that it will continue to stand on its own two feet either with or without it: "When was the last time that you watched a really good Grand Prix? It was years ago, back when the cars had wings. I was watching a video of Jackie Stewart winning the 1969 Italian Grand Prix at Monza by a few inches (from Jochen Rindt, Jean-Pierre Beltoise and Bruce McLaren), It was great 'Formula Ford' dicing and made doubly fantastic as it was Formula One and therefore the cars were the fastest around at the time. But while we have aerodynamics influencing the cars - and not that I'm trying to have it taken away as I enjoy the physical effort of driving the cars - the cars were well balanced if you consider grip to power back then. Take it today, though, and we don't have enough enough grip level to the power and the downforce. So, we need to change this to improve the racing. However, this really doesn't seem to bother people. You get one overtaking manoeuvre per race and people talk about it. I've read that it's the anticipation of a goal that makes football so exciting, whereas in basketball you get hundreds, but I guess that why Formula One remains so popular: it's the anticipation..."

RIGHT AN EYE ON SUCCESS: COULTHARD FOCUSES ON THE TRACK AHEAD IN HIS PACE-SETTING 1998 McLAREN.

KENWO

PIQUET FERRARI BOUTSEN McLAREN PATRESE LOLA

SENNA PLAYS ROUGH

t was Ayrton Senna versus Alain Prost again. As in 1988, Senna took the spoils. But at one time it looked as though he wasn't going to be allowed to start the championship at all.

The trouble between Senna and the authorities stemmed from his disqualification from the 1989 Japanese Grand Prix. He accused FISA President Jean-Marie Balestre of ruling in Prost's favour and was refused entry for 1990. It was only with the season approaching that Senna was readmitted.

Kicking off at Phoenix, Senna tracked down Jean Alesi's Tyrrell, took the lead, was re-passed by the Frenchman, then pulled in front for good. Thierry Boutsen was third in his Williams.

Senna had been set for his first home win at Interlagos when Satoru Nakajima collided and forced him to pit for a new nose, confining him to third behind Prost and Berger.

Williams's Riccardo Patrese won at Imola, ending a seven-year drought. Senna led from pole but a stone jammed in his brakes and he spun off, while Prost was classified fourth behind Berger and Benetton's Alessandro Nannini.

Senna won at Monaco, chased home by Alesi. Prost ran second, but retired with Berger finishing third. Berger jumped the start in Canada and was given a one-minute penalty. With rain falling, McLaren called Berger in and then Senna. Berger was faster and Senna waved him past. Yet, charge as he did, Berger could make up only enough time for fourth, behind Senna, Nelson Piquet's Benetton and Nigel Mansell's Ferrari.

Senna led in Mexico, but had a puncture, handing the race to Prost. Mansell

and Berger banged wheels around the banked Peralta corner, with Nigel on the outside, but Mansell held on to complete a Ferrari one-two.

CAPELLI PRODUCES A SHOCK

Prost won at Paul Ricard, but Ivan Capelli led for 45 laps for Leyton House, a team that had hitherto not scored. Team-mate Mauricio Gugelmin ran behind Capelli until his engine blew. Then Prost took the lead three laps from home with Capelli second.

Mansell stole the headlines at Silverstone by announcing his retirement. Victory on the day went to Prost, once Mansell had retired with gearbox problems and Boutsen snatched second, with Senna third after a spin. Germany was next, and it was Senna's turn to win after struggling to re-pass Nannini who

ran a non-stop strategy. Senna was pipped by Boutsen in Hungary, then beat Prost to win at Spa.

Derek Warwick's Lotus destroyed itself against the barriers at the end of lap one at Monza. Amazingly, he ran back to the pits and climbed into the spare for the restart. For the records, Senna won from Prost.

Mansell left his mark in Portugal by not assisting his team-mate. He chopped across at the start, causing Prost to lift off and fall to fifth. In an instant, the way was clear for Mansell to race untroubled to win from Senna and Prost.

Martin Donnelly was lucky to survive

at Jerez when his Lotus disintegrated on impact with the barriers in qualifying. This time Prost won, with Senna retiring.

Senna and Prost clashed again at Suzuka, this time giving Senna the title. Then the quarrels began. Meanwhile Piquet led home a Benetton one-two ahead of Roberto Moreno who had replaced Nannini after the latter had severed a hand in a helicopter crash.

Benetton won again in Australia, through Piquet, with Mansell and Prost second and third. And, by dint of having scored two wins to Berger's none, Piquet claimed third overall.

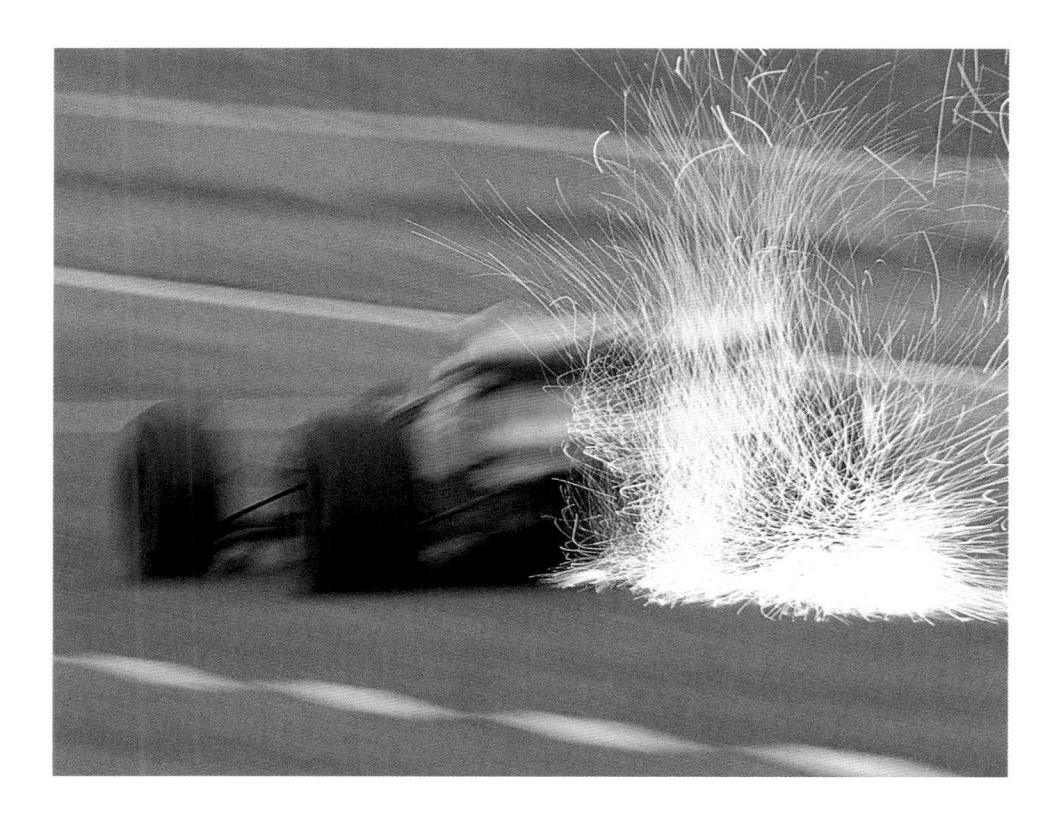

LEFT FAITHFUL RICARDO: PATRESE BACKED UP THIERRY BOUTSEN AT WILLIAMS TO RANK SEVENTH OVERALL. ABOVE FORMULA ONE SPECTACLE:
TITANIUM SKIDPLATES GAVE
PHOTOGRAPHERS SOME
STUNNING OPTIONS.

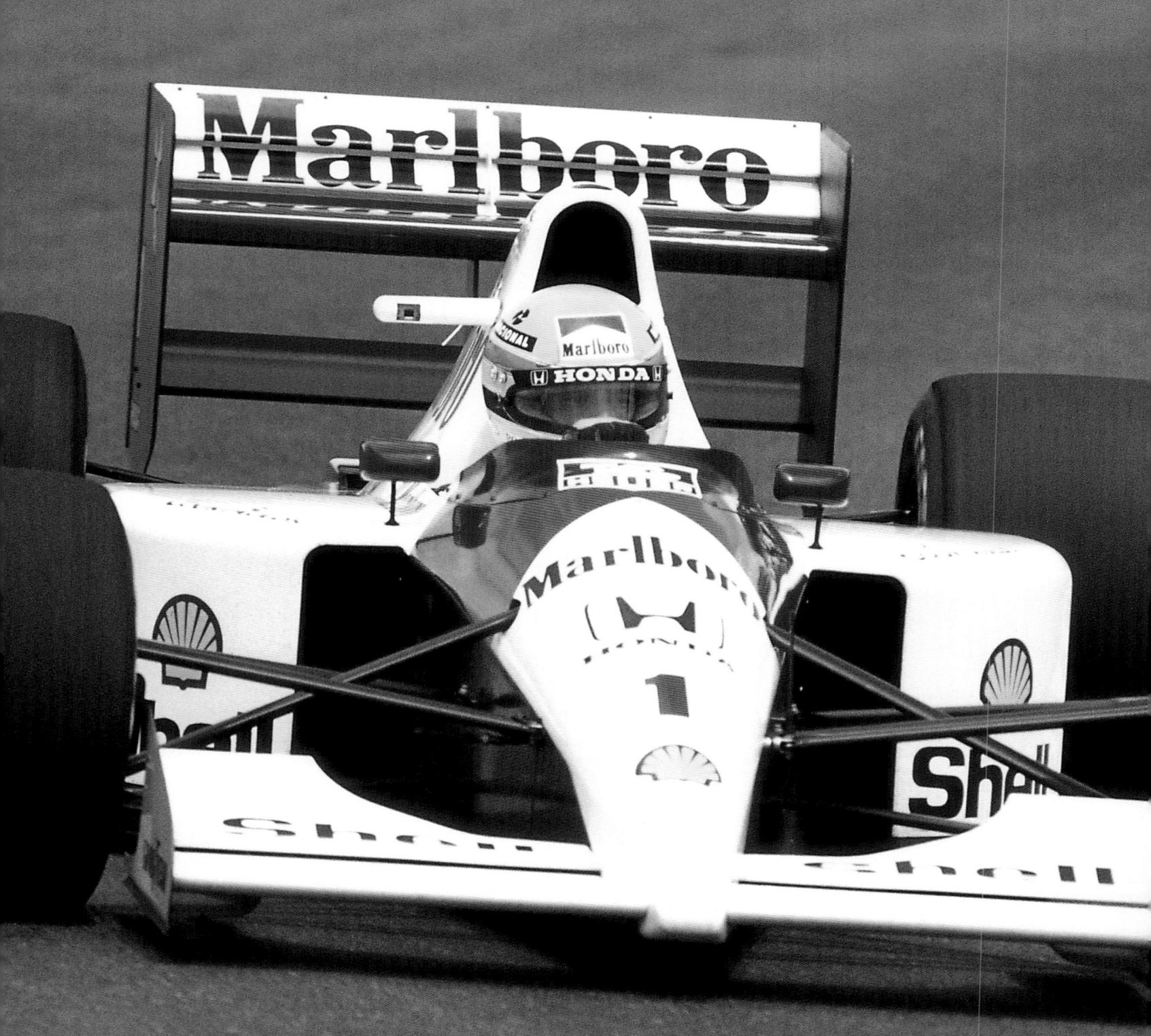
McLAREN BERGER BENETTON PROST TYRRELL PIQUET

SENNA LEADS FROM START

yrton Senna and McLaren made it two titles in succession, while Nigel Mansell elected not to retire but to race for Williams, offering a strong challenge.

Senna won the first four races. The first was at Phoenix, when he easily beat Alain Prost's Ferrari and Nelson Piquet's Benetton.

In Brazil, Senna beat Riccardo Patrese's Williams with McLaren team-mate Gerhard Berger close behind. Imola was easier, with only Berger on the same lap. Patrese led, but was slowed with engine problems, while Mansell went off after colliding with Martin Brundle's Brabham and Prost fell off on the parade lap.

Senna won at Monaco, and the closest anyone got was Stefano Modena with his best drive. But his Tyrrell's engine blew, also accounting for Patrese who went off on its slick, so Mansell claimed second.

Mansell failed within sight of the line in Montreal. He was waving to the crowds, but his engine died and Piquet nipped by. Modena finished second, to atone for Monaco. Patrese hit the top in Mexico after a late-race challenge from Mansell. Senna followed them home, having recovered from flipping his McLaren in qualifying.

MANSELL COMES GOOD

Mansell took his first win of the year in the French Grand Prix, held at Magny-Cours for the first time. He swapped the lead with Prost, but was in front when it counted. Senna resisted a late challenge from Alesi for third. Mansell repeated his success at Silverstone, triggering wild scenes. Senna should have been second, but he ran out of fuel, letting Berger and Prost past.

Senna's points lead was reduced further at Hockenheim when Mansell made it three in a row. Patrese made it a Williams one-two ahead of Alesi. Senna ran out of fuel on the last lap again, losing fourth place.

With his points advantage over Mansell down to eight, Senna was delighted to win in Hungary. Indeed, with the power circuits ahead, it was to be his last likely victory for a while. Mansell pushed hard, but could find no way by on this narrow track.

Spa favours those with power, such as the Renault in Mansell's Williams. So it was a surprise to see Senna win after being outpaced by Mansell and then by Alesi, but both retired. Andrea de Cesaris was heading for second for Jordan, but his engine gave up. His team-mate that day was Michael Schumacher, making

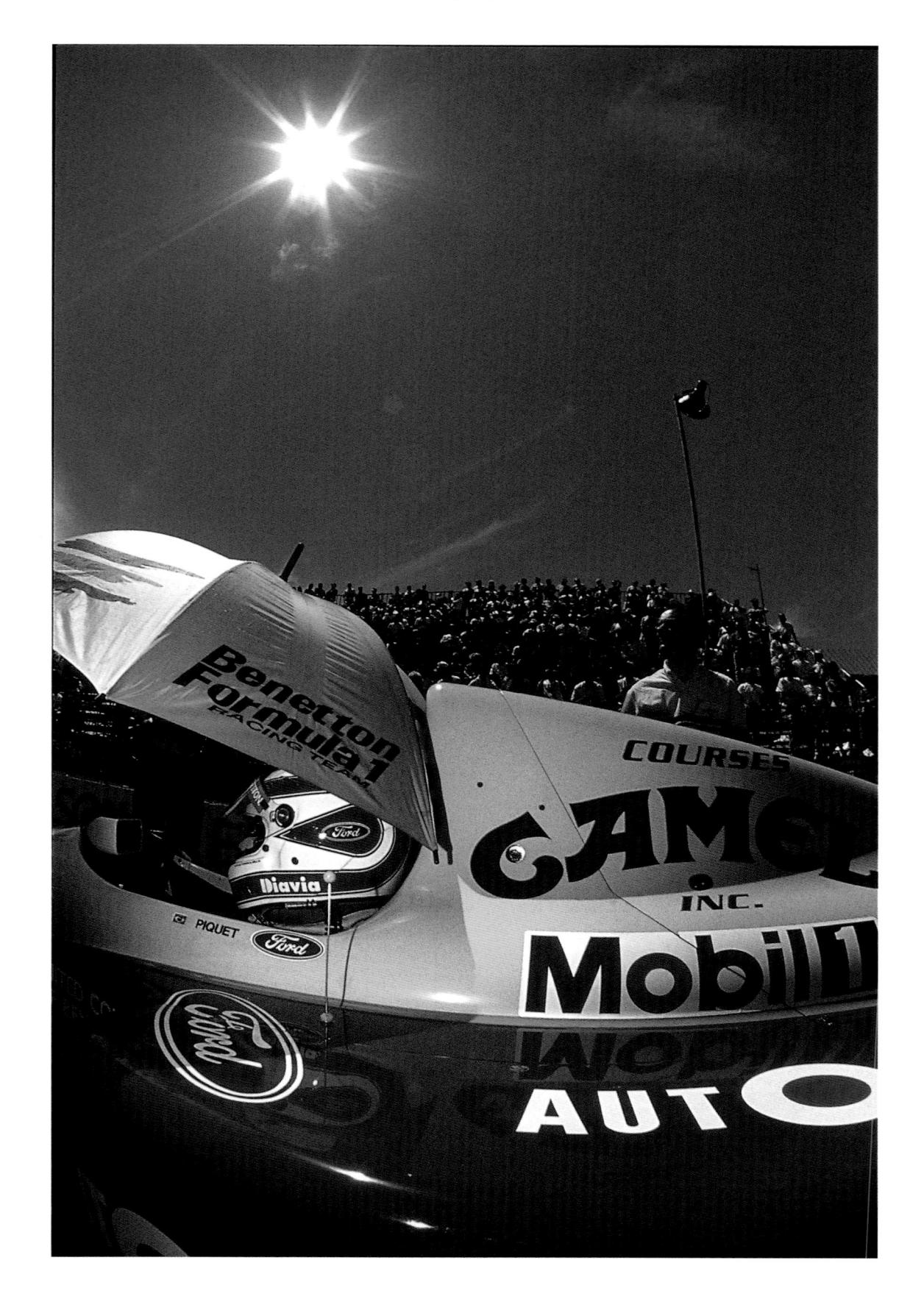

LEFT KEEPING HIS COOL: PIQUET KEEPS THE SUN OFF HIS HEAD BEFORE RACING TO HIS ONLY WIN OF 1991, IN CANADA.

BELOW LEFT TAXI! TAXI!: SENNA HITCHES
A LIFT WITH WINNER MANSELL AFTER
RETIRING IN THE BRITISH GRAND PRIX.

BELOW RIGHT CENTRE OF ATTENTION:
EVERYONE WANTED A SLICE OF
MANSELL'S TIME AT SILVERSTONE. HE
DIDN'T DISAPPOINT.

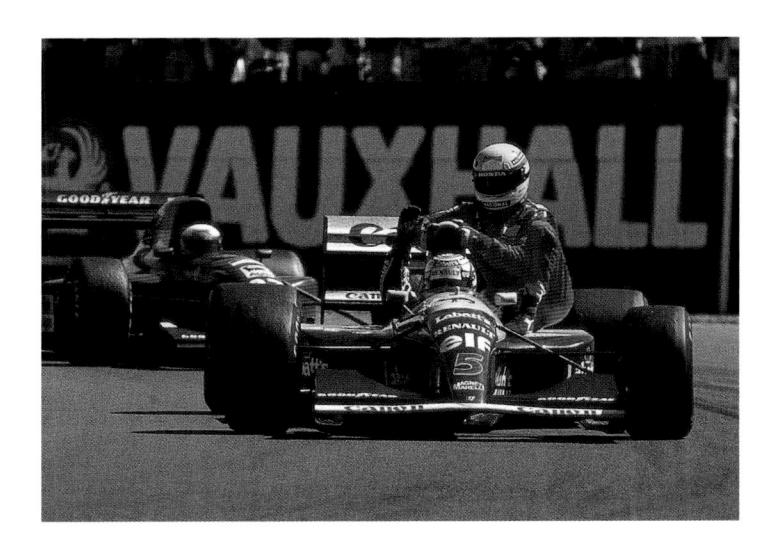

his debut. He outqualified de Cesaris, but was out on lap one. However, we would hear a great deal more from him.

Mansell won at Monza to stay in the title chase. Senna led, but was eating his tyres in an attempt to stay ahead of Patrese then Mansell, so had to settle for second. Schumacher scored his first points for fifth place.

Patrese won again in Portugal, but this was handed to him when Mansell lost a wheel leaving the pits. The wheel was reapplied, but in an illegal place, so he was disqualified. Second place for Senna put him 24 points clear with three races to go. Giving his best, Mansell won at Barcelona from Prost and Patrese with Senna fifth. Berger won in Japan, albeit only after Senna let him past on the final lap. By then he no longer needed the extra four points as the title was already his, as Mansell had spun off. Sadly,

Senna took the occasion of his third title to attack outgoing FISA President Jean-Marie Balestre, raking over old ground.

Luckily, the season was brought to a happier end in Australia when Senna starred in torrential conditions in a race that was halted after 14 laps. There was further drama, as Prost had been fired by Ferrari. He was going anyway, tired of the politics. In view of the conditions, he probably wasn't disappointed.

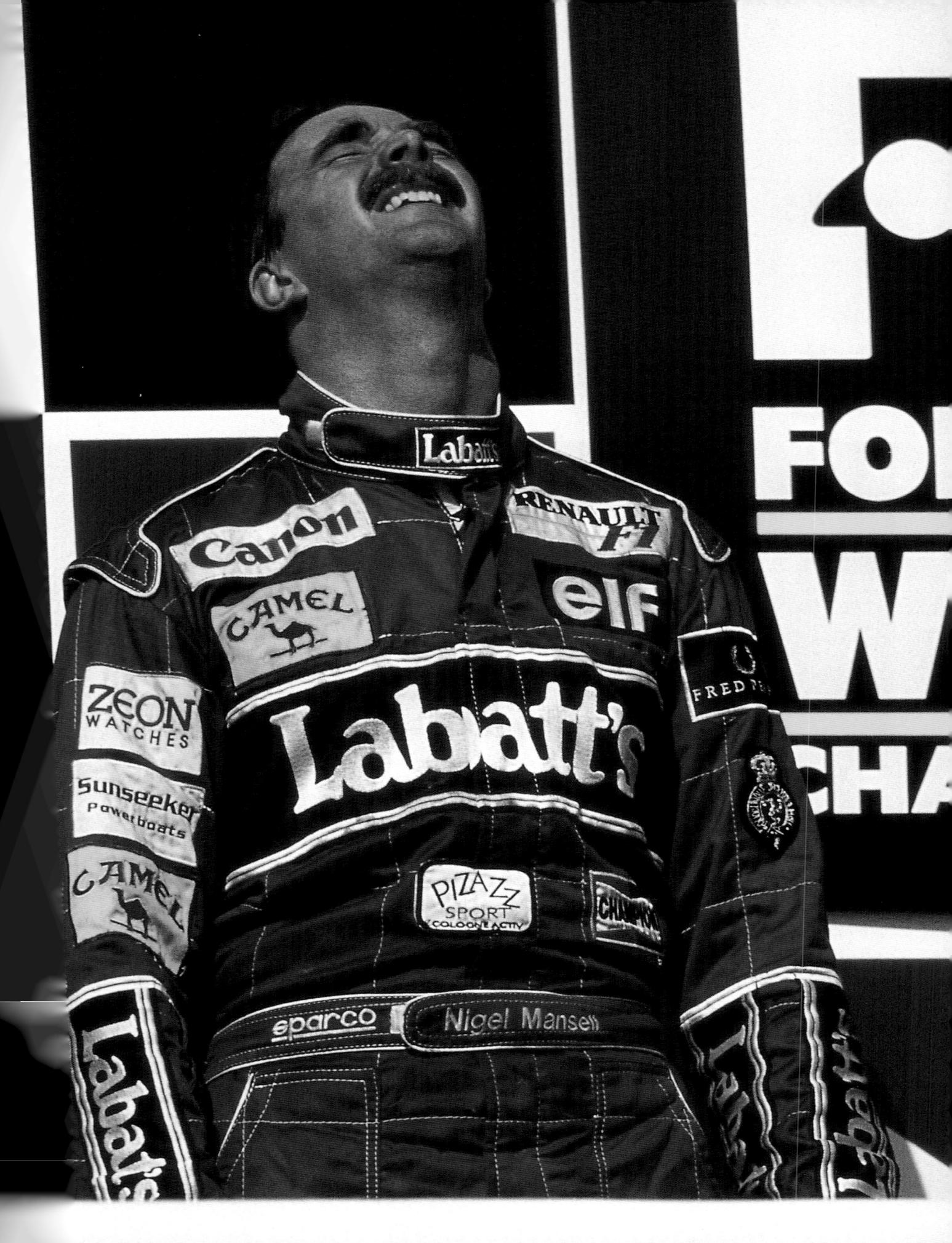

THE BRITISH BULLDOG

Mansell showed the world he could be a champion, not just a melodramatic challenger. And seldom has any driver dominated to such an extent.

Mansell planted his Williams on pole at Kyalami and led every lap from teammate Riccardo Patrese. It was the same story in Mexico, with Mansell leading home a Williams one-two. Benetton's Michael Schumacher finished third. Mansell and Patrese were again first and second at Interlagos next time out, again with Schumacher third.

With Mansell dominant at Barcelona, Patrese spun out of second to elevate Schumacher. Jean Alesi brought his Ferrari home third.

The fifth of Mansell's wins came at Imola, with Patrese taking his fourth sec-

ond place. Ayrton Senna fought his way around to third, but his input had been so great that it was 20 minutes before he could climb out of his McLaren.

Mansell's run came to an end in Monaco. But he was only 0.2 seconds from victory when he crossed the finish line after a monumental struggle to repass Senna after pitting when one of his tyres deflated.

Canada provided a surprise as Gerhard Berger won for McLaren ahead of Schumacher. Senna had led, but his electrics failed, by which time Mansell had spun out of second, elevating the Austrian.

The French Grand Prix should have heralded victory for Patrese, but it was halted by rain and he lost out on the restart as team orders forced him to wave Mansell past. Benetton's Martin Brundle finished in third place.

Mansell didn't just beat the opposition at Silverstone, he demoralized them with pole, fastest lap and victory by 40 seconds. Patrese was second and Brundle third after Senna pulled off. Mansell won again in Germany ahead of Senna, with Schumacher finishing third ahead of Brundle.

Mansell hoped to wrap up the title in Hungary with another win, but had to play second fiddle to Senna. Even so, there was typical drama when he had a puncture at three-quarters distance and had to fight his way past Berger for second. It was enough, though.

SCHUMACHER'S FIRST WIN

Schumacher scored the first of what would be many victories by winning in Belgium with a lucky break. Everyone

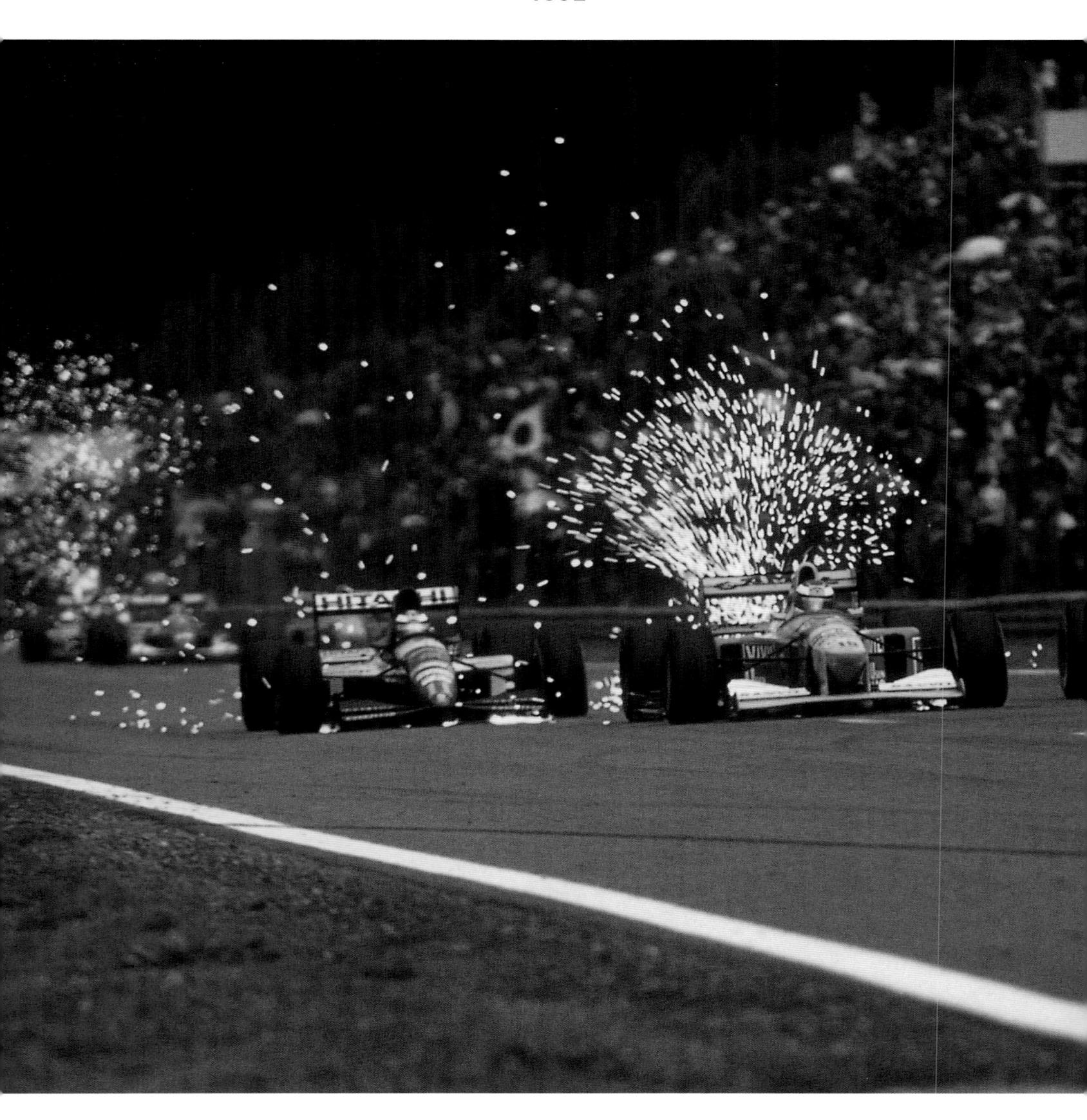

started on slicks in light rain. But the rain worsened and only Senna fought on with slicks, falling back as others pitted. If the rain had stopped it would have been a masterstroke, but it didn't and Senna would finish fifth. Schumacher was third, but ran wide and dropped behind Brundle. In an instant he noticed his team-mate's tyres were blistering and, reckoning his were doing likewise, dived into the pits. It proved the optimum moment and put him in the lead ahead of Mansell and Patrese by the time they too had pitted.

The Italian Grand Prix was overshadowed by two stories. Firstly, Mansell announced his retirement from Formula One. Secondly, Honda was pulling out, too. Mansell led, then ceded the lead so Patrese could win on his home patch, but both hit gearbox problems. Mansell retired, while Patrese limped home fifth as Senna won the race from Brundle and Schumacher.

Mansell was back to winning form at Estoril, taking a record-breaking ninth win in a season. He was nearly caught out by debris after Patrese suffered a huge accident when he clipped Berger's McLaren. Berger continued to finish second, while Senna made it past Brundle for third.

Mansell played hero at Suzuka and waved Patrese into the lead, but his engine blew and so Berger and Brundle completed the top three.

The season ended in Adelaide with Berger grabbing victory ahead of Schumacher and Brundle in a race that lost Mansell and Senna in a shunt when the Brazilian was attempting to take the lead.

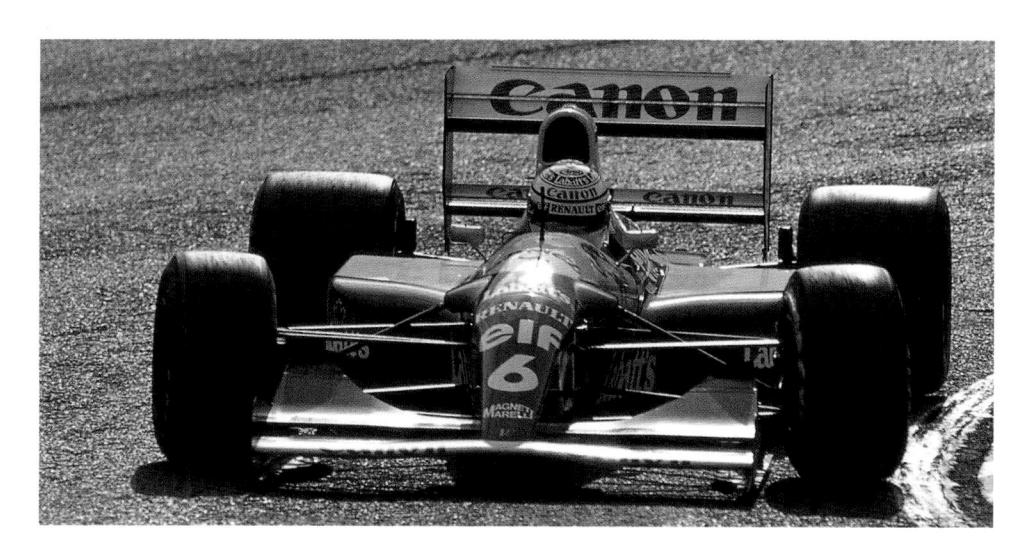

ABOVE TOKEN VICTORY: PATRESE WAS WAVED THROUGH BY TEAM-MATE MANSELL AT SUZUKA FOR HIS ONLY WIN OF 1992.

LEFT KICKING UP THE SPARKS:
SCHUMACHER'S DRIVE TO VICTORY
WAS THE HIGHLIGHT OF THE BELGIAN
GRAND PRIX. HERE HE SPLITS
HAKKINEN AND ALESI.

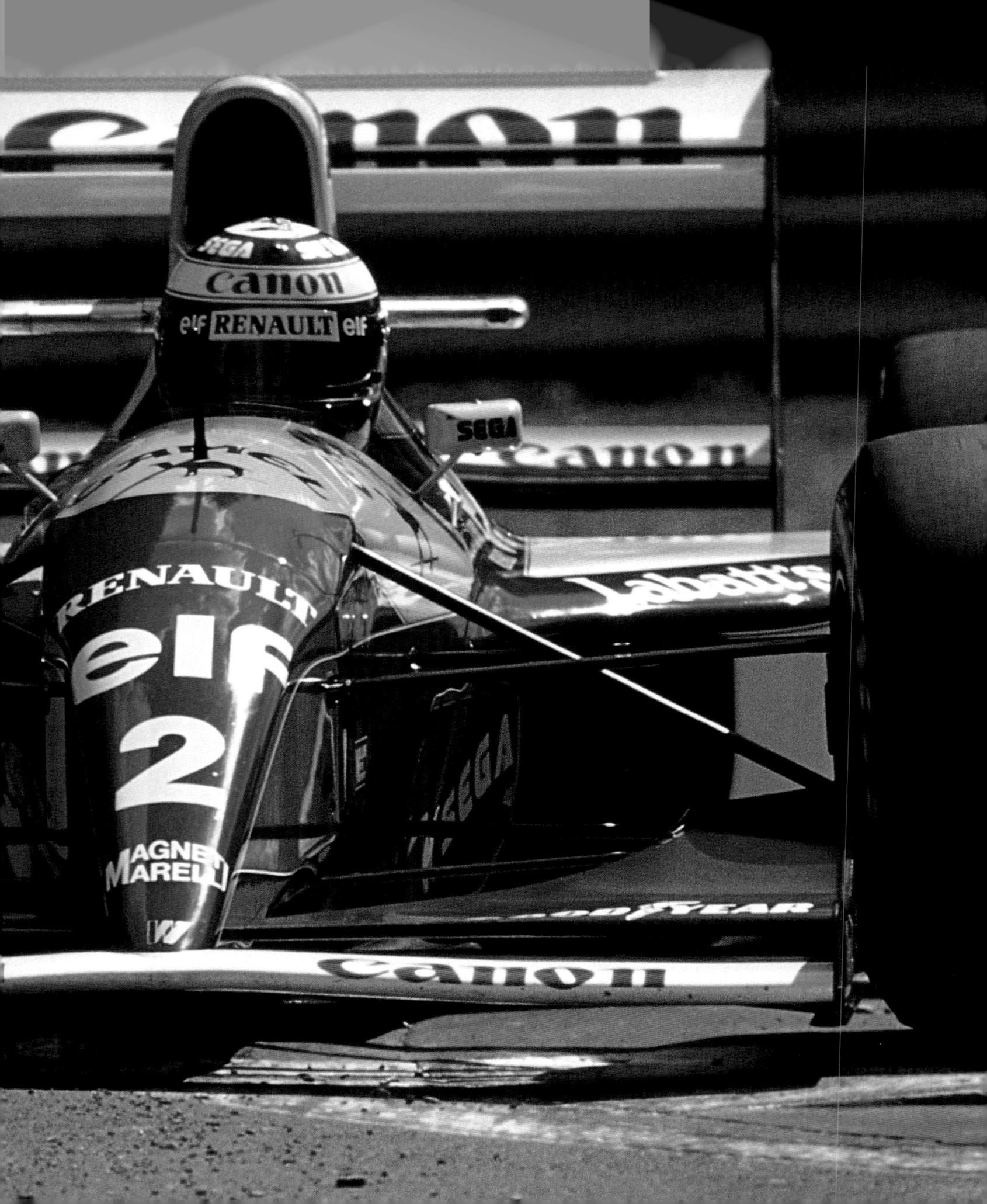

PROST'S MASTERCLASS

his was another year of Williams domination, this time with Alain Prost taking the title, triumphing after a year away from the cockpit.

Prost had spent 1992 commentating and it was known early in Nigel Mansell's championship year that Frank Williams was anxious to have him for 1993 in place of Mansell, precipitating the Englishman's departure to Indycars. Thus Williams began 1993 with Prost and Damon Hill upgraded from the test team.

Prost won at Kyalami after Senna had made the early running, with Mark Blundell a surprise third for Ligier. Then McLaren's Senna took a tactical win at Interlagos. Prost was leading when it rained and he hit a car that had spun. This put Hill in front, but he was to be Senna's prey in the Brazilian Grand Prix.

Rain struck the European Grand Prix

at Donington Park, but Senna put on one of the drives of all time as he forced his way from fourth on the grid into the lead by the end of the opening lap, going on to beat Hill by over a minute, while Prost showed his dislike for the rain and was a lapped third.

Furious at the slating he received from the French press, Prost answered them with a controlled win at Imola, albeit only after Hill spun off. Senna was second when his hydraulics failed, so he yielded his position to Benetton's Michael Schumacher.

Hill was looking good at Barcelona until his engine blew, leaving Prost to win from Senna and Schumacher. Senna's team-mate, Michael Andretti – son of 1978 world champion Mario Andretti – finally finished a race, scoring points for fifth place.

Prost led at Monaco, but was given a stop-and-go penalty for jumping the start and magnified the punishment by stalling. This put Schumacher in front, but his hydraulics failed and so Senna won. Hill came second with Jean Alesi third for Ferrari. Then Prost won in Canada, as Schumacher benefited from Senna's late retirement to come second, with Hill third.

Williams scored a one-two at Magny-Cours. Hill led from pole, but was delayed in the pits and was bumped to second by Prost, with Schumacher third. In front from the start at Silverstone, Hill saw his efforts come to nought when his engine blew. Prost needed no second asking and motored on to his 50th win, with Benetton's Schumacher and Riccardo Patrese second and third.

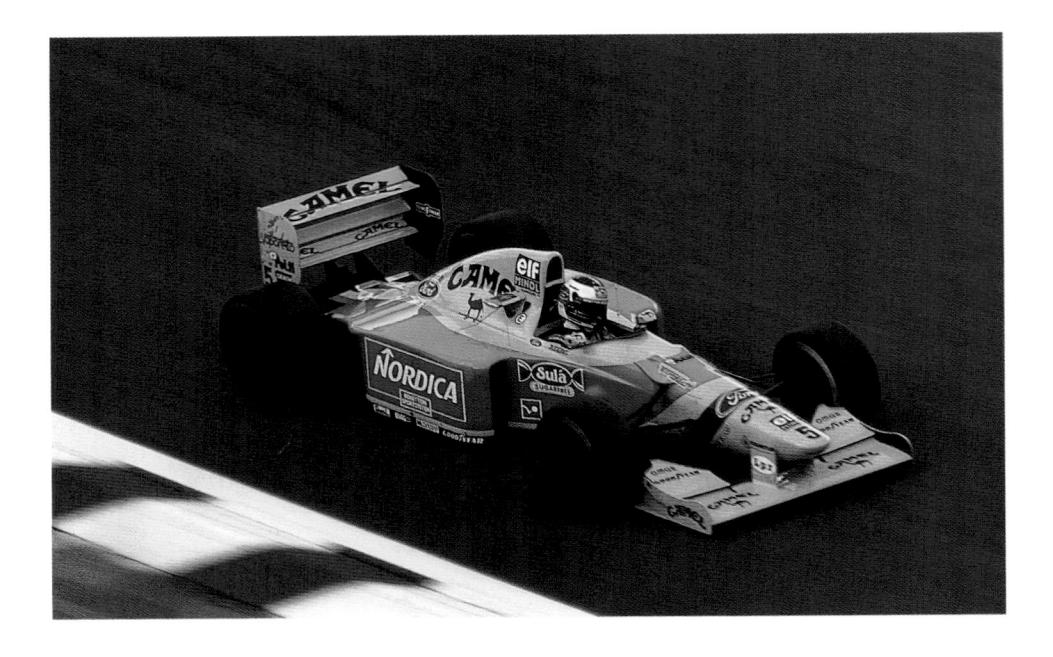

ABOVE MR CONSISTENT: SCHUMACHER'S BENETTON WAS NOT THE BEST CAR, BUT HE WAS OFTEN ON THE PODIUM, WINNING IN PORTUGAL.

RIGHT LOTUS STRUGGLES: THIS ONCE-GREAT TEAM WAS AT THE WRONG END OF THE GRID THROUGHOUT 1993.

Hill was set for success in Germany until a tyre cruelly blew two laps from the end. Prost, ten seconds behind after another stop-and-go penalty, flew past with Schumacher and Blundell second and third.

Hill finally won in Hungary. Despite qualifying behind Prost, Hill led all the way when Prost was forced to start from the back after stalling on the parade lap. Senna pressed Hill, but retired and left the way clear for Patrese and Berger.

The next two races had two things in common: both were won by Hill, and both witnessed shocking accidents. Alessandro Zanardi shunted while qualifying at Spa, rattling his Lotus off the barriers at Eau Rouge. Then at Monza,

Christian Fittipaldi clipped his teammate's car on the sprint to the finish line and flipped. Amazingly, his Minardi landed the right way up.

Schumacher won in Portugal, where Prost, one second behind, claimed the title and announced his retirement. Hill stalled and tigered through to third from the rear of the grid.

Senna won in style in Japan, but he threw a punch at Jordan's sixth-placed debutant Eddie Irvine who he felt had blocked him. Prost and Mika Hakkinen – in at McLaren in place of Andretti – were second and third.

The season ended in Adelaide, and victory for Senna helped McLaren pass Ferrari become the most successful team ever. Prost was second and Hill third.

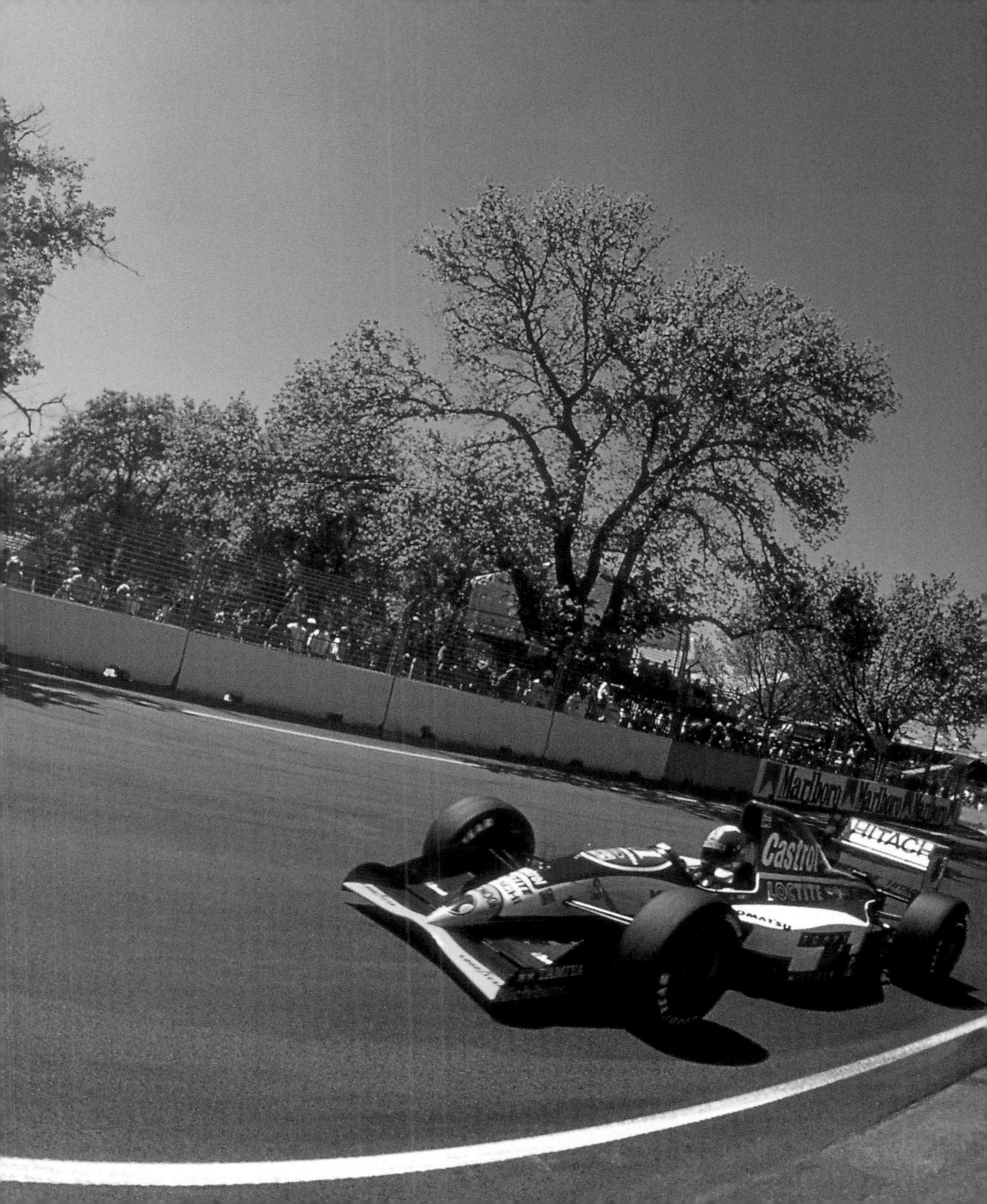

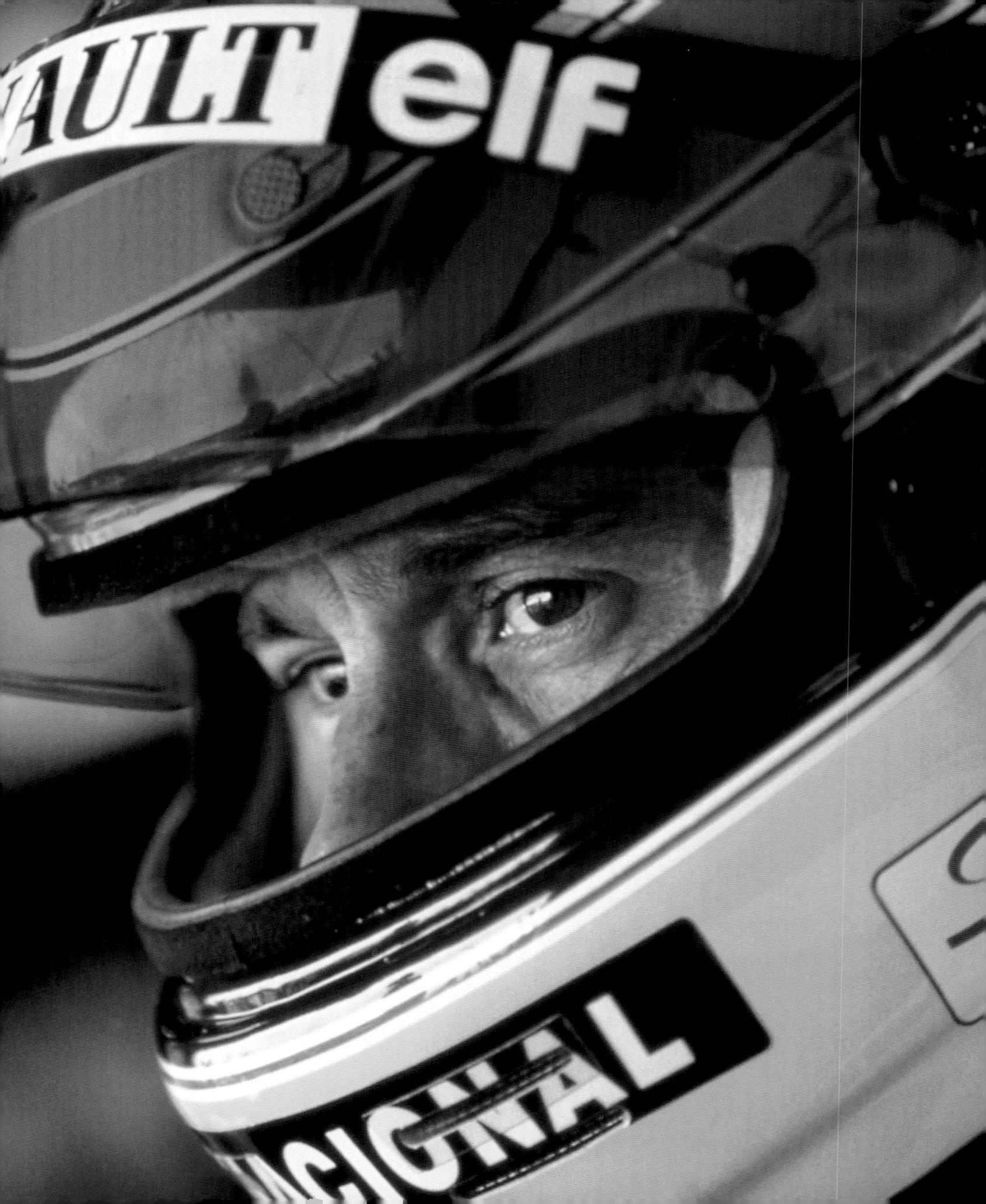

BENETTON HILL BERGER MCLAREN JORDAN MANSELL

THE KING IS DEAD

t was marred by Ayrton Senna's death then spoiled by controversy as Michael Schumacher beat Damon Hill to the crown in questionable fashion. Williams' new signing Ayrton Senna led in Brazil. But, the first pitstops revealed that Benetton were kings as they had Schumacher back out faster than Williams could turn Senna around. Senna couldn't keep up and spun into retirement, letting team-mate Hill finish second, with Ferrari's Jean Alesi third.

The new TI Circuit in Japan was next and Senna was tipped off at the first corner by Mika Hakkinen's McLaren. This left Schumacher to win from Gerhard Berger's Ferrari and Rubens Barrichello who scored Jordan's first podium.

Friday qualifying at Imola nearly saw the demise of Barrichello in an accident. He was lucky, but the next day Roland Ratzenberger fatally hit a wall in his Simtek. Then Senna crashed out of the lead at the Tamburello kink. The man who seemed immortal had died. Schumacher won from Ferrari's Nicola Larini and Hakkinen.

At Monaco Karl Wendlinger crashed his Sauber and fell into a coma. Schumacher made it four from four with McLaren's Martin Brundle second and Berger third.

The drivers insisted on chicanes at Barcelona where they felt run-off was insufficient. Schumacher led but became stuck in fifth gear and Hill went by. Amazingly, Schumacher was able to finish second, with Mark Blundell third for Tyrrell. Schumacher returned to his winning ways in Canada, beating Hill by 40 seconds, with Alesi and Berger next up.

Worried by falling TV viewing figures,

Nigel Mansell was brought back from Indy Cars for the French Grand Prix. He qualified on pole, but Schumacher dominated with Hill second and Berger third as Mansell retired when third.

The "fun" began at Silverstone as Schumacher broke grid order on the parade lap. He was shown the black flag during the race. But he ignored the flag and earned a two-race suspension. Eventually he came in for a stopand-go penalty, and so Hill won from Schumacher and Alesi.

FERRARI ENDS ITS DROUGHT

Benetton arranged for Schumacher's suspension to be deferred so that he could race at Hockenheim, but he wasn't to win. Victory went to Berger, breaking Ferrari's 58-race victory drought. However, the race will be recalled more for a refuelling

fire that engulfed Benetton's Jos Verstappen who escaped with burns.

Schumacher and Verstappen sandwiched Hill in first and third in Hungary. Then controversy returned at Spa where Schumacher won from Hill and Hakkinen. But he had ground away too much of his 'plank' and was disqualified, elevating Verstappen to third.

Schumacher missed the next two races, so it was essential that Hill win both. At Monza he worked his way past the Ferraris and was heading a Williams

one-two when David Coulthard's ran out of fuel on the last lap, letting Berger and Hakkinen claim second and third. Then, at Estoril, Hill overcame being flipped in qualifying to lead Coulthard home and close to within a point of Schumacher.

Schumacher beat Hill on his return at Jerez when the Williams wouldn't take on the right amount of fuel in a pit stop.

The Japanese Grand Prix was run in heavy rain. Schumacher led, but Hill stuck to his tail, nearly blind in the spray. But Schumacher chose to make two pit-

stops, Hill just one. It was very close, but Hill held on to cut Schumacher's advantage to just one point. Schumacher and Hill dominated the Australian Grand Prix Adelaide. But Schumacher grazed a wall. Hill dived for a gap at the next corner and Schumacher, knowing his car was damaged, appeared to drive into Hill. Schumacher was tipped out of the race, but he had made himself champion, since Hill's car was too damaged to continue, leaving Mansell to win from Berger and Brundle.

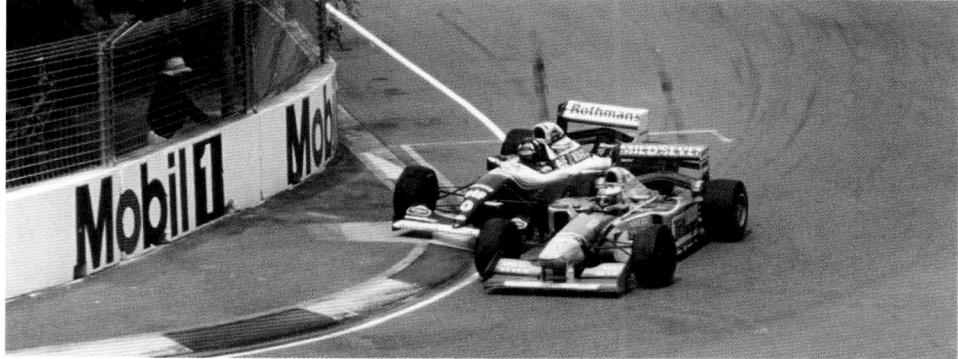

ABOVE PIT STOP CRISIS: JOS VERSTAPPEN WAS ENGULFED IN FLAMES WHEN HIS BENETTON CAUGHT FIRE AT HOCKENHEIM, BUT ESCAPED WITH MINOR BURNS. IT WAS A MIRACLE.

LEFT MOMENT OF TRUTH: SCHUMACHER MOVES HIS DAMAGED BENETTON TO THE APEX AND INTO THE PATH OF HILL.

BOTH RETIRED: SCHUMACHER WAS CHAMPION.

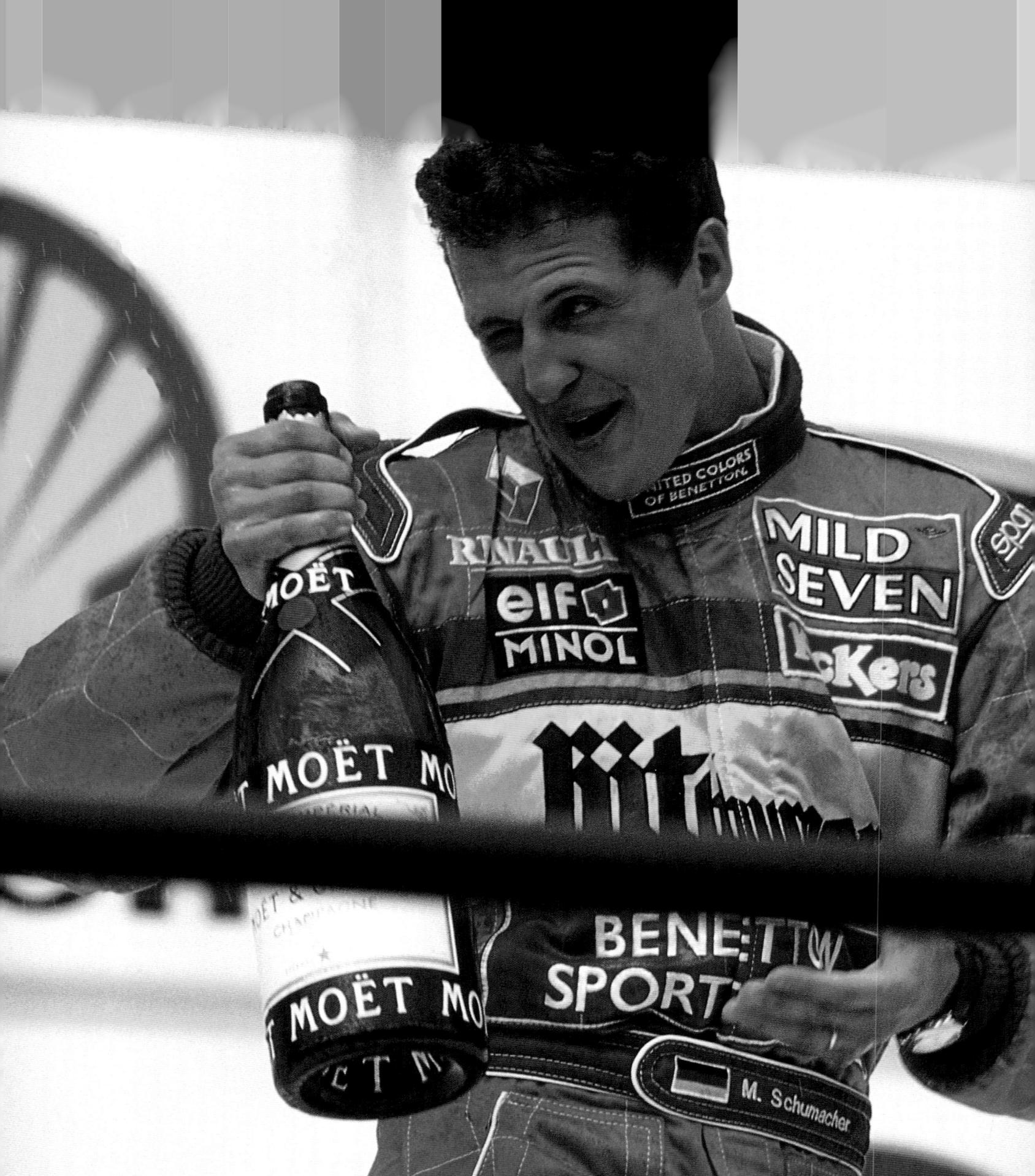

HEDR:

BENETTON COMES GOOD

illiams versus Benetton.
Damon Hill against Michael
Schumacher. There was
action aplenty, but it was all
over with a race to spare as Schumacher
claimed his second title.

Like Hill's Williams, Schumacher's Benetton was now armed with a Renault. Equal on horsepower, the German might have expected pole for the Brazilian opener, but Hill showed his qualifying prowess and was leading when his suspension collapsed, allowing Schumacher to win from Hill's team-mate David Coulthard. Then Hill dominated in Argentina from Jean Alesi's Ferrari and an off-form Schumacher.

Luckily, all went well at Imola, and Hill won from the Ferraris, Alesi beating Gerhard Berger after Schumacher crashed out. Schumacher headed Benetton teammate Johnny Herbert home in Spain as Hill fell from second to fourth on the final lap as his hydraulics failed. Benetton's one-stop tactics at Monaco helped Schumacher beat the twice-stopping Hill.

In Canada, Schumacher had an unscheduled pitstop and Alesi nipped through for his first win after 91 attempts, with Jordan's Rubens Barrichello and Eddie Irvine second and third.

Schumacher beat Hill in France, taking control with his pitstop strategy. Hill was caught in backmarkers when Schumacher pitted, then couldn't call into his own pits as his team-mate was there. Coulthard resisted Martin Brundle's Ligier for third.

The first of the clashes between the protagonists came at Silverstone as Hill fought to pass Schumacher. The

move was optimistic and took both out. Coulthard thus looked set for his first win, but was called in for speeding in the pitlane and thus Herbert came through to win from Alesi.

Hill opened out a lead on the first lap at Hockenheim and promptly crashed. Schumacher then won from Coulthard. But Hill made amends in Hungary with pole, fastest lap and victory, with Coulthard finishing second again and Schumacher retiring.

Coulthard dominated at Spa, but his gearbox failed and through came Hill and Schumacher. There was contact as Schumacher (on slicks) did his utmost to block Hill (on new wets). And he stayed ahead to win, but was given a suspended one-race ban for his tactics.

Coulthard led at Monza before retiring, and Hill hit Schumacher as they

BELOW A WINNER AT LAST: JEAN ALESI HAD WAITED YEARS TO WIN A
GRAND PRIX AND DELIGHTED EVERYONE WHEN HE DID SO IN CANADA.

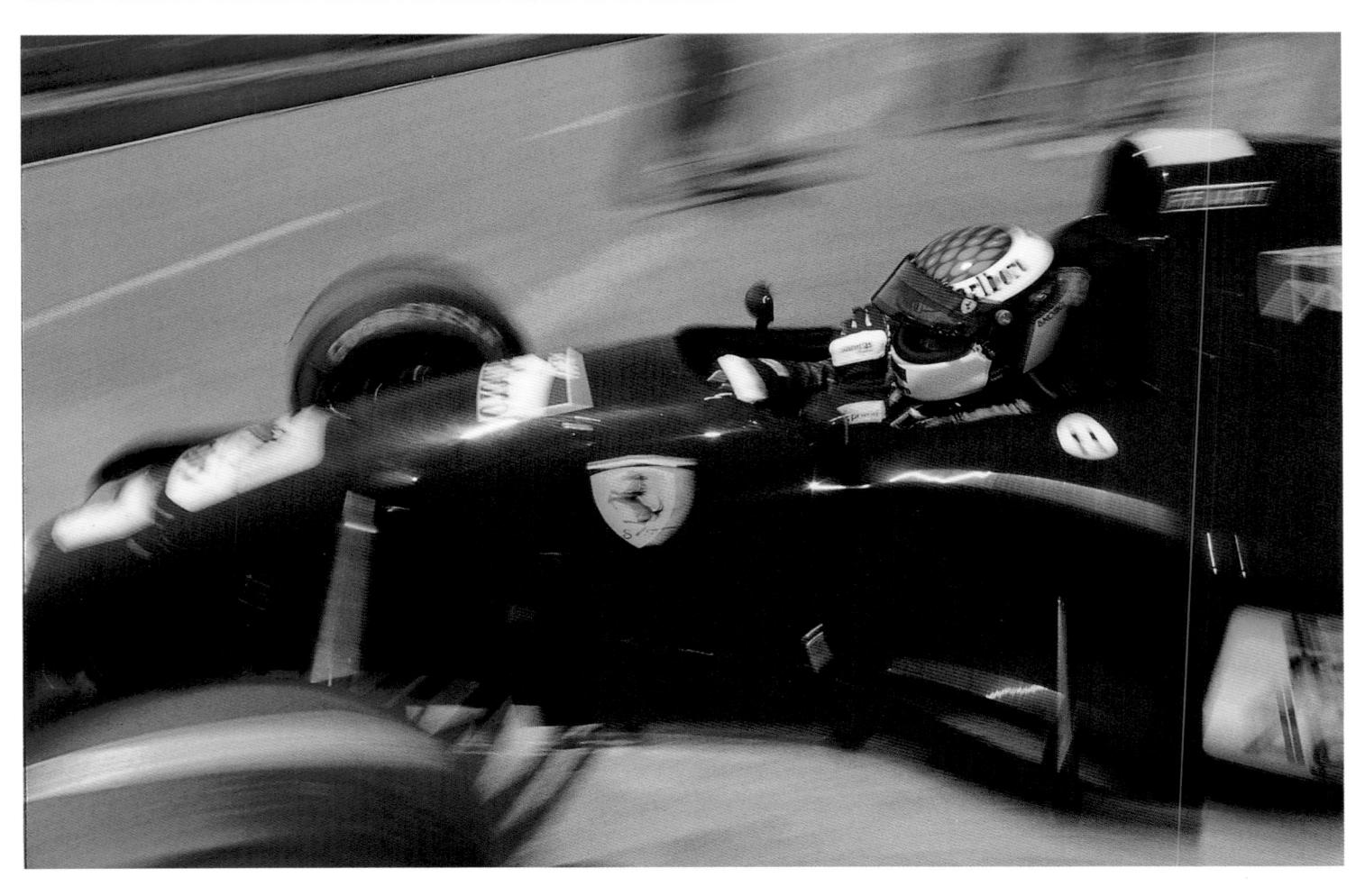

passed a tail-ender while chasing Berger. Alesi took over, yet he too parked up and Herbert won from Mika Hakkinen's McLaren and Heinz-Harald Frentzen's Sauber.

Coulthard finally got his reward in Portugal, with Schumacher demoting Hill to third. Ukyo Katayama caused the race to be restarted when he barrel-rolled his Tyrrell at the start.

The Grand Prix of Europe at the Nurburgring was run in damp conditions, and Alesi starred by starting on slicks then working his way through into the lead. Hill crashed out and this left Schumacher to catch and pass Alesi with three laps to run to win.

A JAPANESE DOUBLE

Two Japanese races followed, with the Pacific Grand Prix at the TI Circuit won by Schumacher who thus claimed his second world title. Coulthard led, but Schumacher's three-stop strategy to his two was the key. Hill was a distant third.

Schumacher took his ninth win at Suzuka which was enough to give Benetton its first constructors' crown.

Run in mixed conditions, Hill and Coulthard both spun off, and this helped Hakkinen to finish second ahead of Herbert.

Coulthard wanted to end his time at Williams with victory at Adelaide, but he pitted from the lead and crashed into the pit wall. Hill then won as he pleased, while Schumacher was chopped by Alesi and retired, letting Frentzen move into second. But he too retired. Herbert did likewise, and Hill won by two laps from Olivier Panis's Ligier and Gianni Morbidelli's Arrows.

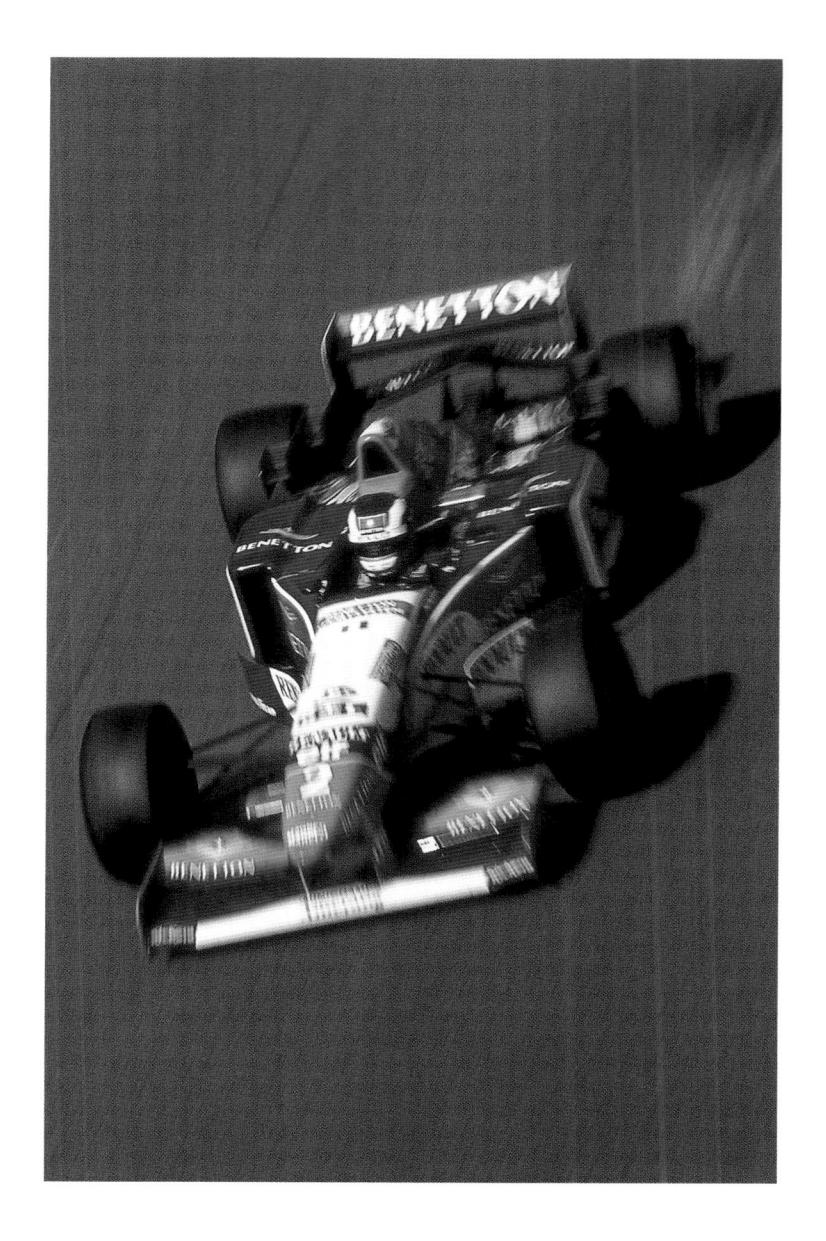

LEFT DOUBLE WINNER: JOHNNY
HERBERT WAS ANOTHER TO BREAK
INTO THE WINNER'S CIRCLE.

BELOW CHAMPAGNE SHOWER:
COULTHARD IS SOAKED BY SCHUMACHER AFTER HIS MAIDEN WIN AT ESTORIL.

BOTTOM BENETTON'S CLINCHER:

CROWNED CHAMPION AT THE PREVIOUS
RACE, SCHUMACHER'S WIN AT SUZUKA
GAVE BENETTON THE CONSTRUCTOR'S

CHAMPIONSHIP.

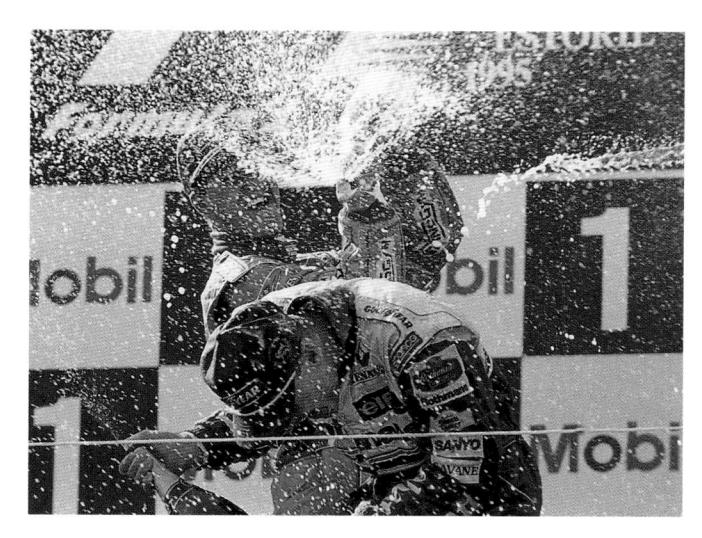

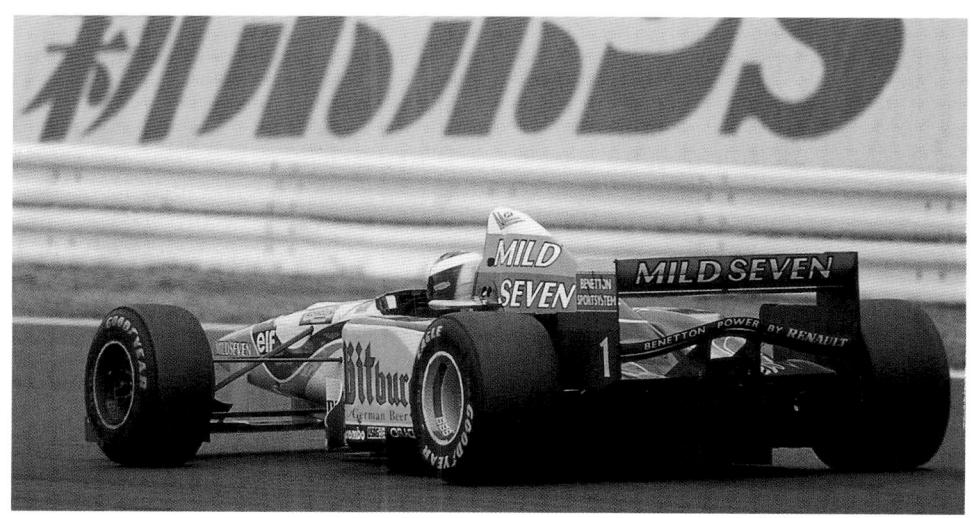

WILLIAMS HAKKINEN MCLAREN BERGER JORDAN PANIS

LIKE FATHER, LIKE SON

t was a case of mission accomplished for Damon Hill. For, in 1996, he landed the title that Michael Schumacher had twice kept out of his grasp, making the might of Williams pay.

This was the season in which Hill was going to put the record straight. With 1994 and 1995 World Champion Schumacher moving to Ferrari, the idea was that there would be no-one who could stop the Englishman from emulating his late father, Graham Hill by becoming World Champion.

From the first race in Melbourne Hill found there was a threat, though, from new team-mate Indycar Champion Jacques Villeneuve who had enjoyed a good winter's worth of testing. The little Canadian even had the temerity to show Hill the way until an oil leak forced him to slow and finish second.

With Hill winning the Brazilian and Argentinian Grands Prix ahead of Benetton's Jean Alesi and Villeneuve respectively, Villeneuve had to wait until the fourth race, the Grand Prix of Europe at the Nurburgring, to hit the big time, winning a great chase to the line ahead of Schumacher.

Hill re-established his dominance at Imola ahead of Schumacher. But then came the shock of the year as Olivier Panis mastered changeable conditions to guide his Ligier to victory at Monaco ahead of McLaren's David Coulthard. Amazingly, this was the French team's first win since 1981. Hill had been leading when his engine failed, while Schumacher crashed out on lap one.

Schumacher atoned by driving masterfully in the wet to win at Barcelona on a day when he was clearly a cut above the rest, with Hill spinning out of contention as Alesi finished second ahead of Villeneuve.

Hill prevented team-mate Villeneuve from claiming a precious home win at the Montreal circuit named after his late father Gilles. Then Hill won again at Magny-Cours, again ahead of Villeneuve, to give himself a 25-point lead over Villeneuve. However, Hill had no such luck on home ground at Silverstone where he fell off when third and Villeneuve won from Benetton's Gerhard Berger and McLaren's Mika Hakkinen.

HILL UNDER PRESSURE

Hill's world appeared to cave in at the next race, at Hockenheim, when a story broke that he was to lose his ride at Williams to Sauber's Heinz-Harald Frentzen. He was able to leave Germany

wearing a smile, though, as he picked up a fortunate win when Berger had his Renault engine blow with three laps to go, giving Hill a 21-point lead over Villeneuve.

This was soon whittled down, as Villeneuve won in Hungary by a short head from Hill, then reduced Hill's advantage to 13 at Spa as he placed second behind Schumacher with Hill fifth after a mix-up over when to come in for tyres. Then Williams announced that Frentzen

would be replacing Hill, leaving the world champion elect with few options as all the top drives were now filled.

HILL TRIPS UP

When Hill crashed out of the lead in Italy, matters looked serious. But Villeneuve also failed to score, so Hill was in a position to wrap it all up in Portugal, and he led until lap 48 of the 70-lap race distance. But then Villeneuve motored past him after a fabulous drive that saw him

pass Schumacher around the outside, and this took the title race to the final round in Japan, albeit with Hill needing just one point.

And Hill stamped his authority on proceedings at Suzuka and led all the way to sign out with a win ahead of Schumacher and Hakkinen. However, he had already become the first ever second generation world champion as Villeneuve had lost a wheel and crashed out of the race.

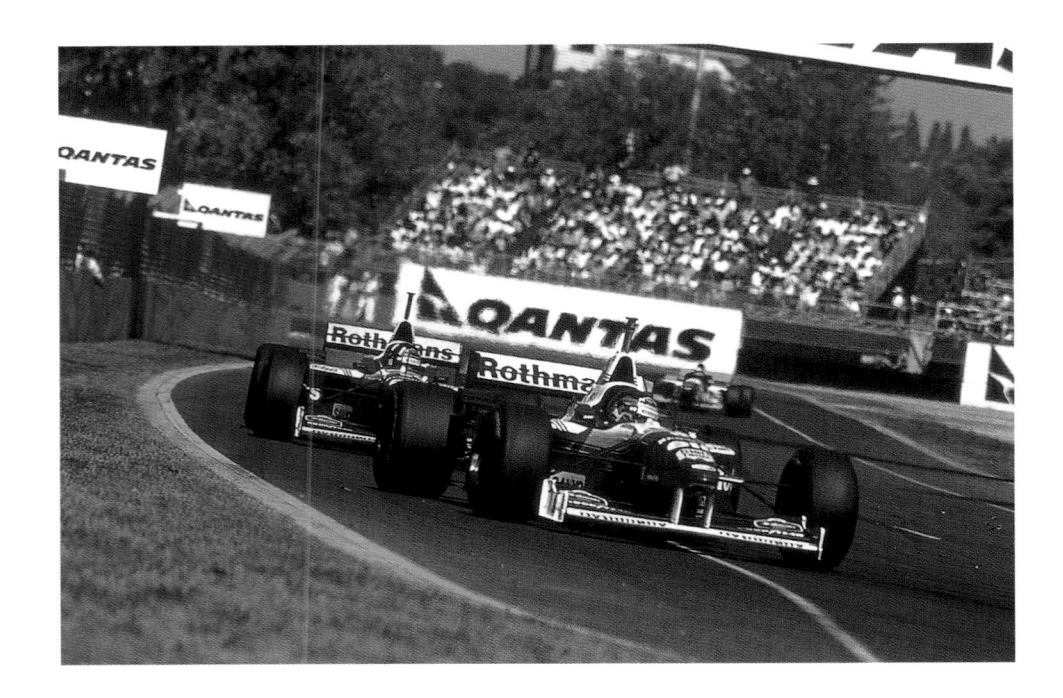

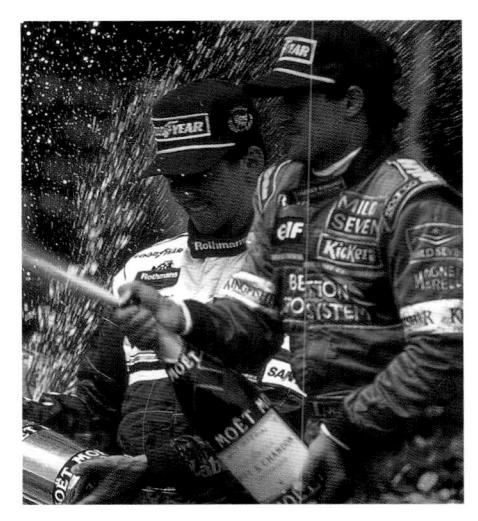

ABOVE FIRST TIME AT MELBOURNE:
VILLENEUVE LEADS HILL ON THEIR
FIRST RACE AS WILLIAMS TEAMMATES.

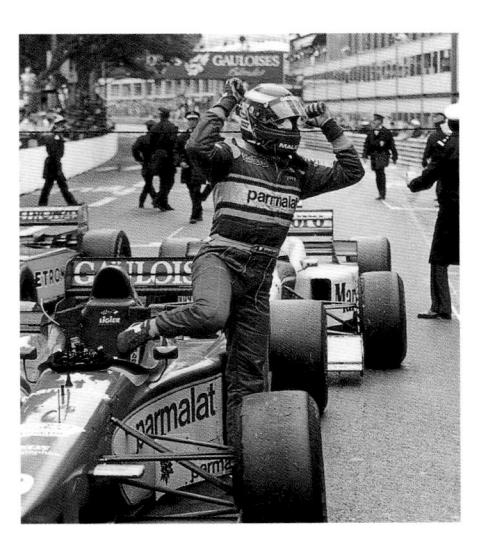

ABOVE REGULAR PODIUM FINISHERS:
HILL AND ALESI DISPENSE THE
BUBBLY AT THE CANADIAN GRAND
PRIX.

LEFT LIGIER'S CONQUERER: OLIVIER PANIS SHOWS HIS DELIGHT AFTER BEATING THE CONDITIONS AND THE OPPOSITION TO WIN AT MONACO.

ABOVE SHATTERED HOPES: JACQUES VILLENEUVE'S BROKEN WILLIAMS LIES TRACK-SIDE IN JAPAN AFTER LOSING A WHEEL ENDED THE CANADIAN'S SLIM TITLE HOPES.

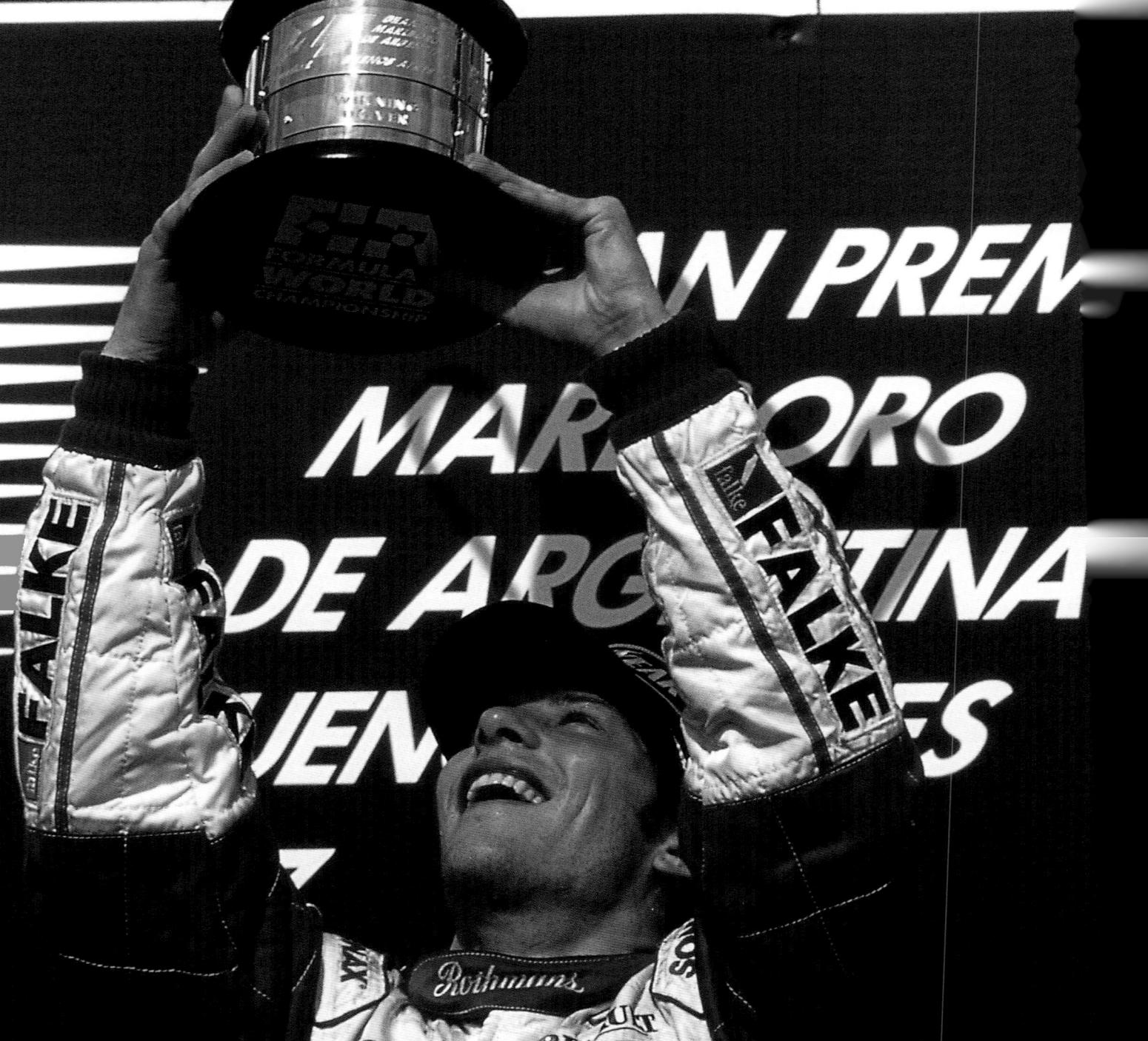

COULTHARD WILLIAMS HAKKINEN BENETTON BERGER

VILLENEUVE: AT THE LAST

ichael Schumacher returned to the antics of 1994 when he tried to prevent Jacques Villeneuve passing him at the final round. But this time he failed and Villeneuve became champion.

So, instead of being applauded for taking challenging the Canadian's superior Williams-Renault package, Schumacher was sent away with his reputation sullied. The FIA confiscated all his points.

Villeneuve was on pole in Melbourne by 1.7 seconds from team-mate Heinz-Harald Frentzen. But he was taken off at the first corner by Schumacher's team-mate Eddie Irvine. Frentzen didn't push on his second set of tyres and fell behind David Coulthard then crashed out when a brake disc collapsed, leaving the Scot to score McLaren's first win since 1993, followed by Schumacher and his own

McLaren team-mate Mika Hakkinen.

Status quo was re-established when Villeneuve won in Brazil, chased by Benetton's Gerhard Berger. He won again in Argentina, this time pushed by Irvine.

The pressure was starting to mount on Frentzen, but he responded at Imola to win from Schumacher as Villeneuve hit gearbox problems.

SCHUMACHER GETS GOING

Schumacher dominated at Monaco, as it rained, with his day being made by Williams coming away with nothing. Rubens Barrichello delighted Stewart by finishing second on only the team's fourth outing.

Barcelona brought tyre problems, but Villeneuve was in control for his third win. Olivier Panis was again impressive in finishing second, but his luck was to run out in Canada when his Prost thumped the barriers, breaking his legs. The race was stopped and Schumacher was declared winner, which was cruel luck on the dominant Coulthard whose engine stalled at his second pit stop, dropping him to seventh as the red flag flew.

Schumacher won in France, with Frentzen second and Villeneuve fourth. The British Grand Prix at Silverstone went to Villeneuve, but only after fighting back from a bungled pitstop and having Hakkinen lose the lead with a blown engine.

Berger had missed three races due to illness, and so his return at Hockenheim was even more amazing as he overcame a challenge from Jordan's Giancarlo Fisichella to win from Schumacher.

There was nearly an even bigger shock in Hungary as Villeneuve had to

ABOVE DRIVER MISSING: VILLENEUVE'S CAR SITS ABANDONED AFTER ITS FIRST-CORNER ACCIDENT IN AUSTRALIA. WINNER COULTHARD DRIVES BY, FOLLOWED BY SCHUMACHER.

RIGHT NOT A GOOD START: FRENTZEN
WAS STILL OUT OF THE POINTS AFTER
HIS RETIREMENT IN ARGENTINA.

wait until half a lap before the end before passing Damon Hill's slowing Arrows to win, with Hill limping home second. Schumacher bounced back to win in Belgium from Fisichella as Villeneuve paid for a poor tyre choice in the rain and fell to fifth.

Coulthard triumphed at Monza. But it was a tight race decided by pitstops, during which McLaren eased him ahead of Alesi.

Prost was given a boost in Austria, as Panis's stand-in Jarno Trulli led half the race before Villeneuve moved past to win. Sadly, Trulli's engine blew and Coulthard bagged second.

Villeneuve was lucky to win the Luxembourg Grand Prix at the Nurburgring. Firstly, Ralf Schumacher took his brother out at the first corner. Then Coulthard blew up mid-race when second and half a lap later so did leader Hakkinen.

Villeneuve was adjudged to have passed under a yellow in qualifying at Suzuka and, with a suspension hanging over him, was banned. He raced under appeal but struggled to fifth as Schumacher won. And so Schumacher went to Spain with a one-point lead.

The crunch at Jerez came as Villeneuve attempted to pass Schumacher. It caught the leader by surprise. He turned in on Villeneuve, but bounced into a gravel bed. Villeneuve led until he took the precaution of letting the McLarens past in the final metres, as third was enough for the crown. And so Hakkinen finally landed his first win.

LEFT A TRACK LIKE NO OTHER:

MONACO CONTINUES TO PROVIDE AN

UNRIVALLED SPECTACLE WITH THE

TRACK AROUND ITS STREETS AN

ETERNAL LINK TO THE PAST.

ABOVE A SHOCK SHOWING: HILL
ACKNOWLEDGES THE APPLAUSE
AFTER LEADING MOST OF THE WAY
IN HUNGARY AND FINISHING SECOND
FOR ARROWS.

BELOW THE CHAMPIONSHIP CLINCHER:
SCHUMACHER PULLS ACROSS ON
VILLENEUVE AT JEREZ. THE GERMAN
RETIRED, HIS CANADIAN RIVAL
BECAME CHAMPION.

TALENT REWARDED

his was one of the epic encounters with Mika Hakkinen versus Michael Schumacher and McLaren versus Ferrari. And no quarter was given.

Grooved tyres and narrower to increase overtaking, but ten of the 11 teams left the opening race at Melbourne with long faces, for McLaren had scored a one-two and lapped the field. Adrian Newey's design skills and Mercedes horsepower, plus the skills of Hakkinen and David Coulthard were going to be very hard to beat. Hakkinen dominated in Brazil with Coulthard close behind. Michael Schumacher progressed to finish third and finish on the same lap. Then the arrival of a wider Goodyear front tyre plus aerodynamic changes from Ferrari helped him win in Argentina after muscling Coulthard out of the lead. Hakkinen

was second with Eddie Irvine making it a doubly good day for Ferrari by finishing third

This appeared to have been a false dawn as McLaren dominated at Imola when Hakkinen dropped out but Coulthard won from Schumacher. Hakkinen and Coulthard then dominated in Spain and Hakkinen won at Monaco where Coulthard's engine blew. Schumacher scored nothing after pitting for repairs after clashing with Alexander Wurz. Still, he came off better than the Austrian whose Benetton later collapsed in the tunnel and he was fortunate to escape without injury. At least Benetton could smile, though, as Giancarlo Fisichella beat Irvine to second place.

McLaren looked set for another win in Canada, but Hakkinen lost all drive at the second start, after Wurz had

triggered a restart with an aerobatic moment. Coulthard led but retired, leaving Schumacher to win despite taking in a stop/go penalty for forcing Heinz-Harald Frentzen's Williams off the track when leaving the pits.

When Schumacher and Irvine got ahead of the McLarens at the second start at Magny-Cours they bottled them up and finished first and second. Then Schumacher made it a hat-trick at Silverstone after Hakkinen lost a 40s lead when the safety car was deployed as the track was waterlogged. Hakkinen then spun and Schumacher took the lead. Then he was called in for a stop/go penalty, but he got around this by taking this penalty in the pits after passing the chequered flag and was allowed to keep his win because of a procedural cock-up.

Hakkinen and Coulthard finished first

and second in Austria and Germany and could have repeated this in Hungary, but Ferrari's Ross Brawn put Schumacher on a three-stop strategy that worked for a famous win.

Schumacher slammed into the back of Coulthard in Belgium and ripped off a wheel, throwing away a 30s lead over Damon Hill's Jordan which went on to the team's first win ahead of team mate Ralf Schumacher and Jean Alesi's Sauber. Schumacher was gifted a win on home ground at Monza, though, when

Coulthard retrired from the lead and Hakkinen fell to fourth with brake problems. Although he led at the Nurburgring, Hakkinen came from behind to win. Schumacher had to win the final round at Suzuka with Hakkinen third or lower to be champion, but he stalled at the start and was forced to take the restart from the back. Hakkinen duly raced off to his eighth win and the title.

There was a three-way shoot-out for third in the constructors' cup between Williams, Benetton and Jordan. Yes, the 1997 cup-winning team had fallen from grace, with Williams struggling with ex-works Renault engines badged as Mecachromes. Indeed, so were Benetton, and both suffered from a lack of grunt. Villeneuve and Frentzen struggled, finishing no higher than third, while Fisichella scored Benetton's best results with two second places. But Jordan's one-two in the crash-torn Belgian Grand Prix and a run of strong results in the second half of the season helped them pass Benetton into fourth place overall.

ABOVE ARGY BARGY: MICHAEL
SCHUMACHER (LEFT) BASHES DAVID
COULTHARD'S McLAREN OUT OF THE
WAY EN ROUTE TO VICTORY IN ARGENTINA.

LEFT ONE-TIME WINNER: COULTHARD WAS FORCED TO BE HAKKINEN'S NUMBER TWO AT MCLAREN AND WON ONLY AT IMOLA.

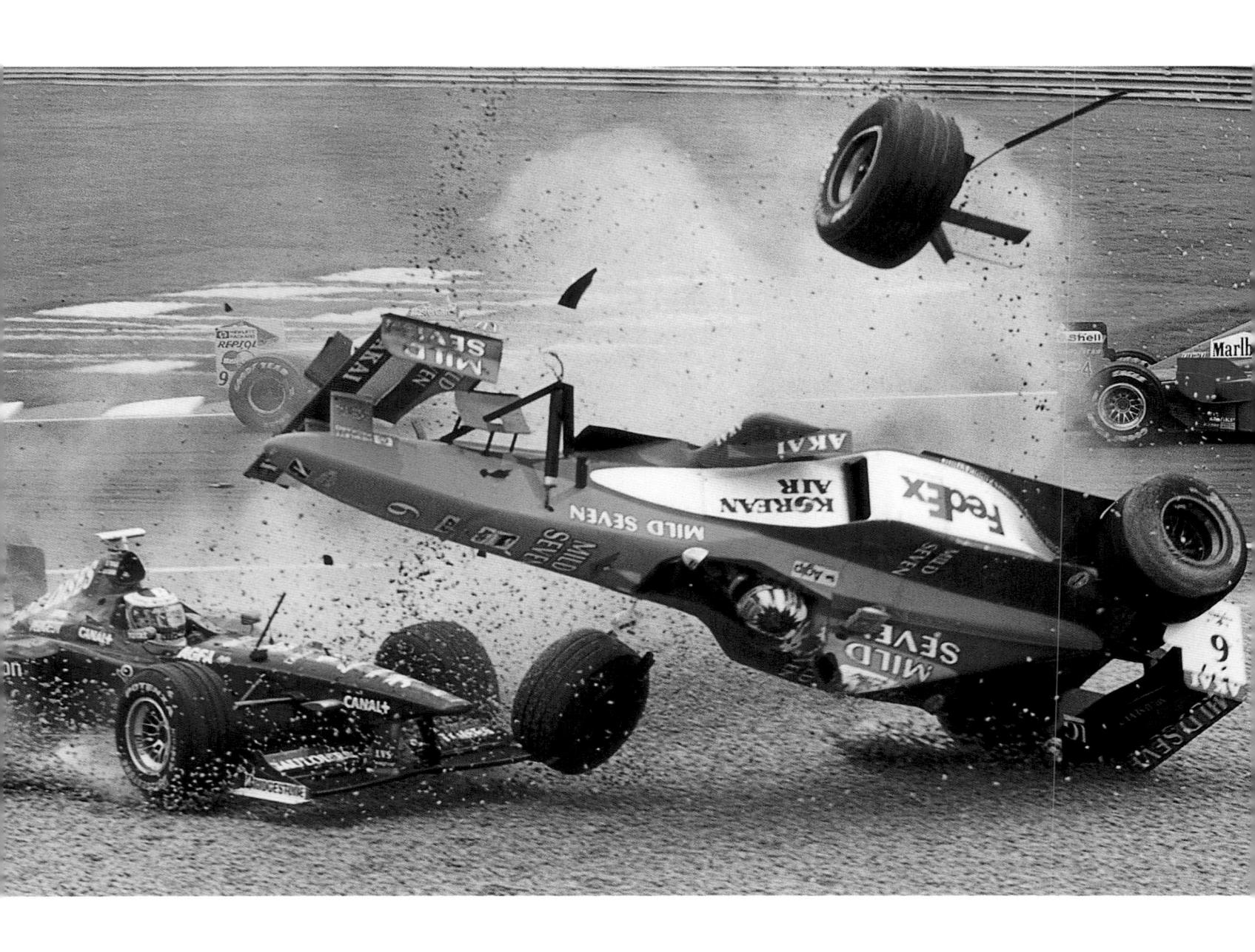

LEFT ROLLERCOASTER RIDE:
ALEXANDER WURZ'S BENETTON IS
INVERTED AT THE ABORTED START OF
THE CANADIAN GRAND PRIX.

RIGHT JOY FOR JORDAN: DAMON HILL SLITHERS TO JORDAN'S FIRST VICTORY IN THE BELGIAN GRAND PRIX.

BELOW JOB WELL DONE: COULTHARD LOOKS UP TO HAKKINEN AFTER HIS TEAM-MATE HAD CLINCHED THE WORLD TITLE IN THE FINAL ROUND AT SUZUKA.

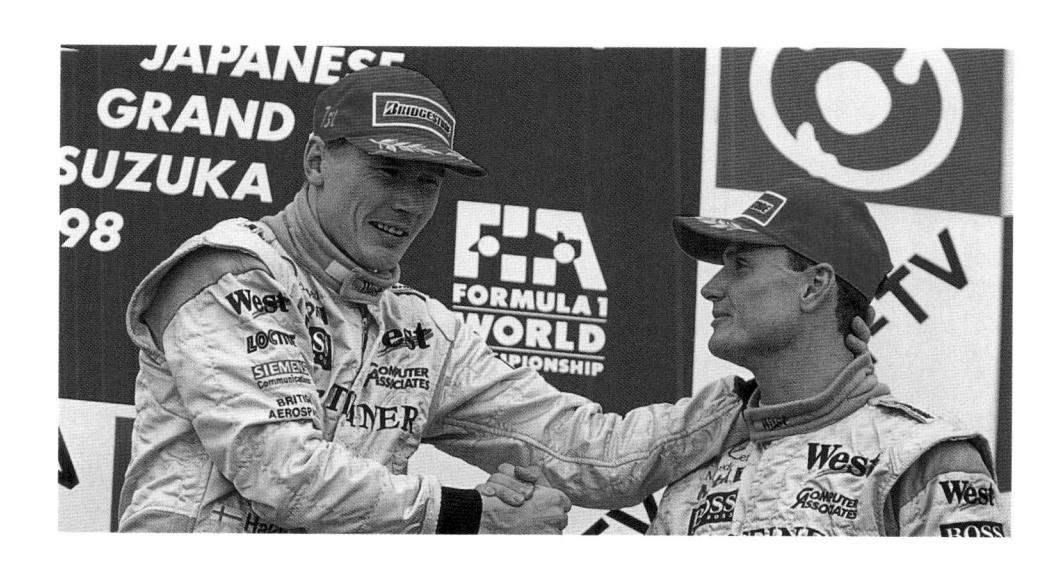

A GOLDEN FIFTIETH

his was always going to be another battle between Mika Hakkinen and Michael Schumacher. And so it proved, until Schumacher broke a leg in the British GP and team-mate Eddie Irvine stepped up to the breech. Ultimately, Irvine failed, but he made Hakkinen wait until the final round before he made it two titles on the trot.

As in 1998, the speed of the McLarens in the first round at Melbourne was remarkable and they seemed set to dominate. Fortunately for the other 10 teams, both McLarens retired. So, Ferrari took the honours, though not through Schumacher who started from the rear of the field and failed to score but Irvine, narrowly leading home Heinz-Harald Frentzen on his first outing for Jordan and Ralf Schumacher on his maiden run for Williams.

Rubens Barrichello led in Brazil for Stewart, but he wasn't running to the same tyre strategy as the McLarens and Ferraris and retired as Hakkinen overcame a gear selection problem to pass Michael Schumacher and win. Frentzen emphasised how competitive he was at Jordan by coming third.

The third race, at Imola, should have been a Hakkinen benefit. But, amazingly, he crashed into the barrier coming onto the start/finish straight. Schumacher proved more effective in traffic than Coulthard and gave the tifosi the win they craved. Then Schumacher and Irvine respectively got the jump on Hakkinen and Coulthard off the grid at Monaco, and Irvine moved up to second when Hakkinen slid up an escape road.

McLaren re-established control at Barcelona, a race notable for Jacques

Villeneuve running third for the new BAR team ahead of the Ferraris. As in all the previous races, the Canadian retired and it was Mika Salo – standing in for Ricardo Zonta who had injured an ankle at Interlagos – who became the first driver to get a BAR to the finish line.

It was Michael Schumacher's turn to have a red face at Montreal as he crashed out of the lead. With Hakkinen leading, Coulthard and Irvine clashed after the safety car peeled off for the third time and fell down the order. Irvine made it back to fourth which became third when, with four laps to go, Frentzen crashed out of second, elevating Benetton's Giancarlo Fisichella to his best result of the year.

Rain hit Magny-Cours and made qualifying a lottery that was won by Barrichello who set his time early on. Coulthard took the lead after six laps, but,

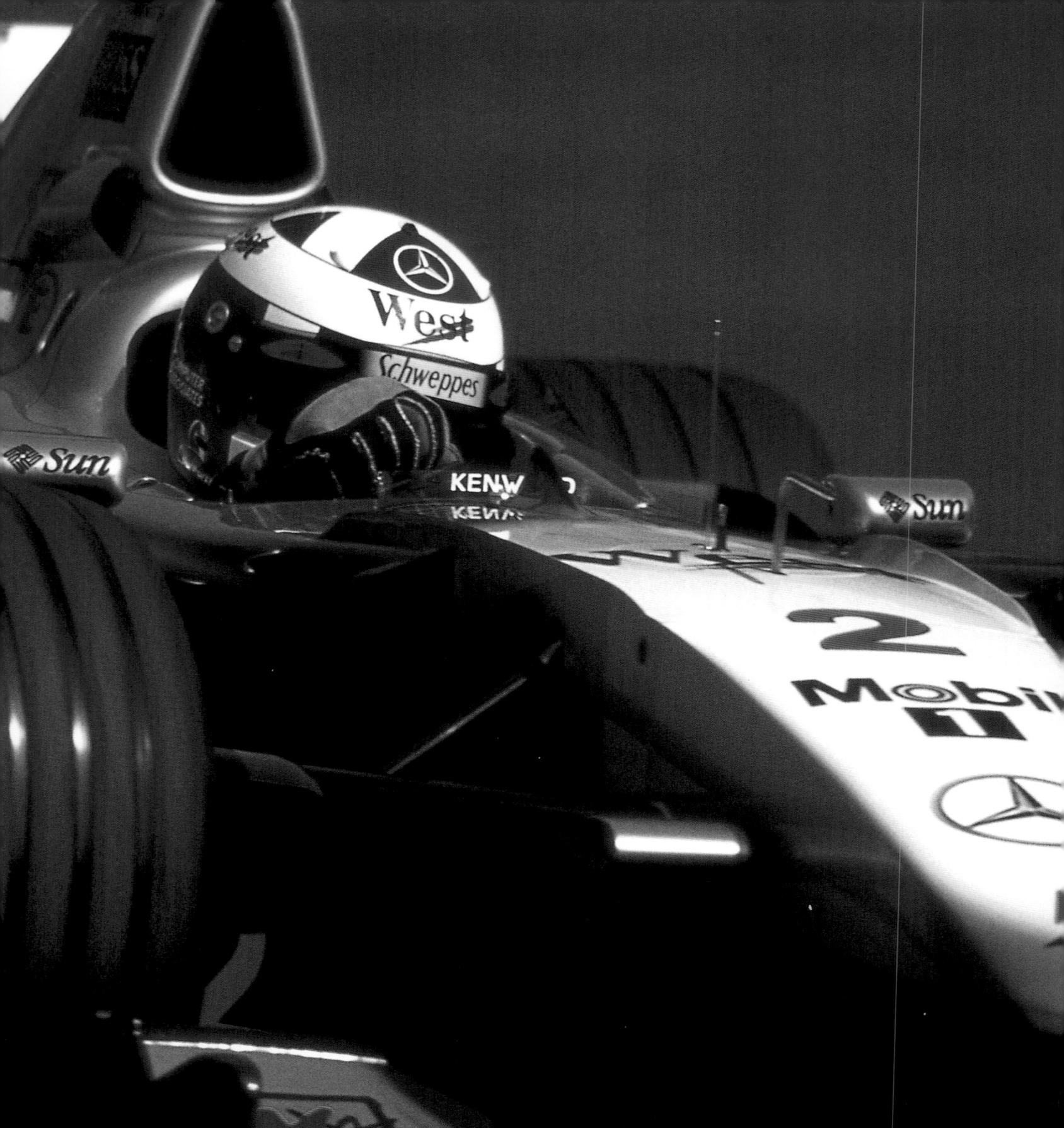

1999

yet again, his car was to fail him. Hakkinen moved from 14th to take the lead before the first pitstops when Stewart did a better job and put Barrichello back into the lead. Hakkinen spun and fell to seventh as he tried to regain the lead. Michael Schumacher hit gearchange problems and so Frentzen scored his first win for Jordan.

It was at the British GP that the season turned as Michael Schumacher speared off on lap one at Stowe corner. He broke his right leg and would miss six races. Hakkinen ought to have won, but

his right rear wheel didn't go on properly, requiring a slow lap and a further stop. Later, it fell off for good. This put Irvine and Coulthard clear, and the Scot won, helped by the Ulsterman overshooting his pit as he was unsighted by the McLaren crew working on Hakkinen's car.

Then Coulthard spun his team-mate Hakkinen out of the lead on the opening lap of the Austrian GP. His drive back to third from stone last was outstanding, but he certainly didn't shake the Scot's hand on the podium. Not that Coulthard was smiling as he was outraced by Irvine who won

after a mid-race charge put him ahead.

The tide turned Ferrari's way at Hockenheim as Hakkinen hit refuelling trouble and Coulthard was stuck behind Salo's Ferrari – the Finn now acting as Schumacher's stand-in – and had to pit for a new nose. Having fallen to fourth, Hakkinen crashed coming into Agip Kurve when a rear tyre failed, leaving Salo to hand the lead to Irvine and complete a Ferrari one-two.

Hakkinen won the Hungarian GP, with Coulthard passing Irvine for third. When Coulthard beat polesitter Hakkinen to the

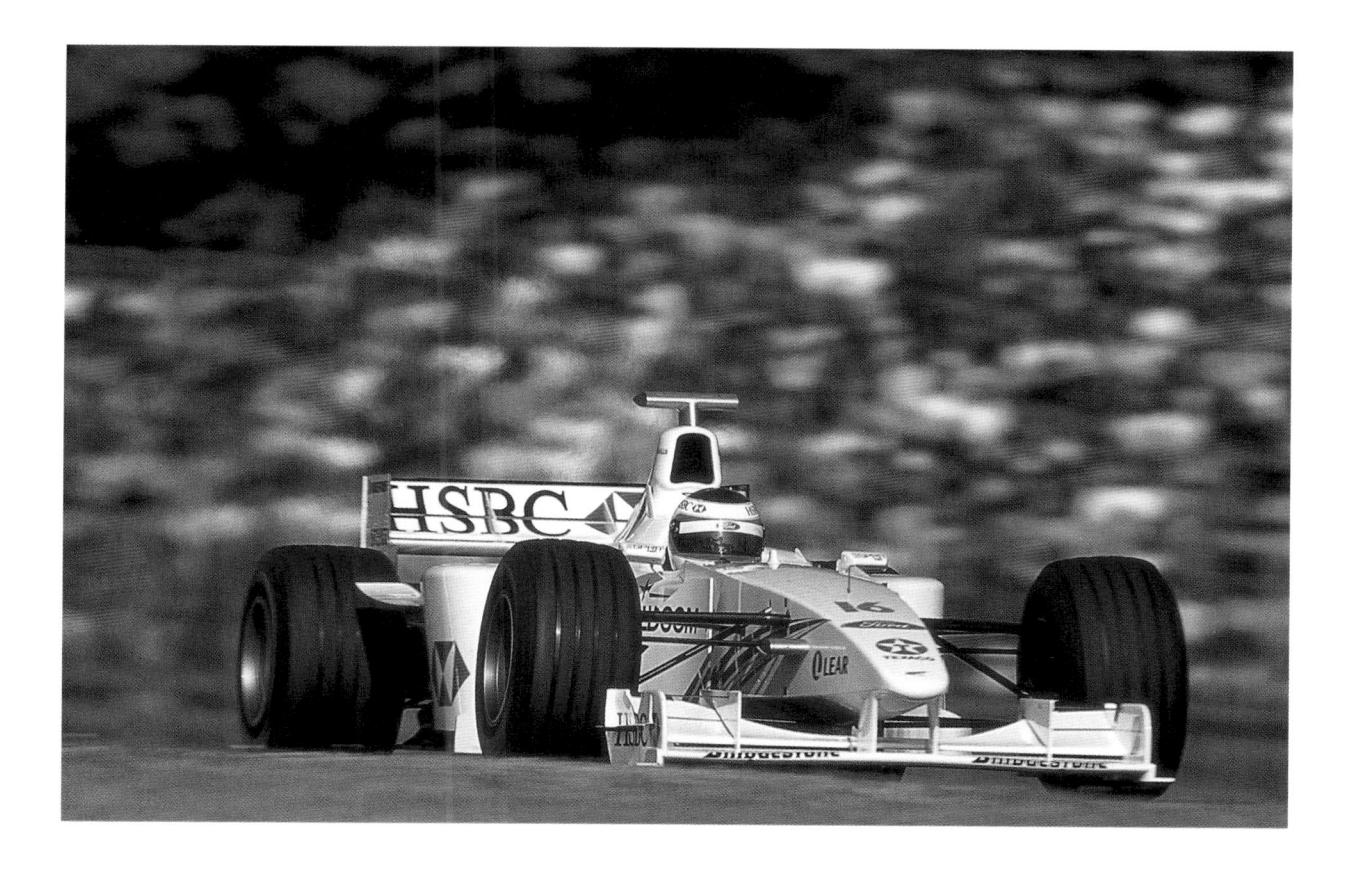

ABOVE FORD'S FLIER: RUBENS

BARRICHELLO PUSHED STEWART AND

FORD TO THE FRONT BY LEADING HIS

HOME GRAND PRIX IN BRAZIL.

LEFT SUPER SCOT: DAVID COULTHARD STILL HAD TO PLAY SECOND FIDDLE TO 1998 CHAMPION MIKA HAKKINEN.

first corner at Spa-Francorchamps and went on to win, many said that McLaren boss Ron Dennis should have ordered Coulthard to move aside, but he replied that no team orders would be issued. When Hakkinen spun out of the lead at Monza, Dennis must have reconsidered those words. Fortunately for Hakkinen, Irvine was able to finish only sixth as Frentzen won from Ralf Schumacher and Salo.

There was a great battle for the lead between Frentzen and Coulthard in the

European Grand Prix at the Nurburgring. But Frentzen pulled off and then Coulthard slid off the wet track. Fisichella did likewise and through it all came Johnny Herbert to give Stewart its first, and only, win.

Schumacher returned for the first ever Malaysian GP and did a great job by shielding Irvine from Hakkinen and finishing a dutiful second. Post-race, there was a scare as the Ferraris were disqualified for a technical irregularity, but they were reinstated. With a win vital for either driver in the final round at Suzuka, it was Hakkinen who delivered and Irvine who trailed home a distant third.

Of the support players, Frentzen rebuilt his reputation by completely overshadowing team-mate Hill, Ralf Schumacher built his and his team-mate Alex Zanardi dropped right out of the reckoning in a massive comedown after his two Champ Car titles. BAR also failed to impress, failing to score a single point.

ABOVE GOLDEN MOMENT: EDDIE IRVINE FINALLY HIT THE BIG TIME BY WINNING THE AUSTRALIAN GRAND PRIX FOR FERRARI.

LEFT OPPOSITE EMOTIONS: MICHAEL
SCHUMACHER CONTAINS HIS
PLEASURE AFTER BEING BEATEN BY
MIKA HAKKINEN IN BRAZIL.

FAR LEFT NEW KIDS ON THE BLOCK:

JACQUES VILLENEUVE QUIT WILLIAMS

TO JOIN FORMULA ONE'S NEWEST

TEAM, BRITISH AMERICAN RACING.

THE NOUGHTIES

JARNO TRULLI

Honours: 2ND 1999, 4TH 1998

Grand Prix record: 252 STARTS, 1 WIN

There are natural talents with speed to burn, and there are scrappers who will always come out on top if they get into a neck-and-neck dice. Jarno Trulli is one of the former. Blindingly fast over a single lap, but with only one grand prix win to his name from his four pole positions, he remains something of an enigma. However, Jarno's cerebral approach makes him an ideal man to discuss the past decade.

The decade ended as it began, with Ross Brawn's team locked in combat with a team running Adrian Newey's cars. The difference was that the two most talented and successful backroom boys of the era had both changed camps, and what had once been Benetton versus Williams, and then Ferrari versus McLaren, had now become Brawn versus Red Bull Racing.

In fact, the 2009 season saw many changes as new rules contributed to the form book being thrown away, and it was far from representative of what had gone before. Different teams and drivers came to the fore, and the established winners struggled.

The first decade of the new millennium was one that saw the rise – and to some degree the fall – of the manufacturers, and the expansion of the sport into new markets across the planet as Bernie Ecclestone encouraged eager governments to invest in ever more impressive circuit facilities.

Only five drivers who competed in the Australian GP in 2000 were still in action at the end of the decade, namely Rubens Barrichello, Jenson Button, Giancarlo Fisichella, Nick Heidfeld and Jarno Trulli.

One of the smartest drivers in the pitlane, and for many years a strong voice within the GPDA, Trulli is my pick to comment on how the sport developed over the decade.

The likeable Italian never quite got himself into the right environment, but for that whole period he was regarded as one of the very best qualifiers. He was on the front row at Monaco with Jordan in 2000 and on pole in Bahrain with Toyota nine years later. In between, he had a spell at Renault where he had a very competitive car, but had the misfortune to have the prodigiously talented Fernando Alonso as his team-mate, a man who was extremely adept at getting those around him to work for his side of the garage. In Monaco in 2004, Jarno did at least prove himself a Grand Prix winner, after a brilliantly judged drive.

"You can always do better," he says, "but you should never have to turn around and say I could have done this or I could have done that. I was never at the right place at the right time. I don't regret anything. I have achieved what I was able to achieve and I don't think my team-mates achieved much more than I did.

JARNO TRULLI

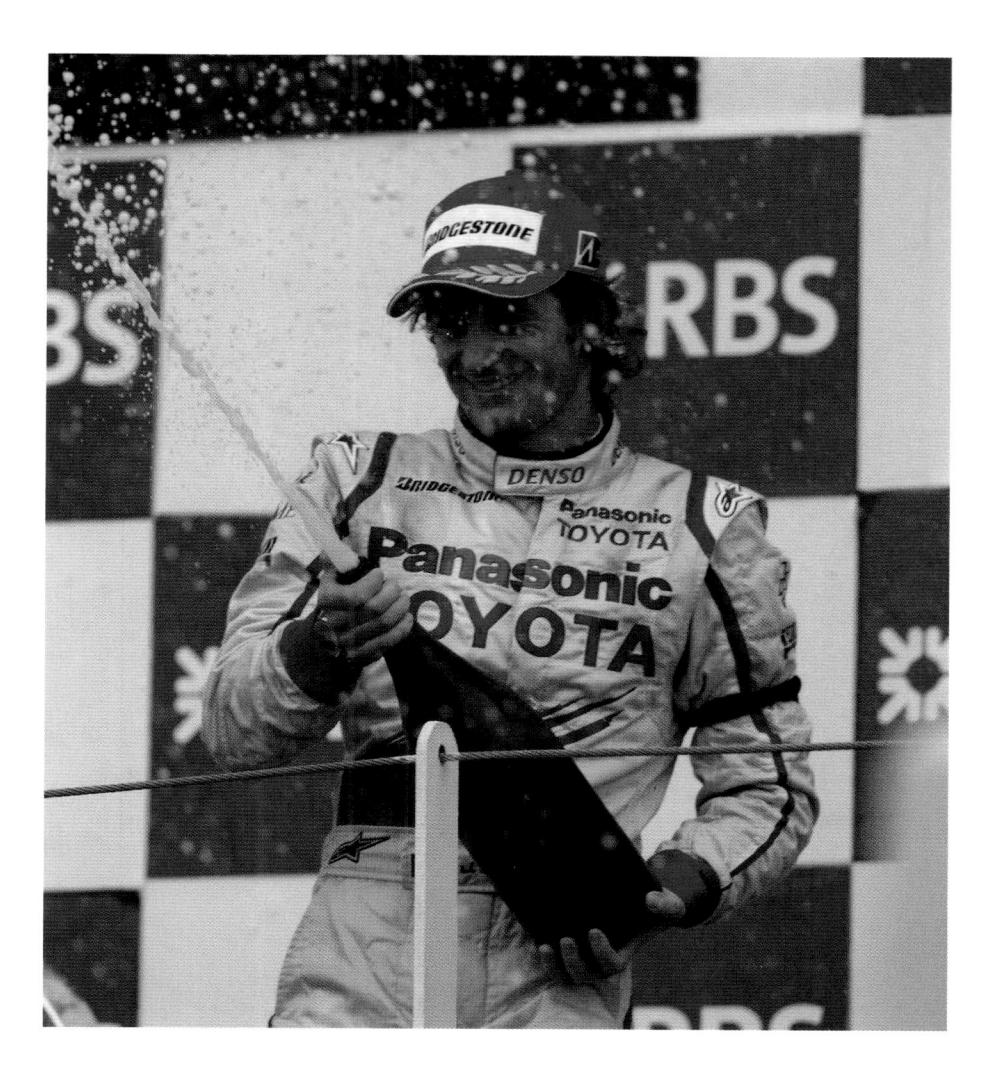

"The win in Monaco was very special. I'm the kind of person who thinks I've done it, but I then have to look towards the next achievement. I was happy after the race, but I didn't carry on thinking about that race any more. I just proved to myself first of all and to many others that I could do it.

"In 2004, it was a good season as I was sharing time with Fernando and I was happy with him, but the atmosphere [in the team] was a bit difficult!"

Trulli was not the first driver to fall out with Renault team boss Flavio Briatore, though, and at the end of 2004 he joined Toyota.

"It has been frustrating through my career as I have been in some circumstances where politics have played quite a bad role, and especially I could see that the politics were taking us or the team nowhere. Playing politics is a waste of time.

"I'm really happy to see that things are going in a better way now at Toyota. I think we could have done it more quickly, but in Italy we say late is better than never! When I joined Toyota it was a new team with a different mentality. It's not easy to arrive in F1 and cope with all these written rules and unwritten rules. In fact, we still have some more work to do, as there are some areas where we need to improve compared to some other teams. But the good thing is the base is there now."

Over the decade, Trulli experienced many different types of cars, as the sport's governing body regularly made attempts to trim speeds by adjusting the rules. The switch from V10 to V8 for 2006 was significant, but nothing matched the massive package of changes for 2009, including reduced downforce, a return to slick tyres and the introduction of KERS.

"The cars have changed in many areas," he says. "Aerodynamics have changed dramatically, as well as the mechanical parts, because huge development has been done in both areas. From the electronics point of view there have been quite a lot of changes, with the handling of the engine, and with a lot of electronics aids. I prefer it without traction control, to be honest. It's more natural to drive. The change of engines in 2006 was quite big in terms of power. Now obviously we've got used to it, but we lost quite a lot."

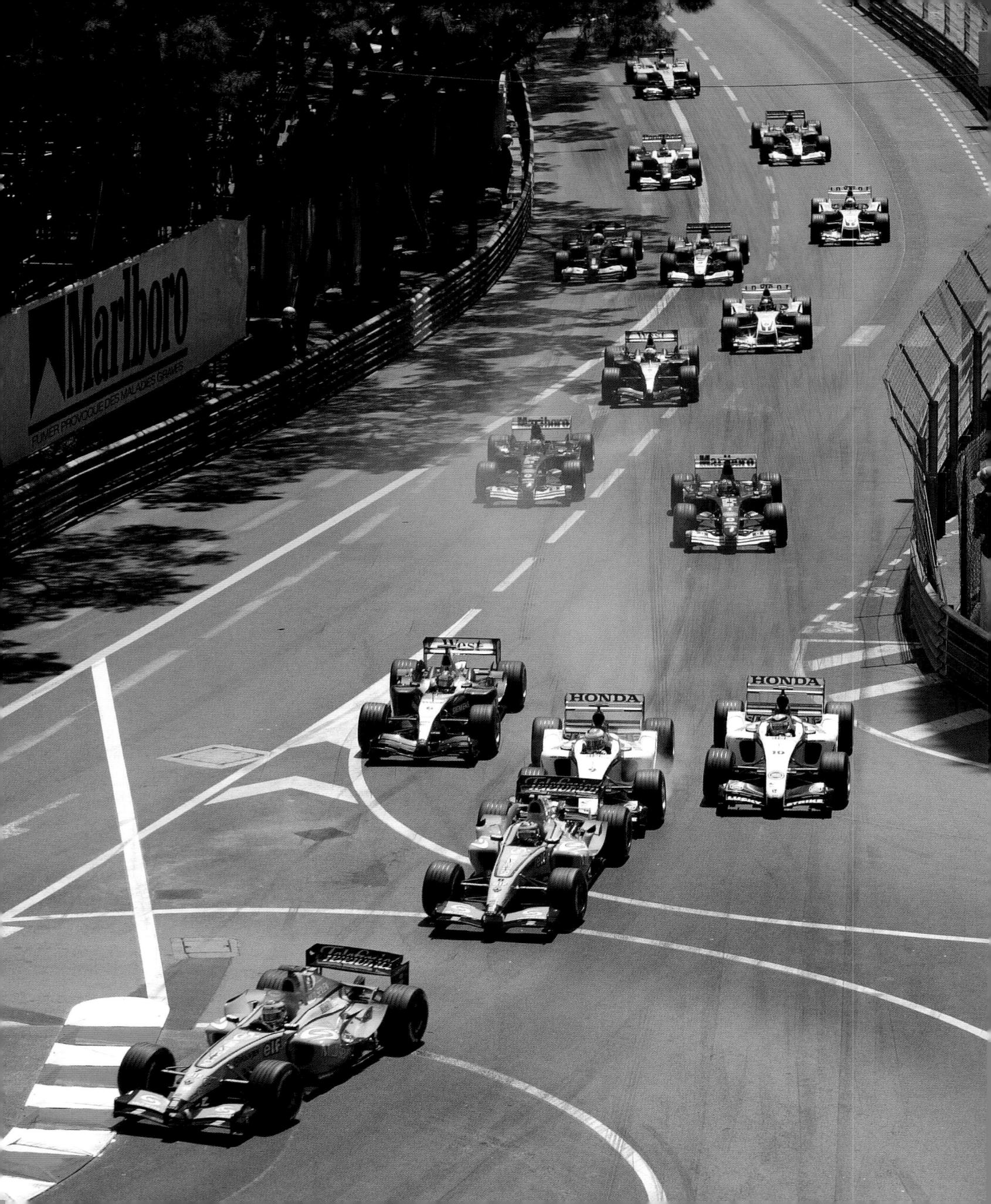

JARNO TRULLI

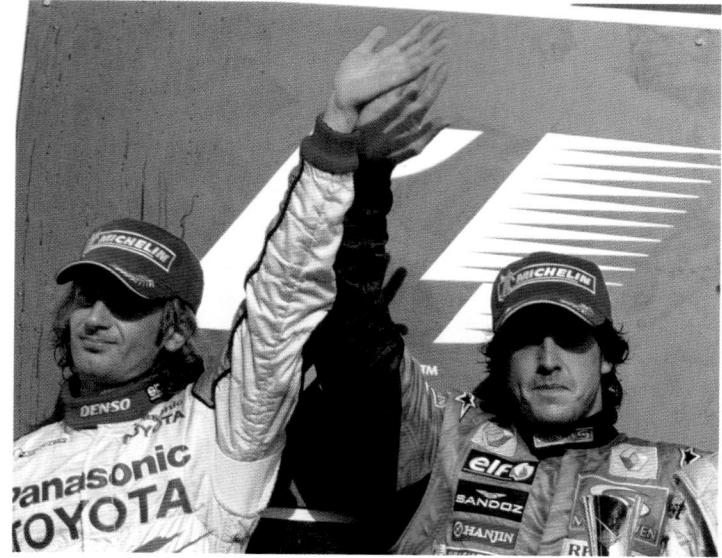

ABOVE JARNO TRULLI MADE A STEP FORWARD BY MOVING FROM PROST TO JORDAN. HE'S SHOWN HERE HEADING FOR FOURTH PLACE IN THE 2001 SPANISH GRAND PRIX AT BARCELONA.

LEFT TRULLI'S ONLY WIN TO DATE CAME AT MONACO IN 2004.
HE QUALIFIED ON POLE AND LED HIS RENAULT TEAM-MATE
FERNANDO ALONSO INTO STE DEVOTE ON THE OPENING LAP.

ABOVE HAVING TRANSFERRED TO TOYOTA FOR 2005, TRULLI CELEBRATES IN BAHRAIN AFTER HIS SECOND CONSECUTIVE SECOND PLACE BEHIND RENAULT'S FERNANDO ALONSO [RIGHT].

Tyres have always been a key element in F1. From 2001 to 2006 the sport largely revolved around a fierce battle between Bridgestone and Michelin, and Ferrari's advantage during that time derived largely from its special relationship with the Japanese supplier. For one season, in 2005, matters were complicated by the necessity to make a single set of tyres last for a whole race.

Bridgestone enjoyed a monopoly from 2007, but tyres were still very much in the news when in 2009 the FIA finally mandated a return to slicks for the first time since 1997.

"I wasn't a fan of grooved tyres," says Trulli, "and I always thoughts slicks were more the real racing tyre. We couldn't change tyres during a race in 2005, and the tyres were obliged to be much more stable in terms of performance, graining control, and so for a driver like me who normally suffered from graining I had a much more stable situation that was easier to handle and predict through the race. You could predict if it was going towards understeer or oversteer, and you could handle it.

"I always enjoy a challenge, but when Michelin was still involved we used to spend all our time testing tyres, tyres, tyres! It was unbelievable. Nearly every run we'd spend nearly three quarters of a test day working just for the tyre supplier, leaving you very little time to set-up the car."

The penultimate race of the nineties, the inaugural Malaysian GP at Sepang, set a precedent. It led to a string of ultra-modern venues, designed almost exclusively by Hermann Tilke. Sepang was followed closely by circuits in Bahrain, Shanghai and Istanbul, each raising the standard a little further. New temporary venues in Valencia and Singapore (a spectacular night race) provided further change in 2008, while the extraordinary Abu Dhabi project set a standard that is unlikely to be matched.

Traditional venues struggled to keep up, many of them beset with financial problems. Seen as a huge boost for the sport when it was first held in 2000, even the United States GP at the specially built road course at Indianapolis did not survive beyond 2007.

"It was good that some new tracks came along," says Trulli. "I don't necessarily like all of them, but in terms of safety, it was quite a big step, so I can't complain. I like Sepang, while Bahrain and Istanbul are so-so, but I don't like Shanghai. I didn't really enjoy Singapore, as it was far too bumpy. Also, racing at night wasn't interesting for me, but it probably was for the spectators!

"I don't care much about where we race, I just drive. You're so focussed most of the time that you hardly notice the atmosphere. But sometimes when you look at the grandstands they're empty, and people don't seem so interested."

The first half of the decade saw near domination by Scuderia Ferrari and Michael Schumacher. After four years of hard slog and near misses, the Maranello 'superteam' finally hit its stride. However, even the Schumacher era didn't last forever, and young guns Fernando Alonso, Kimi Raikkonen and Lewis Hamilton all went on to become World Champion.

"I don't like commenting too much about other drivers. It was a pleasure for me to drive against them all, and some achieved great things. I never had a problem with anyone, even Michael! I got on pretty well with Fernando and we had a lot of fun together. Kimi isn't the kind of person who talks much, so I can't say much about him. Lewis deserved his title, because he drove well for two years, and eventually he got the championship, proving that he could win given a car that was capable of doing it.

"At one stage in this decade we had complete dominance by McLaren and Ferrari, which was killing the sport. You can say that if they made a better job, you can't really argue. If you look at 2009 for example, it's better, because it's more even. Everyone can have their chance as new rules have mixed up the situation a little bit, and it's a very tight grid."

Largely boosted by Schumacher, the levels of fitness required by drivers increased and that came in unison with a general fall in the average age. Trulli was 25 at the start of 2000, and 35 (and a rare exception) at the end of 2009. That in turn ensured that he had to work hard away from the track.

"It wasn't such a high standard before, but I was lucky enough when I came into F1 that I always loved doing sport and I had a sports doctor with many years of experience teaching me what F1 drivers needed," says Jarno. "Now I would say that the average of the drivers' fitness is very good.

"I see age in a different way. No matter how old a driver is, how old he is in his head and in his spirit is what matters. The other thing is it's not like 20 years ago, when cars were dangerous, as there is no danger now. As long as he is quick, a driver can race until he is 40 or whatever. In 2009, for example, the changing rules meant that an experienced driver can really save a team a great deal of time and money."

There's an argument that younger drivers who have grown up as part of the Playstation generation are more in tune with today's gizmo-laden cars. Trulli disagrees: "Some of them don't know as much as I do about computers, so I don't care!"

Politics played a large role during the decade, notably towards the end of it when McLaren had a fractious relationship with the FIA. There was also a strengthening of the bonds between the teams, firstly under the auspices of the GPMA – which was just the manufacturers, less Ferrari – and later under the all-encompassing FOTA. The drivers also gained a voice, mainly on safety matters, as the GPDA went through a revival.

"Drivers have always had a strong voice," continues Jarno. "We are more united now, more people sharing the same view. We understand that sometimes we could do more, but we are only drivers and are only looking after safety. We don't really have a major role. We can only give our opinion to the FIA, to the teams, but we can't change things on our own. All-in-all, I think it was better to be there rather than not be there."

All parties have had to learn how to play the media. The rise of the internet as a channel of communication was arguably one of the most significant developments of the decade.

"Sometimes with the media, and the internet especially, it has been quite bad in the way you handle the communication," says Trulli. "One word can be misunderstood or else turned into a completely different story, but that's part of the business."

The global economic crisis had a huge impact on the sport in 2009, and even the drivers – for so long immune to what was going on in the 'real' world – had to pay attention.

"F1 is a business now, it's not a sport. And you have to run the business according to the economic situation around yourself," concludes Jarno. "I think we're still doing well as F1 has always been huge entertainment, and even if the crisis is hitting everyone, the entertainment is still high. But the problem on the other hand is that the people who make the entertainment, the manufacturers, are hit on the other side, and this affects the situation, so we really have to be very careful."

RIGHT TRULLI'S 2008 CAMPAIGN FOR TOYOTA FADED, BUT HIS AND THE TEAM'S FORM EARLY IN 2009 WAS FAR STRONGER.

FERRARI DOES IT AT LAST

uite how Ferrari had failed to land a drivers' title since Jody Scheckter was first in 1979 will always be something of a mystery. But, in 2000, thanks to Michael Schumacher, it finally all came together.

As in 1998, the battle was between him and arch-rival Mika Hakkinen and the German's tally of nine wins from the 17 rounds to the McLaren racer's four meant that the treasured title was his with a round still to run.

For the second year running, all cars were on Bridgestone-spec tyres, meaning that any advantage had to be found through the teams' engines, chassis and their drivers. In short, Michael was exemplary, making up for the legbreaking interruption to his 1999 season that undoubtedly delayed his crowning by a year. There were very few changes at

Ferrari, save for Eddie Irvine being replaced in the (very much) number two car by Rubens Barrichello. Irvine moved on to Jaguar, the team formed from what had been Stewart before, with Johnny Herbert as his team-mate. At Williams, Alex Zanardi had been dropped to make way for last-minute selection Jenson Button, straight from Formula Three, and BMW engines replaced the Supertec V10s.

MICHAEL'S FLYING START

Three wins from the first three grands prix set Michael's show on the road. Conversely, two retirements in the first two outings with engine-related problems when leading tipped Hakkinen off course. In fact, the points he lost in Melbourne and Interlagos were more than the difference between being

champion and being runner-up. Victory by a second over Hakkinen at Imola made it three.

Muscle flexing by the FIA saw the organisers of the British GP punished for some slight or other by the race being shunted forward from July to April, something that caused a huge problem as Silverstone's car parks were waterlogged after a wet winter, causing fans to be turned away from Saturday's qualifying. At least there was a home win to cheer on the following day, as David Coulthard led home Hakkinen.

Then Hakkinen hit the front at Barcelona for another McLaren one-two before Michael usurped him at the Nurburgring, with even third-placed Coulthard lapped.

Jarno Trulli showed great promise by running second to Michael at Monaco.

Below JACQUES VILLENEUVE STARTED WELL WITH FOURTH PLACE FOR BAR IN AUSTRALIA, BUT HE WAS NEVER TO MOUNT THE PODIUM.

but his Jordan retired with gearbox problems and Coulthard moved up to second place, which turned to first when Michael's suspension was bent.

This vaulted Coulthard past Hakkinen in the race to beat Michael, but neither could do much as Michael extended his lead with a win in Canada ahead of Barrichello, with Giancarlo Fisichella taking his second third place in a row. Coulthard kept up his challenge with victory in France, but that was to be his last of the year as Hakkinen rediscovered his form to beat him in Austria.

RUBENS BREAKS HIS DUCK

Rain and a track invader thwarted McLaren at Hockenheim, letting Barrichello come through after a great run in mixed conditions to score his maiden grand prix win. How the tears of joy flowed on the podium. Michael could only look on, having crashed out at the opening corner with Fisichella. Second and third places for Hakkinen and Coulthard left them just two points adrift in the title race.

Then Hakkinen hit the front with victory ahead of Michael in Hungary and the same again in Belgium. That order

Below NO-ONE COULD BEGRUDGE BARRICHELLO HIS VICTORY IN THAT WET-DRY RACE AT HOCKENHEIM, THOUGH McLAREN HAD BEEN THWARTED BY A TRACK INVADER.

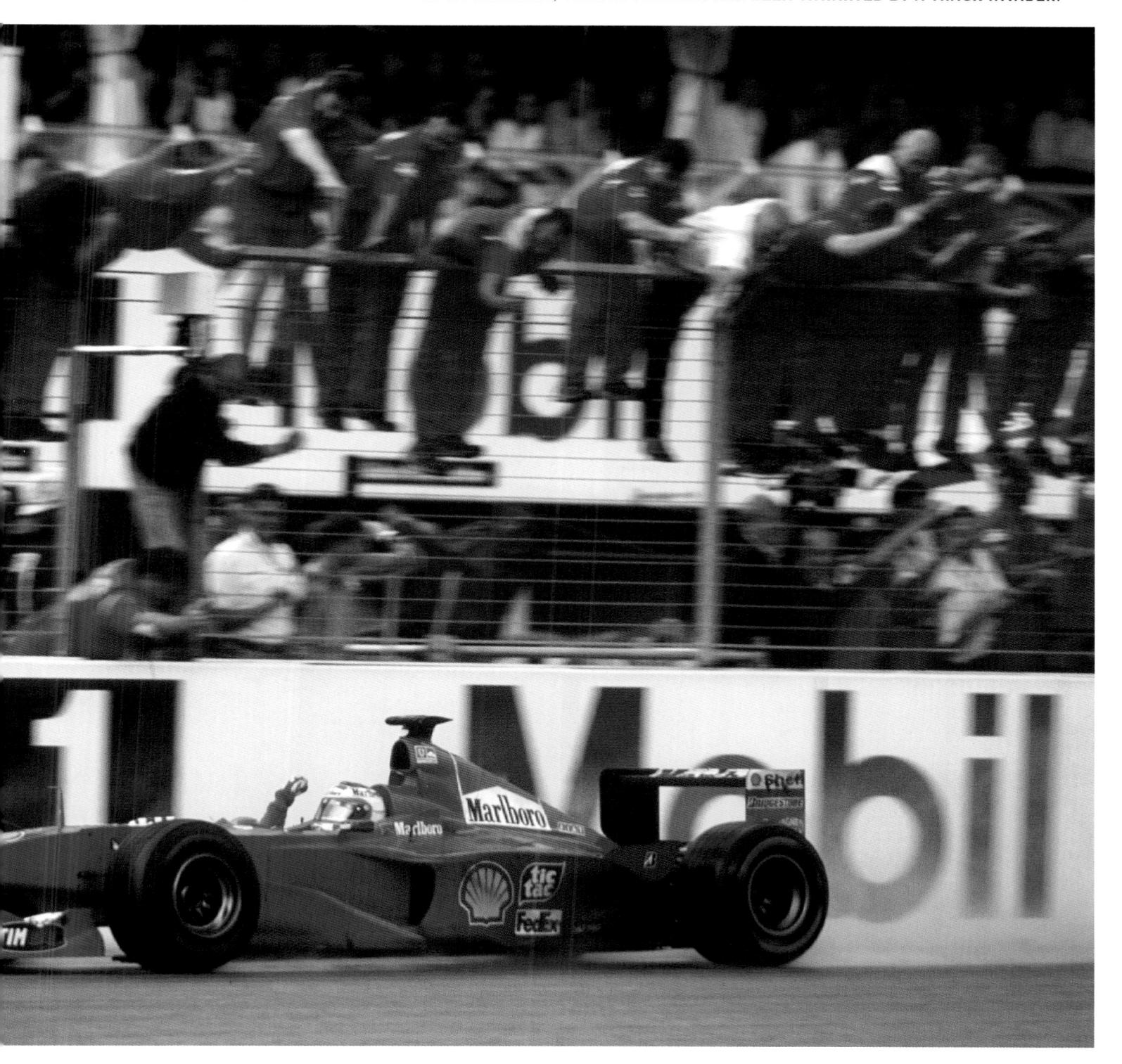

RIGHT MIKA HAKKINEN PUSHED MICHAEL
SCHUMACHER HARDEST, BUT THE
MCLAREN DRIVER'S FORM FADED AT
YEAR'S END.

BELOW RIGHT CELEBRATION TIME FOR MCLAREN'S DAVID COULTHARD AFTER TAKING THE SECOND VICTORY OF HIS 2000 CAMPAIGN, AT MONACO.

BELOW MICHAEL SCHUMACHER IS
SWAMPED BY HIS MECHANICS AT
SUZUKA AFTER LANDING THE POINTS
THAT MADE HIM WORLD CHAMPION.

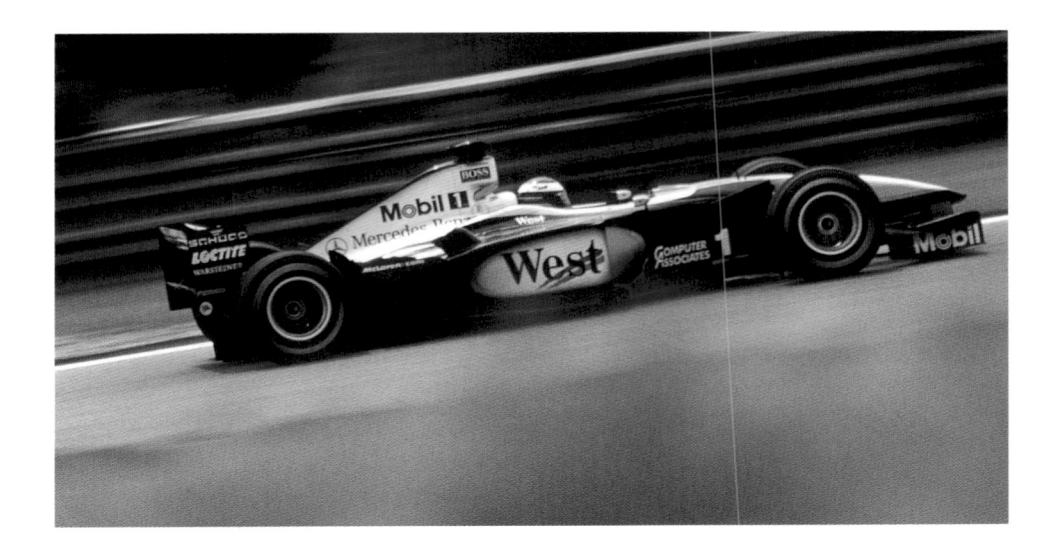

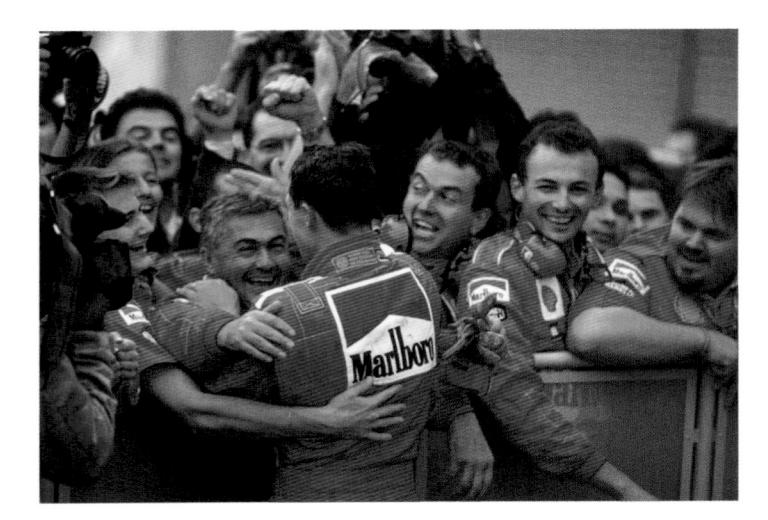

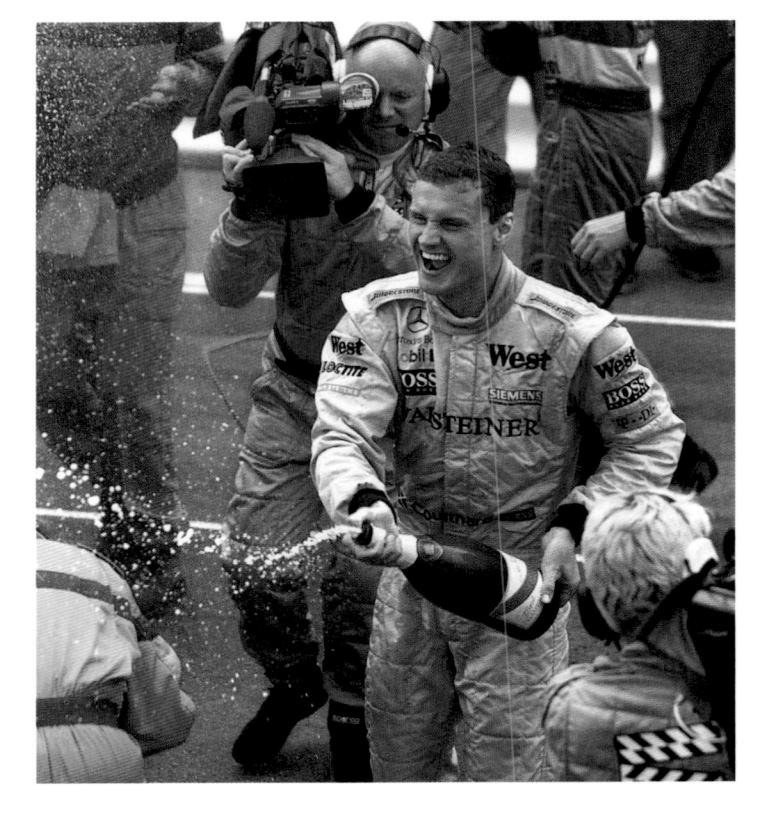

was reversed when Michael beat him at Monza, but it was on the visit to Indianapolis – amazingly, the first outing to the USA for a decade – that Michael broke clear, benefiting when Hakkinen's engine blew.

This gave him an eight-point

advantage and a narrow win over Hakkinen in Japan meant the title was his, with his win in the final race at Malaysia proving academic. Coulthard's second place there ensured that he'd rank third overall ahead of Barrichello, Ralf Schumacher and Fisichella.

A late run of minor points scores meant that Jacques Villeneuve showed a marked gain for BAR in ranking seventh, a place ahead of Button, who came on strong in the later races. The Prost and Minardi teams failed to register a point.

RENAULT BAR ALONSO FERRARI HEIDFELD JORDAN PANIS

TWO IN A ROW

f Michael Schumacher had to fight for that first world title in 2000, it was totally different in 2001 as he ended up with almost double the points tally of the second-ranked driver, McLaren's David Coulthard.

There was little change among the top teams, save for Michelin breaking Bridgestone's monopoly on the tyre front as Williams, Benetton, Jaguar, Prost and Minardi threw in their lots with the French firm.

The other new arrival was Champ Carstar Juan Pablo Montoya at Williams, in place of Jenson Button who joined Giancarlo Fisichella at Benetton, for whom Renault had now placed its name on the flanks of the engine before a full takeover in 2002.

For all this, Michael and Ferrari won the opening race and followed this with victory in Malaysia, although this owed a lot to fortune as rain fell just after he'd slipped off the track, with the fitment of intermediate tyres – when others fitted wets – proving inspired. In a class of his own, Michael won on seven more occasions, wrapping up his fourth title with four races still to run.

Rubens Barrichello emerged more from Michael's shadow but was forced to play a supporting role again and failed to win a race. Only when Michael had been crowned did Ferrari start to help his challenge to beat Coulthard and Ralf Schumacher to be runner-up.

Coulthard was inspired in victory in Brazil, but underdeveloped launch control left him stranded at the start at Barcelona. He then qualified on pole at Monaco, only to have his launch control fail. Despite winning the French GP, David spent the rest of the year in Michael's wake. Team-mate Mika

Hakkinen was spooked by a suspension breakage that pitched him off in Australia and mechanical failure in the Spanish GP when he was half a lap away from victory, allowing Michael to win. He was reinvigorated by winning at Silverstone. Then, one race after announcing his intention to take a sabbatical, he won again at Indianapolis.

Running on Michelins was a gamble for Williams. Yet, with powerful engines from BMW – which were to become the most powerful of all – they were confident. Off the pace when conditions were cool, they struggled at Imola, until it warmed and Ralf romped clear of the McLarens for his first win. This was repeated at Montreal and at Hockenheim. Montoya muscled his way past Michael Schumacher in Brazil, later being deprived of victory at Hockenheim. But his day of days came at Monza when he

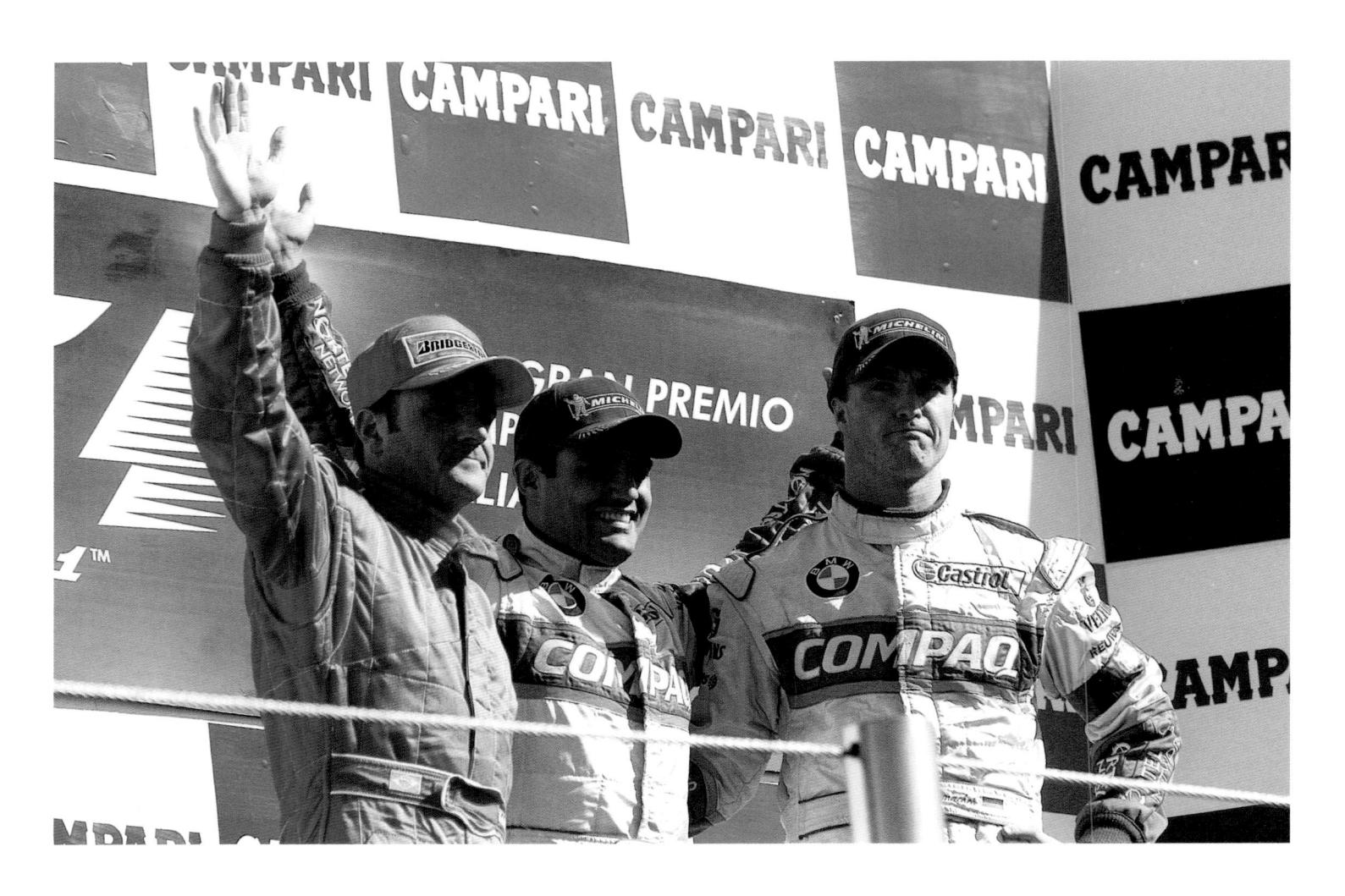

ABOVE JUDGING BY THEIR FACES,
YOU CAN TELL WHO WAS THE WINNER
AT MONZA. IT'S MONTOYA, NOT
BARRICHELLO OR RALF SCHUMACHER.

RIGHT IN GENERAL, MIKA HAKKINEN HAD
A DISAPPOINTING YEAR BUT HIT TOP
FORM TO WIN THE US GP, A RACE THAT
STANDS AS HIS FINAL TRIUMPH.

LEFT MICHAEL SCHUMACHER

CONTROLLED PROCEEDINGS AT WILL

TO LEAD HOME A FERRARI ONE-TWO

AT THE HUNGARORING.

BELOW NICK HEIDFELD PUSHED HIS
SAUBER AS HARD AS HE DARED AND
WAS REWARDED WITH THIRD PLACE
AT THE BRAZILIAN GP.

scored his maiden win.

Sauber ranked fourth. Running with Ferrari engines from 2000 – badged as Petronas engines – allowed Nick Heidfeld to shine. Rookie team-mate Kimi Raikkonen arrived with 23 car races to his name, having bypassed Formula Three and Formula 3000, and placed sixth on his debut.

Jordan ended up fifth only after Jarno Trulli's disqualification from fourth at Indianapolis was overturned. Heinz-Harald Frentzen was dropped before the year was out to make way for Jean Alesi.

Benetton ran wide-angle Renault engines, but were close to the rear of the grid in the first half of the year. However, they upped the power and both scored points in the German GP. Two races later, in Belgium, Fisichella ran second before being demoted by Coulthard.

Like Jordan, BAR lacked grunt from their Hondas, but their main worry was the chassis, leaving Jacques Villeneuve and Olivier Panis to scrap for points. Jaguar also failed to shine, with boss Bobby Rahal being shown the door to make way for Niki Lauda. Eddie Irvine claimed a surprise third at Monaco, but neither he nor Pedro de la Rosa had much to smile about.

Arrows lacked both power and budget, but Jos Verstappen often showed well early in races, although this could be seen as artificial as he'd be running with a light fuel load. While the arrival of airline magnate Paul Stoddart saved Minardi, Alain Prost's team folded shortly after the final race.

SAUBER FRENTZEN TOYOTA SCHUMACHER ARROWS WEBBER

TOTAL DOMINATION

ichael Schumacher and Ferrari dominated as never before, appearing to win almost so easily that it belittled the stature of his achievement as he landed the drivers' title at the French GP in July, with six grands prix still to run. Rival teams simply couldn't wait for the season to end so that they could concentrate on making sure that they could take the battle to Ferrari in 2003.

The only real change at the front was that Mika Hakkinen was to be found at home by a lake in Finland, with fellow Finn Kimi Raikkonen taking his seat at McLaren. Renault was hoping to escape from the midfield, having metamorphosed from Benetton, with Jenson Button joined by Jarno Trulli, who'd swapped with Giancarlo Fisichella, who crossed to Jordan. The seat vacated at Sauber by Raikkonen went to Brazilian

Felipe Massa, while Prost had failed to last the winter, with Toyota keeping the numbers up with its brand new and wellfunded team.

Michael set the ball rolling in Australia after a dramatic start when brother Ralf's Williams got airborne over Rubens Barrichello's pole-sitting Ferrari and the mêlée took out six other drivers. Juan Pablo Montoya finished second for Williams, but had Raikkonen not made a slip-up, he'd have claimed the position, having to make do with third instead. Debutant Mark Webber raced home fifth for little-fancied Minardi as only eight of the 22 starters made the finish.

Ralf made amends in Malaysia, followed home by Montoya for Williams' first one-two since 1996, despite having a drive-through penalty for "causing an avoidable incident" after a first corner clash with Michael.

FERRARI UPS THE ANTE

With Ferrari delaying the introduction of its F2002 chassis until the third round, Michael produced a run of four wins in four races, at Interlagos, Imola, Barcelona and the A1-Ring.

At the last of these, Ferrari's top brass ended up with egg on their faces as they ordered Barrichello – fastest all weekend – to let Michael through to win, even though this was at the sixth of the 17 rounds, not the 16th.

Montoya had reason to regret running too close to Michael in Brazil, losing his nose, which left him in fifth place behind Ralf and McLaren's David Coulthard. Ralf put up a brave charge at Imola, but fell to third behind Barrichello. Then Montoya gave it his best shot to come second in Spain, 35 seconds behind Michael.

ABOVE IN ATTEMPTING TO STAGE
A DEAD-HEAT IN THE US GP,
SCHUMACHER GOT IT A BIT WRONG
AND IT WAS BARRICHELLO WHO
TOOK THE WIN.

RIGHT KIMI RAIKKONEN SHOWED HIS SKILLS BY KEEPING MICHAEL SCHUMACHER IN HIS WAKE IN THE FRENCH GP UNTIL A LATE SLIP-UP.

2002

McLAREN FIGHTS BACK

McLaren came up trumps at Monaco, with Coulthard getting the jump on poleman Montoya, then leading every lap, with Michael rising to second after Montoya's engine failed.

Michael resumed his winning ways in the Canadian GP in Montreal, chased by Coulthard and Barrichello as engine failures left the Williams drivers on the sidelines.

A good start for Barrichello at the reshaped Nurburgring and a spin for Michael ensured that he triumphed. After winning at Silverstone, Michael profited

from a slip by Raikkonen with five laps of the French GP remaining, his win leaving him with an unassailable tally of 96 points.

Michael won at Germany's other reshaped track – Hockenheim – before, perhaps as a payback for Austria, he played second fiddle to Barrichello at the Hungaroring, thus easing Barrichello into second overall as Montoya failed to score. Arrows was unable to pay for its engines so failed to race in Hungary and was never to appear again.

Ferrari kept on winning, with Michael dominating at Spa and Barrichello

BELOW ALL IS CALM ON THE RUN TO THE FIRST CORNER IN THE OPENING RACE IN AUSTRALIA, WITH BARRICHELLO LEADING RALF SCHUMACHER'S WILLIAMS AND THE TWO MCLARENS. BUT THEN RALF CLIPS THE REAR OF HIS FERRARI AND IS SUDDENLY HEADING SKYWARDS. CHAOS ENSUES...

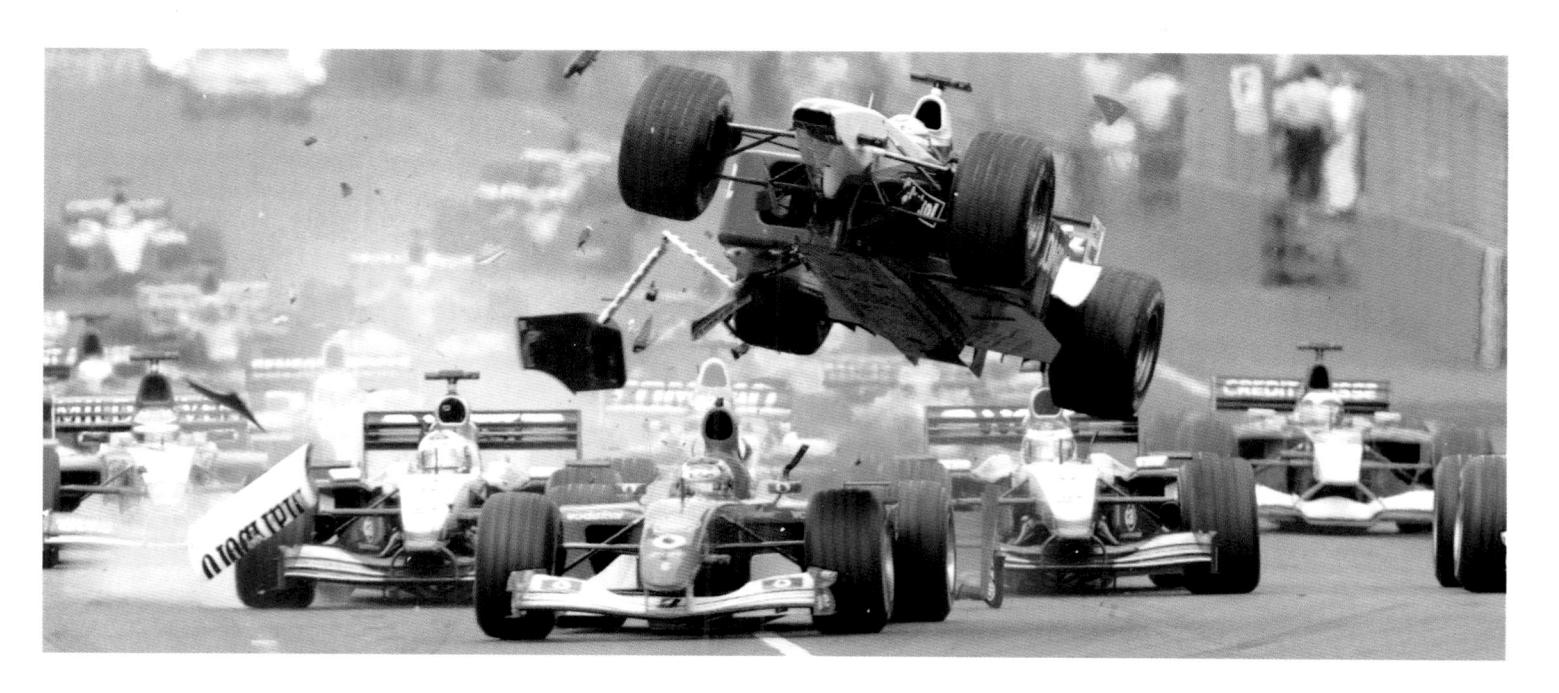

leading him home at Monza. The sight of former Ferrari racer Eddie Irvine up there with them was a shock, as his Jaguar hadn't been competitive all year.

The penultimate race, at Indianapolis, was another Ferrari one-two, but Michael tried to stage a dead-heat and Barrichello

nosed ahead for victory.

Michael completed his season by winning at Suzuka – amazingly this was his 11th win from 17 starts – in a race in which the crowd went wild as Takuma Sato scored his first points, finishing fifth for Jordan.

ABOVE TOYOTA WAS THE FIRST NEW TEAM FOR YEARS, COMPLETE WITH A HUGE BUDGET, BUT IT FAILED TO MAKE MUCH OF A SPLASH.

RIGHT TAKUMA SATO CHOSE THE RIGHT PLACE TO SCORE HIS FIRST POINTS, AT THE JAPANESE GP AT SUZUKA IN FRONT OF MANY ADORING FANS.

MICHAEL BY A NOSE

wo things stand out from 2003. Firstly, that it was extremely close between the top teams, with Michael Schumacher claiming the title only in the closing laps of the final round and, secondly, that this was the year in which likely future champions finally took the battle to Schumacher, with Kimi Raikkonen and Fernando Alonso throwing down the gauntlet.

There was a major change to qualifying as each driver was sent out on a one-at-a-time run of one flying lap each, running in an order determined by their speed in a session on Friday.

Jaguar, Sauber and Toyota also occasionally sent their drivers out with a light fuel load to ensure a superior grid position if not a better race chance. Points were awarded for the first time to the first eight drivers rather than

just to the first six, with a 10-8-6-5-4-3-2-1 scoring system.

With the six drivers across the top three teams – Ferrari, Williams and McLaren – remaining the same, there was no change at the front, with the arrival of Alonso, stepping up from testing duties at Renault, the main change.

COULTHARD STARTS WELL

The opening grand prix was a shambles and David Coulthard was fortunate to come away as victor. However, he lost deserved wins in Malaysia and Brazil. The race at Sepang went to team-mate Raikkonen, this his first, while the one at Interlagos was a masterful performance by the Scot in changing conditions that was brought to a premature end when Mark Webber crashed his Jaguar just after Coulthard had made his final stop,

leaving him fourth at the premature end. Raikkonen was declared the winner, but the countback ruling proved that Jordan's Giancarlo Fisichella had finally scored a grand prix win.

And Michael? He simply wasn't competitive as he waited for the arrival of the 2003 car. However, he made amends by winning at Imola ahead of Raikkonen.

The arrival of the F2003-GA brought Michael victory in Spain, albeit only after a battle with Alonso, who added 20,000 fans to the crowd.

Another win followed in Austria, but then it was Juan Pablo Montoya's turn for glory, giving Williams victory at Monaco, which started a run of results for him and team-mate Ralf Schumacher.

Michael resisted a limp challenge from Ralf in Canada. Then Ralf struck back to win at the Nurburgring and

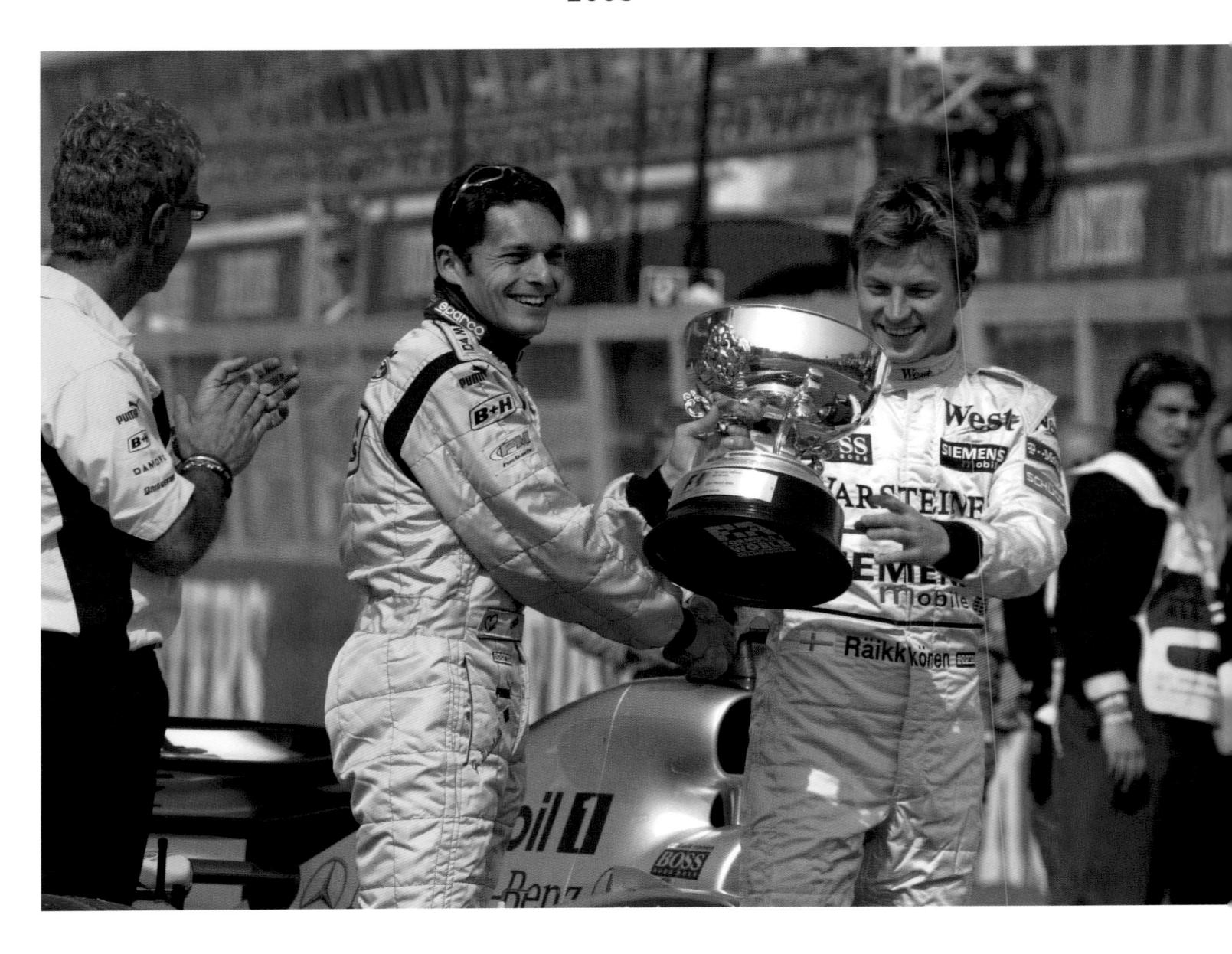

ABOVE OVER TO YOU: KIMI RAIKKONEN HANDS OVER THE BRAZILIAN GP TROPHY TO GIANCARLO FISICHELLA AT THE FOLLOWING RACE AT IMOLA.

Magny-Cours. At the first of these, Raikkonen had blown up when in front and Michael spun when Montoya passed him, falling to fifth. The second of these was Ralf from start to finish.

THE RACE OF THE YEAR

Barrichello won a British GP that had its order scrambled when the safety car came out while a track invader was escorted off and then saw him pass Raikkonen in a move that lasted four corners... Montoya also passed the Finn to finish second. Montoya went one better to dominate the German GP, a race that was spoiled when Ralf,

Barrichello and Raikkonen clashed at the first corner and Michael suffered a late-race puncture.

Renault was then rewarded for its improving form when Alonso triumphed in Hungary, becoming the youngest driver ever to win a grand prix at the age of 22 years and 26 days. Michael finished eighth after he stalled in a pit stop, his points lead down to one over Montoya, two over Raikkonen.

McLaren talked of unveiling its 2003 chassis, the MP4-18, but it was shelved and Raikkonen and Coulthard struggled at Monza where only Montoya could challenge Michael. The three-way title

Below FERNANDO ALONSO HIT GOLD WITH A DOMINANT MAIDEN WIN FOR RENAULT AT THE HUNGARORING. MARK WEBBER RAN SECOND.

BOTTOM KIMI RAIKKONEN CELEBRATES HIS FIRST-EVER WIN, AT SEPANG.
HE WASN'T TO WIN AGAIN, THOUGH HE FINISHED SECOND SIX TIMES.

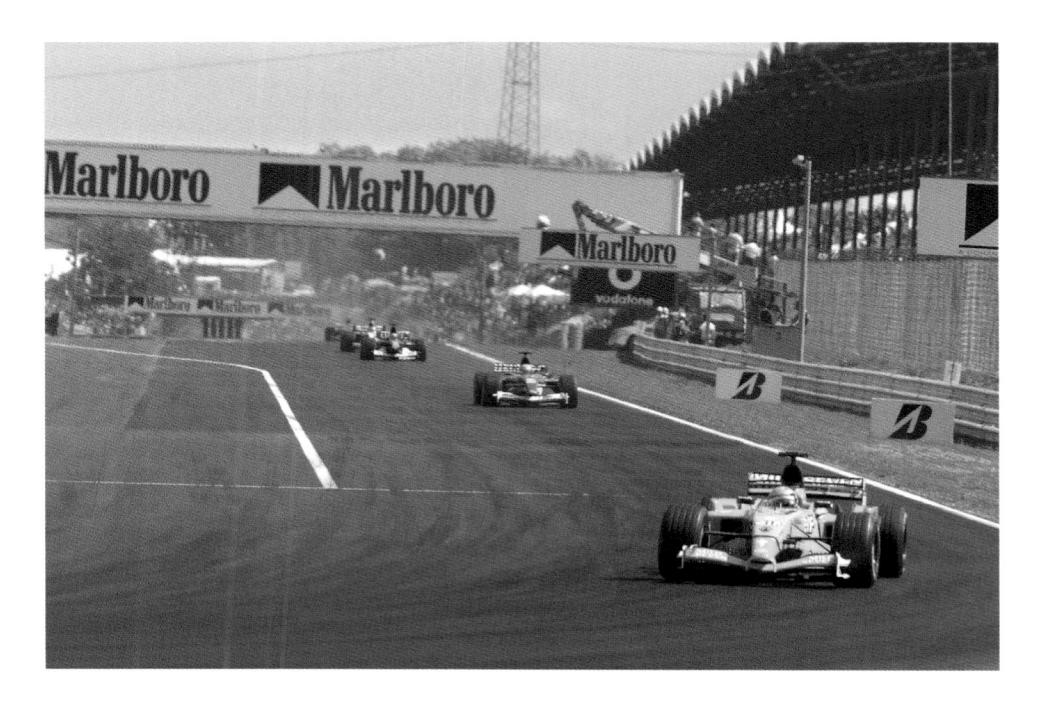

fight lost Montoya at Indianapolis when he was given a drive-through penalty for a clash with Barrichello. A damp track favoured the Michelin runners, but as soon as the rain intensified Michael was in a class of his own.

At Suzuka, Michael had only to finish eighth for his record-setting sixth title. Raikkonen had to win, but Barrichello stepped up a gear and won to help Michael to the title, which was fortunate as Michael drove a wretched race from 14th on the grid. Raikkonen's second-place finish was his seventh in 16 starts. In reality, though, it was only the revised points system that had kept it close.

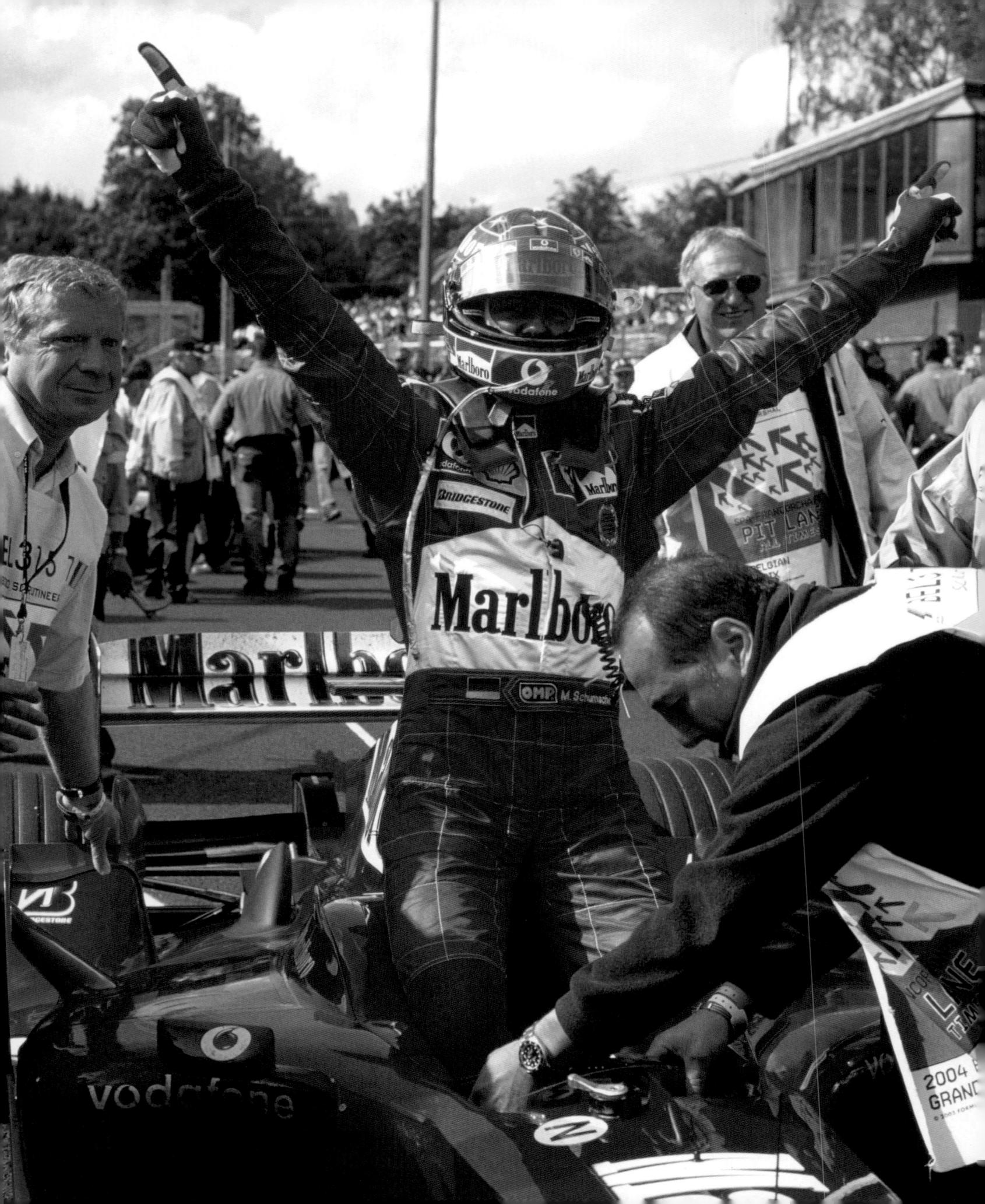

GUESS WHO?

ichael Schumacher recorded a fifth drivers' title in a row and Ferrari landed its sixth consecutive constructors' crown as Ferrari took an iron grip on a championship that offered little in the way of challenge. In short, Ferrari and tyre supplier Bridgestone were just too good for the rival teams. It came as little surprise. then, that negotiations raged throughout the close-season as the other teams sought ways to reduce the seemingly limitless testing that Ferrari carried out as they tried to peg back both the Italian team's speed advantage and have budgets pegged as they lagged behind.

In fact, only one team – Toyota – had a budget to match Ferrari's, but this counted for little as the German-based Japanese team struggled to score more than a few points. For the record, Ferrari outscored closest rival BAR two to one.

TWO TOP TEAMS STUMBLE

Perennial Ferrari challengers McLaren and Williams ended up with egg on their faces in 2004.

McLaren came out with its second duff chassis in two seasons and only improved after notable modifications in the second half of the season. Williams took an aerodynamic leap with a high-nose, twin-keel front – dubbed a 'walrus nose.' It didn't work and time was wasted before a more normal front was introduced.

In their stead, it was left to Renault to take up the challenge, with Fernando Alonso finishing third behind the Ferraris at the Australian opener before BAR's Jenson Button came on strong. He was twice on the podium at the next two races.

No-one, though, could live with Michael's pace as he won the first five

races, the third of which was in the inaugural Bahrain GP. He was going for a record sixth straight win when, in Monaco, he was taken out by Juan Pablo Montoya's Williams during a safety car period. This left the way clear for Jarno Trulli to score his first win for Renault.

That Michael bounced back to win the next seven rounds, with team-mate Rubens Barrichello finishing second in three of these, rubbed salt in their rivals' wounds.

McLAREN FINDS ITS FEET AGAIN

Michael wrapped up the title at the Belgian GP, but the headlines were filled by the driver who beat him across the line. This was Kimi Raikkonen who gave McLaren's updated MP4-19B chassis its first win.

The Ferrari team leader then proved that he was human after all by having

ABOVE MICHAEL SCHUMACHER HIT THE GROUND RUNNING AND HIS WIN IN THE INAUGURAL BAHRAIN GP WAS THE MIDDLE OF A FIVE-WIN RUN.

RIGHT THE FIRST NEW PORT OF CALL FOR FORMULA ONE WAS BAHRAIN, ITS PALM TREES AND DESERT PROVIDING A VERY DIFFERENT BACKDROP.

FAR RIGHT FORMULA ONE WENT TO CHINA
FOR THE FIRST TIME AND RUBENS
BARRICHELLO DROVE A MASTERFUL
RACE TO BE THE FIRST WINNER THERE.

two off races in a row, spinning down the order at Monza, albeit before powering back through to second place as track conditions favoured his Bridgestones, and then on Formula One's first visit to Shanghai where he floundered around to finish 12th. Barrichello triumphed in both races as he tends to when Ferrari let him off the leash once Michael has the drivers' title in the bag.

This spurt of points made it clear to Button that third would be as high as he could rank overall, but the Briton had worked wonders for BAR, boosted by ever stronger engines from Honda. He and Takuma Sato gathered sufficient

points to outscore Renault, which inexplicably ditched Trulli for the final three races and replaced him with Jacques Villeneuve – back from a year out.

The last laugh went to Williams and Montoya, though, as he won a wonderfully exciting championship-closer at Interlagos. Once more Barrichello was frustrated when his home race escaped him yet again.

Despite his win in Belgium, Raikkonen could rank only seventh and David Coulthard only 10th, before being dropped to make way for Montoya for 2005. This left the 1998 constructors'

champions only fifth overall behind Williams. Williams had lost continuity with the loss of Ralf for six races after he suffered a back injury in a monumental collision with the wall in the US GP. Antonio Pizzonia proved more effective than Marc Gene as a stand-in. Impressively, Ralf raced to second at Suzuka on his second race back.

Fall of the year went to Jordan which scored but five points then had to be bought out over the winter of 2004/05 to ensure its future. Likewise, Jaguar would only continue after being bought by Red Bull and renamed accordingly.

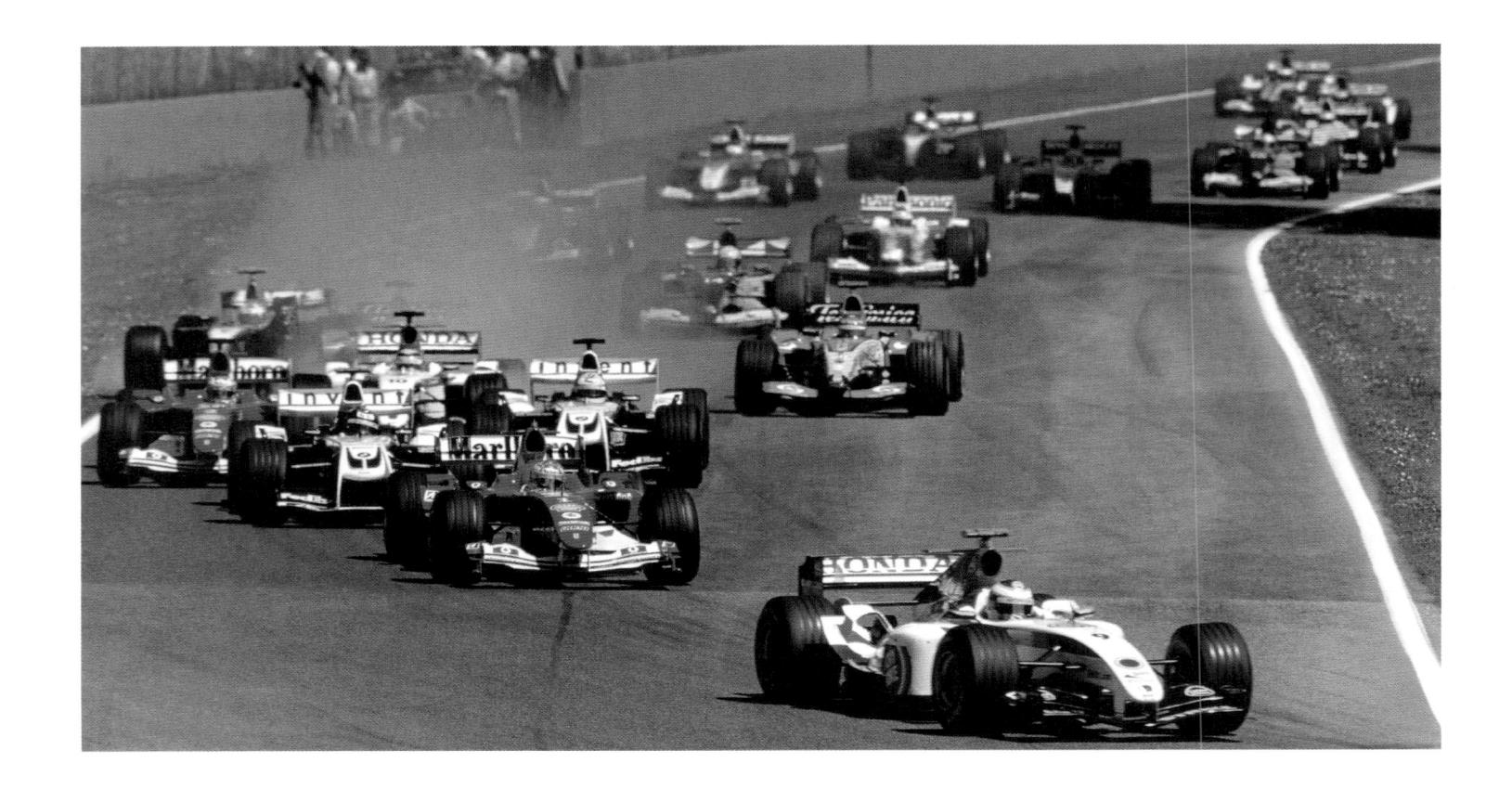

ABOVE JENSON BUTTON LEADS AWAY FROM POLE AT IMOLA, BUT IT WAS MICHAEL SCHUMACHER (BEHIND) WHO POWERED THROUGH TO WIN.

RIGHT QUALIFYING ON POLE AT MONACO,

JARNO TRULLI CONTROLLED THE RACE

FROM THERE FOR HIS FIRST WIN.

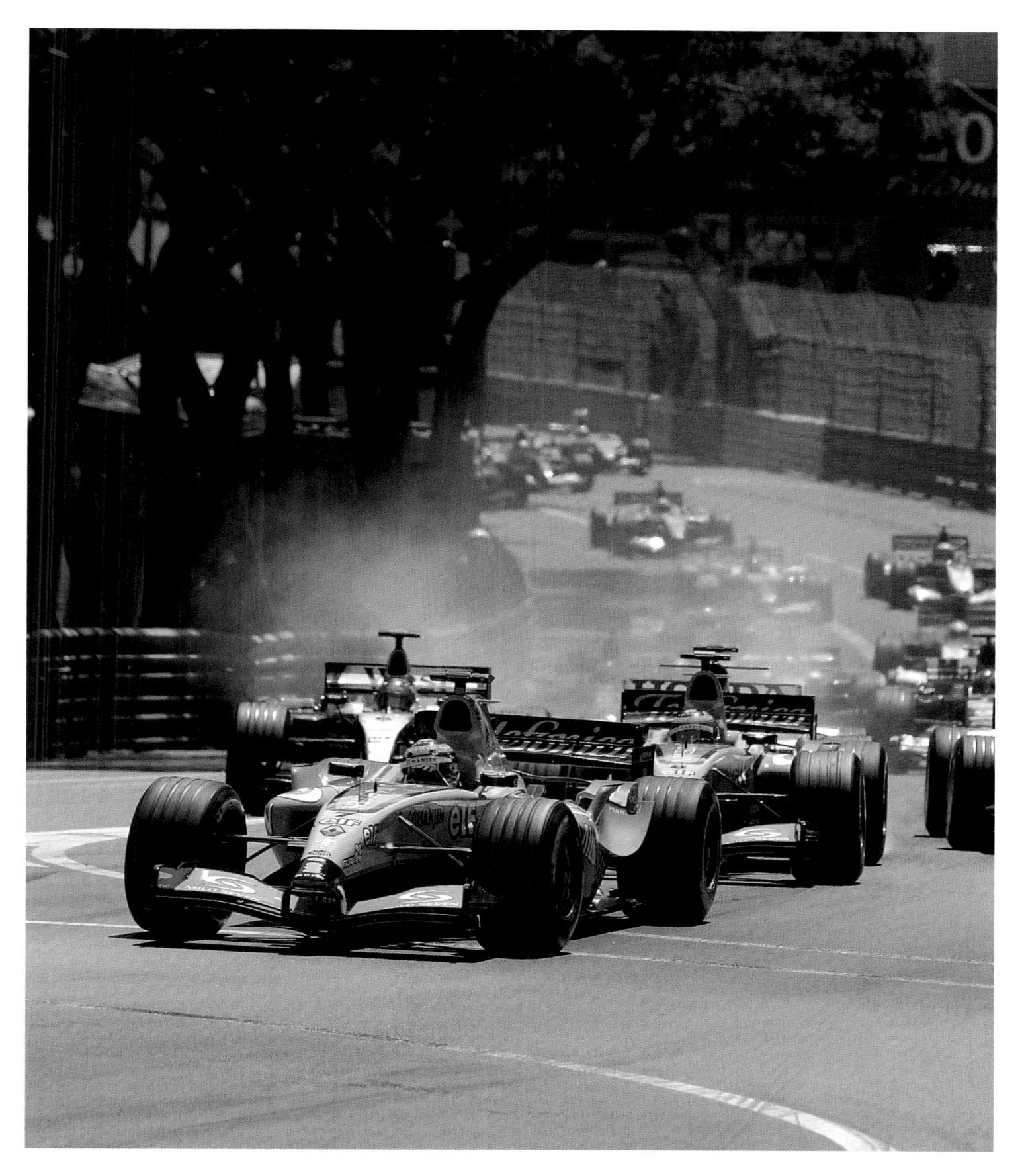

THE FIRST OF THE NEW BREED

t had seemed that the day would never come, but someone other than Michael Schumacher became World Champion in 2005, with Renault's Fernando Alonso ending the German's run of five straight titles. In so doing, he became the youngest World Champion ever, at 24 years and 58 days, to break Emerson Fittipaldi's record set in 1972.

Perhaps Ferrari and Bridgestone's slide from dominance was down to a rule change that dictated that there would be no tyre changes during pit stops. Yet its difficulties were multiplied by being the only top team on Bridgestone tyres, and the lack of comparative testing hampered Bridgestone's quest to maximize their tyres' performance as their Michelin-shod rivals worked towards

a more competitive package for this new format.

There was a further rule stating that engines must last two grands prix. So, perhaps there were grounds for Michael to explain why not only was he beaten by two rivals, but that one outscored him more than two to one and the other ended up 50 points clear.

The dominant duo were Alonso and McLaren's Kimi Raikkonen, two drivers already at the vanguard of Formula One's next generation of champions.

RENAULT'S FAST START

Third in 2004, with less than half of Ferrari's points tally, Renault was on the pace from the outset. The wet/dry/wet weather helped Giancarlo Fisichella to benefit from a new one-at-a-time qualifying system to claim pole in

Australia. He was out when the track was at its driest, leaving Juan Pablo Montoya back in ninth, Raikkonen 10th, Alonso 13th and Schumacher 18th on the 20-car grid. Fisichella made the most of this and won from Ferrari's Rubens Barrichello, but Alonso's charge from the back to third was ominous. Schumacher came away with nothing after clashing with Nick Heidfeld's Williams.

If that opening race had an element of lottery about it, the writing was on the wall at the second round, in Malaysia, as Alonso and Fisichella qualified first and third, split only by Toyota's new signing Jarno Trulli. Michael Schumacher again qualified outside the top 10, with Barrichello also struggling, to prove that Ferrari had work to do.

The team wasn't alone in having to find speed from somewhere as Alonso

Below THE UNITED STATES GP TURNED INTO A FARCE WHEN ALL BUT SIX CARS (THE BRIDGESTONE RUNNERS) PEELED INTO THE PITS AFTER THE FORMATION LAP AND DECLINED TO START THE RACE.

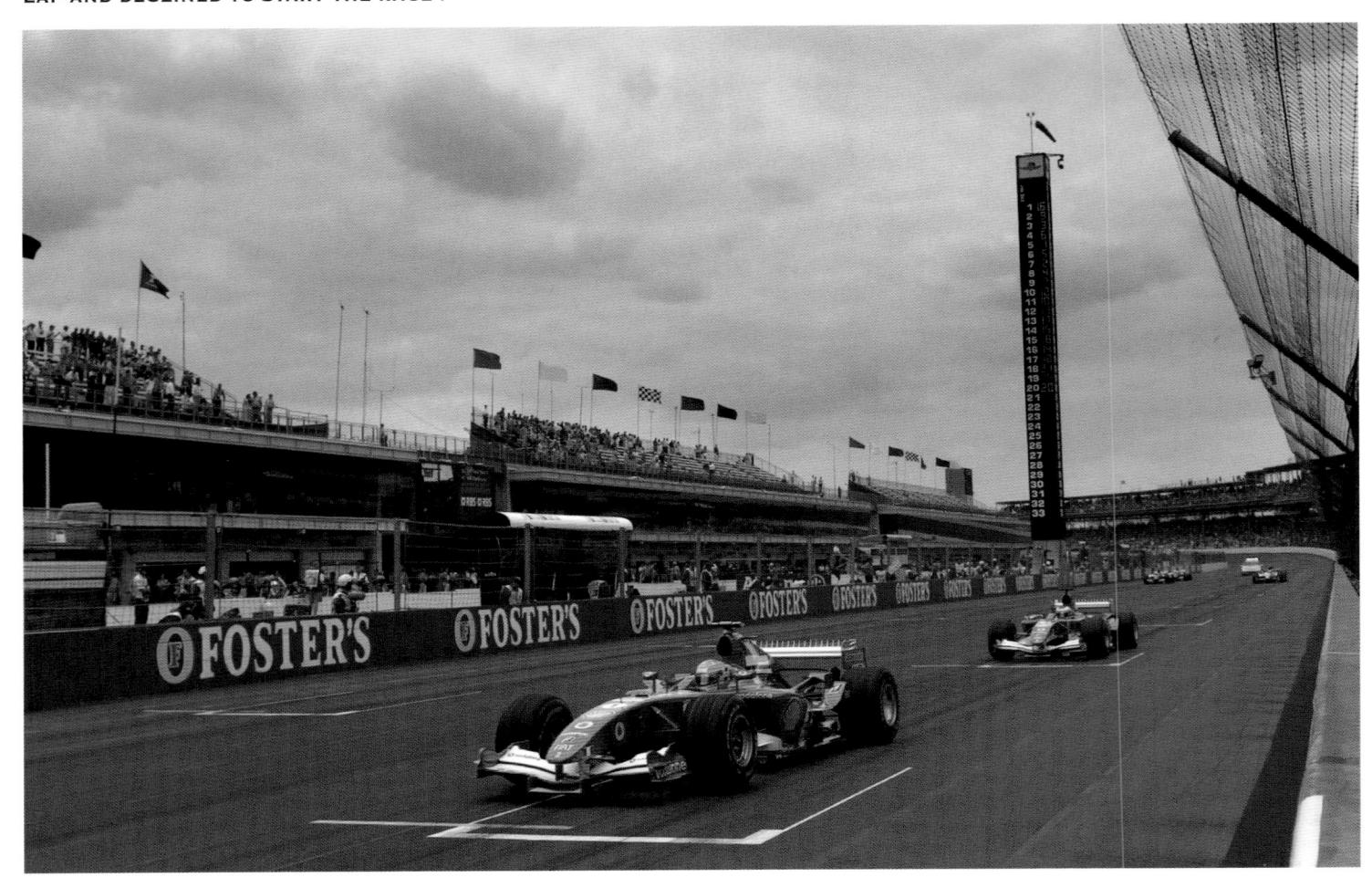

won from Trulli – Toyota's first podium finish – by 24s, with Heidfeld third. Mark Webber had been heading for third place in the other Williams, until a clash with Fisichella took both out. McLaren, like Ferrari, was missing out on podiums, but at least Montoya took fourth at Sepang, while Schumacher was seventh.

BAD NEWS FOR BAR

And what of BAR, the team that ended as runner-up to Ferrari in 2004? Having failed to score in Melbourne, Jenson Button and Anthony Davidson – a standin for a sick Takuma Sato – were both out after two laps of the Bahrain GP with their Honda engines having failed. It would get worse at Imola when the team was disqualified for being underweight and banned for two races, after Button had come home a greatly improved third and Sato fifth.

Alonso, who had beaten Trulli again in Bahrain, was first again at Imola, but only just. Schumacher finished just 0.2s down after Alonso proved that he could defend as well as attack.

The Spaniard was dominant, but Fisichella failed to carry momentum from his opening round win, retiring from the next three rounds, including two accidents. Although Trulliaugmented his good start with third next time out, in the Spanish GP, his form faded and team-mate Ralf Schumacher's second third-place finish at the final round in China moved him ahead of the Italian to rank sixth overall.

Several other teams improved during the season, most notably McLaren. The key to Ron Dennis's team gaining speed was sorting out a problem in getting heat into its tyres. Raikkonen qualified on pole at Imola and was pulling away when his engine failed. Infuriatingly even though

ABOVE THIS WAS THE MOMENT THAT KIMI RAIKKONEN LOST VICTORY ON THE FINAL LAP AT THE NURBURGRING.

RIGHT ALONSO AND JUAN PABLO MONTOYA CONTEST THE LEAD AT INTERLAGOS.

he won the next two races, at Barcelona and Monaco, both from pole, and was heading for victory in the European GP at the Nurburgring until hit by suspension failure on the last lap, this was to be the first of several Mercedes V10 failures. Raikkonen's bad luck handed victory to Alonso, leaving Alonso 28 points clear.

Like Fisichella at Toyota, Montoya was left in the shade at McLaren, not helped by missing two early-season races after reportedly injuring a shoulder playing tennis. Pedro de La Rosa stepped up from the test team to finish fifth and set fastest lap in Bahrain, then Alexander Wurz did likewise at Imola and his fourth place finish was improved to third when the BARs were ejected.

Montoya look set for victory in Canada after Alonso crashed as the Colombian moved onto his tail. A message for him to pit after a safety car was sent out didn't reach him until he had passed pit entry. Angry as he left the pit lane next time around, he passed a red light and was disqualified, handing victory to Raikkonen.

INDIANAPOLIS FARCE

What followed remains one of Formula One's darkest moments. This occurred at Indianapolis where Ralf Schumacher hit the wall at Turn 13 (for the second year in a row). As a result, because Michelin couldn't guarantee the safety of its left rear tyre on the banking, the seven Michelin-shod teams pulled out of the race after the formation lap, leaving just six cars to start. The fans were livid and few cared that Ferrari took a one-two for its only win of the year, or that Jordan's Tiago Monteiro claimed a once-in-a-lifetime third place.

The season really turned against Raikkonen at Hockenheim, as hydraulic failure cost him a clear victory... and handed it to Alonso. At least the Finn had the satisfaction of winning the next race, the inaugural Turkish GP. Alonso won only once more, in the final round, but a string of second places was enough to keep him clear of Raikkonen and see him crowned champion, at Interlagos, with two races to go.

For all of Alonso's efforts, McLaren took the points lead in the constructors' championship in Brazil, when Montoya led home a one-two. Third place was enough for Alonso to become champion.

Ferrari ranked third overall, ahead of Toyota, but only because of its one-two at the US GP. Williams was up and down, but fell away after Heidfeld and Webber finished on the podium at Monaco. The team's partnership with BMW soured and they parted company at season's end, with BMW buying Sauber.

BAR edged out new team Red Bull Racing, for whom David Coulthard twice finished fourth through wily performances. Sauber scored when others hit trouble, with Jacques Villeneuve taking fourth at Imola when the BARs were thrown out, and Felipe Massa doing likewise in Canada.

Jordan and Minardi ended up bottom, both treated to one-off hauls of points at Indianapolis. Before the 2006 season started, both teams had been taken over.

A LEGEND RETIRES

nspired by his first world title in 2005, Renault's Fernando Alonso added another, this time pushed by a resurgent Michael Schumacher rather than Kimi Raikkonen as Ferrari rediscovered its form while McLaren fell away and failed to win a race.

Schumacher announced his retirement from racing during the season, as had been expected, bringing to an end the most garlanded career in Formula One history. He finished with a tally of 91 wins and seven world titles in 250 grand prix starts.

Another notable moment in 2006 was Jenson Button giving Honda its first win since 1967. It was a fitting reward for the Japanese manufacturer. Honda took over BAR, which had been winless in its seven years in the sport despite launching itself with the fatuous catchline of "a tradition of excellence."

After Ferrari had been caught out by the rule changes for 2005, there was another round of changes for 2006, with teams again allowed to change tyres during races, helping Ferrari and Bridgestone to get back to the front. Perhaps the major change, though, was that engines were downsized from 3000cc V10s to 2400cc V8s.

Qualifying was also reconfigured, with the slowest six drivers being eliminated after the first 15 minutes to fill 17th to 22nd positions on the grid. After a further 15 minutes, the six slowest of the remaining 16 drivers would be eliminated, leaving the fastest 10 to take a tilt for pole.

ALONSO GETS A FLYER

Renault was fast from the outset, with Alonso and team-mate Giancarlo Fisichella winning the first three races. Alonso kept up the pressure by adding wins at Barcelona, Monaco, Silverstone and Montreal to take a 25-point advantage midway through the 18-race season.

Then down and down came the gap between Alonso and Schumacher as the Ferrari ace won at Indianapolis, Magny-Cours, Hockenheim, Monza and Shanghai. With two races remaining, Schumacher and Alonso were level on points and a record-extending eighth world title for Ferrari man was very much on the cards.

Amazingly, something almost unheard of during his 11 years with Ferrari happened when Schumacher was controlling the Japanese GP from the front: his engine blew. This boosted Alonso from second place and left him with a 10-point lead heading to the final round, the Brazilian GP, where he would have to score just one point in case Schumacher won.

Felipe Massa, a winner already in Turkey, was in sparkling form on his home track, Interlagos, but second place was enough for Alonso to be champion.

SCHUMACHER'S FINAL CHARGE

Schumacher's already faint chances were scuppered when his fuel pressure dived as he went out for his final run, leaving him 10th. Determined to end his career on a high, he went on a charge but clashed with Fisichella as he passed for fifth and suffered a puncture that dropped him to last of the 18 remaining cars before he drove one of the races of his life to make it back to fourth. It wasn't enough, but it was a magnificent way to sign out and even went a long way to erase the memory of his unsporting manoeuvre in qualifying at Monaco where he apparently

blocked the track to prevent Alonso from usurping his pole time. Schumacher's punishment from the stewards was to be put to the back of the grid.

Fisichella and Massa spent the year in their team-mates' shadows, while McLaren wasn't guite up to the challenge and Raikkonen was the first to come unstuck in the new-for-2006 qualifying format. Starting 22nd wasn't the dream way to get his season underway and although flashes of speed were there, a pair of second places were to remain his best results. McLaren's season was also interrupted by the departure of Juan Pablo Montoya for a new career in NASCAR stock cars. His replacement, Pedro de la Rosa, finished second in a tospy-turvy Hungarian GP, but wasn't able to match Raikkonen.

JENSON'S ON THE BUTTON

Button finally rewarded Honda's input by winning in Hungary, his first win at his 114th attempt. He achieved it from 14th on the grid in an unusual race. It started on Friday when Schumacher and Alonso were given 2s qualifying penalties, so they started from 11th and 15th.

The track was damp at the start. Polesitter Raikkonen led, but was distracted as de la Rosa closed in on him and vaulted over Red Bull's Vitantonio Liuzzi who had pulled over to let himself be lapped. By pitting late, Alonso looked to have pulled off a masterstroke, but a wheelnut came loose and he crashed, leaving Button to win from de la Rosa by half a minute. Button also finished on the podium in Brazil, but team-mate Rubens Barrichello failed to get on with the RA106.

ABOVE MICHAEL SCHUMACHER
PRODUCED A SCINTILLATING RUN IN
HIS FINAL GRAND PRIX, IN BRAZIL,
RECOVERING FROM A FLAT TYRE THAT
HAD LEFT HIM LAST TO FINALLY
FINISH FOURTH.

TOP RIGHT THE RENAULT CREW HOLD
FERNANDO ALONSO ALOFT AFTER
SECOND PLACE IN BRAZIL ROUNDED
OUT HIS SECOND STRAIGHT TITLEWINNING YEAR.

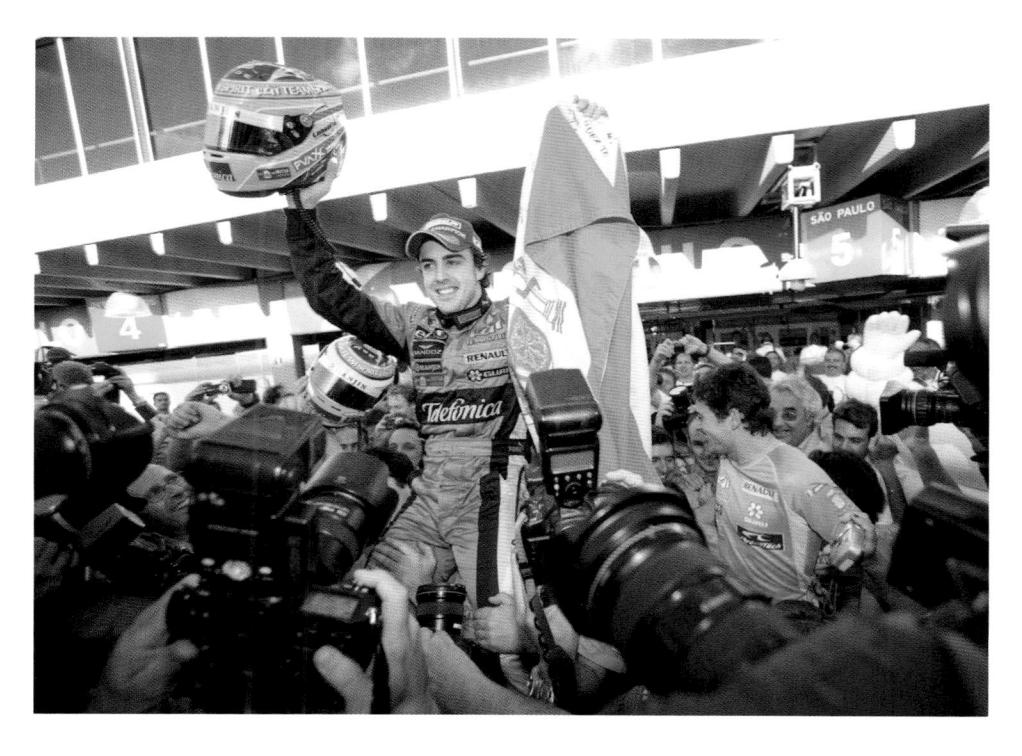

Boosted by BMW money, Sauber improved as the campaign progressed. They took a big step forward when Robert Kubica replaced Jacques Villeneuve with six races to go to. He finished third in only his third outing, at Monza, equalling Nick Heidfeld's best result, to help BMW Sauber rank fifth.

Conversely, Toyota slid to sixth, with technical director Mike Gascoyne fired after only three races. Emphasising that Japanese corporate culture doesn't always fit with the individual ways of the top brains, Geoff Willis was then ousted from Honda.

Third place for David Coulthard at Monaco was the highlight of Red Bull's year, but it lagged behind technically so the team chose to focus its efforts on its car for 2007. Christian Klien was replaced in the team's second car by Robert Doornbos before the season was out.

Williams had a torrid season, having to make do with running a non-works engine rather than a manufacturer-supplied one. The Cosworth V8 was much admired, but Cosworth's budget was tiny against their rivals, and poor reliability often thwarted Mark Webber, though he did produce a powerful drive to third place in Monaco. Team-mate Nico Rosberg starred by finishing seventh on

his debut, with the fastest lap, but he was in the points only once more.

Scuderia Toro Rosso, formerly Minardi, was allowed to run rev-restricted V10s, upsetting some rivals, but Red Bull's money bought just one point when Liuzzi came eighth at Indianapolis. Teammate Scott Speed had been denied a point for eighth at the Australian GP when he was penalised 25s for passing Coulthard under yellow flags.

The team that had been Jordan, MF1 Racing, changed its name again before the year was out, becoming Spyker after being bought out by Michiel Mol and renamed after the Dutch sports car manufacturer. Neither Christijan Albers nor Tiago Monteiro scored.

Super Aguri was an all-new team, created by former racer Aguri Suzuki at the 11th hour, largely to stem criticism of Honda in Japan that Takuma Sato had been kicked out of BAR when it was rebadged as Honda Racing. Its first car was brought to the opening round in Bahrain with next to no testing and was way off the pace. But the car improved as development parts finally came on-stream until Sato raced to 10th place in the final round. Sato's three teammates – Yuji Ide, Franck Montagny and Sakon Yamamoto – all struggled.

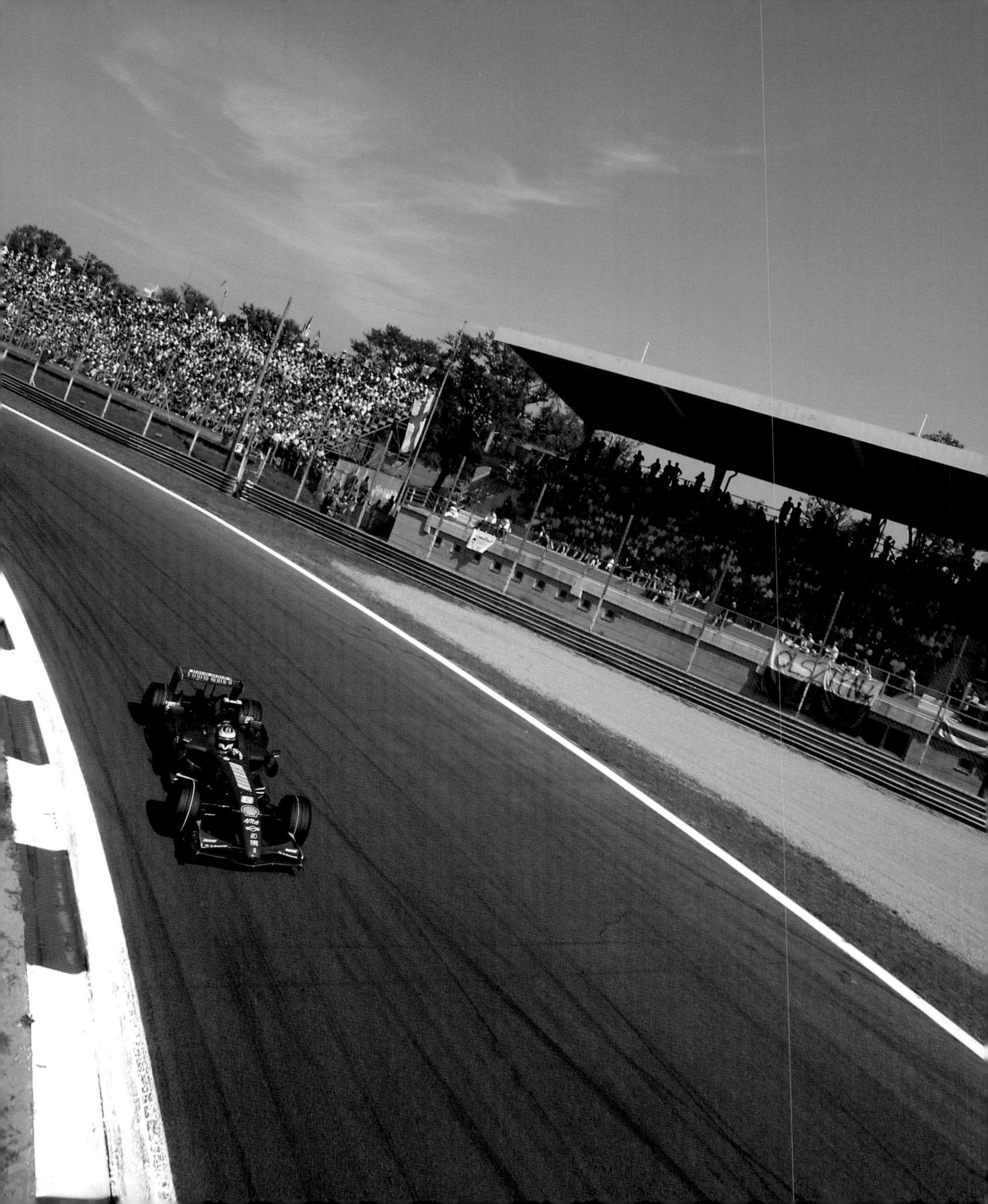

TOO CLOSE TO CALL

o script writer would have dared come up with a storyline of three drivers heading into the final round of the season with a shot at the title, with the championship going to the least favoured of the three having been handed victory by his team-mate. Yet, this is what happened in 2007, much to the delight of Formula One ringmaster Bernie Ecclestone.

The new champion was Ferrari's Kimi Raikkonen, who overcame team-mate Felipe Massa and McLaren's duo of astonishing rookie Lewis Hamilton and reigning champion Fernando Alonso.

However, to go with all the excitement, there was plenty of acrimony. After a strong start with McLaren, Alonso fell out with the team. Many believed that Hamilton's sheer speed had upset the defending

champion, thus preventing him from being seen as the team's de facto number one – irrespective of the fact that McLaren never designates its drivers as one and two, as it prides itself in running equal cars.

It was undeniable that Hamilton, who been team chief Ron Dennis's protégé for a decade, was very quick and also was well liked within the team. The matter came to a head during qualifying for the Hungarian GP, after which it was clear that the Spaniard's sojourn at McLaren would last one year and no more.

SPYGATE

However, McLaren were involved in a considerably more serious matter, one that cost the team all of its points in the constructors' championship. Ferrari accused McLaren of industrial espionage

after Mike Coughlan, McLaren's chief designer, was found with Ferrari technical drawings in his possession, supposedly passed to him by disenchanted Ferrari race and test technical manager, Nigel Stepney.

Whatever the reality of the situation, McLaren was punished severely by the FIA, the governing body removing all of the team's points – past and future in 2007 – and hitting the team with a \$100m fine. Renault, which was also said to have another team's technical details – McLaren's – escaped without punishment.

HAMILTON WOWS THEM

This was a shame, as the racing in 2007 was magnificent, something that became clear from the opening round when Hamilton showed an exciting lack of respect for his elders by passing Alonso

before the first corner at Melbourne, even after a poor getaway. There was clearly a new ace in the pack.

That first day belonged to Raikkonen, who got his Ferrari career off to a winning start, from pole, proving the best on the new spec tyres – Bridgestone had signed a deal during the offseason to be sole supplier of rubber. But Alonso showed his grit by passing Hamilton to finish second and he won as he pleased next time out, at Sepang. Ron Dennis's smile was made even wider as Hamilton finished second, well clear of Raikkonen. It appeared this would be McLaren's year and Alonso's third title in a row.

Racing doesn't always run to plan, though, and Ferrari's Felipe Massa gave the Italian team hope by winning in Bahrain and Spain. Alonso put McLaren back on track by winning at Monaco, in a race that Hamilton felt could have been his. After an unprecedented five consecutive podium finishes at the start of a Formula One career, Hamilton claimed his first win, at Montreal, staying cool at the head of a race interrupted by safety car periods.

When Hamilton won again, at Indianapolis, he led the championship by 10 points and Alonso was really rattled. Raikkonen won again at Magny-Cours, then at Silverstone too. Despite failing to score at the Nurburgring, Hamilton was still two points clear of Alonso and 11 up on Massa, with Raikkonen, who had retired, seven further back.

ALONSO'S FRUSTRATION BOILS OVER But then came the Hungarian GP when Alonso and Hamilton got personal in qualifying. Alonso was demoted five places for impeding Hamilton, who was thus promoted to pole and would go on to win, from Raikkonen, who had been bottled up behind him all race.

Massa was dominant in Turkey, where a puncture dropped Hamilton to fifth. At Monza, Hamilton was outraced by Alonso, who reduced his lead to three points. Next up was the Belgian GP and Raikkonen led another Ferrari one-two. However, when Hamilton showed the world how to drive in the (very) wet on Formula One's return to Fuji, he was 12 points clear with two races to go and seemed set to be Formula One's first rookie World Champion. But it wasn't to be...

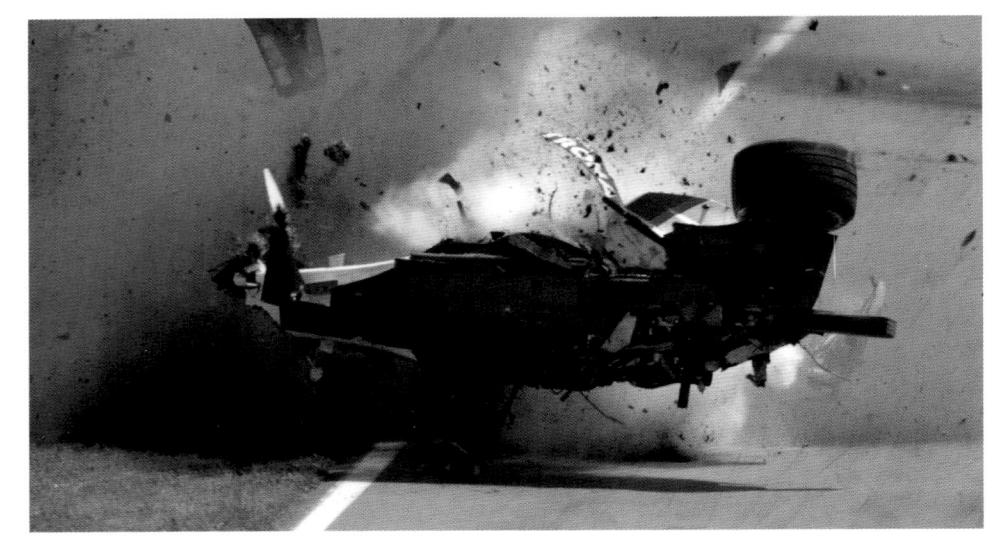

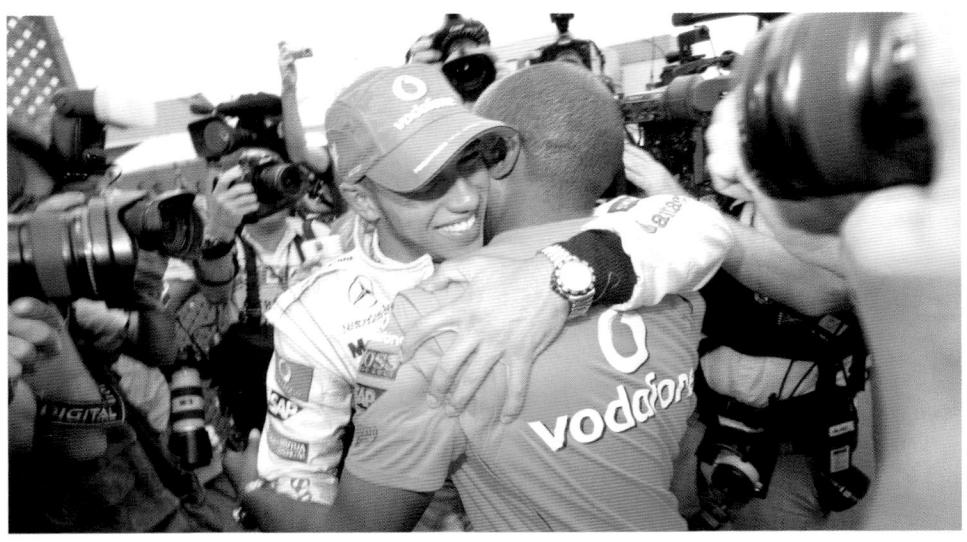

ABOVE LEFT BMW SAUBER'S ROBERT KUBICA WAS LUCKY TO SURVIVE THIS HORRIFIC CRASH IN THE CANADIAN GP.

LEFT LEWIS HAMILTON THREATENED TO WIN FROM HIS DEBUT AND TOOK HIS FIRST IN CANADA IN ROUND SIX.

ABOVE RIGHT LEWIS HAMILTON LOST OUT IN BRAZIL, WHERE VICTORY FOR KIMI RAIKKONEN (BEHIND) WAS ENOUGH FOR THE TITLE.

The image of Hamilton's McLaren beached in the pit entry gravel trap at Shanghai will remain with his fans for years. He had just been passed for the lead by Raikkonen, and didn't need to win, but McLaren declined to bring him in for new tyres, even though his were threadbare. McLaren's plan, it appeared, was to wait for a change in the weather, but it backfired and Hamilton's failure to score any points left him just four clear of Alonso going to the final round, with Raikkonen a further three behind.

Hamilton started second behind Massa in Brazil, but was passed by Raikkonen going into the first corner, then got blocked and fell behind Alonso. This would have been fine, but Hamilton attempted to fight back, only to go wide and drop to eighth. Six laps later, after regaining two places, a gearbox problem slowed Hamilton's car and dropped him to 18th before it could be righted.

That left him with a mountain to climb, and it proved too much. Massa led for much of the race but handed victory to Raikkonen. Alonso was a lacklustre third while Hamilton could climb back only to

seventh, so Raikkonen was champion.

BMW Sauber were next best behind Ferrari and McLaren, with Nick Heidfeld and Robert Kubica deserving of more. Their best result was Heidfeld's second place in Canada. McLaren's removal from the constructors' championship table left Mario Theissen's team second overall.

Renault's form plummeted, with rookie Heikki Kovalainen taking half the season to find his feet before outperforming Giancarlo Fisichella. Conversely, Williams made ground, but its form was still inconsistent, making it hard for Nico Rosberg and veteran Alex Wurz. The team's only podium finish was Wurz's on a crazy day in Montreal.

Red Bull Racing was even more up and down en route to fifth in the constructors' championship, with its RB3 increasingly fast but fragile. Mark Webber lost several strong point scores and was outscored by David Coulthard. Toyota slipped to sixth, its meagre points tally the most expensive in the sport's history. The team's TF107 defeated both Jarno Trulli and Ralf Schumacher.

Toro Rosso was going nowhere fast,

then hit the points in the penultimate round when rookie Sebastian Vettel (who crashed out of third in the previous race) finished fourth and Vitantonio Liuzzi took sixth.

The team that was once Minardi finished ahead of Honda and this summed up how excruciating life must have been for Rubens Barrichello and Jenson Button. At least a fifth place finish for Button saved the embarrassment of being ranked behind the Super Aguri team to which Honda provides engines.

Super Aguri could even have landed a podium finish, in Canada, but a marmot bent Anthony Davidson's front wing and the crew weren't ready when he pitted. However, the race yielded sixth for Takuma Sato when he passed Alonso on merit.

Underfinanced Spyker brought up the rear and, when rookie Adrian Sutil calmed down, it made progress. Markus Winkelhock started the European GP at the Nurburgring on wet weather tyres and took the lead on lap 2 when everyone dived for the pits, then stayed there for six laps, which wasn't bad for his debut and was more than his late father, Manfred, managed during his Formula One career in the 1980s.

THE FINAL ACT OF THE FINAL RACE

he 2008 Formula One World Championship had the most exciting conclusion ever. At the end of the final race, first one driver won the title, then, 30 seconds and one overtaking manoeuvre later at the last corner, it was plucked from his grasp. Felipe Massa was the vanquished party and Lewis Hamilton the victorious one, in so doing breaking Fernando Alonso's record from 2005 to become the youngest ever World Champion, at just 23 years 300 days.

There was a major rule change: the banning of electronic driver aids, much to the delight of purists who felt that these had narrowed the gap between the good and the best. A standard engine 'brain', the ECU, was made mandatory and a gearbox was now to last for four sets of grand prix Saturdays and Sundays, with a five-place grid penalty if one needed to be changed. Engines

continued to be expected to last for two Saturdays and Sundays.

There were also two new venues. A street circuit around the docks in Valencia became the new home of the European GP, but it was eclipsed by Singapore's street circuit that hosted Formula One's first night-time grand prix, offering novelty and a stunning backdrop.

EARLY SURPRISES

Hamilton helped McLaren emerge from its winter of discontent by racing from pole to an easy victory in the Melbourne opener, with Nick Heidfeld second for BMW Sauber. Reigning champion Kimi Raikkonen had started 16th after a fuel pump problem, but made it back to eighth. Raikkonen then waltzed to victory at Sepang, with BMW Sauber's other driver, Robert Kubica, second, giving Stefano Domenicali his first win since

taking Ferrari's reins from Jean Todt. He was pleased again, when Massa won in Bahrain, from Raikkonen, with Hamilton clashing with Fernando Alonso's Renault. Third and fourth put BMW Sauber top of the points table.

The fourth race, in Barcelona, will be remembered for three things: first, Raikkonen led home Massa in another Ferrari one-two; second, Heikki Kovalainen survived a massive accident in the second McLaren; and third, it turned out to be the final appearance for Super Aguri before the team folded.

A fourth straight Ferrari win, this time for Massa in Turkey, might have been bad news for McLaren, but Hamilton was on his tail after running an aggressive threestop pit strategy because of tyre concerns. Kovalainen reckoned that he might have won the race, but a first lap clash with Raikkonen left him with a puncture.

LEFT THE FIRST EVER SINGAPORE GP
WAS FORMULA ONE'S FIRST NIGHT
RACE. NICO ROSBERG IS SHOWN LEADING FROM JARNO TRULLI, GIANCARLO
FISICHELLA AND ROBERT KUBICA.

LUCKY PUNCTURE

McLaren rediscovered its winning touch at Monaco when Hamilton triumphed. The driver clipped a barrier and had to visits the pits to change a puncture, which just happened to put him on a perfect stopping strategy.

Victory in Canada ought to have been Hamilton's too, as he was dominating, but a safety car was deployed and it all went wrong when the pit lane opened and everyone pitted. Kubica and Raikkonen were the fastest away, causing Hamilton to panic and fail to notice the light was red at pit exit. He slammed into Raikkonen's Ferrari, not only costing him the race, which Kubica went on to win to give BMW Sauber its first victory, but also suffering a 10-place grid penalty for the next race, in France.

As a consequence, Hamilton was towards the back of the pack when he ran off the Magny-Cours track passing Vettel's Toro Rosso and was punished with a drive-through penalty. That left him out of the points and he ended the weekend 10 points behind race winner Massa.

To become champion, Hamilton was going to have to get his act together, and this he did in style, first at a rain-lashed Silverstone, then with a feisty drive at Hockenheim. In this race, one-stopping Renault driver Nelson Piquet Jr came from 17th on the grid to lead for six laps

before finishing second. In Hungary, Massa had Hamilton's measure before the Englishman's front left tyre blew, but Massa's engine failed, leaving Kovalainen to take his first win.

CONTROVERSY IN BELGIUM

Massa trotted out wins in Valencia and Spa-Francorchamps, but the latter was controversial. Hamilton had worked his way past Raikkonen in the wet, but had gained an advantage out of the final corner by jumping the chicane. He immediately ceded position, then struck back at the next corner. The stewards decided this wasn't enough and the 25s time penalty they gave him dropped him to third.

Then came the Italian GP. Three days of streaming rain made Monza treacherous, yet Vettel not only placed his Ferrari-powered Toro Rosso on pole but also led from start to finish to become the youngest ever winner at 21 years and 73 days. Hamilton, who had plumped for intermediate tyres in qualifying, started 15th and ended up seventh.

Renault was finally on the pace in Singapore, with Alonso tipped to take pole, only for a fuel line to come off, leaving him 15th. Fortuitously or otherwise, just after he had made an early first pit stop, team-mate Piquet Jr crashed and brought out the safety car, putting Alonso into the lead. Even with a drive-

through penalty, Nico Rosberg brought his Williams home second, just ahead of Hamilton. Early leader Massa's hopes were dashed when he tried to leave the pits with his fuelhose still attached and had to wait for it to be removed.

Hamilton made a desperate lunge to regain the lead into the first corner at Fuji, pushing all the frontrunners wide. This allowed Kubica to take the lead, from sixth, and Hamilton was given a drive-through penalty, as was Massa for tipping Hamilton into a spin a lap later. With Raikkonen's car damaged by Kovalainen at the first turn, Alonso made it two wins in a row.

Shanghai held bad memories for Hamilton from 2007, but he was supreme in victory in 2008. Massa remained in the title hunt when Raikkonen let him through for second.

STUNNING CLIMAX

And then came the finale in Brazil. Starting with a seven-point lead, it was again Hamilton's championship to lose, and he so nearly did it when rain triggered a rush for the pits with five laps to go. Massa was leading, although Hamilton, in fourth place, would take the title with that finish.

But Vettel passed Hamilton, who appeared unable to respond. Toyota's Timo Glock had not pitted, so was also

ahead of Hamilton, but struggling for grip. Massa crossed the line, as champion, but Vettel and Hamilton both came upon Glock with one corner to go, flashed past and the title was Hamilton's.

Kubica was deprived of third place overall by Raikkonen after mistakenly starting the race on dry tyres. Renault had promised to improve and did, as did Toyota, with Trulli and the promising Glock both claiming one podium finish.

There was much bad feeling that Toro Rosso appeared to be running a car that was a clone of the Red Bull, and it usurped its senior partner thanks to Vettel's win and a late-season run when its Ferrari engines appeared stronger than Red Bull's Renault V8s, much to the frustration of Mark Webber and David Coulthard.

Williams was again inconsistent over the season, but Honda's year was even more spasmodic. The team left Rubens Barrichello and Jenson Button looking silly as it chose instead to focus on 2009, with only Barrichello's third in the British GP to smile about. Then, late in the year, Honda withdrew its backing. Force India, formerly Spyker, failed to score, making Adrian Sutil's removal from fourth at Monaco by Raikkonen all the more wretched.

ABOVE TOP SEBASTIAN VETTEL BECAME
THE YOUNGEST EVER WINNER, AT JUST
21 WHEN HE WON AT A SOGGY MONZA
FOR TORO ROSSO.

BELOW RIGHT LEWIS HAMILTON SHOWED

JUST WHO WAS BOSS WHEN HE

DIVED INSIDE FELIPE MASSA AT THE

GERMAN GP.

WEBBER BUTTON TORO ROSSO MASSA MCLAREN BARRICHELLO

A NEW ORDER

change in the rules often produces a season of excitement, with something of a reshuffling of the pack, but it's hard to recall if there has ever been such a changing of the order as in 2009, with erstwhile pace-setters McLaren left struggling to emerge from the midfield and Ferrari scoring not a single point in the first three Grands Prix.

Yet more remarkable than that, the team that won three of the first four Grands Prix, in Australia, Malaysia and Bahrain, wasn't even in existence at the 11th hour in the run-up to the first race. This was Brawn GP, the team that had been Honda Racing until late November 2008 when the Japanese manufacturer pulled the plug, mindful of the global economic recession. Indeed, several manufacturers had to balance their F1 programmes against laying off staff at their factories as sales of road cars fell. Technical director Ross Brawn took the helm and agreed reluctantly for the team to be called Brawn GP, and the new car's speed from its handful of preseason tests was startling. This was of extra delight for drivers Jenson Button and Rubens Barrichello who had looked

to be out of F1 until the team was given its reprieve.

It is true that Brawn had focused on the 2009 car at the expense of development of the 2008 challenger that was good enough to leave the team only ninth overall, but many of the sport's insiders pointed to the pace of the white Mercedes-powered cars and that of the Williams and Toyota duos as being down solely to the shape of their diffusers, claiming that they were bending the rules by running a double-diffuser setup. The FIA rejected this charge, leaving the other teams to copy the concept or lose out, with aerodynamic benefits coming from the gap in the transition between the two diffusers being used to direct airflow out the back of the car above the diffuser tunnel.

PRESS KERS TO PASS

If the grids looked strange in Melbourne, almost reversed, the cars looked even more odd, as they sported the new aerodynamic packages that left them with wide, driver-adjustable front wings, no bargeboards or any of the multifarious winglets that used to adorn their flanks, and a narrow, high rear wing. On the plus

side, these changes were made to make it easier for a driver to follow then pass another car and the cars were fitted with slick tyres, back for the first time since 1997. Under the skin, cars were allowed to run with a KERS system that stores energy generated by braking then releases it to boost acceleration. The downside is its weight, and some teams started the year with a system far better than others who chose to wait and develop their KERS further.

With Brawn and Toyota being the standard bearers in the first two races, with flashes of speed from Williams' Nico Rosberg, there was an early opportunity for the stewards to get busy, and it sprang from an innocuous moment when Jarno Trulli ran off the track behind the safety car and reigning champion Lewis Hamilton slipped past before letting him back by. Trulli was given a 25s penalty, but Hamilton was later found to have been at fault and was disqualified. His reputation took a knock, but it was worse for McLaren sporting director Davey Ryan who was fired, while Ron Dennis chose to stop all of his involvement with McLaren's F1 team and focus on its road car division instead.

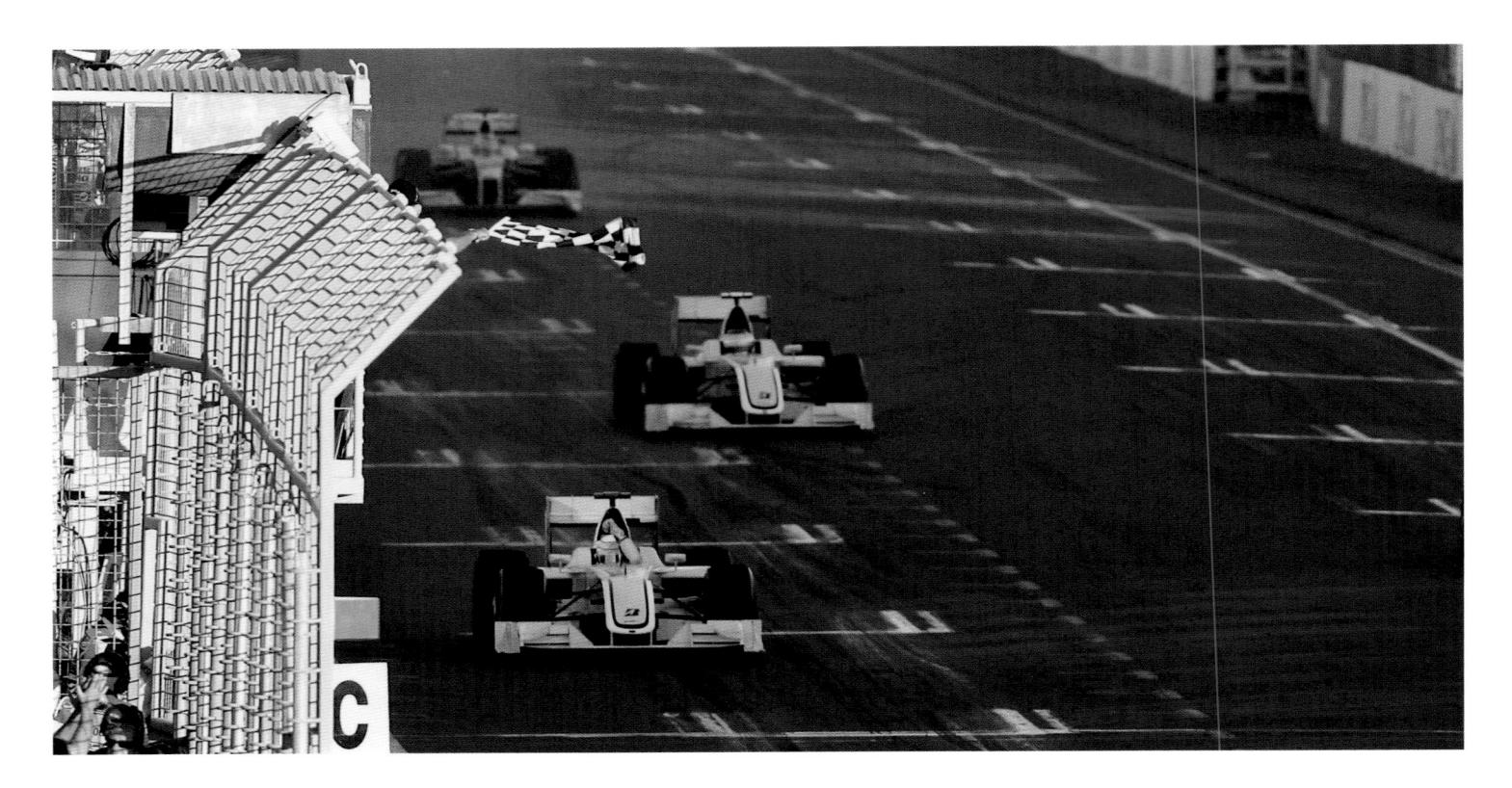

The third race, in heavy rain in China, gave Red Bull Racing its first win, with Sebastian Vettel qualifying on pole, as he had at Monza in 2008 when he gave sister team Scuderia Toro Rosso its maiden win, then racing to victory. Teammate Mark Webber might have had a crack at it, but ran wide, as so many drivers did, and lost time behind Button before pulling off a great move to go back past into second place. Quite simply, the Renault-powered Red Bull RB4 was superior to the Brawn BGP 001 in these conditions.

Yet, in the dust and heat of Bahrain, it was Button's turn to win again, and the rest of the teams knew that they would have to develop or drop behind, with many banking on gains arriving in Spain with their first wave of development parts. Try as they might, though, they couldn't stop Button and Brawn, with the English driver racing to victory in the next three races in Spain, Monaco and Turkey. Team-mate Barrichello was second in two of these, but it wasn't the Brazilian who eventually stopped Button's run but Vettel. Annoyingly for Button, this came on home ground at Silverstone, but colder conditions there seemed to suit the Red

Bulls better and they scored a one-two, with Webber second. The Australian then scored his maiden win next time out, at the Nurburgring, even with a drive-through penalty.

A third team got in on the act at the 10th round, in Hungary, when McLaren's Hamilton led Ferrari's Kimi Raikkonen home. However, this was overshadowed by an incident befalling the other Ferrari driver, Felipe Massa, who was hit on the helmet during qualifying by a spring that dropped off Barrichello's car and fractured his skull.

BARRICHELLO WINS AGAIN

Brazilian F1 fans were given some succour at the following round, though, as Barrichello triumphed in the European GP on Valencia's street circuit. That it was perhaps helped by McLaren's pitcrew not being quite ready for Hamilton's final pitstop only added to their delight. Barrichello then unleashed his effervescent emotions to mark his first win since the 2004 Chinese GP. Ferrari's longtime test driver Luca Badoer was drafted in to replace Massa and, surprisingly, struggled.

The Belgian GP was dramatic from the start as Romain Grosjean's Renault

clipped Button into a spin and Hamilton was hit by Jaime Alguersuari's Toro Rosso as he took evasive action. Giancarlo Fisichella had shocked by qualifying on pole for Force India and he came within a whisker of turning that into victory, being denied only by Raikkonen. By the following race, Fisichella was a Ferrari driver, taking over from Badoer, but his ninth place at Monza, on a day when Barrichello won again, was to prove his best result for the Italian team.

RENAULT MANAGEMENT TAKES RAP

In Singapore, Hamilton made amends for crashing on the final lap at Monza when challenging Button for second. The main news interest, though, was focused on a clear-out at Renault as a result of findings that the team had manipulated the result of the same race 12 months earlier by instructing Nelson Piquet Jr to crash to enable Fernando Alonso to win. The outcome was team principal Flavio Briatore and director of engineering Pat Symonds being banned from the sport.

Despite Button's early-season dominance, Vettel was still in with an outside chance of the title when the teams arrived at Suzuka and a win for LEFT JENSON BUTTON LEADS RUBENS
BARRICHELLO HOME FOR A FAIRYTALE
ONE-TWO FOR BRAWN GP ON ITS DEBUT
IN THE 2009 AUSTRALIAN GRAND PRIX.

FIGHT RED BULL RACING SCORED ITS
FIRST WIN IN TORRENTIAL CONDITIONS
IN CHINA. WINNER SEBASTIAN VETTEL
IS FLANKED ON THE PODIUM BY
TEAM-MATE MARK WEBBER WHO
FINISHED SECOND AND JENSON
BUTTON (THIRD).

BELOW HAMILTON WAS THE DOMINANT FORCE AT THE SINGAPORE GP.

the German as Button was penalized five grid positions for not slowing for yellow flags and could advance only to eighth kept his hopes alive. At the penultimate round, at Interlagos, Button CHINESE CHINES

lost out when rain struck during qualifying, leaving him 14th. Yet, from there, he made it to fifth as Webber won and this was enough to make Button champion.

The final race was at Abu Dhabi's allnew Yas Marina circuit and a one-two for Red Bull there showed that there could be a different team leading the way in 2010.

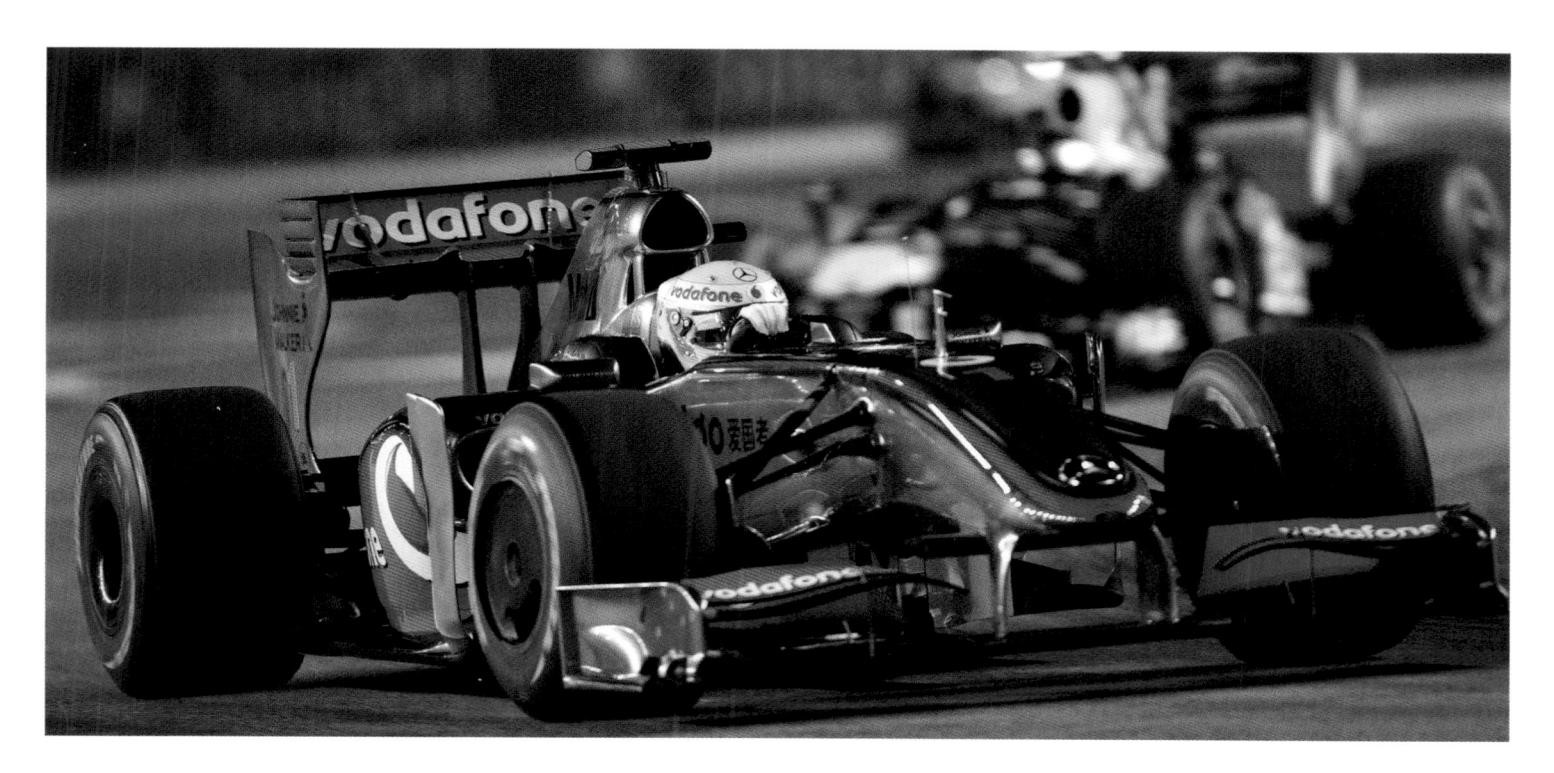

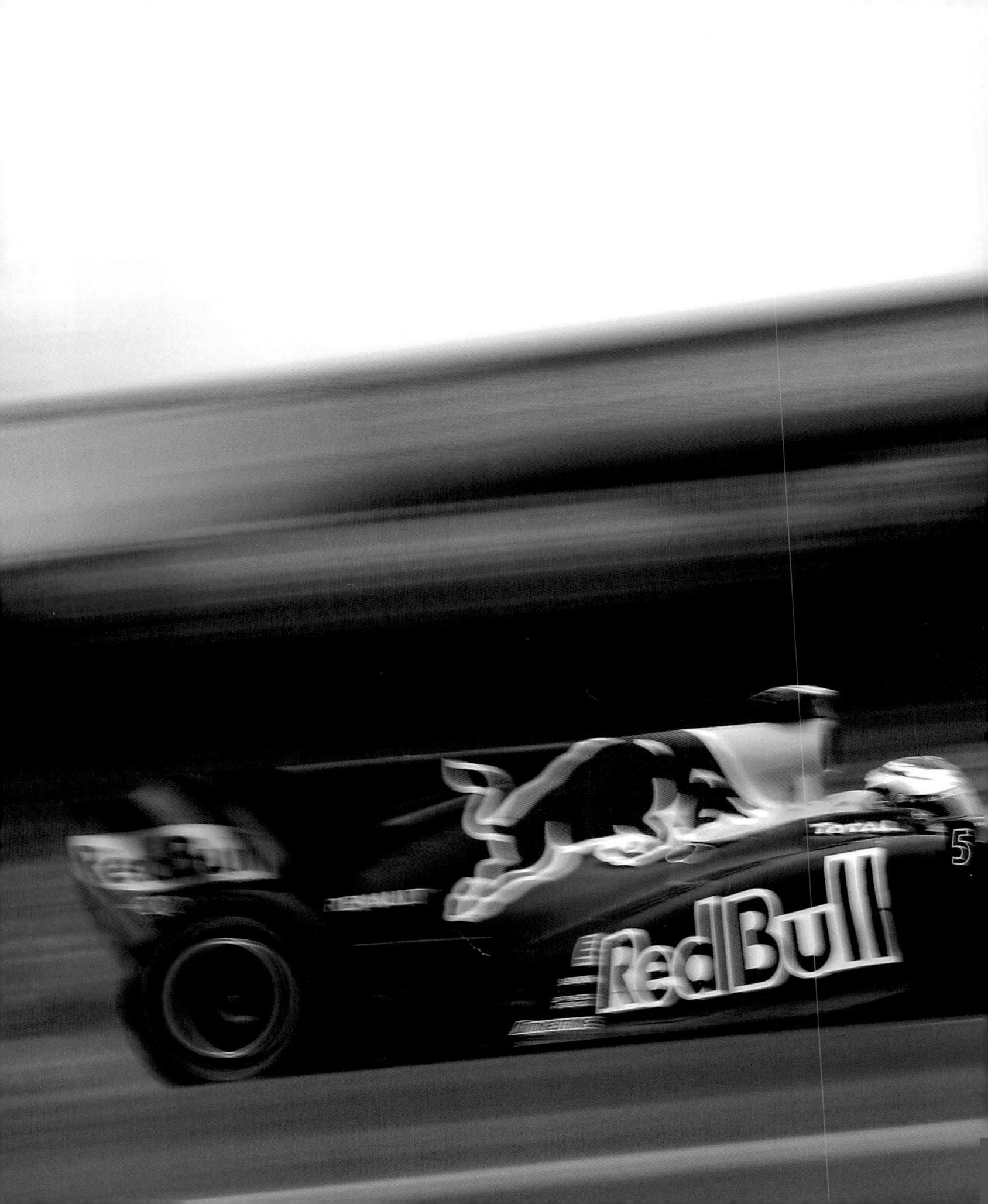

THE TEENS

MARK WEBBER

Honours: 3RD 2010, 2011, 2013

Grand Prix record: 215 STARTS, 9 WINS

Mark's F1 career spanned a dozen years, periods of domination by two German multiple World Champions, produced nine wins and earned considerable admiration for his straight-talking, honest approach that was devoid of pretence or hyperbole. He is an out-and-out racer cast from something of an old-fashioned mould and as such often seemed an adult in an increasingly infantile world. So, he is ideal to talk about F1's many changes and the extraordinary rise of teenage F1 racers.

When summarizing this wry Australian's career, an array of thoughts spring to mind. His unexpected charge to fifth on his F1 debut with tail-enders Minardi, his outstanding qualifying efforts for Jaguar Racing, his transition into a winner with Red Bull Racing and his battling with team-mate Sebastian Vettel. However, what trumps all this is the esteem in which Mark is held in the paddock. Honest, athletic and consistent, he could always be called upon to speak sense, always able to cut to the nub of the matter and apply real world perspective. Small wonder, then, that in 2013, he was courted by Ferrari, to bring solidity to the cauldron at Maranello. Instead, he opted to race for Porsche in the 2014 World Endurance Championship, to get away from the glitz and glamour and to enjoy longer gaps between races.

Mark's first F1 test with Benetton was in 2000. The fact that he even got to this point was testament to ability rather than the outpouring from a family bank account.

"That test organized by Flavio Briatore is what got me into F1," explains Mark, "and I got that on merit after what I'd done

in sportscars then F3000. There was a lot more testing for F1 then and the teams needed drivers of merit to back them up. I was operating as a professional and got paid a wage. That way in to F1 doesn't really exist any more as there's so little testing, but that's the way that many of us reached F1 back then.

"It was so different then. Look at the calibre of the drivers at the tail of the grid when I started with Minardi in 2002. I was fighting with Eddie Irvine and Mika Salo, which is very different from people like Marcus Ericsson and Pastor Maldonado at the back of the grid now."

One thing that was simpler was the approach to F1, with F3 then F3000 then F1. Now it's harder to talent spot as F3000 was replaced by GP2 and has Formula Renault 3.5 at a similar level.

"It was a smaller industry when I approached F1 and the teams trusted the junior categories more," says Mark. "It was easier to identify the talent too, as this was before the use of Pirelli spec tyres which have to be preserved, whereas we were able to drive flat-out in F3000."

MARK WEBBER

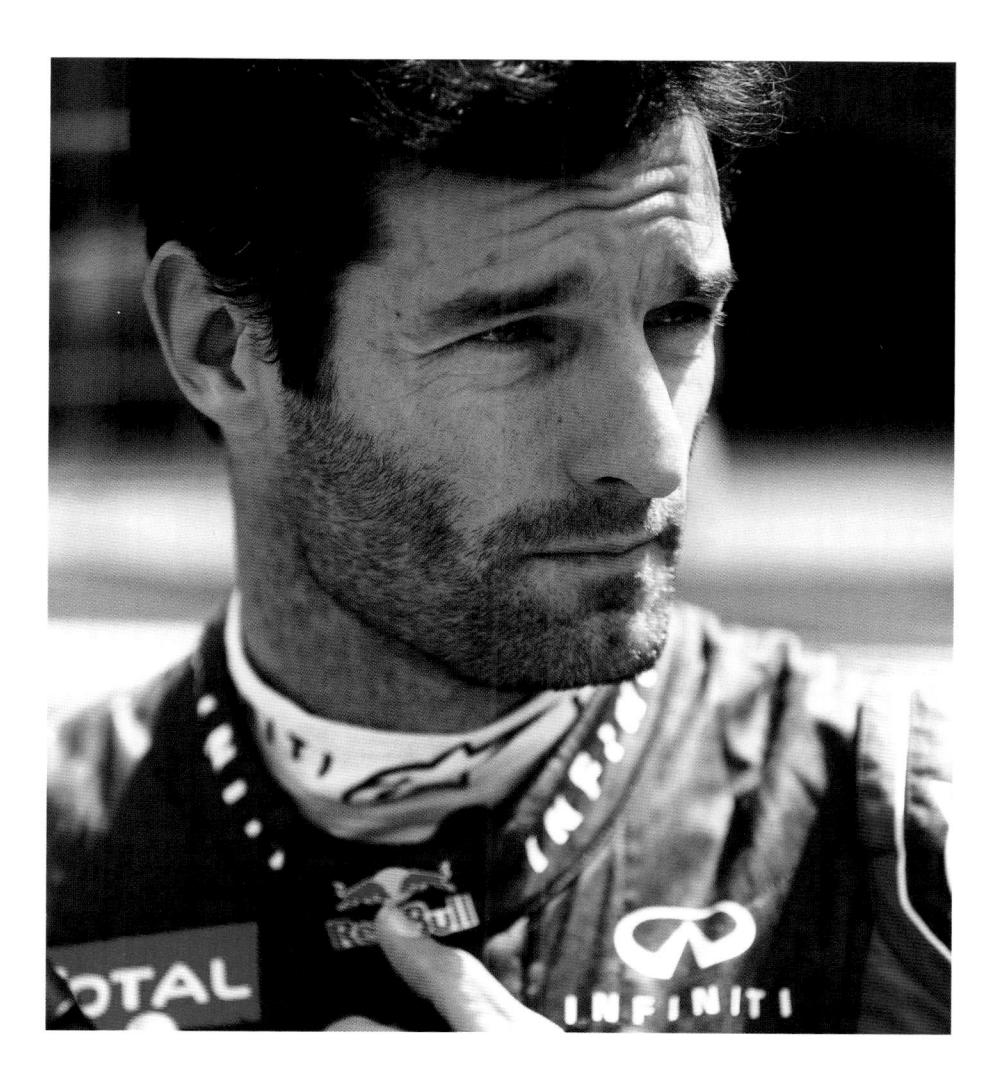

Paul Stoddart had run Mark in F3000 in 2000 and gave him his F1 racing break in 2002 at the age of 25. That first deal was for the opening three races, which is why Mark's run to fifth on his debut in Melbourne was heaven sent. At a stroke, Minardi had points – awarded only to the top-six finishers – and Mark's drive was made firm for the rest of the season.

This gambling was nothing new to a driver who didn't have family wealth. Indeed, when he started the British F3 season in 1997, with a loan from rugby ace David Campese, the money was there only for the first four rounds. So, a win at Brands Hatch fourth time out also did the trick, with Mercedes paying for the rest of his campaign. "Without that," says Mark, "I'd have been going home to Australia. I'd been in Europe for only a year and a half, so it was quick to get manufacturer support."

Then, without the finance to advance to F3000, Mercedes used Mark as part of its attack on the FIA GT1 Championship in 1998, with he and Bernd Schneider ending the year as runner-up to team-mates Klaus Ludwig and Ricardo Zonta.

"Sportscars helped me to become a professional driver at an early age," Mark continues. "[Mercedes motor sport boss] Norbert Haug wanted me to stay, and it hacked him off, but he knew I hadn't given up on my F1 ambitions.

"Later, Briatore did the deal for me to race for Jaguar in 2003, bringing me in with Antonio Pizzonia to replace Pedro de la Rosa and Irvine. Some say that they'd never consider Flavio and I as a natural pairing, as we're not alike, but we proved that we were an effective little team."

The Jaguar was better than the Minardi, but still not a pace-setter. Yet, Mark was still serving his F1 apprenticeship and his expertise seemed to be qualifying, as he explains. "The car was very strong in one-lap qualifying trim but exceptionally poor in the races. There was a lot going on with [parent company] Ford and then the team was sold to Red Bull during 2004 and I was off to Williams."

Three teams in four years isn't the best approach for a young driver, and Williams was no longer the team that it had been

THE TEENS

ABOVE MINARDI TEAM OWNER PAUL STODDART AND MARK
MOUNT THE PODIUM TO CELEBRATE MARK'S FIFTH PLACE
ON HIS F1 DEBUT. SUITABLY IN AUSTRALIA.

TOP RIGHT MARK'S SECOND TEAM WAS JAGUAR RACING, BUT HIS SECOND SEASON WITH THEM, IN 2004, PRODUCED JUST SEVEN POINTS.

OPPOSITE TOP AFTER A TWO-YEAR SPELL WITH WILLIAMS,
MARK JOINED RED BULL RACING AND LANDED HIS FIRST
F1 VICTORY AT THE NURBURGRING IN 2009.

OPPOSITE BOTTOM MARK COULDN'T MATCH THE PACE OF TEAM-MATE SEBASTIAN VETTEL IN 2011, BUT HE GOT THE BETTER OF HIM TO WIN THE FINALE IN BRAZIL.

and, although he claimed his first podium, Mark was anxious to move up the grid. This meant re-joining a team he'd raced for before, albeit as Red Bull Racing for 2007. What was the main difference? "Adrian Newey," Mark quips. "Having a decent budget helped too. The team did a lot of head hunting."

This suggests a team in turmoil, and Mark is a fan of continuity, as he explains: "Ferrari got the results it got in the 2000s with Michael Schumacher because it had continuity. It was working as one and things tend to work when everything is going well and a team's personnel are working without one-upmanship. Since Adrian has left McLaren, it's been tough... What a good team needs is for its heads of department to be beacons, to fight for their corner. If you're not winning, though, people start questioning your work."

It was at Red Bull Racing that Mark worked his way to the front of the field, with his first win coming in 2009 at the Nurburgring. Ranked fourth, as Jenson Button dominated for Brawn GP, Mark then scored four wins in 2010, but was overhauled at the final round by team-mate Vettel, and so it was that the enemy was within for the next three years as Vettel

collected three more titles and Mark had to settle for third overall in 2010, 2011 and 2013.

One of the issues in this time was the spectre of team orders, something that Vettel famously ignored at Sepang in 2013.

"There's a lot of paranoia surrounding team orders. It's very difficult to keep both drivers happy," says Mark. "Team orders are only an issue when your team is in a position of dominance and the team doesn't want to shit in its nest. Also, people don't like to see manipulation. Some might wonder why Rubens [Barrichello] appeared to have so many sticky pitstops with Ferrari... And a team can do you on the starts too, if it wishes."

Ask Mark about which drivers he rates across his time in F1 and he doesn't go straight for vaunted team-mate Vettel. "Fernando [Alonso] is pretty complete and has been good across all the regulation changes," he starts, "whereas Sebastian and Kimi [Raikkonen] didn't like their cars in 2014. Fernando is also very precise and consistent. Is he as quick as Ayrton Senna was over a lap? Absolutely not. Michael [Schumacher] was the Sunday afternoon computer."

MARK WEBBER

"The best way to beat Sebastian is mentally. If you could get him rocking, he might not deal with a situation well, like I did in early 2012 when we were running with the non-blown floor. When he gets confident, though, he's very, very potent. In 2014, you've seen him with a car he doesn't like and this doesn't help him find a set-up as he can't feel the car as he wants."

Assessing his own strengths as a driver, Mark replies: "One of my strengths was fast corners. Look at some of the tracks now, like Abu Dhabi, with so many second gear bends, where are you supposed to make time up? Give me Copse, Maggotts, corners like that."

This brings Mark to his thoughts about F1 cars today compared to the ones when he started in F1. "Back in the first half of the 2000s, F1 was much more physical. You see the drivers get out after a Grand Prix now and they don't even look tired. Also, cars then looked as though they were on fast-forward through the corners. Sure, they're fast on the straights now, but not so much in the corners. F1 was such a major step up from any other racing formula then. Nowadays, sportscars are almost as fast and GP2 only a few seconds slower."

Track safety wasn't as good back in 2002, though. "Racing at Le Mans remains the most dangerous thing I've done, as there are many old school elements to the lap and also more variables," Mark grimaces. Yet he appears to thrill at the challenge. New tracks leave him a little cold: "I think that the tracks built in the last decade, like in Bahrain, are horrendous and they certainly don't reward you like the old ones do," comments Mark. "Everyone raved about Abu Dhabi, but if you strip away the flashy buildings it's a very ordinary track. We don't want second and third gear bends, we want seventh gear bends. Give us a little camber too, then we can play with our lines. I've always said that the track that tows the best produces the best racing. Look at Turn 11 in Turkey, at Blanchimont at Spa and at 130R at Suzuka.

"You need undulations too and variations in track width that make it hard to get the right line in qualifying let alone in the race."

"I had two big shunts in F1, in Brazil in 2003 and Valencia in 2010, and I was thankful for F1's safety requirements of high cockpit sides. Composites have helped too. I wouldn't have wanted to go back to Jackie Stewart's day in the 1960s and

1970s, and getting rid of the threat of fire was brilliant, but drivers really don't get punished for mistakes any more."

What about F1 as a showpiece? Mark doesn't think F1 it's great currently: "No, it's too clinical and the fans can see that. With all the instruction over the radio, it's not just distracting but a little demeaning. After all, can you imagine Roger Federer being told to serve left or right? No one can see what we're going through in the car. They certainly can't see our emotions. Also, wouldn't it be great if drivers were allowed to grab a flag after winning?"

Max Verstappen will make F1 history as its youngest driver when he races for Toro Rosso in 2015 at the age of 17. Does Mark think this rise of youth is a good thing? "Absolutely not. It's not good for the drivers either, as not all will make it and nobody talks about the young ones whose careers have crashed and burned, like Jaime Alguersuari. Take Jan Magnussen too. On the other hand, look at Kevin Magnussen's career and it's unbelievable.

"The young drivers have got to earn their stripes. They've got to build their physicality and people should start to worry that it's possible for a 17-year-old to get the most out of an F1 car. Put them in a 2004 Ferrari and it would snap them in half.

"This young generation now wants things very quickly and they can try them too, on simulators. Was I ready for F1 at 18? No. At 20, probably not..."

Finally, what does Mark think of F1's constant: Ferrari, a team he came close to joining after Red Bull?

"You'll have to wait for my book to discover how close I came... What I will say is that if you were at a winter test at 21:00, the Pom mechanics would be working away, which I like, and the Italian mechanics would be smoking behind the garages...

"The lure of joining Ferrari was a change of environment, but did I still have the motivation in my 30s to learn 700 people again? The passion for Ferrari was a draw, and you only have to visit Italy to feel their love for F1. Ferrari is definitely good for the sport."

RIGHT MARK WON HIS 'OTHER HOME RACE', THE BRITISH GP, TWICE, WITH THIS WIN IN 2012 BACKING UP THE ONE HE SCORED AT SILVERSTONE IN 2010.

1 ANTANDER

Santaler

GIVES YOU WINGS

ROSBERG FERRARI RED BULL WEBBER RENAULT BUTTON

CHANGE AT THE LAST

ne element that was always going to focus the teams' minds for 2010 was the banning of refuelling. Pit stops continued for tyre changes, but this rule change meant that the cars had to carry up to 180kg of fuel at the start of each race rather than around 60kg as before. To accommodate this change, each car had to be fitted with a larger fuel tank and this forced the designers to move the engine and gearbox further back to accommodate it, with the obvious effect on the car's balance plus an encouragement for the manufacturers to make their engines more fuel-efficient so that they could start with a lighter fuel load.

Other changes included a move to narrower front tyres, down from 270mm to 245. The cars also had to run with a higher minimum weight, up by 15kg to 620. These changes were across the board, but the teams that had developed KERS through 2009 – Ferrari, McLaren and Renault - were disheartened by the dropping of the energy release system, costing them a hard-earned advantage.

As with all periods of change, though, F1 continued to be a hotbed for ingenuity and one of the developments of 2010 was the F-duct introduced by McLaren. It worked by piping air through a duct on the top of the nose to the rear wing, with the driver operating this by moving his left knee to cover a slot in the pipe in the cockpit side when on the straights to allow all the air to flow towards the rear wing. This extra air then stalls it – separating airflow from the wing element to make it less effective and so reduce drag – before releasing it as they brake. It wasn't easy for others to copy, as they

had to make space for the ducting through their already tight monocoque design.

QUALIFYING BY ELIMINATION

Aimed to make the Grand Prix meetings more exciting, the format of qualifying was changed, with the slowest seven drivers eliminated after the first qualifying session then the seven slowest at the end of the second session also made to drop out, leaving just 10 drivers for the final session. In this, they had to take into consideration that they would have to start the Grand Prix on the tyres they fitted for this final tilt at pole.

To give the races extra spice, too, points were now awarded to the top 10 finishers rather than just the top eight, with a win no longer worth 10 points but 25, making the difference between first and second seven points rather than two.

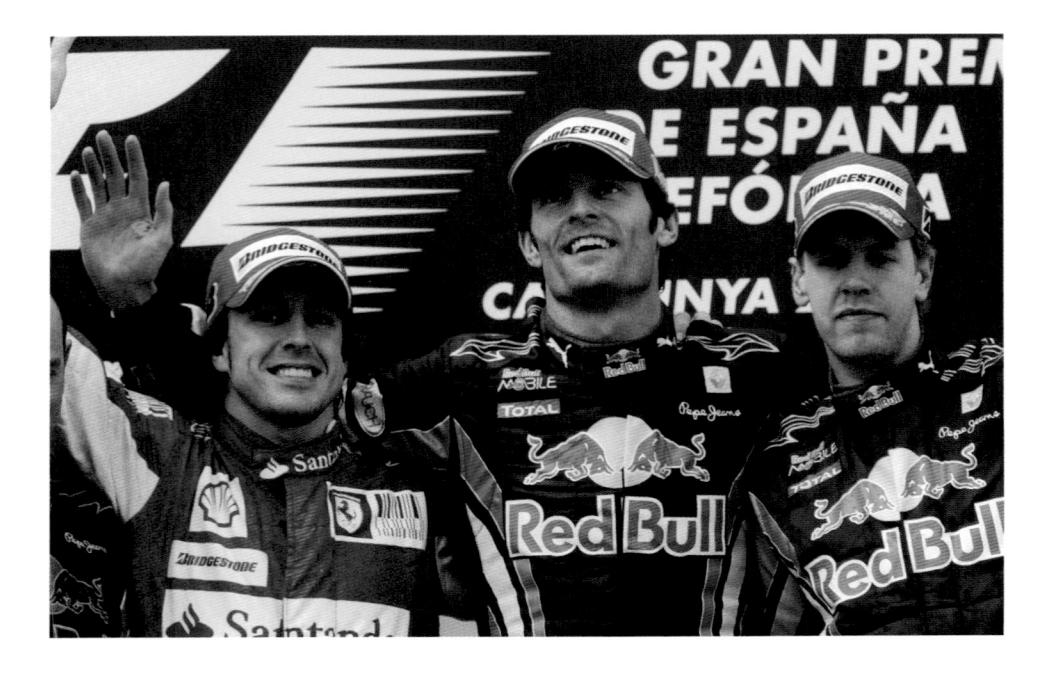

LEFT MARK WEBBER IS JOINED ON THE SPANISH GP PODIUM BY FERNANDO ALONSO AND SEBASTIAN VETTEL AFTER TAKING HIS FIRST WIN OF 2010.

Below LEWIS HAMILTON POWERS UP TO RAIDILLON AHEAD OF MCLAREN TEAM-MATE JENSON BUTTON.

RIGHT FERNANDO ALONSO CELEBRATES
WINNING THE ITALIAN GP FOR
FERRARI.

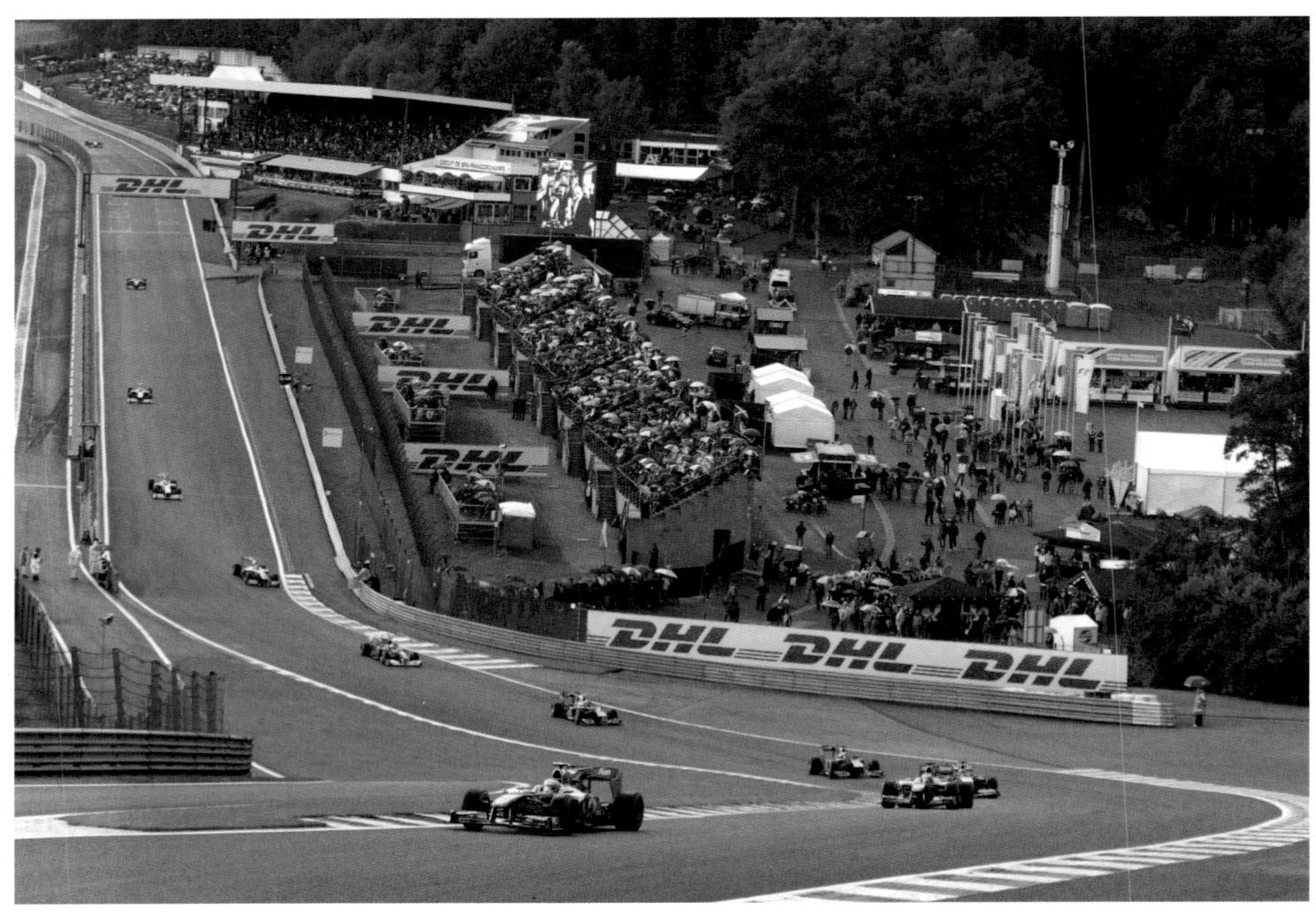

One of the most remarkable changes for 2010 was that Brawn GP, the team that had been formed from the ashes of Honda Racing and promptly won both the teams' and drivers' titles in 2009 was no more. Instead it came to the grid for 2010 as Mercedes GP, with the same personnel but different drivers. Button had moved to take his chances at McLaren alongside Lewis Hamilton and Rubens Barrichello to Williams where he'd line up with promising rookie Nico Hulkenberg. In their place, Rosberg had gone in the opposite direction to Barrichello, and seven-time World Champion Michael Schumacher had come out of retirement for further glory. Another change of note was Fernando Alonso moving from Renault to Ferrari to partner Felipe Massa who was returning from the head injuries he'd suffered in 2009.

ENTER THREE NEW TEAMS

In a year of unusual change, Toyota had quit F1 after eight years and this, along with a move to attract more teams, had resulted in space for four new teams. These were Lotus (a team with no connection with the original), Virgin and HRT. The fourth, Team US F1, never made it to the grid and so Sauber – no longer BMW Sauber after BMW's withdrawal – was allowed to remain by taking the final team slot.

Alonso won the season-opener in Bahrain ahead of Massa and Hamilton, but the win would have gone to Vettel had his RB6 not dropped to fourth with an electrical problem. Then, at the second round in Melbourne, Button showed that he had no interest in playing a supporting role to Hamilton by producing one of his trademark drives of excellence in mixed conditions. Again, though, Vettel could have won, but his front left wheel came loose. Webber ought to have had a chance too, but bogged down at the start and then was made to wait an extra lap before pitting when rain fell.

Then, as the other teams feared might happen judging by Red Bull's form at the end of 2009, the team from Milton Keynes cut loose. Its first win came at Sepang. Mixed weather helped Button win again in Shanghai, then Webber used pole to good effect in Spain, then again in Monaco before a crack appeared in Red Bull's attack. This came in Turkey when Webber was told to slow as his fuel consumption was too high and was surprised by Vettel attacking him. They clashed and handed victory to Hamilton.

FERRARI MANIPULATES RESULT

Through the course of the summer, McLaren continued to show strong form to challenge Red Bull, as did Ferrari on occasion, although its manipulation of the result at Hockenheim by telling Massa

to let Alonso through to win upset some. A win for Webber in Hungary after Vettel was hit with a drivethrough penalty, put him on top, but this year kept chopping and changing and wins for Hamilton then two for Alonso meant that the Spaniard moved past Vettel and Hamilton. A onetwo for Vettel and Webber at Suzuka moved Vettel into the reckoning, but then Alonso triumphed at a soaking and only just completed Yeongam circuit as Korea hosted its first grand prix. Then, having finished third behind Vettel and Webber in Brazil to take an eight point lead over Webber to the championship finale at Yas Marina, with Vettel starting a further seven points back, Alonso must have fancied his chances. He was to be frustrated though, as a safety car deployment handed the title to outside shot Vettel by four points from Alonso. with eighth place only just enough to keep Webber ahead of Hamilton in the final standings. It was the first time Vettel had topped the table all year, but it was the right time and so he became the youngest world champion, at 23 years and 134 days.

People might have expected Mercedes GP to pick up where Brawn GP had left off, but it didn't and there were no wins for Rosberg or Schumacher, although the younger German impressed by not being overawed by his illustrious team-mate, indeed appearing on the podium three times to Schuey's none, with the latter only really rediscovering his form late in the season to enable Mercedes to rank fourth ahead of Renault who benefited from the form of its signing from Sauber, Robert Kubica. The Pole hinted at great things as he raced to second place in Australia and was twice third. Then, late in the year, Williams rediscovered some form, first through Barrichello and then Hulkenberg who took pole position in Brazil, enabling Williams to edge past Force India for sixth place in the final standings.

Behind them, Sauber had an unspectacular season, led by Kamui Kobayashi, while having to build its own car for the first time, rather than use the previous year's Red Bull, left Toro Rosso at a disadvantage and it was able to beat only the three new teams, of which Tony Fernandes's Lotus was the pick of the bunch.

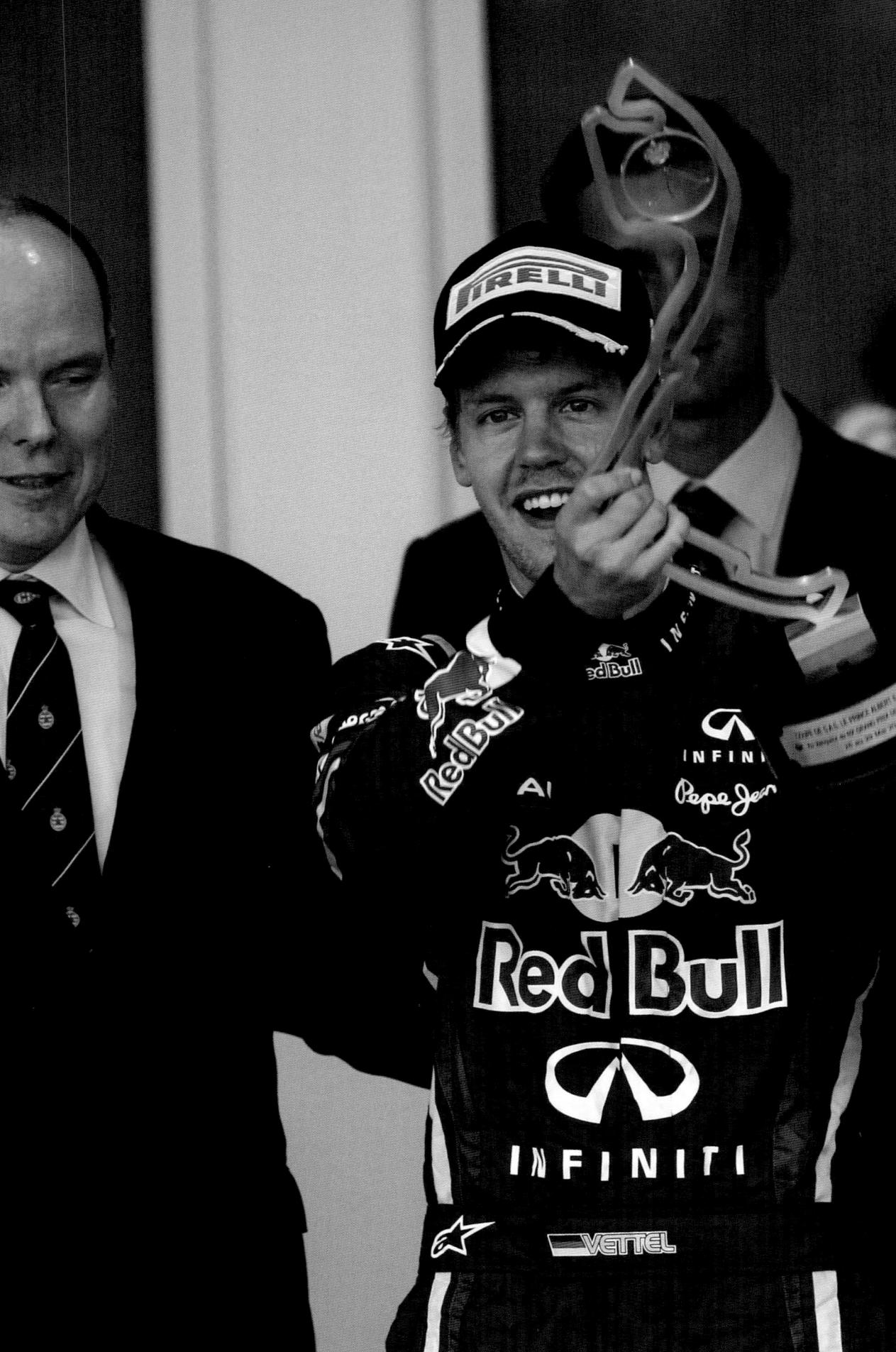

VETTEL SHOWS HIS CLASS

f Red Bull Racing laid its foundations in 2009 and then built on those in 2010, then it unveiled its masterpiece in 2011 as its cars won 12 of the 19 Grands Prix and Sebastian Vettel left even his closest rival trailing by 122 points by season's end.

The Renault-powered Red Bull RB7 was obviously the class of the field, but it was in qualifying that it was at its most deadly, with Vettel and his team-mate Mark Webber claiming pole position at every race bar one, with the German more often than not then proving able to dominate from there.

Perhaps a bigger surprise was the extent to which Webber was outperformed by Vettel after they had been so closely matched in 2010. After the opening nine rounds, Vettel had six wins and three second places, whereas the Australian

had just one second place and four thirds to his name. The reason for this appeared to be that he didn't like the RB7's behaviour on the new Pirelli tyres, but also that he made poor starts in the early races and also the fact that he's 10kg heavier than Vettel meant that the team had more choice where it placed ballast in the German's car. Add to this the fact that Vettel simply seemed to be continuing to develop his craft and the slight but crucial performance difference can be explained. Previous talk of Vettel being the 'new Michael Schumacher' was very much something of the past, as he was certainly his own man, forging his own place in F1 history. Webber's form did improve in the second half of the year, culminating in victory in the final round at Interlagos, but this was only enough to promote him from fourth overall to third.

INDIA JOINS THE F1 SHOW

Vettel had to make do with second place in that final race, but he had long before clinched his second title, doing so at the 15th round, the Japanese GP at Suzuka. He then underlined his superiority by winning on F1's second visit to Korea and then on its first to India. This was one of the landmark moments of the 2011 season and the teams were hugely impressed by the all-new Buddh International Circuit outside capital city New Delhi, if less so by the exceptional degree of bureaucracy that seemed to override every action.

After the 19 rounds, Jenson Button, in his second year with McLaren, proved himself to be the best of the rest, this time getting the upper hand over teammate Lewis Hamilton, showing how his personable ways could augment his

racing intelligence and excellence in mixed conditions, as demonstrated par excellence in the Canadian GP. With the MP4-26 being developed successfully through the season, both scored three wins. However, it was Button's ability to gather points that left him as runner-up at season's end, while Hamilton clashed with Ferrari's Felipe Massa on more than one occasion and seemed to be a little fragile emotionally, his focus on the task in hand not always complete, leaving him to end the year fifth overall.

LEFT JENSON BUTTON DROVE AN INCREDIBLE RACE IN MIXED CONDITIONS TO WIN THE CANADIAN GP. HERE, HE LEADS THE MERCEDES.

BELOW A NEW VENUE FOR F1 WAS
THE BUDDH INTERNATIONAL
CIRCUIT, HOME OF THE INDIAN GP.

RIGHT MARK WEBBER CHASED
AFTER SEBASTIAN VETTEL AT
THE BRAZILIAN GP AND WENT
THROUGH TO SCORE HIS ONLY
WIN OF 2011.

ALONSO STARS FOR FERRARI

Fernando Alonso's second year with Ferrari was another strong one and he won the British GP to mark the occasion of the 60th anniversary of the team's first World Championship victory at Silverstone, but the 150 Italia's fluctuating form hurt his championship chances. Alonso was very much the team leader, as team-mate Massa was yet to rediscover the form that he enjoyed before his head injury at the 2009 Hungarian GP and scored fewer than half of the points that the Spaniard managed, with none of his finishes higher than fifth.

The top three teams divided all of the spoils between them, proving that they had adapted best to the rule changes that outlawed double-deck diffusers and F-ducts. More obvious changes were the introduction of rear wings that could be adjusted on the straights to add an extra 8mph and the return of KERS – an extra 80bhp achieved through the storage of kinetic energy harvested from braking and its release at the press of a button – both of which made overtaking easier to achieve.

In its second season as the reinvented Silver Arrows, Mercedes GP finished a distant fourth overall, failing even to record one top-three finish, with Nico Rosberg again outscoring Michael Schumacher, even though his older compatriot achieved the team's best result, a fourth place in Canada.

RENAULT HAS A SETBACK

Renault had had high hopes for its 2011 campaign, with the attacking Robert Kubica leading its push for glory, but disaster struck when the Pole was sidelined before the start of the season when he suffered a debilitating arm injury after crashing while contesting a rally. This left Nick Heidfeld to join Vitaly Petrov, with the Russian grabbing third place at the opening round in Australia, followed by Heidfeld doing the same next time out, in Malaysia. Unfortunately for Renault, the team couldn't keep up in the development stakes and fell away, with Heidfeld being replaced for the final eight rounds by Bruno Senna. With fewer than half of Mercedes GP's tally, Renault ended the year fifth overall, just a single point ahead of Force India, with the Silverstone-based team coming on strong in the second half of the year through the best efforts of Adrian Sutil and F1 rookie Paul di Resta.

Of the other six teams, only Sauber and Scuderia Toro Rosso showed any stomach for the fight, with Kamui Kobayashi peaking with fifth place in the Monaco GP and team-mate Sergio Perez seventh at Silverstone. For Toro Rosso, Jaime Alguersuari outscored the marginally more experienced Sebastien Buemi, but neither displayed the sort of form that suggested that they'd become good enough to achieve their obvious goal of being promoted to Red Bull Racing.

Williams slipped from the midfield as it had a disastrous year, with even the influx of a sizeable budget that came with GP2 champion Pastor Maldonado not enough to make the Cosworth-powered FW33 more competitive. Despite his years of experience, Rubens Barrichello could collect only a pair of ninth places in the team's lead car.

Of the three teams that had made their F1 debuts in 2010, Team Lotus was by far the best in their second seasons, albeit with Tony Fernandes's team not managing to break into the top 10 at any of the 19 rounds, with a trio of 13th places scored by Jarno Trulli in Melbourne and Monaco and Heikki Kovalainen at Monza being their best in a year in which Fernandes expended considerable effort on a distracting matter. This was an ongoing battle with the Renault F1 team over which of them should be allowed to use the Lotus name in F1 circles.

With its MVR02s proving less than competitive, Marussia Virgin Racing had to do a u-turn and give up on its policy of trying to break the mould by using only CFD in the design of its chassis, thus reverting to spending development time in a wind tunnel as well. Yet, what left it ranking behind money-strapped HRT was the 13th place finish scored by Vitantonio Liuzzi in the rain-strafed Canadian GP, this being worth more than Virgin Racing's pair of 14th place finishes for Jerome d'Ambrosio in Australia and in Canada. Of course, neither of these finishes yielded championship points, but a team's best position outside the top-10 is used to determine their end of season ranking, all of which affects how much prize money they receive.

No one, though, had even got close to Vettel.

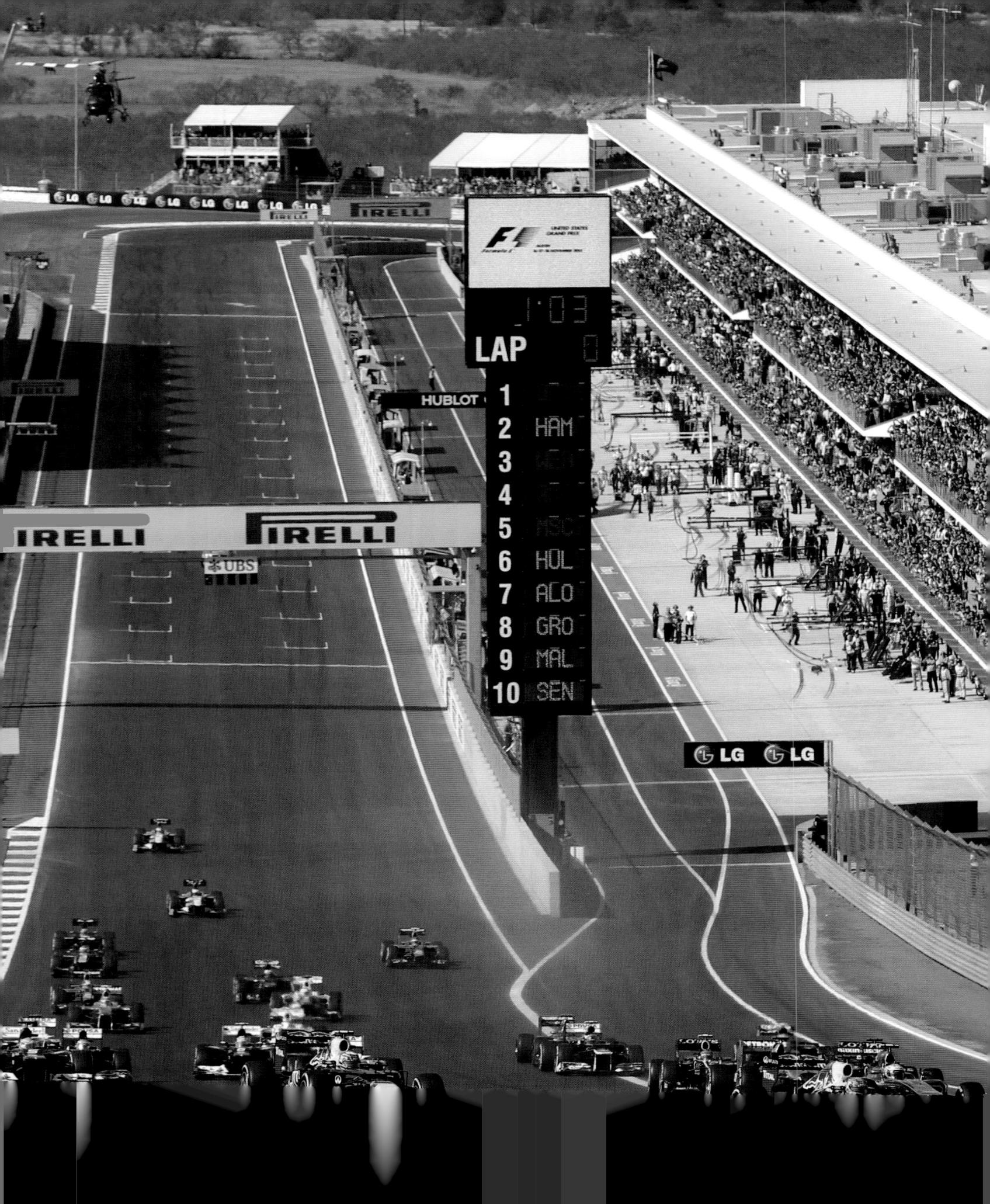

VETTEL BY A NOSE

hree-time World Champions are rare enough in Formula One, but drivers who have won three titles in consecutive years are rarer still, which made Sebastian Vettel's feat in 2012 all the greater. The only others to have achieved this feat are Juan Manuel Fangio and Michael Schumacher, putting the 25-year-old's achievement into stark perspective. Certainly, Red Bull Racing provided him with a great car in the RB8 and built its attack around him, but he had to deliver, which he did, then resist a late-season charge from Ferrari's Fernando Alonso, which he also did.

Pirelli's new tyres produced more grip, resulting in teams having to manage their fuel load better, and a new maximum height for the car's nose, helped to create the unusual situation in which seven different drivers won the season's first

seven Grands Prix. Indeed, it was not until the end of June before the season had its first two-time winner. Fittingly, it was Alonso at Valencia in the European GP who achieved it. In a season in which he performed with consistent excellence, Alonso was fortunate as only alternator failure prevented Vettel from becoming the first two-time winner.

What was clear through 2012 was the excellence of Alonso's attack, as his Ferrari was seldom even the second best car, which was usually the McLaren, but he kept on pressing and not only won three rounds – at Sepang, Valencia and Hockenheim – but usually appeared on the podium if he didn't win. Felipe Massa looked set to be dropped from the second Ferrari seat, but upped his form in the second half of the season to keep his ride for 2013.

A SEXTET OF CHAMPIONS

One historic first in 2012 was that the grid contained six F1 champions for the first time thanks to the return of 2007 World Champion Kimi Raikkonen to pit his talents against Michael Schumacher (1994 and 1995 then 2000 to 2004), Alonso (2005 and 2006), Lewis Hamilton (2008), Jenson Button (2009) and Vettel (2010) and 2011). The Finn was back after a twoyear foray into rallying after quitting Ferrari. This time, he was driving for Lotus Renault GP. To avoid confusion, this was the team that had been Renault in 2011 but had taken over the Lotus name from Tony Fernandes's team that was now known as Caterham. These name changes were not popular, especially as neither of these teams had any connection with the original Team Lotus that ran in F1 from 1958 until 1994. Furthermore, the 'new'

RIGHT HRT BROUGHT UP THE REAR IN
ITS THIRD YEAR OF F1, NEVER FINISHING HIGHER THAN 15TH PLACE. THIS IS
PEDRO DE LA ROSA.

Lotus started life as Toleman before becoming Benetton then Renault...

None of this worried the sanguine Raikkonen though and he was back on the podium by his fourth race back after finishing second in the Bahrain GP. He was even a winner again before the year was out, and his victory in Abu Dhabi helped ensure that he finished third overall. His team-mate Romain Grosjean – back in F1 after dropping down to GP2 following his F1 debut in 2009 – also impressed, peaking with second place in Canada, but earned a reputation for wildness, most notably after triggering a first corner accident at the Belgian GP.

WILLIAMS WINS AGAIN

The other return of sorts, and a widely welcomed one at that, was Williams finally landing another win to add to its illustrious total when Pastor Maldonado managed to keep not only his propensity to collide with others in check but to resist a forceful attack from local hero Alonso to win the Spanish GP. This was the team's first win since 2004 and everyone in the pitlane was delighted, as this remains a racing team pure and simple. Yet, showing what a freak result this was, the Venezuelan's next best result was a fifth place while Ayrton Senna's nephew Bruno peaked with sixth place in the team's other car in the second round, at Sepang.

Hamilton raised his game after his disappointing 2011 campaign and was in the running for McLaren up until the Singapore GP and ought to have backed up his win at Monza with another on the Marina Bay street circuit but suffered gearbox failure. A further mechanical failure and an accident while fighting for

OPPOSITE TOP NICO ROSBERG SCORED HIS BREAKTHROUGH F1 WIN IN THE CHINESE GP. IT WAS MERCEDES' FIRST VICTORY SINCE 1955.

the lead in two of the remaining six races dropped him to fourth overall. This left him just two points ahead of team-mate Button who bookended his season with wins in the first race in Australia and the last in Brazil but was seldom Hamilton's match through the year as he wasn't as effective at getting heat into his tyres.

Vettel's team-mate Mark Webber showed a marked improvement in qualifying, as shown by his pole in Monaco that helped him to victory there. However, his season was affected by a series of poor starts and some gearbox maladies that led to grid penalties with the obvious disadvantages from there. His highlight was passing Alonso in the closing laps at Silverstone and racing on to victory.

Nico Rosberg was again Mercedes' top scorer, helped by winning in China, and, at the end of the season, Schumacher hung up his helmet for good, disappointed

OPPOSITE BOTTOM ROMAIN GROSJEAN FLIES
HIS LOTUS OVER FERNANDO ALONSO'S
FERRARI AT THE FIRST CORNER OF
THE BELGIAN GP.

not to have taken a win for Mercedes during his three-year return to F1.

One of the highlights of 2012 was the United States of America's return to the calendar and its perpetual quest to find its Grand Prix a home brought it to the Circuit of the Americas in Texas. This purpose-built circuit outside Austin thus became the race's sixth home, after Sebring, Riverside, Watkins Glen, Phoenix and Indianapolis, but it felt as though there had been more, as there had also been separate Grands Prix at Long Beach, Las Vegas, Detroit and Dallas. More thought appeared to have gone into its design than that of other recent new tracks, with a considerable amount of gradient change augmenting its mixture of corners. The drivers loved it, especially Hamilton who won there. Crucially, its grandstands were packed, helped in no small part by being just across the border from Mexico, a country starved of F1 action.

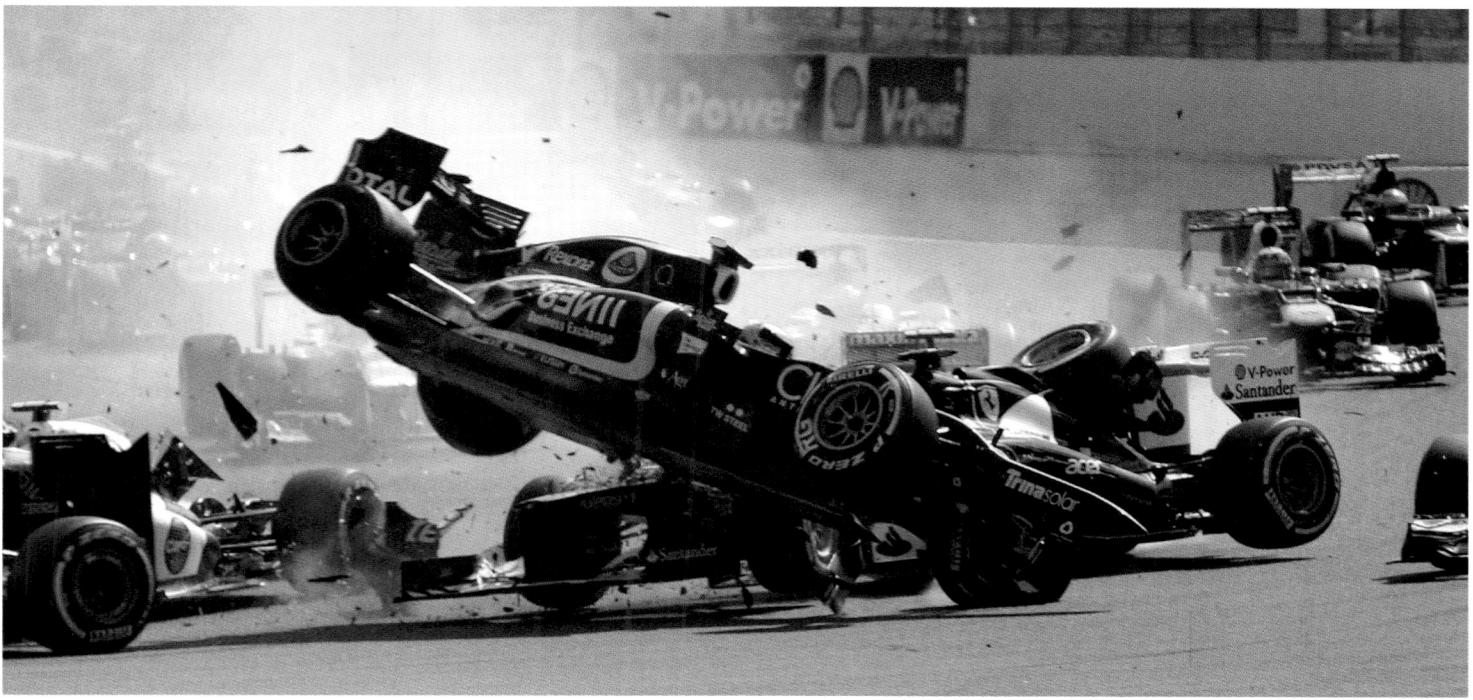

PETROBRAS

)S

FOUR IN A ROW

ooking back on 2013, Sebastian Vettel's fourth World Championship-winning campaign, his rivals can at least say that he didn't win the opening race in Australia, as he finished third in Melbourne. This, though, is grasping at straws, as there was little else that Vettel failed to win, and his streak of nine victories in the final nine rounds shows just how superior he and his Renaultpowered Red Bull RB9 were. Thirteen wins across the year's 19 rounds are all the proof that you need of the advantage that the team offered him and the way in which he made the most of it.

That he had done enough by the 16th round – the Indian GP at the Buddh International Circuit – to secure his fourth F1 title in succession in the 2010s proves just how dominant he had been.

McLAREN STRUGGLES

The opening round in Melbourne had been a real wake-up call for the teams as they were shocked just how rapidly their Pirelli tyres went off in the race, with some drivers describing their car's performance as having 'fallen off a cliff'. Canniest of all, though, was Kimi Raikkonen who triumphed for Lotus as even Red Bull found that its tyre performance was extraordinary. Fernando Alonso finished second for Ferrari and Vettel third for Red Bull. Of McLaren, though, there was no sign at the sharp end of the field and Jenson Button did well to finish ninth in a car that was 2.5s off Vettel's pole time. Journalists even enquired of team principal Martin Whitmarsh whether the team would go back to its 2012 chassis.

Yet, things changed very quickly through the opening rounds as teams

reacted to the behaviour of the latest Pirellis and, unusually, it was Vettel who was among the most displeased, calling them "chocolate tyres". Red Bull chief technical officer Adrian Newey said that they were "very sensitive to high load conditions, so you couldn't go through high-speed corners without destroying them". Then, just when rivals thought that they might have a chance of toppling Vettel, Red Bull Racing returned from the summer break to win the Belgian GP then did so in every other race from then until the end of the season. Vettel's eventual tally of 397 points left him 155 clear of his closest rival, Alonso.

This sequence for Vettel shattered the records. It might have been helped slightly by some rival teams taking their eye off continued development as they prepared instead for the comprehensive set of

RIGHT KIMI RAIKKONEN TRIUMPHED IN
THE SEASON-OPENER IN MELBOURNE
FOR LOTUS AS OTHERS STRUGGLED TO
KEEP LIFE IN THEIR TYRES.

BELOW LEWIS HAMILTON SCORED HIS FIRST WIN FOR MERCEDES MIDWAY THROUGH THE SEASON, AT THE HUNGARIAN GP.

technical rule changes for 2014, but his continued excellence at the wheel played a large part too. Indeed, team-mate Mark Webber, nobody's fool, was a frequent podium finisher in what was to be his final season in F1 before moving to spearhead Porsche's return to topline sportscar racing. His end of year ranking of third overall matched Mark's best ranking which was also achieved in 2010 and 2011.

RETURN TO 2012 COMPOUNDS

There was one other key factor to Red Bull Racing's midseason surge in form, though. This was that Pirelli reintroduced its 2012 tyre compounds after the summer break and this appeared to make more of a difference to Red Bull than to any other team. The team had been pressing for this since the opening round, but the impetus that forced teams opposed to this step came at the British GP when no fewer than five cars suffered blow-outs.

It wasn't all sweetness and light at Red Bull Racing, however, and Vettel earned both bad press and the booing of fans at the second round of the year, the Malaysian GP, when he chose not to heed a 'Multi 21' radio instruction, which means to hold position, and overtook Webber who was leading at the time when the call was made so as not to squander what would be a one-two finish; that was deemed particularly valuable at this second race of the year as the team was struggling for race pace.

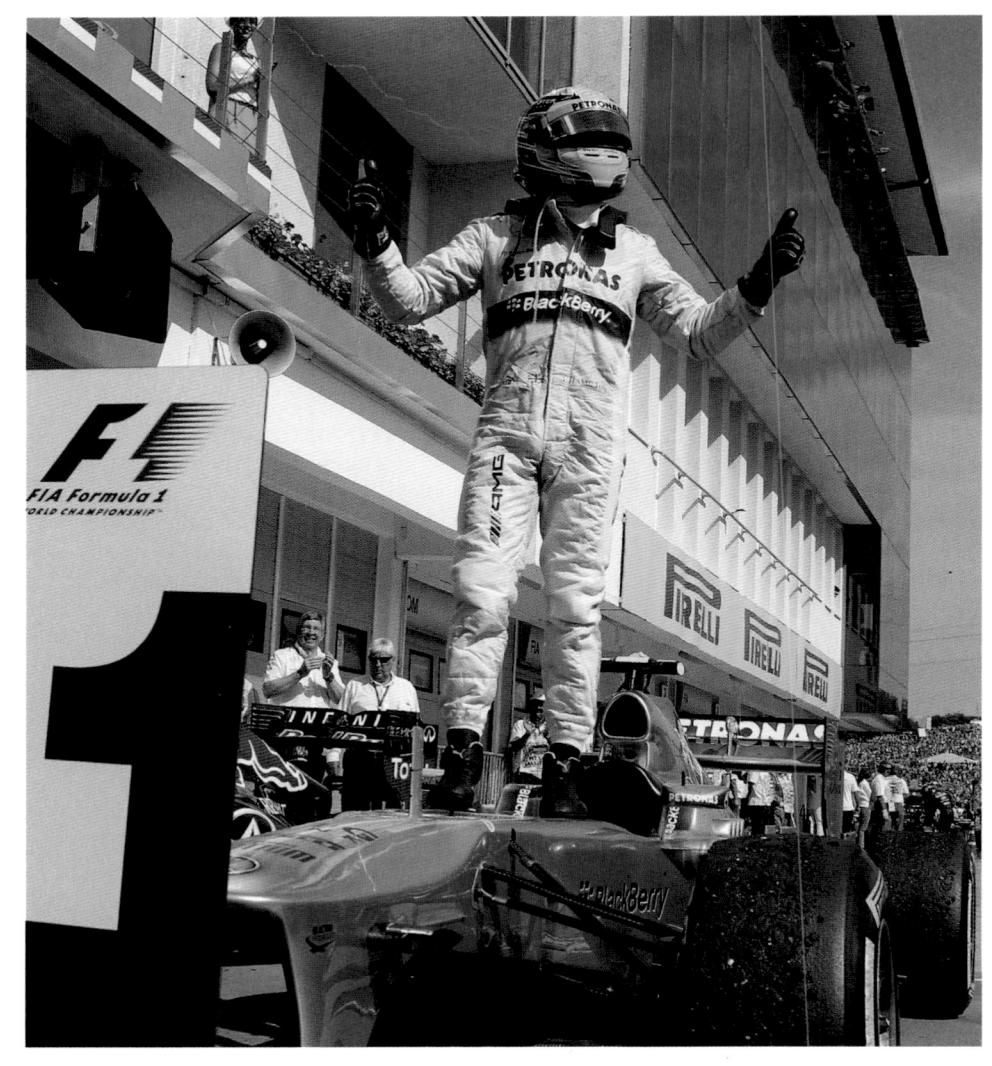

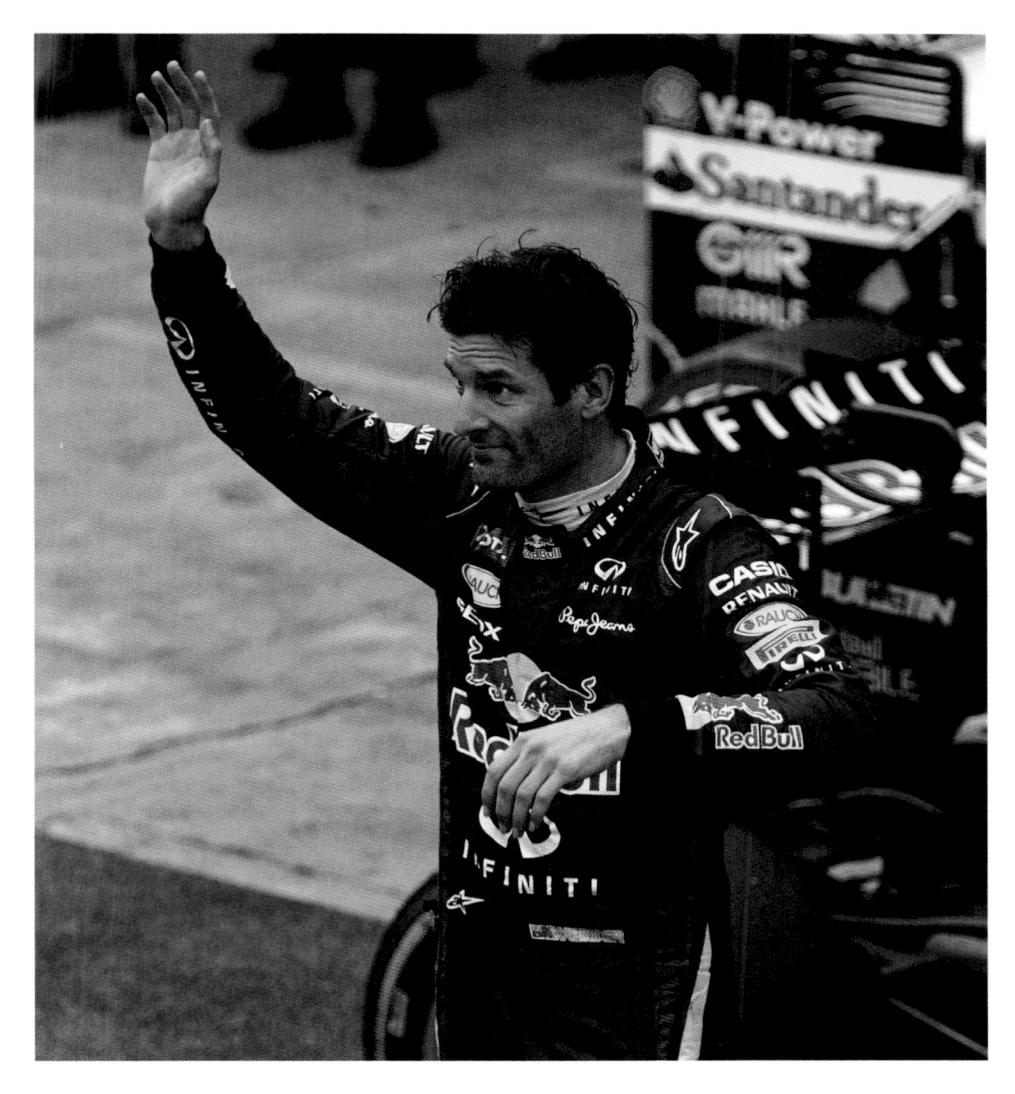

More so than in the previous few seasons, Alonso really achieved more for Ferrari than the car deserved. The F138 was far from the pick of the bunch as shown by Massa ranking only eighth overall in his, yet the Spaniard not only won in China and on home ground in Spain but constantly finished higher than he had qualified. This was the third time that he had ended the year as runner-up in four years. In the sister car, Massa's best finish was third place in Spain.

The team move that attracted the most media attention before the start of the season was Lewis Hamilton's from McLaren to Mercedes GP, where he took over from Michael Schumacher. Paired with his former karting team-mate Nico Rosberg, he won just once, in Hungary, making his team swap look questionable, but it had been suggested that he simply

needed to express himself in a new environment, having been linked to McLaren since he was 11. Rosberg was able to win, in Monaco and then at Silverstone in a race that would have gone to Hamilton had he not been the most high-profile driver to suffer a blowout. However, the team made clear progress in 2013 and Hamilton was seen to be the one at the forefront of this progress and his four other podium finishes helped him to rank fourth at year's end.

Hamilton's seat at McLaren was filled by Sergio Perez who had so impressed for Sauber in 2012, but the MP4-28 was so much less competitive than its predecessor had been that he could rank only 11th overall, two places behind clear team leader Jenson Button. This was not the first year that McLaren hadn't started LEFT MARK WEBBER WAVES GOODBYE
AFTER FINISHING SECOND IN THE
BRAZILIAN GP, HIS FINAL OUTING
AFTER 12 YEARS IN THE SPORT'S
TOP CATEGORY.

the season well, but it was the first time in decades that it hadn't then worked its way back towards the front. Indeed, it took until the final round of the year to manage even a fourth place finish.

RAIKKONEN QUITS LOTUS

Splitting the Mercedes drivers in the final championship table, Raikkonen never managed to match that victory in the opening round, but finished second a remarkable six times and was third overall with three rounds to go but then had a public spat over the radio when asked in the Abu Dhabi GP to pull over and let team-mate Romain Grosjean by. He refused and then, revealing that he hadn't been paid all year, quit. Heikki Kovalainen took over for the final two races and it was in the first of these that Grosjean scored his best F1 finish, second place in the USA.

Of the other teams, Force India proved to be the best of the rest through the combined efforts of Paul di Resta and Adrian Sutil, but both were outscored by Sauber's Nico Hulkenberg who was able to qualify as high as third at Monza.

With Webber quitting F1, the pressure was on for the Toro Rosso drivers to outperform each other in the hope of landing the seat. Daniel Ricciardo came out on top, but only by a small margin over Jean-Eric Vergne. Williams – winners in 2012 – slipped back into oblivion, scoring but five points all year.

When the dust settled in Sao Paulo after Vettel's 13th win of the year that took Red Bull to an eventual winning margin of 236 points in the constructors' championship, the teams packed their cars away, knowing that it would be all change for 2014. The drivers wouldn't race their like again as the rule changes for 2014 meant an end to the reign of 2.4-litre V8 engines and their replacement by 1.6-litre V6 turbos.

MULA 1 MIO DI Pernopus BlackBery. L. HAMILTON

MERCEDES TAKES CONTROL

ith a comprehensive change in the technical regulations – the replacement of 2.4-litre V8 engines by 1.6-litre turbocharged V6s and the introduction of hybrid power, plus the banning of exhaust-blown floors and the reduction in the width of nose wings – it was always possible that one team would get it more right than the others and so find an advantage.

One might have thought that Adrian Newey and the design team at Red Bull Racing would continue their dominance, but it was Mercedes that came good, and how.... By dint of applying themselves to the task sooner than their rivals, Mercedes not only produced the best engine, but also mastered the best way to package this along with the hefty energy recovery system. That the teams that used the new Mercedes V6 all rose

towards the top emphasized just how good the motor was, with teams using Renault or Ferrari engines finding themselves some way adrift.

A NEW DRIVING STYLE

The teams were worried after their minimal close-season testing that they might not be able to meet the new fuel economy figures that required them to race with a third less fuel, but their engineers did the job and they all mastered that from the very first round. What was not so easy was the challenge that faced the drivers, as these cars were very different to drive when ERS was employed and offered an extra 160bhp for as much as 33s per lap, with braking having to be handled differently and the loss of exhaust-blown downforce making the handling even trickier than before.

Nico Rosberg won that opener in Australia in a race that might have gone to his Mercedes team-mate Lewis Hamilton but for an engine failure on the third lap. That the British driver bounced back by winning the next four on the trot, with Rosberg second each time, showed how the title fight would be between only them.

In fact, such was their performance advantage that it took the pair of them hitting mechanical trouble in Canada before any other driver got a look in.

Through the course of the season, Rosberg surprised people by being more than a match for Hamilton in qualifying, taking pole on 11 occasions to the British driver's seven. In the races, though, Hamilton was the sharper tool. There was considerable concern when they went to Yas Marina for the final round that despite

having 10 wins to Rosberg's five, a mechanical failure of which Mercedes had suffered a few, might trip him up or slow him enough for the double-allocation of points to enable Rosberg to be champion. As it was, he jumped into the lead from the start and it was then Rosberg whose car was slowed, losing its ERS, and so Hamilton raced on to his 11th win and his second title.

A season's tally of 16 wins from 19 races, with 18 poles and 12 fastest laps showed just how great Mercedes' dominance was.

RICCIARDO BEATS VETTEL

The only team to beat Mercedes was Red Bull Racing, but it was surprisingly not Sebastian Vettel who took the battle to the Silver Arrows but his new team-mate Daniel Ricciardo. Disqualified from second place at the Melbourne opener for excessive fuel flow, he mastered the new driving style better than his quadruple World Champion team-mate, also being kinder on his car's tyres, taking his first win in Canada.

He also won the Hungarian and Belgian GPs and was a very worthy third overall in the final rankings, helping Red Bull to be runner-up in the constructors' championship after a year in which having Renault power was a considerable disadvantage.

Ferrari was also at a deficit when it came to its engine, and both they and Red Bull pushed without success to have the engine freeze that lasted throughout the season lifted so that they could attempt to redress the balance. At least Red Bull Racing made progress with its car though, which was more than could be said of Ferrari, leaving Kimi Raikkonen with a car in which he had little confidence and Fernando Alonso simply frustrated. The Spaniard was ceaseless in his attack, but the lack of form or even hope of improvement in the immediate future led him to cut his ties and quit the Scuderia. After the final race, the team replaced its team principal too.

WILLIAMS HITS FORM

While Red Bull Racing and Ferrari were disappointed with their lack of competitive edge, Williams was quite the reverse, as Pat Symonds' new control over its technical side led to the sleekest of chassis designs. Combined with Mercedes power, the FW36 became a serious challenger to be the best of the rest behind Mercedes. Valtteri Bottas was a frequent podium visitor from the middle of the year, with Ferrari refugee Felipe Massa taking pole in Austria before ending his season just a few seconds down on Hamilton in Abu Dhabi. This upsurge in form propelled Williams from ninth overall in 2013 to third in 2014. This once great team's return towards the top of the table was welcomed by all.

McLaren just didn't get going in 2014. Yes, rookie Kevin Magnussen and Jenson Button were promoted to second and third in the opening round when Ricciardo was disqualified, but their best results

after that were when Button finished fourth on four occasions. Yet, by the end of the season, Button didn't even know if he was being kept on or not.

Force India also used Mercedes engines and transmissions too and, despite a considerably smaller budget than McLaren, led the team from Woking in the early rounds. Nico Hulkenberg was the point scorer par excellence, while Sergio Perez had flashes of brilliance, finishing third in Bahrain, but also losing second in Canada on the final lap.

Toro Rosso replaced Ferrari power with Renault V6s and probably benefited from that, but the drivers found that their often excellent form in qualifying was seldom matched in the races. Russian rookie Daniil Kvyat impressed from the outset, scoring on his debut and, rather unfairly to team-mate Jean-Eric Vergne, was picked to step up to Red Bull Racing for 2015 following Vettel's departure.

Lotus did the opposite to Williams and was in all sorts of trouble from the start of the year; they duly plummeted from fourth overall in 2013 to eighth, with Romain Grosjean struggling not only with the Renault engine's comparative lack of power but also with a chassis that failed to inspire confidence, with the team giving up on it early on to focus instead on its 2015 challenge.

Sauber probably spent most of 2014 wondering whether it would even make it into 2015, as it struggled for money every

LEFT JULES BIANCHI GAVE MARUSSIA ITS FIRST EVER POINTS BY FINISHING NINTH IN MONACO.

bit as much as its drivers Adrian Sutil and Esteban Gutierrez struggled for points and eventually failed to score a single one. Marussia pushed the Swiss team back to 10th in the rankings through Jules Bianchi's surprise ninth place at Monaco. Sadly, the Frenchman suffered a bizarre accident in the wet at Suzuka and was left in a coma.

At the back of the pack, life was far from rosy, with the tail-end teams struggling to keep going. The new engines forced their costs up and both Caterham and Marussia were forced to miss the US and Brazilian GPs. The former sought public funding and achieved enough to make the Abu Dhabi finale, but their continued involvement is very much in doubt, with their current owners at least. It could hardly feel more different from the well-heeled end of the pitlane where Mercedes had earned the right to be world champions.

TOP F1'S RETURN TO AUSTRIA BROUGHT ANOTHER WIN FOR MERCEDES, THROUGH NICO ROSBERG.

MIDDLE DANIEL RICCIARDO DIVES PAST FERNANDO ALONSO'S FERRARI IN HUNGARY TO SCORE HIS SECOND WIN FOR RED BULL RACING.

RIGHT HAMILTON'S AMAZING START AT THE ABU DHABI FINALE PROPELLED HIM PAST POLE-SITTING TEAM-MATE ROSBERG AND ON TO THE TITLE.

THE FIFTIES

	VERS'	WORLD C	CHAMPION	SHIP 1950	
POS.			NAT.	CONSTRUCTOR	PTS
1		PE FARINA	ITA	ALFA ROMEO	30 27
2		ANUEL FANG	IO ARG	ALFA ROMEO	21
Best 1	four scores	to count			
DRI	VERS'	WORLD C		SHIP 1951	
POS.	DRIVER		NAT.	CONSTRUCTOR	PTS
1		ANUEL FANG		ALFA ROMEO	31
2		ASCARI	ITA	FERRARI	25
Best 1	four scores	to count			
DRI	VERS'	WORLD C	HAMPION	SHIP 1952	
POS.	DRIVER		NAT.	CONSTRUCTOR	PTS
1		O ASCARI	ITA	FERRARI	36
2		E FARINA	ITA	FERRARI	24
Best 1	four scores	to count			
DRI	VERS'	WORLD C	HAMPION	SHIP 1953	
	DRIVER		NAT.	CONSTRUCTOR	PTS
1		O ASCARI	ITA	FERRARI	34.5
2		ANUEL FANG	IO ARG	ALFA ROMEO	27.5
Best 1	four scores	to count			
DRI	VERS'	WORLD C	HAMPION	SHIP 1954	
os.	DRIVER		NAT.	CONSTRUCTOR	PTS
1	JUAN MA	ANUEL FANG	IO ARG	MASERATI & MERCEDES	40
2	FROILAN	GONZALEZ	ARG	FERRARI	25.14
	VERS'	WORLD	HAMPION NAT.	SHIP 1955 CONSTRUCTOR	PTS
1		ANUEL FANG	IO ARG	MERCEDES	40
2	STIRLIN	g Moss	GBR	MERCEDES	23
Best 1	five scores	to count			
DRI	VERS'	WORLD C	HAMPION	SHIP 1956	
	DRIVER		NAT.	CONSTRUCTOR	PTS
1	JUAN MA	ANUEL FANG	IO ARG	FERRARI	30
2	STIRLIN		GBR	MASERATI	27
Best 1	five scores	to count			
DRI	VERS'	WORLD C	HAMPION	SHIP 1957	
	DRIVER		NAT.	CONSTRUCTOR	PTS
1	JUAN MA	ANUEL FANG	IO ARG	MASERATI	40
	CTIDIIN	g Moss	GBR	VANWALL	25
2					
2	five scores	to count			
2 Best 1	five scores		HAMPION	SHIP 1958	
Best f	five scores		HAMPION NAT.	SHIP 1958 CONSTRUCTOR	
Best f	VERS' DRIVER MIKE HA	WORLD C	NAT. GBR	CONSTRUCTOR FERRARI	PTS 42
DRIPOS.	VERS' DRIVER MIKE HA	WORLD C	NAT.	CONSTRUCTOR	
DRIPOS.	VERS' DRIVER MIKE HA	WORLD C	NAT. GBR	CONSTRUCTOR FERRARI	42
Best f DRI POS. 1 2 Best s	IVERS' DRIVER MIKE HA STIRLING six scores 1	WORLD CAWTHORN G Moss to count	NAT. GBR GBR	CONSTRUCTOR FERRARI	42
DRI POS. 1 2 Best :	IVERS' DRIVER MIKE HA STIRLING six scores 1	WORLD CAWTHORN G Moss to count	NAT. GBR GBR CHAMPION NAT.	CONSTRUCTOR FERRARI COOPER & VANWALL SHIP 1959 CONSTRUCTOR	42 41 PTS
DRI POS. 1 2 Best :	VERS' DRIVER MIKE HA STIRLING six scores 1	WORLD C	NAT. GBR GBR	CONSTRUCTOR FERRARI COOPER & VANWALL SHIP 1959	42

FROM 1950 TO 1957 THERE WAS NO CONSTRUCTORS' CHAMPIONSHIP

POS. CONSTRUCTORS' CUP POS. CONSTRUCTOR PTS 1 VANWALL 48 2 FERRARI 40

CONSTRUCTORS' CUP Pos. constructor PTS 1 COOPER-CLIMAX 40 2 FERRARI 32

THE SIXTIES

DR	(VERS' WORLD CH	AMPION	301F 1960	
POS.	DRIVER	NAT.	CONSTRUCTOR	PTS
1	JACK BRABHAM	AUS	COOPER-CLIMAX	43
2	BRUCE MCLAREN	NZL	COOPER-CLIMAX	34
Best	six scores from 10 races to o	count		
DR	VERS' WORLD CH	AMPION	ISHIP 1961	
POS.	DRIVER	NAT.	CONSTRUCTOR	PTS
1	PHIL HILL	USA	FERRARI	34
2	WOLFGANG VON TRIPS	GER	FERRARI	33
Best	five scores from eight races	to count		
DR	VERS' WORLD CH	AMPION	ISHIP 1962	
POS.		AMPION NAT.	ISHIP 1962 CONSTRUCTOR	PTS
				PTS 42
	DRIVER	NAT.	CONSTRUCTOR	
POS. 1 2	DRIVER GRAHAM HILL JIM CLARK	NAT. GBR GBR	CONSTRUCTOR BRM LOTUS-CLIMAX	42
POS. 1 2	DRIVER GRAHAM HILL	NAT. GBR GBR	CONSTRUCTOR BRM LOTUS-CLIMAX	42 30
POS. 1 2	DRIVER GRAHAM HILL JIM CLARK	NAT. GBR GBR	CONSTRUCTOR BRM LOTUS-CLIMAX	42 30 PTS
POS. 1 2 DR	DRIVER GRAHAM HILL JIM CLARK IVERS' WORLD CH	NAT. GBR GBR AMPION NAT. GBR	CONSTRUCTOR BRM LOTUS-CLIMAX ISHIP 1963 CONSTRUCTOR LOTUS-CLIMAX	42 30 PTS 54
POS. 1 2 DRI POS.	DRIVER GRAHAM HILL JIM CLARK VERS' WORLD CH DRIVER	NAT. GBR GBR AMPION NAT.	CONSTRUCTOR BRM LOTUS-CLIMAX ISHIP 1963 CONSTRUCTOR	42 30 PTS 54 29
POS. 1 2 DRI POS.	DRIVER GRAHAM HILL JIM CLARK VERS' WORLD CH DRIVER JIM CLARK	NAT. GBR GBR AMPION NAT. GBR	CONSTRUCTOR BRM LOTUS-CLIMAX ISHIP 1963 CONSTRUCTOR LOTUS-CLIMAX	42 30 PTS 54

100	STRUCTORS' CUP	
POS.	CONSTRUCTOR	PTS
1	COOPER-CLIMAX	48
2	LOTUS-CLIMAX	34
CON	STRUCTORS' CUP	
POS.	CONSTRUCTOR	PTS
1	FERRARI	40
2	LOTUS-CLIMAX	32
CON	NSTRUCTORS' CUP	
POS.	CONSTRUCTOR	PTS
1	BRM	42
2	LOTUS-CLIMAX	36
CON	ISTRUCTORS' CUP	
POS.	CONSTRUCTOR	PTS
1	LOTUS-CLIMAX	54
2	BRM	36

est s	DRIVER	NAT.	CONSTRUCTOR	PTS		POS.	CONSTRUCTOR		
	JOHN SURTEES	GBR	FERRARI	40		1	FERRARI		P
	GRAHAM HILL six scores from 10 races to	GBR	BRM	39		2	BRM		2
₹ 1									
	VERS' WORLD CH						NSTRUCTORS'	CUP	
.	DRIVER JIM CLARK	NAT. GBR	CONSTRUCTOR LOTUS-CLIMAX	PTS 54		POS.			P
	GRAHAM HILL	GBR	BRM	40		2	LOTUS-CLIMAX BRM		
ts	six scores from 10 races to	count							
? I	VERS' WORLD CH	AMPION	ISHIP 1966			COL	NSTRUCTORS'	CUP	
S .	DRIVER	NAT.	CONSTRUCTOR	PTS		POS.	CONSTRUCTOR		P
	JACK BRABHAM JOHN SURTEES	AUS GBR	Brabham-Repco Ferrari/Cooper-Maserati	42 28		1	BRABHAM-REPCO FERRARI		
t f	five scores from nine races t		TERROR OF ER MASERATI	20		2	FERRARI		
S I	VERS' WORLD CH	AMPION	ISHIP 1967			COL	VSTBUCTORS!	CUD	
	DRIVER	NAT.	CONSTRUCTOR	PTS			NSTRUCTORS' CONSTRUCTOR	COP	P
	DENNY HULME	NZL	BRABHAM-REPCO	51		1	BRABHAM-REPCO		
t r	JACK BRABHAM nine scores from 11 races to	AUS o count	BRABHAM-REPCO	46		2	Lotus-Ford		
٠.	VEDS: WOD! D S!!		10111P 4000						
	VERS' WORLD CH	NAT.	ISHIP 1968 CONSTRUCTOR	PTS			VSTRUCTORS'	CUP	
,000	GRAHAM HILL	GBR	LOTUS-FORD	48		1	CONSTRUCTOR LOTUS-FORD		P
	JACKIE STEWART 10 scores from 12 races to c	GBR	MATRA-FORD	36		2	McLaren-Ford		
	VERS' WORLD CH						NSTRUCTORS'	CUP	
	DRIVER JACKIE STEWART	NAT. GBR	CONSTRUCTOR MATRA-FORD	PTS 63		POS	CONSTRUCTOR MATRA-FORD		P
	JACKY ICKX	BEL	BRABHAM-FORD	37		2	BRABHAM-FORD		
t r	nine scores from 11 races to	count							
	JOCHEN RINDT JACKY ICKX	AUT BEI	LOTUS-FORD FERRARI	45		1	LOTUS-FORD		
	JACKY ICKX	BEL	FERRARI	40		2	FERRARI		
	11 scores from 13 races to c								
	VERS' WORLD CH	AMPION	SHIP 1971				NSTRUCTORS'		
	DDIVED.		CONCTRUCTOR					CUP	
	DRIVER JACKIE STEWART	NAT. GBR	CONSTRUCTOR Tyrrell-Ford	PTS 62		POS.	CONSTRUCTOR	CUP	
	JACKIE STEWART RONNIE PETERSON	NAT. GBR SWE		PTS 62 33				CUP	
	JACKIE STEWART	NAT. GBR SWE	TYRRELL-FORD	62		POS.	CONSTRUCTOR TYRRELL-FORD	CUP	
t n	JACKIE STEWART RONNIE PETERSON nine scores from 11 races to VERS' WORLD CH	NAT. GBR SWE count	TYRRELL-FORD MARCH-FORD	62 33		POS. 1 2	CONSTRUCTOR TYRRELL-FORD BRM NSTRUCTORS'		
t n	JACKIE STEWART RONNIE PETERSON nine scores from 11 races to VERS' WORLD CH DRIVER	NAT. GBR SWE count AMPION NAT.	TYRRELL-FORD MARCH-FORD SHIP 1972 CONSTRUCTOR	62 33		POS. 1 2 COP POS.	CONSTRUCTOR TYRRELL-FORD BRM NSTRUCTORS' CONSTRUCTOR		P
t n	JACKIE STEWART RONNIE PETERSON nine scores from 11 races to VERS' WORLD CH DRIVER EMERSON FITTIPALDI JACKIE STEWART	NAT. GBR SWE Count AMPION NAT. BRA GBR	TYRRELL-FORD MARCH-FORD	62 33		POS. 1 2	CONSTRUCTOR TYRRELL-FORD BRM NSTRUCTORS'		P
t n	JACKIE STEWART RONNIE PETERSON nine scores from 11 races to VERS' WORLD CH DRIVER EMERSON FITTIPALDI	NAT. GBR SWE Count AMPION NAT. BRA GBR	TYRRELL-FORD MARCH-FORD SHIP 1972 CONSTRUCTOR LOTUS-FORD	62 33 PTS 61		POS. 1 2 COP POS. 1	CONSTRUCTOR TYRRELL-FORD BRM NSTRUCTORS' CONSTRUCTOR LOTUS-FORD		P
t n	JACKIE STEWART RONNIE PETERSON nine scores from 11 races to VERS' WORLD CH DRIVER EMERSON FITTIPALDI JACKIE STEWART 10 scores from 12 races to c VERS' WORLD CH	NAT. GBR SWE Count AMPION NAT. BRA GBR COUNT	TYRRELL-FORD MARCH-FORD SHIP 1972 CONSTRUCTOR LOTUS-FORD TYRRELL-FORD	62 33 PTS 61 45		POS. 1 2 COP POS. 1 2	CONSTRUCTOR TYRRELL-FORD BRM NSTRUCTORS' CONSTRUCTOR LOTUS-FORD	CUP	P
t n	JACKIE STEWART RONNIE PETERSON nine scores from 11 races to VERS' WORLD CH DRIVER EMERSON FITTIPALDI JACKIE STEWART 10 scores from 12 races to c VERS' WORLD CH DRIVER	NAT. GBR SWE Count AMPION NAT. BRA GBR COUNT AMPION NAT.	TYRRELL-FORD MARCH-FORD SHIP 1972 CONSTRUCTOR LOTUS-FORD TYRRELL-FORD SHIP 1973 CONSTRUCTOR	62 33 PTS 61 45		POS. 1 2 COP POS. 1 2 COP POS.	CONSTRUCTOR TYRRELL-FORD BRM NSTRUCTORS' CONSTRUCTOR LOTUS-FORD TYRRELL-FORD NSTRUCTORS' CONSTRUCTORS' CONSTRUCTOR	CUP	F
t n	JACKIE STEWART RONNIE PETERSON nine scores from 11 races to VERS' WORLD CH DRIVER EMERSON FITTIPALDI JACKIE STEWART 10 scores from 12 races to c VERS' WORLD CH	NAT. GBR SWE Count AMPION NAT. BRA GBR COUNT	TYRRELL-FORD MARCH-FORD SHIP 1972 CONSTRUCTOR LOTUS-FORD TYRRELL-FORD	62 33 PTS 61 45		POS. 1 2 CON POS. 1 2 CON POS. 1	CONSTRUCTOR TYRRELL-FORD BRM NSTRUCTORS' CONSTRUCTOR LOTUS-FORD TYRRELL-FORD NSTRUCTORS' CONSTRUCTOR LOTUS-FORD	CUP	P
t n RI'	JACKIE STEWART RONNIE PETERSON nine scores from 11 races to VERS' WORLD CH DRIVER EMERSON FITTIPALDI JACKIE STEWART 10 scores from 12 races to c VERS' WORLD CH DRIVER JACKIE STEWART	NAT. GBR SWE Count IAMPION NAT. BRA GBR Count IAMPION NAT. GBR BRA	TYRRELL-FORD MARCH-FORD SHIP 1972 CONSTRUCTOR LOTUS-FORD TYRRELL-FORD SHIP 1973 CONSTRUCTOR TYRRELL-FORD	62 33 PTS 61 45 PTS 71		POS. 1 2 COP POS. 1 2 COP POS.	CONSTRUCTOR TYRRELL-FORD BRM NSTRUCTORS' CONSTRUCTOR LOTUS-FORD TYRRELL-FORD NSTRUCTORS' CONSTRUCTORS' CONSTRUCTOR	CUP	P
t n	JACKIE STEWART RONNIE PETERSON nine scores from 11 races to VERS' WORLD CH DRIVER EMERSON FITTIPALDI JACKIE STEWART 10 scores from 12 races to c VERS' WORLD CH DRIVER JACKIE STEWART EMERSON FITTIPALDI 13 scores from 15 races to c	NAT. GBR SWE Count NAT. BRA GBR Count AMPION NAT. GBR BRA Count	TYRRELL-FORD MARCH-FORD SHIP 1972 CONSTRUCTOR LOTUS-FORD TYRRELL-FORD SHIP 1973 CONSTRUCTOR TYRRELL-FORD LOTUS-FORD	62 33 PTS 61 45 PTS 71		POS. 1 2 CON POS. 1 2 CON POS. 1 2	CONSTRUCTOR TYRRELL-FORD BRM NSTRUCTORS' CONSTRUCTOR LOTUS-FORD TYRRELL-FORD NSTRUCTORS' CONSTRUCTOR LOTUS-FORD TYRRELL-FORD TYRRELL-FORD	CUP	P
t n RI'	JACKIE STEWART RONNIE PETERSON nine scores from 11 races to VERS' WORLD CH DRIVER EMERSON FITTIPALDI JACKIE STEWART 10 scores from 12 races to c VERS' WORLD CH DRIVER JACKIE STEWART EMERSON FITTIPALDI 13 scores from 15 races to c VERS' WORLD CH DRIVER	NAT. GBR SWE O count IAMPION NAT. BRA GBR Count IAMPION NAT. GBR BRA COUNT AMPION NAT.	TYRRELL-FORD MARCH-FORD SHIP 1972 CONSTRUCTOR LOTUS-FORD TYRRELL-FORD SHIP 1973 CONSTRUCTOR TYRRELL-FORD LOTUS-FORD SHIP 1974 CONSTRUCTOR	62 33 PTS 61 45 PTS 71 55		POS. 1 2 CON POS. 1 CON	CONSTRUCTOR TYRRELL-FORD BRM NSTRUCTORS' CONSTRUCTOR LOTUS-FORD TYRRELL-FORD NSTRUCTORS' CONSTRUCTOR LOTUS-FORD	CUP	P 9 9 9 9 9 9 9 9 9 9 9 9 9 9 9 9 9 9 9
t n RI'	JACKIE STEWART RONNIE PETERSON nine scores from 11 races to VERS' WORLD CH DRIVER EMERSON FITTIPALDI JACKIE STEWART 10 scores from 12 races to c VERS' WORLD CH DRIVER JACKIE STEWART EMERSON FITTIPALDI 13 scores from 15 races to c VERS' WORLD CH DRIVER EMERSON FITTIPALDI DRIVER EMERSON FITTIPALDI	NAT. GBR SWE Count AMPION NAT. BRA GBR COUNT AMPION NAT. GBR BRA COUNT AMPION NAT. BRA	TYRRELL-FORD MARCH-FORD SHIP 1972 CONSTRUCTOR LOTUS-FORD TYRRELL-FORD SHIP 1973 CONSTRUCTOR TYRRELL-FORD LOTUS-FORD SHIP 1974 CONSTRUCTOR MCLAREN-FORD	PTS 61 45 PTS 71 55 PTS 55		POS. 1 2 CON POS. 1 2 CON POS. 1 2	CONSTRUCTOR TYRRELL-FORD BRM NSTRUCTORS' CONSTRUCTOR LOTUS-FORD TYRRELL-FORD NSTRUCTORS' CONSTRUCTOR TYRRELL-FORD TYRRELL-FORD NSTRUCTORS' CONSTRUCTORS' CONSTRUCTORS' CONSTRUCTORS' MCLAREN-FORD	CUP	P
t 1 RI'	JACKIE STEWART RONNIE PETERSON nine scores from 11 races to VERS' WORLD CH DRIVER EMERSON FITTIPALDI JACKIE STEWART 10 scores from 12 races to c VERS' WORLD CH DRIVER JACKIE STEWART EMERSON FITTIPALDI 13 scores from 15 races to c VERS' WORLD CH DRIVER	NAT. GBR SWE Count NAT. BRA GBR Count IAMPION NAT. GBR BRA Count AMPION NAT. BRA SWI	TYRRELL-FORD MARCH-FORD SHIP 1972 CONSTRUCTOR LOTUS-FORD TYRRELL-FORD SHIP 1973 CONSTRUCTOR TYRRELL-FORD LOTUS-FORD SHIP 1974 CONSTRUCTOR	62 33 PTS 61 45 PTS 71 55		POS. 1 2 CON POS. 1 2 CON POS. 1 2	CONSTRUCTOR TYRRELL-FORD BRM NSTRUCTORS' CONSTRUCTOR LOTUS-FORD TYRRELL-FORD NSTRUCTORS' CONSTRUCTOR LOTUS-FORD TYRRELL-FORD TYRRELL-FORD NSTRUCTORS' CONSTRUCTORS' CONSTRUCTORS' CONSTRUCTORS'	CUP	P
t n RI'	JACKIE STEWART RONNIE PETERSON nine scores from 11 races to VERS' WORLD CH DRIVER EMERSON FITTIPALDI JACKIE STEWART 10 scores from 12 races to c VERS' WORLD CH DRIVER JACKIE STEWART EMERSON FITTIPALDI 13 scores from 15 races to c VERS' WORLD CH DRIVER EMERSON FITTIPALDI CLAY REGAZZONI 13 scores from 15 races to c	NAT. GBR SWE Count AMPION NAT. BRA GBR COUNT AMPION NAT. GBR BRA COUNT AMPION NAT. BRA SWI COUNT	TYRRELL-FORD MARCH-FORD SHIP 1972 CONSTRUCTOR LOTUS-FORD TYRRELL-FORD SHIP 1973 CONSTRUCTOR TYRRELL-FORD LOTUS-FORD SHIP 1974 CONSTRUCTOR MCLAREN-FORD FERRARI	PTS 61 45 PTS 71 55 PTS 55		POS. 1 2 CON POS. 1 2 CON POS. 1 2	CONSTRUCTOR TYRRELL-FORD BRM NSTRUCTORS' CONSTRUCTOR LOTUS-FORD TYRRELL-FORD NSTRUCTORS' CONSTRUCTOR LOTUS-FORD TYRRELL-FORD NSTRUCTORS' CONSTRUCTORS' CONSTRUCTORS' CONSTRUCTORS' CONSTRUCTORS' FERRARI	CUP	P P 9
t n RI'	JACKIE STEWART RONNIE PETERSON nine scores from 11 races to VERS' WORLD CH DRIVER EMERSON FITTIPALDI JACKIE STEWART 10 scores from 12 races to c VERS' WORLD CH DRIVER JACKIE STEWART EMERSON FITTIPALDI 13 scores from 15 races to c VERS' WORLD CH DRIVER EMERSON FITTIPALDI CLAY REGAZZONI 13 scores from 15 races to c VERS' WORLD CH DRIVER	NAT. GBR SWE Count AMPION NAT. BRA GBR COUNT AMPION NAT. GBR BRA COUNT AMPION NAT. BRA SWI COUNT	TYRRELL-FORD MARCH-FORD SHIP 1972 CONSTRUCTOR LOTUS-FORD TYRRELL-FORD SHIP 1973 CONSTRUCTOR TYRRELL-FORD LOTUS-FORD SHIP 1974 CONSTRUCTOR MCLAREN-FORD FERRARI	PTS 61 45 PTS 71 55 PTS 55		POS. 1 2 CON POS. 1 CO	CONSTRUCTOR TYRRELL-FORD BRM NSTRUCTORS' CONSTRUCTOR LOTUS-FORD TYRRELL-FORD NSTRUCTORS' CONSTRUCTOR LOTUS-FORD TYRRELL-FORD NSTRUCTORS' CONSTRUCTORS' CONSTRUCTORS' CONSTRUCTORS' MCLAREN-FORD FERRARI NSTRUCTORS'	CUP	P P
t n RI'	JACKIE STEWART RONNIE PETERSON nine scores from 11 races to VERS' WORLD CH DRIVER EMERSON FITTIPALDI JACKIE STEWART 10 scores from 12 races to c VERS' WORLD CH DRIVER JACKIE STEWART EMERSON FITTIPALDI 13 scores from 15 races to c VERS' WORLD CH DRIVER EMERSON FITTIPALDI CLAY REGAZZONI 13 scores from 15 races to c VERS' WORLD CH DRIVER EMERSON FITTIPALDI CLAY REGAZZONI 13 scores from 15 races to c	NAT. GBR SWE O count IAMPION NAT. BRA GBR COUNT IAMPION NAT. GBR BRA COUNT AMPION NAT. BRA SWI COUNT AMPION NAT. AUT	TYRRELL-FORD MARCH-FORD SHIP 1972 CONSTRUCTOR LOTUS-FORD TYRRELL-FORD SHIP 1973 CONSTRUCTOR TYRRELL-FORD LOTUS-FORD SHIP 1974 CONSTRUCTOR MCLAREN-FORD FERRARI SHIP 1975 CONSTRUCTOR FERRARI	PTS 61 45 PTS 71 55 PTS 55 52 PTS 64.5		POS. 1 2 CON POS. 1 1 2 CON POS. 1 C	CONSTRUCTOR TYRRELL-FORD BRM NSTRUCTORS' CONSTRUCTOR LOTUS-FORD TYRRELL-FORD NSTRUCTORS' CONSTRUCTOR LOTUS-FORD TYRRELL-FORD NSTRUCTORS' CONSTRUCTORS' CONSTRUCTOR MCLAREN-FORD FERRARI NSTRUCTORS' CONSTRUCTORS' CONSTRUCTORS' CONSTRUCTORS' CONSTRUCTORS' CONSTRUCTORS' CONSTRUCTORS'	CUP	P P 72
t n RI'	JACKIE STEWART RONNIE PETERSON nine scores from 11 races to VERS' WORLD CH DRIVER EMERSON FITTIPALDI JACKIE STEWART 10 scores from 12 races to c VERS' WORLD CH DRIVER JACKIE STEWART EMERSON FITTIPALDI 13 scores from 15 races to c VERS' WORLD CH DRIVER EMERSON FITTIPALDI CLAY REGAZZONI 13 scores from 15 races to c VERS' WORLD CH DRIVER	NAT. GBR SWE O count IAMPION NAT. BRA GBR COUNT IAMPION NAT. GBR BRA COUNT AMPION NAT. BRA SWI COUNT AMPION NAT. BRA SWI COUNT AMPION NAT. AUT BRA	TYRRELL-FORD MARCH-FORD SHIP 1972 CONSTRUCTOR LOTUS-FORD TYRRELL-FORD SHIP 1973 CONSTRUCTOR TYRRELL-FORD LOTUS-FORD SHIP 1974 CONSTRUCTOR MCLAREN-FORD FERRARI SHIP 1975 CONSTRUCTOR	62 33 PTS 61 45 PTS 71 55 PTS 55 52		POS. 1 2 COP POS. 1 COP POS.	CONSTRUCTOR TYRRELL-FORD BRM NSTRUCTORS' CONSTRUCTOR LOTUS-FORD TYRRELL-FORD NSTRUCTORS' CONSTRUCTOR LOTUS-FORD TYRRELL-FORD NSTRUCTORS' CONSTRUCTORS' CONSTRUCTOR MCLAREN-FORD FERRARI NSTRUCTORS' CONSTRUCTORS' CONSTRUCTORS' CONSTRUCTORS' CONSTRUCTORS' CONSTRUCTORS' CONSTRUCTORS'	CUP	P P 72
t n RI' t 1 RI'	JACKIE STEWART RONNIE PETERSON nine scores from 11 races to VERS' WORLD CH DRIVER EMERSON FITTIPALDI JACKIE STEWART 10 scores from 12 races to c VERS' WORLD CH DRIVER JACKIE STEWART EMERSON FITTIPALDI 13 scores from 15 races to c VERS' WORLD CH DRIVER EMERSON FITTIPALDI CLAY REGAZZONI 13 scores from 15 races to c VERS' WORLD CH DRIVER EMERSON FITTIPALDI CLAY REGAZZONI 13 scores from 15 races to c VERS' WORLD CH DRIVER DRIVER DRIVER DRIVER DRIVER DRIVER LAUDA EMERSON FITTIPALDI 12 scores from 14 races to c	NAT. GBR SWE Count IAMPION NAT. BRA GBR COUNT IAMPION NAT. BRA COUNT AMPION NAT. BRA SWI COUNT AMPION NAT. BRA SWI COUNT AMPION NAT. BRA SOUNT COUNT	TYRRELL-FORD MARCH-FORD SHIP 1972 CONSTRUCTOR LOTUS-FORD TYRRELL-FORD SHIP 1973 CONSTRUCTOR TYRRELL-FORD LOTUS-FORD SHIP 1974 CONSTRUCTOR MCLAREN-FORD FERRARI SHIP 1975 CONSTRUCTOR FERRARI MCLAREN-FORD	PTS 61 45 PTS 71 55 PTS 55 52 PTS 64.5		POS. 1 2 CON POS. 1 CO	CONSTRUCTOR TYRRELL-FORD BRM NSTRUCTORS' CONSTRUCTOR LOTUS-FORD TYRRELL-FORD NSTRUCTORS' CONSTRUCTOR LOTUS-FORD TYRRELL-FORD NSTRUCTORS' CONSTRUCTORS' CONSTRUCTOR MCLAREN-FORD FERRARI NSTRUCTORS' CONSTRUCTORS' CONSTRUCTOR FERRARI BRABHAM-FORD	CUP	P P 72
t n RI' S. t 1 RI' S. t 1 RI'	JACKIE STEWART RONNIE PETERSON nine scores from 11 races to VERS' WORLD CH DRIVER EMERSON FITTIPALDI JACKIE STEWART 10 scores from 12 races to c VERS' WORLD CH DRIVER JACKIE STEWART EMERSON FITTIPALDI 13 scores from 15 races to c VERS' WORLD CH DRIVER EMERSON FITTIPALDI CLAY REGAZZONI 13 scores from 15 races to c VERS' WORLD CH DRIVER NIKI LAUDA EMERSON FITTIPALDI 12 scores from 14 races to c VERS' WORLD CH	NAT. GBR SWE Count AMPION NAT. GBR BRA Count AMPION NAT. BRA SWI Count AMPION NAT. BRA SWI Count AMPION NAT. AUT BRA Count AMPION	TYRRELL-FORD MARCH-FORD SHIP 1972 CONSTRUCTOR LOTUS-FORD TYRRELL-FORD SHIP 1973 CONSTRUCTOR TYRRELL-FORD LOTUS-FORD SHIP 1974 CONSTRUCTOR MCLAREN-FORD FERRARI SHIP 1975 CONSTRUCTOR FERRARI MCLAREN-FORD SHIP 1976	PTS 61 45 PTS 55 52 PTS 64.5 45		POS. 1 2 COPPOS. 1	CONSTRUCTOR TYRRELL-FORD BRM NSTRUCTORS' CONSTRUCTOR LOTUS-FORD TYRRELL-FORD NSTRUCTORS' CONSTRUCTOR LOTUS-FORD TYRRELL-FORD NSTRUCTORS' CONSTRUCTOR MCLAREN-FORD FERRARI NSTRUCTORS' CONSTRUCTORS' CONSTRUCTORS' CONSTRUCTORS' CONSTRUCTORS' STRUCTORS' NSTRUCTORS' NSTRUCTORS' NSTRUCTORS'	CUP	P P 72
t 1 RI'	JACKIE STEWART RONNIE PETERSON nine scores from 11 races to VERS' WORLD CH DRIVER EMERSON FITTIPALDI JACKIE STEWART 10 scores from 12 races to c VERS' WORLD CH DRIVER JACKIE STEWART EMERSON FITTIPALDI 13 scores from 15 races to c VERS' WORLD CH DRIVER EMERSON FITTIPALDI CLAY REGAZZONI 13 scores from 15 races to c VERS' WORLD CH DRIVER EMERSON FITTIPALDI CLAY REGAZZONI 13 scores from 15 races to c VERS' WORLD CH DRIVER DRIVER DRIVER DRIVER DRIVER DRIVER LAUDA EMERSON FITTIPALDI 12 scores from 14 races to c	NAT. GBR SWE Count IAMPION NAT. BRA GBR COUNT IAMPION NAT. BRA COUNT AMPION NAT. BRA SWI COUNT AMPION NAT. BRA SWI COUNT AMPION NAT. BRA SOUNT COUNT	TYRRELL-FORD MARCH-FORD SHIP 1972 CONSTRUCTOR LOTUS-FORD TYRRELL-FORD SHIP 1973 CONSTRUCTOR TYRRELL-FORD LOTUS-FORD SHIP 1974 CONSTRUCTOR MCLAREN-FORD FERRARI SHIP 1975 CONSTRUCTOR FERRARI MCLAREN-FORD	PTS 61 45 PTS 71 55 PTS 55 52 PTS 64.5		POS. 1 2 COPPOS. 1	CONSTRUCTOR TYRRELL-FORD BRM NSTRUCTORS' CONSTRUCTOR LOTUS-FORD TYRRELL-FORD NSTRUCTORS' CONSTRUCTOR LOTUS-FORD TYRRELL-FORD NSTRUCTORS' CONSTRUCTORS' CONSTRUCTOR MCLAREN-FORD FERRARI NSTRUCTORS' CONSTRUCTORS' CONSTRUCTOR FERRARI BRABHAM-FORD NSTRUCTORS' CONSTRUCTORS' CONSTRUCTORS' CONSTRUCTORS' CONSTRUCTORS' CONSTRUCTORS' CONSTRUCTORS' CONSTRUCTORS' CONSTRUCTORS'	CUP	P P 722
t 1 RI'	JACKIE STEWART RONNIE PETERSON nine scores from 11 races to VERS' WORLD CH DRIVER EMERSON FITTIPALDI JACKIE STEWART 10 scores from 12 races to c VERS' WORLD CH DRIVER JACKIE STEWART EMERSON FITTIPALDI 13 scores from 15 races to c VERS' WORLD CH DRIVER EMERSON FITTIPALDI CLAY REGAZZONI 13 scores from 15 races to c VERS' WORLD CH DRIVER NIKI LAUDA EMERSON FITTIPALDI 12 scores from 14 races to c VERS' WORLD CH DRIVER JAMES HUNT NIKI LAUDA	NAT. GBR SWE O count IAMPION NAT. BRA GBR Count IAMPION NAT. GBR BRA Count AMPION NAT. BRA SWI Count AMPION NAT. AUT BRA Count AMPION NAT. AUT BRA Count BRA Count AMPION NAT. AUT BRA Count BRA Count AMPION NAT. AUT BRA COUNT	TYRRELL-FORD MARCH-FORD SHIP 1972 CONSTRUCTOR LOTUS-FORD TYRRELL-FORD SHIP 1973 CONSTRUCTOR TYRRELL-FORD LOTUS-FORD SHIP 1974 CONSTRUCTOR MCLAREN-FORD FERRARI SHIP 1975 CONSTRUCTOR FERRARI MCLAREN-FORD SHIP 1976 CONSTRUCTOR	PTS 61 45 PTS 55 52 PTS 64.5 45 PTS		POS. 1 2 COP POS. 1 CO	CONSTRUCTOR TYRRELL-FORD BRM NSTRUCTORS' CONSTRUCTOR LOTUS-FORD TYRRELL-FORD NSTRUCTORS' CONSTRUCTOR LOTUS-FORD TYRRELL-FORD NSTRUCTORS' CONSTRUCTOR MCLAREN-FORD FERRARI NSTRUCTORS' CONSTRUCTORS' CONSTRUCTORS' CONSTRUCTORS' CONSTRUCTORS' STRUCTORS' NSTRUCTORS' NSTRUCTORS' NSTRUCTORS'	CUP	P P 72
t 1 RI'	JACKIE STEWART RONNIE PETERSON nine scores from 11 races to VERS' WORLD CH DRIVER EMERSON FITTIPALDI JACKIE STEWART 10 scores from 12 races to c VERS' WORLD CH DRIVER JACKIE STEWART EMERSON FITTIPALDI 13 scores from 15 races to c VERS' WORLD CH DRIVER EMERSON FITTIPALDI CLAY REGAZZONI 13 scores from 15 races to c VERS' WORLD CH DRIVER NIKE NIKE DRIVER DRIVER DRIVER SCORES FORM 14 races to c VERS' WORLD CH DRIVER VERS' WORLD CH DRIVER JAMES HUNT	NAT. GBR SWE O count IAMPION NAT. BRA GBR Count IAMPION NAT. GBR BRA Count AMPION NAT. BRA SWI Count AMPION NAT. AUT BRA Count AMPION NAT. AUT BRA Count BRA Count AMPION NAT. AUT BRA Count BRA Count AMPION NAT. AUT BRA COUNT	TYRRELL-FORD MARCH-FORD SHIP 1972 CONSTRUCTOR LOTUS-FORD TYRRELL-FORD SHIP 1973 CONSTRUCTOR TYRRELL-FORD LOTUS-FORD SHIP 1974 CONSTRUCTOR MCLAREN-FORD FERRARI SHIP 1975 CONSTRUCTOR FERRARI MCLAREN-FORD SHIP 1976 CONSTRUCTOR MCLAREN-FORD SHIP 1976 CONSTRUCTOR MCLAREN-FORD	PTS 61 45 PTS 55 52 PTS 64.5 45 PTS 69		POS. 1 2 CON POS. 1 C	CONSTRUCTOR TYRRELL-FORD BRM NSTRUCTORS' CONSTRUCTOR LOTUS-FORD TYRRELL-FORD NSTRUCTORS' CONSTRUCTOR LOTUS-FORD TYRRELL-FORD NSTRUCTORS' CONSTRUCTORS' CONSTRUCTOR MCLAREN-FORD FERRARI NSTRUCTORS' CONSTRUCTOR FERRARI BRABHAM-FORD NSTRUCTORS' CONSTRUCTORS' CONSTRUCTOR FERRARI BRABHAM-FORD NSTRUCTORS' CONSTRUCTORS' CONSTRUCTORS' CONSTRUCTORS' CONSTRUCTORS' CONSTRUCTORS' CONSTRUCTORS' CONSTRUCTORS' CONSTRUCTOR	CUP	P P 8
t n RI'	JACKIE STEWART RONNIE PETERSON nine scores from 11 races to VERS' WORLD CH DRIVER EMERSON FITTIPALDI JACKIE STEWART 10 scores from 12 races to c VERS' WORLD CH DRIVER JACKIE STEWART EMERSON FITTIPALDI 13 scores from 15 races to c VERS' WORLD CH DRIVER CLAY REGAZZONI 13 scores from 15 races to c VERS' WORLD CH DRIVER NIKI LAUDA EMERSON FITTIPALDI 12 scores from 14 races to c VERS' WORLD CH DRIVER JAMES HUNT NIKI LAUDA 14 scores from 16 races to c VERS' WORLD CH DRIVER JAMES HUNT NIKI LAUDA 14 scores from 16 races to c VERS' WORLD CH	NAT. GBR SWE O count IAMPION NAT. BRA GBR COUNT IAMPION NAT. BRA COUNT AMPION NAT. AUT COUNT AMPION	TYRRELL-FORD MARCH-FORD SHIP 1972 CONSTRUCTOR LOTUS-FORD TYRRELL-FORD SHIP 1973 CONSTRUCTOR TYRRELL-FORD LOTUS-FORD SHIP 1974 CONSTRUCTOR MCLAREN-FORD FERRARI SHIP 1975 CONSTRUCTOR FERRARI MCLAREN-FORD SHIP 1976 CONSTRUCTOR MCLAREN-FORD FERRARI SHIP 1976 SHIP 1976 CONSTRUCTOR MCLAREN-FORD FERRARI SHIP 1977	PTS 61 45 PTS 55 52 PTS 64.5 45 PTS 69 68		POS. 1 2 COPPOS. 1 COPPOS.	CONSTRUCTOR TYRRELL-FORD BRM NSTRUCTORS' CONSTRUCTOR LOTUS-FORD TYRRELL-FORD NSTRUCTORS' CONSTRUCTOR LOTUS-FORD TYRRELL-FORD NSTRUCTORS' CONSTRUCTOR MCLAREN-FORD FERRARI NSTRUCTORS' CONSTRUCTOR FERRARI BRABHAM-FORD NSTRUCTORS' CONSTRUCTOR FERRARI MCLAREN-FORD NSTRUCTORS' CONSTRUCTORS'	CUP CUP	P
t n RI'	JACKIE STEWART RONNIE PETERSON nine scores from 11 races to VERS' WORLD CH DRIVER EMERSON FITTIPALDI JACKIE STEWART 10 scores from 12 races to c VERS' WORLD CH DRIVER JACKIE STEWART EMERSON FITTIPALDI 13 scores from 15 races to c VERS' WORLD CH DRIVER EMERSON FITTIPALDI (CLAY REGAZZONI 13 scores from 15 races to c VERS' WORLD CH DRIVER NIKI LAUDA EMERSON FITTIPALDI 12 scores from 14 races to c VERS' WORLD CH DRIVER NIKI LAUDA LEMERSON FITTIPALDI LEMERSON FITTIPA	NAT. GBR SWE O count IAMPION NAT. BRA GBR COUNT AMPION NAT. BRA SWI COUNT AMPION NAT. AUT BRA COUNT AMPION NAT. GBR BRA COUNT AMPION NAT. GBR BRA COUNT COUNT	TYRRELL-FORD MARCH-FORD SHIP 1972 CONSTRUCTOR LOTUS-FORD TYRRELL-FORD SHIP 1973 CONSTRUCTOR TYRRELL-FORD LOTUS-FORD SHIP 1974 CONSTRUCTOR MCLAREN-FORD FERRARI SHIP 1975 CONSTRUCTOR FERRARI MCLAREN-FORD SHIP 1976 CONSTRUCTOR MCLAREN-FORD FERRARI	PTS 61 45 PTS 55 52 PTS 64.5 45 PTS 69		POS. 1 2 COPPOS. 1 COPPOS.	CONSTRUCTOR TYRRELL-FORD BRM NSTRUCTORS' CONSTRUCTOR LOTUS-FORD TYRRELL-FORD NSTRUCTORS' CONSTRUCTOR LOTUS-FORD TYRRELL-FORD NSTRUCTORS' CONSTRUCTOR MCLAREN-FORD FERRARI BRABHAM-FORD NSTRUCTORS' CONSTRUCTOR FERRARI BRABHAM-FORD NSTRUCTORS' CONSTRUCTORS' CONSTRUCTOR FERRARI MCLAREN-FORD	CUP CUP	P

RIV	ERS' WORLD CH	AMPION	ISHIP 1978				NSTRUCTORS'	CUP	
	DRIVER	NAT.	CONSTRUCTOR	PTS		POS.	CONSTRUCTOR		P
N	MARIO ANDRETTI	USA	LOTUS-FORD	64		1	Lotus-Ford		8
F	RONNIE PETERSON	SWE	LOTUS-FORD	51		2	FERRARI		5
est 14	scores from 16 races to	count							
RIV	ERS' WORLD CH	AMPION	ISHIP 1979				NSTRUCTORS'	CUP	
	DRIVER	NAT.	CONSTRUCTOR	PTS		POS.	CONSTRUCTOR		P
J	JODY SCHECKTER	RSA	FERRARI	51		1	FERRARI		1
C	GILLES VILLENEUVE	CDN	FERRARI	47		2	WILLIAMS-FORD		
st eig	ght scores from 15 races t	to count							
	"我们的"	TH	IE EIGHT	ries					
S. C	VERS' WORLD CH DRIVER ALAN JONES NELSON PIQUET	IAMPION NAT. AUT BRA		PTS 67 54			NSTRUCTORS' CONSTRUCTOR WILLIAMS-FORD LIGIER-FORD	CUP	1
S. D st 10	ORIVER ALAN JONES NELSON PIQUET I scores from 14 races to	IAMPION NAT. AUT BRA count	SHIP 1980 CONSTRUCTOR WILLIAMS-FORD BRABHAM-FORD	PTS 67		POS. 1 2	CONSTRUCTOR WILLIAMS-FORD LIGIER-FORD		1
st 10	ORIVER ALAN JONES NELSON PIQUET I scores from 14 races to	IAMPION NAT. AUT BRA count	SHIP 1980 CONSTRUCTOR WILLIAMS-FORD BRABHAM-FORD	PTS 67 54		POS. 1 2	CONSTRUCTOR WILLIAMS-FORD LIGIER-FORD		1
S. D st 10 RIV S. D	DRIVER ALAN JONES NELSON PIQUET Scores from 14 races to FERS' WORLD CH DRIVER	IAMPION NAT. AUT BRA count IAMPION NAT.	ASHIP 1980 CONSTRUCTOR WILLIAMS-FORD BRABHAM-FORD NSHIP 1981 CONSTRUCTOR	PTS 67 54 PTS	30	POS. 1 2	CONSTRUCTOR WILLIAMS-FORD LIGIER-FORD NSTRUCTORS' CONSTRUCTOR		1
S. D st 10 RIV S. D	DRIVER ALAN JONES NELSON PIQUET Secores from 14 races to of VERS' WORLD CH DRIVER NELSON PIQUET	IAMPION NAT. AUT BRA count IAMPION NAT. BRA	ISHIP 1980 CONSTRUCTOR WILLIAMS-FORD BRABHAM-FORD ISHIP 1981 CONSTRUCTOR BRABHAM-FORD	PTS 67 54 PTS 50		POS. 1 2 CO POS. 1	CONSTRUCTOR WILLIAMS-FORD LIGIER-FORD NSTRUCTORS' CONSTRUCTOR WILLIAMS-FORD		1
S. D. A. S. T. S. D. C. S. D. C.	ORIVER ALAN JONES NELSON PIQUET OSCORES FROM 14 races to VERS' WORLD CH ORIVER NELSON PIQUET CARLOS REUTEMANN	IAMPION NAT. AUT BRA count IAMPION NAT. BRA ARG	ASHIP 1980 CONSTRUCTOR WILLIAMS-FORD BRABHAM-FORD NSHIP 1981 CONSTRUCTOR	PTS 67 54 PTS		POS. 1 2	CONSTRUCTOR WILLIAMS-FORD LIGIER-FORD NSTRUCTORS' CONSTRUCTOR		1
S. D. A. S. T. S. D. C. S. D. C.	DRIVER ALAN JONES NELSON PIQUET Secores from 14 races to of VERS' WORLD CH DRIVER NELSON PIQUET	IAMPION NAT. AUT BRA count IAMPION NAT. BRA ARG	ISHIP 1980 CONSTRUCTOR WILLIAMS-FORD BRABHAM-FORD ISHIP 1981 CONSTRUCTOR BRABHAM-FORD	PTS 67 54 PTS 50		POS. 1 2 CO POS. 1 2	CONSTRUCTOR WILLIAMS-FORD LIGIER-FORD NSTRUCTORS' CONSTRUCTOR WILLIAMS-FORD BRABHAM-FORD	CUP	1
S. D st 10 RIV S. D	ORIVER ALAN JONES NELSON PIQUET OSCORES FROM 14 races to VERS' WORLD CH ORIVER NELSON PIQUET CARLOS REUTEMANN	NAT. AUT BRA count IAMPION NAT. BRA ARG	CONSTRUCTOR WILLIAMS-FORD BRABHAM-FORD NSHIP 1981 CONSTRUCTOR BRABHAM-FORD WILLIAMS-FORD	PTS 67 54 PTS 50 49		POS. 1 2 CO POS. 1 2	CONSTRUCTOR WILLIAMS-FORD LIGIER-FORD NSTRUCTORS' CONSTRUCTOR WILLIAMS-FORD BRABHAM-FORD NSTRUCTORS'	CUP	1
S. D. A. St 10 RIV S. D. St 11 RIV	PRIVER ALAN JONES NELSON PIQUET Scores from 14 races to PERS' WORLD CH DRIVER NELSON PIQUET CARLOS REUTEMANN Scores from 15 races to	IAMPION NAT. AUT BRA count IAMPION NAT. BRA ARG count IAMPION NAT.	ASHIP 1980 CONSTRUCTOR WILLIAMS-FORD BRABHAM-FORD NSHIP 1981 CONSTRUCTOR BRABHAM-FORD WILLIAMS-FORD NSHIP 1982 CONSTRUCTOR	PTS 67 54 PTS 50 49 PTS	30	POS. 1 2 CO POS. 1 2	CONSTRUCTOR WILLIAMS-FORD LIGIER-FORD NSTRUCTORS' CONSTRUCTOR WILLIAMS-FORD BRABHAM-FORD NSTRUCTORS' CONSTRUCTORS'	CUP	1
S. D. A. S. T. S. D. C. S. D. C. S. D. C. S. T. S. T. S. T. S. T. S. T. S. D. C. D. C. S. D. C. D. C. S. D. C. S. D. C. D. C. D. C. D. C. S. D. C. D. C. D. C. D. C. D. C. D.	PRIVER ALAN JONES NELSON PIQUET OF SECOND TO THE PRIVER NELSON PIQUET CARLOS REUTEMANN SCORES from 15 races to	IAMPION NAT. AUT BRA count IAMPION NAT. BRA ARG count IAMPION NAT.	ASHIP 1980 CONSTRUCTOR WILLIAMS-FORD BRABHAM-FORD ISHIP 1981 CONSTRUCTOR BRABHAM-FORD WILLIAMS-FORD ISHIP 1982 CONSTRUCTOR WILLIAMS-FORD	PTS 67 54 PTS 50 49 PTS 44		POS. 1 2 CO POS. 1 2 CO POS. 1	CONSTRUCTOR WILLIAMS-FORD LIGIER-FORD NSTRUCTORS' CONSTRUCTOR WILLIAMS-FORD BRABHAM-FORD NSTRUCTORS' CONSTRUCTOR FERRARI	CUP	1
S. D St 10 RIV S. D st 11 RIV	PRIVER ALAN JONES NELSON PIQUET Scores from 14 races to VERS' WORLD CH DRIVER NELSON PIQUET CARLOS REUTEMANN scores from 15 races to VERS' WORLD CH DRIVER	IAMPION NAT. AUT BRA count IAMPION NAT. BRA ARG count IAMPION NAT.	ASHIP 1980 CONSTRUCTOR WILLIAMS-FORD BRABHAM-FORD NSHIP 1981 CONSTRUCTOR BRABHAM-FORD WILLIAMS-FORD NSHIP 1982 CONSTRUCTOR	PTS 67 54 PTS 50 49 PTS		POS. 1 2 CO POS. 1 2	CONSTRUCTOR WILLIAMS-FORD LIGIER-FORD NSTRUCTORS' CONSTRUCTOR WILLIAMS-FORD BRABHAM-FORD NSTRUCTORS' CONSTRUCTORS'	CUP	1

DR	VERS' WORLD CI	HAMPION	ISHIP 1983	
POS.	DRIVER	NAT.	CONSTRUCTOR	PTS
1	NELSON PIQUET	BRA	BRABHAM-BMW	59
2	ALAIN PROST	FRA	RENAULT	57
Best	11 scores from 15 races to	count		
DR	VERS' WORLD C	HAMPION	ISHIP 1984	
POS.	DRIVER	NAT.	CONSTRUCTOR	PTS
1	NIKI LAUDA	AUT	McLaren-Porsche	72
2	ALAIN PROST	FRA	McLaren-Porsche	71.5
Best	11 scores from 16 races to	count		
DR	IVERS' WORLD C	HAMPION	ISHIP 1985	
POS.	DRIVER	NAT.	CONSTRUCTOR	PTS
1	ALAIN PROST	FRA	McLaren-Porsche	73
2	MICHELE ALBORETO	ITA	FERRARI	53
Best	11 scores from 16 races to	count		
DR	IVERS' WORLD C			
			CONSTRUCTOR	PTS
POS.	DRIVER	NAT.		
POS.	ALAIN PROST	FRA GBR	MCLAREN-PORSCHE WILLIAMS-HONDA	72 70

DRI	VERS' WORLD C	HAMPION	ISHIP 1987	
POS.	DRIVER	NAT.	CONSTRUCTOR	PT:
1	NELSON PIQUET	BRA	WILLIAMS-HONDA	7:
	NIGEL MANSELL	GBR	WILLIAMS-HONDA	6

POS.	DRIVER	NAT.	CONSTRUCTOR	PTS
1	AYRTON SENNA	BRA	McLaren-Honda	90
2	ALAIN PROST	FRA	McLaren-Honda	87

POS.	DRIVER	NAT.	CONSTRUCTOR	PTS
1	ALAIN PROST	FRA	MCLAREN-HONDA	76
2	AYRTON SENNA	BRA	McLaren-Honda	60

COL	NSTRUCTORS' CU	P
	CONSTRUCTOR	PTS
1	WILLIAMS-FORD	120
2	LIGIER-FORD	66
COL	NSTRUCTORS' CU	
POS.		PTS
1	WILLIAMS-FORD	95
2	BRABHAM-FORD	61
	NSTRUCTORS' CU	
POS.	CONSTRUCTOR	PTS
1	FERRARI _	74
2	McLaren-Ford	69
-	NSTRUCTORS' CU	В
POS		PTS
1	FERRARI	89
2	RENAULT	79
COI	NSTRUCTORS' CU	P
	CONSTRUCTOR	PTS
1	McLaren-Porsche	143.5
2	FERRARI	57.5
COI	NSTRUCTORS' CU	P
POS.	CONSTRUCTOR	PTS
1	McLaren-Porsche	90
2	FERRARI	82

1	WILLIAMS-HONDA	141
2	McLaren-Porsche	96

POS.	CONSTRUCTOR	PTS
1	WILLIAMS-HONDA	137
2	McLaren-Porsche	76

col	NSTRUCTORS'	UP
POS.	CONSTRUCTOR	PTS
1	MCLAREN-HONDA	199
2	FERRARI	65

COI	NSTRUCTORS' CU	P
POS.	CONSTRUCTOR	PTS
1	MCLAREN-HONDA	141
2	WILLIAMS-RENAULT	77

THE NINETI

DRIVERS' WORLD CHAMPIONSHIP 1990							
POS.	DRIVER	NAT.	CONSTRUCTOR	PTS			
1	AYRTON SENNA	BRA	MCLAREN-HONDA	78			
2	ALAIN PROST	FRA	FERRARI	71			
Best	Best 11 scores from 16 races to count						

CONSTRUCTORS' CUP							
POS.	CONSTRUCTOR	PTS					
1	McLaren-Honda	121					
2	FERRARI	110					

	DRIVER	NAT.	ISHIP 1991 CONSTRUCTOR	PTS			NSTRUCTORS' CU	
	AYRTON SENNA	BRA	MCLAREN-HONDA	96		1	CONSTRUCTOR MCLAREN-HONDA	
	NIGEL MANSELL	GBR	WILLIAMS-RENAULT	72		2	WILLIAMS-RENAULT	1
sc	ores counted			, =		_	WILLIAMS-RENAULI	
	VERS' WORLD CHA	AMPION	ISHIP 1992			co	NSTRUCTORS' CU	P
3.	DRIVER	NAT.	CONSTRUCTOR	PTS			CONSTRUCTOR	
	NIGEL MANSELL	GBR	WILLIAMS-RENAULT	108		1	WILLIAMS-RENAULT	
sc	RICCARDO PATRESE	ITA	WILLIAMS-RENAULT	56		2	MCLAREN-HONDA	
۲ I	VERS' WORLD CHA	AMPION	ISHIP 1993			-	NSTRUCTORS' CU	_
	DRIVER	NAT.	CONSTRUCTOR	PTS			CONSTRUCTOR	P
	ALAIN PROST	FRA	WILLIAMS-RENAULT	99		1	WILLIAMS-RENAULT	
	AYRTON SENNA	BRA	MCLAREN-FORD	73		2	MCLAREN-FORD	
sc	ores counted					_	MCEAREN-I ORD	
	VERS' WORLD CHA					co	NSTRUCTORS' CU	Р
	DRIVER	NAT.	CONSTRUCTOR	PTS			CONSTRUCTOR	
	MICHAEL SCHUMACHER	GER	BENETTON-FORD	92		1	WILLIAMS-RENAULT	
sc	DAMON HILL ores counted	GBR	WILLIAMS-RENAULT	91		2	BENETTON-FORD	
21	VERS' WORLD CHA	MPION	ISHIP 1995			-	NSTRUCTORS' CUI	_
	DRIVER	NAT.	CONSTRUCTOR	PTS			CONSTRUCTOR	-
	MICHAEL SCHUMACHER	GER	BENETTON-RENAULT	102		1	BENETTON-RENAULT	
	DAMON HILL	GBR	WILLIAMS-RENAULT	69		2	WILLIAMS-RENAULT	1
sc	ores counted					_	WILLIAMS KENASEI	
	VERS' WORLD CHA		ISHIP 1996			co	NSTRUCTORS' CU	P
	DRIVER	NAT.	CONSTRUCTOR	PTS		POS.	CONSTRUCTOR	E1895
	DAMON HILL	GBR	WILLIAMS-RENAULT	97		1	WILLIAMS-RENAULT	
	JACQUES VILLENEUVE	CAN	WILLIAMS-RENAULT	78		2	FERRARI	
	ores counted							
	VERS' WORLD CHA						NSTRUCTORS' CUI	P
	DRIVER	NAT.	CONSTRUCTOR	PTS			CONSTRUCTOR	
	JACQUES VILLENEUVE HEINZ-HARALD FRENTZEN	CDN GER	WILLIAMS-RENAULT	81		1	WILLIAMS-RENAULT	1
s	chumacher's points were ann		WILLIAMS-RENAULT e FIA for his wreckless driving in	42 the final		2	FERRARI	1
	of the season, at Jerez.							
• (VEDS! WOD! D S.					CO	NSTRUCTORS' CUI	Р
21	VERS' WORLD CHA							
1	DRIVER	NAT.	CONSTRUCTOR	PTS			CONSTRUCTOR	
1	DRIVER MIKA HAKKINEN	NAT. FIN	CONSTRUCTOR MCLAREN-MERCEDES	100		1	MCLAREN-MERCEDES	
I	DRIVER	NAT.	CONSTRUCTOR					1
RI Sc	DRIVER MIKA HAKKINEN MICHAEL SCHUMACHER ores counted VERS' WORLD CHA	NAT. FIN GER	CONSTRUCTOR MCLAREN-MERCEDES FERRARI	100		1 2	McLaren-Mercedes Ferrari	1
e c	DRIVER MICHAEL SCHUMACHER OTES COUNTED VERS' WORLD CHA DRIVER	NAT. FIN GER AMPION NAT.	CONSTRUCTOR MCLAREN-MERCEDES FERRARI	100		1 2	MCLAREN-MERCEDES FERRARI NSTRUCTORS' CUI	1 1
e c	DRIVER MICHAEL SCHUMACHER OTES COUNTED VERS' WORLD CHA DRIVER MIKA HAKKINEN	NAT. FIN GER AMPION NAT. FIN	CONSTRUCTOR MCLAREN-MERCEDES FERRARI	100 86		1 2	McLaren-Mercedes Ferrari	1 1 P
RI.	DRIVER MICHAEL SCHUMACHER OTES COUNTED VERS' WORLD CHA DRIVER	NAT. FIN GER AMPION NAT.	CONSTRUCTOR MCLAREN-MERCEDES FERRARI SHIP 1999 CONSTRUCTOR	100 86 PTS		1 2 CO POS.	MCLAREN-MERCEDES FERRARI NSTRUCTORS' CUI CONSTRUCTOR	1 1

DR	IVERS' WORLD CHA	MPION	SHIP 2000				CO	NSTRUCTORS' CU	D
POS.	DRIVER	NAT.	CONSTRUCTOR	PTS			POS.		PTS
1	MICHAEL SCHUMACHER	GER	FERRARI	108			1	FERRARI	170
2	MIKA HAKKINEN	FIN	McLaren-Mercedes	89			2	MCLAREN-MERCEDES	152
All s	cores counted							meant mendebes	132
DR	IVERS' WORLD CHA	MPION	SHIP 2001				CO	NSTRUCTORS' CU	P
POS.	DRIVER	NAT.	CONSTRUCTOR	PTS			POS.		PTS
1	MICHAEL SCHUMACHER	GER	FERRARI	123			1	FERRARI	179
2	DAVID COULTHARD	GBR	McLaren-Mercedes	65			2	MCLAREN-MERCEDES	102
All s	cores counted								102
DR	IVERS' WORLD CHA	MPION	SHIP 2002				COI	NSTRUCTORS' CU	P
POS.	DRIVER	NAT.	CONSTRUCTOR	PTS			POS.		PTS
1	MICHAEL SCHUMACHER	GER	FERRARI	144			1	FERRARI	221
2	RUBENS BARRICHELLO	BRA	FERRARI	77			2	WILLIAMS-BMW	92
All so	cores counted								
DR	IVERS' WORLD CHA	MPION	SHIP 2003				COL	NSTRUCTORS' CU	ь
POS.	DRIVER	NAT.	CONSTRUCTOR	PTS			POS.		PTS
1	MICHAEL SCHUMACHER	GER	FERRARI	93			1	FERRARI	158
2	KIMI RAIKKONEN	FIN	McLaren-Mercedes	91			2	WILLIAMS-BMW	144
All so	cores counted						_	WILLIAMS BINV	144
DR	IVERS' WORLD CHA	MPION	SHIP 2004				COL	NSTRUCTORS' CUI	ь
POS.	DRIVER	NAT.	CONSTRUCTOR	PTS			POS.		PTS
1	MICHAEL SCHUMACHER	GER	FERRARI	148			1	FERRARI	262
2	RUBENS BARRICHELLO	BRA	FERRARI	114			2	BAR-HONDA	119
All so	cores counted						_		113

DRIVERS' WORLD CHA	MPION	SHIP 2005	
POS DRIVER	NAT.		PTS
1 FERNANDO ALONSO	ESP	RENAULT	133
	FIN	MCLAREN-MERCEDES	112
All scores counted			
All scores counted			
DRIVERS' WORLD CHA	MPION	SHIP 2006	
POS. DRIVER	NAT.	CONSTRUCTOR	PTS
1 FERNANDO ALONSO	ESP	RENAULT	134
2 MICHAEL SCHUMACHER	GER	FERRARI	121
All scores counted			
DRIVERS' WORLD CHA	MPION	SHIP 2007	
POS. DRIVER	NAT.	CONSTRUCTOR	PTS
1 KIMI RAIKKONEN	FIN	FERRARI	110
2 LEWIS HAMILTON	GBR	McLAREN-MERCEDES	109
All scores counted			
DRIVERS' WORLD CHA	MPION	SHIP 2008	
POS. DRIVER	NAT.	CONSTRUCTOR	PTS
1 LEWIS HAMILTON	GBR	MCLAREN-MERCEDES	98
2 FELIPE MASSA	BRA	FERRARI	97
All scores counted			
DRIVERS' WORLD CHA	MPION		
POS. DRIVER	NAT.		PTS
1 JENSON BUTTON	GBR		95
2 SEBASTIAN VETTEL	GER	RED BULL-RENAULT	84
All scores counted			

COL	NSTRUCTORS' CUP	
POS.	CONSTRUCTOR	PTS
1	RENAULT	191
2	MCLAREN-MERCEDES	182
COL	NSTRUCTORS' CUP	
POS.	CONSTRUCTOR	PTS
1	RENAULT	206
2	FERRARI	201
601	NSTRUCTORS' CUP	
POS.	00110111001101	PTS
1	FERRARI	204
2	BMW SAUBER	101
COI	NSTRUCTORS' CUP	
POS.	CONSTRUCTOR	PTS
1	FERRARI	172
2	MCLAREN-MERCEDES	151
CO	NSTRUCTORS' CUP	
POS.		PTS
1	BRAWN-MERCEDES	172
2	RED BULL-RENAULT	
2	KED BOLL-KENAOLI	. 55.5

THE TEENS

DRI	VERS' WORLD CHA	MPION	SHIP 2010		
POS.	DRIVER	NAT.	CONSTRUCTOR	PTS	
1	SEBASTIAN VETTEL	GER	RED BULL-RENAULT	256	
2	FERNANDO ALONSO	ESP	FERRARI	252	
_	cores counted				
DRI	VERS' WORLD CHA	MPION	SHIP 2011		
	DRIVER	NAT.	CONSTRUCTOR	PTS	
1	SEBASTIAN VETTEL	GER	RED BULL-RENAULT	392	
	JENSON BUTTON	GBR	McLAREN-MERCEDES	270	
	cores counted				
DR	IVERS' WORLD CHA	MPION			
POS.	DRIVER	NAT.		PTS	
1	SEBASTIAN VETTEL		RED BULL-RENAULT	281	
2	FERNANDO ALONSO	ESP	FERRARI	278	
All so	cores counted				
		MOLON	CHID 2012		
	IVERS' WORLD CHA			PTS	
POS.	DRIVER	NAT.		397	
1	SEBASTIAN VETTEL			242	
_	FERNANDO ALONSO	ESP	FERRARI	242	
All so	cores counted				
DR	IVERS' WORLD CHA	MPION	SHIP 2014		
POS.		NAT.	CONSTRUCTOR	PTS	
1	LEWIS HAMILTON	GBR	MERCEDES	384	
	NICO ROSBERG	GER	MERCEDES	317	
All s	cores counted				

CON	ISTRUCTORS' CUP	
POS.	CONSTRUCTOR	PTS
1	RED BULL-RENAULT	496
2	MCLAREN-MERCEDES	454
CON	ISTRUCTORS' CUP	
POS.	CONSTRUCTOR	PTS
1	RED BULL-RENAULT	650
2	MCLAREN-MERCEDES	497
	ISTRUCTORS' CUP	
POS.		PTS
1	RED BULL-RENAULT	460
2	FERRARI	400
CON	ISTRUCTORS' CUP	
POS.		PTS
1	RED BULL-RENAULT	596
2	MERCEDES	360
	ISTRUCTORS' CUP	
POS.	CONSTRUCTOR	PTS
1	MERCEDES	701
2	RED BULL-RENAULT	405

The publishers would like to thank the following sources for their kind permission to reproduce the pictures in this book:

Action Images: /Sporting Pictures; Diana Burnett; Getty Images; LAT Photographic: /Lorenzo Bellanca: 263R, 295R, 298-299, 300, 302B, 312-313; /Charles Coates: 1, 307T, 311T, 317B, 322B, 323; /Glenn Dunbar: 265, 299R, 306, 326T, 326B, 338, 339R; /Steve Etherington: 10, 261, 262, 263L, 294, 296, 307B, 308, 311, 316R, 320, 327, 331B, 335, 339T, 339B; /Andrew Ferraro: 258-259, 302T, 319, 322T, 324, 328, 330, 332; /Andy Hone: 2, 8-9, 315, 331T; /Alastair Staley: 310, 334T, 336; /Steven Tee: 4, 6-7, 292, 295L, 303, 304, 317T, 334B; Ludvigsen Library Ltd; Mirrorpix.com; ©Phipps Photographic; Nigel Snowdon.

Every effort has been made to acknowledge correctly and contact the source and/copyright holder of each picture, and Carlton Books Limited apologises for any unintentional errors or omissions, which will be corrected in future editions of this book.

Extended thanks are due to Zoë Schafer at LAT Photographic whose efforts greatly rendered the burdens of picture research. Also to David Phipps for all his help and co-operation with this project.